The Oliver Stone Experience

The Oliver Stone Experience

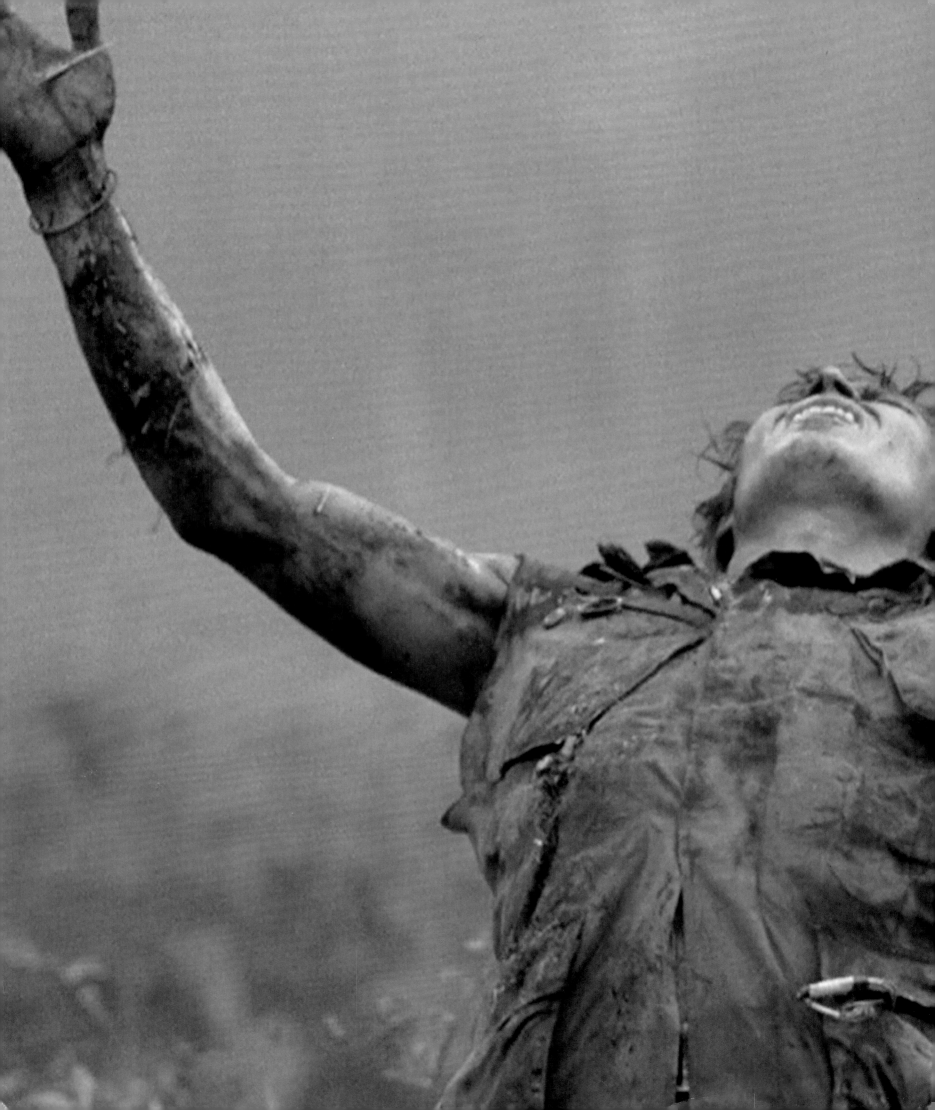

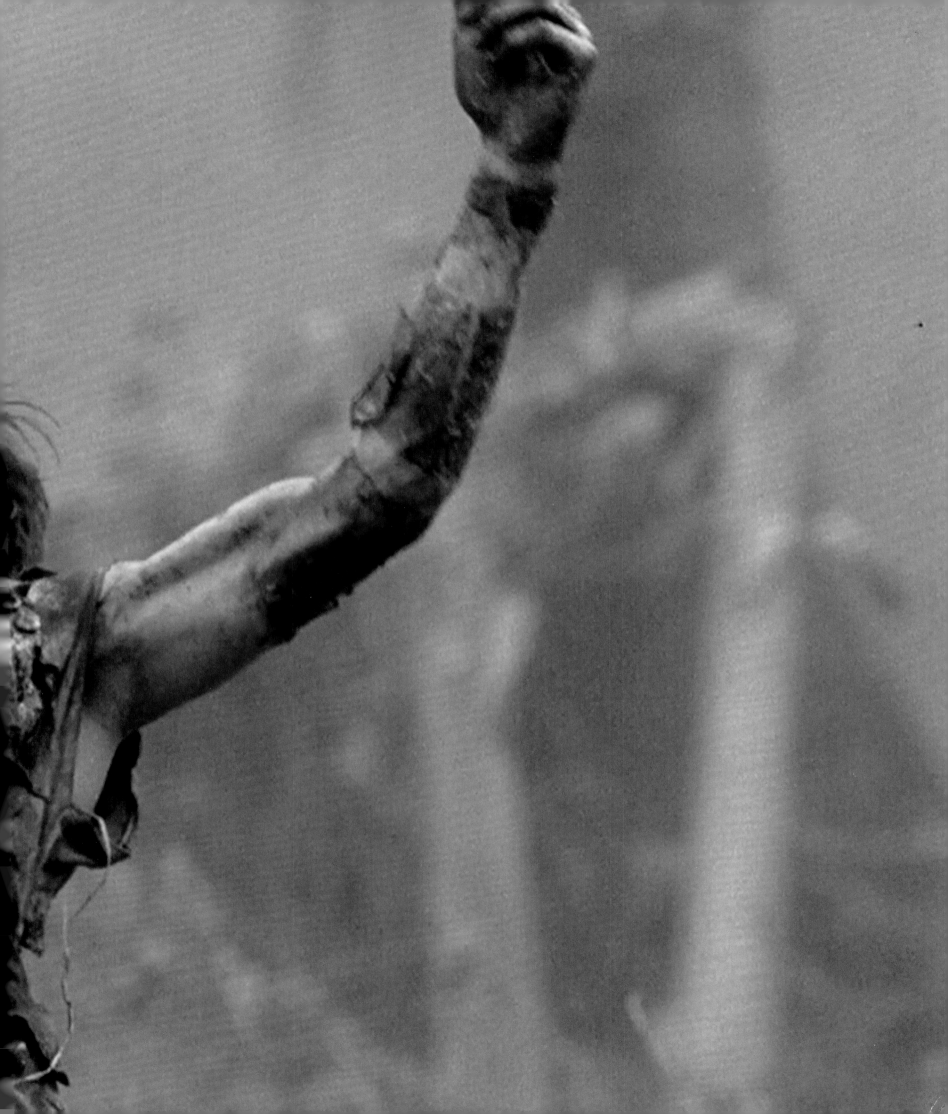

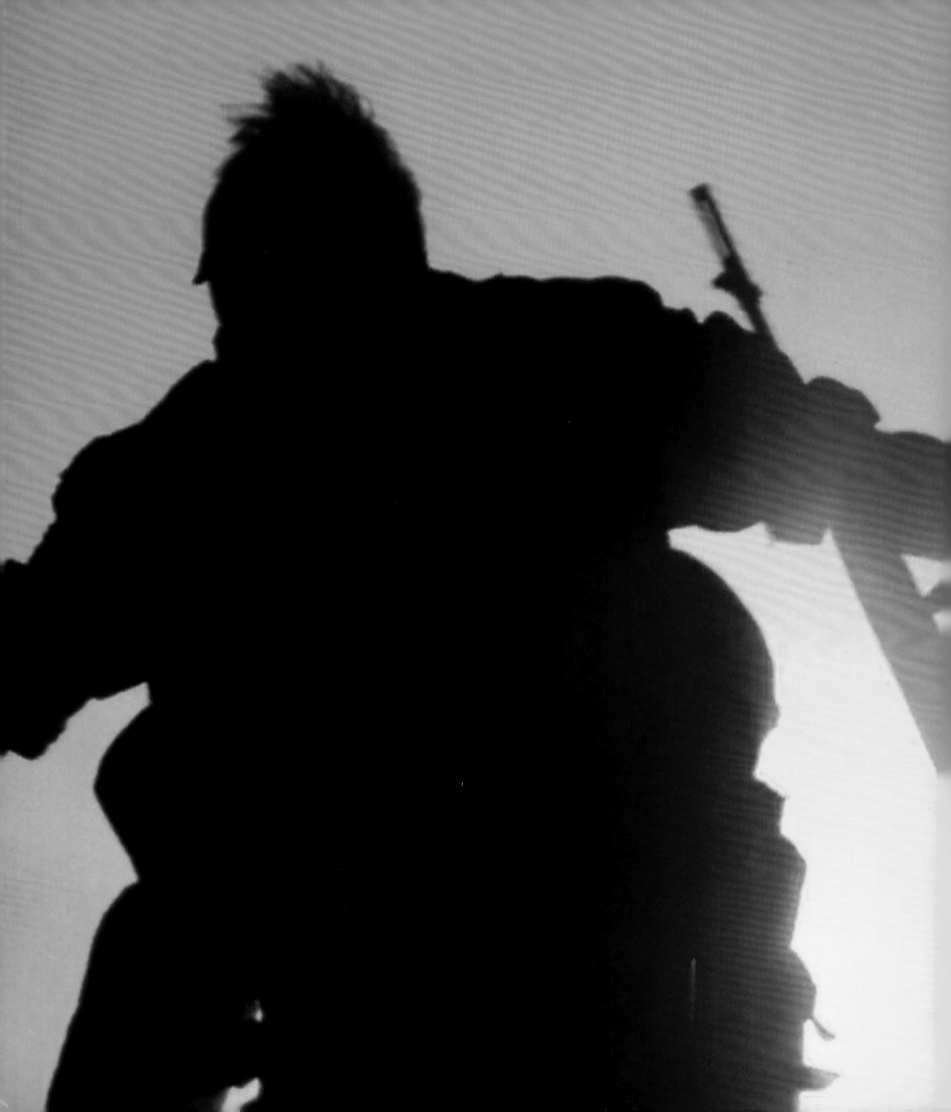

The Oliver Stone Experience

The Oliver Stone Experience

by **Matt Zoller Seitz**

Foreword by **Ramin Bahrani**

Introduction by **Kiese Laymon**

The Oliver Stone Experience

Contents

The Oliver Stone Experience

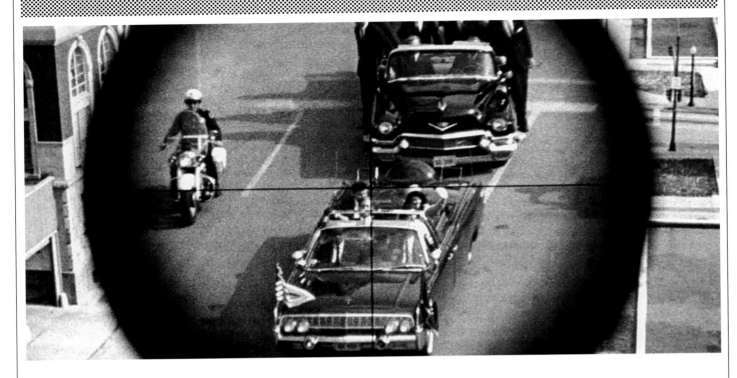

......... RAMIN BAHRANI

Platoon, Wall Street, Born on the Fourth of July, JFK, Natural Born Killers, The Untold History of the United States. These works, by Oliver Stone, are giant films, iconic films of exceptional artistry and social, political, and metaphysical power. If an alien being came to earth and felt confused as to where it was, these films would stand like monoliths, like massive pools of human reflection, the way we consider great works of literature and drama—like *Lord Jim* or *Death of a Salesman*.

Very few filmmakers anywhere in the world can claim they've made films that captured the mood and ideology of an entire decade of their society. If I step outside my apartment, stop any random strangers, and say, "Greed is good," there's a good chance they will know exactly what I am talking about.

Many know Oliver Stone as a political and social filmmaker whose work has often created polarizing controversy. As a filmmaker myself, I know Stone as one of the most important filmmakers of the last forty years in American cinema—or globally, for that matter. His blistering writing, frenetic staging, bold and muscular use of camera, multi-format shooting techniques, and astonishingly innovative editing have pushed the boundaries of how films and television are made. His films have inspired a generation of filmmakers, and I am one of them.

The first Oliver Stone film I saw was *JFK*. I was a teenager, maybe sixteen, and wasn't fully invested in cinema yet. I went because, like so many, I sensed that this was an important film.

Not only was I riveted for three hours, but I left the cinema with a feeling that I was walking through shadows, and at any moment could be pulled into them by forces too powerful for me to fend off. The film was a fever dream of bewildering energy and masterful craftsmanship. Stone knocked us into a nightmare that was cleverly presented as a detective story.

The structure is so simple and single-minded, yet so elaborate and complex. Jim Garrison's goal is to prove there was more than one shooter and to ask who else was behind the assassination. For three straight hours, the film piles on facts, details, questions—in 35 mm, 16 mm, Super 8 mm, color, and black and white. That a film of such scope and complexity could move so relentlessly toward one simple goal is mind-boggling.

Technically the film is a marvel. The editing of *JFK* is wholly original and revolutionary for mainstream narrative film-making. Stone sometimes cuts to a shot for three seconds or even just three frames (images we may have never seen or need to see again!) to build the framework of both the film and Garrison's case. I will always contend that the greatest modern American directors who are also master editors are Martin Scorsese and Oliver Stone.

After seeing *JFK*, I quickly dived into Stone's films, starting with *Platoon* (how did he make *Salvador* that same year?!), a film so authentic that it was obviously made by a man who had fought in the war. What struck me most about *Platoon* was the mood in the soldiers' camp—the authenticity of the music, the sets, the language, the issues of race—and the total chaos of the men in the jungles. The battle was happening everywhere and at all times. There was no clear sense of where the enemy was or who was shooting at whom. Sometimes it was too dark or too blindingly bright for the men to understand what was happening. The soldiers staggered about like zombies, burned out by lack of sleep, zapped of all energy and patience by the bugs; the slightest itch could make them pull the trigger and kill anything or anyone for any or no reason whatsoever. This was not my generation's war, but Stone's film made it alive and visceral in ways that haunted me.

This aggressive, chaotic sense that anything could happen and the entire world was out of control remains a central quality in many of Stone's greatest films, and *Born on the Fourth of July* is no exception. The film's hero, Ron Kovic, arrives on the dusty beaches of Vietnam and is immediately blinded by the sun and sweat in his eyes. The 360 degrees of chaos is made palpable by Stone's fast-moving camera with CinemaScope lensing. I had never seen the camera move on that lens with that speed in any film prior to this. The impact was intense and unforgettable.

The sequences of Kovic in the hospital are worse than any of Kafka's dreams, and all the more terrifying as we know they are based on reality. The film is epic in scope, deeply personal, political, and metaphysical. The camera movements, editing, use of sound and music, and deep attention to production design, color, and transitions over decades are the work of a master—it's surreal that Stone made this epic tour de force and *Talk Radio* just a year apart, as if he had some mysterious twin who has been directing every other film for him!

Stone returned to Vietnam to make his moving and philosophical *Heaven & Earth*. Then, he pushed the techniques he had been developing to radical extremes and new heights in *Natural Born Killers*, a film that left an indelible mark on American cinema and is often cited among the top ten most controversial films of all time. Although Stone was in his late forties by the time he made it, the modernity of *NBK* makes it feel like the product of a filmmaker half that age raised on trash television. The film's ferocious energy and radical stylization recall Kubrick's shocking filmmaking in *A Clockwork Orange* (Kubrick was also in his forties when he made that film). I watched *NBK* again recently, and when Stone cuts to a nightmarish sitcom of Mallory's childhood with the stand-up comic Rodney Dangerfield as the demented father, I was stunned. The film premiered more than twenty years ago, but it feels like it was made yesterday.

Stone talks about the volatile reactions to *JFK* and *NBK* as career altering for him. He believes that critics, members of the press, and the film industry unfairly turned on him after these films. Much of this vitriolic harangue has been documented.

But like all great natural-born filmmakers, Stone was undeterred. He remains a beacon to filmmakers to this day. Since *NBK* he has directed more than ten other features and produced or written about a dozen more. They include the richly impressive *Nixon*, a character study of Shakespearean ambition, and the football drama *Any Given Sunday*, a modern mythical version of the ancient gladiators told with startlingly experimental techniques of sound and style.

Perhaps most exciting has been Stone's late interest in documentary filmmaking, starting with *Comandante*. I was especially taken with the searching quality of *South of the Border*, where the digital filmmaking and small crew allowed for wonderfully light moments of improvisation with Stone and his subjects. For *The Untold History of the United States*, a twelve-part Showtime documentary series accompanied by a book, Stone and his collaborator, the history professor Peter Kuznick, spent years researching an alternative to the history that so many Americans have been taught in high school and beyond.

Like Werner Herzog and Robert Altman (someone should please curate a film series "Altman & Stone—Visions on America" as soon as possible! One double bill could be *M*A*S*H* and *Born on the Fourth of July*), Stone keeps generating work, despite the system. And like a good foot

soldier, he always finds his way back in—most recently with *Snowden*, a biography of the man who blew the whistle on the National Security Agency's illegal surveillance of citizens. It is the perfect character and subject matter for Stone to discover and uncover with his camera.

In the last few years, I have been lucky enough to meet and spend time with Stone. His curiosity, passion, hunger, and work ethic are more intense and energetic than those of most young filmmakers I've met. I wanted to let him know that his seminal film *Wall Street* had deeply impacted my film *99 Homes*. I wanted to discuss many things, including his early career as a successful screenwriter (*Midnight Express*, and *Scarface*, among others) and the perseverance and determination he displayed after initial failures to launch his career as a director (with *Seizure* and *The Hand*), and how literature played a crucial role in his adventurous life.

This is a man who made pretty much one film every year—sometimes two!—for more than a decade. Not just any films, but wildly ambitious, deeply political, challenging, meaningful films that were uncharacteristic of the studios in that era (and today). The force of will required to achieve this remains an inspiration to me.

Oliver Stone has done what very few filmmakers have been able to accomplish—make big-budget pictures that reflect his own revolutionary vision as a filmmaker and artist. And his journey is not over yet.

Like the young man who went to Vietnam as an infantryman, Stone is still searching for reinvention, experience, knowledge, and cinematic expressions. I imagine him as Caspar David Friedrich's *Wanderer above the Sea of Fog*, carrying Picasso's *Guernica* under his arm, and pulsing with the wild energy of Jackson Pollock. His cinema of the next decade will inevitably surprise and astonish us, and will most certainly burn its mark into the fabric of the country, igniting a fire in the hearts and imaginations of filmmakers and moviegoers for years to come.

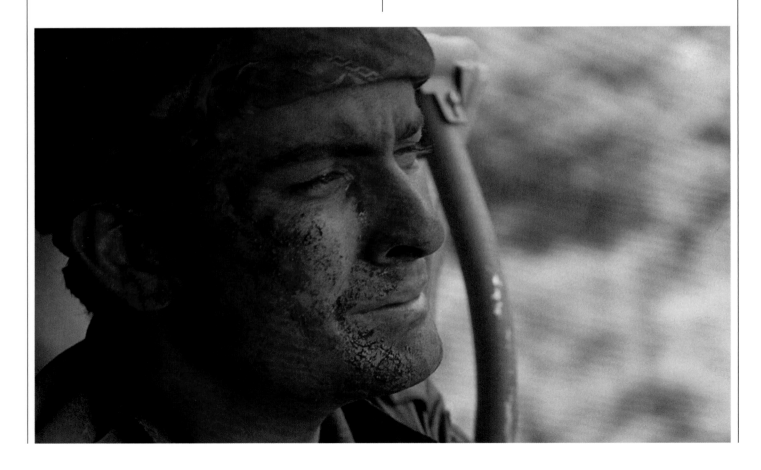

The Oliver Stone Experience

......... KIESE LAYMON

When I told my friend I was writing a piece about Oliver Stone, she laughed and said, "What else did he do other than *Malcolm X?*" My friend, an accomplished writer and teacher, knew that *Malcolm X* was Spike Lee's masterpiece and not Stone's, though Stone had supported Lee in his battle with Warner Bros. over length, and contributed motorcade footage from *JFK* for Lee's assassination sequence. But for many other black filmgoers I've talked to in the past two decades, *Malcolm X* fell snugly in the Oliver Stone genre, not just because, like *The Doors, JFK, Nixon, Alexander*, and *W.*, it was a huge biopic, but because it was a huge biopic that at least partially aimed to warn white American men that the past is never the past, and that their crumbling interior lives, and crumbling standing in the world, was an inevitable consequence of refusing to reckon with their investment in American empire.

By twenty-three, I decided I was going to be a black American writer. I didn't know for sure what that meant, but I assumed it meant spending a lot of time using a pen and the blank page warning American white men of how their failures impacted the rest of us. As much as I found influence and inspiration in Baldwin and Morrison, I was obsessed with Stone's film interviews. When I should have been writing or reading, I watched Stone talk about this idea of America denying its original sins, and spreading an innocent evil through the nation and the world. I questioned whether Stone could be fully invested in how black women and men saw the world.

Although he talked in interview after interview about the nation's crimes against Native Americans, blacks, immigrants, women, and the citizens of other countries, his art seemed unable to imagine us as sole facilitators of white men's morality. As a native black Mississippian, I found Oliver Stone to be the closest storyteller I had to Faulkner. And just like with Faulkner's novels, I went into every Oliver Stone movie looking to find something that made me mad at his white elite masculinity. For nearly fifteen years, I took pride in knowing that Oliver Stone's father was an investment banker,

that Stone was raised by nannies and went to prep school. Of course, I told myself, he was obsessed with *Catcher in the Rye*. When I found out his father paid for Stone's first sexual experience with a sex worker from New Jersey named Robin, I had everything I needed to secure my cynicism. I didn't need to know he went to Yale. Didn't need to know that when all the hippie folks around him hated Nixon, Stone was a closet Republican, still indebted to his father's values and perceived wisdom.

Then I learned that Oliver Stone went to Central America in the eighties on a fact-finding mission with Richard Boyle, the real person *Salvador* is about, because he saw parallels between what was happening in Central America and what had happened in Vietnam. Far more than using film to simply hold other white men accountable, I realized, Stone was actually using film to judge himself and his conditioning. I wondered if Stone, like Faulkner, while a student of a very different, regionally shaped narrative, was attempting to dissociate himself from spoiled white American masculine power, in the hopes of shocking other white people into going on a journey like the one that he's been on for nearly five decades now.

This is nowhere more evident than a scene from *Natural Born Killers* where Wayne Gale (Robert Downey Jr.) is interviewing Mickey Knox (Woody Harrelson). A prison cell, filled with uniformed white men, lots of long guns, and two white women, is the site of the interrogation. Sitting adjacent to Mickey and Wayne is the film's embodiment of evil, a prison warden played by Tommy Lee Jones. While the interaction between Downey and Harrelson shows us how potentially evil and "like the weather" American media can be, Stone's use of Mallory (Mickey's wife, played by Juliette Lewis), the camera itself, television, and the incarcerated black and brown men in the prison watching the interview might be the most breathtaking example of how inward looking his critique of the nation is.

"Everyone got the demon in here," Mickey says in the interview. "It feeds on your hate. Cuts, kills, rapes. It uses your weakness, your fears. Only the vicious survive here. We all know we're no good pieces of shit from the time we could breathe. After a while, you become bad. . . . You know the only thing that kills the demon, Wayne? Love. That's why I know that Mallory's my salvation. She was teaching me how to love."

Though I've watched the film at least fifteen times, it wasn't until grand juries failed to indict police officers in Ferguson, Missouri, and Staten Island, New York, that I realized that Oliver Stone was dismantling the interrogation clichés by framing the scene as your experience of the incarcerated men's experience of Mickey, Wayne, and Oliver Stone's own reckoning. Stone invites the viewer to sit in judgment of the white American men's conditioning, not because the white American men's position is the important one, but because it's a *defining*, *deadly*, and *pitiful* one. In the interrogation scene, we learn that an old Native American man and a white woman are the real facilitators of the white American hero's long-deferred moral development. In the flashback, we see Mallory, thrusting her finger into Mickey's chest after he's killed the Native American man.

"Bad, bad, bad," she says.

It was "bad, bad, bad," I heard Oliver Stone saying primarily to white American men for the last twenty years. And "bad, bad, bad" that I finally heard him saying to himself and his conditioning through *Natural Born Killers*.

"It is a peculiar sensation, this double-consciousness," W. E. B. DuBois wrote in 1903. "This sense of always looking at one's self through the eyes of others, of measuring one's soul by the tape of a world that looks on in amused contempt and pity." DuBois wrote about black American "two-ness,—an American, a Negro; two souls, two thoughts, two unreconciled strivings; two warring ideals in one dark body, whose dogged strength alone keeps it from being torn asunder."

The spoiled white American man's *innocent* gaze—an extension of his abusive power and irresponsible handling of history—has necessitated this double consciousness, and also necessitated that dark bodies of women and men be torn asunder, while the character of white American men be easily cast as clearly bad or good. Stone has, however, made a career targeting the bifurcated consciousness of white American men, smashing bifurcated notions of innocent or evil. His work and his critiques of the way white men have gone about making this country constantly summon James Baldwin, who wrote, "People pay for what they do, and, still more, for what they have allowed themselves to become. And they pay for it very simply: by the lives they lead."[1]

We see this most glaringly in Stone's white heroic depictions, like the hero of *Platoon*, realizing that he has to pick a side and kill the representative of "the machine." We see this in the hero of *Wall Street* selling good fathers,

including his blood father, to get in good with Michael Douglas. We see it in the hero in *Born on the Fourth of July*, buckling under a superior officer's pressure to lie about battlefield atrocities, then rising up years later to oppose the entire war effort.

Nearly as important as Stone's cinematic heroes are the characters who are unable to escape the conditioning Stone has been railing against his entire artistic life. *Nixon*, for instance, depicts a servant of the machine, or as Nixon calls it, "the Beast." His conditioning cannot be undone. The husband of the heroine in *Heaven & Earth*, who can't stay out of Vietnam—can't stop making war and being a part of the machine—finally blows his brains out. Most recently, there's the title character in *W.*, who never really questions anything except his own need to prove himself different from his father, and ends up leading the nation into another Vietnam. All these white men, unlike the men (and women) who choose to watch Stone's films, and ultimately unlike Stone himself, have chosen their path and can't or won't abandon it. They are irrecoverable.

This might be what connects Oliver Stone to parts of most Americans, regardless of race, class, or gender: The life of the nation that his movies scrutinize is filled with successes of one kind or another, but it is ultimately a story of national and personal failure. In urging us to disbelieve Americans' version of American history, and in specifically telling elite white American men not to shackle themselves to what their fathers taught them, Stone is telling everyone who watches his films to question who they are and how they came to be, and recognize the cost of being who this nation wants them to become.

"Fuck you and fuck your order," Stone is cinematically yelling, crying, moaning over and over again. Stone talks in interviews about the pieces of twisted shrapnel lining the inside of his leg and ass. The shrapnel, he says, is a result of a satchel charge that went off too close to him in Vietnam. He has used his films to discover, in effectively brutal ways, exactly how the material remnants of terror, war, and empire find homes in bodies like his.

Stone is a perpetual failing crusader who never ever stops warning, and really teasing, Americans about the importance of the next crusade, a different kind of crusade. His journey to improve himself as an American and a man has been ongoing, and it has been twinned with his crusade as an artist to demand that the country's ruling elite take responsibil-

ity for its own crimes and cover-ups. Acknowledging one's complicity is not enough in the art and mind of Oliver Stone; he is much more interested in how to undo the harm done to ourselves, and the world. I don't know that there's another American filmmaker, at nearly seventy, who feels as much like a work in progress as Oliver Stone. He seems to believe that he can never be successful in his own quest if his country continues to fail. This is part of the generous genius and tragedy of Oliver Stone.

In *Platoon*, the character Elias tells Chris Taylor, the character closest to Oliver Stone, "We've been kicking other people's asses for so long, I figure it's about time we got ours kicked." Getting our American asses kicked, in the art of Oliver Stone, has never simply meant being pummeled into specks of red, white, or blue dust. It has, however, always suggested a kind of pedagogical mangling where we viewers are violently taught that we must change the future by courageously reckoning with our personal and national past. Stone has ritualized the work of making that American part of all of us more aware of, and responsible to, our power and our past.

His greatness is his audacity, which lies partially in his talent as a skilled storyteller, but mostly in his ability to explore and exploit his moral mediocrity while standing utterly unafraid of looking at how bad, bad, bad our nation has made you, him, and me. With every film, one gets the sense that Stone wonders, with all his rabble-rousing, if he has even made a difference in the way we Americans see ourselves. For nearly forty years, Stone has never ceased beating a drum of artistic and cultural reform for a nation of people passively sipping sugar water, slowly killing ourselves and others, and wiping popcorn-buttered hands on our shirts made in China. Stone will never give up, though we may never really listen. This is his American greatness.[2]

1 James Baldwin, *No Name in the Street* (New York: Penguin, 1972).

2 Oliver Stone says he agrees with most of the sentiments in this essay, but worries that it is too pessimistic in describing his view of America's potential for reform: "There are things that I mourn in American history, but also things that I celebrate."

The Oliver Stone Experience

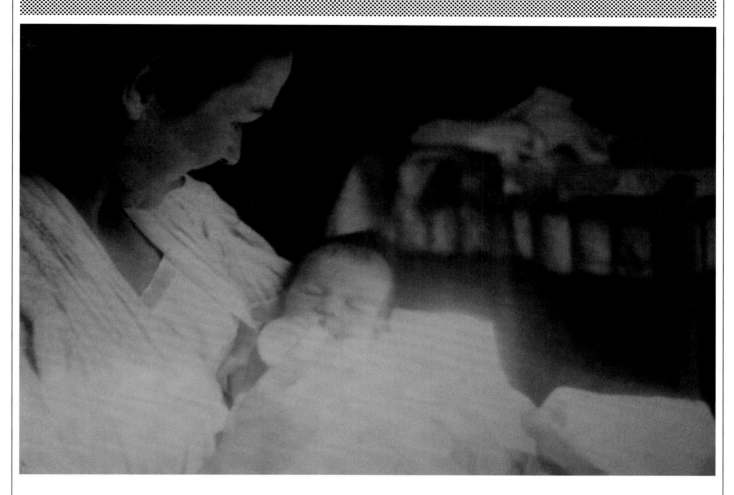

......... MATT ZOLLER SEITZ

(opposite) Stone: "This was in Bali, '93/'94, taken by a photographer who was also a beautiful French–Asian girl."

(above) Oliver Stone shortly after his birth on September 15, 1946, in the arms of his mother Jacqueline Stone.

The Oliver Stone Experience **is not just a portrait of a filmmaker.** It is a tribute to him. He meant a great deal to me during a critical period in my life, and he is one of the reasons I eventually became a critic. This book will try to present the man and his art, his complexities and contradictions, his virtues and faults, because that's how an Oliver Stone character should be presented, and the original Oliver Stone character is Oliver Stone. Because I've gotten to know him during the writing of this book, this preface will refer to him as Oliver.

Oliver was my gateway to contemporary mainstream auteurist cinema that was connected to actual history, not just film history. The gate swung wide for me in 1986, the year he released *Salvador* and *Platoon*. By that point,

Apocalypse Now had been tarred as an almost fiasco, *Heaven's Gate* as a complete fiasco. Well-received, big-budget personal films would continue to be made at major studios in the eighties, including *Reds* and *The Right Stuff*, but for the most part, by the time Oliver settled into the director's chair for his great eighties and nineties run, that kind of work had quickly become a cultural outlier. The financial successes of such directors as George Lucas, Steven Spielberg, Robert Zemeckis, and James Cameron—many of which were essentially B pictures made on a gigantic scale, with state-of-the-art technology, despite the undeniably personal voices of their directors—encouraged Hollywood to concentrate its resources on more pictures in that vein, because when one of them hit big, the returns could be *Star Wars*–size. As larger

conglomerates that obsessed over "vertical integration" and merchandising swallowed up the major studios, this became even more commonplace. Oliver got the memo, but ignored it. He used the clout he'd accumulated as a highly paid writer of hard-edged studio genre pictures in the seventies and early eighties—*Midnight Express, Conan the Barbarian, Scarface, Year of the Dragon*—to direct Oliver Stone Movies: films that told edgy, often violent, unabashedly melodramatic yarns while exposing recurring faults in US foreign and domestic policy, and showing how they were linked to the American character. He came late to the party. Films like Oliver's were more characteristic of the seventies, which produced as much filler and outright garbage as any cinematic decade but also produced such peculiar and expressive cultural phenomena as *The Godfather* and *The Godfather: Part II, Dog Day Afternoon, Network, All the President's Men, Taxi Driver, Chinatown, Shampoo, Apocalypse Now, All That Jazz,* and *Raging Bull*: art made seemingly without compromise yet aimed at wide audiences.

Salvador, Platoon, Wall Street, Talk Radio, Born on the Fourth of July, The Doors, and *JFK* were more films in that vein. They came out in the space of five years, one after the other, like waves in an ongoing, one-man cultural invasion. It's hard to describe to somebody who wasn't alive at the time (and old enough to see R-rated movies—Oliver never made films for kids) how thrilling it was to watch him gain confidence and skill and break fresh ground with each project. His movies were brash, confrontational, sometimes assaultive, often tawdry or nasty, greedily sensual, anti-bourgeois, and fueled by the urgent energy of an artist who wanted to make big statements on subjects that the mainstream preferred to avoid. And they were ferociously cinematic, showing and telling at the same time, and often conceiving their most powerful moments as series of images distilled to their iconic essences, in the manner of the boldest silent cinema. Oliver's films didn't just make you feel and think at the same time, they inspired argument and pushback, alarm and offense and righteous fury. They showed that films and directors could still be issues and that, even in the glitzy eighties, contemporary Hollywood cinema could recapture some of the stripped-down power of silent cinema without devolving into pure spectacle divorced from life. His films filled me with a desire to understand how deftly assembled images could produce primordial reactions without short-circuiting rational thought.

Oliver's films are also partly responsible for encouraging me to question received wisdom, and understand how politics and popular culture join hands to perpetuate ideology. I came of age in the eighties, a staunchly conservative time, in Dallas, Texas, a staunchly Republican part of the country. Dallas was the kind of city where people who affixed Democratic candidates' bumper stickers to their vehicles could expect to have their doors keyed or their tires slashed. My mother told people we lived in the Park Cities, one of the richest neighborhoods in the state, but we actually lived closer to Love Field airport, in a middle-class, mostly black neighborhood. I gorged on received right-wing wisdom like a foie gras goose: The Vietnam War was a noble cause, but its execution was flawed, and those goddamned protesters lost it for us. The country was better off before hippies and liberals and feminists and blacks started whining about how bad things were and demanding handouts and special rights. And so on, and so on: Archie Bunker talking points. I bought it. I was the kind of kid who watched the hit TV sitcom *Family Ties* and thought the money-grubbing, right-wing-slogan-spouting yuppie teenager, Alex P. Keaton, was the hero, and his ex-hippie parents were drippy killjoys. After President Ronald Reagan won reelection in 1984, I brought a copy of the *Dallas Morning News* to school, walked over to a lunchroom table where a group of my depressed liberal friends were commiserating, pointed at the headline, and exclaimed, "Thank God!"

"Look at Reagan," I remember my stepfather saying, as we watched live TV coverage of the president commemorating the one hundredth anniversary of the Brooklyn Bridge. "Look at how strong he looks with his hair blowing in the wind, not like that wimp Carter"—Carter, of course, being Jimmy Carter, Reagan's predecessor, who'd won a Nobel Peace Prize for brokering peace between Israel and Egypt, installed solar panels on the White House roof, forgiven draft dodgers who fled to Canada during the war, and seemed amenable to counterculture values and uninterested in the sort of action hero/grandpa posturing that Reagan made a centerpiece of his presidency. Reagan broke the back of the unions in this country by firing striking air traffic controllers in 1981, and his revolution, or devolution, continued from there. He was the president, but he also played him on TV, and the public loved the act. Reagan trotted out descriptions of movie scenes (some of which he acted in) as if they had actually happened. He cited Dirty Harry's catchphrase "Go ahead,

make my day" when threatening to veto a congressional tax hike, and quoted Sylvester Stallone's Vietnam War–refighting Green Beret, John Rambo, in a speech celebrating the June 1985 release of thirty-nine American hostages in Beirut, Lebanon: "In the spirit of Rambo, let me tell you, we're going to win this time!"

The following spring Oliver released his third feature film, *Salvador*. His timing was either dreadful or perfect, depending on how you felt about the political mood. *Salvador* was a muckraking contemporary drama, a genre that sixteen-year-old me hadn't seen. It blasted the Reagan administration's covert war in Latin America, an intervention fueled by the same fear of Communist infiltration as the war that right-wing fantasy characters like Rambo reframed as a thwarted crusade. The film showed atrocities being committed by groups funded with US money. There were street executions, assassinations, rapes, beheadings. The movie said, *Pay attention to this—it's another Vietnam, it's happening right under your noses, and as Americans, you should care*. "Is that why you guys are here?" Boyle taunts a bunch of CIA spooks advising El Salvador's death squads. "Some kind of post-Vietnam experience, like you need a rerun or something?"

At the time I knew little about Vietnam except that it produced a steady supply of deranged loners for the heroes of TV cop shows to kill. *Salvador* shook me out of my ignorance and sent me to the library. It made me second-guess the mind-sets that produced the sorts of policies *Salvador* abhorred. And it introduced me to a different kind of American movie hero: a down-and-out sleazeball worth listening to because of the value of his words, not because he was dashing or lovable or nice. Richard Boyle (James Woods) was a con artist, boozer, and drug fiend who'd gone to El Salvador mainly because his life in the States had fallen apart; he and his buddy, Dr. Rock (Jim Belushi), were horny, arrogant Yankees who drove to Latin America talking about how cheap the hookers were. The lesson imparted by the film's choice of hero made as big an impression on me as Oliver's choice of subject: It announced that disreputable, broken people could tell harsh truths.

That year, 1986, was a great one for American cinema, a delayed hiccup of the seventies. It saw the release of Jonathan Demme's *Something Wild*, Michael Mann's *Manhunter*, Woody Allen's *Hannah and Her Sisters*, James Foley's *At Close Range*, and Spike Lee's *She's Gotta Have It*. But of all those pictures, only the last two could be described

as political, and only in a tangential way. *Salvador* was different. It was aggressively, even stridently political, and personal, too—scary and funny and raw. It was not a hit—in fact, it was barely seen in theaters—but anyone who cared about movies had to have an opinion on it.

At the time, nobody else was making these kinds of movies within the system and getting them into multiplexes (I would later learn that *Salvador* was barely "of the system"—funded independently and released through a small distributor, Hemdale). By the end of the year, Oliver would make another classic, the Vietnam memoir *Platoon*; unlike *Salvador*, its timing would be perfect. It hit theaters about six months after *Top Gun*, one of the defining films of the Reagan era. I'll never forget hearing a packed opening-night audience whoop when *Top Gun*'s arrogant, self-pitying fighter pilot hero, Maverick (Tom Cruise), banished his grief over his buddy's death in a training accident and destroyed Soviet MiGs in a dogfight over the Indian Ocean. If I hadn't been thinking about *Salvador* and reading about El Salvador as a result of seeing Oliver's movie, and concurrently developing a fascination with the Vietnam War, I might have reacted as the rest of that audience did—like a good little Commie-hating, uniform-worshipping, tight-assed Dallas boy. Instead, I was bewildered and sickened. Maverick had started World War III, but the film treated him like the quarterback of a football team who'd just won the championship, and cared about nothing but his happiness and validation.

Platoon was the corrective to *Top Gun*'s bloodless fantasy of self-help through destruction. It was also a rebuke to the Rambo movies and the *Missing in Action* trilogy and *Uncommon Valor* and the other films in which the rescue of prisoners of war in Vietnam was treated as an excuse to show how the conflict could have been won, were it not for the bureaucrats and liberal politicians and hippies and the sun that was in our eyes. The grunts in *Platoon* had no beef with the enemy, who comprised elusive and efficient killers animated by the power of belief; those who thought they had a beef with the Vietnamese, like the scar-faced veteran Sergeant Barnes (Tom Berenger), were repeating the slogans that their country had placed in their minds. Three years later, *Platoon* would be followed by Oliver's *Born on the Fourth of July*, wherein Ron Kovic, a middle-class conservative white boy not unlike the author of this essay, goes to Vietnam hoping to kill Commies, shoots women and children instead, is commanded to cover up the massacre, then charges like John Wayne or John

Rambo in the middle of a firefight—and gets shot in the spine and has to spend the rest of his life in a wheelchair, pissing into a tube. The film's use of patriotic iconography and language (anthems, flags, parades, fireworks, military recruiters in spit-and-polish uniforms) elucidated precisely how Ron ended up in Vietnam. His brain had been fattened on the same black-and-white, us-versus-them war machine hype that I'd grow up with a generation later. (*Born*'s hero was played by Tom Cruise—a casting masterstroke.)

When Oliver won a slew of Oscars for *Platoon* and more for *Born*, he was the only Vietnam veteran so honored. At that time I didn't know the details of his service, but I could tell by the tone his movies took that he'd been through something that Francis Ford Coppola and cowriter John Milius (*Apocalypse Now*) and Michael Cimino (*The Deer Hunter*) understood mainly in terms of symbols and storytelling tropes. Oliver brought an authenticity to his portrait of soldiering, plus an intellectual understanding of propaganda and psychological conditioning at the heart of America's war machine. Vietnam echoed through every film he made, even the ones that weren't set on a battlefield. *Wall Street* showed how the desire to acquire or destroy drove peacetime business deals as well as military strategy: War played out in puts and calls and trades. *Talk Radio* showed how the same left-wing/right-wing split that fueled the intra-unit tension in *Platoon* played out in everyday, contemporary domestic life as well. *Heaven & Earth* reached further back into the past, showing how the US intervention in Vietnam was merely the latest iteration of colonialism there, and how the controlling, paternalistic attitudes that sent us there also poisoned the domestic lives of servicemen after they returned home. *JFK* and *Nixon*, two more of Oliver's masterpieces, showed how the war machine and its political and logistical support systems enable, and in some ways *demand*, a steady supply of interventions. Stone had a phrase to describe this sentient network of ideologies and appetites: "the Beast."

Oliver would later conclude, with evident sadness, that his films must not have made a difference in US foreign policy or the American moviegoing mind-set, because if they had, we wouldn't have ended up in Panama in 1989, and Kuwait and Iraq in 1991, and Iraq again in 2003. But that strikes me as too much of a burden to assign to commercial cinema. No art can affect life as decisively as Oliver might have dreamed.

But it can affect individual personalities and worldviews. Oliver's films absolutely affected mine, and I know they've affected those of other filmmakers, critics, and movie buffs, some of whom wrote essays for this book: Ramin Bahrani, Kiese Laymon, Walter Chaw, Kim Morgan, Michael Guarnieri, Alissa Wilkinson, Jim Beaver.

He disillusioned a lot of people who might otherwise have skated through the eighties and nineties uncritically consuming jingoistic films like *Top Gun*, the Rambo pictures, *True Lies*, and their ilk, and thinking of them as "just" entertainment. Oliver also showed us, time and time again, that leading characters did not have to be saintly or even likable as long as they were interesting—a lesson that I believe is just as valuable, and connected in some way. Although Jim Garrison in *JFK* was a cheat—the reasons for which are elucidated in chapter 7 of this book—and his late-career smash *World Trade Center* is stocked with salt-of-the-earth men and women, these are the exceptions. He seems to prefer characters who are not immediately lovable. The most arrogant or self-pitying or violent among them practically dare us to care about them. And then we do care, because they are fascinating, and they make valid points even when we loathe them.

Boyle in *Salvador*, Barnes in *Platoon*, Bud Fox and Gordon Gekko in *Wall Street*, Jim Morrison in *The Doors*, Richard Nixon, pretty much everyone in *U-Turn* and *Savages*, Alexander the Great, and all the witnesses in *JFK*, including the flirty male hustler and the drug-addled pilot with his hideous toupee—all these characters are presented as worthy of interest, even as the films ignore the kind of simplistic "likability" that Hollywood tends to wallow in. At one point in this book, I use the hack screenwriting phrase "audience surrogate" in conversation with Oliver to describe the sorts of blank, bland lead characters that Hollywood prefers, and Oliver asks me to define it. He never got that memo, either.

There is a sense in which Oliver's characters all start to seem like extensions of Oliver Stone, the Cassandra of popular culture, warning us of impending disaster by way of fire-and-brimstone screenplays and hallucinatory visuals that shake our complacency and make us question our responses to his art, and ask how much of that response is genuine and how much is a vestige of conditioning.

On top of all that, his films are unabashedly visual, visceral, sensual. People don't just make love in Oliver Stone movies: They fuck. They also take drugs and get drunk, and it's all presented as part of life, sometimes as an attempt (romantic or self-destructive) to expand the frontiers of

experience. Sometimes his characters kill for no good reason at all, and Oliver expects us to understand their violence even if it appalls us. He seems to be daring you to sit in judgment, by insisting that every character who passes in front of his lens, sweet or loathsome, straight or twisted, subtly realistic or grotesquely caricatured, be recognized as a human being muddling through life.

All of which brings us, in its circuitous way, to the book you hold in your hands: *The Oliver Stone Experience.*

I first interviewed Oliver in 2001, shortly after the 9/11 attacks. He was one of many voices quoted in a *Star-Ledger* feature that speculated on how the footage of the burning towers might affect the popular imagination. (I gave him the closing line: "People who have never experienced violence have experienced it now.") I interviewed him again in 2010, when he was on tour promoting *Wall Street: Money Never Sleeps*, and took the opportunity to give him the short version of my history with his movies, and thank him for his effect on my consciousness. He seemed genuinely humbled.

Then I told him about the time that I worked as an extra during the Kent State protest sequence of *Born on the Fourth of July*, which was set at Syracuse University in New York but filmed at my alma mater, Southern Methodist University in Dallas. Because I had short hair, I'd been cast as one of the young Republicans egging on National Guardsmen to attack hippies and Vietnam Veterans Against the War. Oliver had assigned casting people to different factions of extras (the hippies, the vets, the young Republicans, the National Guardsmen, and so forth) and hyped them on ideology, to approximate the unstable energy of that time. I ended up on the cutting-room floor, but I did take part in the filming, which included brutal attacks by "National Guardsmen." The Guardsmen were split into two groups: One had real clubs, which they rattled against their riot shields; the others had fake clubs made of foam. The ones with the foam clubs were supposed to "beat" the protesters, but after take three or four, the guards with real clubs got caught up in the moment and started swinging. My "young Republican" broke ranks and tried to rescue a couple of hippies (I was into the scene, what can I say?)—and got chased into the parking lot behind the administration building and beaten by a Guardsman with a real club. "Jesus fucking Christ, stop! It's a movie!" I yelped, shielding my skull. The

Guardsman froze. Then he lifted his visor, revealing the face of a guy in my statistics class.

"Everybody was really into it," I told Oliver in 2010.

"Belatedly, Matt, thank you," he said, "and I'm sorry."

I asked Oliver to do this book not long after that, and he said yes. Between 2011 and 2015, I spent about one hundred hours interviewing him, and untold more hours hanging around with him. He provided personal photos, documents, script pages, and production materials to me; these were contained in dozens of file boxes dating back to the early seventies that had to be hauled out of storage by his employees.

When people ask me what the relationship is like, I tell them to imagine the one between the Skipper and Gilligan on *Gilligan's Island*, but with conversations about Luis Buñuel and the Powell Doctrine and the future of the European Union. Oliver would always begin our talks by bringing me up to date on a project he was working on. The conversation would turn to the front page of that day's newspaper, then settle on whatever new films we'd seen. It would be possible to fill a whole other book with our arguments about such filmmakers as Richard Lester (he loves *Petulia* but thinks *A Hard Day's Night* is overrated), Terrence Malick (I adore him; Oliver finds his films beautiful but vague and would rather watch "a movie that moves, man!", except for *The Thin Red Line* and *Tree of Life*, which he saw three times), and his old colleague Kathryn Bigelow (I argued that *Zero Dark Thirty* had a conflicted attitude about torture; Oliver thought the film was an ad for it). We don't even agree on time wasters. Oliver declared that all my opinions were suspect because "you liked fucking *Pacific Rim*!" and then proceeded to argue that *Battleship*, which I found interminable, was a superior example of the same sort of movie.

Then he'd excuse himself for a bit to take a work-related phone call or answer an e-mail, and leave me to study the spaces he inhabits. Oliver's New York apartment is a small, austere place, packed into a corner of a building with a view of the East River and the Statue of Liberty; his coffee table is stacked with texts about Buddhism, festooned with multicolored Post-it notes. His Los Angeles house has an upstairs office with forty years' worth of diaries arrayed on bookshelves, a long table that seems to have been carved out of a prehistoric tree, and chairs that might have been hacked out of stumps; Oliver sometimes holds production meetings there, and I like to imagine his crew toasting one

another with goblets of mead. Oliver's backyard has a Buddhist shrine and a fishpond and is canopied by tall trees. It looks like exactly the sort of place where Oliver Stone would go to sit and think.

There have been times when he took an interest in me that could be described as fatherly, or at least big brotherly. When I spent a long interview squirming because of a volley-ball-related back injury, he implored me to get well as soon as possible because "I can't stand seeing you suffer like this." Last June he spotted me on a Tribeca street corner en route to interview him and crossed the street to chastise me for wearing shorts, a T-shirt, sneakers, and a baseball cap. "What the hell is this?" he demanded, palms out. "I just came from dropping my son off at summer camp," I said. "Are you going *with* him?" Oliver exclaimed, then put a hand on my shoulder, looked me in the eye, and intoned, "Now, I want you to promise me you'll never be seen in public dressed like this again." I watched Oliver get into a dinner-table debate during the Washington, DC, leg of the *Snowden* shoot with his *Untold History* co-screenwriter, the history professor Peter Kuznick, over whether Alexander Hamilton or Thomas Jefferson was the greater Founding Father. Kuznick is a Jefferson man; Oliver is Hamilton all the way. They argued with the abandon of kids debating whether Batman could beat up Superman. At one point Oliver leaned across the table, jabbed a finger in Kuznick's face, hollered, "Eat your words! Eat your words, motherfucker!" and then burst out laughing.

Oliver likes to bust chops and play head games and make jokes so dry that at first you aren't sure they're jokes; it's how he shows affection. You may already know that Oliver unwinds by smoking weed—he's the only two-time Oscar-winning director to appear on the cover of *High Times*—but what you don't know is how his weed smells: astonishingly rich and sweet, like destruction and creation. For a long time he declined to offer me any because "trust me, you can't handle it—you'll never stay on track in an interview if you smoke this." One day I asked him how he got his favorite strain from Los Angeles to New York, and he replied that he smuggled it through airport customs in his ass. "I smuggle everything in my ass, Matt," he said. Then he saw my incredulous face and said, "Oh, for Christ's sake—I'm sixty-eight, I don't smuggle things in my ass. I was *kidding*! And you call yourself a journalist! This is how we ended up in Iraq!"

He eventually did offer me some. I expected prismatic visions of Kent State and Wounded Knee, Jim Morrison

and 9/11, capped by a trip to the emergency room. But it was a mellow high.

Over time it became clear to me that to interview Oliver is to accept him on his own terms. Although he is in many ways very far left by Hollywood standards, he is also not the most enlightened person when it comes to feminism, race relations, homophobia, and the like. He struggles with terminology, and like most straight men of his generation, he tends to go into a rhetorical defensive crouch when interrogated about his language and beliefs, especially by members of groups to whom he's sympathetic. But to Oliver's credit, he still let me prod him with questions about these hot-button subjects and others—including his difficulty getting big films made after the box office failure of *Nixon*—and he answered frankly. I have no idea what it's like to work with Oliver, but I can tell you that to interview him is a pleasure, because he's self-aware and self-critical and willing to cede any point he can't refute.

This book was originally envisioned as a tour of Oliver's life and influences, along the lines of *The Wes Anderson Collection*, but it turned into a roundabout critical biography, told through a long interview plus memorabilia and essays. On more than one occasion, Oliver introduced me to colleagues and friends as "my biographer," a phrase that flattered me with trust even as it terrified me with responsibility. Early in the process I became concerned that Oliver was coming off as too much the unreconstructed caveman auteur, even though he had proved himself evolved and sophisticated in other ways. I soon realized that to protect Oliver from himself would run contrary to the spirit of his best work. I hope Oliver is all right with it, because he did me the courtesy of insisting that I have final cut, as it were, over this book, trusting me to tell his story my way.

Oliver's views on politics, history, and culture have been presented as-is, though of course some editing and condensation was necessary, given the sheer volume of raw audio that resulted from our talks. In certain portions of the interviews, as well as in footnotes and end notes, I've tried to provide context and even a contrary or "devil's advocate" view, but not all the time, because the intent is to represent something close to Oliver's worldview, not that of the institutions or schools of thought that he has questioned or opposed throughout his adult life. There are innumerable books, films, television programs, and official documents representing a mainstream or "official" view on events and phenomena Oliver talks about in conversations with me, and in his

movies. Readers will have no trouble finding them should they choose to seek them out.

The conversations between us are edited, as I've described them to friends, in a biographical or "documentary" style—by which I mean I've cut and pasted together comments from many different exchanges about the same subjects to minimize redundancy and maximize flow. Everything he said to me is on a recording somewhere, but he might not necessarily have said everything in a particular section of this book on the same day or during the same month. There were also times when I'd interview Oliver for an hour or two, then get a phone call while I was writing at my desk at *New York* magazine or standing on the sidelines at my son's soccer practice and hear his assistant say, "I have Oliver on the line," and then Oliver would come on and clarify a point he'd tried to make about the Tet Offensive or his relationship with Warner Bros. That stuff, too, is integrated into existing text.

Here and there you'll see lines that are redacted instead of deleted. No one will ever know who requested the redactions—a lawyer working for me or for Abrams Books; my editor or a copy editor; Oliver; me—or what, exactly, is hidden under the redaction lines, but I wanted them to have a

presence on the page, even if you couldn't actually read them. You should think of these blackened lines as spirits cut down during the battle to get this book to press, but which still manage to make their presence known—an Oliver Stone–like touch, I hope.

"What the hell is this book, Matt?" he asked me last year. "I'm having a hard time picturing it."

"It's an Oliver Stone movie about Oliver Stone, but in the form of a book," I told him.

He thought about it for a moment, then grinned and said, "Yes. I see it."

Oliver Stone near the University of Illinois campus in 2014, before a repertory screening of *Born on the Fourth of July* at EbertFest. The author and Stone were walking through the cemetery when Stone spotted a gravestone with the same last name as his. "You should take a picture of me next to this," he said. "It'll come in handy someday."

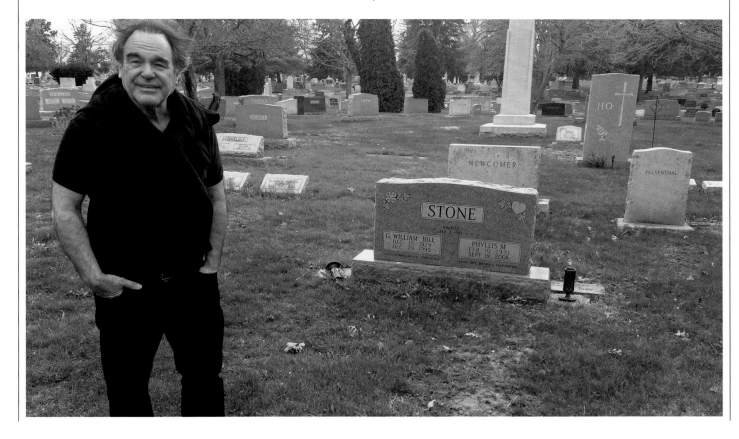

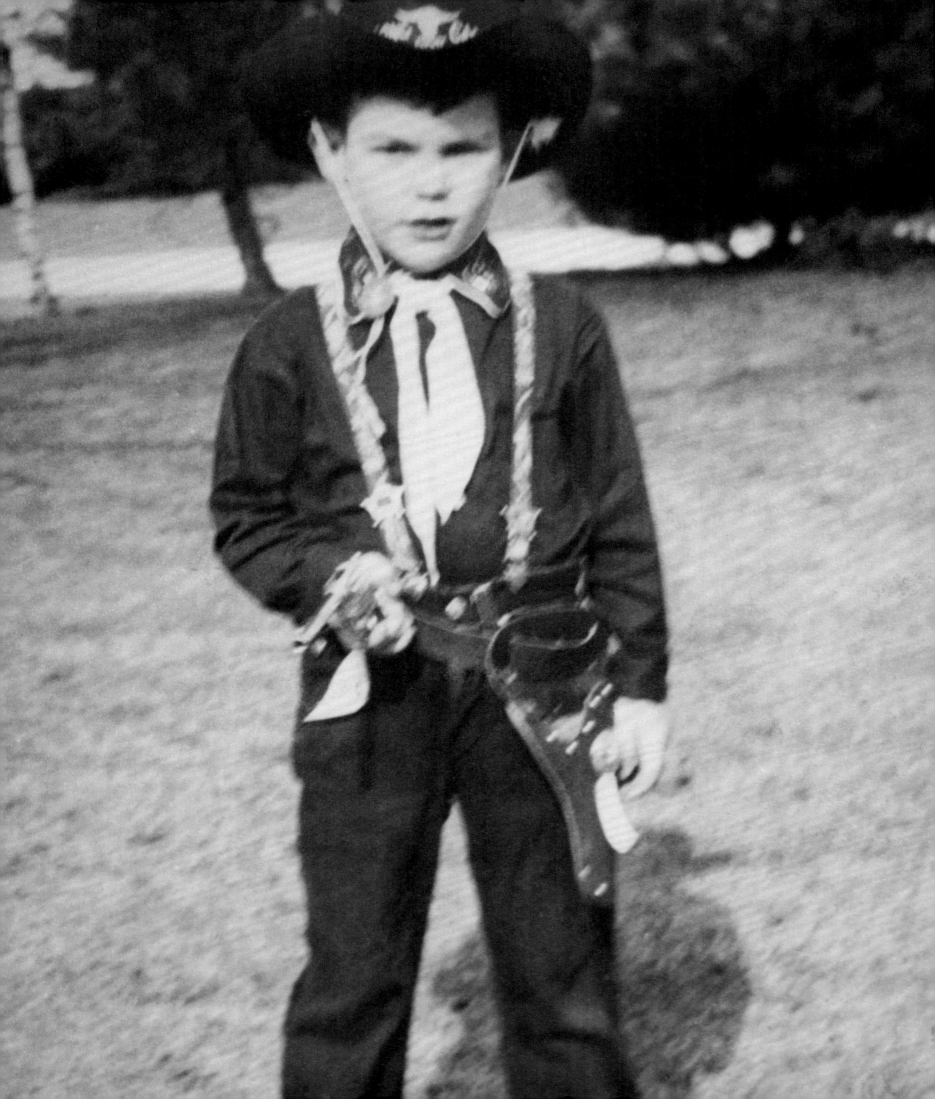

★ ★ ★ ★ ★ **O YOUNG MAN, IN THY YOUTH** ★ ★ ★ ★ ★

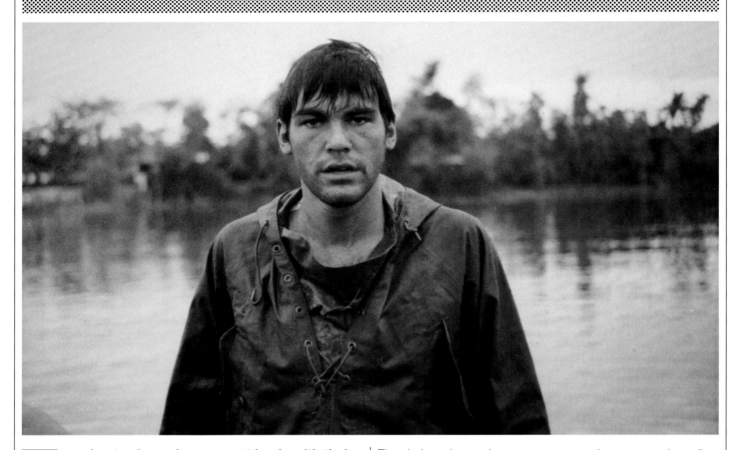

To understand people, you must begin with their beginnings. This is especially true for William Oliver Stone, an artist who has spent forty years fusing his own psychodramas with fantasy and history, and projecting the results on screen. As this book was being laid out in the autumn of 2015, Stone was busy making his twentieth feature film, *Snowden*. It's superficially a ripped-from-the-headlines drama about Edward Snowden, the National Security Agency whistleblower who exposed the United States' post-9/11 program of illegal surveillance. It's the tale of a patriotic and serenely certain young American who grows disillusioned, questions the handed-down values that shaped his mentality, and goes to extreme ends to warn his fellow citizens not to let themselves be warped and used as he once was. This is a familiar Stone narrative. It is in many ways the Oliver Stone Experience. He told coded or refracted versions of it in *Platoon*, *Wall Street*, *Born on the Fourth of July*, and *JFK*, and, in their own ways, *Scarface*, *The Doors*, *Alexander*, and *Savages*. To varying degrees, they are all about people defining themselves apart from the ideology-reinforcing myths that shaped them.

The choices they make are momentous, the repercussions dire. They can obey orders and accept the official story and go on living a relatively stable existence, or rebel and suffer. They can live a careful, repressed, obedient life, or test the boundaries of law, respectability, even consciousness itself, at risk of ending up burned-out, imprisoned, or dead.

Stone was a financially privileged, emotionally deprived young man. His father, Louis, was a Wall Street stockbroker, a New Yorker, an Eisenhower supporter, a playwright and poet; his mother, Jacqueline, was sensual, flighty and warm, Catholic and French, socially liberal. Their son was a lonely only child. He was raised in large part by nannies and a "houseman"; by teachers and administrators at boarding school; by Jacqueline's extended family in France, where he summered; and by his feverish imagination, which was stoked by films, TV shows, novels, history books, and trading cards.

Stone became emotionally self-reliant early because he had no choice. He developed a fear of, and intoxicated

fascination with, women, because his upbringing kept them at a remove, locked them in circumscribed roles, or presented them as goddesses to be pleased or objects to be won. He could see himself voting for whomever his father voted for and wearing a suit and tie to work. He had to escape and confront his upbringing. He did this first in his mind, through fiction and essays; in his late teens and early twenties he did it physically, by doing unusual work far from his home country. He wrote a novel at nineteen to exorcise his demons and transform them into art. He became a teacher in Vietnam and a merchant mariner in the Pacific, then went back to Vietnam, this time as a soldier.

Stone keeps going back to Vietnam, Vietnam, Vietnam. But it is not just Vietnam the country or Vietnam the war or Vietnam the Oliver Stone Experience that he returns to. It's Vietnam the historical milestone, Vietnam the metaphor, Vietnam the nightmare, Vietnam the prophecy.

Stone first imagined Vietnam in *A Child's Night Dream*, a 1,400-page manuscript he wrote in a feverish burst in 1966, at age nineteen, upon returning from a stint in the merchant marine, and that would remain unpublished until 1997. When he finished the last page, he was a few months away from enlisting in the army and starting his first tour of combat duty. The manuscript's rejection by publishers pushed him over the edge and made him sign up.

When the ink is dried on his signature, the United States government had already been in Vietnam since 1950, when it first sent military advisers to help Vietnam's prior occupiers, the French, who were sent packing in 1954. US involvement escalated through 1962, with the number of advisers doubling and then tripling in response to fears that the country might be annexed by the worldwide Soviet-Chinese "Red Menace." Domino theory. Cancer, metastasizing. Slice it out, nuke it, kill it: That was the idea. In 1965, less than two years after President John F. Kennedy's murder, the United States committed regular infantry for the first time. The draft was in effect. Men in their teens and twenties were scared of dying in a country toward which they felt no animosity. Although Louis Stone believed in the Domino Theory, he still didn't want his son going to Vietnam, and in theory the teenager shouldn't have had to. Young Americans of Stone's social pedigree could get a deferment by enrolling in college, getting married, or just having a well-connected relative pull strings; Stone did not do this, and as is often the case with Stone's filmic alter egos, his motivations were complex and conflicted. The teenage Stone was a Republican like his father. He believed in the anti-Communist cause.[1]

And yet, *A Child's Night Dream* still reads like a sensitive young artist's fantasy of becoming a traitor to his class, and willingly immersing himself in a hellhole that many of his boarding school classmates escaped: running away to become a merchant mariner, rebelling, writing, brawling, fucking, and finally going to war. The book contains a description of a thunderous battle between American and North Vietnamese forces in Vietnam, written a year before Stone would see action there. Like the bloody infantry combat scenes in Stephen Crane's *The Red Badge of Courage*, which Stone cites as an influence, the chapter is a young man's fantasy of an experience that was real and terrifying for many.

Stone was decorated with a Bronze Star for Heroism in combat in Vietnam. He returned to the States in 1969 with a Purple Heart in his satchel and bits of shrapnel in his body, and enrolled in New York University's film school. It was there, under the tutelage of Martin Scorsese, that he made his first personally significant film, *Last Year in Viet Nam*, a silent, black-and-white short about a traumatized veteran, played by Stone himself. Somewhere around this time Stone wrote his first (still unproduced) feature-length script, *Break*, an expressionistic piece that turned the war into a psychedelic interior journey, equally influenced by European art cinema, youth exploitation pictures, and the rock and roll that made life bearable for soldiers in the bush. Stone sent a copy of the screenplay to Jim Morrison, who was eking out his final days in Paris; this gesture was a dual tribute to the lead singer of Stone's favorite band, the Doors, and his favorite sergeant, Elias, a Long Range Reconnaissance Patrol infantryman, whom Stone described as having a Morrison-like face and a dreamy, mystic quality.

After NYU, Stone obsessed over the war while he wrote spec scripts, worked odd jobs in the East Coast film scene, and drove a cab at night. In 1976, Stone wrote the first draft of a screenplay titled *The Platoon*—a more straightforward account of his experiences than "Break," filled with journalistic details and savage violence, and anchored to a blank-slate hero not unlike Crane's Henry Fleming. In 1986, Stone finally got to direct *Platoon* (the title lost its article along the way). He followed it with movies that expanded his vision of American involvement in Vietnam beyond one soldier's experience on the ground.

The second was 1989's *Born on the Fourth of July*, based on the paralyzed marine-turned-antiwar-activist Ron Kovic's memoir, itself a bicentennial work, published in 1976 and adapted by Stone two years later. Unlike *Platoon*, which confined politics to stray lines of dialogue, *Born* was mainly about ideology's role in building a warrior's sense of self. It showed how a teenage American from a placid suburb could end up in a place like Vietnam, fighting without clear purpose against shadowy foes who knew exactly what they wanted: to expel the invaders by any means necessary. Stone's other official Vietnam film was 1993's *Heaven & Earth*. In adapting it, Stone tried to see war, and Asian history, through "enemy" eyes. His main sources were the memoirs of the Vietnamese immigrant and activist Le Ly Hayslip. The film is infused with images and lines derived from variants of Buddhism, a religion that Stone had been fascinated by since adolescence, but that he only began seriously studying in the nineties. It also contains scenes of indifference, manipulation, cruelty, and sexual exploitation by Americans; some texture was, Stone says, drawn from his experiences and are part of a larger strategy of filmmaking as atonement, for the violence that he personally committed and the destruction wrought by the army that employed him.

Beyond this triptych, many of Stone's non-Vietnam films are, in some sense, also about Vietnam. Stone's first and second features, 1974's *Seizure* and 1981's *The Hand*, are officially "horror" films with supernatural overtones. But nestled within all the familiar tropes are stories of frustrated artists who deny or repress trauma, are frightened by the horrifying visions that drive their art, and project their inner turmoil onto relatives, friends, and strangers; these are all emotions that Stone grappled with in the two decades following his return from Vietnam. In *JFK*, the former black ops expert X tells the crusading hero Jim Garrison that Kennedy died because he wanted to pull American troops out of Vietnam. The title character of Stone's *Nixon*—who gets shouted down by Kovic on the floor of the 1972 Republican convention in *Born*—wins the presidency in 1968 based partly on his promise of a "secret plan" to end the war, prolongs American involvement to burnish his credentials as a hawk, and worries that the secret army of saboteurs and assassins that he helped create while serving as Eisenhower's vice president ("the Beast," Nixon calls it) somehow got out of control and contributed to Kennedy's death. Despite his fear of complicity, Nixon resents antiwar activists who want the United States to leave Vietnam,

and he blasts politicians and journalists who oppose the war as cowards, traitors, and unmanly men.

You hear premonitory echoes of this terror of emasculation in arguments between the liberal *Talk Radio* provocateur Barry Champlain and his more conservative listeners. Their taunts prefigure Nixon's and Kissinger's sputtering fury at the hippies and Jews and Negroes and homosexuals protesting Vietnam.[2] They are conversational shadow plays, reenacting the left wing–right wing animosity that's been part of American political culture since the end of World War I—a cycle of ritualized rhetoric and ad hominem attack that drives interventionists to commit troops to foreign soil, and antiwar activists either to oppose such actions on principle or to step aside for fear of being smeared as cowardly or ending up on the wrong side of history.[3] This is part of what Stone is trying to get at when he has his *Platoon* alter ego, Chris Taylor, say that Americans fought themselves in Vietnam. It's a different way of rephrasing and re-asking the oft-mocked question that the corrupt trader Bud Fox whispers on the balcony of a penthouse he bought with morally suspect money: *Who am I?* And, by extension: *Who are we as a country?*

Richard Boyle, the photojournalist hero of *Salvador*, gets an up-close look at the sort of covert American intervention that X describes in *JFK*. The film is set in a country that then president Ronald Reagan feared would go Communist in the eighties and give the Soviet Union another toehold in the Western Hemisphere (after Cuba, which provided black ops soldiers for *JFK* and *Nixon* skulduggery, and banished criminals to Florida in the opening of the Stone-scripted *Scarface*). "You've not presented one shred of proof to the American public that this is anything but a legitimate peasant revolution," Boyle tells a US military adviser who inveighs against the Communist menace. "Don't tell me about the sanctity of military intelligence. Not after Chile and Vietnam. . . . It's a lie that this war can be won militarily. It can't." This is not just about Vietnam as military intervention and expression of US foreign policy; it's about the never-ending rhetorical combat between left- and right-wing mind-sets that expresses itself most fully in war, and that seethes under the surface of American life even in peacetime, and has since the twenties, when labor activists were smeared as "Bolsheviks."

"When that final bullet blasted open Kennedy's brain," wrote *Entertainment Weekly* critic Owen Gleiberman in

his 1991 review of *JFK*,[4] "in some dread-ridden way it almost seemed as if America itself had killed the President. Regardless of who (or how many whos) pulled the trigger, the simple fact that a leader so beloved could be struck down with such incongruous horror told us that we weren't the nation we thought we were, that beneath our lingering postwar optimism lay demons and madness." Stone would explore that "madness" in a glancing way in *Scarface*, *Natural Born Killers*, *U-Turn*, and *Savages*. These four movies are set in self-contained wastelands, as bereft of law, order, and decency as a battlefield. Their stories play out as a series of nasty skirmishes between competing groups of killers, or "soldiers," as "civilians" look on in numb lack of interest or crude fascination when they aren't ducking behind the nearest tree. Some of the wasteland's inhabitants want to stay in, perhaps someday own, the "place." Others just want to make a score and get out before they're gutted, shot, tortured, or blown up.

But even as Stone expanded his palette to encompass different genres and subjects, the ideological forces that drove the United States, and Oliver Stone, into Vietnam were never far from the director's mind. He examined them obliquely in *Alexander*, about a Western conqueror who seeks glory but finds betrayal and ruin in the East; in the documentary *South of the Border*, about Central American leaders' paranoia that the United States will intervene to keep their governments from becoming too leftist or "anti-American"; in three films about Fidel Castro, the leader of the Western Hemisphere's first Communist "domino"; and in *Untold History*, a twelve-part series that amounts to a psychic X-ray of the political and economic factors that drew the United States into wars and covert actions.

You could look at Stone's complete work and conclude that, in trying to get over Vietnam through filmmaking, he ensured that he himself would never entirely escape it—and that some part of his artistic imagination will always reside there. But Vietnam did not arrest Stone's psychological and artistic development; it forced him to evolve, to think, to question, and to keep refining and revising his worldview and interrogating himself. As Stone returned and returned and returned to Vietnam, in war films and crime films and political films, he became more firmly convinced that America never really left Vietnam; that it had, in a sense, been to Vietnam before, and would go there again in different guises; and that the lessons of Vietnam, as Stone saw and

felt and constructed them, should be made inescapable as well, through his films.[5]

In a 2013 interview with Movies.com[6] about *Untold History*, Stone said he made the TV series partly as an allergic reaction against the war in Iraq, which was the second stage in a military strategy founded on a kind of "reverse domino theory": Make the Middle East friendly to the United States by crushing authoritarian regimes and installing democracies. Stone said he saw the invasion and occupation as "a nightmare, a personal nightmare, as a veteran of the Vietnam War . . . we were repeating everything that we had done wrong. I thought, 'We've got to do something more for our children.'"

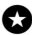

1 Stone: "I sometimes worry that you're overhyping this idea of my father being this Republican hardass and me inheriting all my values to him. That's true to a degree, but my father was also a sensitive man who wrote poetry. And he hated McCarthy."

2 Stone: "There is this concept throughout your book that I do things in my movies for political reasons, but most of the time I really don't. I can understand why you would see that in *Born on the Fourth of July*, but honestly, it's just the story of a guy who gets twisted by life, and turns it around."

3 Stone says, "Again, I know what you're trying to do here, looking for an autobiographical subtext in everything, but I really think you are mischaracterizing *Talk Radio* here. I don't know if there's a lot of left wing, right wing in this movie. The guy is Howard Stern, or Eric Bogosian's version of Howard Stern, but Alan Berg, the real DJ the character is based on, is also crucial. He pissed off the KKK, or whatever they were in that period, more by being Jewish than anything, talking about Jews, blacks, and race. And again, it was me adapting Eric's story. I did it because it was a hell of a little play with a lot of tension and great dialogue, and because it let us learn technique and get confidence to make *Born*, which is also a movie with a very claustrophobic feeling. You can criticize the movie, call it a five-finger exercise or whatever the fuck you call it later in the book. But at least try to understand what we're trying to do."

4 Owen Gleiberman, review of *JFK*, *Entertainment Weekly*, December 15, 1991.

5 Stone: "In some way, am I really still in Vietnam? It's not for me to say, but I really like to think I've moved past it."

6 Scott Huver, "Dialogue: Oliver Stone on Creating Controversy Yet Again with an American History Documentary," *Movies.com*, October 17, 2013.

Palisades Amusement Park

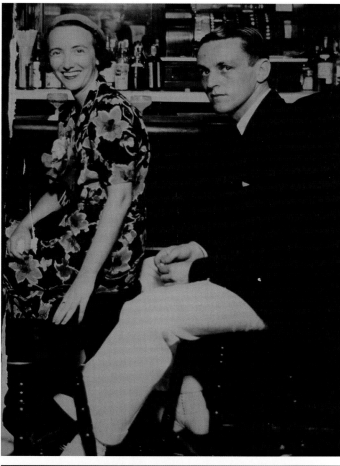

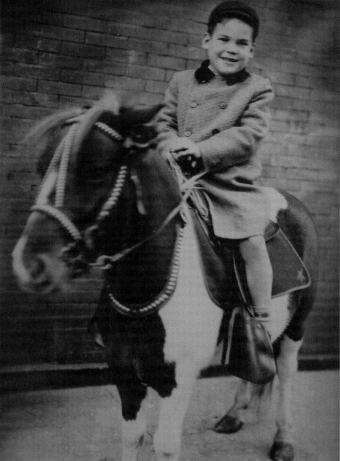

(opposite) Oliver Stone at the Palisades Amusement Park circa 1955, with his mother Jacqueline Stone.

(left) Stone: "This is my father, I'm not sure what year. That's not my mother with him, though—that's Lady Iris Mountbatten, one of my father's early girlfriends, from a distinguished English family. You can see he's a very good-looking man."

(below) Stone: "I'm seven, maybe eight years old in this picture. This is a thing where you could take a picture with the ponies, somewhere on the Upper East Side. I had a chipped tooth because I accidentally hit a parking meter when I was turning around to look at a girl."

MATT ZOLLER SEITZ In the preface of your novel, *A Child's Night Dream* [END 1], a fictionalized account of the early years of your life that was published in 1997, you write about the meaning of the word "stone." I thought maybe we could start with that.

(The interviewer slides the book across the table to Oliver Stone. He puts his glasses on and reads from it.)

OLIVER STONE "The Indians once told me stones are the most revered and ancient of recording devices, having seen and witnessed all since the beginning of time. And that perhaps I am here on this earth to write of these mute histories—just another stone, an 'oliver' stone."

Maybe this is one of those passages I added later. That's what I think now, not when I was nineteen. That seems to be wisdom I got along the way, when I was studying with the Indians and the peyote people [END 2]. This would be more of a peyote comment: that stones are one of the oldest things on earth. They listen and they see, and a lot of the spiritual cultures believe in that.

distinguish himself by any exterior mannerisms or names but only by his work and his mind.

Your mother, Jacqueline, a French Catholic woman, and your father, Louis Stone, a Jewish American who worked on Wall Street, are at the heart of a lot of your work. The struggle between them, and the struggle within you as you tried to understand them, obviously affected you profoundly. Is that struggle encapsulated in the question of what to call yourself?

(Stone laughs.) Well, yes. When you're young it's very sensitive. Oliver was not a normal name, and my mother was saying it with a French accent, so naturally I felt like a bit of an outsider. Who's called Oliver? I was a little embarrassed by it. Thank God there was *Oliver Twist*, but he was an orphan.

I think I changed to William pretty early. In school certainly, at the Hill School [END 3], they didn't know me as Oliver when I went back to the reunions. They said, "You're Bill Stone, you're Willie Stone, William Stone." Willie Mays[1] was a hero, so if you wanted to call me Willie, that was fine.

Who's called Oliver?
I was a little embarrassed by it.

And it struck me that they are recording devices, they're watching us. We think we're watching them, but they see us, and perhaps I'm here on earth to write of these mute histories, these people who pass by.

You were born William Oliver Stone. Most people know you as Oliver, but that wasn't always what you called yourself. The central character of *A Child's Night Dream* shares your name, William Oliver Stone, and he also wrestles with what to call himself.

In the introduction to the novel, you write that you were named:
William (after my American father's preference) and Oliver (after my French mother's preference). Both names are used in this book, William being the more practical and anonymous American identity chosen for me by a father who, deeply scarred by the Depression, insisted that a man should not

At home my mom would call me Oliver, and sometimes my father would. He went back and forth, but in the book I say he called me William, maybe because I associated him with that side, the American side, where you don't show off. Oliver's a flashy name. It calls attention. My father didn't want that.

And it's French.

"O-li-vyay" is French, but my mother called me Oliver.

My mother is something out of an F. Scott Fitzgerald story. She loved me, yes, she loved me. But I like to say that she's a close-up or a long shot. She's not a medium shot. Consistency is not there.

1 Famed African American center fielder who began his career in the Negro Leagues in 1947 and ended his career in 1973 with the New York Mets.

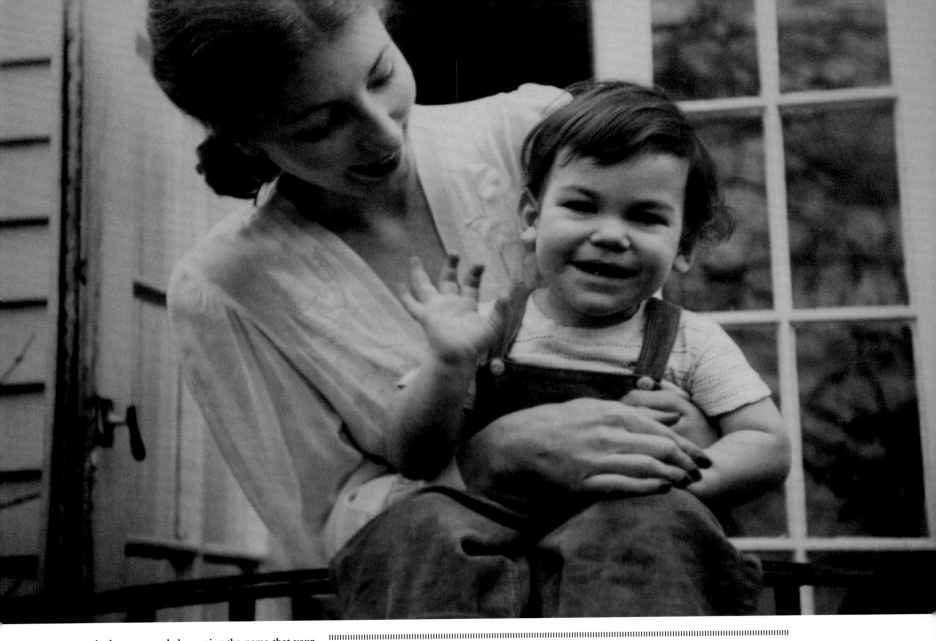

And yet you ended up using the name that your mother always preferred.

In the merchant marine, it was William. In the army, it was William, and after the army.

I guess I was at NYU after Vietnam, working on short movies, when I switched to the name Oliver. I guess at that point I had embraced the left side of my brain, or whatever they call it, the artistic side?

Interesting that you put it in terms of sides. That's always how I saw it, as a moviegoer sitting out there in the darkness, watching Oliver Stone films. In your movies, you constantly see this struggle between the traditional life—the man in the gray flannel suit, "watch your bottom line" sort of life—and this wild, romantic, Dionysian existence. It's in your novel, too.

That struggle is all the way through the book.

You had no brothers or sisters. Your father worked a lot. Your mother was AWOL a lot of the time. Who's looking out for Oliver? Emotionally, who's looking out for Oliver?

She loved me, yes, she loved me. But I like to say that my mother's a close-up or a long shot. She's not a medium shot.

I picture you as a young boy, being by yourself a lot, being raised by nannies a lot of the time.

Helen—a great nanny, but she was tough. I think I was extremely sensitive. I wanted to be alone, you know? And then there was Karlo, the houseman. He was crucial during my teenage years. He was gay, a Yugoslav, and an ex-prisoner of war in a Nazi camp. He lived upstairs from me, one floor up. At night he wore cold cream on his face, and a turban on his head after he washed his hair. What was beautiful about Karlo was his ability to cross that border between man and woman. He was my first example of somebody who could do that, and I admired him very much.

When did you start writing?

When I was a kid I wrote "themes" for my father, one or two pages, to make money. I made twenty-five cents a week.

He paid you?

Yeah. That was good, because I wanted the money to buy comic books. I bought all the comic classics. The classic stories rendered nicely, not just Marvel. *Three Musketeers*, all the Rob Roys [END 4], all the old stories and great novels were rendered into classic comics. In France they also have a great comic history, so they have great comics in France. It was very visual. I had a lifetime subscription

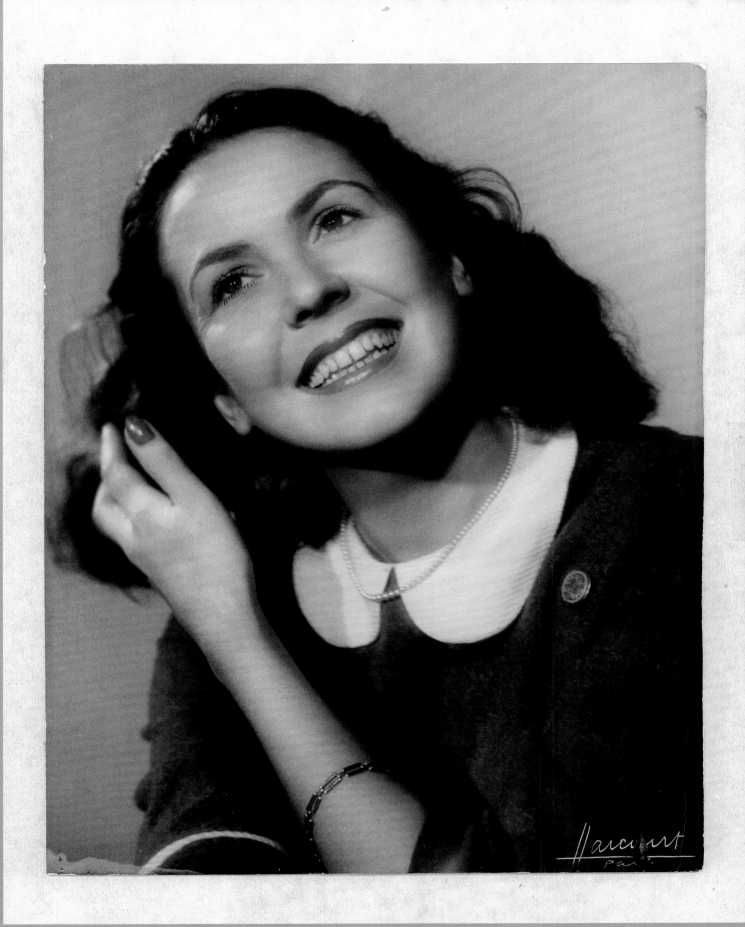

ically, and just in terms of his view of America, and what it means to be American. You dedicated *Nixon* to him, and *Wall Street*, both of which are at least partly studies of what, in the book, you call the "irongray life."

And yet he also wrote poetry.

He wrote good poetry, too. It was more like Tennyson[5]—no, a less Victorian cadence.

I have one of his poems here, if you'd like to see it.

Let me see it.

(Interviewer hands Stone a copy of James Riordan's biography Stone: The Controversies, Exploits, and Excesses of a Radical Filmmaker, *open to a page that includes one of Louis Stone's poems. Stone reads it aloud.)*

**I have a tale to tell, of little note,
Except it shows a strange philosophy—
The reason for a happiness denied.
The Fates one day were playing at their game
Of carefully dealing almosts and not quites
And mixing things to form a proper broth
Whose bitterness would equal its delights.
They looked down to the Earth this day,
They saw a man who thought he'd found his one desire
A woman who could set his heart on fire.
"This is too beautiful a thing," they cried,
"And Beauty, be it sight or sound or thought,
Was never meant to be a lasting thing.
It must be glimpsed, not stared at or embraced.**

**We will devise a way of ending it." They did.
Their doctrine is perhaps all wise.
The man is thankful for his glimpse of beauty.
He goes his way, a vision in his eyes.**

Very good.

It's also, from a biographer's perspective, quite rich, because it's showing you this man who has

5 Poet laureate of the United Kingdom during the reign of Queen Victoria. Author of "The Charge of the Light Brigade," "Tears, Idle Tears," and "Crossing the Bar"; "'Tis better to have loved and lost / Than never to have loved at all."

I DIVE AROUND IN IT LIKE A PORPOISE!

to *Uncle Scrooge*! *(Laughs)* I thought he was funny, with his pool of money!

Scrooge McDuck, diving through his gold doubloons like a porpoise!

You remember that? He was a character. I liked him.

Oliver Stone's *Scrooge McDuck*! I'd like to see that!

Now, in this idiot culture, I should make a movie about him!

I was also a big card collector, too. Mostly sports: baseball, football. And I went into the store one day, I guess I might've been seven or eight, and they had these other cards called *Look 'n See* [END 5], by Topps, the people who made the sports cards. I don't know why they decided to make these history cards, or who they thought would buy them, but they made them and they put them in packs with bubblegum, numbered, broken into subjects: Explorers, Men of the West, Military Leaders, Inventors. Babe Ruth, Ponce de León, Sir Isaac Newton, FDR.

I can't imagine anything like that being sold in stores today.

They had an illustration or picture on the front, then you flipped them over and they had a paragraph on the back with a summary of the person. And there was a piece of bubblegum in every package. They were wonderful!

But you know, I was interested in history before that, I think, and in stories. As a boy I liked being told stories, telling stories. I was bored one summer in France and started a novel about the French Revolution. It was on onionskin,[2] and I may have written thirty, forty, fifty pages, but I wasn't able to go the distance.

You spent a lot of time in France as a kid, didn't you?

Summers, when I was younger, longer when I was in preschool. I'd go there sometimes for long stretches. But summers mostly.

You were raised on images of war, the mythology and history. You go over to France, you've got your French grandfather telling you stories of the war, you're teasing your cousin about the dismal performance of the French in Vietnam, and you're collecting toy soldiers, aren't you?

Yeah, tons of them. Because I went to France, I would get the best of the French soldiers.

They really do a masterful job in France making Napoleonic soldiers and the chevaliers on the horses, very beautiful. So I'd have little mock battles with all these soldiers, you know? People would give me Christmas presents. I was spoiled because I was an only child, and I'd have a lot of Christmas presents. I'd get beautiful soldiers from the friends of my parents, and I'd also get a fort, which I loved, and cavalry and Indian soldiers. A classic martial youth, with all boys in schools.

No women around.[3]

I went to camp in Switzerland in '58, and another camp in Denmark in '59. There were beautiful girls there. But I was shy. In one of the camps, I was the chosen beau of the prettiest girl. I was a good-looking boy, I think, and I was the guy who was supposed to be with her.

But school was always boys. Hill School, the military, and the merchant marine—women were a thing of flowers. They were not available, but when they were, they were exciting.

I always had a feminine side, which I was not in touch with; so I loved that, finding it again. I think you see a lot of it in the novel.

When you went to France as a child, did your mother and father stay with you?

No. My mother would dump me in a middle-rent forty-room hotel in Paris that my grandparents owned and ran. One bath per floor. Old-style France. We used to shovel charcoal into the boiler in the basement. They also had a small house in the country, and that was a beautiful experience. She'd dump me there and go to the South of France to have some fun. My mom was a party girl. She was selfish in her way. "I'll be home later, darling." "What time?" "Oh, midnight, no later." I'm waiting, waiting, waiting for Mom to come up and give me a goodnight hug or kiss, and at one thirty in the morning,

she comes up. It was a bit of an Oedipus complex!

My father had three brothers and one sister, and his father was a millionaire back in the twenties and lost it in the Depression. His father had some apartments—nice apartments—in Harlem, but he lost them.

But Dad made it on his own. He really didn't have much help. It's the American story: Does he go out and risk it all? He had moments like that. I have pictures of him as a bum. He used to do that once in a while.

But he had a lot of girlfriends, and then before you know it, he's making a bit of a living. He moves his way up on Wall Street, likes it—and boom, the war hits! Next thing

<hr>

He liked sexy, slithering women. He loved women in nylons, and there were some hot ones!

<hr>

you know, he's in the War Department, part of the financial offices overseas, checking on Russian counterfeit plates and stuff. Three more years go by, all these girlfriends, London, great life, Paris, Berlin.

And then he meets this French girl.

She was a party girl. She was a social animal. And he didn't like that, in a way. I mean, that was not his style. He liked sexy, slithering women! *(Laughs)* He loved nylons and shit, beautiful, tall, fifties models like Bettie Page,[4] that kind of thing. He loved women in nylons, and there were some hot ones! I'm sure he had a kinky sex life.

Your description of your father is fascinating: so many contradictions. You've described him to me as an outwardly very conservative man, polit-

<hr>

2 A lightweight, durable, and often translucent paper.

3 *Stone*: "'No women around'? I see what you're doing here. I know you're going to make a big thing about women all through this book, and it's going to be one of the longer aspects. You make a huge deal throughout about my early films, and my rejecting your interpretation of the women in my early films! I think you go on too much about it."

4 1923–2008; The "Queen of Pinups"; early star of the erotic photography industry; later converted to evangelical Christianity; spent much of the second half of her life in a psychiatric hospital being treated for paranoid schizophrenia.

(opposite) Stone: "This is not my mom. This is another woman whom my father had a relationship with, Margot, a lovely woman."

(below) Examples of *Look 'n See*, a series of bubblegum cards released in 1952 covering major figures in US and world history.

WOODROW WILSON
PRES. U. S. 1913-1921

52 BALBOA
No. 2 of 6 Explorers

Balboa was in Central America when he heard he was going to be called back to Spain. He didn't want to return without performing some great deed in order to get into favor with King Ferdinand. Taking with him 190 Spaniards, 1000 natives, and a pack of blood-hounds, he set out across Panama and . . . after 26 days of struggle and hardship . . . he reached a great body of water which he claimed in the name of Spain!

LOOK 'n See

WHAT GREAT OCEAN WAS DISCOVERED BY BALBOA?
PLACE THE RED PAPER OVER THIS CARD AND SEE THE ANSWER.
©T. C. G. PRINTED IN U.S.A.

FRANKLIN D. ROOSEVELT
PRES. U. S. 1933-1945

45 AMELIA EARHART
No. 2 of 4 Famous Women

It was pitch dark, for the moon had hidden behind the clouds. A storm was blowing up, and the lightning shook her plane. But Amelia Earhart was happy. She had always wanted to cross the Atlantic alone. Suddenly, her altimeter stopped working! Then she saw flames at the back of the plane! She climbed higher, going ahead, until the break of day. Finally, she landed in an English pasture—just as the flames leaped close to the cockpit!

LOOK 'n See

WHAT GREAT RECORD RECORD WAS HELD BY AMELIA EARHART?
PLACE THE RED PAPER OVER THIS CARD AND SEE THE ANSWER.
©T. C. G. PRINTED IN U.S.A.

CLEOPATRA
QUEEN OF EGYPT.

74 ALEXANDER GRAHAM BELL
No. 7 of 7 Inventors

Bell, the creator of one of the world's greatest electrical instruments, knew practically nothing about electricity! He was an elecution teacher when he thought of the idea that was to make him famous. He hired a young mechanic, Thomas A. Watson, to help him on the invention, and finally . . . in 1875 . . . it was completed! He took out a patent on the invention . . . the most valuable single patent even issued in this country!

LOOK 'n See

WHAT WAS THE GREAT INVENTION OF ALEXANDER. GRAHAM BELL?
PLACE THE RED PAPER OVER THIS CARD AND SEE THE ANSWER.
©T. C. G. PRINTED IN U.S.A.

AMERIGO VESPUCCI
EXPLORER

2 WOODROW WILSON
No. 3 of 9 Presidents

For two years there had been war in Europe, and President Wilson had done everything possible to keep the U. S. out of it. Then, quite suddenly, German submarines sank the "Lusitania," with over 100 Americans on board. The American people were indignant, yet the Germans announced they would continue with submarine warfare! President Wilson therefore suggested that war be declared upon the Germans.

LOOK 'n See

OF WHAT COLLEGE WAS WOODROW WILSON THE PRESIDENT?
PLACE THE RED PAPER OVER THIS CARD AND SEE THE ANSWER.
©T. C. G. PRINTED IN U.S.A.

REMBRANDT
ARTIST

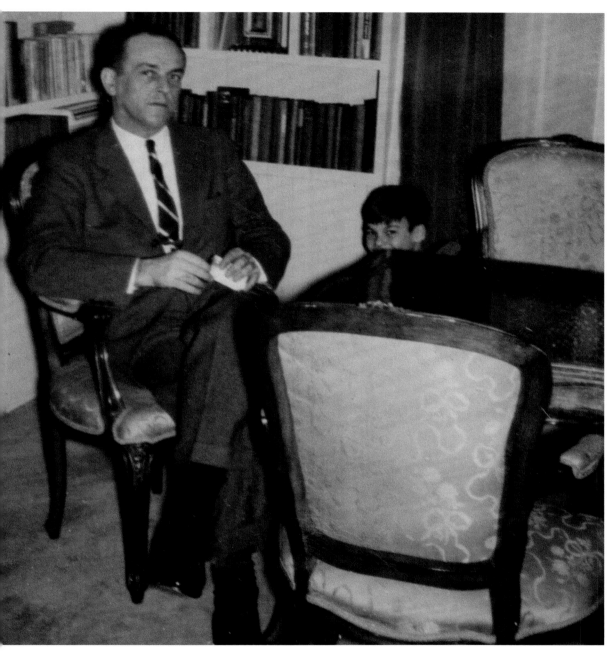

it was intellectual gravity. It wasn't money, it was gravity. It was more than being a stockbroker. He was a good stockbroker—he took care of his clients—but he was also a philosopher and an economist who liked Milton Friedman[9] and liked capitalism, yes, but he always made it eloquent.

Is it possible that his reluctance to engage with that literary or artistic side of himself came out of circumstance? The Depression?

Yeah, and the war. That's a real fear, for men and women who lived through that: How do you make money? His real fear was ending up in some poorhouse in a line. My father hated lines.

Dad, he was a wild man. He had the wildest sexual life I've ever . . . I mean, certainly he set a standard. I didn't know about all that stuff, but it's like John Updike's[10] book *Couples.* Everybody in the fifties and sixties was fucking around—not everybody, but a lot of people were. The straights were not.

That was the world I grew up in, in New York City. Here's a man, my father, and a woman, my mother, but he's fucking everyone he can, as well as hookers, and my mother is sometimes humiliated, sometimes embarrassed, but puts up with it, bears it, with increasing isolation, and by the end of the fifties, beginning of the sixties, she gets her own boyfriend, whom she's paying for with her allowance. The boyfriend's a great guy, I admired him. He's teaching me things that my father could not teach me, and he's a friend of Mom's, and when my parents got divorced,

this almost uncontainable, Dionysian impulse— but, I guess you would say, tamping it down.

And of course, this echoes with many of your own works, too, that struggle.

Every child to some degree expresses the secret desire of the father, they say. Dad was a sensitive man. In 1932, it was the heart of the Depression.[6] What a shitty time to graduate from college! And he's a Jew, too—a hidden Jew! So it's not easy in that era, but he survived and became a floorwalker, and so forth and so on, thirty-five dollars a week. But imagine the Depression. I mean, he must've looked

at these people like T. S. Eliot[7] and Ernest Hemingway[8] with some awe. He wanted to be a playwright. He wrote plays and kept them in the drawer! He showed them around to some people, but nothing got produced. He also wrote a monthly letter. An economic letter. I have copies of it: It was about economics, but he always started with a quote from the classics. And he would describe things in a philosophical and metric way.

He was a good writer, a very good writer. My dad's monthly letter was one of the most popular on Wall Street from the fifties to the seventies, and it was important to him because

6 The US stock market crash of October 29, 1929 (also known as "Black Tuesday"), precipitated a worldwide economic Great Depression that lasted for much of the thirties.

7 A major poet of the twentieth century and 1948 winner of the Nobel Prize in Literature; "The Love Song of J. Alfred Prufrock" (1915), *The Waste Land* (1922), and *Four Quartets* (1943).

8 *A Farewell to Arms* (1929), *For Whom the Bell Tolls* (1940), and *The Old Man and the Sea* (1952); part of the "Lost Generation" expatriate community that included F. Scott Fitzgerald, T. S. Eliot, Isadora Duncan, and John Dos Passos.

9 An American economist who extolled the virtues of a free-market economic system with minimal intervention; a major adviser to President Ronald Reagan.

10 Author of the Rabbit series (1960–2000) and *Couples* (1968), which examine the sexual peccadilloes of the American bourgeois.

my dad tells me why they got divorced, and I realize my mom's friend is actually her lover!

Goddamn it, how stupid am I? I'm sixteen, fifteen, and I didn't realize it? It's really amazing how naive I was. Why am I not running around figuring out life? Why am I not having sex at fourteen?

Who told you about the divorce?

both of your parents, or one of your parents, to come out to the school and see you.

My dad didn't take the bull by the horns. He had called the headmaster, who had told him, *We've dealt with these cases a lot; let me handle it.* But I'd read *The Catcher in the Rye*,[14] so obviously to bolt was the first thought—to go to New York on the train. But my father was not inviting me. He was saying,

was the reason she just didn't want to see me. She was embarrassed. Her whole life was a shambles. She had no credit cards. They were canceled. She had no money. She was in a very tough place at the time.

But your mother had known of his infidelities with other women prior to that?

Yes.

So she knows of his infidelities, yet she continues to be married to him for years, but when he finds out about *her* infidelities, he divorces her?

Not immediately. This was going on for a long time. Two summers went by. I don't know what my father knew, but I think he was figuring out the details because she was in love with the other man, and that's what broke him up.

I guess the pact was, she was supposed to be the mother and the family keeper, and he was playing the role that he played—that role that sophisticated men played in the Jazz Age.[15] So when she couldn't continue the role that she had, he went and got proof of adultery. It was ugly, to get proof like that.

That period was hard. It hurt my mother. She laughs about it now, but at the time—can you imagine?

That's a real fear, for men and women who lived through that: How do you make money?

My headmaster put a note in my box. I then spoke to my godmother, Suzanne [LaFrance],[11] who told me that my parents were separating. And then I tried to reach my dad, but I couldn't reach him. My mother had vanished to France.

It was a horrible couple of days. My headmaster was a scary guy, very strong, a man I deeply respected. He had nose hair and strong features. He was a leading figure in the East Coast establishment, a friend of William Buckley,[12] Robert Frost,[13] and all these people who came to the campus. He wanted to see me. When my godmother told me this was happening, I didn't go to see him, and I got bawled out the next day. The headmaster was furious that I had refused to come see him [END 6], but I was too embarrassed. Divorce was not a normal thing at that time.

I finally spoke to my father, who told me a broken-down version of this. But it's hard, because I expected, in a situation like that, for

I'll see you on spring vacation and we'll spend some time together.

How far off was spring vacation?

Probably a month at least.

He was going to make you wait a month to talk about divorcing your mother?

Yeah, yeah. I'm sure he was hurt, too. He had made the decision to evacuate the house, take everything out, and cut her off completely with credit cards. It was fast. He caught her, because New York State law required proof of adultery, so he had a private investigator follow her to California, where she was with her boyfriend. The investigator broke into the hotel, actually got a room key, and it was done in the old-fashioned way. He took a flash photo of them together. This was humiliating for my mother, you have to understand. This

11 Stone's godmother, Suzanne LaFrance, was also his father's secretary during the war.

12 Conservative commentator, founder (in 1955) of the *National Review*, host of PBS political talk show *The Firing Line* (1966–99), author of a syndicated newspaper column and a series of spy novels about CIA agent Blackford Oakes. Briefly served in the Central Intelligence Agency under E. Howard Hunt; Hunt would later become part of President Richard Nixon's team of "plumbers" masterminding the Watergate break-in; see Stone's film *Nixon*, chapter 7, page 316, for more.

13 American poet examining loneliness, stoicism, and free will in the idiom of his native New England; winner of four Pulitzer prizes for his poetry anthologies; poet laureate of the United States and, later, Vermont; best known for "Birches," "The Mending Wall," "The Road Not Taken," and "The Silken Tent."

14 J. D. Salinger's 1951 best seller about rebellious prep school teenager Holden Caulfield.

15 Coined by F. Scott Fitzgerald, author of *The Great Gatsby*, to define the free-spirited twenties, when jazz music and dance became popular in the United States, Britain, and France.

We're going to skip ahead in time, here, Oliver, about four years, to when you wrote your first draft of *A Child's Night Dream*. I have this bit marked, and I'd like to read it to you. It's about that phrase you use in the book, the "irongray life." You're talking to your father in this scene, and you say:

Sad little Olivers. In the vice. Who am I, in my little college room, going home and saying, "Father, you're wrong, Eliot's poem is structured on the belief that . . ." as each eight-thirty morning, two million workers pour into Wall Street to give their souls. In hordes that pass me by. Fear stepping down to my simple level. The plexus of irongray life.

Maybe it's because I've formed my own mythology about you, but I see you as a child, as a young man, desperately not wanting to let that "irongray life" swallow you up.

It was scary, because my father lived in a Midtown apartment and was divorced. My father was a strange man, because he liked to rent everything. He rented a hotel suite at the Beverly Hotel on Fiftieth Street and Lexington. Good service, high ceilings, and I had a room there. But it was so commercial. You know what the East Fifties are like. For that reason I've always hated the East Fifties—you can't go out in the street!

I was trying to be a writer, didn't know girls, didn't have many friends, because I'd gone off and realized I'd left the world I'd been in at Yale. I'd been away for a year and a half, and when you're young that's a big difference! It's not like you call up a lot of people and say, "Hey, how've you been?" It's just not that easy.

As I talk to you about your youth and adolescence, I get this sense of wanting not to have an ordinary existence. It's definitely there in your memoir as well: At different points, including the passage we just looked at, you quote lines from T. S. Eliot's "The Love Song of J. Alfred Prufrock," which seems to be tremendously important to you: "I grow old . . . I grow old . . . / I shall wear the bottoms of my trousers rolled. . . . Do I dare to eat a peach?" and so forth.

Fear of life, I think, is a big theme in all my life. I'm still scared, in many ways. My father was scared of life. That's why he preached or practiced a certain degree of anonymity, and inside that anonymity, going to work from nine to five and being a respectable father.

But also inside that anonymity, he was a wild man, too! He had a lot of girlfriends, some of them hookers. Most of them that I met were great ladies! They were nice to me. They were not cheap—they were good girls, in the sense that they gave me a lot of education. I remember four or five of them—one of them I wanted to fuck so badly! They were so human. I like the underside of life. I don't like people who are corrupt, but these people were not corrupt.

I hate it when cynics just put down hookers! My father enjoyed them. He loved to talk to them. He'd bring them out with his man friends and woman friends. Then he had another mix of richer women who were more educated, but he never wanted to marry. There was this one rich woman, very lovely. I said, *Marry her, Dad, she's good for you!* But he didn't want to marry her. She was upper class, Connecticut, not his style.

Your mom had a boyfriend or boyfriends?

Three or four—very handsome and younger, all of them. But one at a time! I don't want to give the wrong impression.

Who cheated on whom first? Do you know?

My dad. Right away. My dad never wanted to marry. He was a bachelor in his heart. He told me. *I married your mother to have you, to have children. She'd make a good mother*, he used to say. He thought she'd make a good mother—how wrong he was!

He said, *She's a peasant from France.* She came from a good, really solid hotel family, you know, people who worked hard. Her mother and father, my grandparents, were unpretentious, nice people. I loved them. And they were the best models I ever had for a family, because they stayed married for fifty years. My grandfather was also a handsome player, like six feet two, and he loved women. Even when he was old, I used to crack up when we'd go to the bakery in town and get the fresh bread, and he'd be looking at the French chicks, always! But he was faithful to my grandmother. They were the best couple I saw when I was young.

They told you stories, your grandparents.

Oh yeah. My father told me stories, too. He was a great storyteller.

You have to realize, he played ball with me and did all those good things. He was a busy man and a little bit older, I guess—he didn't have me until he was forty—but he was a good father, and fun, although he had a bad temper. And my grandmother told me classic French horror stories, and my grandfather told me stories of World War I, so they were all storytellers.

Fear of life, I think, is a big theme in all my life.

My mother wasn't. My mother was another type of woman.

Her perfume at night—I describe it in the book.

My dad paid for the first woman I ever had sex with. I was at boarding school.[16]

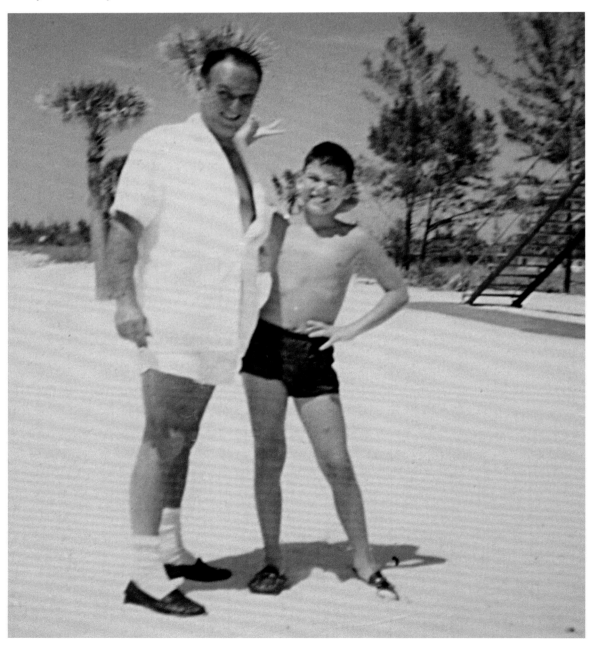

You lost your virginity to a prostitute?

What's wrong with that? That's the New York style. That may shock people, but I didn't know any girls! Like, I'm supposed to have a sweet love? Natalie Wood's [17] gonna fall in love with me at sixteen?

Dad was great; the girl was great. It was a beautiful night. He arranged it because he knew I was miserable in terms of something I didn't know much about. Just yearning, and not knowing enough. He arranged for a hooker, who came from New Jersey. I'm sure he'd been with her. My father left the apartment that night and brought her in. She had a wonderful smell.

fulfilled! And unlike a lot of my classmates, I had experience! It made me more of a man, in a way. Like, *Hey, I've actually done it! Have you done it?*

To have experiences was very important—specifically experiences that a man was supposed to have.

Yeah. I didn't think of it as wrong. I thought of it as perfect. You paid for it? Big deal, if you could afford it.

Then you went to Yale and got restless or bored, and you dropped out. You wanted to become a mercenary at some point, right?

Like *The Magnificent Seven* [END 7] or something.

You have to understand, I was willing to go. In fact, I checked it out, but there was an age thing. I inquired but it didn't work out, and instead, I ended up teaching English, history, and mathematics at the Free Pacific Institute in Cholon,[21] which was a Catholic organization based in Taiwan. I started in June of '65.

I was later told by a student who came to see me years after that this school was part

16 Her name was Robin.

17 Former child actress (notably in *Miracle on 34th Street*) who graduated to adult roles that often fetishized her dark-haired beauty and made her into an icon of repressed, incendiary sexuality; *Rebel Without a Cause* (1955), *Splendor in the Grass* (1961), *Love with the Proper Stranger* (1963); drowned in 1981 on a boat trip with her husband, actor Robert Wagner.

18 A Tibetan word that refers to the "intermediate state," between death and the next life on earth, when a soul is not connected to a physical body.

19 A colony that existed in Central Africa between 1908 and 1960, ruled by Belgian colonizers; now Democratic Republic of the Congo.

20 First democratically elected prime minister of the Democratic Republic of the Congo; founded the Mouvement national congolais and helped win his country's independence from Belgium in 1960 before being deposed and executed.

21 A Catholic high school in the ethnic Chinese section of Saigon.

||

My dad never wanted to marry. He was a bachelor in his heart.

||

I remember that smell because it was dark. A woman takes off her clothes and lies with you in the most intimate way. It's a strange experience. She makes love like milk. It was milky, sweet. And obviously you come very fast when you're younger, I guess! It's over before you know it! It's like death, like going to the *bardo* [18] at full speed! You don't ever see anything—what happened?

And then I went back to boarding school. I was the happiest boy, because I had been

It was in '65, that first year at Yale. After the first year I checked all the bulletin boards and magazines trying to get into the Belgian Congo,[19] which was heating up. That was a horrible group. I mean, those guys were very right wing! I didn't know what I was in for! To me, [Patrice Émery] Lumumba[20] was the enemy. Lumumba was a bad guy, and all these mercenaries were cool! I mean, it was like a movie, right?

of a CIA program to spread American culture through Asia, sort of a future Psyops campaign.[22]

How did you end up in the merchant marine?

Later that year in December I was able, with the help of the US consulate, to get a job in the merchant marine. There were many ships in the harbor bringing equipment over and they were often losing sailors who bailed on their ships for whatever reason. I was hired as a wiper, but I didn't really tell my parents much.

You could've gone anywhere in the world, and you went to the East. Why?

The East is so beautiful and fertile. It's where all the heroes go: Perseus, Theseus, Alexander, and Achilles [END 8]. They all go east. That's where the money is; that's where the resources are. That's where the beauty is.

And frankly, I didn't know all that. It came late to me; but I did it. I went east, and I'm glad I did, because if I had gone to Africa, it wouldn't have been the same thing. I would've had a different life. It was a real turning point.

I went to the East and somehow it flowered, because I encountered Asian women, quite a different experience than the women I knew in America. When I went back after my second stint in Vietnam, the military tour, I went back into a "William" kind of thing and married a proper, beautiful woman, Lebanese, worked at the UN.[23] Beautiful, accented voice. She had that kind of allure. Cary Grant[24] courted her for a bit. He gave her a TV set, I remember. He liked sophisticated women, that style.

And then after a bit, you leave the school, and you join the merchant marine.[25]

It was awful. I was the only wiper on the ship, because the other one, who was crazy, quit.

What does a wiper do?

He cleans up the engine room every day, blows the boilers, as well as cleans toilets. He's the lowest guy on the ship. But at least you're union, you know? I got my union card after that. It's where you start.

There were supposed to be two wipers, so they needed a wiper, and they put me on a ship with a crazy wiper who was nuts: Jimmy.

Was Jimmy the guy you came to blows with in _A Child's Night Dream_? Two of the most intense sequences in your book are the description of the boiler room explosion that almost kills you, and your fight with the sailor whose neglect caused it, and who was going to let you take the fall for it.

Some version of that, yes. We were traveling light when we were coming back—that's very important, because when you have a V8 ship, which is huge, taking tons of shit to Vietnam, when they return, they're coming back empty. And in the north Pacific in January, even in the mid-Pacific, you've got strong currents and winds so your ship is rocking a lot. I got over vomiting. It comes out as white spit after a while.

And the boiler went down off Taiwan. Disaster. The boiler was out for a day, maybe a day and a half, and we were trying to fix this fucking thing while we're rocking crazily from side to side with no forward momentum. The engineers and oilers were coming and going because they were on four-hour shifts, and I was the guy who stayed on from shift to shift. And then we were running out of gaskets, because we kept ruining them fixing this giant boiler!

There's an almost Conradian quality to that part of the novel.

I love Joseph Conrad.[26] He motivated me because he had been a commercial sailor. Merchant mariners are like a lot of wandering guys—they returned to land for six months. A lot of broken marriages, booze, broken lives, put it that way. And then they go back to the sea to make some cash and then back to land again.

All these guys had lived colorful lives. I remember this fucking guy Red, a third engineer; he was a tough, mean motherfucker who almost got me killed on the boiler. There was even a Rasta on the ship, a beautiful black guy with a beard and dreadlocked hair. There was this Colby guy, who said he was ex-CIA. He was nutty. They were always complaining about getting home to the wife or some relationship, but they'd always end up going back to the sea, because it was their heart. They all had this love.

I loved the sea, too, in a way, and I want to go back before I die and take a trip, just as a passenger on a trawler or something, just to live that out again because it was so beautiful, and so wild, wild, wild. The nights, freezing nights, looking out over the ocean.

||

The East is so beautiful and fertile. It's where all the heroes go.

||

That section of the book is like a Robert W. Service[27] poem: "The Shooting of Dan McGrew." "How Jock MacPherson Held the Floor." "The Cremation of Dan McGee."

"The Cremation of Dan McGee" was one of my father's favorite poems! He used to recite it to me when I was a kid.

One of my best friend's fathers used to read Service's poems to his son and his friends whenever kids would spend the night there. He would read Robert W. Service poetry by candlelight. They were poems of machismo.

(Stone laughs.) Like Rudyard Kipling.[28] My father loved him.

Lord Jim **is a big one for you, isn't it?**

22 Psyops, also known as Psychological Operations and Military Information Support Operations (MISO), were meant to induce or reinforce behavior favorable to US objectives.

23 Najwa Sarkis, Stone's first wife, from 1971 to 1977; for more about her, see chapter 2, page 76.

24 The epitome of the suave leading man; _Bringing Up Baby_ (1938), _Notorious_ (1946), _North by Northwest_ (1959), and _Charade_ (1963).

25 The fleet of merchant vessels, owned by civilians and operated by either the government or the private sector, that transports goods and provides services in and out of the nation's navigable waters.

26 Polish author who wrote in English; best known for _Heart of Darkness_ (1899), which inspired Francis Ford Coppola's Vietnam War film _Apocalypse Now_ (1979).

27 British Canadian poet nicknamed "the Bard of the Yukon."

28 Popular English writer whose stories and poems were often set in colonial India; best known for _The Jungle Book_ (1894), the short story "The Man Who Would Be King" (1888), and the poems "Gunga Din" (1890) and "The White Man's Burden" (1899).

44

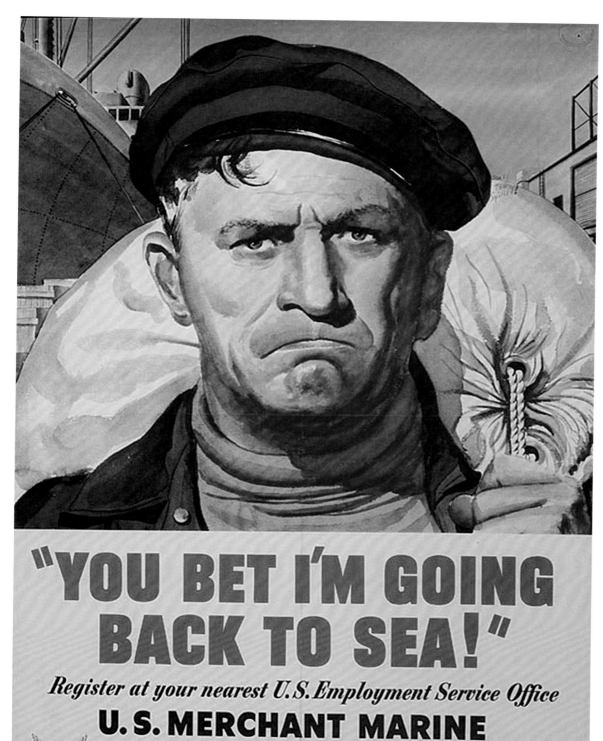

"YOU BET I'M GOING BACK TO SEA!"

Register at your nearest U.S. Employment Service Office

U.S. MERCHANT MARINE

War Shipping Administration

MAN THE VICTORY FLEET

tried to kill my cousin in France, that summer. That's in the book.

Can you go there?

Yeah, sure.
(Flips through book, slides it over the table to Stone.)

I was very young. Dien Bien Phu[29] is mentioned here. He talks about *I'd first learned to kill*, about the fish, I remember that, the fish in the sink. And now he's choking his cousin.
(Reads.)

. . . moving swiftly and ruthlessly behind his chair in an instant's pride, grasping him at his unprepared ease from behind his back, taking his throat, in all its soft embedding flesh, thoroughly in the small of my hand, his cartilage piercing into my palm, and, fragile, squeezing mightily with my fingers and strong frame, killing . . . my hands, . . . killing! . . .

My cousin not knowing why this is happening, crying croupously, so surprised! choking on the natural difficulty of . . . *[Strangulation sounds]* **. . . Squeezing on! You shall die because you shall die! and I. I am killing you. . . . The power the glory! Of killing! Raw brute force. Master mocking his dog. Dog meating his master. . . . Gurgling there bubbling. An ugly French face rasping red. So ugly, haha, that you deserve to die!**

And Mémé. In this drama. At last pouring from the kitchen. Into my ear. Her face of deepest shock. Shrieking above the rain, . . . This sixty-year-old woman lunging at me with all her creaking force. Grabbing and twisting my arms with all her peasant strength. Petrified thoughts of murder. My spell broken. Hatched. Cracked. Ooze. Lose. . . . Jean-Claude slumping on the floor.

All that rage. Isn't that amazing?

Where did that come from?

It probably comes from some denial, or something that happened very young, some negligence.

Or it could've been from a past life. Buddhists say that sometimes you come with that karma. It's evolutionary karma. You have the brutality in you. At least I've faced it.

Very much so. It was a book I read outside class and was one of the first ones that opened me up to the concept of literature. I loved it because of his pure writing skill, and his sense of mystery. I'm not a plot person that much. Sometimes it's a mood—the mood in Conrad, right? The way he weaves a spell.

Here you are, it's the 1960s, but you have this almost nineteenth-century concept of what it means to be a man: to bed beautiful and exotic women, to go east, to go to war, to kill, to fight. It's a Robert W. Service poem, but it's you.

That brutality you mentioned in the merchant marine was evident earlier, though, when I

29 Climax of the First Indochina War, ending with the Viet Minh Communist and nationalist revolutionaries defeating the French and ending their colonial rule in that part of Asia.

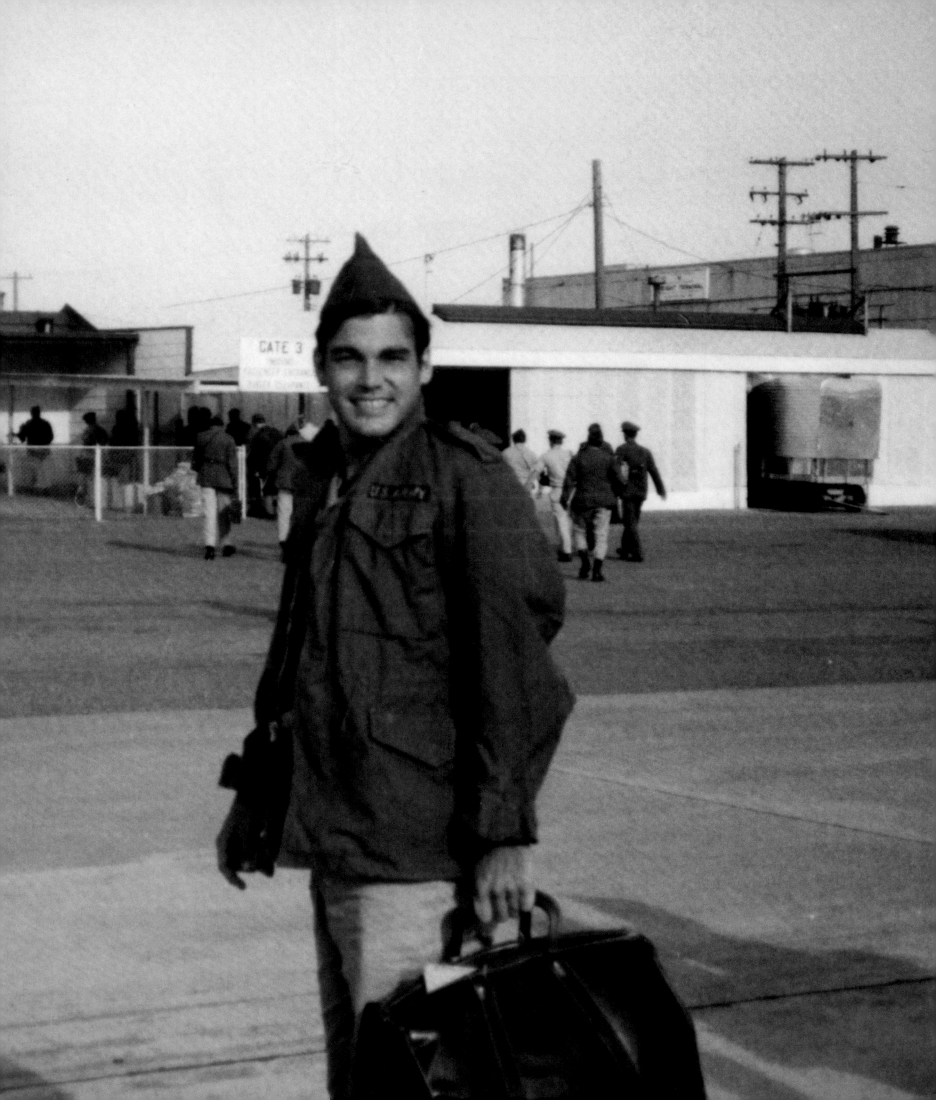

You don't write shit like that without giving yourself away.

In the book, you go to Vietnam and then you're a merchant marine. But in life it was the other way around, right?

Yes. The merchant marine was before the army.

So the combat sequences in *A Child's Night Dream*, those were written before you enlisted? You're just imagining what combat is like?

Oh yeah, absolutely. Custer's Last Stand[30] also. There was no experience. I may have changed a little thing or two when I published it years later, but no, that was all imagination.

Throughout the novel, and in a lot of your stories about your life, there's a sense of woman as Other, woman as mysterious [END 9]. I wonder if perhaps Catholicism doesn't play a role in how you look at women when you're younger? It's the angel or the whore a lot of the time, not much in between.

Angel! Whore! It's always about that with you critics! I was nineteen. Give me a break! Angel/whore. You could say that, I guess. But it's *your* favorite terminology, probably your story! What about the Vietnamese peasant [in the novel] who gets shot in the rain? What is she?

OK—not everyone.

What's the beautiful Mei Lin, whom he makes love with, who has beautiful language? What is it for her? It's love in its way. It's a passion.

It is.

She's a Vietnamese prostitute. And yet, we had compassion and tenderness. Mei Lin is very important. And my mother, too—my mother. And the woman in the rain. I respect the woman who gets killed by the Vietnamese officer working with US troops.

(Flips through novel, finds passage.)
So this is Mei Lin, and I'm saying here *(Reads)*:

Close this door. A ball of energy in my balls.

I'd just been to the movies. And I was moved.

And this, then and diffident, urinating. The jolly green giant. Closeup of his penis quaffed. Now the names: Molly and John. Good title.

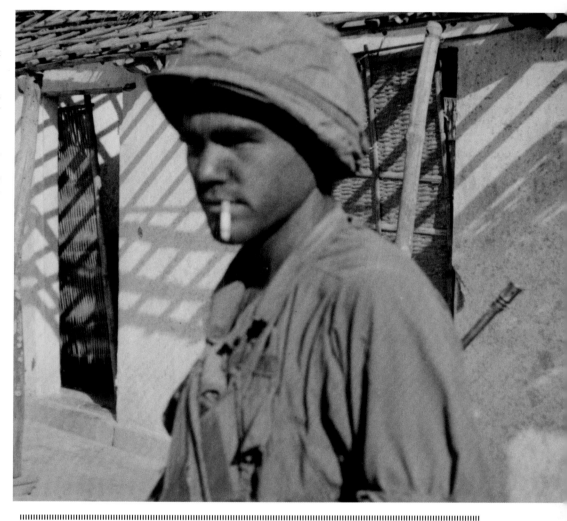

All that rage!
Isn't that amazing?

Molly and John is the title of a porno. Molly, like Molly Bloom in *Ulysses*.[31] That's from a porno film I saw, great stuff. The first black-and-white porno I'd ever seen. It was beautiful, not like these modern pornos.

And then there's a moment here with:

Licking the little hairy leaves 'neath these arms. Spider copyright. And my warm tongue sipping the unpasteurized liquids of your lips. Such light fine black hair. How fares it? Put it into this male's mouth. And taste its grassy brim. Treading on tiptoes the path of spring. Now lick it, the chops of memory, and may you never forget till the day you die the sweet taste of this in your palate of memory. Taste. Tarry. The blossom

is too sweet for cutting. For. What is it that I foresee in the foggy mists of futurity? Some physical evil. Happening, it happens. To me . . . or is it to you?

30 Major armed confrontation in the Great Sioux War of 1876 between three American Indian tribes (the Lakota, Northern Cheyenne, and Arapaho) and the Seventh Cavalry Regiment of the US Army, under Lieutenant Colonel George Armstrong Custer.

31 James Joyce's 1922 novel; considered one of the major works of modernist literature. It chronicles a day in the life of the Irishman Leopold Bloom, paralleling his mundane adventures with those of *Odysseus* (aka Ulysses) in Homer's Greek epic poem *The Odyssey*. Molly Bloom, Leopold's wife, is roughly analogous to Odysseus's faithful spouse, Penelope.

And now, as it came, it is gone. The cold fear. Awaiting. Two squelching lips cupping her cunt. Two squab feet cupping my balls. Your tiny fat baby toes rubbing up against my globes. Hemispheres. Strange that . . . that you're thin, and for one so thin, such feet are fat. Intact. Squirming and poppling in my plantigrade grasp. Like this wine, your hind, it is divine, and, as in youth, when to the gods we whispered our aspirations, of whitearmed Helens and yes—Pallas, Pallas Athena in the sack!

She was my goddess because of Greek mythology. I always believed Pallas[32] was on my side.

And then, wow, it's crazy sex.

No, wait. A few beats more, as I stand above the shaded elders of the river and drink deep the effluvia that pervade gleaming sweat of your green pubus. Greedgraced architect 'tis I. Who build these spanking spires to the smoking sky? Earth-born giant, I volumnize the earth, my greed knowing no skull, my ambition no growth. Do I not frighten you, little feather? Aye, what not and all, what are you doing? You're reaching into my hatch of time—man made humble, into my testicle sweating in scent. Your cold finger with its nail disrobing my tinkles of first sorrow, my void, my inevitability—thus traduced by the echoes of humility, this Hercules that's who.

And then he comes, right?

For now is the time of revelation, the time to tell all, to you lying astride me here as no other will do, clutched close to me in the bands of secrets, licking my belly like the fondest dog I ever knew. That I must disappoint you. You see . . . there's just one. With one to go . . .

O Mei Lin! the rosejoy of your lips, softing my sadness and incesting my hard mind with bribes of an intimacy unknown, was it not so long ago when Byron in these sheets slumbered? Three centuries Shakespeare, six centuries Dante, and in the first Himself—say tell, I wish to know, of the sacred hands that defiled your temple, and stole from your organs the sweet sweat of ejection.

No, best not, fumble to kneel, and then to pray, and boldly to washup.

No, she's about to come.

For soon. No. Yes. You understand? I knew you would. That I'm tired of it all. I read much of the night, I go south in the winter, and you mean more than this to me, so much more, now that I am about to lose you, never to see you again. I will sit in a New York office years from now and think with prickly fever about the times of my youth, and you Mei Lin—whatever happened to you? You will be dead, Mei Lin, that's what. Killed by some awful inevitability of the East. Bad-lucked girl. It is so good to be alive when one is young, is it not?

And *then* he comes.

And then it goes into the battle, and that's all written from imagination. That's based on the First Cavalry Division that arrived in the country in '65. They got big-time attacked.

The battle of the Ia Drang Valley.[33] One of the largest conventional battles of the war.

It was pretty bad that day. They got hurt, like Custer's Last Stand.

You went east, you taught, you were a sailor, and it was an incredible adventure. Most American boys at that time did not have those sorts of adventures. Then you went home.

I'd come back via Oregon from the merchant marine with money in my pocket. I went down to San Francisco, partied a bit, spent some money, ended up making my way to LA, where my parents had friends who were studio producers. They produced the old *3:10 to Yuma*[34] as well as some other westerns. They were New York intellectuals.

Then I took a bus to Mexico because I'd always wanted to go there, and I'd never been. I ended up going south, and then stopped in Guadalajara, where I holed up in a hotel. I was lonely, really lonely, and I had an urge to write it out, all these great things I had seen, everything I'd experienced. So it started there.

Did you have any particular influences or models in mind as you started writing your novel?

I'd read a lot of books as a kid. In high school I read the curriculum: *Moby-Dick*, *Ethan Frome*. Then I'd gone to Yale, started to read on a broader level. Later I started to read Conrad, Hemingway, Mailer, everybody I could. I read James Joyce, which I thought was beautiful: the lilt. I loved poetry.

Portrait of the Artist as a Young Man?[35]

Ulysses. *Portrait* was good, but a more conservative book. I wanted to make a splash, I wanted to go out there, and I had read just

I didn't want to write the usual drippy little fucking book.

I wanted to write something
explosive!

enough to believe I could write, like I did in film school when I thought I'd shot enough film to be able to go right away! So I had these bigger ambitions. I wanted to be Norman Mailer.[36] I wanted to be Conrad! I wanted to last! I didn't want to write the usual drippy little fucking book. I wanted to write something explosive! It was passion more than intellect.

I remember that hotel in Mexico. It was a nice little hotel, and in two and a half weeks in Mexico I wrote maybe three hundred pages on onionskin. I was alone in a strange culture. It was very good for me. I loved the aloneness. Remember, I have no brothers or sisters. I went home with a decision to continue the book at home. Why didn't I finish it in Mexico?

32 The epithet given to Athena, Greek goddess of wisdom, courage, inspiration, civilization, law and justice, strategy in war, mathematics, strength, the arts, crafts, and skill.

33 November 14–18, 1965; one of the first large-scale battles of the Vietnam War.

34 Delmer Daves's 1957 western starring Glenn Ford as a captured gunslinger being escorted to a train by a cash-strapped rancher played by Van Heflin.

35 James Joyce's first novel, about the religious and intellectual awakening of Joyce's alter ego, Stephen Dedalus (an allusion to the Greek mythological craftsman Daedalus).

36 Macho American writer best known for his nonfiction novel *The Executioner's Song* (1979) and his 1957 essay "The White Negro."

THE UNITED STATES OF AMERICA

TO ALL WHO SHALL SEE THESE PRESENTS, GREETING:

THIS IS TO CERTIFY THAT
THE PRESIDENT OF THE UNITED STATES OF AMERICA
AUTHORIZED BY EXECUTIVE ORDER, FEBRUARY 4, 1944
HAS AWARDED

THE BRONZE STAR MEDAL

TO

SPECIALIST FOUR E-4 WILLIAM O. STONE US 52758282 UNITED STATES ARMY

FOR

HEROISM IN GROUND COMBAT

ON 21 AUGUST 1968 IN THE REPUBLIC OF VIETNAM

GIVEN UNDER MY HAND IN THE CITY OF WASHINGTON
THIS THIRTIETH DAY OF AUGUST 19 68

GEORGE I. FORSYTHE
MAJOR GENERAL, USA
1ST CAVALRY DIVISION (AIRMOBLE)
Commanding

SECRETARY OF THE ARMY

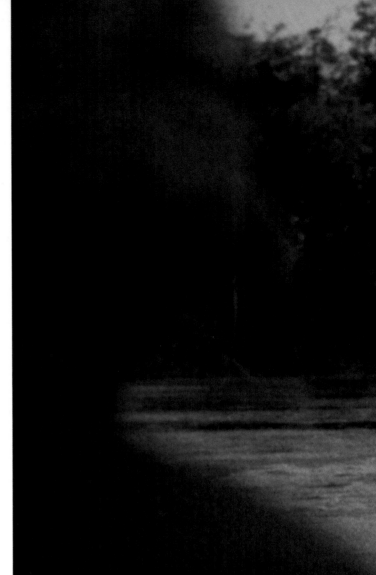

So you go back to New York, you try to finish your novel, you're under tremendous pressure from your father to go back to Yale and finish what you started, and you can't do it, and here's this novel obsessing you, calling to you.

Don't forget the fear thing: to wake up in the morning with eight million people in an apartment in Midtown you don't own yourself, and you're not going to college. I would go out twice a day, maybe just to breathe, and then I'd go back to doing hours a day of writing, which as you know is hard! Just trying to finish this thing, whatever it was, but I didn't know what the end was! So before you knew it, those 250, 300 pages in Mexico grew to 1,000, maybe 1,200!

You wrote the whole thing by hand?

Yeah, sure. I still have part of the manuscript.

So my father had a connection at Simon & Schuster. In those days publishing was a much more prestigious business. Now it's more of a mercantile thing, but back then it was really a snob thing: "the literary life." All those writers were stars—Saul Bellow, Cheever, Updike, Mailer.

I went, through a connection of my parents, to Simon & Schuster, and the big editor there was named Bernstein, as I remember. He took the manuscript very seriously, which surprised me. I thought they'd laugh at it and wouldn't even read it. But they actually read it, and the editor was very good to me.

But they turned it down. I remember being very hurt.

And that's what led to my throwing away many of these pages. I went up to the East River where I used to live on Eighty-first street, and I just threw these fucking pages into the river. I don't know how I separated it, because it's a miracle that I had a good section of it left!

When I destroyed that book, it was over.

What was over?

My life. I couldn't stand it! I couldn't be a novelist.

The rejection from a few publishers made you think, "I'll never be a novelist"?

I was also embarrassed by it! The thing about this book is, how naked am I? *Naked!* I mean, if you brought up certain passages now, I'd cringe, you know? Baring your soul naked— that's what Mailer and the others were doing,

but they were much more sophisticated. The irony is that Mailer read it thirty years later and praised it in a very nice blurb.

Yes. He said "*A Child's Night Dream* is phenomenal." That was on the cover.

But after all that, my life was over. It was very dramatic.

This was all after my first trip to Vietnam as a teacher and that time I spent as a merchant sailor. I'd left Yale at the end of my freshman year. When I came back, I wrote the book, went back to Yale. I kept writing it! I never went to class—missed the entire semester, failed all my courses, and quit when the Dean told me they had no choice but to—I guess fire me. I went back down to New York, finished the book within a month, and when it was rejected, I felt I had pushed my ego to the place where I had written so much about myself, and felt disgusted with that aspect. I didn't want to have an ego like that. I wanted to be anonymous.

Did you talk to your parents much before you decided to enlist in the army?

Not really. Dad supported the war, like most people. He didn't want to see me go, but he didn't stop me. Mom was not part of the equation anymore. I wasn't consulting her at all. I was heartbroken about the book, about many things, and I just wanted to get the fuck out of my life. I hated New York. It was a hard winter. I had no friends, no future. I wanted to throw the dice and see if I had a future. I decided to do the two-year deal, and avoided officer school. It was very important to avoid officer school, because that's where a guy like me would've gone, normally, to become an officer.

Because of your social class?

Yeah, and my intelligence. But I didn't. I insisted, I said, *I want to go to Vietnam. This is the deal, I want to go to Vietnam and be in combat infantry.* I was like J. D. Salinger: "Life is fake." I didn't want to have those Yale officer boys around me. I didn't believe in that shit.

Asking not to be an officer was crucial. Not to be elite in any way. I guess you could say, as FDR [37] more eloquently said, I was "a traitor to my class."

[37] Thirty-second president of the United States and born into an old-money WASP family, but devoted much of his four-term stint in office to constructing a safety net for the working class and poor.

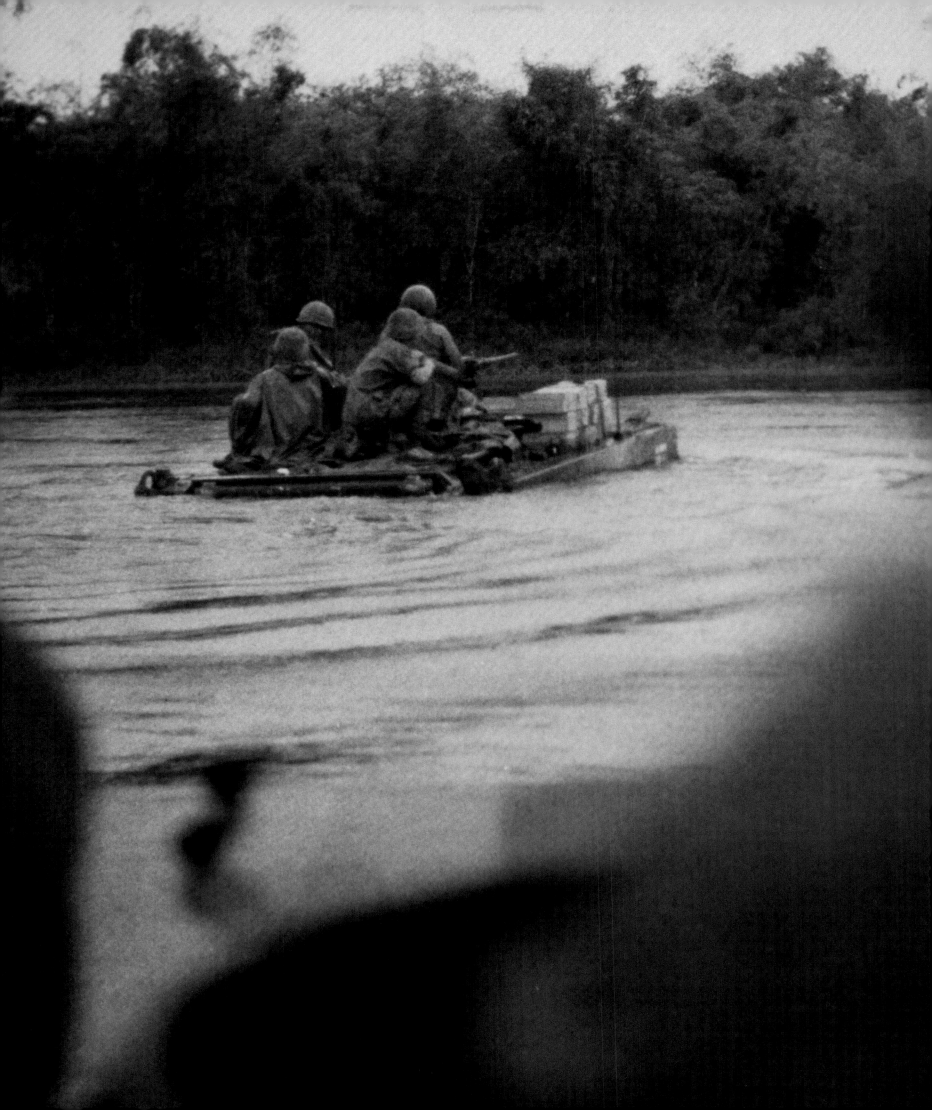

So this act—enlisting in the army, asking for combat duty—that's you stripping the mask off, stripping the costume off?

All the way.

You've said of *A Child's Night Dream* that you were ready for death, that a lot of the book was about the wish to commit suicide.

Going to Vietnam is a form of it. *I'm not going to pull the trigger on myself, but if it's intended for me to not make it, then the deed will be done by someone else.* Enlisting for combat, insisting on frontline duty, is throwing the dice.

So like many decisions, this one was multifaceted. There was that desire to be a traitor to your class, to get down with the common man, such as it was, but also there was a death-wish aspect.

All of the above. Boy, oh boy. Real death is far more ugly than imaginary death. When you've been in combat and seen this shit, I think it gives you a major desire to live, if you can make it. I think you recommit to life. That's what happened.

There's a section in this book that is a description of leaving for war:

Real death is far more ugly than imaginary death.

Cold day. Tarmac apron. Looking back through the porthole of the civilian plane into the airport building. My parents. Suddenly like an old French couple made in Cézanne. Gliding down the Marne on a fishing bark. Eating peaches. Mother in her leopardskin coat, absentmindedly waving adieu with the paw of her miniature, sad-eyed dachshund. Of a sudden piercing my puerile breast, recalling the freezing cold memory of my French grandfather, who only fifteen years ago, on a knoll at Château-Thierry, confronted by the green fields furrowed white with thousands of American crosses, spoke of the great World War One battle, shivering mists of steam parted by the sunshine.

This entire image here is an operatic image of you leaving, and your parents being emotionally, intensely involved in that. But your parents weren't actually there at the airport, were they?

No, not at all. It was a depressing bus ride to Fort Dix, New Jersey, at dawn on a freezing day.

Then I spent four months completing basic and advanced infantry training at Fort Jackson, South Carolina. After home leave, the scene that you just read came from when I left New York for Oakland, where I shipped out. My parents weren't there.

It was weird. I turned twenty-one on that plane from Oakland to Vietnam. We took off late the night of the fourteenth from Oakland. We arrived on the sixteenth at Cam Ranh Bay,[38] and I had crossed the International Date Line, so my twenty-first birthday was up in smoke! I theoretically never became twenty-one in abstract time! I started smoking on that plane because fuck, you know?

I just remember this emotion of leaving home and going off into a strange place where you don't know what's going to happen. I love the word "odyssey." I just know it's never going to be the same, like I can never go back home. There is no home. My home ended at sixteen when my parents divorced. There was no home because my father moved out of the house into a strange apartment in a hotel, and my mother disappeared into her oblivion in Europe, then came back to America and rented a small apartment in New York on the East Side. But it was two different sets of apartments, and it never felt the same. So in a sense, those days were over.

How does a person end up thinking, *I need to go to Vietnam*?

Broadly, I had a tradition. My father and grandfather were in the military. I grew up in

38 Deepwater inlet in Vietnam, in the province of Khanh Hoa, about 180 miles northeast of Ho Chi Minh City (formerly Saigon), where the United States had a military base.

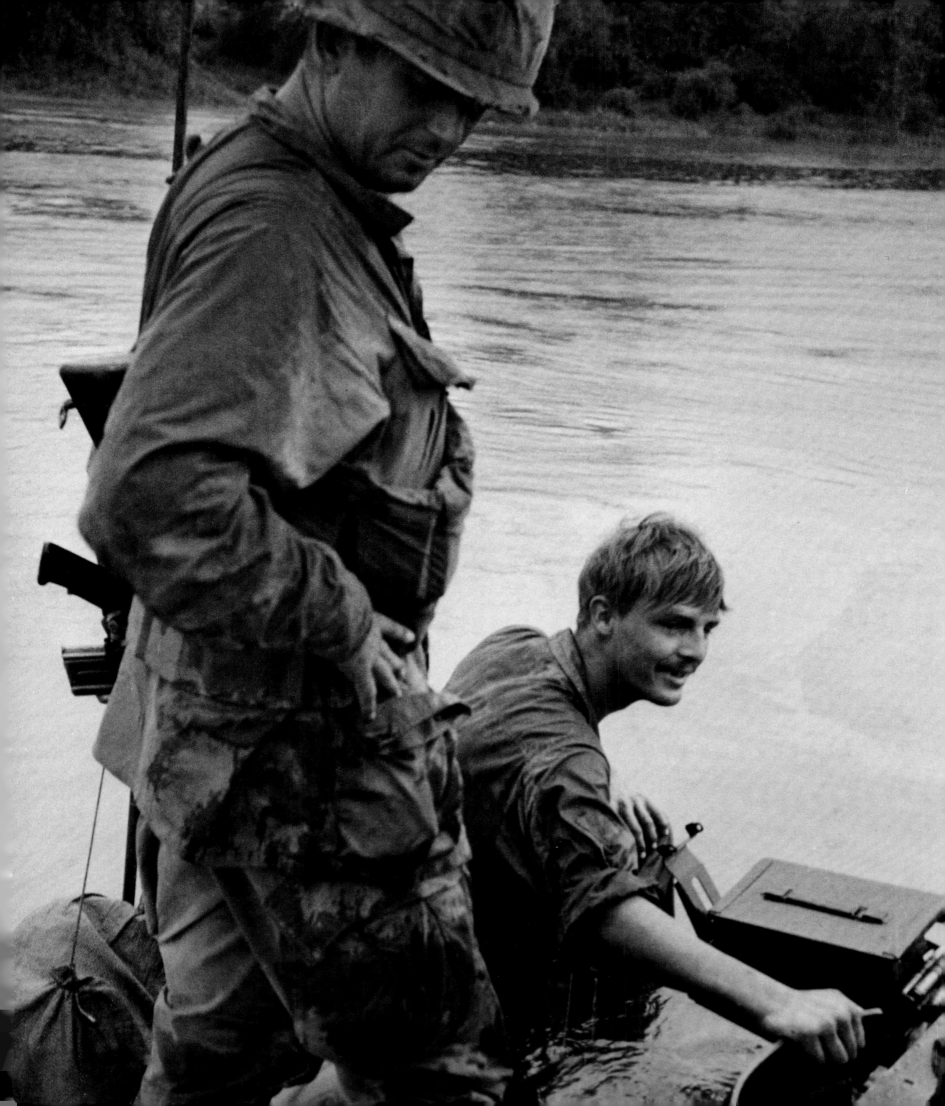

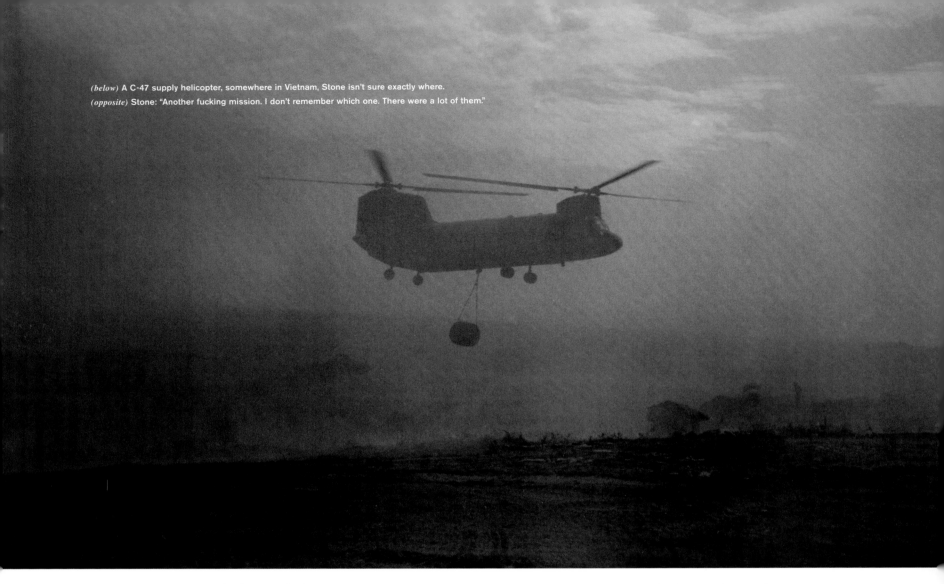

a male-only school, and with images of John Wayne,[39] cavalry and Indians, soldiers, rescue, cavalry in the hero role, rescuing women. That was what American boyhood was like. The Commies were next up. Hollywood did a few anti-Commie propaganda movies in the late forties, early fifties.[40] I believed that stuff about Communists infiltrating us, so it seemed like the right thing to do, politically.

I volunteered for the draft so I would only serve two years, not three, and could get to Vietnam quickly, before the war ended. All I wanted to do was get to Vietnam before it ended. I didn't want to go to Germany, Korea, or officer school. They offered that to me, and I said, *Give me infantry, front line*. They gave me infantry and sent me pretty quickly.

And you wanted to be with the fabled common people.

They weren't fabled. I learned a lot. I wouldn't have learned the same as an officer. I learned more as a lowly guy doing all the shit work than I would have as a lieutenant. I would've come in privileged. I want to repeat that to you—it's very important. You understand, in *Platoon* there's a line about, "I want to be anonymous" [END 10].

At the time, you had an extremely romantic and, to use a word you used earlier, naive view of what it meant to be a regular person—and then in *Platoon*, you've got a character chastising your alter ego, Chris, for thinking that way.

Laughing about it, like, what are you, nuts? Who'd go to Vietnam?

I was cerebral. In my head. I'm a writer, and I'm in this fucking situation that's just rain, muck, monsoon, stay awake, no one's going to help you. All of a sudden you realize that it's dangerous, and you've got to think in 360 degrees, with eyes in the back of your head. Once you're living 360, and that takes time, you really know what's going on in this shit hole—you've got to take care of yourself, and it really is a rugged beginning. You don't stay cerebral, because you can't write anything. With the weather, the paper's always getting wet. So now I'm just dealing with fucking making it, and I'm not thinking, I'm reacting: do my job, survive, and maybe do something good here and there. But I realized after a while that it was far more complicated than that. The point is, when I got out of Vietnam, I was no longer the same person. I got rid of that person. I wanted to be a regular guy in the fucking infantry.

You were wounded twice over there, and you received the Purple Heart.[41] Tell me about the first time you were wounded.

The first time I was wounded was October 15 or 16—night ambush. I'd just gotten into the country. I was fresh, raw meat. It was hot, mosquitoes. Night ambush is tough because often you're pulling them every three nights if you're short a man. It was not a full-size platoon. So it was always undermanned. In that time, we were pulling a lot of what they called listening posts. Now, listening posts are another bitch. That's an all-nighter where two guys, sometimes three, go out, and you're listening just outside the

39 One of the most popular and iconic film actors; *Stagecoach* (1939), *The Quiet Man* (1952), *The Searchers* (1956), *Rio Bravo* (1959), and *True Grit* (1969), for which he won an Academy Award.

40 The most famous during this period was *Big Jim McLain* (1952), in which Wayne and James Arness star as investigators for the House Un-American Activities Committee (HUAC) hunting down Communists in post–World War II Hawaii.

41 The Purple Heart is awarded to US soldiers wounded by an instrument of war in the hands of the enemy, and posthumously to next of kin.

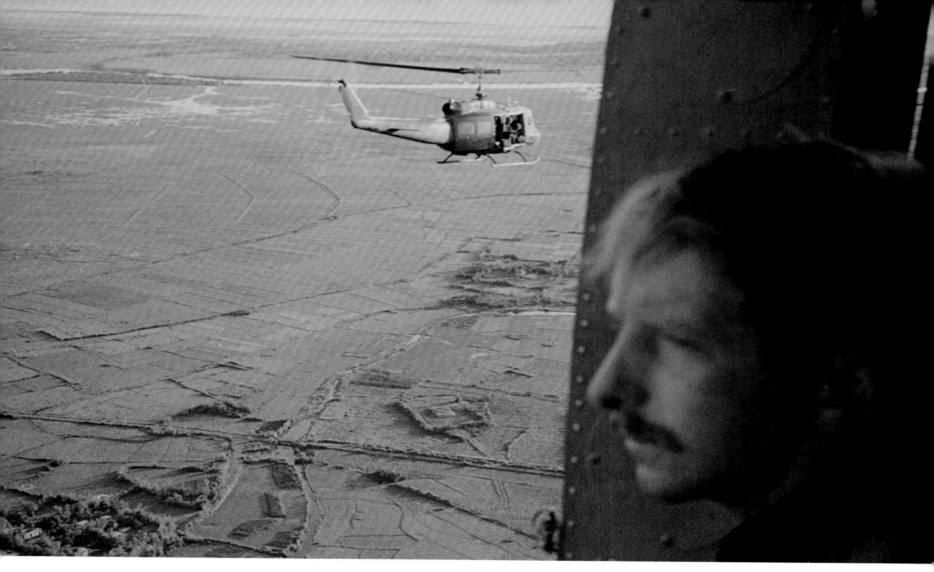

perimeter—fifty or sixty yards, maybe more or less—for the enemy in case they're coming up on you. So you don't sleep that much. And then you have a night ambush on top of that, which means you're going out much further, half a mile, less or more depending, and you're in a ten- or twelve-man position. So you're pulling the same kind of shift, but it's outside, way outside the lines, so it's more dangerous. You've got to see, and think in 360, and not make any mistakes.

You're trying to ambush the enemy?

Yeah, you're out there ambushing the enemy. You set up on a path, trail, where there's been some activity, intelligence. There's an arms cache here; they're moving there. You're up all night, nothing happens. Then you're marching all day in the heat. Then you're back in a foxhole.[42] Let's say you're down to three guys in a foxhole, so you're doing the same shift three nights. You've got to stay awake.

If you're lucky, you get a four-man fox-hole, because then you can do four splits. So maybe you can have one night where you actually rest. Then you're back out—you know what I'm saying? Listening posts, ambush, point man, flank man. I'm telling you, at a certain point it's like that one kid in *Platoon* who's like, "Just shoot me! Fuck it! This is too much!"

So I'm out there in a night ambush, October 1967, and I was with this guy, this black fella. He was a little crazy guy, and very loose the way he talked: loud, in your face, insulting—you know what I'm talking about. There's a style that's early rap. I think he fell asleep on his post—I can't say he fell asleep. Maybe *I* fell asleep, but he was not the most trustworthy foxhole guy. I didn't have a lot of confidence in him. The mosquitoes were horrible, terrible, they really were, so you could only *kind* of fall asleep.

The next thing I knew I was awake, looking at three figures running toward me across an open rice paddy—around three in the morning. They were refracted by the moonlight. It was terrifying. They were getting closer and closer, and I was frozen with fear. I had never seen a living enemy before! Finally, the position next to mine opened up with a claymore, and the next minute was mad. Huge amount of fire from all directions. Then there was an explosion and I was hit. Passed out for a few moments, a minute . . . ?

There was this fat sergeant. He wasn't very respected. He was another one of those guys: name's unknown. It's a funny story, actually, because the guy was a "three stripes,"[43]

coming from Germany. I think he was one or two holes behind me. I think he was the guy that blew me up, which is an asshole thing to do when you don't know where the fucking enemy is. When the firefight was going on, I think he threw a grenade, and I think it blasted right down next to us. I'm very lucky to be alive, because I was sliced through here with, I think, shrapnel from his grenade.

(Gestures toward the side of his neck.)

Jesus.

An inch more, right? It was a clean wound, but I thought I was dying, because the new guy who'd come in with me as a replacement troop had been killed by sniper fire a few days before. He'd been shot in the stomach and we thought it was a good wound, and he was getting out of the field. Lucky man! But it was what they called internal bleeding, which didn't look severe, but internal bleeding can be very severe.

So I thought I was dying, because there was so much fucking blood coming out. And the guy next to me was screaming he'd been

42 A small pit dug as a shelter in a battle area.

43 An insignia indicating the military rank of sergeant.

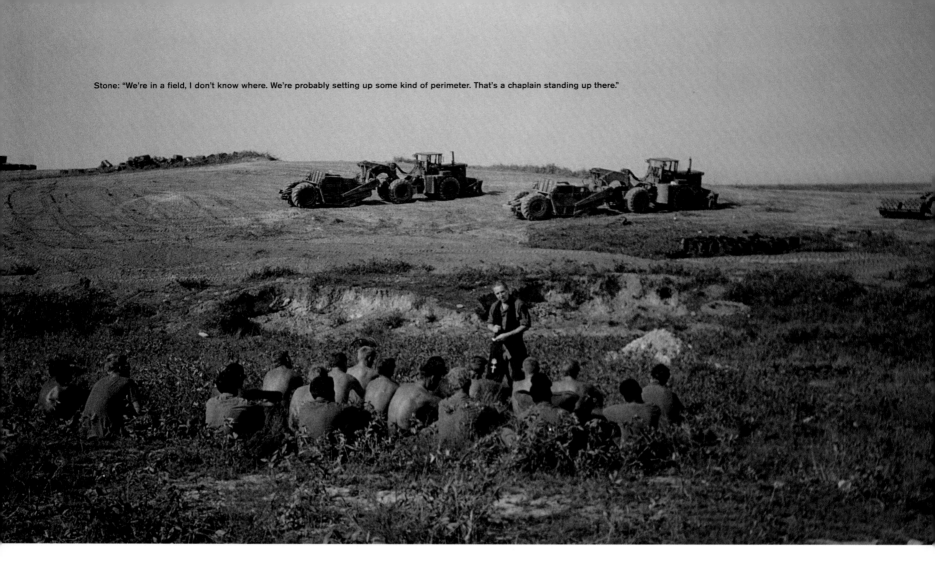

shot. The fight's still going on, Claymores [END 11] being blown, smoke.[44]

But I think it was the sergeant who threw the grenade.

Do you remember anything else about that sergeant?

I remember nothing about him as a sergeant, and I don't know his face, but almost thirty years later I'm on Michael Medved's show,[45] and he says, "We have here a sergeant who served with Stone in the Twenty-fifth Infantry Division," and sure enough, it's this fucking idiot who comes out on the show! He's starting to make snide remarks about me. And I realized he was just a guy dug up by Medved to piss on me for being a guy who in some way had fucked up. And I remember thinking, *This is really bizarre, because he's the guy who I think probably fucking nearly killed me with a badly thrown grenade! Here he is coming out now, twenty-five years later, pissing on me again!*

So you felt like Medved misrepresented you?

Medved was as focused as any right-wing political hack. He was always attacking my films, and I thought by going on the program it might allay the situation. I was wrong about that. I'm still shocked by the extent that

Medved and these political types organized themselves. Here was this incompetent sergeant hinting that I had somehow screwed up and hurt someone, which I hadn't. The reality was that he was probably the one that screwed up and almost killed his own man. And here he was coming out to defame the man he almost killed! What a bizarre situation.

I was inexperienced, but after that first wound, I got better fast! You got to learn your way around the jungle. After all, I wasn't hunting in the Kentucky hills at the age of eleven, killing squirrels. I was a New York City boy. But I learned.

On January 1, 1968, we fought a [North Vietnamese Army] regiment that attacked our perimeter and we took quite a few casualties that night: 25 dead and 175 wounded. We called it Soui Cut [46] because that was the Cambodian name for it.

I'd never seen an all-night battle. I mean, it was going from about 10:30 P.M. to dawn, which was around five. It was really intense. It was another one of those huge, futile actions, where we had already been in this area, right on the border of Cambodia. We set up a two-battalion perimeter. One was armored, the other one was regular infantry, and we were protecting the crossroads from the bottom of the Cambodian Ho Chi Minh Trail across to Saigon. The [North Vietnamese Army] was

moving thousands of men and supplies south in order to make their big push on Saigon. We didn't know this at that time, but this was going to be the Tet Offensive,[47] which later became the turning point of this war.

So, we were sent out there basically to recon the area. We called our position Fire Base Burt. You won't find it in any history of the Twenty-fifth Infantry, but it'll get more attention in time. After the all-night battle, we went out the next day to collect the bodies. We found all sorts of maps of our foxholes. They'd been planning this night attack very precisely.

44 Stone used his pyrotechnic expertise that he gained in Vietnam on *Platoon*, where he took over detonation of explosives during combat scenes. For more, see chapter 4, page 165.

45 Film critic and conservative political commentator. Stone appeared on his TV show several times.

46 On the night of January 1, 1968, a large North Vietnamese and Viet Cong force attacked Fire Support Base Burt at Soui Cut, near the Cambodian border. The base was nearly overrun, but US troops managed to hold it.

47 A campaign of surprise attacks, launched during the Vietnamese New Year (Tet), by the Viet Cong and North Vietnamese Army against South Vietnamese and US strongholds; January–February 1968.

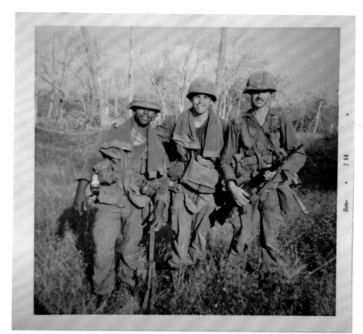

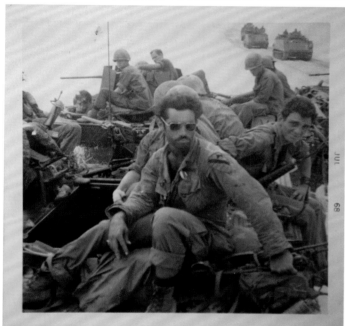

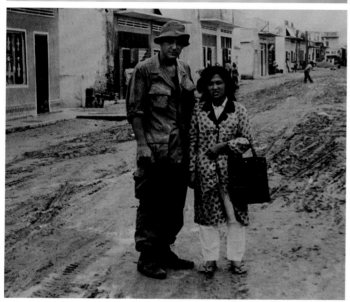

How did they know the best way to hit you?

Because they spied on us. We'd been there before, and now we'd returned for two nights. They knew where our foxholes were. It was a large perimeter, two battalions, so there were three companies on either side. And they knew which was which, and what kind of equipment we had; if they could get inside us, our armored battalion would be firing at us. They planned it, and they had wires running through the jungle to guide them through the night to our foxholes in the dark.

It was quite an attack. And it was scary. We thought we'd be overrun. There was some hand-to-hand fighting in some of the companies. We were out there all night. We fired off huge amounts of artillery. The air force sent in F-16s, I believe, to bomb our perimeter as closely as possible. The NVA were literally that tight with us.

You've described the aftermath of the January 1 battle as horrific: 25 dead Americans, 175 wounded, about 500 enemy casualties, bodies being pushed into open graves with a bulldozer— all that stuff, including the F-16 air strikes, ended up in *Platoon*.

Yes, I saw it with my own eyes. The intelligence we found was enormous. We kept finding huge swatches of [enemy] records. People would come out from Saigon, they'd read this shit. I don't know what the fuck they'd do with it.

But it didn't make any difference, because Tet fell when it did, and it was another fuckup—another bogus intelligence fuckup. The CIA didn't know shit.

Westmoreland[48] came out after the battle, or so I'm told, and he looked around and didn't make much of it, although the casualty count was heavy and the kill count was heavy. It was a real kill count. It wasn't a phony kill count. But Westmoreland just said, *These soldiers aren't dressed properly*, or some crap like that.

Many years later, of course, Westmoreland sued CBS over their documentary special *The Uncounted Enemy: A Vietnam Deception* [END 12], which claimed the army inflated kill counts and downplayed the enemy's strength to make it look like we were doing better over there than we were.

Yeah. Westmoreland was the ultimate West Point[49] guy: dumb as a rock, he stood ramrod

straight with shiny boots. That's all he cared about: kill count and looking good, like a soldier man.

I think that was a significant battle, though.

Why do you think there was so little official recognition of its significance?

The Twenty-fifth Infantry was undistinguished. It got no publicity at all. There was never any press out with us. They followed the glamour guys—Marines, First Cavalry, Airborne Units.

And then two weeks later, on January 15, 1968, we're back in the same fucking area that we were in on January 1. There was an issue, so we would always go back. You'd lose people, then go back and try to do the same thing over again.

We went out for a routine patrol around the area in the daytime, and they got us again. That seems to be the case in Vietnam—we kept going around in circles and losing men. It was a nicely laid ambush.

And that was where you got your second wound?

Yeah, I was Second Platoon, and we came up to help First Platoon, which took some casualties. We were coming up, three of us, and one of the guys popped what they call a tripwire connected to a satchel,[50] the charge in a tree. We heard it and started running from it when it blew. I was swept up and probably flew a few feet through the air and then was unconscious for a bit. When I came to I was checking my lower body to see where I had been hit and glad to feel my genitalia! And it was mostly in the legs and buttocks. Then they evac'ed me out with a good dose of morphine. I was high as a kite. I think I started to fall in love with morphine after getting wounded twice. Funny, the Army made me like getting high.

That was my second wound—that "million-dollar wound," they call it, because you can get out of the field if you want. That was my second wound.

48 William; 1914–2005; Commander of American military operations during the Vietnam War from 1964 to 1968; army chief of staff from 1968 to 1972.

49 United States Army officer training school in West Point, New York, founded 1802.

50 Demolition devices, whether manufactured or improvised, whose primary components are dynamite or C-4 plastic explosive, carried in a satchel or messenger bag.

(*below*) Stone: First Cavalry, somewhere in the Ashau Valley, in the second part of my tour, 1968.

(*opposite*) Stone: "Sydney, Australia, 1968. R&R [Rest and Recreation]."

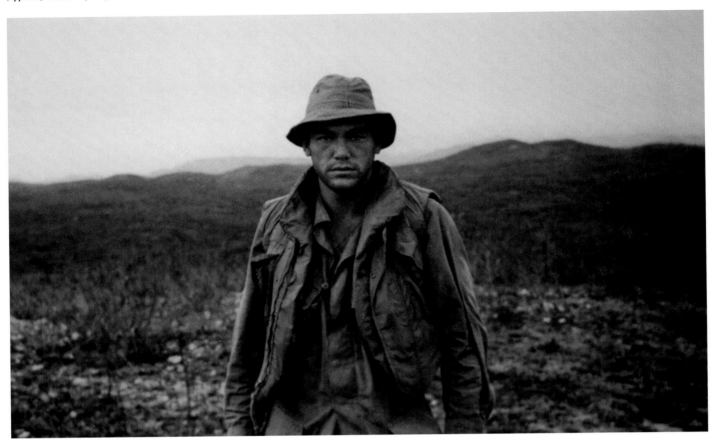

It wasn't too serious. A few days in the hospital. I had some stitches, and as they did with many people, they left some of the shrapnel in me, which gave me some issues later in life, but nothing severe. It used to set off alarms in an airport on a security system—now that the resonance has gotten better, they don't pick up on it.

There's still shrapnel in you?

It travels around your body, actually.

After a few days in the hospital, where I saw some horribly wounded men, I was sent down to Saigon to an auxiliary MP battalion. My duty became guarding the barracks and the billets[51] around Saigon. I'd be assigned different billets every night, and I'd stay up all night. Guard duty is rough in the streets of Saigon, because you never know what the fuck is going to happen.

I didn't like the duty. After the field, I found it to be deadly dull, and we had to live up to army standards again, which you don't have to do in the field. You have to dress; everything has to be clean. I can't blame them—that's the army. But that's where you get fucked with by the sergeants; they're these lifers who have nothing to do except boss you, Southern-style. I mean, what are they going to do all day? There's no combat except occasionally.

I had issues. Clothing issues. Bad attitude issues. I hated the petty bureaucracy.

I ended up in a situation where this sergeant was pissed with me over I forget what, the usual stuff, and I told him basically to fuck off, and he threatened to Article 15[52] me, which is another detention technique. They put you in Long Binh Jail[53] if they can, and they add that on to your time.

The initials of Long Binh Jail are LBJ.

Everything's ironic in Vietnam.

How did you avoid jail time?

I made a deal, basically, to go back to the field.

Rather than be punished or prosecuted?

Yeah. Sent me up to the First Cavalry Division, in First Corps, totally different region, up north, where I served the rest of my tour, which I extended to fifteen months. Here I started fresh with a long-range recon patrol, LURPs for short.

Which is where you met Sergeant Juan Angel Elias, the basis for Willem Dafoe's character in *Platoon*.

Yes. Elias was in the long-range recon. Elias was a handsome young man. He was Apache.

He had an interesting background. He was from New Mexico, I believe, and had lived on an Indian reservation, and he'd had a pretty troubled life, in and out of jail, in and out of problems, drinking, stealing cars maybe, and a stint in the army to get out of jail.

I don't know—I mean, I'm probably imagining some of this stuff! Probably Elias just kind of looked like he was on the other side of the law, you know? But he was a charismatic guy, and the other guys looked up to him because he had experience, and he just seemed like a guy who could really handle himself.

But he was killed after I left the unit. The circumstances were puzzling. People weren't much talking about it, but I believe he was killed by his own fire.

Anyway, before that happened, believe it or not, another "lifer" sergeant took exception to my attitude, that I wasn't "gung ho" enough to be a LURP—and I was moved out of the

51 Billets are temporary lodgings for soldiers; barracks are more permanent.

52 Article of the Uniform Code of Military Justice allowing commanders to discipline troops administratively for relatively minor violations without a court-martial.

53 Military stockade in Dong Nai Province, South Vietnam, generally referred to as "Long Binh Jail," or just "LBJ."

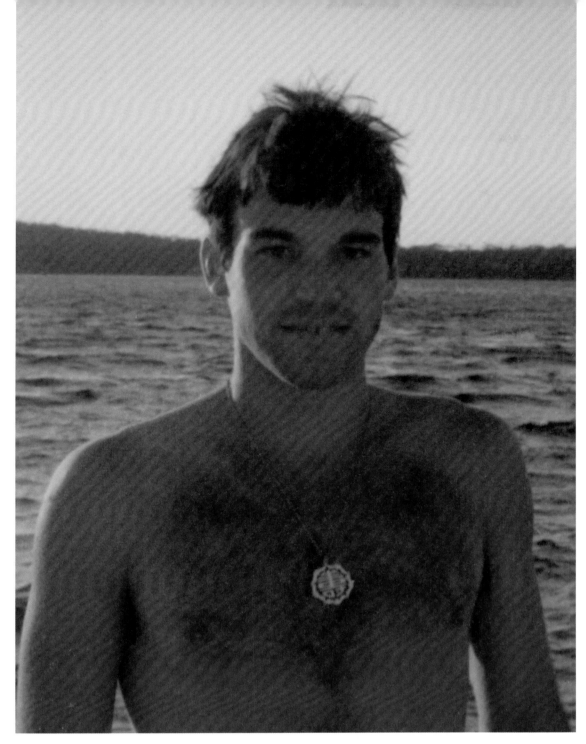

unit to a regular Cavalry unit, the First Battalion, Ninth Infantry. Custer was the Seventh Cavalry, by the way.

I started smoking grass in the Cav, because I'd loosened up I'd seen enough. The First Cav turned into its own thing. Helicopters. A lot of helicopter time. So you'd jump around—there was more money for those operations, which were extensive: we'd go into the Ashau Valley, which is a lot of jungle and forest and hilltops. It runs alongside Laos.

And then on one mission, we got rained in and spent eleven or twelve days straight on a rain-shrouded mountain, building our hutches higher and higher. The leech problem was unbelievable. We had to put tape over our assholes and on our dicks to keep the leeches out when we were catching z's. I had a disci-

pline issue with the long-range recon patrol, and I went to a regular unit, cavalry.

You got a Bronze Star for Heroism in Ground Combat?

Yes. That was in a particularly vicious fight inland from a beach.

I remember the day started when they killed a German Shepherd scout dog I really liked. And they also got the sergeant, and the lieutenant of that platoon. At that point my platoon moved into the skirmish and it was pretty confusing for a while, and I basically ended up in this situation where I think I probably saved some lives by killing an NVA [North Vietnamese Army] sniper who'd gotten himself into a spider hole in the ground

between two different units, which would've created a hell of a crossfire—and probably killed some people.

A school of thought holds that the Tet Offensive, which happened a few months into President Lyndon Baines Johnson's only full term of office, was really a military victory for the United States, but it was also a publicity defeat—and that in the end, it was the publicity defeat that made all the difference. What do you think about that?

There's truth to that. Militarily, Tet was a huge defeat for the NVA. They suffered, and it took them several months to recoup, if not a year, but they did make another second big offensive in April, and they took more US casualties in April.

But politically, the NVA had struck a blow to the heart of American morale. They freaked Johnson out, because Johnson had bombed the shit out of them and they weren't giving up; on the contrary, they were recommitting more and more NVA troops, because originally we had been fighting Viet Cong, and then we realized that more and more NVA were coming down. Those were the guys at my ambush, the one I'd been wounded at. They were so big that we thought they were Chinese.

There's a line from *Platoon*, part of the closing lines of the hero's voice-over narration, that's often quoted as a cudgel against you: "In the end, we didn't fight the enemy. We fought ourselves. And the enemy was in us."

The criticism is that it turns the Vietnam War into a stage on which American cultural divisions can be played out, and that it doesn't pay sufficient attention to the Vietnamese—you know, "Well, Oliver, if the real enemy was within us, then who were all those guys that were shooting at us?"

But as I talk to you, I wonder if that's too literal a way of reading it—if perhaps what you were trying to say was that what led us into the Vietnam War were flaws in our national character, flaws that we keep failing to overcome?

Yes. And here we are still, today, still blind and ignorant.

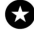

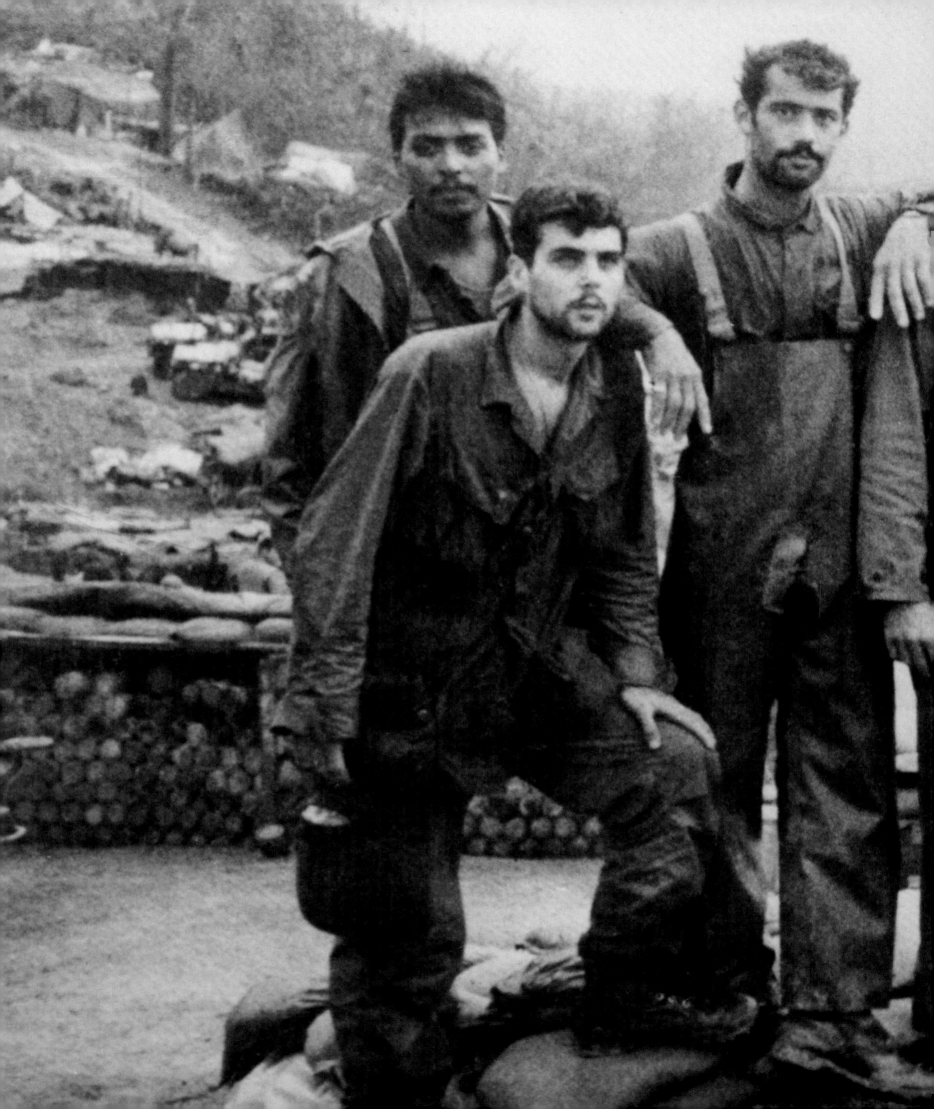

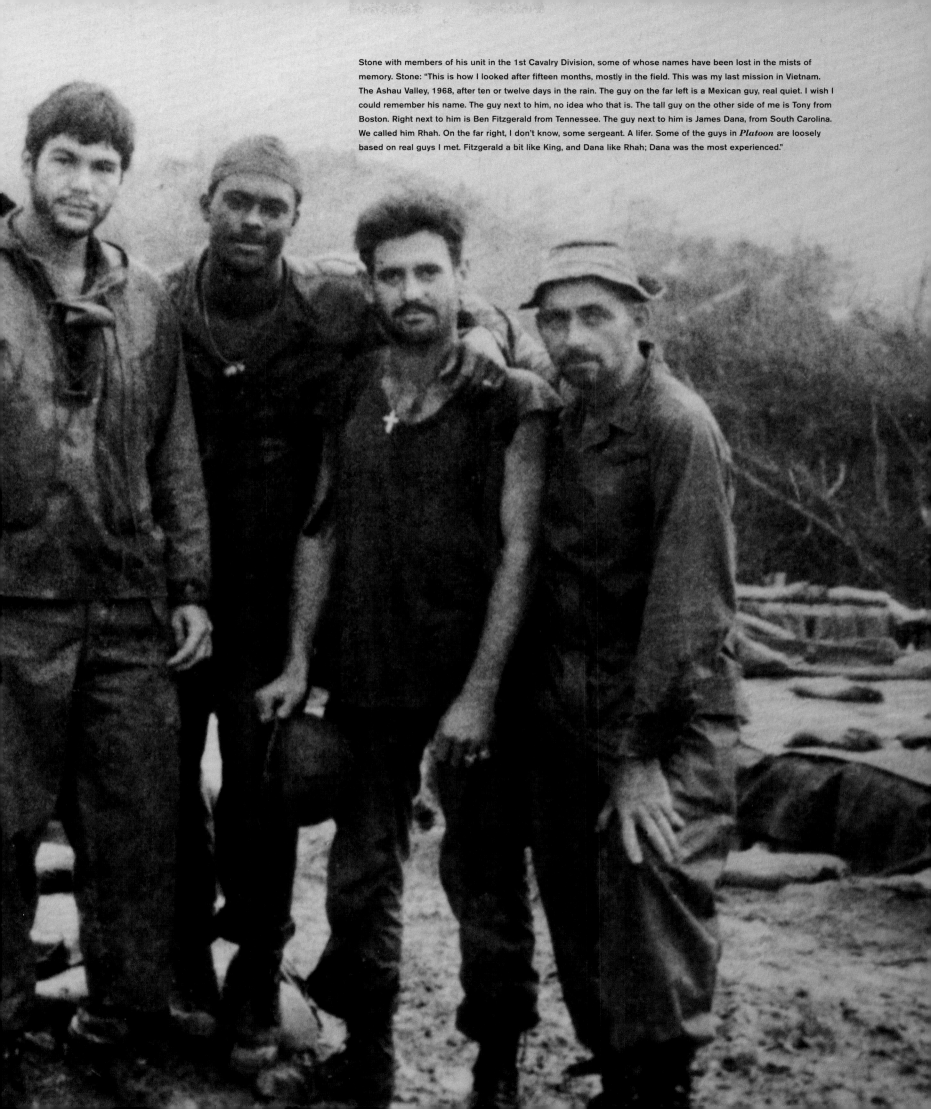

Stone with members of his unit in the 1st Cavalry Division, some of whose names have been lost in the mists of memory. Stone: "This is how I looked after fifteen months, mostly in the field. This was my last mission in Vietnam. The Ashau Valley, 1968, after ten or twelve days in the rain. The guy on the far left is a Mexican guy, real quiet. I wish I could remember his name. The guy next to him, no idea who that is. The tall guy on the other side of me is Tony from Boston. Right next to him is Ben Fitzgerald from Tennessee. The guy next to him is James Dana, from South Carolina. We called him Rhah. On the far right, I don't know, some sergeant. A lifer. Some of the guys in *Platoon* are loosely based on real guys I met. Fitzgerald a bit like King, and Dana like Rhah; Dana was the most experienced."

A Child's Night Dream

What right me,
what right life?

Cold day. Tarmac apron. Looking back through the porthole of the civilian plane into the airport building. My parents. Suddenly like an old French couple made in Cézanne. Gliding down the Marne on a fishing bark. Eating peaches. Mother in her leopardskin coat, absentmindedly waving *adieu* with the paw of her miniature, sad-eyed dachshund. Of a sudden piercing my puerile breast, recalling the freezing cold memory of my French grandfather, who only fifteen years ago, on a knoll in Château-Thierry, confronted by the green fields furrowed with thousands of American crosses, spoke to great World War One battle, shivering mists of steam parted by the sunshine. *[p.29]*

Grisly newsreels were shown throughout France of the colonial defeat in Vietnam and soon Dien Bien Phu, where the French paratroopers were encircled and captured or killed to the last man by the treacherous and supposedly inferior yellow man, was incorporated into children's war games. And Oliver, taunting his older cousin, would make fun of French military might. And Jean-Claude would mock Oliver back saying American lost in Korea, though Claude truly loved the America of the Chicago gangsters who shot their way to success and the comic book images of tough unshaven American G.I.s who beat the shit out of the feared Krauts in the Big War before all the little wars devoured it. And they wrestled together, but Oliver always wanted to lose to the heroic Tarzan core of the older boy, and always would—strangled, knifed, duped, shot, arrested, it didn't matter, the good guy always beat the bad guy in the end, and Oliver saw himself as bad. *[p.59]*

Another time, earlier that summer, I'd first learned to kill. My grandfather Pépé had gone away and left some live fish he'd caught that day in the Marne swimming in the kitchen sink. Jean-

Claude had not yet arrived from Corsica, and Mémé was squeamish about killing animals, as was my mother, who was there briefly. What would they do without a man? *"Bien sûr, que je le ferais!"* "Of course I'll do it!" I proclaimed proudly, after a moment's hesitation, the next eight-year-old man in line. Not quite realizing how cold and ruthless an execution it would be to hold them in the slippery palm of my hand, each fish struggling and leaping for its little life as I swung their terrified brains onto the edge of the white sink, sometimes leaving small splashes of red blood, the voice in my head telling me to do it, to take these fish as sacrifice, and as much as I loved animals, they must die, and I be their executioner. If I hadn't done it, to this day I wonder what would have happened in my life. All its choices came with the concept of sacrifice, my own and the fishes included. I laid all twelve of them out on the sinkboard as Mom and Mémé paraded by, looking at me suddenly with newfound respect in their eyes. Man of the house. *"Comme il est fort! P'tit Oliverre . . . c'est un garçon féroce, n'est-ce pas?"*

Now do you remember?

The boy at the table suddenly experiences the very naked and overwhelming desire to hurt someone. His own void itches him, like the rain, like the playing rain. What is its smell? What is its sound? What is the history of the rain?

At these cards, *La Belotte*, then a popular working man's game played in smoke-filled *tabacs*, and Mémé, hot and dizzied, bringing the four o'clock tea and the freshly heated chocolate bread to the table for her boys. She looks like a big rat, her left eye perpetually ducting with a tear, always moaning about money, one thing or another—*"Mon Dieu, toujours du souci."* "My God, trouble, trouble, all the time trouble." Playing, slap! at the rosewood table, losing, cards shuffling, time crawling, emotions boiling, slap! the card goes down. The sound of a finger rubbing on paper. *Pssssss? Kissss?* What is the sound?

Jean-Claude. His close-cropped skull and ears stretched outward. Taut tough lean face of no suet. And grapplinghook ears of which I have always been afraid. Teasing me as I lose. I feel the fat on my thighs. The moist marrow of my bones. It seems malignant. The rain. Pitterpatting on the granite stones of the gray sad garden at my back. Some drops you know are louder than others. Can hear them. Can hear footsteps in the rain. Can't you, Oliver?

Do you, do you?

What is this voice calling to me all the time, telling me things I don't want to know? From where does it come?

The surge growing in my shoulders. It always starts in the shoulders, at the joint with the arms, sleeping there like toxic cigarette smoke. Sepsis. Sepsistic smoke. And little fragile bendable cards to nervine the inner furor. Like the ringing rain. Drumming in my dead ears.

Thump Thump Thump

Jean-Claude now sneering at me. Slow motion. Saying something about me being a bad loser, taunting me with his hee haws. Children always know how cruelty works. They take no prisoners. In silence, his lips churning. Out with it! French? What is the sound, what is the smell?

How do I measure love?

"Eh quoi!" He demands, *"Qu'est-ce que tu attends! Tu triches ou quoi, petit? Tu n'aimes pas perdre, tu sais, tu es mauvais joueur. . . . Allez, fait suite!"* Things spoken loosely with the madness of rain.

Oliver suddenly leaping and screaming from his seat. Thinking now in American. Foul dirty unstoppable frontier American, in terms of Kill! and the laws that adjust themselves after the fact, you fool! you French fool! you deserve to die, and I, I am all hard inside, hard as I possibly can be, inexorable like Nature, all American, all pioneer, for once for once, faced on a course of action which admits of no . . .

. . . moving swiftly and ruthlessly behind his chair in an instant's pride, grasping him at his unprepared ease from behind his back, taking his throat, in all its soft embedding flesh, thoroughly in the small of the my hand, his cartilage piercing into my palm, and, fragile, squeezing mightly with my fingers and strong frame, killing o killing, with my hands, squeezing so very hard, squeezing myself to death with him, who's to

die first, o killing! Something I learned in a comic book.

My cousin not knowing why this is happening, crying croupously, so surprised! choking on the natural difficulty of *"qu'est-ce que? Questceque? Keke? Keke?"* Squeezing on! You shall die because you shall die! And I. I am killing you. Screaming with my mouth contorted in fury, *"Je vais tu tuer! Salaud, je vais te tuer!"* Ha ha! His ovoid orifice growing red. And redder. Reddest. The red ogre or Mad Ness. The word "squeeeeezzzze." His crewcut head, *en brosse*, ha ha! bending forward now, emitting grunts from deep within his saliva, struggling to be rid of these hands cleaving stuck to his gullet, breath denied, now realizing life denied. The power the glory! Of killing! Raw brute force. Master mocking his dog. Dog meating his master. The rain without beating

down in flurries of strangling finality. *"Je vais te tuer!"* I am going to kill you. Shouting these mercilessly majestic words through the rain raining. Onto the rooftops. Jean-Claude spewing up private liquids through his mouth: onto his chest he sees in the sun when swims. Gurgling there bubbling. An ugly French face rasping red. So ugly, haha, that you deserve to die!

And Mémé. In this drama. At last pouring from the kitchen. Into my ear. Her face of deepest shock. Shrieking above the rain, *"Oliverre! Oliverre! Arrêtes! Je te dit! Qu'est-ce que tu fait! Tu es fou! Fou! Arrête ça!"* This sixty-year-old woman lunging at me with all her creaking force. Grabbing and twisting my arms with all her peasant strength. Petrified thoughts of murder. My spell broken. Hatched. Cracked. Ooze. Lose. Leaving off. Jean-Claude slumping on the floor.

"O la la, ô la Mon Dieu! Qu'est-ce que t'as fait, qu'est-ce que t'as fait! Comme tu es mauvais!" Reviving Jean-Claude, his mottled face coming round, splotchy red and white. I am looking on. I am a criminal. I am mad. And at so young an age. Why? What have I done? How wonderful the feeling. Killing. My wrath. My Hate. It sets me apart.

Jean-Claude now facing me. In the rain and the violence of scurrying clumsy forms the dance to the music of ruptured molecules—never-ending violence! Crash and thud! Kill Kill!

"Je vais te casser la gueule, ça je te le promets!" Lunging at me. *"T'es fou non!"* Mémé trying to restrain *him*.

"Arrête, non arrête! Vous . . . êtes tous fous! Mais non, vous êtes tous fous!"

Jean-Claude punching me and throwing me into the wall and kneeing me in the stomach and kicking me with his shoes and breaking my nose. In fear. In trembling fear.

The trees were green with wet that jungle day in June of '66. Turbulent afternoon shadows camping in the gullies. The twenty-five sticks of June. On this day Custer and his men were wiped from the face of the earth. Ninety years ago.

Moving fast over the surrounding ridges. Swooping and sousing, the camera whirring. Lush green, coming down the northeast ridge of the Ashau mountain range, in the wide open distance the smoking fires of Laos, where the rivers with panthers run and press with the question of laid waste to the land. Just who? You wild wild American boys called Tex and Bones and Ripper. Know no evil, see no evil, it's my movie.

Moving in closer, the rain falling musky and thick. Wet and tired infantryman of the rear security, their numbers thinned by battle, now trudging through a sloping meadow, circular and waisthigh in vegetation. Two hundred meters in width to the camera's eye and stretching downslope half a mile, to the entry of a dense wood, which the First Platoon now enters; the Headquarters Group, Captain Crisanthefoi and Sergeant Ridgeway trailing with the Weapons Platoon. Behind them Second Platoon. And now, at the far end of the meadow, emerging from the upper wood, Third Platoon, Lieutenant Perkins in command. My platoon.

The youth William Stone, black-haired with strong forearms and a Mongolian electricity to his face. Moving the camera in, even closer please; we know what happens now, and in the face of what's to come, we ask for a hero. Possibly he could be. If he willed. But doesn't want. Because he has killed already. No brute, he too is worried and would say. Thinking of the Gauls Before Christ. Never go into a forest after three in the afternoon. The darkness tumbles down very fast.

Am I coward? Like my father? His name on his shirt, spelled "Stone." Born on a Sunday morning in '46. Now '66. Only twenty when he . . .

"Time? Tick tock. Hey—got the fuckin' time?"

Answer him. Words forming. Yet no strength with which to speak.

"Broke ma watch, man."

"'Bout ten thirty," Raines grunted. A handsome, dark-haired Southern boy.

"Hour to chow," someone else said, spitting.

"My feet're killin' me, man," Greek chorus of infantry, idling the air with longing.

"I figger two more clicks today, it's a bitch! Fuckin' heat."

"Fuckin' country. Fuckin' mountains. Fuckin' sky, man. I hate this fuckin' place."

Stone fucking thinking, how many men have I killed now? Do you remember? Pitter patter. The VC you shot out of the tree. Tumbled down like a hard coconut. The one in the Ashau as he was crawling into the abandoned bunker. And the one in the spider hole, looking at you just before your grenade went off under him, and splut! he collapsed like a small building. It wasn't so hard. Mostly luck. How many others? You couldn't count them, could you, in the commotion? In your loincloth, with a flamethrower, running through the mountains screaming like an Indian. Why not? Say what is not possible in this life, say it and you are a fool like Father who says it's a tough life because he never knew how to kill what stood in his way—to overcome! And said life comes up and eats you when you're not looking, the dull the dreary and the dry, goodbye goodbye, fools who never saw life, who never danced contorted dances on nutty floors in nutty dinner jackets with nutty arms that could strangle the living shit out of you. O no! Not that!

The lick of the whip in an orange sky. *Snap! Snap! Snap!* It flared crimson orange and gold and pounced into my eardrums. Dirt like dryness in my throat. A tongue of land detonated. And in the resumed

sudden silence of this field, I can almost make out a farfetched dog barking behind a stucco wall, somewhere perhaps in Mexico in the 1950s, and the eagles in the mountains are peering down at me through clawmade field glasses. I must be mad, but don't fret, they'll soon bury my sorry ass on the day the cannibals come out to play and Mommy and Daddy crying over the taxes on my G.I. insurance, but hey I'm not alone anymore. I'll go down with my unit. Raines and Rizzo, Maloney and Crazybush, who did a year at Elmire and was half crazy Indian and sent his old lady all his money for Christmas, right before she ran away with the biker next door and . . .

Bam Bam Bam! A slow but sudden boredom of riflefire from the meadow below. Crouching. Looking. The fire suddenly surging, picking up, intensifying. Then, *crackety crack wham bam*, and "INCOMING!" Hitting the earth. Machine gun delving into our midst. A bit high. Dull terrifying thuds of bullets whacking into bark. A cry. The sly silliness of first fear. Creeping along its tree. Into bullets. It's like riding the subway. Looking out from my earthbound position in the rain at the dark sky. Lines under my hollow eyes.

"Sit tight. Sit tight!"

Sitting tight. First practical application of the art of war. Crouching in a military costume, what fell fate could be forewarned? Thinking no fuckin' way they gonna get me to attack that machine gun no sirree! That French Army crap, circa '17, waves of slaughtered men. Who'd go now? Sit tight! Yeah, we know. Everything except what's going on. Like at the Yalu, I'm sitting there frying c's, minding my own fuckin' business, and who comes wading across the fuckin' freezin' river in the middle of fuckin' winter, yeah, kiss my ass, a million fuckin' chinks! What'm I supposed to do? Sit tight? Hope they don't see me. And

thinking, I'm getting paid for this. Twelve cents an hour.

The Second Platoon disappearing in the woodline to the right, chasing the ghost. Down a wooded slope. Very quickly, the last packmule disappearing in the wood.

Just what the NVA regulars want. What's his name, Crève-coeur, broken heart? Liver of Christ? Some name like that. Anyway the captain. He won't close up the perimeter. He'll leave the meadow open 'cause he wants to sucker 'em into a fight. The First Platoon at the front, the Third in the rear, and the Second forming the apex of a new triangle. West Point tactics. Like Custer. Won't work. The man with the weird name is gonna kill us all, ho ho, this battle was lost on the playing fields of West Point, it was won in tepee tents where tea does not titillate.

Very heavy concentrated fire from deep in the woods. I'd say 50-caliber machine gun. Right on top of Second Platoon. Ambush! Then a sputter. Sporadic fire. And over the radio, the insane static: "We are surrounded. Repeat—surrounded. Come up on our zulu tango seven, we are meeting main force, a battalion, maybe more. We are . . . !"

Now heavy fire to the front, downslope six hundred meters where the First Platoon, with the Headquarters element, lay in the woods. Across the elephant grass it was impossible to see. The rain still falling thick and heavy. On the radio an unidentified voice: "We're being overrun! Roger that. We're pulling out!" Then it squawked.

Take a peek, O. See what's really going on. I know they tend to exaggerate.

Whing! Wow! Six feet from this moviestar face. Like a flying fox. He's behind me. To the right. In the tree.

Whing!

Moving away. Someday: infrared bullets. Will announce the end of war. Stone turning. Through a film of water.

Wham! Wham! Wham!

A 50-caliber not more than sixty meters to the left rear, opening up. Crossing into the killing zone. Low this time. Bark and earth flying, with low silhouettes, through my atmosphere. Shouts. Hoarse yells from the cave. Winding in the leaves. The fox *volant* through the trees. Ghost of a panther's soul. Coldness cataracting. Jungle soul of songs. The rains. In rich drenching folds, slitting down, miring the earth, dimming.

Fuck, I muttered. Must keep calm. Must not think. All I know is Gee oo dee. Must relax. Oldest law of life. They did it on the sanguinary fields of Troy. Masturbate. Balms the walls, ungyves these knots, washes out the mouth of malcontent.

Abridges the doleful worm.

A night in the bed. She will come for me. Her blond hair floating in the breeze blowing at the window. Smiling. Her body thick, squeezable. The lunging hungerford I never had. Flexing her thighs. Saucy wench. I leer. Come here. He legs, erecting themselves like nutcrackers and—

"Mortar incoming!"

Whoosh! Whump!

Whoosh! Whump!

Heads low, men scurrying from rockface to rockface in the rain. Cry Alleluiah, Alleluiah, Alleluiah!

Whoosh! Whump!

Whoosh! Whump!

Dull deadly thuds sputtering. Tornout grass, golfed up, poppling weakly through the rainhearted air. God's next to worst work. Rockets are worse. Shredding to bits and pieces, balls and all, a giant upheaval, a Doctrine of Final Things, killing men who never believe they're going to die, who can't possibly believe that. . . . Looking up. Into the face of the man lying astride me. Why, it's Crazybush! His eyes opening, fearifed. Cries of "Medic! Medic!" A severed tree trunk inches from our bodies. A few feet away, the stunned and battered coal black face of Sergeant Washington bleeding bright red from

his mashed nose. Heading toward our hideaway. Didn't quite make it. His last moment between living and dying. What the fuck *happened*?

One less. Yes. And not many more to go. You get to a certain pint, and you know you're going to die. It had to happen. But it fits that soldiers are the ones who get killed. They are the restless bitter ones, aren't they? They believe in nothing. Neither God nor Ursula Andress. Is it that belief which divides the world into the You and the They? O to be rich someday! And marry a high-fashion model with cheekbones in her cunt. New York. Paris. Dreams. Without dreams, Death.

One thing I've noticed for the first time is Nature, and how very full it is. I want to write about that. So that when the Angel of the Lord asks me again what are you looking for in life, Oliver, I shan't be nonplussed this time and say something silly like "Happiness"—no, I shall say—"its Fullness, that's all, its Fullness." Now that I know this, that faith is my fullness, I can lie silently in the smallest stillest spots of Nature and witness each struggling sample of life. Some discharge of energy. A leaf that falls. A caterpillar slinking along a blade of grass. A bee burying its head in the flower's hour. Or simply a sound. It never stops, not for you, and have you ever noticed that it is those who are afraid of life who shy away from its Nature, 'tis so. Once I was the transposed soul of Rimbaud, fleeing all moral courage and reading *Vogue* magazine. And suffering as I looked across the abyss at complacent Beauty. But now I am a soldier and as when I young and scraped my knee and Mother said, "now be a little soldier and don't cry," now I know for certain that she was right and that solider is a soldier and a solider can never cry.

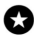

WHO'S GONNA

ME?

★ ★ ★ ★ ★ ★ ★ ★ ★ ★ ★ ★

(previous spread) Stone: "Australia. R and R. '67. A girlfriend took this."
(left) Stone: "New York City, sometime after the war. I was a little bit at a loss.
I tried to be a model. This is a shot I took for potential modeling work.
I was going to acting school at the same time."

The story of Oliver Stone's reentry into society is the most intimate and affecting film that Oliver Stone never made. It is the story of a privileged, educated young man who internalized the values of his staunchly anti-Communist father and carried them with him into Vietnam. Enlisting in part to rebel against his upbringing and dismantle his old self, he returned to the United States a decorated war hero, bearing physical and emotional wounds. He then enrolled in New York University to study filmmaking, prompted by his fantasies of artistic greatness as a child— having written what he hoped would be the Great American Novel at age nineteen, only to see it rejected by publishers.

This was a depressed and lonely young man who felt isolated from society and alienated from himself. Except for nannies and secretaries and a mother who was often absent, Stone had grown up mainly among men and boys. He learned a lot of what he knew about sex from prostitutes, starting with the call girl his father hired to relieve him of his virginity in high school, and continuing in the brothels of Thailand and Vietnam. He had vestigial reactionary impulses. He was out of step with a lot of his peers, who tended to be either inexperienced and repressed or sunbeam-warm and utopian-loose.

At NYU, a school whose students and teachers tended to sympathize with the counterculture that Stone's father despised, he felt out of place but learned to translate his narrative onto film. Stone impressed his teachers and surprised his classmates, most of whom had no idea that the quiet young man in the corner was a veteran who disagreed with pretty much every word they said that wasn't related to filmmaking. Stone slowly grew comfortable among them,

though, and began expressing antiestablishment sentiments, later participating in a 1971 class project to document nationwide protests in the wake of the Kent State killings. Along the way, he met a woman six years older than him who seemed to understand him. They married after a year of off-and-on living together. Suddenly he didn't feel hopeless or alone anymore. He felt strong.

Then, as now, Stone was a fast, passionate writer, capable of banging out rough drafts of screenplays when he wasn't working day jobs in the New York film industry or driving a cab at night or partying with his wife and their mutual friends. Stone wrote a dozen scripts or more in a span of just a few years, in different genres, voices, styles. And he somehow managed to raise the money and find the time to direct his debut feature, *Seizure*. The film is about a writer (Jonathan Frid) whose family and friends are tormented during a woodland vacation by three demonic figures (including a dwarf played by Hervé Villechaize, later of TV's *Fantasy Island*). These monsters seem to arise from the writer's (Stone's) tormented subconscious. *Seizure* is not, to put it mildly, one of the great debuts, and even in 1974, Stone seemed to know this; press notes and publicity interviews acknowledge how hard it was just to finish the damned thing. Years later, Stone would tell the author of the interview book *My First Movie*[1] that he would participate in his project if he could talk about his third film as director, *Salvador*, rather than his first, because it wasn't until his third time behind the camera that he found his directorial voice.

Seizure is not assured enough to rank with the great suspense pictures of that era, and not twisted or arty enough to distract from its obvious budgetary limitations (the acting and sound are hit-and-miss, and the nighttime scenes are very dark). And yet some eerie personal truth manages to claw its way through the film grain. *Seizure* is a feverish movie, one clearly made by a director trying to work through urgent issues that perhaps he himself could not articulate. Just four years out of Vietnam combat, a recently radicalized, recently married, recently reintegrated and artistically committed veteran creates a film about an artist who fears that his imagination might destroy the peaceful little world he's created, and who in the end proves willing to sacrifice love to save his skin. It's as if Stone is fantasizing the worst things an artist could do or be, in order to warn himself.

Seizure came and went, but Stone attracted industry interest for his original scripts (which remained stubbornly unproduced) and finally landed high-profile assignments. One of them was *Midnight Express*,[2] an adaptation of the 1977 memoir by Bill "Billy" Hayes, a young American nabbed while trying to smuggle hashish out of Turkey and brutalized in prison. Stone won the Golden Globe and the Oscar for best adapted screenplay, and officially went from no-name hell-raiser to top-dollar hired-gun screenwriter. He also became, for the first of countless times in his career, an Issue. Turkish officials expressed outrage at the way its guards and prisons were portrayed by Stone and the movie's director, Alan Parker, and accused them of ugly Americanism and racism. Although Stone's Golden Globe acceptance was rambling and barely coherent (the telecast's producers cut him off), when he won the Academy Award a few weeks later he had learned to smile self-deprecatingly and get off the stage as fast as possible. His "speech" was two sentences: "I'm deeply honored. On behalf of all the *Midnight Express* people, and with some consideration for all the men and women around the world who are in prison tonight, I thank you."

1 Stephen Lowenstein (ed.), *My First Movie: Twenty Celebrated Directors Talk About Their First Film* (New York: Pantheon Books, 2000).

2 Bill Hayes, *Midnight Express*; Thomas Congdon Books / E.P. Dutton, New York, 1977.

MATT ZOLLER SEITZ How soon did you start at NYU after your return from Vietnam?

OLIVER STONE About six months later. It was a rocky period—six months of uncertainty and alienation. I was taking a fair amount of LSD during that period. I took my first trip in Australia on R&R one week with a girlfriend, who was a waitress.

Did you go to NYU specifically to study film?

It was a little more vague than that. A friend of mine said that he had taken up film as a career, and other people said there was this film [studies course] in school, which may not sound strange to you, but it was a pretty strange idea back then—to go to a class that was dry and academic, and to actually be able to watch films in the middle of the day and write about them. It was pretty wild.

Also, the GI Bill[1] in those days was covering about 80 percent of the tuition, which is not that high, but still, that was 80 percent.

I know that you took photos when you were in Vietnam, and that you were a writer from a very young age, but do you remember if there was any particular point at which you said, *Not only do I like movies, but I might like to make them as well*?

I had always liked movies, but I had never thought that it was possible to get a life in it, because everyone there was kind of a blessed person. I didn't have any real connections—family connections, and so forth. So I didn't really think it was realistic. The classes were interesting enough, though, and it seemed like a novel idea, so I went, and in that freshman year I was very lucky because the teachers were great. Among them was Martin Scorsese.[2] Marty was there, and we didn't know who he was. He was just a wild-haired, fast-talking New Yorker.

Do you remember the first time you met Scorsese? Can you tell me what impression he made on you? How did he strike you?

A nutcase. A New York nutcase. And definitely funny.

You could barely see Marty's eyes. He had hair down over his forehead and ears. He always looked like he'd not had enough sleep, because he'd probably been up the night before looking at all the old films on TV. That's the only way we could see them back then, unless you went to a museum—understand, there was no such thing as home video. He would stay up pretty late to watch these old classics on the local channels, and then he would have an early class.

I remember him talking fast. I can't say I understood everything at all. I do remember his enthusiasm and his energy for the subject matter, and he was definitely a young protégé of Haig Manoogian, the head of the department. Haig loved Marty. Marty was the protégé who served as the presiding chief. Marty was young, but he was already experienced. By the time I got there, he had already released his first feature, *Who's That Knocking at My Door?*

What course did Scorsese teach?

Marty was our instructor in Sight and Sound, an introductory production class. They taught us the art of filmmaking, and we looked at each other's films. We had a collective where we'd make three or four short films of sixty seconds, up to three or four minutes each over the semester. We all took turns directing, writing, editing, and acting.

It was a chance to make these very low-rent films, black-and-white 16 mm, with the NYU equipment and footage. Not much footage—you had to be economical. I can say that, honestly, most of us didn't know what we were doing. The first couple of films were very clumsy. But we'd have critiques. Like a Chinese Communist collective, we'd come together and watch these films. There'd be pretty harsh criticism. But it was a part of that growing process. You had to sell your idea to the class.

I made *Last Year in Viet Nam* at the end of the first year in film school, when Scorsese was the teacher. It came at the end of a string of short films I made—a bunch of five-minute films, very bad, corny stuff. *Last Year* was a desire to express myself in a better way. It was something that I knew was per-sonal, and Marty had always told us to make personal films. I don't remember the exact thought process, but somehow I decided, *Why don't I just shoot in my father's apartment?* I trusted the cameraman, a Frenchman, and we went around the city together and just constructed it.

I put myself in as an actor and alter ego. It was the simple story of a young man who is a mystery. He has a limp. And basically, through the course of this twelve-minute movie, takes all his possessions from Vietnam and dumps them in the East River from the Staten Island Ferry.

When you were making *Last Year in Viet Nam*, were you thinking at all about the fact that you were translating your experience into art?

No—well, in an unconscious way. At this point, I'm struggling with imagery and how to get the right shot—how to make it look good, how to light it enough. I had to get somebody to shoot it to look good enough. And, you know, it's just finding the position, pacing, editing, and all the basic craft stuff.

How did it feel when you put it all together and looked at it?

It felt good. The best thing I'd done. I suppose that is satisfying. The most satisfying thing

1 Informal name of the Servicemen's Readjustment Act of 1944, a law that provided a range of benefits for returning World War II veterans. In Stone's time, a larger percentage of Vietnam veterans took advantage of such benefits, though the educational opportunities provided were not comparable to what the earlier generation received.

2 One of the most highly regarded filmmakers of the New Hollywood generation, which also included Francis Ford Coppola, Steven Spielberg, Brian De Palma, and George Lucas; Scorsese is best known for *Mean Streets* (1973), *Taxi Driver* (1976), *Raging Bull* (1980), *Goodfellas* (1990), and *The Departed* (2006), for which he won his only directing Oscar.

Like a Chinese Communist collective, we'd come together and watch these films.

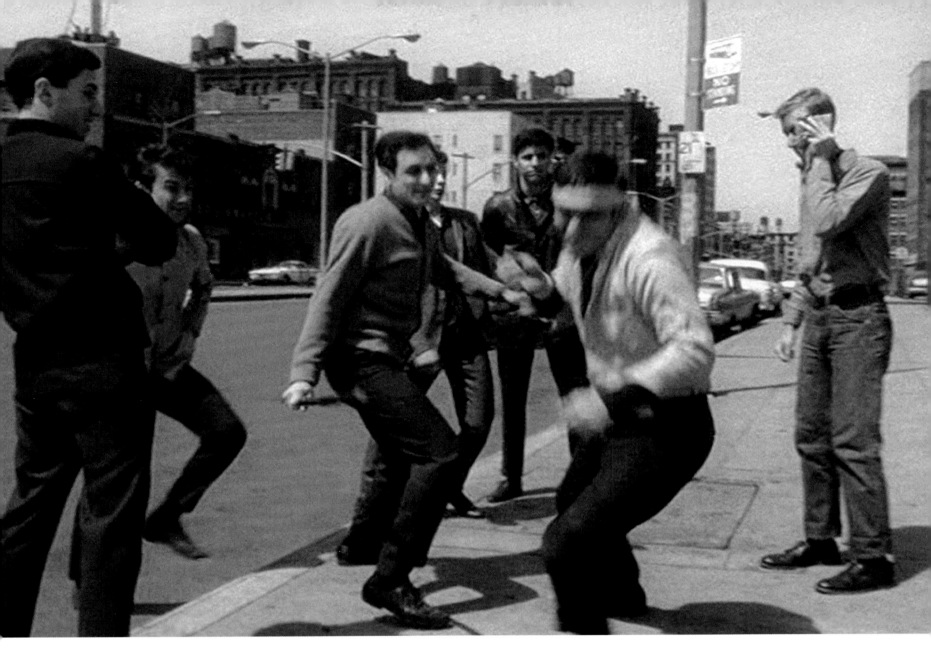

was to say, "You know, maybe I can do this." You're never sure you have that ability when you're doing it—sometimes even now.

But it's nicely done. It was well received. Now it's on YouTube,[3] and they have it way too dark and blurry, but if you look at the black-and-white 16 mm film, it's pretty good.

How did Scorsese respond to it?

When he saw it, Marty said to the class, "Here's a filmmaker." He'd been so critical of other films throughout the semester that it did make an impact on me.

When you showed *Last Year in Viet Nam* to the class, did everyone in the class know by that point that you were a veteran, or were some of them surprised?

Frankly, Matt, I didn't talk to all of them. I was never asked about it. And if they knew, then certainly I would have been on the wrong side of the fence, politically.

Did you know a lot of veterans at the time?

I had one friend in New York who had been to Vietnam, but no one who'd been in combat. I'd known him before the war.

Did you have other friendships during this period?

I had some boyhood friends, but after the separation to Vietnam, it was another world. I didn't come back to those friends. I *couldn't* come back to them.

I was very confused by the war, and I didn't talk about it at all to anyone. I really was into myself. Quiet. And most of the ideas

3 *Last Year in Viet Nam* is strongly influenced by classics of 1960s European Art cinema, particularly *Hiroshima, Mon Amour*, and *Last Year at Marienbad*. It has a lilting, strangely soothing soundtrack, French subtitles, and several long first person tracking shots that travel upriver, echoing (perhaps intentionally) Joseph Conrad's *Heart of Darkness* and Rudyard Kipling's *Lord Jim*.

73

[in the other students' movies] were pretty radical to me, and progressively left. Most of them were New York people or Eastern people, and they were definitely into documentaries about Mao, tunnel workers, labor unions. There was huge interest in what you'd call the left documentary cinema at NYU. George Stoney[4] was one of the teachers.

There's a perception of you as having been this screaming left-winger all your life, but apparently at this stage you weren't that at all. But here, when you're describing the politics of the students and the department, you describe them as being radical left or kind of "New York left."

To me they were. Everybody had to make documentaries about a tunnel worker or about whatever movement was in: black power, revolutionary party stuff. In fact, the school in 1970 went to the left completely, and revolted as part of the Cambodian bombing[5] and the Kent State killings.[6] The students took over the school. No teachers were allowed in, and they trashed the place. I joined the team.

How so?

I was one of several cameramen on a documentary that Scorsese ultimately ended up editing and directing. It was called *Street Scenes 1970*.[7]

It was about those protests in New York [and Washington, DC] in May of 1970, which

were pretty big. They were on Wall Street, they smashed one of our cameras. [The protesters] didn't have much left after that. I must have done another year at NYU after that. I did cover the protests, shot them, and some of my footage is in that film. But I was not part of the protest. I was not protesting against the war. Definitely not.

Did you disagree with the protests?

I was mixed up. I can't tell you I was against them—but to some degree, yeah. I think there was conflict, because we talked so easily about revolution and shit like that, and it was hard for me to buy that, unless you were willing to get a gun and go somewhere on a rooftop and do something about it. I was coming from a more practical experience. So, for me, it was a lot of talk: bullshit. They didn't know how to organize themselves.

Actually, the black revolutionaries were the ones who took over the whole thing. I remember they were the most radical. And they were like, *What do you white people know?* All that shit. So it was a little bit racist,

4 The creator of some fifty nonfiction films, including the documentary *All My Babies: A Midwife's Own Story.*

5 The United States conducted a covert bombing campaign in Cambodia and Laos between March 18, 1969, and May 26, 1970, targeting North Vietnamese and Viet Cong bases and sanctuaries inside those countries (which were officially neutral but did not protest violations by either side).

6 On May 4, members of the Ohio National Guard killed four unarmed students and wounded nine others at Kent State University.

7 A record of anti–Vietnam War protests after the invasion of Cambodia; includes footage of protests in Washington, DC, and of the so-called Hard Hat Riots on Wall Street in New York City, in which construction workers who supported President Nixon and the war fought with protesters. At the end, Scorsese discusses the events with friends and colleagues, including actors Harvey Keitel and Verna Bloom and Bloom's husband, Jay Cocks, future *Time* magazine critic and screenwriter of Scorsese's *The Last Temptation of Christ* and *The Age of Innocence.*

a lot of racism going on there. And I think the negative kind. I'm not saying Black Panthers [END 1] were bad, because they did a lot of good stuff, but a lot of negative Black Panther shit went down during the 1970 protest. So, it was ugly.

[The place] was like a fucking pigsty after a few weeks—"liberated bathrooms" and all that shit. It was just a mess. They couldn't clean up their own stuff! It wasn't like the army, where you have some self-discipline. *(Laughs)* You understand what I'm saying? Nobody's taking care!

So, I didn't like that shit. I was into getting things done, whether it's getting into film school, getting a career, or something.

You were a soldier.

I was! I didn't relate to a lot of that mentality.

I went on to make two other short films there. They were longer, but not as good. They were abstract. By that time I was very much under the influence of Jean-Luc Godard,[8] and Luis Buñuel,[9] and Claude Chabrol,[10] and I thought much more in the abstract. Because remember: I was not dealing, physically, with the war. I was unable to write anything about it until five years after that, when I did the first draft of *Platoon*.

You didn't write any fiction during this period, either?

No. After the war I took up screenwriting. It was a different thing. I wasn't interested in books anymore. In a way, I was dealing with

Vietnam through abstract, European-style filmmaking.

That was very much the thing at that time, if you thought of yourself as a student of film.

8 French Swiss film critic turned director; considered one of the most influential film artists of the French New Wave, credited with reinventing cinematic form with his 1960 crime romance *Breathless*.

9 Spanish director of Surrealist films such as *Un chien andalou* (1929), *Belle de jour* (1967), and *The Discreet Charm of the Bourgeoisie* (1972).

10 Leading director of the French New Wave; *Les bonnes femmes* (1960), *Le boucher* (1970), and *La cérémonie* (1995).

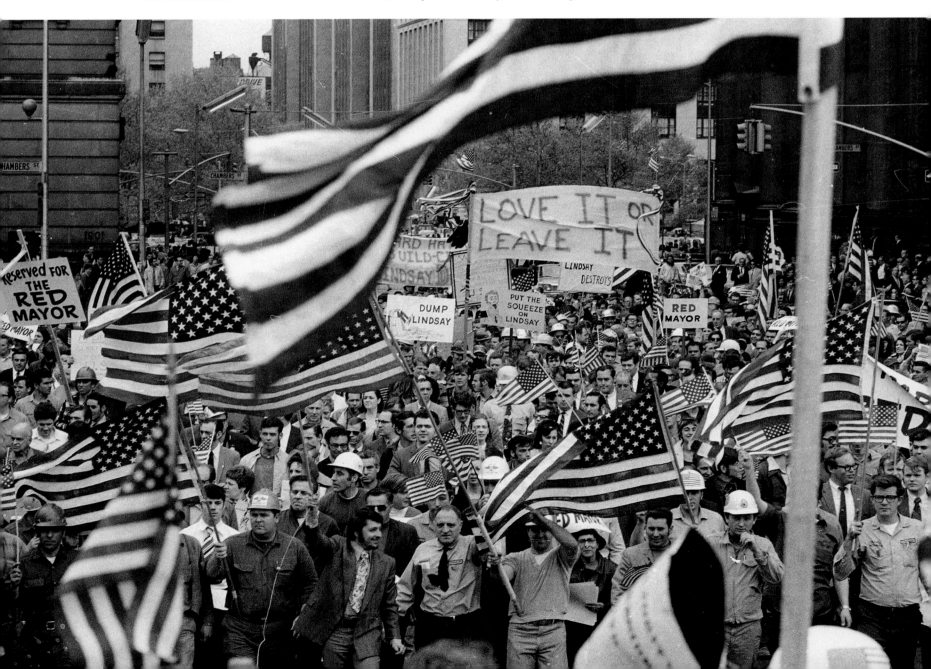

Well, a lot of [the other students] were doing documentaries. *Last Year in Viet Nam* was very realist and simple. After that I started to go off on a tangent, into more baroque stuff.

What did NYU, and New York City, feel like during that period? What were the students like? What were the buildings like? What were the sounds and smells like?

The aesthetic was low budget. The film stock was very low budget. We used to go up to a lab called Beebell, which used to be in business. And we'd get reversal film[11] from DuArt— Tri-X. We shot a lot of Tri-X. These were labs on the West Side, so we'd all hang around the labs. We'd try to get deals. I remember some of the kids did have money, and they put their own money into the shorts. For the most part the experience was pretty grim and grimy. Some of the students had money. Most of them were living hand to mouth.

Like, a bunch of students living in one apartment?

Yeah, there was a lot of that. I used to have a broken window in a small pad on Houston and Mott, I think—a broken-window apartment, and snow drifted in.

Somewhere in there, LSD, grass, and all, I met Najwa.

Najwa Sarkis, whom you'd marry in May of 1971.

Yeah. I started living more and more at her place. I came back from the dead with her.

That's quite a statement.

I couldn't integrate into society. It was easier if you had been over there, and then you came back to a place where people were supportive. But most people weren't like that. Most of them, they'd think about it for two seconds, and then it was like, *Oh man, what a bummer*, or, if not that, then: *That poor guy, he went over there. What a waste of time*. It was a strange phenomenon to be pitied or to be ignored, but I've gotten used to it in my lifetime. *(Laughs)* Societal relations, that's very important. I was alienated deeply from my parents at that time, and from American society. I don't know why, I just felt terrible. I didn't know if I had PTSD [Post-Traumatic Stress Disorder]. I had a lot of anger, and protest was in the air, wild in the streets—*let the young people take over, because this sucks!* I felt part of that. Jail was filled with young people. My anger was real.

But I met Najwa. She was six years older than me. I liked her. I married her. We ended up living together for seven years. So, I was lucky, because she really put my life back together, gave me a sense of integrity. Warmth.

The scenes in *Heaven & Earth* that show Tommy Lee Jones's[12] veteran character failing to reintegrate with society after the war—are those scenes in any way drawing on this postwar period of your life?

No, no! Although I think I could identify with someone like Tommy Lee Jones coming back, and also Hiep Thi Le coming into a society she couldn't recognize.

When you look back on that period, what's the single most important experience you had during those years at NYU? Can you think of anything?

That's not fair! All that pussy?
(Laughter)
Maybe it was just going to film school. Certainly it focused me. The more I learned about film, the more interested I became. That's a pretty conventional story, but it's the truth.

I would go see a lot of films. And remember, one thing that made me a little bit different from a lot of the kids was that they just did not appreciate screenwriting. That was like another world to them. You would go to a screenwriting class, you wouldn't see very many of the other students there. They were in production. They were making films without scripts. Which was, I suppose, OK at the time, because that was the Godard phenomenon—supposedly Godard had a script for *Breathless* and it was only twenty pages [END 2].

And you were writing consistently?

Every year I wrote at least two screenplays as well as treatments, because I liked writing. It was a way to get your inner thoughts out. I was working on soft porno films, as a cab driver, as a messenger boy—in New York winters! *(Laughs)*

After working in daytime and getting stuck in traffic, I decided to go to working nights, to make more money. The night shift started around five thirty or six in the evening, and in those days you could go as long as you wanted. It was pretty scary. There was no [partition] in the cab like there is now. It was *Taxi Driver* cab driving. It paid thirty bucks a night; if you're good with tips, thirty-five. Thirty-five dollars meant a lot of money in those days, enough to survive.

The tips were bigger at night. It was hard because you'd get off at two, three in the morning, sometimes four, and then you'd go across town. There were no buses or subways running, so you had to walk home! Walking home, it could feel like a very lonely existence. New York at three o'clock in the morning in winter in those days was freezing. I remember the cold, so cold. I wore the *Taxi Driver* outfit!

11 Type of photographic film that produces a positive image on a transparent base. Because there is no negative, there is no opportunity to tweak or correct the image; whatever you shoot, that's what you end up with.

12 Actor in dozens of films and TV programs, including *Heaven & Earth, Natural Born Killers, JFK, The Executioner's Song, Lonesome Dove*, the *Men in Black* films, *Coal Miner's Daughter, Blue Sky, Cobb*, and *The Fugitive*; director of *The Three Burials of Melquiades Estrada*; at Harvard, roomed across the hall from future vice president Al Gore.

When you finally saw *Taxi Driver*, did you think, Marty, stay out of my head?

Yeah! I was a little surprised! I thought it was a brilliant film, but I was a little surprised.

What did you think of that film and its portrait of New York City in the seventies?

I thought it was brilliant, acute. It was for me, a generational film that gave us a great hope that there'd be a new, more accurate style of filmmaking, closer to what I wanted to do with *Platoon* as a Vietnam movie. It was accurate to reality and what we knew—to our generation.

What did you know?

That things were not hunky-dory, and it wasn't all middle class. There were hard times, and violence was in the air.

This idea that the seventies was a golden time for American filmmaking: Do you think that's true, or do you think it's nostalgia?

Certain degree of nostalgia, but there was also some truth to it. There was a new depth in American films from *The Graduate* on. The late sixties, all through the seventies, that all felt like a period to me. I liked *The Graduate*. Peckinpah had *The Wild Bunch* and *Straw Dogs*. You had

The French Connection, *The Godfather*. You had Kubrick with *2001* and *A Clockwork Orange*. Richard Lester was a very important filmmaker, stylistically, maybe more of the sixties than the seventies, I guess—though I watched *A Hard Day's Night* again a while ago and thought it was terrible! And Claude Chabrol's *This Man Must Die*, a brilliant movie. And I liked a lot of those movies that Bert Schneider[13] produced: *Easy Rider*, *Five Easy Pieces*. *Easy Rider* was huge for my generation.

Sounds like you were Travis Bickle[14] with better taste in movies.

Well, it wasn't exactly like Travis Bickle! I mean, I had a series of shitty apartments, but Najwa had a nice rent-controlled, one-bedroom apartment, so I could always come home to that. I didn't come back to a dump. Jodie Foster wasn't on my doorstep or anything. My wife was making decent money working at the UN. She was the secretary to the ambassador from Morocco, although she was Lebanese. They liked her, and she'd been there a few years. Her boss was a wonderful guy, and we were invited a couple of times to the embassy and had dinner; I liked him very much.

I was leading a double life, though, because she knew rich people, and I'd go to rich people's places, and then I would drive a cab! I was kind of embarrassed sometimes! If

a rich person stepped into my cab, they might say, "What are you doing? I thought you were married to Najwa!"

Anyway, my wife was an elegant woman with some rich friends, and we met many foreign people who came to New York. I remember I wrote something for Irene Papas later,[15] and I got to know Anthony Quinn[16] and Rex Harrison[17] a bit. But I was just a young guy; they didn't know who I was.

13 Former Screen Gems TV executive who formed the pioneering independent distributor in partnership with filmmaker Bob Rafelson (who had directed the Monkees film *Head*, with Schneider producing) and agent turned producer Stephen Blauner.

14 The protagonist of *Taxi Driver*, an alienated Vietnam veteran played by Robert De Niro.

15 Greek actress and singer, born Irini Lelekou; appeared in 70 films, including the Constantin Costa-Gavras political thriller *Z* (1969), one of Stone's favorite movies.

16 Mexican-born actor; catapulted to international fame after playing Zampano the strongman in Federico Fellini's *La strada* (1954); cast in hundreds of films as a variety of ethnicities; one of his children, actor Francesco Quinn, would play Rhah, a soldier in Stone's *Platoon*.

17 English stage and screen actor; Tony and Oscar award winner for *My Fair Lady*; *The Ghost and Mrs. Muir* (1947), *Unfaithfully Yours* (1948), and *Dr. Dolittle* (1967).

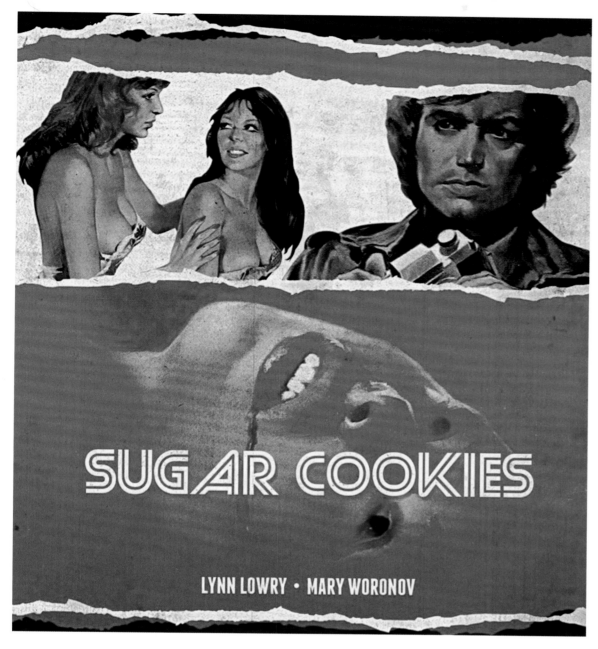

SUGAR COOKIES

LYNN LOWRY • MARY WORONOV

Najwa really was a wonderful woman. She stabilized me, and for that I owe her a lot. We're still friends. I look back on that period sometimes and I think about why it didn't work out. Probably because I still had wild oats to sow. ███████████████████ ████████████████████████ ████████████████████████ ████████████████████████

████████.

████████.[18]

Try to imagine you are able to travel back in time and see yourself during that period, the early seventies. Can you describe this kid Oliver Stone? What did he look like? How did he carry himself?

If you look at *Last Year in Viet Nam* on YouTube, you'll see it. You can see it in that movie. You can see it in the look. It's very dark, wearing black a lot, boots, very, very—I looked like a young actor. A little bit of a Russian thing—maybe like a distrusting Russian! I used to wear a peacoat jacket. It was more like I was a Travis Bickle type. An outsider.

I was also two or three years older [than the other NYU students]. So I would say that I was dark and broody, and that I was not in general agreement with a lot of the dialogue there, which I thought was pitter-patter, or sophomoric.

I didn't want to go back to college, because I had already been at Yale. I didn't believe in that group. I didn't believe in that goal. My dad wanted me to be an East Coast socioeconomic product from a top university, like he was. Work for AT&T. Join Wall Street or the banking community or business. Business was the way to make money. I was resisting that, and college was part of that resistance.

A lot of the NYU stuff was much more mundane. A lot of boy-girl stuff. And I wasn't into any of those girls. I was into older women. The woman I married was six years older than me. It was just that [older women] were more mature, and more interesting. I wasn't into the college life. I wasn't into sophomore-junior shit. You got a picture now?

I had different apartments before I met Najwa. I was in four, five different places, all really cheap and crummy. I was also a messenger and I worked temp jobs in New York City. I worked for a cosmetics company and then I got a decent job as head of advertising for a sports company that did very good business with Major League Baseball.

Sports movies?

Sports documentaries. They were the official national baseball—whatever it was called—filmmaker. But they wanted to expand to Madison Avenue, so John Held, who was a VP of an ad agency and a connection of Najwa's, suggested that I run their new ad branch, which is to say, go over from their office on Broadway and Fifty-second to Madison Avenue and sell their reel, and make them known as filmmakers. It was a bit of a sham because I worked there for a year or more, got paid a bit of money, but clearly it wasn't going to work. That was when I started to goof off.

How so?

Well, after a while and a few disappointments, I stopped going. I'd tell them I'd go out, but I was writing in the back of the office! I was basically slumming on the job, but I was doing what I love, which is writing. About a year in, they got wise and said, *It's not working out.* By that time I could collect unemployment. In those days I don't know how many weeks it was, but I did the unemployment line for a long time. I pushed that. It's a hand-to-mouth existence: You're hoping for that next break, your script is going to this person, and then he might do it, and so forth, and you meet some rich person. And then I did a porno film, a soft porno called *Sugar Cookies.*

This friend of mine from school, an old friend, hired me and two other young guys to be the main [production assistants] on this soft-core. That was my first long-term experience on filmmaking. Mary Woronov[19] was in the

18 Redacted.

19 Cult-movie icon featured in films by Andy Warhol (*Chelsea Girls*, 1966) and Roger Corman (*Death Race 2000*). Later a costar of Stone's directorial debut *Seizure*; see pages 78–86.

movie—it was directed by her husband, Ted Gershon. He was an artist, the beret type, you know, doing the beautiful shots? It was so bad! And so badly written! Anyway, I was basically a non-union gaffer and grip, hauling up the dolly four flights of stairs and lofts. But I was working with two well-off kids, Jeffrey Kapelman and Garrard Glenn, who were both friends, but the Israeli producers who ran the company weren't paying us shit. And we raised money for that fucking movie, that's what pissed me off! So I thought he'd treat us better, but they kept paying us this shit salary, and treating us like dogs! ▓▓▓▓▓▓▓▓▓▓ ▓▓▓▓▓▓▓▓▓▓▓▓▓▓▓▓▓▓▓▓▓▓ ▓▓▓▓▓▓▓▓▓▓▓▓▓▓▓▓▓▓▓▓▓▓ ▓▓▓▓▓▓▓▓▓▓▓▓▓▓▓▓▓▓▓▓▓▓ ▓▓▓▓▓▓▓▓▓▓▓▓▓▓▓▓▓▓.[20]

But I got to know Kapelman and Glenn, and the three of us said, "Why can't *we* do this?" We'd seen this process and thought we could do it ourselves.

Then I had a nightmare and it became

It came to you all in a dream?

Yeah, it did. It felt like a fever dream. A father ends up betraying his son, like a coward, and runs away and wakes up, and of course he thinks it's all a dream, and it all starts again.

This script was originally titled *Queen of Evil*, after the ringleader of these three apparitions that sort of materialize out of nowhere and terrorize the writer's family at his country house. Rounding out the trio is a black giant and a philosophical dwarf played by Hervé Villechaize.[21] The story is very much like something that Stephen King would write years later, about a horror writer whose creations come to life and cause harm to him and his family.

Seizure was a dream—*Dead of Night*, Cavalcanti, that's closer to it—Alberto Cavalcanti.[22] In '69, I'd taken a course in horror films at the New School for Social Research, before NYU, I think. Wonderful

I was also doing acting school. I was trying to do everything. I was with a Russian acting teacher for several months until I gave up, because I got stoned one night—I took LSD and went to class, and I'll never forget, she said, *That's the greatest performance you've given yet!* She studied with Stanislavsky, and had been talking this gibberish for months and I was trying to understand but couldn't! Then I take LSD, do the fucking class, and she says: *That's it! Where have you been, Stone? What have you been doing?* (*Laughs*) I get it! I gotta be on LSD to do this shit!

20 Redacted.

21 Small-statured, French-born actor who played the villainous Nick Nack in the James Bond film *The Man with the Golden Gun* (1974); died in 1993 of a self-inflicted gunshot wound.

22 Brazilian-born film director and producer; best known for the anti-Nazi propaganda film *Went the Day Well?* (1942), adapted from a Graham

(opposite) Jonathan Frid in *Seizure* (1974). Stone: "This is a revelatory shot in the movie, when the hero realizes that what he thought was a dream wasn't a dream."

(below top) *Seizure* costar Martine Beswick's eye.

(below bottom) Hervé Villechaize as the demonic dwarf.

So yeah, I was always interested in writing and directing, but I was interested in acting, too. I was doing many, various things. At HB Studio—that was Uta Hagen's[23] studio with her husband, the acting coach Herbert Berghof— I sat in on a couple of classes, but I didn't have Hagen as a teacher. I had several other teachers there, though, including the great Bill Hickey.[24] I also did a modern dance class. I had the hots for the teacher.

Please tell me there are pictures of you in this modern dance class.

No.

(Seitz laughs.)

Anyway, I made *Seizure* after the sex film in late '73, very cheaply and very wildly.

I gather that *Seizure* was not, to put it mildly, an easy shoot. I read something about the negative of the film being seized, and Hervé Villechaize threatening to kill you. There's an article that quotes him saying, at one point, "I kill you, Stone! You no pay me, Stone, I kill you! I take a knife and stick it in your heart! Fuck off!"

(Stone laughs) Hervé was a character, yeah! It was my theory as a director that all the actors should live in the same house and we should share in this adventure together and shoot it in sequence.

How did that work out for you?

Disaster! *(Laughs)* Complete disaster! Everyone started to crack up. It's very hard to shoot and live in the same house. You've done that, so I know that you know what that's like!

I do! But at least when I shot a movie in my house, I didn't have anyone trying to kill me with a machete.

23 1919–2004; German American actress and drama teacher, notably at New York's Herbert Berghof Studio, and author or coauthor of books about acting that are still used in drama classes; blacklisted in the 1950s.

24 1927–1997; film, TV, and theater actor; *Prizzi's Honor* (1985), *National Lampoon's Christmas Vacation* (1989); Dr. Finkelstein in Tim Burton's *The Nightmare Before Christmas* (1993).

Treatment for

THE LAST WEEKEND

(Alternate Title: THE QUEEN OF EVIL)

Original Story by Oliver Stone
Screenplay by Edward Mann and
Oliver Stone
November, 1971

Presented by::

Euro-American Pictures
319 East 50th Street
New York, New York, 10022
Tel: 212-758-1765

Not very long ago I had a dream. Unlike most dreams, it had a beginning, a middle, and, worst of all, an end, an end from which I was unable to awake in time, and though I am still alive today, I find myself increasingly in the grip of a nightmare which, in the desire to exorcise, I write now as exactly as I can remember it.

It is a cool late Saturday afternoon deep in the Connecticut countryside. There is a nice house with a very green lawn sloping down to a big Etruscan-like pool filled with a dark brown water. Frogs jump in thepool and possibly, I think to myself, a water snake has glided in unnoticed. And beyond the pool the tall beech trees of the forest shake gently in the wind--an ominous forest, it surrounds the house and casts over the place a feeling of an isolated primitive world, a world where my lovely wife can walk naked with dischevelled hair over the brown floorboards of the house and down to the pool.

The house is mine. My name is Edmund Roth. I am 36, in good health, and relatively attractive, part of which comes from that prosperity which has nourished me since I was a child, for my father left me a magazine publishing business which I successfully expanded. Our publications you can compare to LIFE, TIME, and FORTUNE, the educated heartbeat of our nation, self-serving perhaps and pretentious but something which was given me and which I do to the best of my ability eleven months of the year. The only retreat I have is this house and here one month each summer I sanctimoniously guard my family's privacy.

My wife is Nicole. She is 29 but seems older to me because

Payroll—Actors

1. Edmund — Jonathan Frid — 750/week — 4 wks
2. Queen — Martine Beswick — 530/week — 4 wks
 On 4th week she gets one check for $570 expenses.
3. Joe Sirola — 900/wk. — 3 wk
 Charlie
4. Troy Donahue — $2,000 / one week.
 Mark
5. Ann Meecham $ — 526.91/week — 2 wks
 Eunice

PLEASE

Mike Meola — $47.00
Paid Sept. 6...
Receipt of Cameras and Props.
Ch. #115
Jason

10. Roger Decovering — 526.91/week ✓
 Serge
11. Mary Woronov — 526.91/week ✓
 Mikki
12. Christine Pickles — $75/week
 Nicole
13. Lucy Bingham — Being Paid
 Betsy — as cost

(OVER)

VOUCHER
Sept. 6
$25.00
Jean Reed
Cine Film
CH # 115
purchases
Polaroid Film

$120 Given to Jay Apelman
Sept. 6 — From check
receipts due from
$120.00
(Voucher)

Hotel Sonesta
Formerly Hotel America

Hervé Villechaize
$711.70, which inclu...
ment for the final w...
of "The Queen of Evil." I...
a $100.00 bonus payment—
of payment equals $641.30. Ad...
For oct 6 1972 #301 $54...
for photographic services 10...
and labor Bonus — +
bring the full amount to
$711.70 received: Total 64...

Photography.
Montreal Matin
25 oct 5 — 8 X 10 B...
Total

Photography
Weekly magazine
23 oct 5 — 8 X 10 @ $2.40 ...
Total 10...

641.30
+ 20.00
661.30
+ 50.40 photo P...
$711.70

JAMES J. CALDERWOOD
NOTARY PUBLIC, State of New York
No. 03-0537550
Qualified in Bronx County
...ion Expires March 30, 1973

Constitution Plaza Hartford Connecticut 06103 (903) 978-9000

BARCLAYS BANK INTERNATIONAL LTD.
NOV 21 1972

PASS POINT

303 Fifth Ave.
New York, N.Y. 10016

FIDELITY
UNION TRUST COMPANY
MAIN OFFICE
NEWARK, NEW JERSEY 07102

THE QUEEN OF EVIL COMPANY
17 ACADEMY STREET, ROOM 912
NEWARK, NEW JERSEY 07102

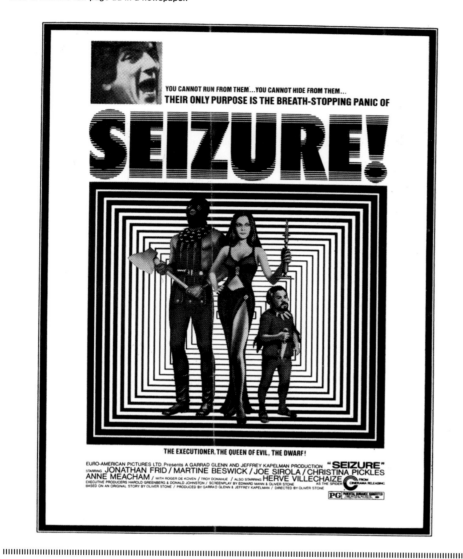

YOU CANNOT RUN FROM THEM…YOU CANNOT HIDE FROM THEM…
THEIR ONLY PURPOSE IS THE BREATH-STOPPING PANIC OF

SEIZURE!

THE EXECUTIONER, THE QUEEN OF EVIL, THE DWARF!

EURO-AMERICAN PICTURES LTD. Presents A GARRAD GLENN and JEFFREY KAPELMAN PRODUCTION "SEIZURE"
STARRING JONATHAN FRID / MARTINE BESWICK / JOE SIROLA / CHRISTINA PICKLES
ANNE MEACHAM / WITH ROGER DE KOVEN / TROY DONAHUE / ALSO STARRING HERVE VILLECHAIZE AS THE SPIDER FROM CINERAMA RELEASING
EXECUTIVE PRODUCERS HAROLD GREENBERG & DONALD JOHNSTON / SCREENPLAY BY EDWARD MANN & OLIVER STONE
BASED ON AN ORIGINAL STORY BY OLIVER STONE / PRODUCED BY GARRAD GLENN & JEFFREY KAPELMAN / DIRECTED BY OLIVER STONE

"I kill you, Stone!
You no pay me, Stone, I kill you!
I take a knife and stick it in your heart!"

That was not Hervé with the machete, by the way. Though Hervé did collect knives and threw them well. That was the special effects man, who was jealous of me because he thought I was screwing the lead actress, and he thought I was making the moves on her. He was so drunk, I don't know what the hell I hired him for. He chased me.

(*opens folder of documents*) This is the press kit for *Seizure*. The official director biography, which I believe you wrote yourself, reads:

Seizure was filmed on location at Val-Morin in Quebec, on a remote country estate. It was shot in five weeks under a hectic schedule with very little money. The actors were American and English, and the crew for the most part French Canadian, the équipe headed by Roger Racine[25] of Montreal. Most of the shooting was done outside from night till dawn. There were many accidents, fights, injuries, and terrible food. The French dwarf in the film, Hervé Villechaize, disgusted, buried a chocolate cake in the face of pro-

ducer Garrard Glenn. **The special effects man broke all the windows in the house in a drunken rage. He was deeply in love with leading lady Martine Beswick, who bore no such feeling for him. Damages to the house were enormous. The producers cowered in fear from the wrath of the burly French Canadians, who finally threw them into an icy lake, hoping they would drown. Countless other humiliations occurred, and without further speech or specifying them, it should be pointed out that it was a miracle the film was finished at all.**

(*Laughs*) Is that my quote?

You must have had to reach a certain threshold of frustration to make *that* your bio.

Yes. But it's true. They threw the producers in the lake, and Hervé fell in a six-foot hole. Did I tell you about that?

No.

He was walking around one night, this place was weird, and he fell into a hole! All night he was like, *Help me! Help me!* (*Laughs*) You're laughing!

You're doing an impression of Tattoo from *Fantasy Island*[26] trapped in a hole! Yes, Oliver, I'm laughing!

Thank God my drunken assistant director went out and took a pee and heard him calling out to us. That was lucky, because Hervé would've died. It was hypothermia time. Hervé was a character.

But we couldn't pay—checks were bouncing, it was a mess. Roger Racine [the director of photography] was an old-time French Canadian, and the crew hated him. He was pissed off at Jeffrey and Garrard, who were amateurs trying to make all ends meet with this money. The film was financed by a Toronto company, which went bankrupt three

25 1924–2014; cinematographer of nearly thirty years' experience by the time he hooked up with Stone; *Ladies and Gentlemen, Mr. Leonard Cohen* (1965) and *Rebel High* and *Zombie Nightmare* (both 1987).

26 American television series that aired on ABC from 1977 to 1984. It starred Ricardo Montalban as Mr. Roarke, the owner of a private resort where guests could pay a high price and live out their fantasies. Villechaize (who did not appear in the final season) was his sidekick, Tattoo.

weeks before we started shooting. I went to their offices in Toronto, and they were really nice, but there was no furniture! They'd floated a lot of Canadian penny stocks in those days, which were notorious. And they went out of business.

So we were out to fucking lunch. We had lost half the budget. We had money from the States, which we'd found, but we only had half a budget.

So you went out and shot with only half a budget?

We made a deal with Harold Greenberg,[27] who owned Bellevue-Pathe Lab, and he swallowed the whole film and took care of it to finish. Greenberg was a legend in French Canada, but tight with the money, taking a five-to-one write-off with his tax shelter deal.

Your *Seizure* files are an incredible record of financial distress: receipts, bills, collection notices, and letters saying, in effect, "Please, please, please send money." It's quite extraordinary.

Najwa helped me as much as she could with her connections. We got a wonderful man, Eddie, to put up twenty thousand dollars. But basically, checks bounced; the crew was not paid. It was a tough crew, very French Canadian, and they went on strike. That's when they threw the producers in the lake. We got things done, and somehow we got through it. Racine was not paid, and he was pissed off. So I'm editing in Montreal—we'd moved the film there—and he didn't get paid and he locked me out of the editing room. I somehow legally "seized" the film back under Canadian law. I accompanied the bailiff and police to Racine's office to get the work print: he was livid. But we couldn't locate the sound masters. But we smuggled the workprint out through the Michigan border in the back of a rented car we hadn't paid for. We had to "re-dub" the whole picture, all from lip-syncing. Motherfucker! That motherfucker! *(Laughs)* And I lost some of the film! It was just a nightmare. Jeffrey had a warrant out for his arrest, and the Mounties were executing it, because of a rental car situation. We'd rented a lot of cars and we didn't pay the bill. So basically, I remember driving the film in the back of my rented car through the border, with the film in the back, you see?

Getting that film across the border, that was scary. I think the negative was in the lab. But then we took the work print out. I got the work print back to the States, which was a big

victory. The sound was still up there. Greenberg had the fucking negative, but I could keep working on the film in New York and hopefully find an investor-distributor. So we did all the sound work, the syncing, and then we took it to Sam Arkoff,[28] and he said, *Not interested*. A lot of people passed.

But we got Cinerama.[29] At that point we'd reconciled a little bit with Greenberg, who had made the deal with Cinerama, a company that had done some classy horror films. It was run by a guy, Joe Sugar was his name. They put *Seizure* at the bottom of a double bill on Forty-second Street. I took my mother, who took several of her friends. She had champagne and we sat up in the balcony on Forty-second Street with a lot of strange people down on their luck to see the film, which was played too dark to see. The projector bulbs were pretty cheap in those days.

What did your mother think of the movie?

She was very proud of me, that kind of stuff.

But it was such a nightmare to get it out there. And it didn't do my career any good, either. You liked some of the Guignol in the movie, right?

I did—although the movie's very rough, as you say, and I think *The Hand* is ultimately a superior take on a similar story.

Vincent Canby, believe it or not, liked *Seizure*!

It was around this period, the early to mid-seventies, that you started to make a bit of headway as a screenwriter, yes?

Yeah. Fernando Ghia[30] read my treatment and brought me out to Hollywood, and it was really an eye-opener, because I'd written a first draft of a really good screenplay, "The Cover-Up," that Robert Bolt[31] redlined with me over a two-to-three-week period at his office in Beverly Hills. Robert Bolt sat in a room with me for almost two weeks straight, just going over the script I'd written and tearing it apart, line by line practically. He rewrote so much of it that at the end of the day it was a brilliant script that really reads

well, but it's a lot of him. The script was sent to the best producers and directors. I learned a lot about the way he thought, and I saw the economy of scale and movement he used. He was originally a socialist schoolteacher, so it really was an education. I felt a real change in my writing, like I was getting better. It

That was not Hervé with the machete,
by the way

was my version of the Patty Hearst kidnapping.[32] That was an important step for me. And through Robert and Fernando, I got an agent.

So, about this unproduced screenplay, "The Cover-Up": The main event in the story, the equivalent of the Patty Hearst kidnapping, turns out to have been a conspiracy. It turns out that two of the people involved in the kidnapping are revealed to have been undercover agents for the police.

There was some evidence to that effect.

It's very *Battle of Algiers*![33] It reads as if the true purpose of the kidnapping is to incite enough rage against the counterculture to justify a government crackdown.

27 Film producer and distributor; founder of the Movie Network and other early scrambled, over-the-airwaves pay-per-view channels; producer of the *Porky's* series.

28 Cofounder, with James H. Nicholson and Roger Corman, of American International Pictures (AIP).

29 Cinerama Releasing Corporation (1967–78); created when the Pacific Coast Theater Chain purchased Cinerama, Inc., to distribute Cinerama-format movies plus select foreign films and movies made by the ABC network.

30 Italian talent agent and producer of *The Mission* (1986), written by Bolt.

31 1924–1995; English screenwriter; *Lawrence of Arabia* (1962), *A Man for All Seasons* (1968), *Ryan's Daughter* (1970).

32 American heiress kidnapped in 1974 by the Symbionese Liberation Army, an urban guerrilla group, and brainwashed into joining them.

33 French Algierian war film (1966) directed by Gillo Pontecorvo. For more on Pontecorvo, see footnote 66, chapter 6, page 290.

I got my information from a radical woman, a leftist living in New York. I didn't follow up on it, but there was a tremendous identity issue about the black fellow who led that gang—

Donald "Cinque" DeFreeze.[34]

Yeah, she had told me about this guy. In this case, I don't remember all the facts versus what we actually used in the script, because it kind of blurs.

But "The Cover-Up" didn't get made. Broke me up, because it was at the time of *Taxi Driver*—Marty was succeeding, and I wanted to make a go at this business!

At that point, my marriage was falling apart. Although Najwa was very wonderful to me, and we had many good things together, it was not a marriage that was going to last. I was too much of a wild man. We broke up, and I moved into a friend's apartment. At that point, summer of '76, I said, *I'm going to make it or break it: I'm thirty years old; I'm either going to get in or out of this business.*

So I wrote *Platoon* in six weeks, because it had been on my head. I wrote it that summer, in that apartment, when we were celebrating America's anniversary, two hundred years.

Jimmy Carter was ascendant.

Beneath all this is a brewing consciousness, and things are changing. The country's changing.

You go through the dark years, '72, '73, we're still in Vietnam, then comes Watergate, Nixon resigns, and then you've got Jimmy Carter becoming president in 1976.

Carter at the Democratic convention in New York City is a huge, very big, spontaneous moment. You were seven then. You probably don't really remember it. But '76 was amazing, it was like Obama in 2008, you know? It was a new turn. And I was proud to be a Democrat and vote Democratic.

Then four years later I found myself voting for Reagan in '80, because Carter's presidency was, partly thanks to the media, a shambles. But in '76, Carter was incredible, that election was so exciting! The convention at Madison Square Garden!

Ron Kovic was there. That's the denouement of *Born on the Fourth of July*: Ron speaking there.

I didn't know him then. His book was optioned two years later. But that summer of '76 it all turned around for me.

I just felt it was a great script, *Platoon*, and it took off right away. It was optioned in two weeks. And right before it was optioned I moved out to LA to a small hotel room, and Marty Bregman[35] wanted me back in New York City to work with Al Pacino[36] on

Platoon, and Sidney Lumet.[37] It was so exciting. I was in with the big leagues. But then Lumet said, *I just can't go into a jungle. At my age, I can't make that kind of picture anymore.* He wanted to do stuff that was a little bit easier on him. He had a very scheduled life, Sidney. He left the apartment at 9:15 every morning. He liked his crew, his scene, to make movies on the clock, like Woody Allen. I forget what happened next, but *Platoon* didn't get made then. The option lapsed.

The *Platoon* script did get me into *Midnight Express*, which was a surprise hit, a very low-budget movie at Columbia—the bottom of their rung.

34 Symbionese Liberation Army leader; shot himself after the house he and other members were in caught fire during a shootout with police.

35 Producer of twenty-nine films, including *Serpico* (1973), *Dog Day Afternoon* (1975), and *Carlito's Way* (1993).

36 1940– ; "Who's being naive, Kay?" "Attica! Attica!" "Say hello to my little friend!" "Whoo-ah," "Favor gonna kill you faster than a bullet." "All I am is what I'm going after."

37 1924–2011; prolific American director, often in a naturalistic New York mode. *12 Angry Men* (1957), *The Pawnbroker* (1965), *Dog Day Afternoon* (1975), *Network* (1976), *The Verdict* (1982).

87

When I interviewed Billy Hayes[38] I conflated him with myself because I'd been busted and I hated the authorities.

Fuck you, Turkey **means** *Fuck your system—fuck you,* **the Man.**

But it turns out Billy was much more than what he said in the book. He'd cowritten the book, more like had it ghostwritten, and the book is what I based it on, because Peter Guber[39] had created the project.[40] But Billy was never honest with the guy who wrote the book or with me. He later clarified to me that he'd smuggled hash out of Turkey three previous times.[41] I swear on my life, if I had known Billy Hayes had smuggled hashish before having the experience he wrote about in the book, I never would have written the film the way that I wrote it.

The Right loves to think of you as "muckraking left-wing filmmaker Oliver Stone," and yet you've been accused of being sexist, of being racist against the Turks in *Midnight Express*, bigoted against Cubans in *Scarface*, and on and on. How do you feel about that? Can you even talk about that?

In relation to what? Which film do you want to talk about?

Well, I guess we could start with *Midnight Express*, and maybe pick up the others later, as we deal with them in your timeline.

I know you're very sensitive about those particular charges about *Midnight Express*: that your script is racist against the Turks. You've said that the script is not so much about the criminal justice system in this particular country, Turkey—that it's more about injustice generally, and more specifically as it pertains to people who end up in jail for drug offenses, like you did.

That's what it was to me, and that's why I conflated my experience and Billy's, because my script wasn't about the Turkish people per se. In fact, my proof of this is the speech I gave at the Golden Globes after I won there for screenwriting in 1979. In a speech that may have been incoherent to some people, I was saying, essentially, *You cannot condemn Turkey. You cannot just condemn Turkey, you must look into yourselves and see what we do here on American television with all these cop shows, where you show these ridiculous drug dealer caricatures and the cops are always busting them. You're creating an environment of the war on drugs, creating enemies all over the world, and above all, you're being hypocrites.* This is what I was saying. And as a result, I got booed off the stage the moment the speech turned on America.[42] So why would I say all that if the movie was only about Turkey?

But I think it's my fault, because I conflated two things: Billy's story, and my anger at being busted in San Diego for two ounces of grass and being in San Diego jail, facing federal smuggling charges of five to twenty years, and not getting any legal attention until finally I got a phone call to my father and we got the lawyer to come in and see me.

Tell me more about your drug bust, and how you got out of jail.

Dad had to pay the lawyer fifteen grand. If I had stayed in jail, I would've faced one of two judges. One of them was in on Tuesdays and Thursdays. With that judge I would've gotten probably three years and I could've gotten out under parole. And the other judge, Monday, Wednesday, Friday—the other prisoners told me all this—was a ball breaker who probably would've given me fifteen years, and I would've gotten out in maybe three to five.

All this for two ounces of grass! That's pretty heavy bullshit. And the guys who were in there were heavier users, but they were stuck in there for six or more months waiting on a trial! There was nobody who'd see them! So that system was what I was really pissed off about.

A system where guys who didn't have your connections to money or influence were just going to rot in jail indefinitely?

Yes. I realized the system was rigged: They were all blacks or Hispanics in jail, very few whites, and I was lucky to get out.

So when I went over to meet Billy, I suppose I took his story under my skin and tried to make it an antiauthoritarian story.[43] If Billy had told me he'd smuggled drugs three times before he got caught, I wouldn't have done the story the way I did. I couldn't have approached it with the innocence thing that I did.

I was looking at it as my story, in a way. So, *Fuck you, Turkey* means *Fuck your system—fuck you, the Man.*

And it was misunderstood, and I didn't apologize. I said I regretted that the film was misunderstood. That's what I told the Turkish press. I never apologized, nor should I have.

38 William Hayes was given a life sentence for smuggling hashish into Turkey on October 7, 1970, escaped from prison on October 2, 1975, and wrote the autobiographical book on which the Stone-scripted *Midnight Express* (1978) is based.

39 Film and music producer; currently chairman and CEO of Mandalay Entertainment; and co-owner of the Golden State Warriors (basketball), the Los Angeles Dodgers (baseball) and the Los Angeles Football Club (soccer).

40 Nancy Griffin's 1996 book *Hit and Run*, a critical account of Guber's tenure running Sony Pictures with movie and music producer Jon Peters, credits Guber with packaging Hayes's story with Stone's script, British ad man Alan Parker's direction, and Giorgio Moroder's pulsing electronic score to make a serious but highly exploitable thriller that would eventually earn $34 million and win six Golden Globes and two Academy Awards (including Stone's award for adapted screenplay).

41 According to a November 14, 2014, profile of Hayes by *The Daily Beast*, "Hayes wasn't a green American nabbed on his first drug smuggling attempt, but a small-time runner who'd made three trips prior to getting nabbed—in April 1969, October 1969, and April 1970. On each trip, he'd purchase two kilos of Turkish hashish for $200 apiece, tape them to his torso (there was no airport security back then), and sell it in the States for $5,000."

42 No video or transcript of this speech exists online, unfortunately.

43 In a January 9, 2004, interview with the *Seattle Post-Intelligencer*, Hayes said, "I loved the movie, but I wish they'd shown some good Turks. You don't see a single one in the movie, and there were a lot of them, even in the prison. It created this impression that all Turks are like the people in *Midnight Express*. . . . I wish they'd shown some of the milk of human kindness I (also) witnessed."

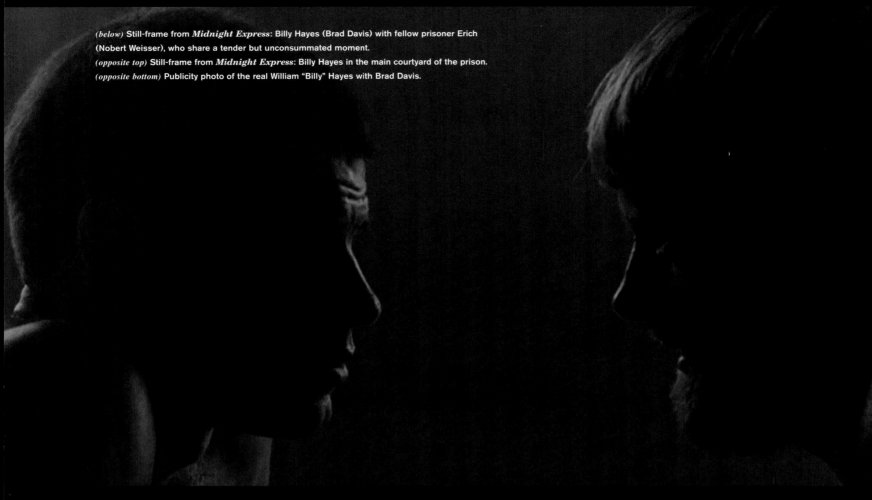

(below) Still-frame from *Midnight Express*: Billy Hayes (Brad Davis) with fellow prisoner Erich (Nobert Weisser), who share a tender but unconsummated moment.
(opposite top) Still-frame from *Midnight Express*: Billy Hayes in the main courtyard of the prison.
(opposite bottom) Publicity photo of the real William "Billy" Hayes with Brad Davis.

Why do you think you shouldn't have had to apologize?

Because the fucking penal system in Turkey *was* abusive, and it was condemned by international human rights groups.

Well, the movie certainly made that clear. "Turkish prison" was a synonym for "hell on earth" for years after that, mainly because of *Midnight Express*.

Yeah, the movie was seen as an anti-Turkish thing, and the tourist trade to Turkey dropped right off.

After *Midnight Express*, I was approached by several Armenian groups to write a movie about the Armenian genocide in Turkey. There was a lot of money behind it. Frank Mankiewicz, our press representative on *JFK* before the movie came out, was hired by the Turkish government in those years after the film came out, to repair the Turkish image. He told me some funny stories about that.

Anyway, after *Midnight Express*, my stock went way up. Somewhere around there, Bregman came back and asked me to work on *Born on the Fourth of July*, which he'd optioned from Ron's book. He'd had another screenplay written by another young writer that was not very good, and I'd gone into that

whole process while *Midnight Express* was going around the world.

When did you first read *Born on the Fourth of July*?

'75 or '76, and it was well received. It was on the front page of the *New York Times Book Review*. Got a lot of attention. The book is a very poetic, structured, fragmented story. It was published only a year after the Vietnam War had ended. I was avoiding material like that, frankly. Martin Bregman, the producer who had optioned my screenplay *Platoon*, brought it to my attention—he thought I'd be perfect to write this for Al Pacino.

William Friedkin wanted to direct *Born*, since he was a legend at the time. He was living in Paris with Jeanne Moreau.[44] We were there, talking to him about how to do it.

What advice did Friedkin give you? And did any of it find its way into the movie in 1989, when you finally did get to direct it?

The structure of it was Billy's idea. He said, "Keep it straight, do it as a linear narrative. It's good corn." The script had been very fragmented up to that time, so we took his advice. I wrote the script with Ron's help, and talked to his friends. I knew a lot of the story from my own experience, but that became the reen-

try movie I always wanted to do. That was a painful writing process, and we geared up with Pacino, but the money wasn't quick to come because it was a dour subject.

Friedkin dropped out to do *The Brinks Job*,[45] and I was so pissed at him, because *Brinks* was an awful movie. I just felt, in my heart, *Billy, you're wrecking your career! If there's one movie you should do, it's this one!* I just knew he'd do a great job! Marty Bregman brought in Daniel Petrie,[46] who was a competent director and a nice man, very nice to me. We rehearsed the whole damn thing. Marty kept promising German money, and Universal would distribute it reluctantly. Dan brought in very fine actors, it was a great rep company, and I saw the whole thing rehearsed.

44 French actress; star of François Truffaut's *Jules and Jim* (1962), among others. Friedkin's wife from 1977 to 1979.

45 Peter Falk starred in this film about the real-life 1950 robbery of nearly $3 million from a Brinks vault in the North End of Boston. While generally well received by critics, Friedkin later said the film "has some nice moments, despite thinly drawn characters, but it left no footprint."

46 Director of *Lifeguard* (1976), *The Betsy* (1978), *Fort Apache the Bronx* (1981), and the TV movies *Sybil* (1976) and *The Dollmaker* (1984). Producer of twenty-nine films, including *Dog Day Afternoon*, *Serpico*, *Scarface*, and *Carlito's Way*.

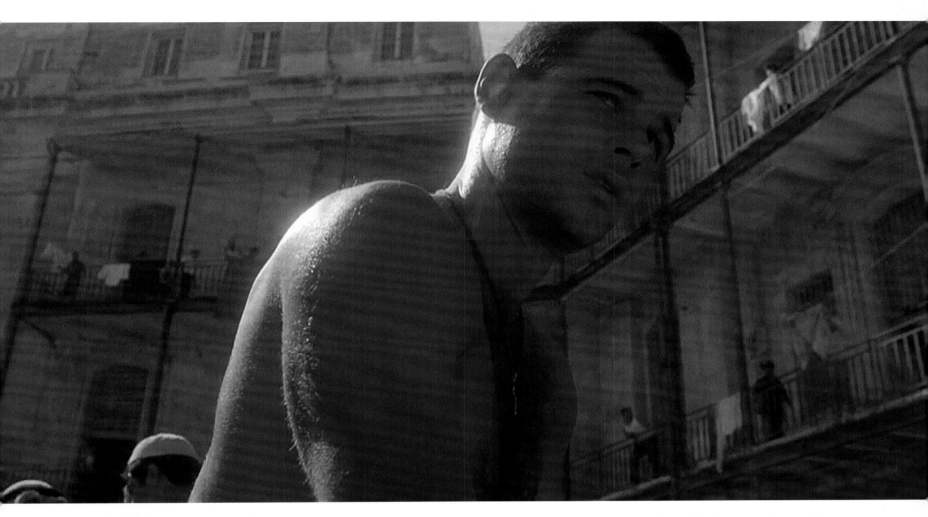

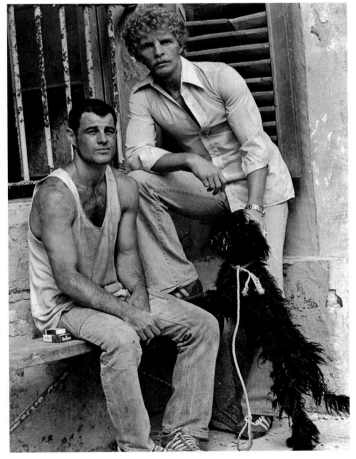

Obviously, I was rewriting, rethinking every day. Al was, to me, a god, and he was good. I saw him in the wheelchair. But he was mid-thirties, whatever?

If that was 1978, he was thirty-eight.

He was so good! It was like watching a Shakespearean performance. He was on fire.

This stood me in good stead later in time, because it was a way of learning. Al didn't have faith in Dan, although I did. That was always an issue. At the same time, Marty's money never was really there, so the project fell apart with three weeks to go. All the locations had been picked. Ron was so heartbroken. He was furious. You have to realize, he didn't know how many days he had left in the chair. I was really depressed also. So I said, *Listen, if I ever get somewhere in Hollywood, I will come back and make this.* He remembered that and always thanked me for it ten years later.

It took a long time for you to realize the dream of seeing those Vietnam films on the screen.

I had no idea that would be the case, because by this time I'd gone through too much and it was clear that they didn't want to make those kinds of movies. These two movies were too dark, they were downers. Everyone had read

these scripts. I felt like a prostitute, and just forgot about it.

The only one who really believed in me was Michael Cimino.[47] He actually came to me because he'd read and loved *Platoon*, and said, "I'd like you to work with me on *Year of the Dragon*," which he was developing from an interesting book by Robert Daley. After *Heaven's Gate*, Michael had to make a deal with the devil, Dino De Laurentiis,[48] not the greatest creative producer. Dino, me, Michael hooked up on *Dragon*, I took half a fee. Since Michael liked *Platoon* so much, and Dino liked Michael but didn't care about me, Michael said, *I want Oliver to direct* Platoon. *I'll produce it.* Dino said, "Sure," because he wanted Michael, but he made sure to cut my fee in half, which had been established at a high rate on *Scarface*. And he never fucking made *Platoon*.

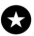

47 Director of *The Deer Hunter* (1978) and *Heaven's Gate* (1980), a huge financial and critical flop. Stone cowrote Cimino's first film after *Heaven's Gate, Year of the Dragon* (1985), discussed in chapter 3, pages 119–27.

48 1919–2010; Italian film producer as known for his grandiose demeanor as for his collaborations with Federico Fellini, Ingmar Bergman, David Lynch, Ridley Scott, and other notable directors.

★ ★ ★ ★ ★ ★ ★ ★ ★ ★ ★ ★

(previous spread) Oliver Stone at his father Louis's apartment. Stone: "This is actually at the Beverly Hotel on 50th Street, a residential hotel where my father made a deal to live by the month or the year. Do you wanna hear a funny story? My dad later rented an apartment that used to belong to Xaviera Hollander, also known as the Happy Hooker. He jumped on the place a few days after she was busted and thrown out by the management."

(above) Oliver Stone and Brian De Palma on the set of *Scarface* in 1982.

After his *Midnight Express* **Oscar, Oliver Stone entered the gun-for-hire phase of his career.** In an industry dominated by studio heads, producers, directors, and movie stars, he became one of the few screenwriters of any era to develop an auteur's profile. Starting with 1982's *Conan the Barbarian* and continuing through *Scarface*, *Year of the Dragon*, and *8 Million Ways to Die*, viewers and critics began to get a sense of what "an Oliver Stone screenplay" was: grand, brusque, oddly romantic, sometimes crude, often violent, occasionally sadistic or masochistic, and stocked with obsessive, macho heroes who had something to say and demanded that you listen.

Stone was also criticized—as with *Midnight Express*—for being histrionic, melodramatic, sexist, racist, and xenophobic. In partial defense of Stone, one could say that his run of early eighties scripts had individual temperaments and styles, that they were all based on preexisting material with situations and characters created by other writers (a thirties film; a pulp and comic book series; two novels), and that they were not developed in conjunction with one another; producers hired Stone to write things that they figured Stone could write.

But that seems too apologetic. Stone's scripts were very much of their era, which is to say that they were at odds with Stone's development as a human being and a political thinker. During the first half of the eighties, Stone became disillusioned with cultural and political assumptions of the country's Republican president, Ronald Reagan, for whom

he'd voted in 1980 in reaction against Reagan's predecessor, Jimmy Carter, an amiable but ineffectual Democrat. The Reagan administration scapegoated and demonized minorities, reversed the baby-steps socialism of Franklin Delano Roosevelt and Lyndon Johnson, restructured the economy to benefit the rich and super-rich, and embarked on a series of misadventures overseas, to beat back the Soviet menace and make the country feel blessed and good and invincible again after a half decade of licking its Vietnam wounds. Major American films released in that decade had an undeniably Reaganesque flavor. The adventures of arrogant but righteous (or righteously funny) white men dominated multiplexes.

If you were an active moviegoer during this period, it could seem as though Stone the screenwriter was lining up nonwhite communities like targets in a shooting gallery: blacks (*Conan*'s villain Thulsa Doom, played by James Earl Jones, the movie's only dark-skinned character[1]); Cuban Americans (*Scarface*); Chinese (*Year of the Dragon*), and Hispanic Americans (*8 Million Ways to Die*). And all of the films Stone scripted were overwhelmingly male in character, demonstrating little interest in women beyond their status as lovers of, or obstacles to, the men. In time Stone would become more aware of his privileged white point of view on people of color; his enlightenment about women would take longer, and prove more difficult.

Conan, *Scarface*, and *Dragon* burst free of their culturally constricted viewpoints through sheer wild-assed delirium. Two were revised, to varying degrees, by their directors—John Milius and Michael Cimino, respectively—but in each case, if you compare Stone's earlier drafts with the shooting scripts, you can see that the dramatic DNA and many notable set pieces are Stone's, as well as the quotable lines: Conan saying that what is best in life is "to crush your enemies, to see them driven before you, and to hear the lamentations of their women"; Stanley White, the hateful cop hero of *Dragon*, intoning that "a great man is one who in manhood still keeps the heart of a child," and warning a squad room full of beat cops, "I give a shit, and I'm gonna make you people give a shit, too," and half whining: "How can anybody care too much?"; Stone's *Scarface* screenplay made it to the screen intact, and contains some of Stone's most pungent lines, including, "The only thing in this world that gives orders is balls" and "When you get the money, you get the power; then when you get the power, then you get the women," and "Say goodnight to the bad guy," and "Chi Chi, get the yeyo."

8 Million Ways, Stone's final solo outing as a screenwriter before establishing himself as a major American director, was a disaster—not just for Stone, whose name stayed on a script that was rewritten (without credit) by *Chinatown* screenwriter Robert Towne, but also for director Hal Ashby, who grappled with a prodigious drug problem during the shoot, and the film's star, Jeff Bridges, who came to the film fresh off the hit thriller *Jagged Edge*. But the other Stone-scripted movies from this period proved impossible to ignore. *Scarface* was blasted for its scabrous language and thunderous violence as well as for its portrayal of street crime in Cuban American Miami. *Conan the Barbarian* was an attempt to cash in on the success of comic book—and fantasy-tinged blockbusters such as *Star Wars* and *Superman: The Movie*, but with gore and sex. Neither *Scarface* nor *Conan* became the *Godfather*- or *Star Wars*-level blockbusters that their distributors wanted, but they did well internationally, eventually becoming cable TV phenomena and pop-culture touchstones and redefining their leading men. *Scarface* spotlighted the shouting-to-the-rafters incarnation of Al Pacino—a mode that would dominate the actor's repertoire from that point on. *Scarface* also summed up the eighties in a single wild image: Tony Montana facedown in a mountain of coke. *Year of the Dragon* confirmed Mickey Rourke, an ascendant scene-stealer, as a Jack Nicholson—styled hateful wiseass lead, and briefly revived the directing career of Cimino, which had stalled after the flop of *Heaven's Gate*. Prior to *Conan*, Arnold Schwarzenegger was known mainly for playing generic "hero" types in *Hercules in New York* and *The Villain*, and for mining an immigrant-hedonist-in-America vibe in the semidocumentary *Pumping Iron* and the offbeat comedy *Stay Hungry* (in which his affable bodybuilder performs a bluegrass song on violin). More than any other film, even 1984's *The Terminator*, Stone's version of Robert E. Howard's barbarian deserves credit for inventing Schwarzenegger as we now know him. Milius's raunchy, bloody, often mystically minded film proved that the Austrian Oak, as he'd become known, was not just a square-jawed goon who could credibly punch out a camel, but a leading man with sex appeal, deadpan wit, and enough charm that audiences didn't mind that they could barely understand him.

Stone wrote the *Conan* screenplay after a series of developmental meetings with Schwarzenegger, hoping to direct the film himself. He tailored the character to fit his sense of Schwarzenegger's potential. It's a personal script,

and not merely because Stone adored Howard's stories and the comics they inspired. *Conan* is an epic about an orphan who grows up a slave; remakes himself as a magnificent fighter and lover; and spouts monologues about fate, justice, the indifference of the god Crom, and the stoicism required to live an adventurer's life. "For us, there is no spring," Conan tells the thief Subotai (Gerry Lopez), "just the wind that smells fresh before the storm." The more you know about Stone's own biography—his emotional estrangement from his parents, his self-reinvention in the brothels and killing fields of Southeast Asia, his fondness for stories about both real and fictional adventurers, including Alexander the Great and Joseph Conrad's *Lord Jim*—the more *Conan* seems like an exuberant and perverse autobiography. "Wealth can be wonderful," says the Wizard (Mako), as if prophesying the Hollywood success story that Stone was only starting to live out when he wrote his first draft of *Conan* in the seventies, "but you know, success can test one's mettle as surely as the strongest adversary."[2] The film ends with a flash-forward to the onetime barbarian astride a throne. "Honor and fear were heaped upon his name," a title card informs us, "and, in time, he became a king by his own hand. . . . And this story shall also be told."

The most fascinating Stone effort from this period, though, is his second feature as director, *The Hand*, based on a 1979 novel by Marc Brandel and released in April 1981. It says a lot about where Stone was at that point, and where his life and art were going. Michael Caine stars as Jon Lansdale, a cartoonist who loses a hand and is plagued by visions and nightmares in which the severed member terrorizes and murders key people in his life. The hand's victims and would-be victims represent aspects of Jon's responsibilities, anxieties, fantasies, and resentments; the hand itself is a manifestation of Jon's ugly impulses, a bottled genie unleashed by catastrophe. The movie is a classically styled return-of-the-repressed narrative—a cautionary nightmare about what happens when we refuse to acknowledge the id. Stone works in a tradition that stretches from Edgar Allan Poe's "The Tell-Tale Heart" up through the Technicolor shock fests of Hammer and the exploitation nightmares of Roger Corman. The car accident that claims Jon's drawing hand is ghastly, and its intimations of battlefield maiming are not incidental. The hero's growing estrangement from his friends and family is elegantly articulated by Stone's script, which likens the maiming to a castration, and by

Caine's performance, which fuses the actor's most distinctive modes, sheepish affability and icy menace.

Seen in the context of Stone's life and career, though, *The Hand* is most fascinating as a reworking of themes that debuted in 1974's *Seizure*. Both are coded parables of an artist who denies aspects of his nature and is terrified that the dark thoughts in his head might translate into violence against those he values most. In that sense, *The Hand* is as much a stealth autobiography as *Conan*, *Year of the Dragon* (whose hero is a war veteran trying, like Stone in Hollywood, to reinvent himself, avenge grievances, and rattle a venal community), and *Scarface* (about a nervy, brutal newcomer to an entrenched community who flouts his status as "bad guy" to get one over on the fancy-pants hypocrites). Stone's eighties projects are all portraits that faintly resemble the painter. They also play like steps in the ascension to a pop-culture mountaintop, where a gap-toothed oracle would brandish Oscars won for making films about young men and battle.

"My child, you have come to me, my son," Thulsa Doom tells Conan. "For who now is your father, if it is not me? I am the wellspring from which you flow." That's the war talking.

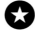

1 Conan creator Robert E. Howard's story "The Cat and the Skull" describes Thulsa Doom as a monster with a face "like a bare white skull, in whose eye sockets flamed livid fire." Jones's presence in the role, after having provided the voice of *Star Wars* villain Darth Vader, made some critics read the film as a racial, even racist, allegory. In his *Chicago Sun-Times* review, Roger Ebert wrote, "[W]hen Conan and Doom meet at the top of the Mountain of Power, it was, for me, a rather unsettling image to see this Nordic superman confronting a black, and when Doom's head was sliced off and contemptuously thrown down the flight of stairs by the muscular blond Conan, I found myself thinking that Leni Riefenstahl could have directed the scene, and that Goebbels might have applauded it." Stone points out that he didn't specify Doom as being of any race. "I didn't cast Jones in that part, Milius did."

2 Stone: "I don't know about this 'look for the life in the films' thing. I feel like you're stretching a bit here."

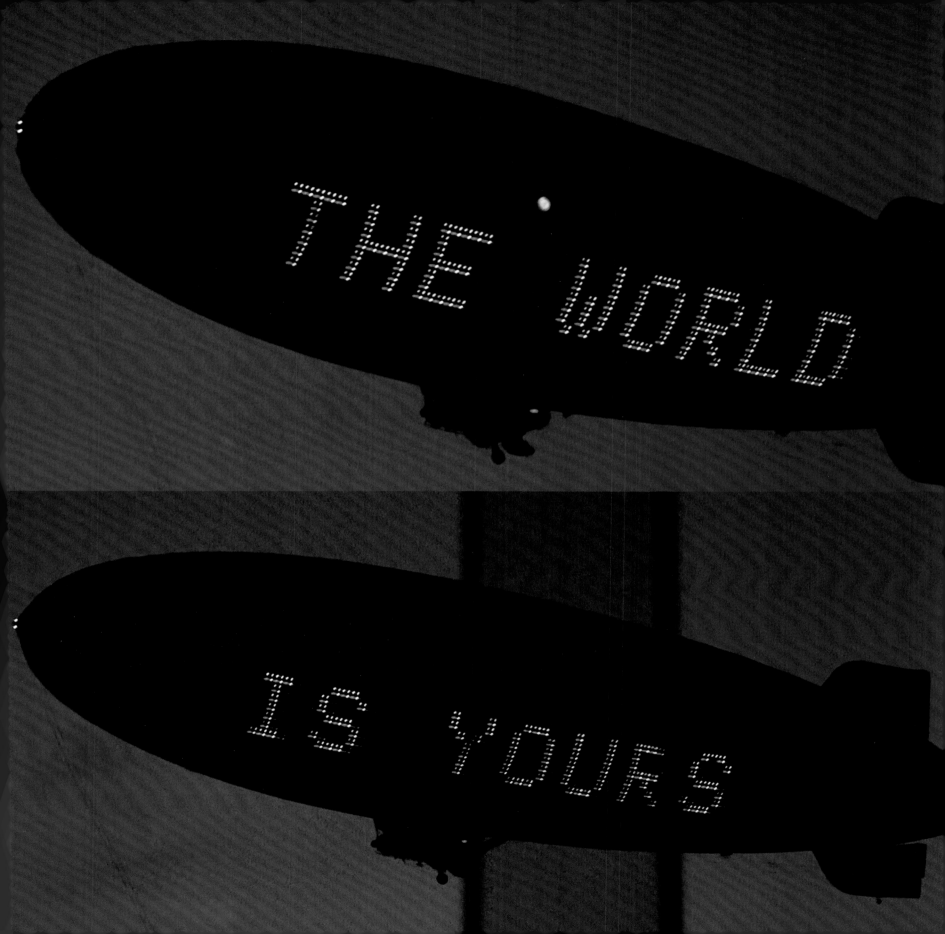

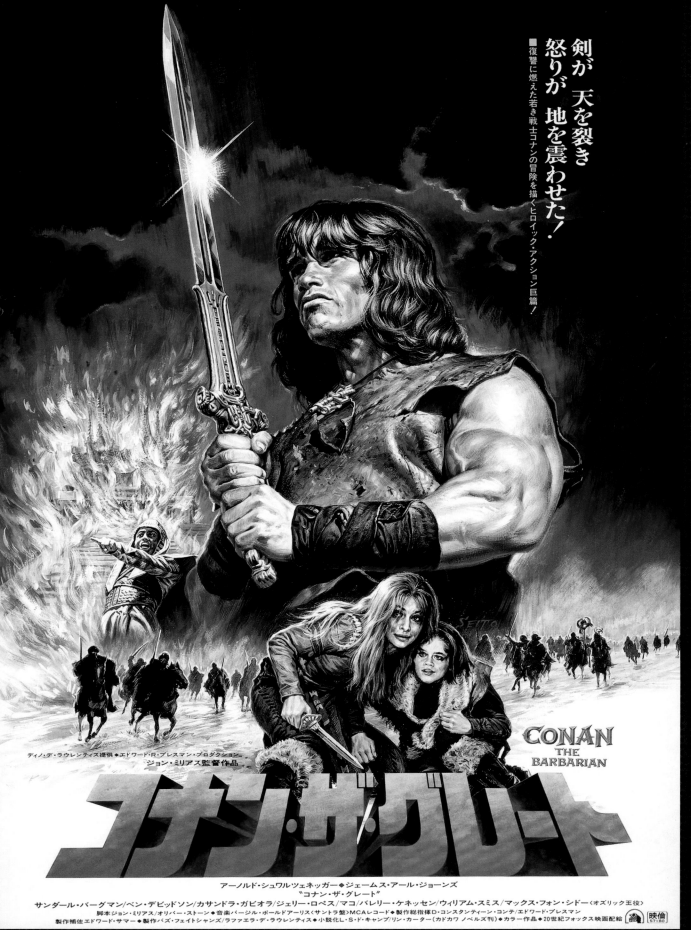

MATT ZOLLER SEITZ After you won a Golden Globe and an Oscar for adapting *Midnight Express*, the floodgates opened up for you. You're not on the outside anymore, you're on the inside, and you start getting big assignments.

This had to have been a shock to your system. You went through a period of many years where you were unbelievably prolific, but you were also struggling, doing all sorts of jobs, driving a cab and all that. Can you chart that evolution for me?

OLIVER STONE From about 1970 on until we split up, I was mostly living with Najwa. She provided stability and she had a day job. I was writing from film school onward, one or two scripts a year and a treatment or two, and I was showing them around and getting a lot of rejections. I wrote a Greek mythology story set in the modern world; I

I definitely felt like an
underdog.

wrote "The Life and Times of Deacon Davis," based on the story of the black prisoner George Jackson.[1] I wrote a western with Charles Bronson[2] in mind, but it never made it to him: "The Ungodly." **[END 1]**.

As you know, the first screenplay I ever wrote was "Break," in 1969. It's insane, it wouldn't be commercial, but it was the earliest version of *Platoon*—totally surreal. I wrote three drafts of it. Each one is different, and progressively more realistic. The most interesting one is the first one, because it's the most unrealistic. It has madness, anger with the father and mother, loss, sex, women. It's very strange. I wish in some ways I could've made it, but it was an expensive movie. I wasn't qualified **[END 2]**. I also wrote the sequel to "Break," "Once Too Much," **[END 3]** which was an interesting, very violent story about my return to the US in 1969.

You wrote so many different versions of this story over the years—the experience of Vietnam, and what it did to you—but all through the seventies and into the eighties, it's this very long period where you're not directing any version of that movie; you're writing and directing

low-budget horror movies, you're writing other people's movies.

But you're also writing your own stuff, original stuff, and it's in your files: some of it finished, some just fragments of things, or ideas.

Like what?

Among other things, I came across a treatment for "Bitter Fruit,"[3] a movie about the United Fruit Company's activities in Latin America in the fifties, which, if it had gotten made, would've felt kind of like a prequel to *Salvador*.

Really? With my name on it?

Yes.

How long?

A few pages. This was a proposal for a muckraking drama, the kind of thing you'd be known for later.

Oh, I had that in me. In the early seventies I definitely started to get more liberal, but I wasn't really understanding it, I was just protesting. I'd been to Vietnam and I'd seen the system as it worked—Amerika, with a "k"—and I believed in Jim Morrison, I'd seen the system in the prisons. No, I wasn't understanding the big picture, but I was certainly angry, I definitely felt like an underdog.

Brando in *The Wild One*: "What are you rebelling against?" "Whaddya got?"

Right, yeah! But you know, I guess when you come out of film school, you are an underdog no matter what, because most of those people don't go out of film school with jobs! Nobody

1 Member of the Black Panther Party and cofounder of the Black Guerrilla Family. While incarcerated at Soledad prison he was charged, along with two others, with the murder of a white guard, John V. Mills. Jackson was shot to death by San Quentin State Prison guards during an alleged escape attempt.

2 1921–2003; granite-faced leading man, with a 19th-century opacity. *The Magnificent Seven* (1960), *Once Upon a Time in the West* (1968), *Hard Times* (1975), *The Indian Runner* (1991).

3 See chapter 4, p. 136–37.

out of my group from NYU was making it except for Jonathan Kaplan,[4] and Scorsese, and a couple of other guys who got little writing jobs, on Roger Corman–type things.

But yeah, it was that underdog thing, the Billy Hayes–*Midnight Express* thing, rooting for the underdog. Conan's the underdog.

Let's talk about Conan the underdog. You wouldn't necessarily think the *Midnight Express* guy would be a natural fit for a fantasy adventure based on old pulp novels and comics. But looking back on it, we can see a lot of recurring Stone themes in there—including the young man, boy really, whose history is effectively erased, and the story of a warrior making his way in the world after enduring great trauma, and getting the crap kicked out of him along the way. Conan almost dies by crucifixion on the Tree of Woe and is healed by spirits, which ties the movie into your more spiritually inclined stories: the Buddhism in *Heaven & Earth*, the Catholicism in *Born* and *World Trade Center*, the Native American mysticism in *The Doors* and *NBK*.

How did you get yourself into *Conan the Barbarian*, and how did it turn into the movie we now know?

I'd read and loved all the *Conan* books, and I loved the comics, and I really had a vision of this thing as a . . . I guess it was before all this series or franchise stuff became popular, but I'd seen the first *Star Wars*, so I could see a series of twelve movies! James Bond came to mind. It could have lasted, because it's a great story! If you follow him, he starts out a nobody, he becomes a king in the end, but then he walks away from the kingdom and finds more adventures. In other words, he rises to the top but he walks away, like Siddhartha, and then he becomes something else, becomes Old Conan.

So the idea was really a twelve-film series, I guess like what they did later with *Star Wars* or *The Lord of the Rings*.

Did you start it of your own volition, or were you hired to write it for someone else?

Well, Ed Pressman,[5] the producer, who worked on other movies with me, hired me to write it: I was the star writer, Ed was the enabler, and Paramount paid me to write it, so I gave them everything I had to make this a big movie to start a series.

But I really wrote that script for myself. I thought I was going to direct it at one point, with Ed backing it, but we couldn't get there.

I'd seen the first *Star Wars*, so I could see a series of twelve movies!

We offered it to Ridley Scott, but Ridley passed because he was going to do *Alien*. Then Dino De Laurentiis came to us, bought it from Ed and fucked us. He hired John Milius, who never really bothered to collaborate. The look of the movie wasn't what I saw. Conan's world needed to be green: the forests, the jungle. Milius's movie is brown and yellow, like a western. It was shot cheaply in Spain. There are so many choices that I just think were wrong.

And yet, in the final version I read, the one that's credited to you and Milius, there's a lot of material, including some of the most widely quoted lines, that are basically what you wrote in that early draft.

Probably. There's probably a lot of [the *Conan* author, Robert E.] Howard, in there, too. I put a lot of heart into it.

But as you could probably tell, though my version wouldn't be as hard to do now, with digital effects, I guess they saw it at the time as a 100-million-dollar movie.

I wondered about that. In your version, the scope is gigantic: bigger than *Star Wars*, bigger than anything that had been done in the sword-and-sorcery genre up to that point. To realize it visually, it probably would've had to be one of those break-the-bank movies, like *Cleopatra*.[6] You have this section where he's fighting this creature, which I guess is the equivalent of the scene in Milius's movie where he's battling the big snake. But the creature that Conan's fighting in your version is this shape-shifting thing that has this Lovecraftian, Cthulu-like quality, where it's a demon.

There were mutant armies in there, too!

As I read it, I was thinking, *How would they do all this in 1979 or 1980?* The special effects, I mean.

Well, there was good work being done in special effects then, remember. But it was a different kind of effects. You built things. It was practical, it was chemical. Rick Baker[7] was doing some good stuff then, and I had dealt with some stuff along those lines after that, when I made *The Hand* with Carlo Rambaldi.[8] I was interested in special effects.

I didn't know exactly how they'd do it! I always thought, "Write it big, write the idealization, and then come back and scale it back if you have to." That was the idea.

What would your *Conan* have been like if you'd directed it?

It would've been as close to what you read in that early draft as I could've made it at the time, but I didn't have the skill yet to pull it off.

I spent time with Arnold, though. I had him read to me from the comic.

I wish there were recordings of that!

I had to change the script because it started to be written without him, but then he came on board pretty early in the process. At the time

4 American filmmaker best known for directing Jodie Foster in her Academy Award–winning performance in *The Accused* (1988); other credits include *Truck Turner* (1974), *Brokedown Palace* (1999), an Asian drug incarceration drama similar to *Midnight Express*; and *Love Field* (1992), a Dallas drama set in the days before Kennedy's assassination.

5 Full name Edward R. Pressman, born 1943; producer on eighty-eight feature films, including Stone's *Wall Street* (1987) and *Talk Radio* (1988), *Badlands* (1973), *True Stories* (1986), *Bad Lieutenant* (1992), *The Crow* (1994), and *Undertow* (2004).

6 A 1963 epic starring Elizabeth Taylor as the queen of Egypt and Richard Burton as Mark Antony; adjusted for inflation, it is still one of the most expensive films ever made.

7 1950– ; pioneering makeup effects artist whose work melded latex, mechanical effects, and suit work in bold new ways; played the title character of the 1978 *King Kong* (produced by sometime Stone collaborator Dino De Laurentiis) in blue-screen scenes; won the first ever Academy Award for Best Makeup given in regular competition, for 1981's *An American Werewolf in London*.

8 1925–2012; Italian-born special effects artist; won a Special Oscar for makeup effects on the 1976 *King Kong*, doing full-sized Kong models to complement a suit worn by Rick Baker (see footnote above); helped devise the title characters of 1979's *Alien* and 1982's *E.T.*

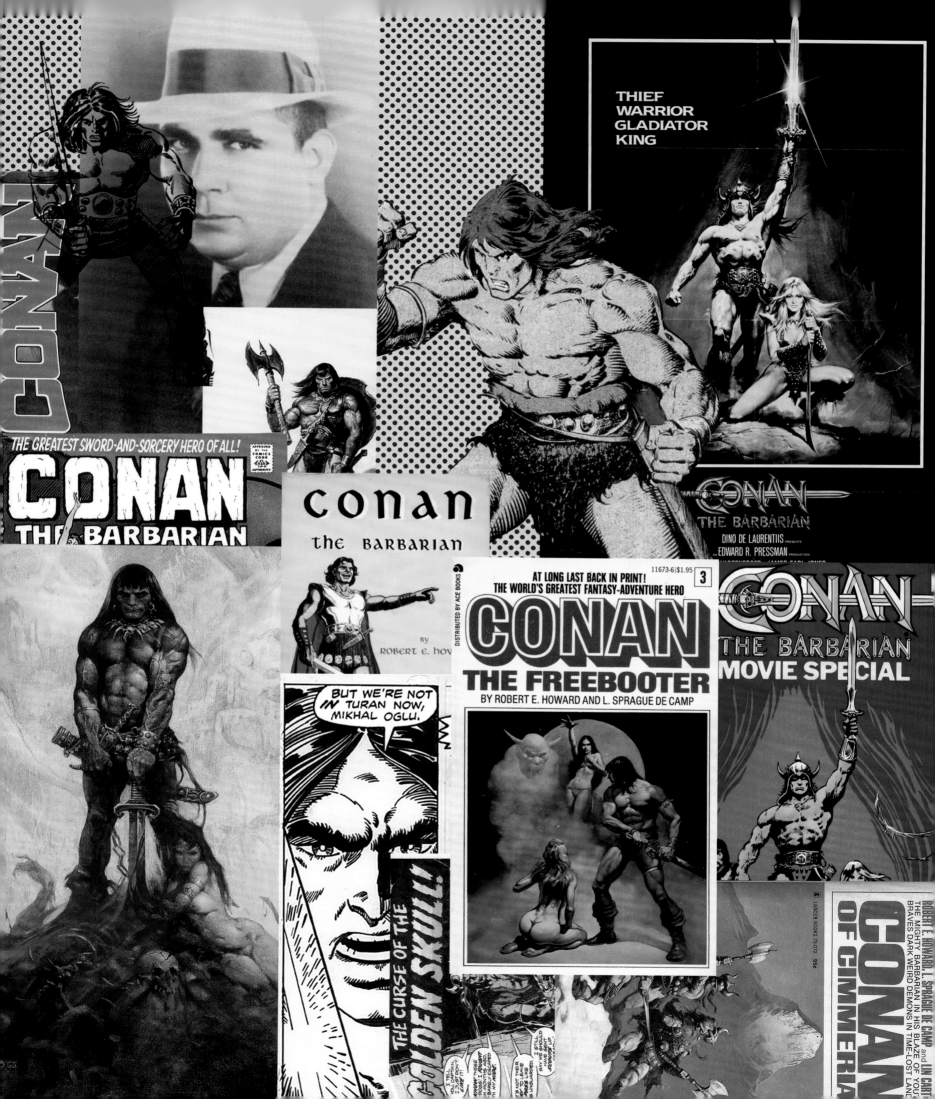

(pages 102–04) From the opening of Oliver Stone's first draft of *Conan the Barbarian*, dated 1979.

NORTHERN VIKING - Big Burly +
BEARDED

THE RIDERS - closer to camera now, bunched in depthless long shot, and we see prominent in foreground - SEVERAL BLACK HOODED FIGURES ON BLACK HORSES, their countenances buried deeply inside their hoods, and ABOVE THEM WE SEE:

FURRY VULTURE BATS flying low and all out, trying to keep up with the stallions in a thunder of cobbed wings and hooked talons, their eyes blood-shot red.

CONAN now coming into his VILLAGE, down the main street ...smoking fires, logs, children playing, dogs, women toiling...a smaller BOY AND GIRL running up out of breath, in whispers.

 CHILDREN
 It's ready...hurry...hurry up, c'mon...!

They tug, he follows.

A DOG raises its gnarled old head at the entry to a BLACKSMITH SHED as

CONAN, accompanied by the TWO CHILDREN, enters, glimpsing

HIS MOTHER, a young, sensual image combing out her long flaxen hair in the waning heat of the sun. Now seeing him and throwing it back with a smile of acknowledgement.

 CHILDREN
 He's here! He's back, Father!

 VOICE
 (bellowing)
 Conan - come ere lad!

 CHILDREN
 Go!

CONAN into the smoky INTERIOR OF A SHED...the clang of hammer on anvil, the blowing of bellows - fumes, heat, flame - and his FATHER in bearskin, his fierce eyes set in a hulking frame, his muscles bulging with blackened sweat, hammering a sword....

 FATHER
 (gesturing impatient)
 Come.

CONAN approaching closer, awed now, laying to rest his hoop of toads and crayfish...PAST THE APPRENTICES at the slag heap, HORSES pent in the shed, and a GROUP OF MEN from the village gossiping, now stop, look at Conan...eyes focusing on

THE SWORD - glowing red.

THE FATHER turning his glance onto CONAN, whose eyes flick
back to the sword appreciatively.

 CONAN
 Mine?

 FATHER
 Aye!

 CONAN
 It's beautiful, Father.

 FATHER
 (snorts)
 Beautiful?...it's strong! That's
 what counts, boy! With it, you can
 kill...you can kill till the moment
 you get killed!

Abruptly pulling the sword from the forge and crossing the
shed; CONAN follows at his heels, dwarfed by his size.

 FATHER
 It won't take you long to find out
 you can't trust anybody in this world,
 Conan - man, woman, or beast. But
 this - you can trust!

PLUNGES the SWORD into a basin of cold water. A sharp HISS.

THE CHORUS of MEN looking on - nod and cluck their approval
as:

THE MOTHER now appears at the entrance of the shed with a
BABY tucked on her breast.

FATHER, noticing - gestures with his head.

 FATHER
 Marthe - come, your boy's being
 baptized today.

CONAN - sensing a strain there

 FATHER
 (back to Conan)
 - and don't count on any gods and
 priests to come and save your ass when
 it's up against the wall. Crom hates
 weaklings. You call his attention to
 you and he'll smash you like a walnut...
 (MORE)

FATHER (CONT.)
He's a savage lousy god but when you
were born, he breathed strength into
you - to eat, to make babies, and to
kill your enemies. Don't expect anything
else and you'll be a man! Let priests
and philosophers brood about Crom.
Don't deny him but...
 (a hint of humor in his
 crafty eyes)
don't trust him too much either...here -
 (extending his arm
 conclusively)
- your sword!

A moment...HIS MOTHER looking on in close background...
CONAN now takes it.

THE CHORUS of MEN send up a roar of approval as:

THE RIDERS thunder to a halt on a grassy knoll in a MEADOW
- CLOSING QUICKLY now on

A ONE-EYED MERCENARY rearing on his horse into a FULL
CLOSEUP - a rich embroidery of the finest white silk
covering the gashed half of his face, down the middle of
which a jagged scar snakes like lightning in a massive
bisection of his persona....Death is in the spring air -
as he YELLS a mighty war cry, his war axe flashing above
his head.

 ONE-EYED MERCENARY
YALALALALALALALU!!!!!!!!!!!!!!

THE SHRIEK is raised by ALL THE HORSEMEN AND:

LOW ANGLE - THE RIDERS THUNDER FORWARD

THE VULTURE BATS shrieking overhead

THE MOTHER - hears the cry. A calmness about her. Flashing
her eyes on her HUSBAND.

 MOTHER
They're back!

THE FATHER - silent, knowing - now reaching for a sword
quickly.

THE MEN likewise grabbing up their swords and bills (long
shafted weapons, half pike, half axe). Voices now:
"Hyperboreans!"

(pages 105–107) Excerpts from a battle described in Stone's original script for *Conan*; essentially revised out of existence, it has no equivalent in the finished film, though some aspects evoke Conan's tryst with the succubus and the confrontation pitting Conan against the serpent incarnation of Thulsa Doom (see lobby card, page 99).

AS HE moves back from across the rim, checking down the
sides - his face now coming into full view, lit with
greed.

> TAURUS
> Hurry up - bring up the rope and
> check the rim again. I'll wait for
> you inside.

CONAN casting a quick glance at him, a hint of suspicion
- but turns, drawing up the cord as

TAURUS moves back across the rim - to a DOOR - glances
surreptitiously back at Conan -

TRACKING TAURUS into a small rounded CHAMBER - dark, marble
statues of faces, serpents - nothing seems to be in it...
stepping forward....SUDDENLY he is GRABBED - GASPING.....
a grotesque SHADOW glimpsed on the wall....

CONAN circling the rim, seeing nothing - now moves towards
the door...

> CONAN
> (whispering)
> Taurus?

Nothing. He pushes the door in.

CONAN stepping inside, freezing as

SHADOWS - WALL - a 'creature' built like a man is throttling
TAURUS who is gasping and rattling desperately just as, with
a decisive grunt, the CREATURE RIPS TAURUS' HEAD right from
its shoulders and holds it severed in the air, tongue dang-
ling out - TURNING NOW AS

CONAN watches in horror from the doorway...

THE CREATURE scuttling around - and tossing the head aside
- he is about six foot nine inches, gaunt, sloped shoul-
ders, a face with boils and scabs all over it and thin long
hairs growing out wildly from the sides of his head, but
bald on top, and arms that seem to stretch abnormally long
to the knees and huge bony strangler's hands clenched in
tension at his kneecaps; leaning forward, a relentless sloped
look in the eyes - but there are NO EYES - only some mucus,
a jellylike greyish substance that fills his sockets...and
behind him is draped the mangled headless corpse of TAURUS
- arms still locked in the air in desperate, hopeless pro-
test...and THE CREATURE wheels forward, naked except for
loincloth and surprisingly fast for his gangling height -

AGAINST CONAN - who draws back, pulling his sword...

THE CREATURE circles, bearing its fangs with relish
- crouches low like a football tackler......charges
in....

CONAN sidestepping and swiping

THE CREATURE circling back, avoiding the swipe - agile...

CONAN, in the same beat, charging forward, sword extended
with two hands like a Samurai....

RIGHT INTO the gut of the CREATURE

TRANSFIXING HIM - the blade coming out the back with a
shearing ugly sound....and NOW

STANDING OUT from his backbone a full foot's length!

THE CREATURE SWIRLING into a 180 degree spin, howling in
agony, spilling onto its knees in CLOSEUP - AS CONAN backs
off behind him....The Creature continuing to howl and
gnash and THEN!

FULL SHOT - TRACKING UP TO A HIGH ANGLE - AS THE CREATURE
rises - streaming blood, a grotesque sight.....turning to
FACE:

OVER SHOULDER - CONAN - shocked, weaponless...the Creature
stalking forward....

CONAN looking for some weapon in the chamber...nothing...

THE CREATURE, fast, now lunges through the air, its hooked
fingers reaching for his neck....

CLOSING AROUND THEM - CONAN crashing to the ground with

THE CREATURE throttling him just like he did Taurus....

CONAN reaches up and locks his own hands on the CREATURE'S
windpipe.

THE CREATURE - straining...

CONAN - veins standing out purply on his temples.

A SILENCE - BOTH of them locked together like statues,
thews and knots rising along their massive arms.

THE CREATURE - wind now whistles between its fanged
rotted teeth, the face going black...and now the statues-
que immobility of the twosome gives way to sudden fren-
zied motion...THEY ROLL...

CONAN now on top - pressing down with all his strength...
the CREATURE letting go of Conan's throat and grasping
his wrists, trying to tear the fingers away - wrenching
and heaving...foaming, eyeballs starting to contort.
Gasping!

CONAN - face damp and blood trickling down his neck where
the Creature's fingers have torn his skin, looks down
without mercy, a dark hypnotized glaze in his eyes...he
now eases off...pauses...gets up, drenched with sweat.

ANOTHER ANGLE - pulling out the word, turning...an INNER
DOOR beyond...He moves towards it, past the late Taurus
of Nemedia, "prince of thieves" - and out...the CAMERA,
with a will of its own, TRACKING BACK to an EXTREME CLOSEUP
of the upturned face of the CREATURE, quite dead, mouth
thrust open in a silent fish-scream (upside down to our
eyes)...and the MOUTH NOW CLACKS SHUT...and

THE CREATURE begins to stir.

 CUT TO:

OLD WOMEN with wrinkled breasts and 10-year-old GIRLS move
silently through medicinal vapors rising from KITCHEN POTS
across the stone floors of a DUPLEX DWELLING devised with
a white, greek simplicity of design giving out on a garden
and pool winding from exterior to interior and set with
flat clean statuary signifying deities such as Mitra and
Ishtar...

ANOTHER ANGLE - into a ROOM described by skeletons, books,
scientific instruments, mantra wall weavings, half-finished
portraits of the faces of the time, the wire model for a
flying machine - a room outside the time, unlike anything
other to be seen in the film - wherein the total renais-
sance man, VALTHEMOS, lies dying of a fever on a simple
cot, attended by a MOTHER FIGURE with huge breasts and
slavic bones with a white bandanna wrapped around her
tresses repeatedly applying compresses of medicinal herbs
and mustards...but he is evidently weak and withered with-
out much hope, about 80 years old with a beautiful bertrand
russell face, hawknose, poetic hair, the eyes of an
intelligent bird gone slighly mad in his last years...
YASMINA is seated close to him, intense and attentive -
RINALDO standing behind.

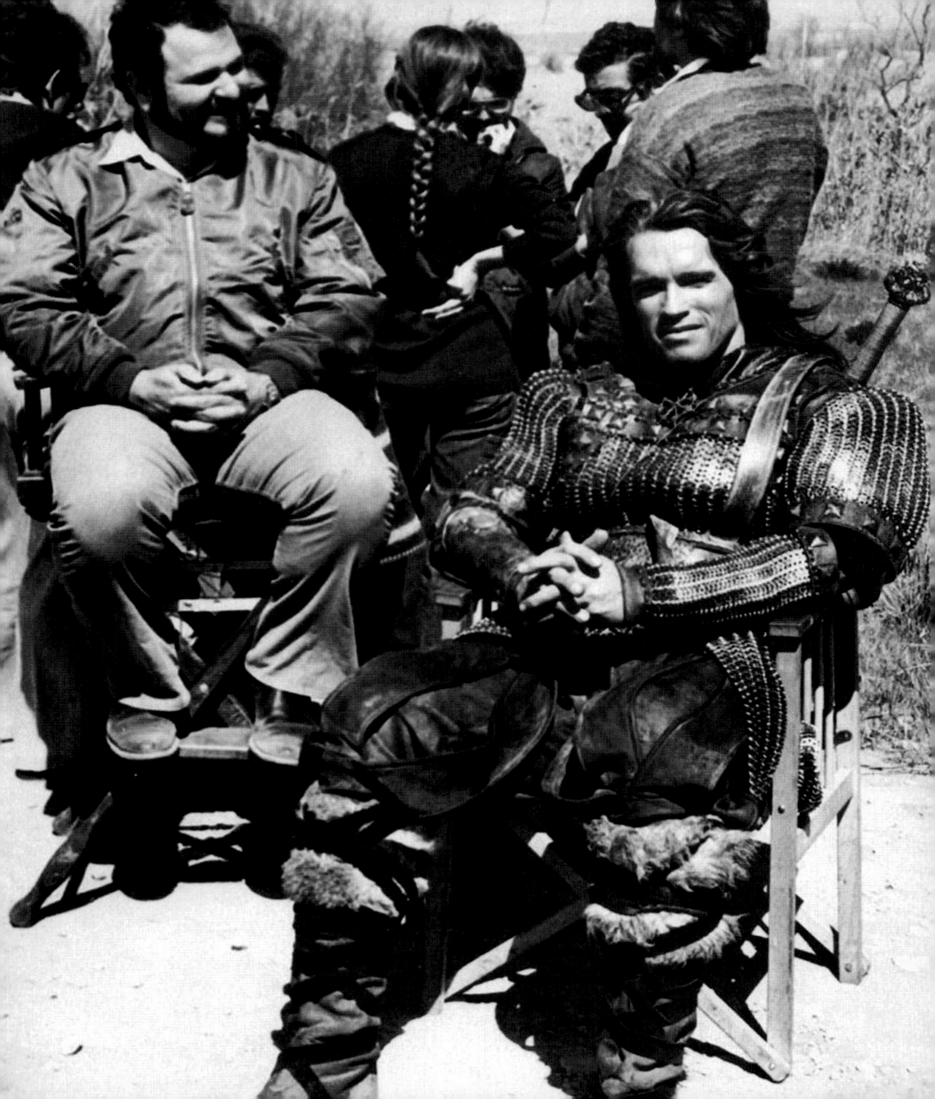

he'd only done one other major film, a pretty good one.

Stay Hungry?

Yeah, Bob Rafelson's film. And he was in the documentary *Pumping Iron*.

He also did *Hercules in New York* and some schlock, and he was one of the thugs working for Mark Rydell's gangster in *The Long Goodbye*. But yeah, at that time, he was not a known quantity.

No, he wasn't established, but I believed in Arnold, I really did. Ed Pressman was a big believer in him.

I could see him also as a Tarzan figure, more Edgar Rice Burroughs than Robert E. Howard, and that was the way he was drawn by Frank Frazetta. I always thought Frazetta's Conan art was a little overdone, though. There was another fellow I went to who was English, Barry Windsor-Smith. Beautiful, classical renderings. He did the original *Conan* comics. We got him to do the hero's drawings in *The Hand*.

And you did all this preparation and took a meeting at the studio?

Don Simpson,[9] Jeff Katzenberg,[10] Barry Diller,[11] Mike Eisner,[12] and Dawn Steel[13]— that's a killer's row! Five of them in a room with me. I was sweating fucking bullets. That was the worst meeting I ever had in the movie business.

And they didn't bite on the idea of you directing, but Dino De Laurentiis ended up producing the movie anyway, with Schwarzenegger as Conan. You had Sandahl Bergman as Valeria the warrior, James Earl Jones as the bad guy, Thulsa Doom. And John Milius[14] directing, and rewriting your script?

It ended up bastardized. He had big ideas, Dino: *I'm going to do the Bible!* But Dino was lacking in vision. He fucked up *Conan*, and he fucked up *Year of the Dragon*! John had big ideas and a sort of warped vision. Dino had no vision.

God, it breaks my heart that Dino ended the series. He was so stupid and so short-sighted! Making the first one with Milius was bad enough, but it got by and made a little bit of money; you know, it wasn't derided. It was silly, I thought, the way he made James Earl Jones look—it was terrible, I didn't buy it—

and there was a lot of hokey shit, especially the snake thing.

And the second movie [*Conan the Destroyer*] was so bad! That ended the series right there! Of course, the whole thing went into turnaround, and the other movies never got made. It was all lost due to Dino De Laurentiis. No question about it. It could've survived anything but him, and I'm sorry we lost it. I remember the night we lost it, in London.

Ultimately *Conan* is John's movie. John was impossible to work with. He called me in because he liked me. I'd been in Vietnam, and John liked to talk about it. As you know, he's fascinated by war, and Vietnam in particular—this is the guy who wrote the script for *Apocalypse Now*! And he enjoyed my worldview because it was different than his.

Politically, you mean? He's a big conservative.

Yeah. John would call me into his office— such a funny character! He still is. I love him in a way. He's such a wonderful, Macedonian character. *Oliver! Come in! I just wrote something; I want you to hear it!* And then he'd read me some section he was working on, read it to me like it was *Apocalypse Now*, like it was just the greatest thing ever! *Whaddya think? Isn't it great? We got it! By Crom, we got it!*

Then he got crazy with Arnold! If you want to get the whole film and understand the vacuity of it in a way—and I love John, I'm saying this with love—you have to listen to the commentary track that he and Arnold did on the fucking DVD. It is unbelievable! It's like, nothing is going on, and they're laughing: *Ha ha ha, ain't it great?*

So you had a disappointing experience seeing other people make *Conan*. But then that same year you wrote and directed your second feature, *The Hand*. And it's more you, even though people had no easy way to know that at the time.

You've got similar aspects to *Seizure* with this idea of the imagination becoming a projection of the artist's deepest, darkest impulses, and causing harm to his family. And it's also about this artist, Michael Caine's[15] character, who is, in a way, chafing at bourgeois constraints. He's

terribly unhappy as a cartoonist and a college professor. It feels almost like an unconscious wish when he gets his hand ripped off, and all kinds of bad shit starts to happen after he loses it.

In *The Hand*, I see you working through feelings of artistic frustration and powerlessness.

The Hand failed as a writing-directing effort, and it failed commercially, though in some ways it's still an interesting movie to me, because by that point I'd been back from

I was sweating fucking bullets. That was the worst meeting I ever had in the movie business.

Vietnam ten years, twelve years, and I'd done a lot of scripts about it.

The frustration of not getting *Platoon* or *Born* made is intense. You ask yourself, what's the point? This society is corrupt, hypocritical; they don't want to make those kinds of movies. They want to do films like that one where they all go back to Vietnam and win the

9 Macho, prodigiously sexual, drug-addicted American producer and filmmaking partner of Jerry Bruckheimer; responsible for hit melodramas and action films whose glitzy yet ponderous aesthetic epitomized Reagan-era Hollywood's cocaine culture: *Flashdance* (1983), *Beverly Hills Cop* (1984), *Top Gun* (1986), *The Rock* (1996).

10 Film producer and studio executive at Paramount and Walt Disney; cofounded DreamWorks SKG in 1994 with Steven Spielberg and David Geffen.

11 Film and TV executive at Paramount and Twentieth Century Fox; cocreator of Fox broadcast network; currently chairman and senior executive of IAC/InterActive Corp and Expedia, Inc.

12 Started out as an executive at ABC and Paramount in the seventies and eighties; CEO of Walt Disney Corporation from 1984 to 2005.

13 One of the only powerful female studio executives in the seventies and eighties, first at Paramount, then at Columbia; author of *They Can Kill You, But They Can't Eat You*.

14 Cowriter of *Apocalypse Now*; director of numerous films about male pride, loyalty, and honor, including *Big Wednesday* (1978), *Red Dawn* (1984), and *Farewell to the King* (1990); famously militaristic and enamored with weapons.

15 British actor appearing in such films as *Alfie* (1966), *The Cider House Rules* (1999), *Hannah and Her Sisters* (1986), *Dressed to Kill* (1980), the *Dark Knight* trilogy, et al; reputedly accepted the lead in *The Hand* to pay for a garage on his house.

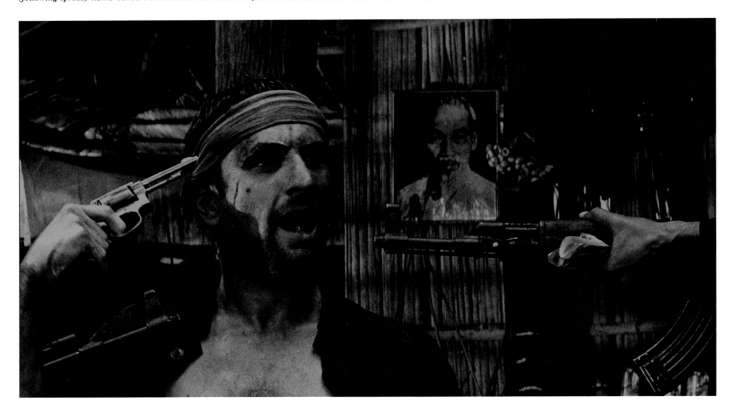

war, the first one like that—what was it, the name of it?

Uncommon Valor,[16] which was probably filming right around the time *The Hand* came out. It was released in 1983.

I was disgusted, especially after the experience of trying to get *Born* made with Al, which was even worse than *Platoon*, the way it fell apart. That was ready to go, rehearsed, everything! Daniel Petrie directing it, Pacino sat through the rehearsals, we made changes, and then two or three weeks away [from shooting], the German money fell out. It was so heartbreaking to me. That was '79, that was a huge defeat.

You still seem pained by the memory when you talk about it.

It *was* painful. Ron took it even worse than I did, and I was angry. It was horrible, because it could have been such a good movie.

And after, I couldn't see the future of it. I'm glad it came back around, but it was supposed to have been done then, in the seventies, and instead they were doing the one with Jane Fonda.

Coming Home.[17]

That one kind of hurt us, because it came out and got acclaim, but didn't make any money, and they had taken a lot of Ron's story, whatever they say. And then *Apocalypse* buried [the early version of *Born*]. And there was also, of course, *The Deer Hunter*. So those two movies, *Apocalypse Now* and *The Deer Hunter*, in a sense had wrapped up the Vietnam experience for American cinemagoers at that point in time.[18] And that was it. In other words, it seemed like from then on, it was going to be that kind of movie or *Rambo*, nothing in between.

Even the good ones had been, to some degree, lies.

How do you mean?

Well, *The Deer Hunter*[19]—that's wonderful to watch on film, but it's not accurate to the experience that I had in Vietnam, although I do think it was accurate to the alienation of coming home.

The De Niro character that can't communicate what he went through?

Yeah.

I like that you're getting into all this, Oliver, because I wanted to ask you about one of the more fascinating newspaper clippings I found in

the files. I think it ties the frustration you were feeling about the Vietnam films falling apart with your own personal experience of the war, and how you were carrying it around with you still.

Do you have it with you?

(Hands newspaper clipping to Stone.)

I'd forgotten about this.

16 Save-the-POWs drama directed by *First Blood*'s Ted Kotcheff.

17 Hal Ashby's '78 tale of a love triangle between a VA hospital volunteer (Jane Fonda), her US Marine husband (Bruce Dern), and a paralyzed Vietnam veteran (Jon Voight) whose personal arc echoes Ron Kovic's.

18 Directed by Francis Ford Coppola and cowritten with John Milius, this loose 1979 adaptation of the Joseph Conrad short novel *Heart of Darkness* follows Captain Benjamin L. Willard (Martin Sheen, father of *Platoon* star, Charlie Sheen) as he journeys into Cambodia to find and "terminate with extreme prejudice" the missing Colonel Walter E. Kurtz (Marlon Brando).

19 Michael Cimino's 1978 Academy Award–winning feature about the effect of Vietnam service on three soldiers from the same small town (Robert De Niro, Christopher Walken, and John Savage).

It's a *New York Times* profile about you, from around the time *The Hand* came out. It talks a lot about your Vietnam service. You'd said elsewhere that one of the reasons you made *The Hand* is because it was a genre film, and you felt that maybe it could be a commercial success and lead to other things, but then you've got this extraordinary quote at the end of the *Times* piece, where you talk about how what you really want to do is go on and make *Born*:

It's been turned down twice by every studio in town. But I'd still like to do it. I don't think the Vietnam story's been told. Vietnam messed a lot of guys up cause it put us out of step with our own generation. I still feel like a freak. When I came back to N.Y.U., which was a hotbed of radicalism at the time, the other students looked upon me as an assassin. It was never discussed, nobody would talk about it, but I think all the vets felt that silence.

About 1976, the whole thing started to surface, books were being written; but there's still so much that hasn't come out. A third of the prison population are Vietnam vets. . . . The suicide rate is enormously high. I've been lucky. I can write. But what about the boys who couldn't express it? Couldn't get it out?

Sometimes I feel like the bad luck will catch up. You look over your shoulder. That's what *The Hand* is about. That unconscious state, that time you do something you're not even aware of. Who knows whether one day you'll pick up a gun and blast your own brains out, without expecting to do it?

For me that connects not only with this idea of the suicide wish in your novel *A Child's Night Dream*, but also with these feelings of alienation that you experienced after Vietnam.

You got into that in kind of a sidelong way, in *Seizure*. The story of *Seizure* also seems like it's about this creative person, Oliver Stone, dealing with the demons of Vietnam, and hoping that they don't bubble up and hurt him or someone else.

I think that's true. *(Reads through newspaper story.)*

I'm surprised—I didn't remember this quote at all: "Sometimes I feel like the bad luck will catch up. You look over your shoulder."

It's about the country; the country had run out of karma. The country had done this to itself. You can't go off and trash another country and kill three million Vietnamese and expect no karma on this, any more than you can with Iraq. Blowback, they call it.

I think you get at that in *The Hand*, in a way.

How?

Instead of a novelist who projects these things out of his imagination, which come back and attack his family like in *Seizure*, it's more focused and direct, because all those bad feelings are concentrated in this one spot, his hand, the thing that translates his thoughts into art. It's a very disturbing film because it's about a man succumbing to rage, despair, and depression and taking it out on the people he loves. And you've also got your blowback idea, too, with a guy who loses his hand and thinks the hand is coming back anyway, to do evil; it's a manifestation of his id, of his rage. Maybe the accident is Vietnam, in some way?

I don't know. Maybe! But you liked it?

Yes, very much. There's not an ounce of fat on it. And it's got that Freudian sense of the uncanny.

Barry Windsor-Smith's drawings are incredible. We had such a good cast. Rosemary Murphy.[20] Andrea Marcovicci! Do you remember her? Very good, in a tricky part. And Michael is so strong in it. It's one of his better

20 Stage and screen actress; *Eleanor and Franklin* (1976), *All My Children* (1977), *Another World* (1988).

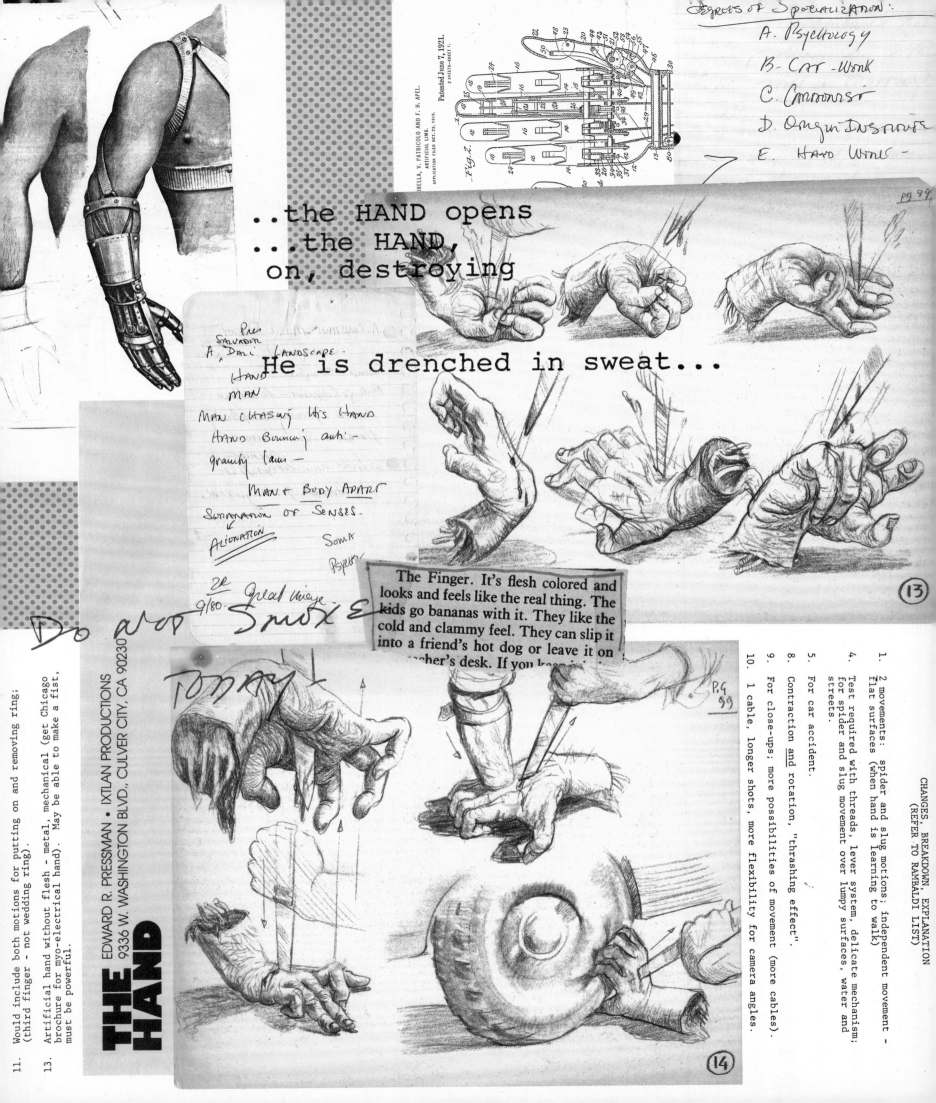

..the HAND opens
...the HAND,
 on, destroying

He is drenched in sweat...

The Finger. It's flesh colored and looks and feels like the real thing. The kids go bananas with it. They like the cold and clammy feel. They can slip it into a friend's hot dog or leave it on teacher's desk. If you keep...

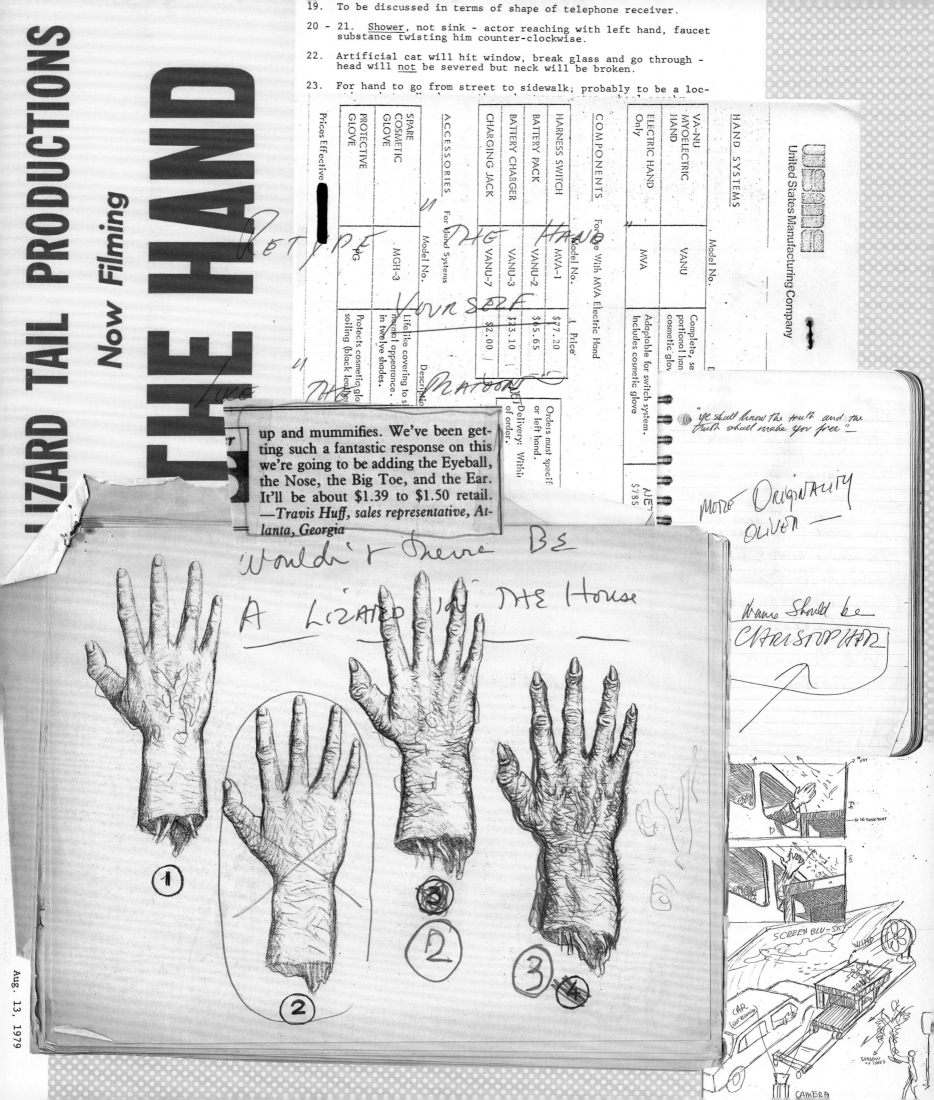

I don't think my writing benefited from cocaine, but I did write *Scarface* completely sober. The research was done stoned, but it allowed me an insight into cocaine!

performances, I think. We shot it back in . . . where was it? Big Bear,[21] that was it. Big Bear. But it felt like . . . My God, why would you go back and tell a story like that again? It's true: *Seizure* is the nut of that idea, what you see in *The Hand*. It's the story you can't get out of, the creation you make. It has the same ending as *Seizure*: The hand comes back.

I got pressure from Orion. They wanted to make a horror film. Jon Peters did, too.

You don't think it's a horror film?

Oh, it is, but the big pressure was to make it *more* of a horror film, and they kept asking me to do more hand shots. That wasn't the movie! The book that it's based on is subtle: *The Lizard's Tail*, by Marc Brandel.

And whatever you think of it, the movie was not a success. It really didn't do anything for me at all.

And then after *The Hand*, Marty Bregman came back into my life and said, *Do you want to do* Scarface*?* I said, *No, I don't like the movie.*

Meaning the original *Scarface*, directed by Howard Hawks.

Yeah. This was '82. I didn't want to do an Italian Mafia movie. We'd had dozens of

these things. But then Bregman came back to me and said, *Sidney [Lumet] has a great idea—he wants to do it as a Marielito picture in Miami*. I said, *That's interesting!* Sidney's idea was a good one.

We pursued it, and I was doing cocaine a lot at the time, along with a lot of Hollywood. I started to hit the trail in '79, and continued till '82. I don't think my writing benefited from cocaine, but I did write *Scarface* completely sober. The research was done stoned, but it allowed me an insight into cocaine!

To an extent, all gangster films are political, because they're often about class warfare, or immigrants who're expected to assimilate. But not all gangster films are political in the way that your version of *Scarface* is. Yours is rooted in history so recent it's practically journalism. De Palma starts with a montage of actual news footage of Cubans arriving after the boatlift, and your screenwriting credit is sandwiched between those images.

I was reading a lot of politics. I remember the [former] Chilean diplomat who'd been blown up with his assistant, five blocks from the White House.[22] That's the basis of the last murder Tony's asked to do, because the guy's a reformer. That had those aspects of it.

Of course, he was an immigrant, he was the guy who was living the American dream, taking everything he could get, fuck everybody, but you have to be loyal to those loyal to you. He fucks it up, because of the coke and the sister, and he ends up killing his best friend.

There's a class anxiety or resentment emanating from Tony. There's also a resistance on the part of the assimilated ethnics and the WASPs toward people like Tony. The scene at the restaurant where Tony rants to the rich white people for designating him as the bad guy, he says, "You're not good. You just know how to hide, how to lie. Me, I don't have that problem. Me, I always tell the truth. Even when I lie."

21 Big Bear Lake, San Bernardino National Forest, California.

22 Stone is referring to Orlando Letelier, a former Chilean official and leading opponent of the Augusto Pinochet regime in Chile who was killed by a car bomb in Washington, DC, on September 21, 1976. The culprits worked for the Chilean secret police (the DINA). It was one of many incidents during the seventies and eighties in the multinational South American campaign of repression known as Operation Condor.

I had that, too.

What, Tony's resentment?

Yeah.

I feel that coming through. In terms of life experience, you had nothing in common with Tony Montana, yet you identify with him very strongly.
 So I guess by that point in your life, intellectually at least, you actually had become a traitor to your class?

I did have resentment, anger, about Ronald Reagan that was growing. I didn't know about

the death squads until *Salvador*, but this *Scarface* period was about '82, '83, when I was researching in that area. I wasn't knowledgeable. But I felt the US interests in that area were conservative, and against reform. I wasn't saying that back then. Myself, I was on the fence. And you see some of that in the way that I wrote it.

Scarface came out at an odd time for American movies, because even though it was released in 1983, in its heart it's a seventies movie.

Tony Montana was an animal. That's what was beautiful about him. The picture is about appetite, and I had that appetite, that madness.

The movie was a nightmare to make, went three months over, and I was on that set all the way to the end. They kept me there. It was like, *Who do you have to fuck to get off this ship?* It was so slow the way they made it, because Brian's not an energy guy, and Al's a retake guy. It cost too much, went over, and was a black sheep from the get-go with Universal.

I had a big fight with Bregman over the editing. They showed me an early cut, I made some notes, and Al asked me my feelings, which I told him, which led to a huge fight between me and Marty. He thought I had betrayed him to Al.

August 11, 1983

Dear Marty:

I'm very sorry we've not been able to talk in person about both "Scarface" and "Defiance" before I left. I am putting these thoughts on paper. I hope you will read them more than once.

I know some of these will disturb you. But the film is more important than any single one of us and right now I am convinced there are some major problems, especially in the middle. As a result it just doesn't work -- not on the level you or I intended. In parts it's downright embarrassing. Unless we fix it now -- while we still can -- we will be hiding from disaster, not taking it by the horns now. I think still the picture could be good, not great -- but good. Right now it's not even that.

I've given my initial impressions to Brian but in the intervening 36 hours I've been unable to sleep and have jotted down various other notes I didn't cover with him so I am sending him a copy of these notes. I am dealing I think only with things that can be fixed, not with things that cannot be changed because they were directed that way. Nor am I going into the many fine things there are in the movie.

Please, look at it again. With humble eyes and a fresh objectivity. Whether or not you choose to do something about my suggestions and whatever you may think of my ability as a film-maker, I pray you will act before it is too late for all of us.

Sincerely yours,

Oliver Stone

(following page) Clippings from Ixtlan's files on the production of *Scarface*.

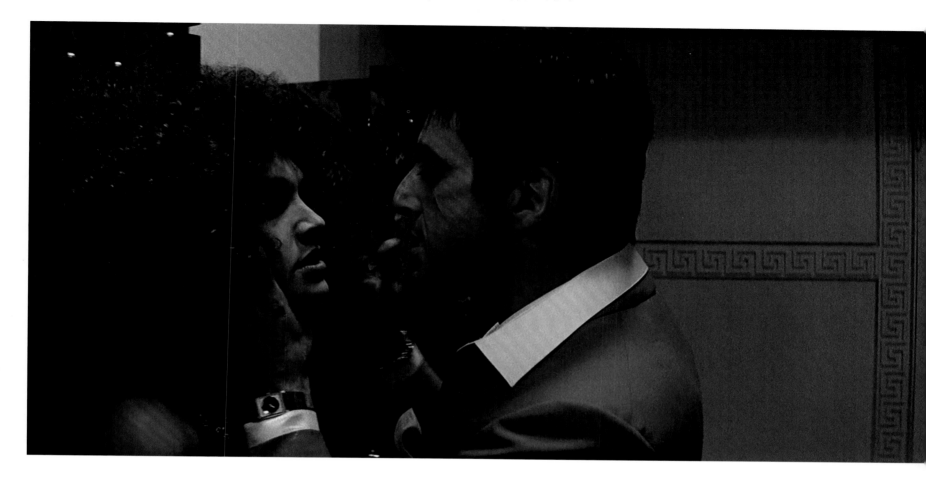

What was the nature of the disagreement?

Let's put it this way: I never talked to Bregman again. I had unfortunately made a deal with him when I was writing a Russian movie.[23] The point was, the Russian script *Defiance* died. It couldn't get out of traction. Bregman had control of my script, an original screenplay. I never talked to him again, until about two years ago. He was hard to deal with for me, and I really didn't want to make *Born* with him. When I got it made, he wasn't involved.

Scarface opened, and the reviews were not very good, except the *New York Times*.[24] The version that opened in theaters was, in my opinion, substantially better than the earlier cut I saw that prompted me to complain to Bregman. But it was still a much-reviled picture. It was treated very harshly.

Among other things, you were accused of being bigoted against Cubans and Cuban Americans. It was a replay of the charges that Howard Hawks got back in 1932 when he did the original *Scarface*, which was about an Italian American gangster modeled on Al Capone. De Palma had to put a disclaimer on the remake, just like the original *Scarface* had: something like, *This does not represent all Cubans*.[25]

Well, Tony Montana was a gangster. His mother and his sister represent the clean-cut Cuban community. His mother scolds him: *You're a scumbag, get out of my house! You're ruining your sister!* So there is a strong morality in the movie. I knew about the criticisms even in advance, that Cubans were not like that.

But I'm sorry: A lot of Cubans did become Marielitos. If I'd done it about Colombians, they would've said the same thing: *You're anti-Colombian.*

The movie is about gangsters. The ethic of being a gangster is criticized by the mother and sister, and by Elvira, the girlfriend.

The language and the violence also set a lot of critics off. I believe there was one critic who counted every "fuck" in the movie.

The movie didn't do me any good. My cred came on the street at that point, believe it or not. I knew the Puerto Ricans and the blacks in New York who got the picture, and I went to see it at the Broadway houses, but I was never invited to the premiere or anything like that. So nothing really happened for me because of *Scarface*.

But you went on to more big assignments, and you had two major screenplay credits in the same

year, 1985. One was *Year of the Dragon*. The other was *8 Million Ways to Die*. What can you tell me about those?

8 Million Ways came at a very strange time in my life. I was on the cusp of breaking back through, after writing *Scarface* and being on

23 "Defiance" was an unproduced screenplay about dissidents in the USSR that Stone researched in the early eighties during visits to Soviet Russia, Ukraine, and Georgia.

24 Vincent Canby's *Times* review favorably compared the *Scarface* remake to *The Godfather* and called it "a relentlessly bitter, satirical tale of greed, in which all supposedly decent emotions are sent up for the possible ways in which they can be perverted."

25 "SCARFACE IS A FICTIONAL ACCOUNT OF THE ACTIVITIES OF A SMALL GROUP OF RUTHLESS CRIMINALS. THE CHARACTERS DO NOT REPRESENT THE CUBAN-AMERICAN COMMUNITY AND IT WOULD BE ERRONEOUS AND UNFAIR TO SUGGEST THAT THEY DO. THE VAST MAJORITY OF CUBAN/AMERICANS HAVE DEMONSTRATED A DEDICATION, VITALITY AND ENTERPRISE THAT HAS ENRICHED THE AMERICAN SCENE."
Post-credits disclaimer for *Scarface*, all caps, red letters on black screen.

'Scarface' Gets R Rating On Appeal

Just how violent is ~~rated~~ 'Scarface'?

By ALJEAN HARMETZ

Special to The New York Times

HOLLYWOOD, Nov. 8 — The X rating given to "Scarface" last week by the rating board of the Motion Picture Association of America was overturned on appeal today.

An appeals board composed of 20 theater owners, major studio executives and independent distributors met in New York this afternoon and awarded Universal's $23.5 million Christmas movie a less restrictive R, which allows children under the age of 17 to see the film when they are accompanied by an adult. An X rating prohibits anyone under the age of 17 from entering the theater.

A two-thirds vote was necessary to overturn the X rating. "The board voted 17 to 3 in our favor," said the producer of "Scarface," Martin Bregman. "I guess that says it all."

Film Stars Al Pacino

Written by Oliver Stone and directed by Brian De Palma, "Scarface" stars Al Pacino as a Cuban immigrant gangster involved in the

'Scarface' As Cuban Boatlift Refugee; See Miami Latino Worry

Miami, Aug. 3.

Spokesmen for Miami's Latin community are reportedly nervous at the potential bad image that could result from the movie "Scarface" now heading into production. The Universal picture is directed by Brian De Palma and stars Al Pacino with a script by Oliver Stone.

Considered to be a revamped contempo version of the 1932 film with Paul Muni about Chicago mobster Al Capone, Stone's treatment concerns the rise of a Cuban refugee off the 1980 Mariel boatlift up through the ranks of a violent drug distribution ring.

The Mariel refugee issue is one of prime concern in Miami, inasmuch as elements of the boatlift are blamed for the city's soaring crime

(Continued on page 28)

THURSDAY, NOVEMBER 17, 1983 · 5D

THE NEW YORK TIMES **ARTS/ENTERTAINMENT** WEDNESDAY, OCTO

De Palma Disputes 'Scarface' Rating

We've never seen our office with a censorship role." she said.

'Scarface' remake scheduled to film; opposition expected

A remake of the 1932 Howard Hawks' classic "Scarface," to be produced by Martin Bregman and directed by Brian De Palma, will be filmed in Miami, Fla., as scheduled, despite opposition from at least one leader of the city's Cuban community.

Bregman said he and his executive producer Lou Stroller decided to go *— continued on page 5*

'Scarface' to be filmed

continued from page 1 —

the production in Miami "basically because we found the Cuban-American community *is* behind us." Bregman cited a number of letters the Miami production office received from professional people within the Cuban community that supported the project.

They also received supportive calls from the Greater Miami Chamber of Commerce and Florida Gov. Bob Graham, who said he opposed censoring filmmakers, Bregman noted. He plans to use not only locations but a number of community people as extras in the eviction, which will star Al Pacino.

gangster."

However, according to wire reports, Perez said his proposed resolution against the filming will remain "active" until he is certain there is no offense to the Cuban community in the movie.

The original "Scarface" focused on the rise and fall of a mobster in Chicago's gangster underworld around the time of the St. Valentine's Day Massacre. The remake, scripted by Oliver Stone and budgeted at about $10 million, "is a contemporary piece," Bregman noted. "Obviously we've made changes but thematically it's the same."

Universal now owns the film, having acquired the original print, story and remake rights from the late Howard Hughes along with a number of other Hughes productions such as "The Outlaw" and "The Conqueror."

Start date for shooting is between mid-October and Nov. 1, said Breg-

STEVEN R PINES CO.
9025 WILSHIRE BLVD STE. 301
BEVERLY HILLS CA 90211

THE Holly REPORTER

XXIII, NO. 16 HOLLYWOOD, CALIFORNIA, THURSDAY, AUGUST 26, 1982

Al Pacino in "Scarface" SEPTEMBER 15, 1983

Screen: Al Pacino Stars in 'Scarface'

By VINCENT CANBY

"SCARFACE," Brian De Palma's update of the 1932 classic directed by Howard Hawks and written by Ben Hecht, is the most stylish and provocative — and maybe the most vicious — serious film about the American underworld since Francis Ford Coppola's "Godfather." In almost every way, though, the two films are memorably different.

This "Scarface," which was written by Oliver Stone, contains not an ounce of anything that could pass for sentimentality, which the film ridicules without mercy. "The Godfather" is a multigenerational epic, full of true sentiment. "Scarface," which is actually a long film, has the impact of a single, breathless anecdote, being about one young hood's rapid rise and fall in the southern Florida cocaine industry.

Where the Coppola film worked on our emotions in unexpected ways, discovering the loves and loyalties that operated within one old Mafia don's extended family, "Scarface" is a relentlessly bitter, satirical tale of greed, in which all supposedly decent emotions are sent up for the possible ways in which they can be perverted. "Scarface" opens today at the National and other theaters.

To someone who never felt completely at ease with Mr. De Palma's flashy, big-budget exercises in grand guignol ("Carrie," "The Fury"), or even with his far more witty and more successful "Dressed to Kill" and "Blow Out," which were as important as examples of film criticism as they were as films, "Scarface" should be a revelation. Here is a movie of boldly original design that looks like some crazy cinematic equivalent to those gaudy Miami Beach hotels, the ones with inappropriately elegant names and interior decorations that suggest that Madame du Barry might have been Louis XV's minister of culture.

Tony Camonte, the Chicago gangster in the 1932 "Scarface," the role of the Italian-American mob boss that made Paul Muni a major star, is now called Tony Montana and played by Al Pacino with such mounting intensity that one half expects him to self-destruct before the film's finale. Though a busy performance, it's not a mannered one, meaning that it's completely controlled.

The new Scarface is a small-time Cuban punk, one of supposedly hundreds among the 125,000 or so legitimate refugees that the Castro Government allowed to immigrate to Florida in the spring of 1980. Quick-witted, hollow-eyed Tony Montana hasn't one redeeming feature, but his greed and ambition are so all-consuming that they are heroic in size if not in quality.

Tony has absolutely no compunction about murdering for profit, which quickly endears him to a Batista Cuban refugee who is the chief of the Bolivia-to-Florida cocaine traffic. In almost less time than it takes to write this synopsis, Tony has succeeded his former mentor and married the now-dead man's mistress, Elvira, a silky blonde junkie played by Michelle Pfeiffer, a beautiful young actress without a bad — or even an awkward — camera angle to her entire body.

Mr. Stone follows the general outlines of the Hecht screenplay with at least one notable difference. Tony's fall comes not only because he ignores the underworld maxim to the effect that one should never underestimate the other man's greed. To his misfortune, he also ignores a second rule: "Don't get high on your own supply." This is a major switch on the work of Hecht, who might have guffawed at the suggestion that Al Capone, Chicago's most powerful Prohibition gangster, might have been done in by alcoholism, though Capone did have syphilis.

Mr. De Palma never understates anything when overstatement will work better. Never is this more evident than in the last quarter of the film, in which we are treated to the spectacle of the paranoid, cocaine-addicted Tony Montana as he loses control of himself and his business. Mr. De Palma pushes "Scarface" very close to the brink of parody when, near the end, the strung-out Tony plays his Gotterdammerung with a large, humiliating clump of cocaine stuck to the end of his nose. It's like watching a Macbeth who is unaware that his pants have split.

Leading up to the final shootout at Tony's Miami mansion, which looks like a slightly smaller Fontainebleau — the chateau, not the hotel — there are a series of scenes of slaughter of such number and explicitness that the film barely escaped receiving an X rating instead of the R it now has. These scenes include dismemberments, hangings, knifings and comparatively conventional shootings by small arms and large. Be warned.

Supporting Mr. Pacino and Miss Pfeiffer who, though she's not on screen that much, will not be easily forgotten, is a large cast of excellent supporting actors. Chief among them are Steven Bauer, who plays Tony Montana's loyal lieutenant (the role played by George Raft in the original); Mary Elizabeth Mastrantonio, as Tony's once-innocent sister; Miriam Colon, who is especially effective as Tony's old-fashioned mother; Paul Shenar, as an elegant Bolivian cocaine supplier; Harris Yulin, as a crooked Miami narcotics detective, and Robert Loggia, as the boss whom Tony succeeds.

All of the film's technical credits are fine — the photography by John A. Alonzo, the music by Giorgio Moroder, and the art direction by Ed Richardson. Though most of the location work was done in and around Los Angeles, the film looks amazingly like southern Florida in every tacky way, from sleazy hotels to those gi-

7 8 Eyes That...
Kenny Rogers
8 9 Colour By Numbers*
Culture Club 8 6
9 5 An Innocent Man
Billy Joel
Rock 'n' Soul, Part 1* 9 12
Daryl Hall/John Oates 10 10

10 10

Copyright © 1983 by Billboard Publications Inc.

Patlan, Inc.
9025 WILSHIRE BOULEVARD
BEVERLY HILLS, CALIFORNIA 90211
TELEPHONE (213) 858-1276

Arts Editor
New York Times Page 2.

Mr. Goodman further levels the charge that the filmmakers are out to use the subject matter to indulge their lust for bloody special effects and sensationalism. Considering that I talked to the FBI, the DEA, U.S. Attorney's office, Miami Homicide, Metro Dade Narcotics, Broward County Narcotics, defense attorneys, and various drug dealers, and considering that there were more than 100 narcotics-related murders in Miami 1981, many of then gruesome executions (the chainsaw murder among them), it seems to me that we made a film that approximated a reality we saw there.

To make a documentary about a war one does not leave out the combat and bodies at the sake of losing the truth. And in Miami, 1981, there was the equivalent of a war. I think in any serious analysis, Scarface portrays the paranoia and futility of drug wealth and is perhaps the most anti-drug film ever made -- and therefore, by Mr. Goodman's moralistic criteria of "proportion", "good" for its audience.

Lastly, I am sad that Mr. Goodman castigates the director, Brian De Palma, for the work and manages to ignore the screenwriter completely. As a writer himself, I wish he had had the courtesy due to a fellow writer to mention his name, even if with poison. Screenplay writers do exist and sometimes, you know, do the same work as playwrights.

Sincerely yours,

Oliver Stone
Oliver Stone
Screenwriter "Scarface"

40 East 94th Street
New York, New York

cc: Vincent Canby

4 August 1982

Mr. Lew Wasserman, Chairman Mr. Lee Stroller, Producer
Universal Studios Mr. Brian DePalma, Director
100 Universal City Plaza Mr. Oliver Stone, Writer
Universal City, Ca 91608 Mr. Al Pacino, Actor
 3500 N.W. 79th Street
 Miami, Fla 33147

Gentlemen:

I have recently become aware of your latest film venture and understand that it will be filmed here in Miami; furthermore, that Mr. Pacino will play the role of a Mariel refugee dealing in cocaine.

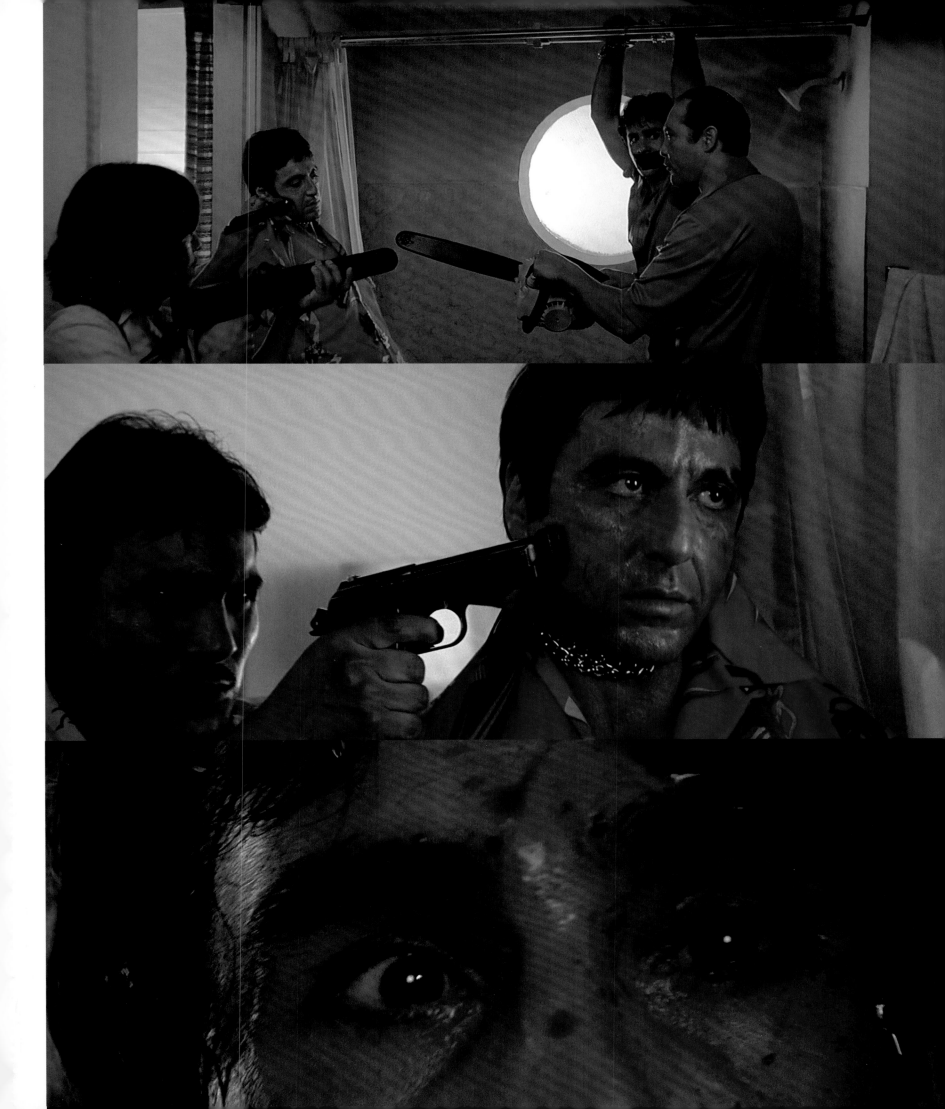

the set with Brian. That movie took a long time to shoot; it seemed like forever.

Then I did *Year of the Dragon* for Michael, but I was always writing, always doing something else. I worked a long time on a screenplay about the Hillside Strangler, a long time. But it didn't work out. I have files on the Hillside Strangler[26] case; I knew a lot about it because Floyd Mutrux put me in touch with two great detectives who'd worked on the case. Do you know Floyd?

The screenwriter, yes: Floyd Mutrux cowrote two Mexican American gangster movies *Blood In, Blood Out* and *American Me*.

Floyd was a great character. He lived in the La Brea Hotel. The two cops Floyd put me in touch with introduced me to the other people in the homicide division, and they put me in touch with the real Stanley White.[27]

The New York police detective from *Year of the Dragon*?[28]

Yeah. Stanley White's a great character, a straight-ahead, gung ho guy. Very cocky, small, powerful. I'll never forget what happened with Stanley and Richard Boyle[29] when I was writing *Salvador*. Boyle was at the house, and Stanley came over for dinner, and the two of them were like opposites, you know? Richard's crazy, and Stanley's a cop who was in Vietnam, a veteran like in the

movie. So they started to cut themselves with knives to show who's tougher, and then they had a knuckle fight.[30] They had a knuckle fight! It was insane! I had to separate them! Richard's knuckles are very powerful. He's a skinny guy, but a great knuckler.

Anyway, *8 Million Ways* came in that period when I'd bought this book with my own money, by Lawrence Block, about a New York detective named Matthew Scudder. I got to know Block a little bit, and I thought he was great. I sat with him and wrote the script set in the Avenue A and B area of New York City, with drug dealers. It was really lower-class America in New York City, another kind of drug movie. And I got to know the cops down there, went to Brooklyn, saw all that shit. At that time, crack was starting to come in, and heroin.

I went to drug dens. They were selling it right out there in the open, and that's all in the script. There were incredible scenes in there, I thought, and I wanted to direct the movie, obviously. I don't remember exactly what happened with it, except I optioned it to Steve Roth,[31] a guy very enthusiastic for it, who made a deal with Mark Damon.[32] He was an independent foreign salesman, like a [John] Daly, and he was getting big at the time. Handsome guy: He was an actor, and then he became a distributor. He was hot, and he bought the script from me and turned it over to Hal Ashby.[33] At that time, though, I was caught up in *Salvador* and I was starting to feel like it was going to happen.

But there was something very strange about the whole thing: Hal told me he didn't know New York City very well, and he looked forward to getting to know it. Then he introduced me to his production designer, a well-

26 For a four-month period in 1977 and 1978, Kenneth Bianchi and Angelo Buono kidnapped, raped, tortured, and killed ten women ranging in age from twelve to twenty-eight in the hills above Los Angeles.

27 White, a Los Angeles police detective, let his name be used as the hero's name in *Year of the Dragon* and served as a technical advisor on *Dragon*, *Platoon*, *The Doors*, *JFK*, and *Heaven & Earth*; he played a New Haven, Connecticut, cop in *The Doors* and a rifleman in *JFK*.

28 The character was named Arthur Powers in the source novel by Robert Daley.

29 Reporter and political activist whose writings about El Salvador were the basis for *Salvador*; see chapter 4, pages 138–55.

30 Bare-knuckle brawling.

31 Birthdate unknown–2008; coproducer of *Scrooged* (1988) and *The Last Action Hero* (1993).

32 1933– ; actor-producer who appeared in Roger Corman's *The House of Usher* and more than forty Italian films; producing credits include *Das Boot*, *9½ Weeks*, and *Lone Survivor*.

33 1929–1988; counterculture-minded director of such classics as *The Landlord* (1970), *Harold and Maude* (1971), *Shampoo* (1975), *The Last Detail* (1973), *Coming Home* (1978), and *Being There* (1980).

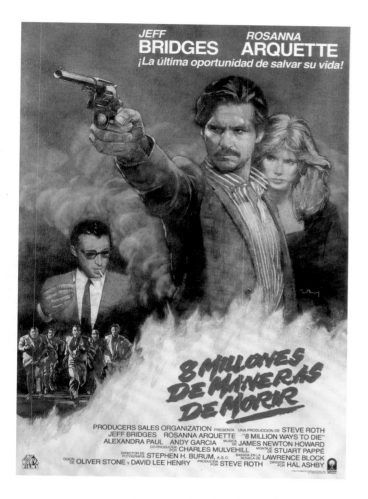

known guy,[34] who told me that he had *never* been to New York! And that struck me! I thought, *Wow, the guy's a production designer, and he doesn't have any interest in seeing New York City?*

I went off to do *Salvador* and had this incredible, intense experience, so I lost track of *8 Million Ways*. But I come back after the *Salvador* experience. And I go off to the set. And they've changed the script.

They brought in Robert Towne[35] to rewrite me, uncredited; the final credit was me and David Lee Henry.[36] I didn't think it needed a rewrite. I mean, I would've offered to do it, but Hal wanted Towne because they'd worked together before. Then I heard they'd changed the location to LA. Can you imagine, changing the location from Avenue A on the Lower East Side to Malibu? I understand the needs of production, but I don't think this helped. They were way behind schedule, the costs were climbing, and I think it cost eighteen million dollars when it finished. And it broke the fucking company! It broke Mark's company! I mean, that was a huge amount of money for a film like that. It should've cost two at that time, or maybe less—maybe three, tops.

But Hal at that point was breaking down. I didn't know he had cancer, that he was sick, but he had no discipline. This designer [and he] had changed the story to Malibu, not the Lower East Side of New York City!

So I went to the set. I'll never forget: I went up to this cliff house over Malibu that had a tram, and everything was opulent, and this, and that, and Porsches. The crew were all driving Porsches! Really, after doing *Salvador*, which was a very low-budget shoot, the whole thing seemed surreal. I remember they broke for lunch or dinner, whatever it was, and they had shrimps, white tablecloths—a banquet! Food to die for! It was an unbelievable set.

I said, *Where's Hal?* and they said, *Oh, he's in the trailer with Jeff.*[37] *When's he coming out? Well, it might be a while.* And then later on I find out they'd been trailer conferencing through the whole fucking movie, sitting in there, probably smoking dope. I know Hal was smoking a lot of dope. But he wasn't coming out—he was rehearsing a movie while the whole crew's sitting there in Porsches with shrimp cocktails and everything!

By that time, the WGA had determined the credits, so they put my name on it, but I didn't know this shit was happening. I saw Robert a few times after that, but we didn't really talk about it much. I don't know why he changed the script, but it really wasn't my script. Block's writing was terrific. Those novels were just great. It was a great story. I'd like you to reread the original script. It's got tone, it's got grit, and it's got the Andy Garcia[38] character, Angel Maldonado, who's the best thing in the movie, I think.

But the bottom line is, my name should not be on that film. I'm embarrassed by it, because it's not really me.

Year of the Dragon, though: I think I can feel your presence in it, mostly through the Mickey Rourke[39] character.

But you and the director, Michael Cimino, got yourself in more trouble with that one. There were complaints of racism, that you made the Chinese out to be a bunch of gangsters.[40] It was *Scarface* all over again, but you were stepping on different toes.

Gangster stories are gangster stories! I had not known that of all the different groups, the Chinese were the largest heroin importers into the US at the time. That came out of the Triad situation in Hong Kong. According to Daley, four corrupt Hong Kong police sergeants had gone to four different places in the world, one of

which was New York. They formed a Syndicate, and were so tight with each other they shipped back and forth. So everything in that movie is pretty accurate in terms of the drug business.

Cimino also made me go to about fifteen dinners with Triads and what they call "associations" in Chinatown. We got to know them pretty well. We were looking for somebody on the inside who'd squeal, but nobody would! We found a dissident—Herbert was his name, Herbert something, crazy name. He'd been inside and dropped out, so he gave us inside information, and the cops and so forth, but nobody really cracked Chinatown in those days. It was a really unknown world. So it was fascinating.

But there's good Chinese!

A lot of people complained that it didn't make sense that this guy would be so obsessed with the Chinese when his experience was in Vietnam. But I thought it made sense, because it's transference by this angry racist vet, and when someone is dealing with pathology, the translation doesn't have to be exact. He had a bad experience in Asia;

34 Stone is referring to Michael Haller (Birthdate unknown–1998), production designer on Ashby's *Harold and Maude* (1971), *The Last Detail* (1973), *Being There* (1980), *The Indian Runner* (1990), and *The Crossing Guard* (1995).

35 1934– ; American screenwriter and director; *The Last Detail* (1973), *Chinatown* (1974), *Shampoo* (1975), *Tequila Sunrise* (1990); script doctor on *Bonnie and Clyde* (1967), *The Godfather* (1972), *Crimson Tide* (1995), and *The Rock* (1996).

36 Pseudonym used by crime novelist R. Lance Hill on such scripts as *Roadhouse* (1990), *Out for Justice* (1991).

37 1949– ; The Dude Abideth.

38 1959– ; impassioned Cuban-American leading man, sexier en Español; *The Untouchables* (1986), *Internal Affairs*, and *The Godfather, Part III* (both 1990), *Jennifer Eight* (1992).

39 1952– ; velvet-voiced New Yorker with the thespian aspirations of Robert De Niro and the frankly menacing energy of Richard Widmark. *Diner* (1983), *Angel Heart* (1987), *Barfly* (1988), *Animal Factory* (2000), *Sin City* (2005), *The Wrestler* (2008). Unfortunately, also a boxer.

40 Author Robert Daley lent his name to anti-defamation complaints, telling the *Los Angeles Times* in an August 28, 1985, interview, "When I read the script, I wanted to cry. . . . I thought about taking out full-page ads . . . dissociating myself from Cimino's work. It is offensive to anybody. . . . The movie makes it appear that to Chinese, life is cheap."

"EIGHT MILLION WAYS TO DIE"

SCREENPLAY BY OLIVER STONE

BASED ON THE NOVELS "EIGHT MILLION WAYS
TO DIE" AND "A STAB IN THE DARK" BY
LAWRENCE BLOCK

SECOND DRAFT

PROPERTY STEVE ROTH PRODUCTIONS
AND
IXTLAN, INC.
PROD. BLDG. 6
BURBANK, CALIFORNIA

STREETS - NEW YORK CITY - ANY NIGHT

MONTAGE -- CREDIT SEQUENCE:

 MATTHEW SCUDDER'S VOICE
 ...New York in the summer's like any
 other tropical port -- Saigon, Rangoon,
 Hong Kong. It swelters and moves and
 sometimes I think there oughta be palm
 trees growing along the sidewalks --
 they fit right in with the whores and the
 hustlers. Some nights I feel Africa's in
 the city, the natives with their cutoffs
 and tank tops, flesh for sale in the
 land of Ugladu. it's a sex-driven city
 'nights in the summer, anything goes,
 an' if you listen real hard sometimes
 you can hear the jungle drums rapping
 out a beat deep along the sewers -- and
 the sidewalks are shakin' tonight.
 Check it out sometime...

We see the back of his head now. As he fiddles with the radio,
picking up King Sunny Ade's "juju" beat on 105FM -- a mellow,
jazzy African beat for the City. There's a second radio, tuned
to a cop band that intermittently broadcasts cop business
over the music. The point of view is from his cruising,
customized van. The streets are like newspaper stories flashing
by, in brief introductions that will be returned to later in
the story.

We're in the Lower East Side area -- with its population of
street junkies and prostitutes loitering openly on the
sidewalks. The buys are being made without caution. Four
Black Guys in a maroon car are rapping with a Spanish Guy
in pigtails. Rich White Kids are coming out of some shooting
gallery, high.

Scudder munches on a piece of cold pizza laid out on the
dashbaord, sips from his red coke can. The van's like a
trailer home, filled with the modus operandi of a nomadic
berber. His conversation is relaxed, somewhat chatty.

 SCUDDER VOICE (Cont'd)
 My name's Matt Scudder -- I used to be
 a cop, detective second grade, Narcotics
 from '75 to '81. I was a Terror on the
 junkies, one of the best. Too good.
 (CONTINUED)

SCUDDER VOICE (Cont'd)

One day this tight-ass Sergeant saw half
a key of heroin in the trunk of my car and
went crazy. I kept it around for my informants.
We did that in narcotics, the best cops,
we had to cause there was no way the
Department was going to front the kind
of grease we needed to make the big buys
and the big busts. But this Sergeant,
who was Irish and who had it in for me,
says I should've turned it over to the
Property Clerk. I told him where he
could stick his head if he could fit
it in there and then one thing led to
another. They investigated me. Two reviews.
Three hearings. A lot of heresay. Bedbugs
coming out of the woodwork, copping a plea,
saying I was this big operator and I never
made a dime out of it. I was clean. I did
my job and looked forward to the day I'd
be Chief of Detectives, right? Wrong!
They went after me to sell out on my partners,
make up stories about all the millions
we stole but I wouldn't do that. One thing
I'm not is I'm not a rat. Long as I know
that I'm all right -- but the facts were
clear to me. Cops aren't cops anymore. Ever
since Miranda and the Knapp Commission.
They don't want to work. They sit there and
want to shuffle paper for 20 years and collect
their half million dollar pensions. More
arrests you make the more trouble you get
into. Only hope is these new young cops
coming in who don't remember what it was
like. But when I look at them I get depressed.
A lot of things are depressing me. I sometimes
think cops are the most depressed people
I know -- but what do I know? Anyway I
quit the Force...

We're in Harlem now -- the radio beat is out on the street,
dance carnivals, water hydrants spewing water like the place
de la concorde. There's a line outside a candy store -- when
did you ever see a line outside a candy store? The juked-up
black hookers are wobbling around in circles waiting for
the next bite. Some of them are real good-looking too --
and that makes it sadder somehow.

We see a fight suddenly breaking out. Some black woman cracks her liquor bottle on a stoop and attacks a black guy. He shoves her back, she seems to have slashed him, he's yelling at her. The others, who were partying with them on the stoop, rush out to restrain them but the black guy is still coming back at her, livid -- as the fight recedes down the sidewalk.

 SCUDDER VOICE
 ...which makes me sort of like a priest
 without a church. It was about the same
 time I broke up with Maureen. Everything
 started going -- the mortgage, the
 checkbook that wouldn't balance, the
 fights. I started drinking -- too much.
 One day Monsignor Flaherty's squad grabbed
 me -- I was still a cop then -- and sent
 me upstate to detox on their farm there.
 Now I'm okay. I drink a lot of coca-cola.
 Maureen kept the house out on the Island --
 Syosset -- and Laurie, she's eight, she's
 out there with her but she likes to come
 and stay with me in the City. That's a
 tough time. I take her to shows, ballgames,
 and I drive her back on Sunday. I don't go
 in the house. I let her out on the street...
 I got a lot of time now. I like to drive
 around at night, I do small jobs here and
 there, I don't have a license but people
 call me anyway, usually cops. I guess I
 could call myself a half-assed detective...

We're moving down Park Avenue, past Regine's where the rich young playboys and girls are arriving in their limousines, giggling and ready to party.

We're moving past another type of party on the street outside Ochenta's on upper Broadway -- a mob of Spanish kids lining up to get into the joint, partying on the street.

We're moving down Broadway. The theatre is ending and the well-heeled crowd is moving along the sidewalks, hailing their cabs and limos.

A dead corpse in a pile of crumpled shopping bags lies on the sidewalk somewhere, attended to by an ambulance team and a couple of cops. They lift the body onto a stretcher and we see the face of an old woman, her face bloated with alcohol.

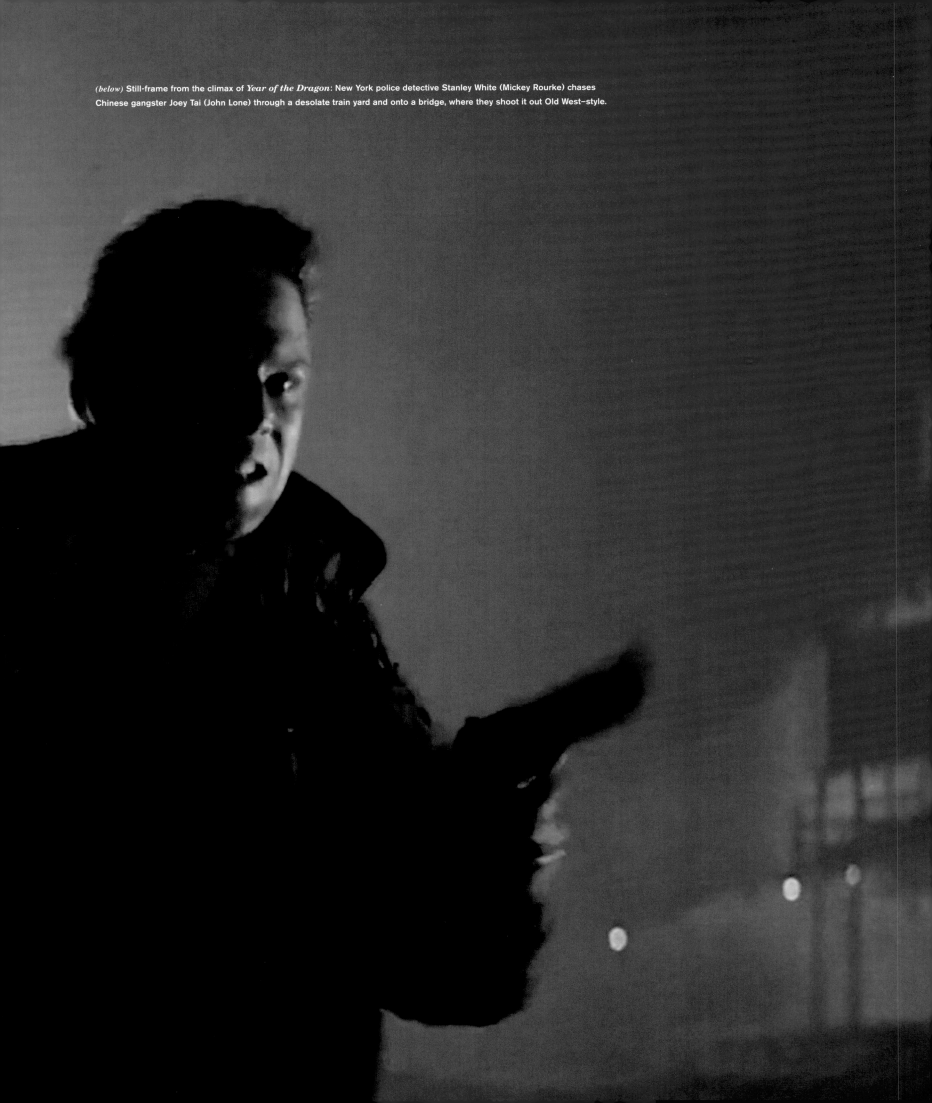

(below) Still-frame from the climax of *Year of the Dragon*: New York police detective Stanley White (Mickey Rourke) chases Chinese gangster Joey Tai (John Lone) through a desolate train yard and onto a bridge, where they shoot it out Old West–style.

and now here he is, surrounded by Asians again, trying to fight an enemy that hides in plain sight, and he freaks out.

Plus, he has that dead marriage to the Caroline Kava[41] character.

She's fantastic.

Yeah, she is. I used her again in *Born on the Fourth*. And also Ray Barry:[42] Mickey's partner, the older cop, Bukowski.

This is another case where you felt like your vision was harmed by producers' notes?

It's another case where Dino De Laurentiis fucked things up! Robert Daley's book ends beautifully. The cop can't get the gangster Joey Tai, no matter what he does; he's just too elusive. But he figures out that he's married to two women at the same time, which is bigamy. The old wife's in Hong Kong, and he's come to the new world and married the new wife. And that's how he gets him.

Like nailing Al Capone on income tax evasion.

Right. But Dino was very 1950s Italy in his attitude, and he's like, *You can't have that in a movie!* He said, *We can't have adultery like that!* And he changed it to the shootout on the bridge at the end, which I guess worked for him. That wasn't in the book, and there were a few other hokey things. Everything Dino sug-gested was hokey, *everything*, including where to shoot it.

Right. The film is set in Chinatown in Manhattan, but they shot it on soundstages in North Carolina.

Michael did a good job. I think the picture is good, I like Mickey in it, John Lone[43] is phe-nomenal as Joey, and I even like the actress who plays Tracy Tzu, the newscaster: Ariane.[44] She caught flak from critics, but I think she's good.

But the movie did nothing for my career. Most of the reviews were bad. It came out and did all right, but nothing great.

And yet I feel I can hear your voice in that movie, through the character of Stanley White.

I personalized a lot of the Mickey Rourke stuff.

Like the scene in the bar with Ray Barry and Mickey? A quiet scene, but a nice, unusual moment between a couple of veterans. They're talking about Vietnam, and Barry's character says something about "the professional belly-aching Vietnam vets." It really feels like a Stone scene to me, almost like a dry run for that scene in *Born on the Fourth of July* where Ron Kovic is drunk at the pool hall and gets reamed by that World War II vet who thinks Vietnam vets are a bunch of crybabies.

It all was a long time ago, so I don't remember exactly what came from the book and what I put in there. But I do know I worked hard on it, and I put a lot of myself into it.

41 *Heaven's Gate* (1980), *Little Nikita* (1988), *Snow Falling On Cedars* (1999), *Final* (2001).

42 Raymond J. Barry (1939–); *Cop* (1988), *Falling Down* (1993), *The Ref* (1994), *Headless Body in Topless Bar* (1995), *Training Day* (2001), *Justified* (2010–2015).

43 1952– ; Hong Kong-born, elegantly handsome American leading man; *Iceman* (1984), *The Last Emperor* (1987), *The Moderns* (1988), *M. Butterfly* (1993), *Rush Hour 2* (2001).

44 Actress and model of Japanese and Dutch descent, full name Ariana Kozumi, 1963– ; *King of New York* (1990).

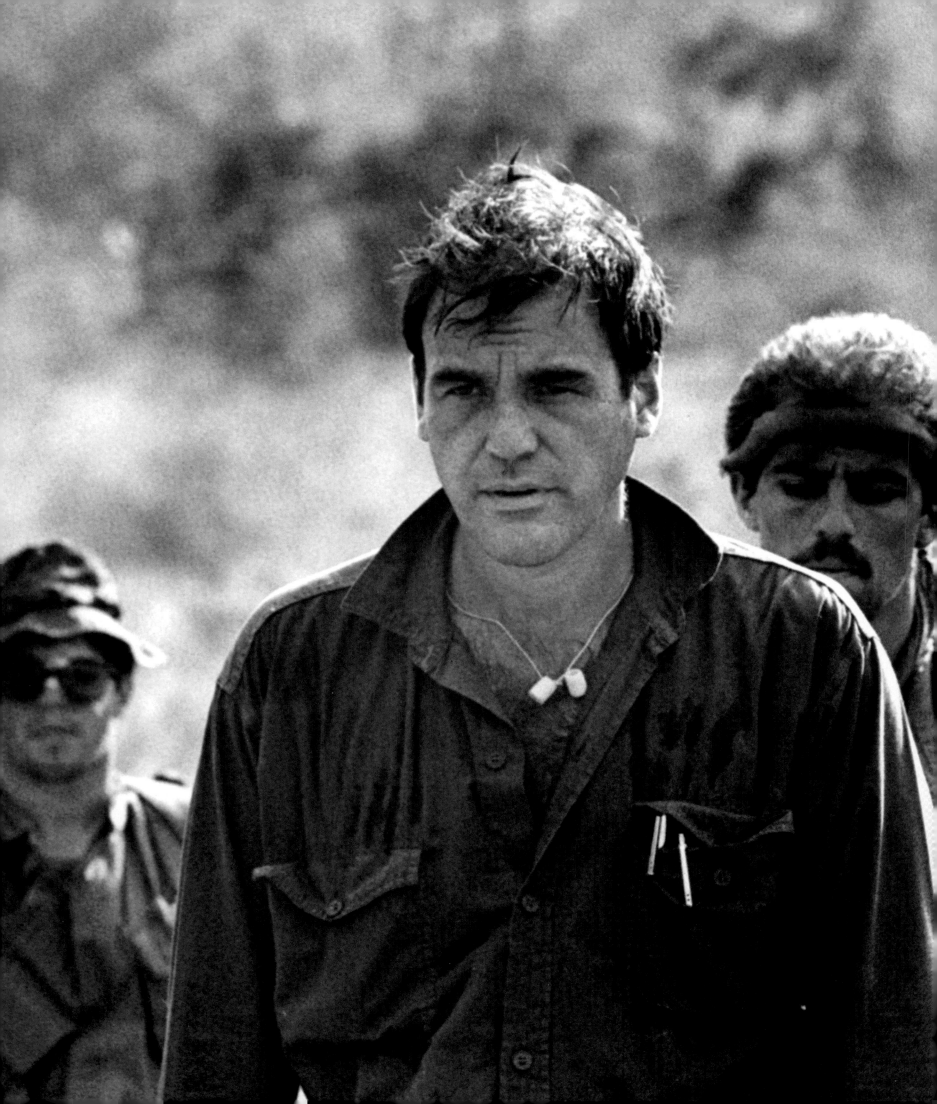

★★★★★★ Ourselves ★★★★★★

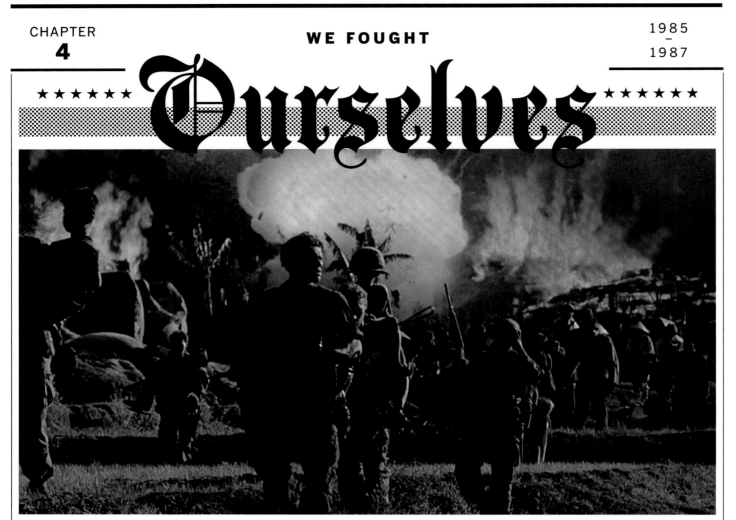

(previous spread) Stone in the Philippines on the set of *Platoon* in 1986, on the day he shot his cameo as an officer who gets blown up by a VC soldier's suicidal grenade attack.

(above) Sgt. Elias (Willem Dafoe, center front) leads his platoon out of a burning village that has been destroyed so that it could be "saved."

Nineteen eighty-six was one of Oliver Stone's peak years, and one of the greatest years any American filmmaker has ever enjoyed. He released two masterpieces ten months apart: *Salvador* and *Platoon*. More ideal companion pieces are hard to imagine. Of modern Hollywood features, only Francis Ford Coppola's *The Conversation* and *The Godfather: Part II* (both 1974) and Steven Spielberg's *War of the Worlds* and *Munich* (both 2005) rival Stone's diptych for proximity of release dates, continuity of theme, and richness of vision. Together, *Salvador* and *Platoon* announced the arrival not just of a major directorial talent but of a fearsomely prolific and driven one. "[Stone] writes and directs as if someone had put a gun to the back of his neck and yelled 'Go!' and didn't take it away until he'd finished," wrote Pauline Kael in her *New Yorker* review of *Salvador*.[1] The description could also have applied to *Platoon*, or to any of the other films that Stone would release between 1986 and 1995—a run of ten mainstream features that the director's contemporaries have matched in quantity or quality, but never both.

Salvador, starring James Woods and James Belushi as drugged-up, horny Yankees prowling war-torn Central America, is set in the early eighties and done in a jagged, hurtling style. The picaresque story inserts fictionalized Americans into actual Salvadoran history in a proto-*Gump* manner. Stone even re-creates the killing of Archbishop Óscar Arnulfo Romero y Galdámez, who was assassinated in 1980 while offering Mass, and puts the photojournalist hero, Richard Boyle (Woods), in the same row as the shooter. The film boasts horrific violence and gleefully indecent humor and is mostly averse to sentimentality—except in scenes between Boyle (Woods) and his girlfriend María (Elpidia Carrillo), whom he wishes to save from El Salvador's political upheaval, and who he believes will save him from moral ruin. *Salvador* is a multilayered title, referring simultaneously to the setting, the hero, his lover, and redemption, a concept that remains deeply romantic even as Stone and Boyle's script bashes it like a piñata.

The stories of Boyle and Dr. Rock (Belushi) are intertwined with the Salvadoran revolution but never seem entirely a part of it. This is by design. The movie is partly

about what it means to get involved, to intervene, to commit—conditions that Americans, especially American politicians, throw around in a cavalier way, never thinking about what it truly means to supply or deny aid, to send advisers, to put "boots on the ground," to topple or establish a government, and how these and other actions continue to resonate, in the targeted country and in surrounding countries, for decades after the Americans have turned tail and gone home.

"If Major Max takes power, you people could sure use some good press," Boyle tells Ramón Alvarez, a leader in a left-wing party, before trying to sell him photos of a right-wing death squad's victims. Ramón snaps and throws the portfolio of negatives at Boyle, then indicates women looking through books of photographs of citizens who have been kidnapped and probably murdered. "Good press," he snarls. "There are ten thousand *desaparecidos* and every day the list grows and you *pendejos* talk about good press." We're constantly aware that for all their distress (and Boyle's increasing fervor), these Americans are tourists and that if they don't get into too much trouble they can always leave. María can't. That's why the *cédulas de identidad*—identification documents that permit the bearer to live—are so important. Boyle can decide to change his life and then actually change it (or talk about the importance of change *without* truly changing—which is what Boyle's extraordinary confession booth scene, with its ever-growing list of exemptions, is about). He and other Yankee characters have privileges as Americans—specifically as American men—that Salvadorans will never have.

For an American, few genres are harder to fund, much less execute, than the muckraking political drama; but of all the paths Stone could've chosen to walk toward directorial success after two critically and commercially unsuccessful features, he still chose this one. That a film like this could get a mainstream release a year into the second term of President Ronald Reagan—who reignited the Cold War with his anti-Soviet pronouncements, and whose administration oversaw the intervention that Stone's film decries—remains astonishing. Together with *Under Fire*, Roger Spottiswoode's film about American journalists covering the US intervention in Nicaragua, it is one of only two American features released in the first half of the decade to acknowledge that a new Vietnam was brewing south of the border. "Hey, what's going on around here?" Rock asks at one point. "I'm starting to feel like it's 1967 and I'm on acid and I'm listening to Jimi Hendrix."

Platoon is part of the same cinematic species, but a different animal. It is set in the sixties, and its story of a young US Army infantryman (Charlie Sheen) torn between a stoner Jim Morrison/Jesus figure (Willem Dafoe) and a leather-faced, alcoholic redneck (Tom Berenger) makes it a domestic political parable as well as a combat drama. But unlike the jumpy *Salvador*, *Platoon*'s tone favors mournful reflection over laughs. The movie is presented as a nightmare recollected in tranquillity by Chris Taylor (Sheen), a well-off young man who enlists in the army because he doesn't believe it's fair that the middle class and poor should bear war's burdens. The film could be a first-person Indochinese update of Stephen Crane's *The Red Badge of Courage*—one of Stone's favorite stories, and an inspiration on his by-then-still-unpublished novel, *A Child's Night Dream*. Chris is noble, naive, doomed: an innocent abroad, coming of age in hell.

Like *Salvador*, *Platoon* was photographed by Robert Richardson, one of the filmmaker's most important collaborators; the cinematography, like Stone's direction, represents a significant artistic leap. Where *Salvador* is mainly a record of things that are said and done, *Platoon* is a record of how things feel, and what they mean. It is expressionistic, at times surreal, with fluid cutting between points of view and supertight close-ups that let us contemplate the faces of characters at pivotal moments: baby-faced Chris emerging from the belly of a C-130 transport plane as if puked up by a leviathan, watching men off-load corpses in body bags, then locking eyes with a scrawny, hollow-eyed veteran heading home; Elias encountering Barnes in the jungle and smiling, then realizing that Barnes has no intention of lowering his rifle; Barnes and Chris locked in hand-to-hand combat, Barnes raising a rock like Cain about to slay Abel, his red pupils reflecting airstrike fireballs. The combat scenes have a hallucinatory intensity: screaming men and screaming shells, clouds of dirt and flesh, flares casting white light from above. The bits between the battles capture the camaraderie, horseplay, tension, and tedium that soldiers through history have described as war's constants, as well as the bugs constantly biting the men, the sweat drenching their uniforms, the terror in their eyes as they gaze into the gloom in search of a wraithlike enemy they barely understand. Elias hunts armed shadows in the stygian murk of tunnels, races through canopied jungle like a forest creature, and grins at a night sky framed by treetops. "I love this place at night, the stars," he tells Chris. "There's no right or wrong in them. They're just there."

(above) Still-frame from *Platoon* (1987): Bunny (Kevin Dillon) weaves through thick forest in the film's opening sequence.

Salvador and *Platoon* are jazz and classical, New Journalism and ancient poetry, but they share an aspect of exorcism, of emotional and political purging. Georges Delerue's score, which is dominated by a reorchestration of Samuel Barber's "Adagio for Strings," weeps for Chris, for Elias, for Barnes, for the Vietnamese, for the land itself. No wonder the movie became such a hit. For two decades, American films had been dealing with Vietnam in metaphor or in code, or denying its impact and lessons by making action films that showed how Vietnam could have been won (*Rambo: First Blood, Part II*) or why it didn't matter anymore, because we were back, baby (*Top Gun*). Stone's two films are uncomfortably personal. Parts of both have a missionary zeal, warning us to look at who we are so that we don't end up in another jungle. Barnes, the scar-faced veteran sergeant played by Tom Berenger, stands in for the obedient redneck (in geographic fact or political spirit) who supports every US war without question, simply because the president told him it was righteous. "Why do you smoke this shit?" Barnes demands of men he catches blazing out. "So as to escape from reality? Me, I don't need this shit. I *am* reality. . . . Now, I got no fight with any man who does what he's told, but when he don't, the machine breaks down. And when the machine breaks down, we break down."

Platoon stages the sacking and burning of a village as a miniature replay of My Lai, and it has its hero muse about the class discrimination evident through so much of the occupation. "Here I am anonymous, all right, with guys nobody really cares about," Chris writes to his grandmother. "They come from the end of the line, most of them, small towns you never heard of: Pulaski, Tennessee; Brandon, Mississippi; Pork Bend, Utah; Wampum, Pennsylvania. Two years' high school's about it. Maybe if they're lucky, a job waiting for them back in a factory. But most of 'em got nothing. They're poor. They're the unwanted. Yet they're fighting for our society and our freedom." When *Salvador*'s drug-addled hero Richard Boyle nearly stops the show to deliver a monologue about the United States' history of intervention in other countries, likening the Reagan administration's interference in El Salvador to the "adviser" period of American involvement in Vietnam, Stone comes on like the bastard son of Hunter S. Thompson and Ken Loach—a hard-partying, left-wing shit-stirrer. "You guys have been lying about that from the fucking beginning," Boyle yells at American military advisers claiming that Communists are taking over the country. "You never presented one shred of proof to the American public that this is anything other than a legitimate peasant revolution, so don't start telling me about the sanctity of military intelligence. Not after Chile and Vietnam."

(*above*) Still-frame from *Platoon*: Vietcong soldiers silently advance on the hero.
(*below*) Still-frame from *Platoon*.

Anyone with eyes and ears looked at *Salvador* and *Platoon* and realized that Stone didn't just want to make movies: He wanted to make movies that changed both himself and others. His cousin Jim Stone told *New York* magazine in 1986[2] that until he saw *Salvador*, "I certainly didn't realize how much his politics had changed. It was as if *Salvador* was Oliver's announcement that he was different now."

1 Pauline Kael, "Pig Heaven," review of *Salvador*, Current Cinema, *New Yorker*, July 28, 1986.
2 Peter Blauner, "Coming Home: Director Oliver Stone Relives His Vietnam Nightmare in 'Platoon,'" *New York*, December 8, 1986.

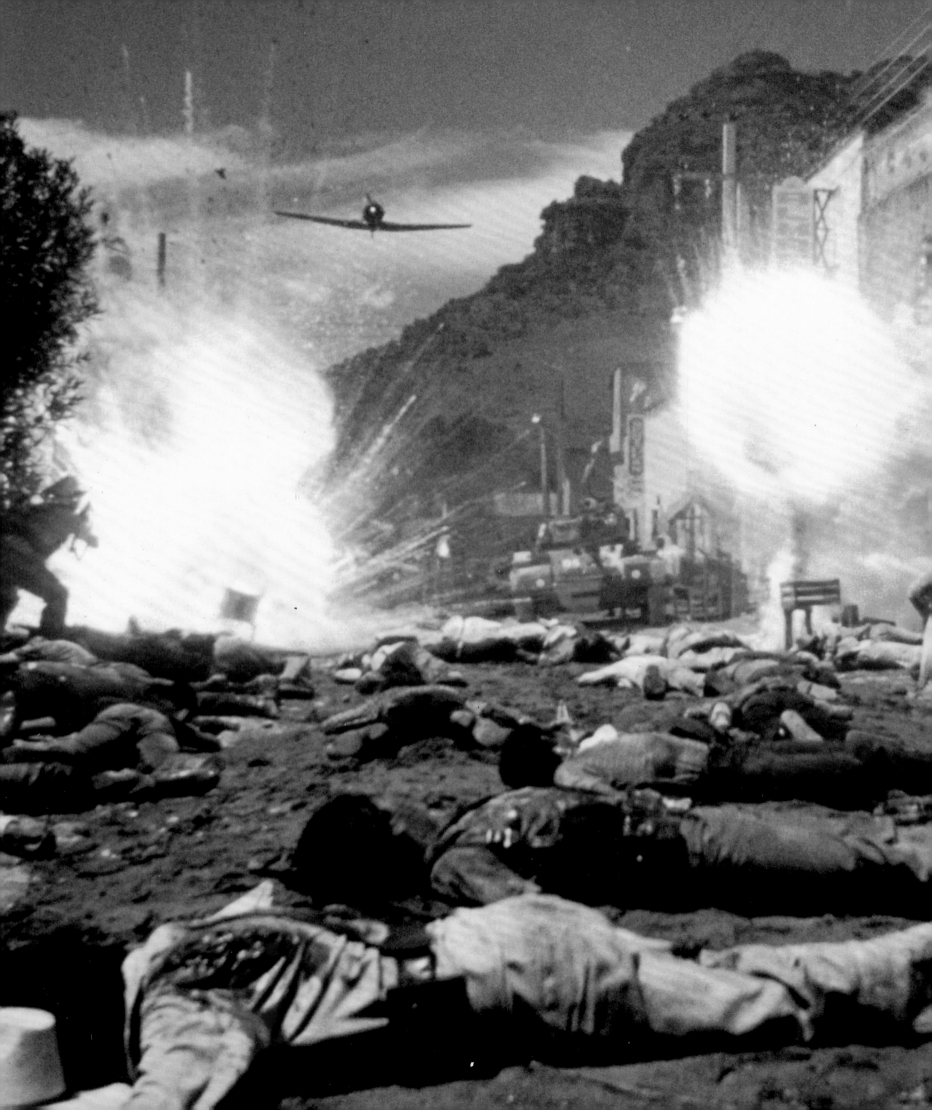

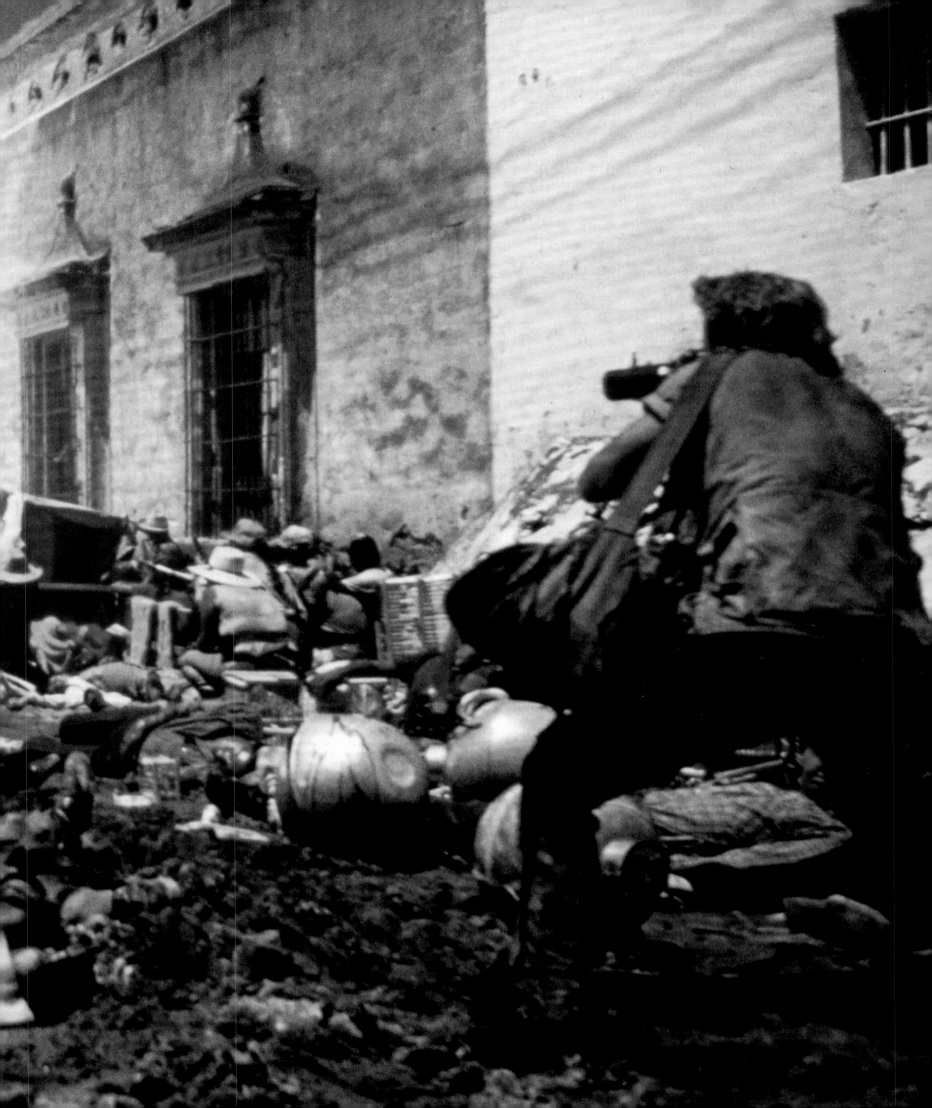

"BITTER FRUIT"

IDEA FOR FILM BY OLIVER STONE

TREATMENT REGISTERED WRITERS GUILD WEST 1982

BASED ON THE BOOK BY STEPHEN SCHLESINGER
AND STEPHEN KINZER

Based on CIA and State Department documents obtained under the Freedom of Information Act, BITTER FRUIT is the true story of the United States Coup in Guatemala in 1954, in which the CIA, the State Department, and President Eisenhower conspired, on behalf of the United Fruit Company, to overthrow the elected leftist (many said Communist) Government of Jacobo Arbenz Guzman and replace him with a Government compatible with the interests of United Fruit.

They succeeded. And more.

In the ensuing years, practically the entire leftist leadership and intelligentsia of Guatemala was either exiled or murdered by a succession of dictators and military men elected in fraudulent elections. And what seems to have been a success for the United States in 1954 has gradually evolved into a nightmare. Guatemala, Haiti, Cuba, and Chile have all become international symbols of North American meddling in support of its economic interests and the hand-picked dictators that can defend them. The bloody revolutions now convulsing El Salvador, Guatemala, and Nicaragua can trace their lineage back to 1954 and before, to the turn of the century; the pattern is well known to South Americans, if not as well to the North American public. It's a pattern that has been too often repeated. And will be again and again -- until we, as a voting public, put a stop to it.

Some highlights from the story:

1. PRESIDENT JACOBO ARBENZ GUZMAN takes office pledging to carry out the Constitution of 1944. Among its liberal principles: 1) censorship of press forbidden; 2) right to organize and voting rights expanded; 3) equal pay for men and women, husbands and wives equal before the law; 4) racial discrimination (vs. the Indian majority) a crime before the law; 5) maximum 40 hour workweek, one day off, social security; 6) ban on private monopolies; 7) universities have complete autonomy; 8) all high officials obliged to file statements of net worth before and after office; 9) military men forbidden to run for office; 10) the President limited to one 6 year term.

SUMMATION

The villains of the story are by now evident. Who are the heroes?

President Jacobo Arbenz? Not really. He was Hamlet.
You like him but he's too weak finally and indecisive
at the crucial moment when he should have organized and
resisted the paper coup. In ways he resembles us all,
neither hero nor villain but painfully splintered.
In accepting a wandering exile and a drunken death years
later in a bathtub in Mexico City, he evokes our pity
and our understanding. Like Hamlet, his is a tragedy
of strong intellect warped by doubt and failure of the will.
He will live out his life, doomed to forever regret his mistake.

The Film opens with his pathetic death in Mexico City and
threads back to the opening days of his triumphant election,
filled with glorious promises for the masses.

Among those masses is the idealistic young communist labor
organizer, handsome Victor Manuel Gutierrez. A popular
orator with a gift for kindness and generosity, he will
live to see his hopes dashed and his idol fallen. He
valiantly struggles to organize the peasant armies against
the might of the CIA and the Guatemalan reactionaries, but
fate defeats him. He goes back underground to fight --
and one day he too disappears. But like the Mexican hero
Zapata, his spirit lives on in the hearts of the new
generation that have come to take what is theirs.

Victor Manuel Gutierrez is a hero for all time.

And then there are the Americans who know what they are doing
is wrong. As progressives, as Adlai Stevenson supporters
and hence on the perpetual losing side of the Cold War 1950s,
they are appalled, angry, and ultimately frustrated. One
such man is a REPORTER for a newspaper who sees clearly what
is happening, but when he tries to write it, the people back
in New York decide he is biased and send another REPORTER down.

Then there is the STATE DEPARTMENT BUREAUCRAT who uncovers
various serious illegalities in his Department's activities
in Guatemala. He tracks down the culprits. He brings charges.
They are quietly suppressed. The BUREAUCRAT is transferred,
his career permanently and adversely affected. But without regret.
For though the price has been high, he knows what he has done
is right and there is no finer feeling in the world, is there?

THE END

A selection of Stone's notes to himself while writing the screenplay to *Salvador*: *(first note)*: 1. "Be more frenetic in San Francisco than Boyle [referring to Dr. Rock]." 2. "Men soften in Salvador." *(second note)*: 1. "Jimmy Woods. Attitude towards trip." 2. "Set up [different] for [Salvador]." 3. "More Boyle transition." 4. "Boyle inarticulate in confessional." 5. "Tragedy at end. 'Just the people.'" *(third note)*: "Jimmy Woods. Very soft, quiet, guy. Soft, simple, something I've never done. Grow, unfold—a transition not seen a month before."

OLIVER STONE OLIVER STONE OLIVER STONE

MATT ZOLLER SEITZ **How did the story of *Platoon* become resuscitated after that period when it had been more or less dormant, professionally?**

OLIVER STONE After *Year of the Dragon*, I crewed up and got a cast together, went to the Philippines, started the whole process. Emilio Estevez[1] was going to play Chris Taylor, the hero, who of course Charlie Sheen played later. I can't remember everyone else who was supposed to be in it, but I could if I went through the notes.

At this point, I was thinking, *I gotta give up on America!* Here's an honest movie about Vietnam, and *Rambo* comes out and makes a fortune, and fucking Chuck Norris *Missing in Action* pictures make a fortune!

Three of them![2]

And they can't make my movie for *nothing*? Only four million bucks?

You were historically out of step, though, through no fault of your own, because at that

At this point, I was thinking,
I gotta give up on America!

How were you feeling at that point?

Not good. The reviews on *Dragon* were no good! It was pretty depressing. Then *Platoon* fell apart. I'm not saying Dino De Laurentiis was completely duplicitous, but he couldn't get anybody to distribute it—even a sweetheart of a deal he had at MGM with Frank Yablans, couldn't even get them to commit to one to three million dollars in distribution. In other words, Dino said, *I'd pay for it, but you have to match me on distribution*. Nobody would touch me.

point, the attitude toward Vietnam had taken a turn toward the triumphal. We were rewriting history in those action movies you mentioned, and all throughout the Reagan era. The speeches Reagan and his administration were giving were all about putting the counterculture and Vietnam and all that ugly questioning behind us, and the Iran hostage situation that ruined the Carter administration,[3] and getting out there and kicking ass and making money. The Grenada invasion happened in '83,[4] mainly so we could feel like we'd finally won something militarily again.

1 Charlie Sheen's older brother; son of Martin; 1980s leading man thanks to *The Breakfast Club* and two *Stakeout* movies; later a film director. Estevez's 1996 movie *The War at Home*, based on James Duff's play about a Vietnam veteran struggling to adapt to peacetime life, evokes the 1970 Massapequa section of Stone's *Born on the Fourth of July*; Estevez plays the hero, Martin Sheen the father.

2 *Missing in Action* (1984); *Missing in Action II: The Beginning* (1986); *Missing in Action III* (1988).

3 Fifty-two American diplomats and citizens were held in Tehran by members of the Muslim Student Followers of the Imam's Line, in a crisis that lasted from November 4, 1979, to January 20, 1981, and included a failed rescue attempt by the US military on April 24, 1980. The hostage takers were hostile to the United States because it had backed the recently deposed Shah of Iran, Mohammed Reza Pahlavi, who was widely thought of as a US puppet. The crisis tarred the Carter administration as helpless in the face of terrorism and set the stage for the hawkish Reagan's election.

4 On October 25, 1983 (just two days after the bombing of US barracks in Beirut, Lebanon), US troops invaded the Caribbean island of Grenada, on the pretext of rescuing American medical students threatened by political upheaval there.

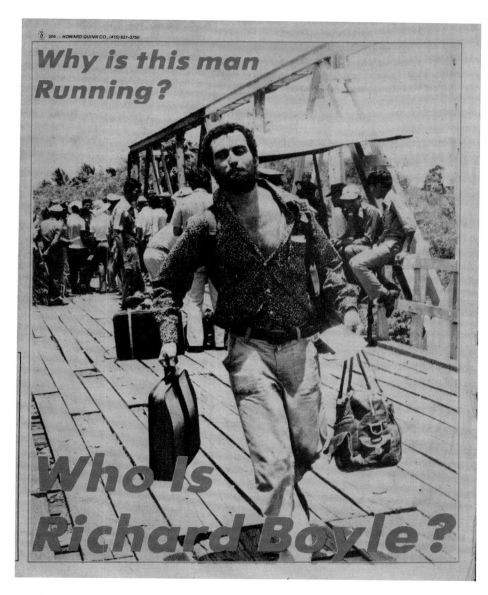

Why is this man Running?

Who Is Richard Boyle?

Campaign literature for Boyle's unsuccessful 1977 run for the San Franscisco board of supervisors. The previous year, he had lost an election for state Senate. In 1988, he lost a bid to become the Democratic nominee in California's 42nd District against Republican assemblyman Richard L. Mountjoy of Monrovia.

foreign rights salesman, nothing came about, and his option lapsed. I moved back to LA and met a scoundrel who I loved named Gerald Green,[10] an English producer–advertising guy, but a typical English guy—making foreign deals, making bad movies. Anyway, he knew John Daly,[11] the guy who saved this whole fucking show. John Daly was a young British producer, a little older than me, from the streets, a boxing promoter. He had promoted the Ali-Foreman fight in Zaire, ████████ ████████████████████████████████ ████████████████████████████████ ████████████████████████████████ ████████████████████████████████.[13]

This had an incredible, Atlantis-like flowering in the eighties.

5 "If a Russian nuclear sub can be fifteen miles off the coast of New York harbor, what difference does it make if the Russians are in Nicaragua?" Stone told Patrick McGilligan in a 1987 *Film Comment* interview.

6 "I don't think the American people have even begun to come to terms with Central America," Stone told Gary Crowdus in a 1988 *Cineaste* interview.

7 Attorney representing Tom Cruise, Philip Seymour Hoffman, Andie MacDowell, Roseanne Barr, and other celebrities; cameos in *The Doors, Nixon,* and *Heaven & Earth.*

8 1929– ; American entertainment lawyer whose clients have included the Beatles, Michael Jackson, Tom Cruise, and Warren Beatty.

9 1935– ; entertainment and banking lawyer who became a film producer; *Platoon* (1968); *The Fugitive* (1993); *Se7en* (1995).

10 1922–2006; producer of *Salvador* and *Platoon* (1986) as well as *The Far Side of Paradise* (1976), *Sunburn* (1979), and *Rescue Dawn* (2006). In 2009, Green and his wife Patricia were found guilty of conspiracy to violate the Foreign Corrupt Practices Act and money laundering laws in the US after paying $1.8 million in kickbacks to the governor of Thailand's Tourism Authority to run the Bangkok International Film Festival.

11 1937–2008; see footnote 10 on this page.

12 Redacted.

13 Hemdale's name is an amalgam of the first syllables of the last names of its founders, John Daly and actor David Hemmings (*Blow-Up*). Daly told Roger Ebert in a 1969 *Chicago Sun-Times* interview that they founded Hemdale "as a way of avoiding England's high personal tax rates." The company produced two back-to-back Best Picture Oscar winners, *Platoon* and *The Last Emperor*, plus a number of successful genre films, but followed them up with a series of flops and went bankrupt in 1996.

And intervention in Central America, which had been going on for decades, was going full steam, because of fear of Communism. Right around the time you were cutting *Salvador*, the British edition of *Mad* magazine put Rambo on the cover, getting his orders from Reagan, who was pointing to a map of Central America. It's like they were reading your mind.[5]

It was a nightmare. You have to become dead or cynical. In a certain way, I did.[6] It was heartbreaking to see this cast fall apart, and the relationship between Michael and Dino started to sour a little bit. *Dragon* came out in '85, didn't do as well as everyone had hoped. This is why Dino is a cretin. Not only did he not make the picture [*Platoon*], he *kept* the fucking material and wouldn't give it back to me! So I'm fucked because he didn't pay me my full fee on *Dragon*, and the picture was about to open, so thank God, I got really angry, went to a lawyer—one of the few times I ever initiated a lawsuit—to try and get my script back! The decent thing to do is let me run with it at least! So Bob Marshall,[7] a litigator at Bert Fields's[8]

office, came up with a ploy: We're going to go after copyright on *Dragon*, and we did.

The moment we started making noise of, *You can't release* Dragon *because you did not fulfill your contract with this employee, blah blah blah,* I forget what the litigation deal was, but basically, that scared Dino. My father was dying in the meantime, so this was really painful for me—at my father's bedside in New York and on the phone with a lawyer trying to get my script back! Dino was charming, but a motherfucker in business. It wasn't the first time he fucked me. He did it *five times*! He did it on *Conan*, and on *Alexander*, but we'll get to that later—that's twenty years down the road.

So who ended up in your corner?

At this point, everybody'd read the script. It felt like it'd been trashed, it had been around and around, I was just hopeless. So I gave it to a Greek American guy who was trying to sell it in some weird deal, but I didn't really have any hopes. Somehow, his option expired and Arnold Kopelson[9] entered the deal. He was a

THE WHITE HAND

Over 1,000 CIA-trained killers have formed their own Murder, Inc. in Latin America—and now even the CIA is worried that this independent terror network is permanently out of control.

ALBUQUERQUE JOURNAL Saturday, April 10, 1982 A-3

Nicaragua, El Salvador

fostered Bolshevistic hegemony intervening between the United States and the Panama Canal.'

Today, it is Secretary of State Alexander Haig warning of "Marxist-Leninist inspired and controlled subversion spreading from Nicaragua to El Salvador and throughout Central America.

Negotiations arranged by Secretary of War Henry L. Stimson ended the fighting and ensured the presidency for Diaz, but one rebel leader refused to participate, Augusto Sandino.

Sandino was 34 in 1927, the educated son of a coffee-plantation owner and wily leader of more than 1,000 guerrillas opposed to the presence of the Marines and Washington's deep involvement in Nicaraguan affairs. Today, the administration charges the Nicaraguans with supplying Soviet-bloc arms to the leftists in El Salvador. Sandino was accused

of bearing arms provided by Moscow.

Richard O'Connor, writing in American Heritage, said reporter Carleton Beals, of The Nation, visited Sandino in his hideaways and found the arms did have Russian markings.

"Investigation showed, however, that they had been manufactured in the United States for export to the Kerensky regime (which succeeded the Czar which gave way to the Bolsheviks), subsequently they were sold as army surplus to Mexico and were among the four boatloads of arms that Mexico sent to the Liberal revolutionaries just before the Nicaraguan revolution broke out," O'Connor wrote.

The Marines, with superior arms and devastating air power, eventually wore down Sandino's rebels in intensive jungle fighting. U.S.-supervised elections were held again but Sandino

refused to lay down his arms.

But finally he joined in disarmament talks at Managua with Sacasa and Anastasio Somoza, the commander of the National Guard.

Sandino had dinner with Sacasa's family on Feb. 21, 1934, under an amnesty. After his party left the president's residence, their cars were stopped outside the grounds.

The rebels were taken to the Managua airport, stood before a machine gun and shot.

Somoza forced Sacasa to resign, assumed the presidency and managed Nicaragua as his personal fief. He was assassinated, and in 1967 his West Point-educated son became president.

Sandino was remembered not only in the mountains where he fought, but has been regarded as an exemplar throughout the Southern Hemisphere.

Central America's History of Turmoil

Long and Complex U.S. Involvement
Spotlighted by Strife in El Salvador

exclusive report on
in El Salvador's offi

Terror, Right and Left

A bloody struggle rips Central America and endangers U.S. interests

Nation

QUO VADIS, CENTROAMERICA

CENTRAL AMERICA

MEXICO

BELIZE

GUATEMALA

HONDURAS

EL SALVADOR

NICARAGUA

COSTA RICA

PANAMA

COLOMBIA

Military aid $10 million
Economic aid $38 million

Miskito Indians

Military aid
Economic aid $10 million

Military aid $0
Economic aid $11.7 million

Military aid $80 million
Economic aid $104 million

Military aid $50 thousand
Economic aid $51 million

★ Recent fighting
■ Guerrilla activity

San Salvador ★★

EL SALVADOR

CARIBBEAN

Panama Canal

PACIFIC OCEAN

All U.S. aid figures for 1982 fiscal year

40 miles

0 100 miles

TIME Map by Paul J. Pugliese

BEHIND THE DEATH SQUADS

BY ALLAN NAIRN
PHOTOGRAPHS BY MICHAEL KIENITZ

(Copyright © 1984, The Progressive, Inc.)

(Continued from Cover)

(opposite) Documents from the files at Ixtlan Entertainment containing news articles from the early eighties on the political situation in Central America, used by Stone and *Salvador* cowriter Richard Boyle while writing the film's screenplay.

(below) Elpidia Carrillo, costar of *Salvador*, in one of a series of stylized photos commissioned for the film's press kit but never used.

Had he been straighter, he could've been the first Harvey Weinstein. At that point, Hollywood was changing. The video thing started happening in the eighties. *The River's Edge*[14] in '86, a small film, seven, eight million dollars, did well on video.

Their first big one was *The Terminator* in '84. It did all right in theaters,[15] but it made a ton on videocassette, which was the model that a lot of successful indie films followed then.[16]

That was Daly's first hit, I guess. John was this tough guy, but there was something about him that gave me hope.

I'm in the dumps then, you have to realize—I've been writing the script of *Salvador* in '85.

With my own money I paid Richard Boyle, and we went down to Salvador, in Central America, and I was down on my luck. Nothing had come from *Scarface* or *Dragon*, except for problems, and *Platoon* had been heartbreaking. So I said, *I'm just desperate, desperate*. I went up to San Francisco and I saw Richard, who I'd known through Ron Kovic, and Richard was a funny character, running for Board of Supervisors in San Francisco. He had no money, was living out of the back of his broken down MG, his girlfriend was living in a trailer.

On my way to the airport, he had stacks of loose pages in the back of his car, and when I asked, *What are these?* he went, *Oh, those are my Salvador stories!* I said, *Let me read it!* I read it and I was really magically transported. I was like, *This is great fucking stuff!* It wasn't a screenplay, just a series of his adventures in Salvador, but it was great!

I brought the guy down in early '85, I guess. My wife had our first child, Sean, who was literally crawling around on the floor while Richard and I hacked it out—I was writing, making notes, doing my structure thing and having fun with it, and Richard was drinking everything he could! He drank the fucking baby formula out of the icebox. My wife was like, "I want him out of the house!" He was trying to fuck the nanny, too! He was the ultimate bad houseguest! I think he *did* fuck the nanny! I know that Jimmy Woods did.

Where else do you meet people like that? Where else do movies come from? This one was about the life adventures of a maverick! Well, Boyle was a maverick journalist—he wrote a book about it, *Flower of the Dragon*.[17] It was about being on a forward base in Vietnam

when a mutiny of soldiers took place. Separately, he was in Cambodia at the French embassy right to the bitter end, when the Khmer Rouge came into Phnom Penh in '75. He's always been a bit of a thrill seeker, too, but at the same time he believes in justice, and he's fought for it, and written about it. He's a definite left-winger. He ran for the Board of Supervisors in

14 Dark youth drama written by Neal Jiminez and directed by Tim Hunter, about a teenager who murders his girlfriend and contrives with his peers to keep it a secret.

15 Total worldwide theatrical gross $78 million, versus $6.4 million budget.

16 According to an article by Tino Balio in 2002's *The Film Cultures Reader*, "Home video, a fledgling technology early in the 1980s, became the fastest growing revenue stream in the business. . . . Although the theatrical box office reached a new high of $5 billion in 1989, retail video sales and rentals had surpassed that figure by a factor of two."

17 Boyle went through three tours in Vietnam as a war correspondent. The book *Flower of the Dragon: The Breakdown of the U.S. Army in Vietnam* (Palo Alto, CA: Ramparts Press, 1972) emerged from that experience. For more on Boyle, see the section on Salvador on page 120 of chapter 3.

7.
(Rev 2/16/8

ATTENDANT (worried, moves away, to his
(assistant)

Boyle grabs Rock, calming him, getting him out of there.

BOYLE
Come on Doc, let's get out of here,
we're on shaky ground...

12. BOYLE'S TENEMENT APARTMENT - DAY

Boyle runs up the stairs, Doc following.

BOYLE
...Carla's got a few bucks in the bank.
I think she'll help us but we gotta
tell her real nice... *but no monster acts.*

The eviction notice is on the door. Boyle rips it off.
On the back is scrawled in large letters "FUCK YOU" in
Italian. Doc looks at it over Boyle's shoulder.

DOC
What's that, Italian? What's it mean?

BOYLE
"Fuck you" *in Italian* ...

As he enters the apartment. It's stripped, except for his
dirty clothes. And the black and white TV. His face
registers a moment of sorrow and despair. And then it's
covered over by his optimism.

DOC (sympathetic)
Oh shit man, it's too bad...

BOYLE
She'll come back, she loves me... come on.

As he sails out the door without another thought. Except
to turn back and grab the little TV *and his typewriter.*

13. DESERT OUTSIDE LAS VEGAS - DAY

The skyline of Vegas as Boyle and Rock speed towards it
in their MG. Rock smoking joints, listening to his rock
and roll radio, Boyle intent over the wheel, eyes like
marmosets, looking now, suddenly, in his pockets. Crumpled
bills, papers, money -- a mess. He's pissed.

70. CONTINUED:

Pauline Axelrod writing down his response to her question
("thank you"). Max looking around for the next question.
A bunch of raised hands. His supporters all wearing Major Max
tee-shirts, "Casanoca Youth," etc. Boyle pushes his way up
to the front, a two-man VIDEOTAPE CAMERA CREW, both Salvadorans,
with him from CNN. Cassady is there also, shooting stills.

 BOYLE
 Mister Casanova - it's widely rumored
 that you're the head of the Death Squads
 that are terrorizing the countryside
 and the city? Would you please comment?

Max looking at Boyle very cool. Murmurs all around the room.
There is pushing and shoving and it looks like Boyle is going
to get beat to shit.

 CASSADY (whispering)
 You're pressing your luck, Rich.

Max grinds out his cigarette in the ashtray as he responds, very
calm on the outside. Gomez flicks his eyes at him.

 MAX
 It's curious that this question comes from
 an American journalist...we're after all
 fighting this war for America. I resent your
 question personally because when you accuse,
 you've got to present proof. Why do you never
 ask the Communists how many have they killed,
 how many have they raped, and kidnapped and robbed.
 You insult our struggle when you accept as fact
 that we're the only ones doing the killings and that
 they're the only victims.
 There are no "death squads" in El Salvador.
 It is a political struggle...it's simply the
 outrage of the people against the foreign
 Communist agression. This outrage can not be
 stopped...nor does it need to be organized by anyone.

O.K but too long (handwritten note)

 PAULINE
 Sir, polls still show you trailing the Christian
 Democrats, do you really think you can get the
 Catholic and the Woman's vote.

 MAX
 Have you seen what Duarte looks like?
 Who would you vote for?

OK. (handwritten note)

Laughter as the Press Conference ends.

2. *RN take out* *too ugly, not likeable* *see it without it.*

Cut out only girth you o minutes

7. Cut out Belushi drunk with 16 year old girl.

8. Cut down and make more tender the second
 love scene with Marie. If possible, use
 a close-up of faces. ⟶ *more lyrical.*

9. Cut down by one-third the middle part of the
 battle scene where the principals are not
 involved. ⟶ *too many explosions OVERKILL*

"I love it here in El Salvador" too... *omit*

10. Open on Belushi appearing in hospital with
 baby. Cut out Belushi statement in car that
 he is really happy that Richard brought him
 to Salvador. *street after street (who identifies)*

"I hear you. Will cut down on Oliver Stone for being gratuitous... too of scarface make point - move on

11. Please, I urge you to cut down on some of
 the blood and guts. Also, I seriously ask
 you to look at how many times we have to
 see the dead nuns coming out of graves as
 we do get the point immediately. *2 shots + cut shallow graves - sparing - till get to his fall woods.*

12. Finally, cut out the last card and ~~centre~~ *focus* on
 Marie and Richard. *TO JD. LT. shorn head justified*

 (13) *Recut Guerrilla (amp — Cut night xx*

Oliver, I do not want to have a legal battle with you
but, for the good of the film, I am asking for your co-
operation.

I am prepared to have these discussions with you and
any other third party, including the principal actors
and, if it is at all helpful, I will work with Claire
to at least show you what I have in mind.

Regards,

P.S. Finally, Oliver, as my Company will be resonsible
for getting back approx. $10 million in negative, prints
and advertising, plus interest, it is my intention to
have a 2-hour version.

Take out Smiling Death's death.

① *Take out Smiling Death's death.*
② *Take out Burning Boy*
③ *City Hall — 2nd time*

Jim Carlos

Just a look can do an awful lot.

|||

So we go to Salvador, and we concoct this plan —
it was insane!

|||

San Francisco and he lost. He was strange. A scoundrel, yes. Jimmy hated him. But I think Richard was always the spirit behind the movie.

So we go to Salvador, and we concoct this plan—it was insane! We met with Colonel [Ricardo] Cienfuegos, who was the chief spokesman for the Salvadoran armed forces, and we were going to get the whole Salvadoran army on our side!

Wait, what? You're telling me that you went to El Salvador in the 1980s to try to get the army of El Salvador to help you make your film about how bad the army of El Salvador was?

It was an amazing con game, and we really played it! We went to the offices in Salvador, and we had no money! We were trying to make this movie with nothing!

Did anybody in the government of El Salvador actually read the script?

Yeah, but it wasn't the real script. We gave them dummy scripts! We were going to go to Mexico to finish it, but we wanted to get their approval first, so we could shoot as much as we could there.

Ricardo Cienfuegos was our main ally. He got us in with all the military people. I met all the big shots in the military. Cienfuegos was a good guy. He was killed the day I got to New York. And on the front page of the *New York Times*, there was a picture of his body on a tennis court, draped under an FMLN[18] flag. That was Ricardo! That was bad news.

So there went our plan. Another setback. Poor Cienfuegos! I gave the script to Gerald Green in there, and he loved it and immedi-

ately went to Daly. Daly literally came to me, and I remember a conversation we had in early '85, where he said, "Which one do you want to do first, Oliver? *Salvador*, or *Platoon*?"

So the studio was going to make both movies, and it was just a question of which order you'd prefer to shoot them in? That's quite a reversal of fortune from what you'd been dealing with earlier.

18 Farabundo Marti National Liberation Front. An umbrella group consisting of five partipants in the Salvadoran civil war. Demobilized after the signing of 1992 peace accords, they became a left-wing political party.

After all those years of shit!

And in the end, the movies came out in the same calendar year!

I made a mistake at that point, because I should've said, *Let's do* Platoon *first,* but I was scared because of the curse that had followed me on two different productions, so instead I said, *Let's do* Salvador—*it's timely and* Platoon*'s never going to happen.* I said we could do *Salvador* for two, three million, and we couldn't, but anything to get it made.

So he said, *You have my blessing, go!* And literally, we went.

I wanted to put Boyle in it at that point.

To play himself?

Because he was so crazy! We did a screen test, which I have somewhere—it's hilarious! Richard, because of the drinking, was one day green, one day red, and the other yellow! He could never have the same skin tone! But he did do the screen test, because he wanted to fuck all the girls! John was very nice, he was like, *Oliver, don't you think we should use an actor?* I thought, "OK," so we went with Martin Sheen.

By that point Sheen had played dark or crazy before: *Badlands, The Little Girl Who Lives Down the Lane, Apocalypse Now,* and *The Dead Zone.* So why'd you end up going with Woods?

Because Jimmy Woods walked in to play Dr. Rock, we went to dinner somewhere, and the whole dinner, he talked me out of Martin Sheen! Martin was having problems with the violence and the sex anyway, since he's a very clean-cut, Catholic guy. Jimmy, ironically, ended up hating Boyle anyway, because Boyle was so insane. Jimmy likes order, he's a very ordered guy, but insane [END 1]. Boyle was insane, too!

What was that shoot like?

I'll never forget the shoot. It was one of the most insane shoots I've ever been on in my life. Gerald Green takes all the money from Daly he can get: 3 million. He decides to cash in on it overnight and make another movie off that money. So he has a sweetheart of a deal at the Mexican bank, puts all the money in, and the next week they devalue the currency and the 3 million is worth like 2.4 or 2.3! We lost 800,000 dollars! It was a mess! Everything

possible went wrong! The crew quit five times. Mexican labor crews are very tough. Woods was complaining from beginning to end. The conditions were tough—you saw the picture, it was a mess! We ran out of money, got kicked out. Literally kicked out of Mexico.

Why?

We hadn't paid the crew! I like Gerald, he got the movie made, but at the end of the day it was so painful. But John, because of his success, put up another million to finish this

damn thing. I told him I had no beginning and no end but a great middle, so we finished shooting in San Francisco, for the beginning, and the ending in the desert of Las Vegas, so thank God I didn't shoot the beginning or the end first, because they would've cut the middle for sure! *(Laughs)*

But the last scene, I didn't know what I was doing! I took all these vehicles out in the desert, and I'll never forget, the new production manager had all the money in a briefcase, and somebody opened it and it was like *Treasure of the Sierra Madre*—the money was flying around! It was insane! We finished the last shot as the sun went down.

And then it was ready to go?

Orion looked at *Salvador* during the editing process, and said, "It's too violent, it'll get an X rating, we'll never take it." It broke our hearts and that was hard, because we needed a distribution deal. But things were changing with the video revolution. Daly had more confidence, so he said, "I'll form my own distribution company." And he did! We fought like cats and dogs in the editing room, though. Daly wanted to control some things and I refused. It was a catfight there, because it was a violent picture, the first cut three and a half hours, and I had to get it down to two!

And you did.

Two ten, or something like that. But some scenes got butchered in the process. I had people giving blow jobs under tables in the

movie, stuff that was just insane.

It still has an edge, though. It feels counterculture. It's *Fear and Loathing in Central America.*

It was! It was a real thing.

And you have a main character in Boyle who genuflects toward wanting to be redeemed, but it's pretty clear that that's never going to happen for this guy—that Boyle is who he is. The confession scene, where he's promising to reform if he can save his lover but keeps carving out little excep-

Cienfuegos was a good guy. He was killed the day I got to New York.

tions for himself: That's one of the great scenes in your filmography.

I didn't write the scene! I was so angry with Woods that day that when I was discussing the scenes, I said, *Just go in there and tell them what a weasel you are!*

So that's just James Woods winging it?

It is, and he starts with, *I'm a weasel! (Laughs)* It reads like a made-up scene, but it is him.

He and I were almost killing each other. One day he walked off the set, on foot, into the Mexican wilderness.

Was he angry about the conditions?

Everything was wrong. Jimmy's a chronic complainer. I love him now! But when he walked off, we cut off all the cars. I called all the cops and said, *There's a lunatic loose on the roads! Recoup him for us!* So we had cops looking for him to bring him back as a madman! He walked for about an hour and a half along the road some fucking place, and we finally got him back.

I mean, every day with Jimmy was rocky. On *Salvador* he was the lead, so that was tooth and nail. *We were like two madmen in a Cuisinart,* he said. Isn't that a great expression [END 2]?

It is.

Jimmy was the star of the film, and a bit of a bully. He had the most work experience of any of us, so naturally he knew where the

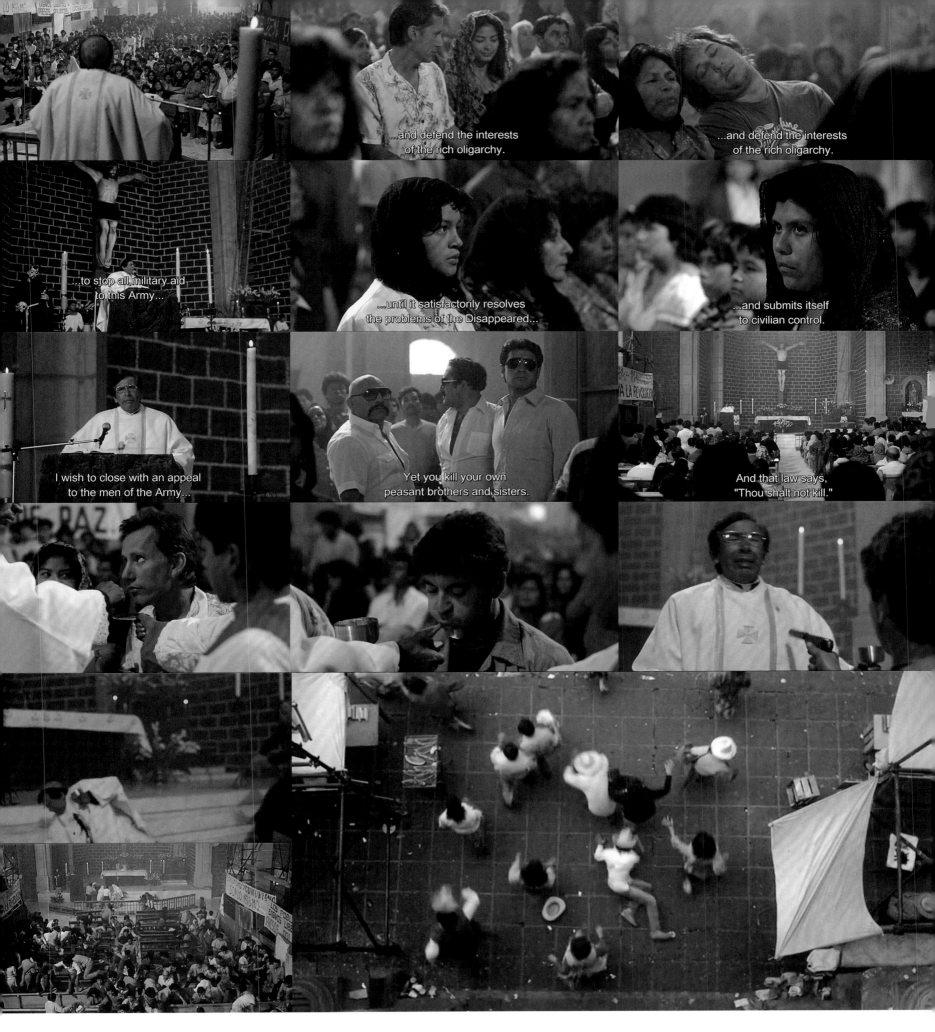

149

camera should go! And he had a lot of complaints about Mexico. He doesn't travel well—talking about how he was "stapled to the toilet seat," that kind of stuff. "This place sucks." He doesn't like to travel, he's anal in that way. His house that he bought was very clean. He had the cleanest house, almost like no one could touch anything!

But he was fun. He was great. He was great in *Salvador*. He got an Oscar nomination out of it. And he was great in *Nixon*, don't forget, as Bob Haldeman, and as the team doctor in *Any Given Sunday*, giving shit to Matthew Modine. Every time, he gave me great energy. Jimmy's got the mind of a steel trap. He's very articulate, fun and witty, much more sophisticated and sexy than people realize, if they don't see the side of him that women are attracted to.

Sometimes he's crazy, but that's what makes a great actor. There has to be some craziness there. Jimmy was born that way.

You're very left wing, and James Woods has very right-wing political views, more so now than when you first worked with him almost thirty years ago. Would that stop you from working with him again?

I don't think so. I had dinner with him a while ago.

A documentary of you and James Woods having dinner would be very entertaining.

We have fun. He's very smart; people know that.

Do you have conservative friends?

Sure. I like Milius, he's a big conservative. I cast [Charlton] Heston in *Any Given Sunday*, and I enjoyed Heston. It's good to hear the right-wingers. I don't know what the hell they're thinking—they might be out of their minds!—but I'll hear it. That doesn't bother me. It's fun, you know?

I did three movies with Jimmy, but even when he played H. R. Haldeman in *Nixon*, he never hit me with any of that right-wing stuff! I was a little depressed after 2002, when he became a little more active as a conservative. And you know, my friend Stanley [Weiser] wrote a 2003 movie about Rudy Giuliani for TV, *Rudy: The Rudy Giuliani Story*, with Jimmy as Giuliani. He

150

(*opposite*) Stone, James Woods, and John Savage on the set of *Salvador* in Mexico in 1985.

(*below top*) Set photo of the early scene from *Salvador* in which Boyle (Woods) tries to hustle up work.

(*below bottom*) Notions for the screenplay that would later become *Salvador*, from Stone's archive. "x Hoagland [NEWSWEEK]—Salvador—#4 yrs— x
x – US. Press Photog – – x, x Shot by sniper—Grunt, fire-fight x, 'magic'—'no bullet made can get me' in love w/Laura, Salvadoran woman" ("Hoagland" is a reference to
Newsweek war photographer John Hoagland, who was gunned down on March 16, 1984, while photographing two Salvadoran soldiers.)

Just go in there and tell them
what a weasel you are.

said Jimmy wanted to change a lot of it; I don't know what the result was of all that. Jimmy's Rudy Giuliani devotion was not my cup of tea. But I don't think I ever had an argument with him about it.

Guys from Vietnam, guys like Stanley White—there are plenty of people in my life who are conservative. I know their arguments; I try to listen to them. But I don't talk politics with friends. They know my politics to some degree, because they know my work, so I'm not about to belabor that. If they ask me about politics, sometimes I get upset, but I'd rather not be. I'd like to have fun with people. Jimmy is great. I'd rather talk to Jimmy than some left-wing bore.

Tell me about the style of *Salvador*. It seems very controlled yet also loose. Parts of it look like it's a documentary with actors.

Robert Richardson[19] had done a documentary on El Salvador, so I liked him. He did his job, and so did Bruno Rubeo,[20] a great production designer. We had a censor, Mexican censor,

exhilarating. The editing of *Salvador* was very rough and tough, because it was a raw experience. We finished in fall of '85, and we had a hard time with John Daly. That was his only problem: his control of the editing room. But I was tough, too, and we went back and forth many times. He had the money; I was over budget. So I was indebted to John, and at the same time anxious, because I wanted to make *Platoon*, but I

do any business in New York. Essentially it died on the vine.

If I didn't have *Platoon* to lift me up and carry me into that next round, I don't know that I could've gone back. I was pretty depressed.

How were you able to move on and finally get *Platoon* made?

Orion had passed on *Salvador*, but then had a "maybe we'll distribute it" kind of thing for *Platoon*. There was nothing locked. They'd look at it. But they were very concerned about my violence level.

We went down to the Philippines, made it under very averse conditions because, believe me, the 6.5 million, whatever it was [END 4], didn't travel very far. But we were very well organized and we shot it like a drill camp. I mean, no matter how difficult the conditions, we would always go out there. We drove them hard, the cast and crew. The crew was great. It was a Filipino crew. We were working in jungles, and it takes a toll.

"We were like
two madmen
in a Cuisinart."

very sensitive, on the set the whole time. I wanted all the dirt and shit in this Central American town, and she'd come up and go crazy! She'd say, *This doesn't represent Spanish people!* So our associate producer, Clayton Townsend,[21] had to keep her off the set, and he did a pretty good job of doing it! We'd have to bargain, cut the amount of rubbish and vultures down, which is what Salvador was like when I drove there. You can imagine: It was crazy.

It was that kind of production, catch-as-catch-can. John [Daly] had full faith. But I was scared that because I'd been on the edge of destruction so many times, they'd have no faith in me to make another movie—that this would be the end of my directing career, that I'd have *Salvador* and that's it. But John never lost faith. John kept the faith, and he sent me back to *Platoon*.

There was tremendous excitement in '85, doing *Salvador*, and I felt like we had something. The editing was torturous but

didn't want to have a knife held to my throat and say, *Well, if you don't cut it this way, we're not going to make* Platoon. Do you understand? I was the strong guy, I'd hold on to my cut as much as possible, but it was three hours. Too bloody, too violent. It got turned down everywhere.

By theatrical distributors? Which means you're at risk of having your movie go straight to video, which you definitely don't want.

Right. But he decided to distribute it. [Making the film] was always against the odds, and all of a sudden, it opens in April of '86. It had a thrust of some original, good reviews in Los Angeles—the *Chicago Tribune* review by Michael Wilmington was great—but in New York, another *New York Times* guy was saying this was leftist propaganda, that it was Costa-Gavras all over again, which to some degree it was; but it was not a nice review [END 3]. The film didn't

19 1955– ; documentary cinematographer who moved over to dramatic features; shot Stone's films from *Salvador* (1986) through *U-Turn* (1997), plus films for Martin Scorsese (including 1999's *Bringing Out the Dead* and 1995's *Casino*) and Quentin Tarantino (from 2003's *Kill Bill, Vol. 1* through 2015's *The Hateful Eight*).

20 1946–2011; Italian-born production designer on *Salvador* (1986), *Platoon* (1986), *Talk Radio* (1988), *Driving Miss Daisy* (1989), *Born on the Fourth of July* (1989), *Kindergarten Cop* (1990), and *Sommersby* (1993).

21 Served in production capacities on Stone films from *Born on the Fourth of July* (1989) through *Any Given Sunday* (1999); also produced for director Judd Apatow from 2005's *The 40-Year-Old Virgin* through 2012's *This Is 40*.

153

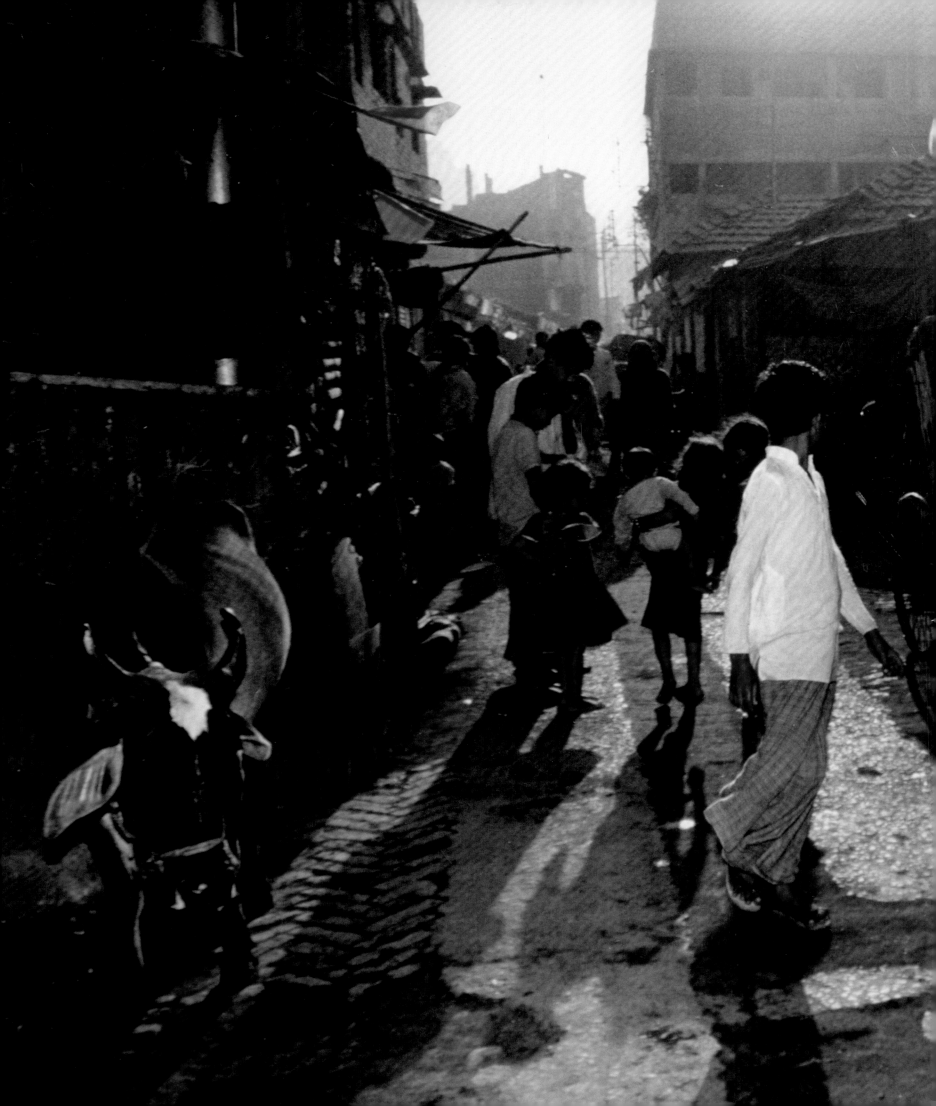

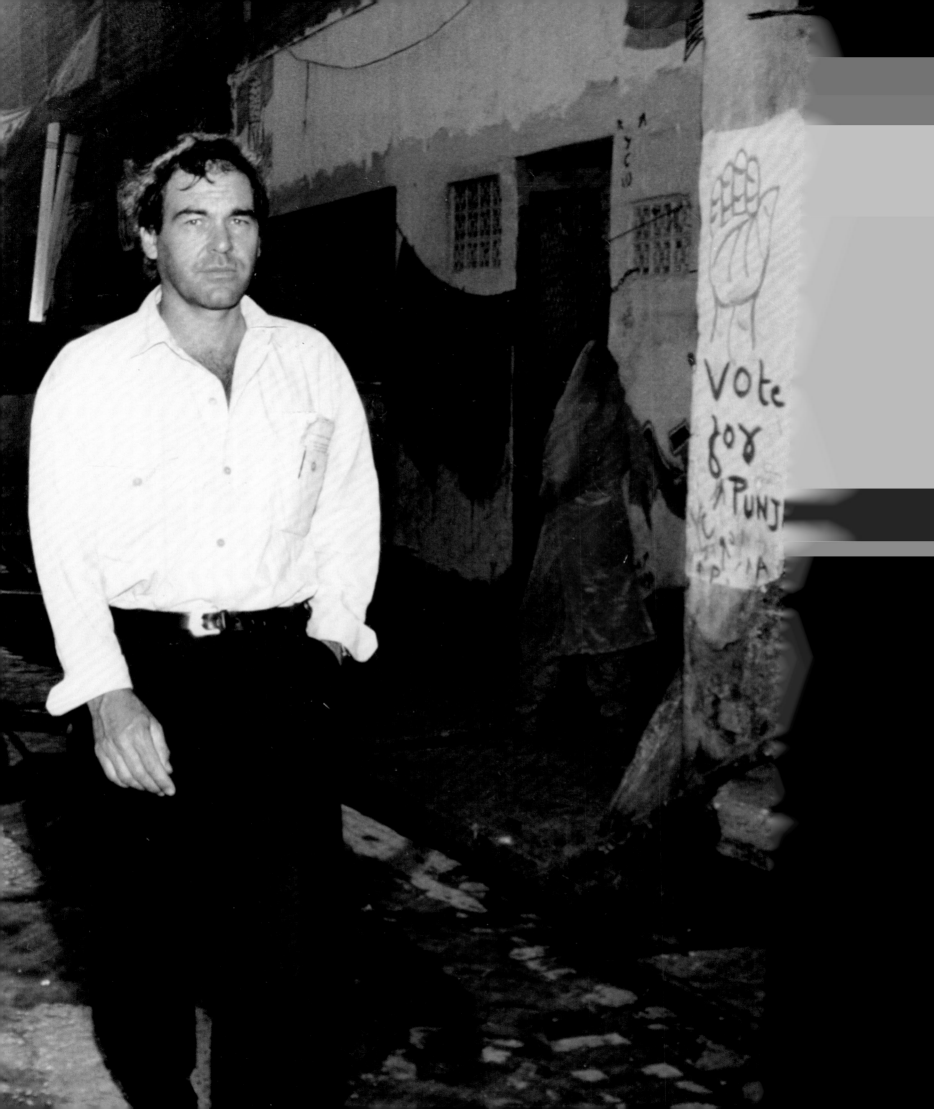

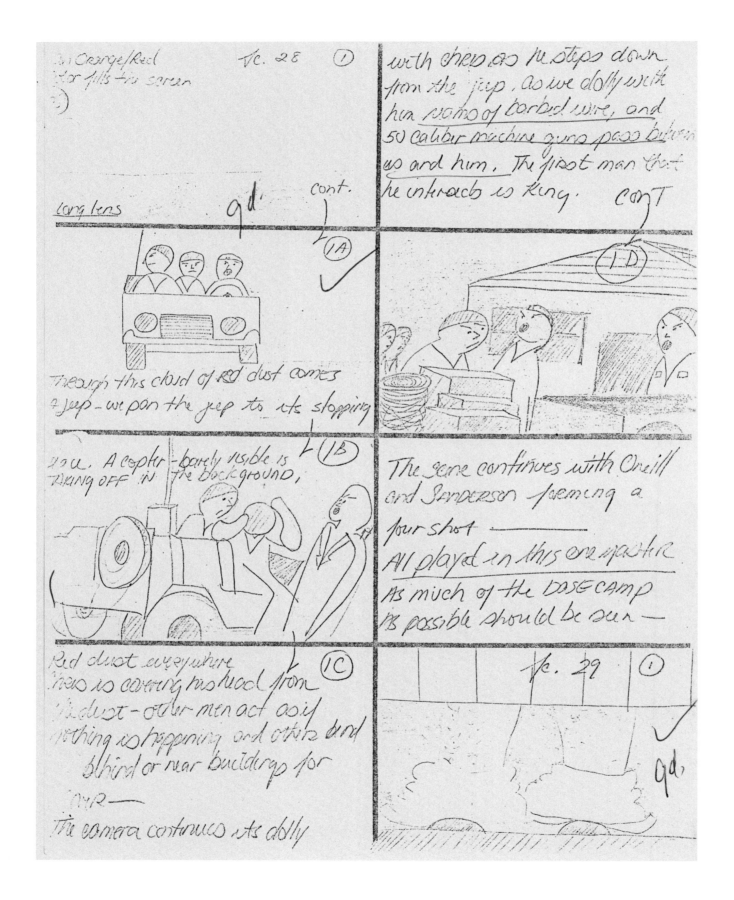

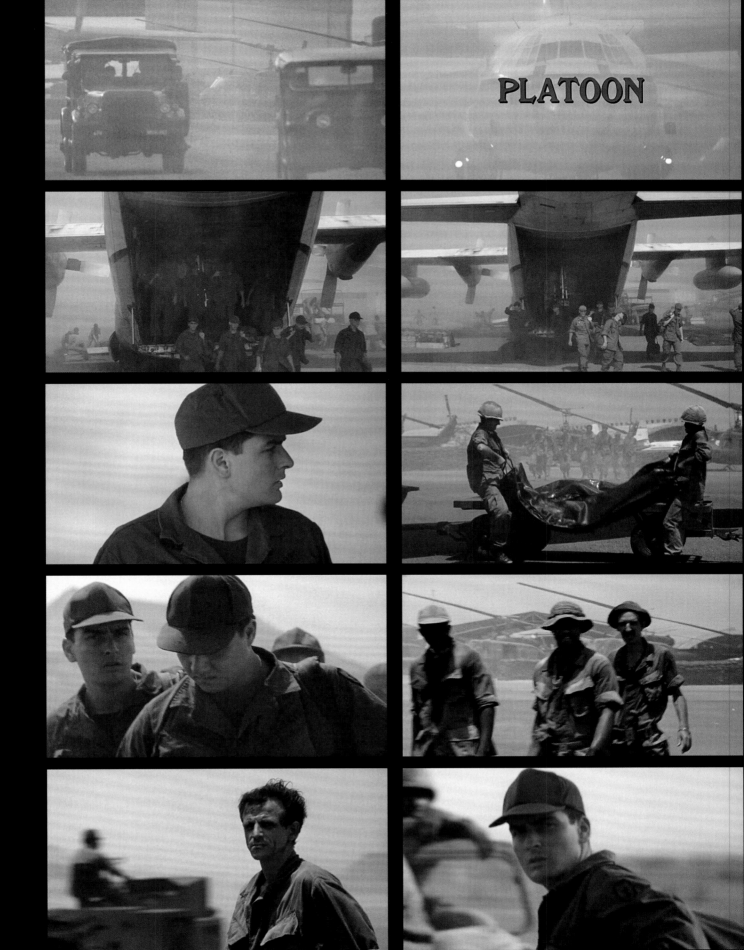

1.

FADE IN slowly on:

1. THICK JUNGLE. Abundant, suffocating, cloying to the senses.
 Trees writhe to thirty foot heights. Birds and mysteriously
 unidentified animals make uneven rackets of SOUND that carry
 throughout the movie.

 CREDITS begin over:

 SOUNDS of men moving through jungle. Machetes. CHOP -
 SLASH - WHACK. Shove. Push. Grunt. Rip. Then:

 A sweating FACE comes into view and moves past. A tough
 stolid Hawaiian Chinese face - FU SHENG, in faded G.I.
 green, machete raised in right hand, M-16 in left.
 Followed by:

 ELIAS - strikingly handsome face tanned by sun, dark eyes,
 black hair, three stripes on a faded partially unbuttoned
 army shirt with flaps on the broad shoulders; a .38 re-
 volver in a holster under his armpit and in his hand a
 modified M-16 with collapsible stock and ventilated barrel;
 a silver wristband on his hairless left arm. Accompanied
 by SOUNDS of radio static suggesting a force of men behind.
 He moves past, followed by more FACES.

 SUPERIMPOSE: SUBTITLE - December 25, 1967. BRAVO COMPANY,
 FIRST BATTALION, TWENTY SECOND INFANTRY, THIRD BRIGADE,
 TWENTY FIFTH DIVISION - ON SEARCH AND DESTROY ADJACENT
 THE CAMBODIAN BORDER, SOUTH VIETNAM.

 VARIOUS ANGLES AND FX of the march formation as CREDITS
 continue:

2. LIEUTENANT RICHARD WOLFE, moving with the Platoon CP,
 monitoring the radio; irritated and wiping his face with
 a towel. He is over six feet, thickset, 23. Followed by:

 ACE, a wiry little kid with a rough stubble on his cheeks,
 a deep bitterness in his eyes, hauling the platoon radio;
 a shotgun in one hand. Constant low keyed radio STATIC
 from other webs. Followed by:

 DOC, the platoon medic, tousled curly hair and a birdlike
 face, 19.

3. SGT. O'NEILL, a freckled short red head, 36, a lifer,
 four stripes, hard looking. Followed by:

 TEX, carrying the big M-60 machine gun perched in a see-
 saw fashion on his shoulder; a lean tall white kid with
 a fancy cowboy mustache curled at its edges.

4. ANGEL - a tough little blondish 18 year old carrying a 12
 gauge rakishly slung in one hand, his shirt open on a
 hairless chest. A tatoo on his arm: DEATH BEFORE DISHONOR,
 and graffitti on his helmet: FUCK A COMMIE FOR CHRIST.
 Followed by:

 (Cont'd.)

CHRIS PEDERSEN
TONY TODD
CORKEY FORD

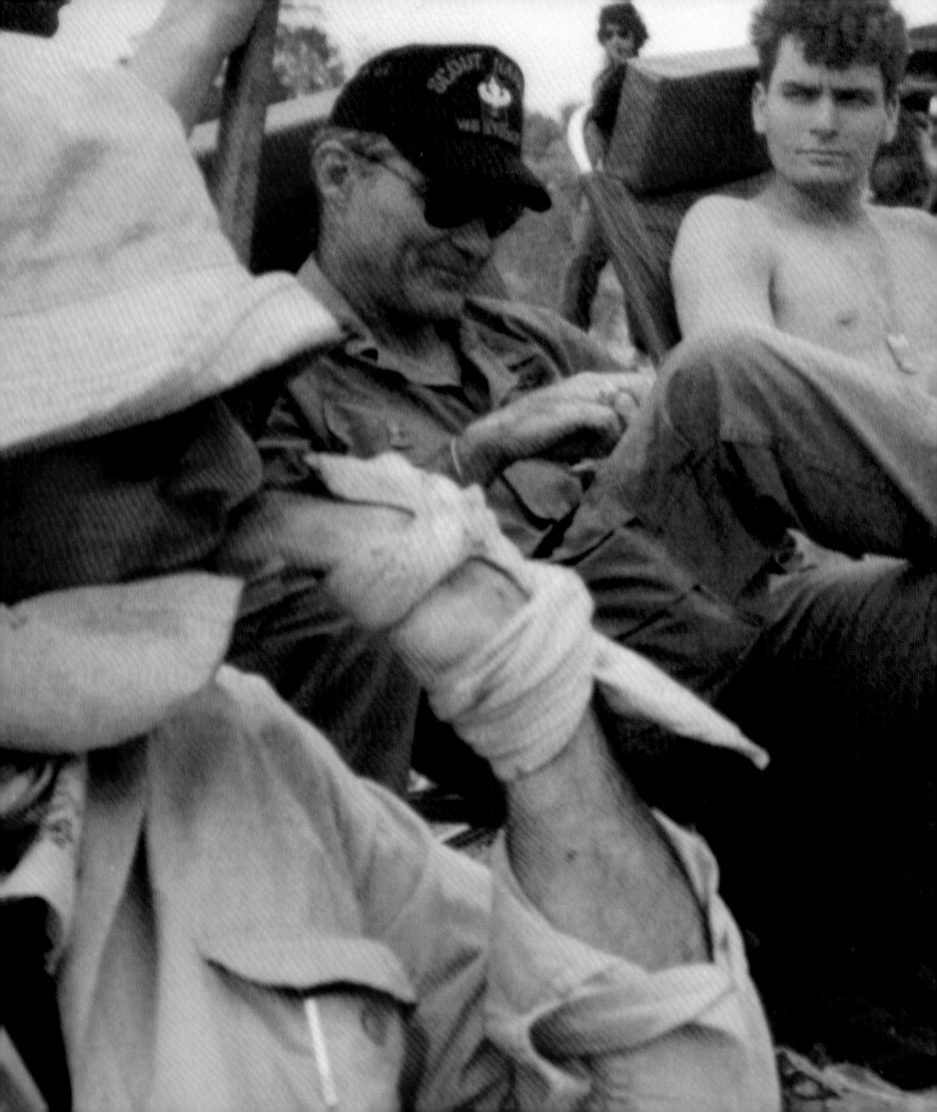

I hired Dale Dye[22] somewhere in the editing of *Salvador* to help me train these actors in *Platoon*, because what I wanted to do is get a tired, ravaged look. That was the feeling of Vietnam. Guys didn't sleep. When you've gone through three days, four days of bad sleep, you get very antsy. You get very curt, sometimes nasty. You get in a killer mood, you know? So the idea was to starve the actors out of sleeping. And that's important. It's like, you have to be on duty twenty-four hours. It's a 24/7 deal, and you've got to trust the next man in the foxhole. He's watching out while you're snoozing, you know?

From reading stories, I got the idea that they were going through an abbreviated version of basic training with [Captain] Dye. But what you're describing sounds more like psychological conditioning or something.

Yeah. We decided to do it every night for two weeks, so we got the Filipino army to help us. We set them all up in a jungle. We brought all the actors from LA and New York—mostly New York, I think—and they were SAG [in the Screen Actors Guild], and three of them had complained before they took off that we

were breaking the rules of the actors' union: They had to have twelve hours off from work so that they could rest. And I understand that. But this was not acting; this was a form of

training. So anyway, we fired those three or let them go, and we signed on another three or four who weren't going to complain. Took the whole unit over there. I went over there. I was preparing the whole movie, too.

Dale was in charge of the camp. He ran it very well with three assistants, three military guys. I would go in and out. Some of the actors were really pissy going in, but I remember that on the last day of training camp, they were all rah-rah! It was one of the first training camps ever done like that, maybe the very first one, I suppose. Everyone kind of copied that idea afterward.[23]

I guess you and Dale Dye got along, because you worked with him off and on for almost twenty years, all the way up to *Alexander*, where he re-created ancient Macedonian army tactics for

When you've gone through three, four days of bad sleep, you get very antsy.
You get in a killer mood.

22 Retired US Marine Corps captain, Vietnam veteran, and founder of Warriors Inc., a Los Angeles–based company that advises filmmakers on accurate military tactics through the ages. Dale's company has worked on several Stone films, including *Alexander*, plus *Saving Private Ryan*, the History Channel documentary *The Conquerors*, and the *Medal of Honor* video game series. Also a distinguished character actor.

23 "In too many war movies you get the impression that the actors have just come out of their trailers and that we've put mud on their faces," Stone told Michel Clement in a 1987 *Positif* interview.

(opposite) Technical adviser Dale Dye with Stone on the set of *Platoon*, 1985.

(below top) Bunny (Kevin Dillon) in his final moments; this is an example of one of the many scenes in *Platoon* lit mainly by the fall-off light cast by magnesium flares.

(below bottom) One of the film's many on-set explosions, supervised and in some cases personally triggered by Stone.

you. And he acted for you. He's in *Platoon*, and there's that cameo in *Born on the Fourth* where you're the skeptical journalist and he's the marine predicting victory.

Yeah, I like Dale. He had been over there as a marine, I'd been over there in the army, so we had different points of view. Our politics kind of clashed a few times, as you can imagine.

Why, is he a conservative?

Of course. He's a dedicated marine. They don't think too much about who they're gonna go in and shoot, they just go do it. He was much more gung ho [about Vietnam] than I was. But it doesn't matter. We agreed that we would get the basics right.

What do you remember in particular from the shoot?

The bugs at night would be horrible. Night shooting with bugs! We had so many problems with the bugs around the lamps in the jungle, making so much noise, that we couldn't have a soundtrack!

Were they being zapped by the lights?

Yeah, I guess so. If you take ten thousand bugs and put a light in the jungle at night, they're going to come for it. So we devised different ways of lighting. That's one of the reasons we went to flare light: very naturalistic, low-level lighting, with the flares up above.

So the scenes where they're fighting underneath flares, those are actual flares providing the light?

A lot of the time it's supplemental, but yeah, we used a lot of flares, after Bob [Richardson] saw how powerful the flares were, just like in Vietnam. At lot of the combat in the film takes place at night. Once he discovered the power of this magnesium flare, we just went with it, and it became part of the look of the film.

I remember the forty-second day—there were only fifty days in the shoot—there was a night shoot, and it felt like we were down to half a crew or maybe less. Everybody was kind of sick. It was pretty rough shooting the climactic night battles. We were out in the jungle all night with bugs, a thousand bugs. We kept having to relight everything. But you know, technically, we were solving everything. We brought a special effects guy from England who was very good—I think Yves

De Bono[24]—with Gordon Smith[25] on makeup and prosthetics, very important to this movie, including the mask on Barnes.

And the actors, we'd let them go. I mean, after a while everybody starts to bitch and moan, but as we killed their characters off, we'd let the actors go. So we tried to shoot in a certain order.

In sequence?

In sequence as much as possible.

And I think we had maybe six or seven prime locations, and I think it was a unique look. We were doing the realistic *Apocalypse Now*, a film that had been shot in the Philippines, so a lot of our crew had also worked on that movie. And Francis [Ford Coppola] had the opposite experience, because he had come in there and had been hurricaned out.

So we were aware of these issues and tried to plan everything to the season. We still got hit with rain a few times, but we shot through the rain. It doesn't photograph as rain, but we shot through the rain. And we shot these rain sequences sometimes where the rain

is coming from very flimsy, cheap rain machines. We had water towers that came from the fire department of the Philippines, and we're depending on their schedules, but we had a lot of rain scenes, so we had issues with the fire department here and there.

The production manager was iffy to me. I had a fight with him. I kicked him in the ass because I was so fucking angry one day.

You literally kicked him in the ass?

Kicked him in the ass. I was really upset because the fire department was never on time, and we're shooting into the sunlight and we have no time to fuck around, and they were sloppy, and I want rain, you know? So I kicked him in the ass and he went out

24 Special effects supervisor on *Salvador*, *Platoon*, *Empire of the Sun* (1987), and *Interview with the Vampire: The Vampire Chronicles* (1994), among others.

25 Special makeup effects artist on five Stone films, starting with *Salvador*; also *Jacob's Ladder* (1990), *X-Men* (2000), and *X-Men 2* (2003).

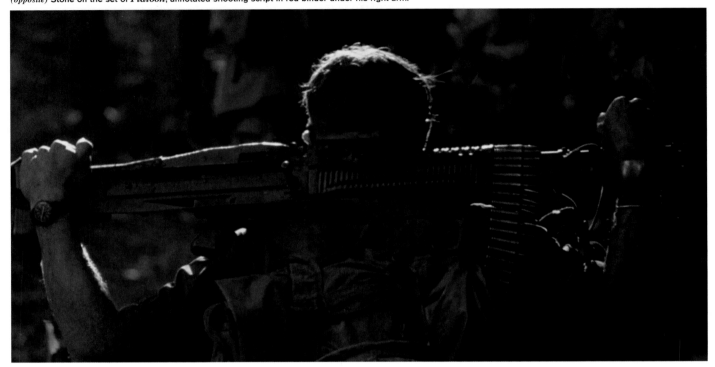

and said he was going to kill me, because he was a hot-blooded, proud but stupid S.O.B. The Philippines is very violent. Everybody had a handgun. People were warning me, *Don't go back, he's there, he's waiting for you, he's going to shoot you.* I apologized to him publicly, so that he would not lose face [END 5].

What are some of the other things you recall about that shoot?

There was a snakebite. We were in the jungle. We were in water. We had leeches. And the Filipino army played a huge role, too, because they helped us. We had background from them. We also used US soldiers who were allowed to work, but they were not officially allowed to work because the Pentagon had turned down *Platoon*—they'd read the script and had suggested mass changes, and rejected it. They sent me a document that listed what they wanted, including not having the hero shoot a fellow soldier, and the amount of expletives.

The Pentagon thought the soldiers should curse less?

They had a very by-the-book view of the war. But we had to get equipment, and so we had to be very inventive. The helicopters in the Philippine army were shit. They were just not up to the standard and would not maintain well. When I was in the chopper one time, we were overweight and we were not clearing the ridgeline. We were coming out of a valley and we couldn't clear it. And Dale [Dye] and I were in the same chopper and we were looking at each other, thinking: *This is it, we're buying it.* And it was just barely clearing the ridge line!

To make it through Vietnam, and then to die making a *film* about Vietnam!

We were very lucky. That was not the only near miss. And we were flying very close in the choppers. You have to realize that on a

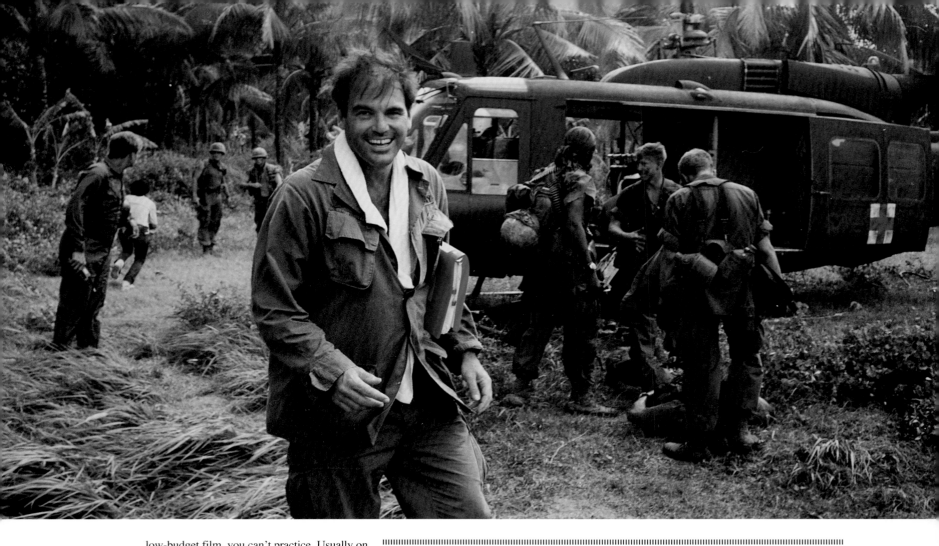

low-budget film, you can't practice. Usually on a big-budget film you have safety instructors, you have these guys who come and they run you through it. I was blowing up these things myself! I was dictating when to blow! And sometimes I would hold it in my own hands!

The detonators?

Well, let's say we let out thirty charges. I'd blow them all sometimes, because I wanted to control when it happens to the camera. And we didn't have time to go over it and over it with the special effects man supervising everything. I was there with the camera so sometimes you surprise some of the actors. And that was good for the actors, because sometimes when you see their look of surprise in the film when an explosion goes off, it's because they really were surprised! No one got hurt from our staff, except for basic bruises and stuff that would normally happen on a cowboy film. Nobody broke anything as far as I know. Heat exhaustion, maybe. But in a way it was fun, just to control the set. When I did *Savages*, part of my unhappiness was just sitting there, waiting for those [pyrotechnics] guys to do safety checks. It's overdone! It's like an over-bureaucratization of something that is basically safe. But they have to, you know, because of insurance, and over the years this thing gets into a fucking . . . it becomes a racket.

There was snakebite. We were in the jungle. We were in water. We had leeches.

What was Charlie Sheen like on that shoot?

He was a bit spoiled. Malibu, sheltered kid, like the kid in the script. His mom sent a package out, I think, a few days in, and the rest of the guys were making fun of him, knowing that she sent the package from Malibu with goodies. Charlie was a nice-looking kid who was living a good life. And he wasn't looking to change the world. In fact, we found out after the movie was over that, in terms of his real desires, he really loved money. I mean, he wasn't his father, but he had the look of his father, and I thought that perhaps he had the intentions of his father.

He certainly had the voice of his father. More than one review commented on that.

But I read into him an intention that was perhaps not there. When I continued on with him, it became clearer to me that he was not that person. I used Charlie as an alter ego, and to a degree, I thought he was me, but . . . I think we should get into that another time.

Well then: You got a lot of praise for your supporting cast, none of whom were stars at that point. Did you approach bigger names?

Not really. Tom Berenger was great. As Barnes, he really anchored the thing. That scar, of its time, was a work of genius by Gordon Smith, Toronto, special effects. Gordon was a man who worked with all kinds of new latexes. To apply that scar the old-fashioned way would've been several hours every day, and you couldn't do that with the perspiration and humidity out there. So we had to find new ways to put that look on his face, which is extensive, and not overdo it. I love what Gordon did. He made Tom look like somebody with a hobnailed boot walked across his face! The real Barnes, he was in the First Cavalry, too, but not the same unit as Elias. I was his first radio operator.

Willem Dafoe was great as the bad guy in *To Live and Die in L.A.*, and that's why I cast him—because of that, and because he was a lovely man who looked like no one I'd seen. As I said, I wanted a Jim Morrison type, with dark black hair.

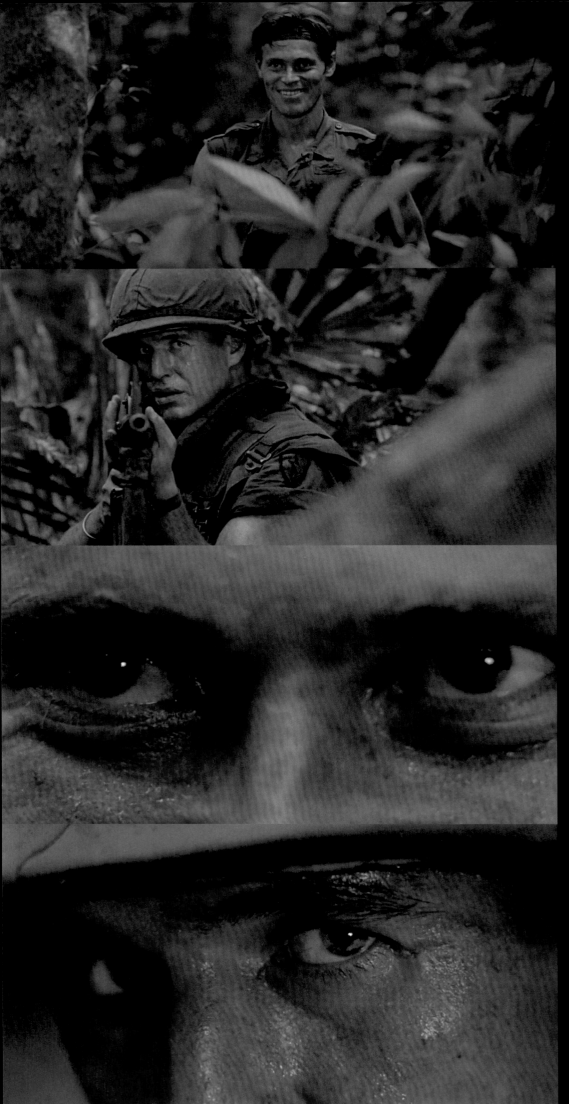

The whole thing's filled with guys who are sort of like guys I knew. I told you that the real Elias was a very handsome young man. He was Apache. I couldn't find the right Native American actor to play that guy. I auditioned a lot of them, but none of them felt right to me. I thought I'd be nailed for not casting a Native American. And then I went with Willem, I guess because he had that strange look, with those cheekbones. He looked like a traditional bad guy, but I think there was something thrilling about the fact that you could spin that and get something electric off it. Lee Marvin[26] had done it: Sometimes when actors with bad-guy looks play heroes, it comes off as fascinating.

From the film, I never got the impression of Elias as a Native American. Was that something that was in the back of your mind but never stated in the film?

It's in the script. I don't know if there was a reference to it in the finished film, except maybe subtly, in things like the way he moves through the forest.

Willem was so great I didn't ask him to try to be an Apache, I just let him play it Midwest eccentric, or something. Elias was killed before I left. I never saw him die, but it was in action. His unit had gone out, and it was a friendly fire incident. So I don't know what happened.

Was there any indication that he got killed by one of his own men, like Elias in the movie?

Not that I know of, but I think that idea came to me as I was patrolling, going through all the stories that were starting to circulate about discontent and differences. There was a growing feeling of, *What do you want to die for?* You're walking into this fucking

26 1924–1987; much-decorated U.S. Marine, wounded during the Battle of Saipan in World War II, who became a versatile and beloved character actor with a leading man's charisma; *The Caine Mutiny* (1954), *The Man Who Shot Liberty Valance* (1962), *The Dirty Dozen* and *Point Blank* (both 1967), *Paint Your Wagon* (1969); played Hickey in John Frankenheimer's film adaptation of *The Iceman Cometh* (1973). His role as the grizzled sergeant in fellow World War II veteran Samuel Fuller's *The Big Red One* (1980) would be considered the closest he got to "playing himself" had the film's combat taken place in the Pacific instead of in Europe.

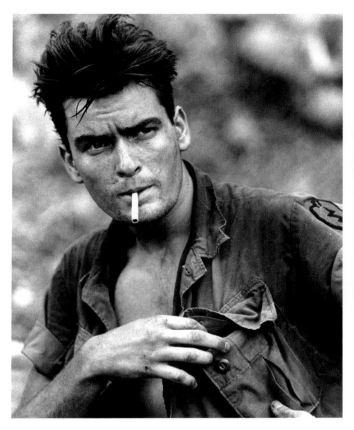

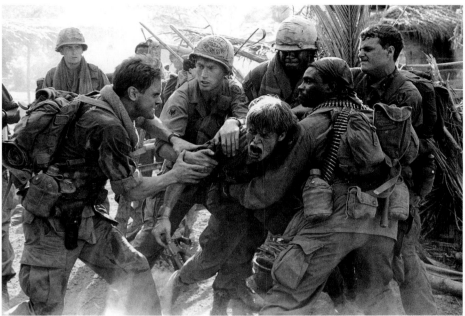

Charlie was a nice-looking kid who was living a good life. And he wasn't looking to change the world.

village, going down a path—you're doing this for what? You know we're not going to win this thing. Some of the guys had this look on their faces like, *Get me out of here.* I was just trying to make it, to survive.

Not that anybody talked about it in those terms. People are inarticulate that way. It's a sort of hopelessness, because that's why you smoke pot, do drugs. It's, *Who gives a shit, man?* But still, it was like, *Who gives a fuck?* The black guys were saying that much more openly—that's in the movie. Maybe it was partly the racism, too: They felt like they were getting killed in more numbers; they felt like they were getting shittier duty. At the same time they're being drafted to fight in this war for supposed liberation in another country, back home the civil rights movement is giving way to the black power movement, because it's clear that the country isn't gonna give them their rights.

It's Nam, you know? Banging out drugs to survive. *Don't bitch, who ya gonna bitch to?* Right? You know these people are going to be fucked all their lives; they're just trying to get out of here, to survive. *So here I am, and some asshole dickhead sergeant who's got an attitude wants me to kill gooks, wants me to go out there and do that? Risk my life? Fuck that. I've been around. I don't want to do that!* It's *that* kind of attitude. You couldn't get guys to do things anymore. It all got ugly.

Tell me about the scene when Elias dies.

Complicated sequence.

It became the iconic poster image of the movie.

As these things can sometimes happen—it wasn't thought of as that. It was a bit hokey. I had written it so that he dies in the jungle, and then, because of the layout, somewhere in the location, I just thought we'd soak it a little further and make it very evident to Charlie that there'd been a crime. And perhaps it wasn't evident enough to Charlie. But if you saw the sergeant come back, and then he saw in the helicopter what his reaction was . . . you know, he'd put two and two together that something evil had happened.

There are a lot of sequences in the movie that resonate with images we know from the news, or historical incidents that we have chewed over as a country, like the My Lai massacre. The buildup to the burning of the huts in the village sequence—it feels like it's not exactly a representation of My

Lai, but it feels like an examination of the sort of conditions that can lead to an event like that.

That certainly played into my consciousness. I remember My Lai [END 6]. I remember being shocked by Calley's callousness and distrusting [Ernest] Medina's [27] comments. The My Lais that I saw were much more individual. We didn't really interact with civilians that much, but we did fuck with civilians. We did fuck with them.

How so?

Trash their villages looking for weapons, not finding them, frustration, burning shit, sometimes burning stores of rice, because I guess we worried that there might be some use for it. I'm not sure. I was not agricultural. And I could see that we were fucking with them constantly, and I understood their confusion and their fear. I'd been there before. And I liked the Vietnamese, but I was wary because I didn't know what I was into. I was like, *Are they enemy or are they friends?*

I realize now that they had no fucking friendship for us. Why should they? It was about survival. But their villages, I mean, all those things happened in one form or another. I did lose my temper and almost killed a villager once, but I let him live.

27 A captain of infantry in the US Army who ordered the mission into My Lai and neighboring hamlets, telling his men that everyone present would be the Viet Cong enemy; acquitted of failing to stop the massacre; resigned from the military soon after.

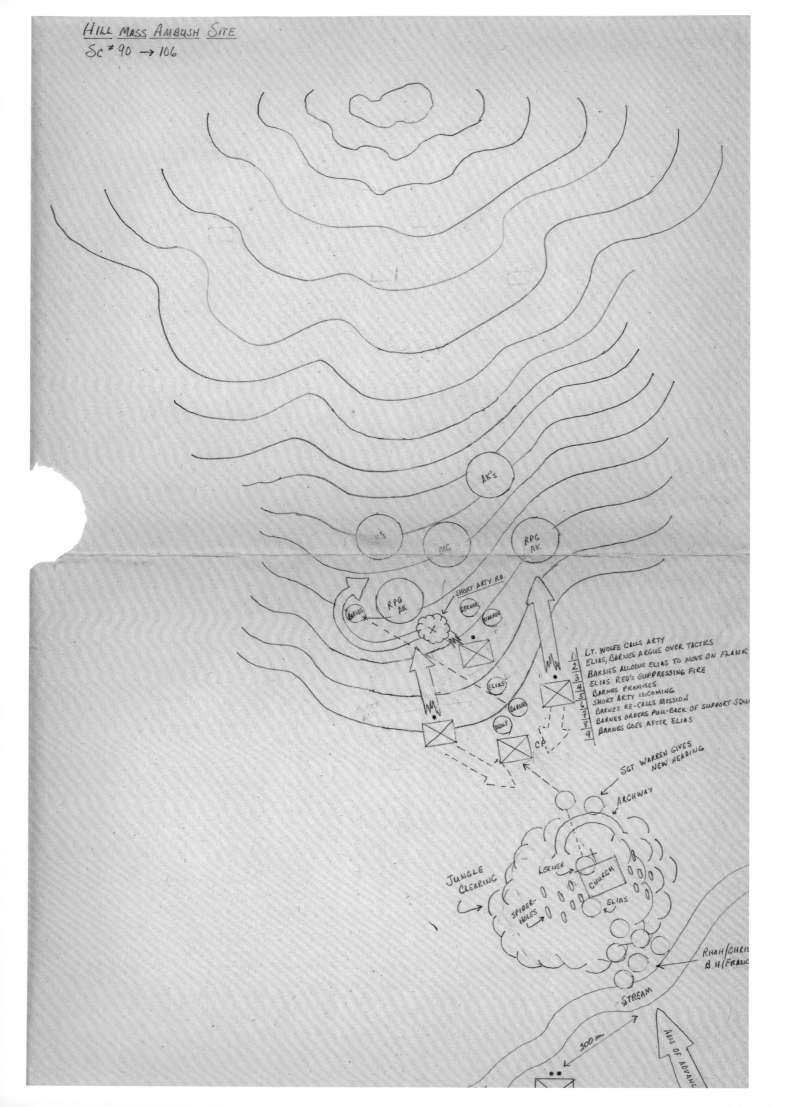

HILL MASS AMBUSH SITE
Sc # 90 → 106

(opposite) Hand-drawn map of the action sequence involving Elias's investigation of Viet Cong "spider-holes" and an ambush near a church. The sequence climaxes with Barnes shooting Elias.

(below) Handwritten note tucked into Stone's 1985 shooting script for *Platoon*: "Any story you write has to be Personal drama. Choose: life or death. Concl[usion]: Die with hostages or seek to survive. Must come to this ultimate question: Self above the group or not. Ideal tension is man like Dickens' Sidney Carton—for himself throughout—then the last second, he goes to sacrifice [himself] for group.—In war, knowing yourself for what you are. No illusion"

What were the circumstances?

There was an older man who just didn't understand what I wanted. And I think he was irritating me, because you could get very angry. And you don't realize. You get very short-tempered, especially if there's a lot of tension in the air, and you're scared. There are a lot of draftees, or squad leaders, or—how do you call it—first sergeants, who are not, like, wedded to the military. Barnes was an exception to the rule. And Elias was, I thought, a little younger, but he was raw and he had that leadership capability.

You know, it was Michael Cimino who told me to pull that script out of the closet. When I'd given up on *Platoon* in '84, he basically said, I will produce *Platoon* for you if you help me with *Year of the Dragon*, which I did. And he tried, faithfully, to produce it, but Dino De Laurentiis wouldn't do it. But it was Michael who was really pushing it at that point, not me.

And he said to me, prophetically in '83, '84, *You'll see, Vietnam will come back*, because *Deer Hunter* and *Apocalypse* had happened, and I'd thought, *Who gives a shit? It's over. Nobody cares about the realities of what I saw,* and he said, *You're wrong. Stanley Kubrick is making this picture.* And he respected Kubrick enormously, as we all did.

And Kubrick was making *Full Metal Jacket*, so in a way, I do think that figures into this story, because we did beat Stanley's picture out by half a year. Stanley's picture took much longer. It's certainly a stunning picture, but in a different style.

And it's about urban combat more than jungle combat.

It's more about Hue,[28] the [US] Marine First Corps . . . and it was actually a marines story. I liked it better the second time. I had reservations: The first time, I was like, *It's not realistic,* the second half especially. But the second, third, fourth time, I saw a mythic quality about it, which I love, and the training sequence is stunning in the beginning, in the first half.

So the second half of the film where they go to Vietnam, that's generally not true to your experience?

No. But it is true to combat experience: the fuckups, and the fact that one female sniper can cause so much damage—absolutely, that is so fucking true. I mean, it's so easy to trick American soldiers, because the US responded then, as it does now in Afghanistan and Iraq, with heavy fire. You fire on US troops, they automatically—instead of thinking, *Think here, watch, listen, get intelligence before you open up,* they tend to open up, and then they open up big. All the noise drowns out the enemy. There's a fear factor there. *Kill the fear and somehow it'll go away.* But somehow it doesn't solve it.

You see that in *Full Metal Jacket*: the buildings being hammered by these heavy machine guns, and they have no idea where the sniper is.

And also in *Platoon*, you see people overresponding,[29] and that is what we did after the attacks on New York and DC in 2001. When I

And he said to me, prophetically in '83, '84, "You'll see, Vietnam will come back."

28 Battle in the centrally located former national capital of Hue; one of the longest and bloodiest battles of the Vietnam War, lasting from January 30 to March 3, 1968.

29 For more on overresponse after 9/11, see chapter 8, pages 381–82.

169

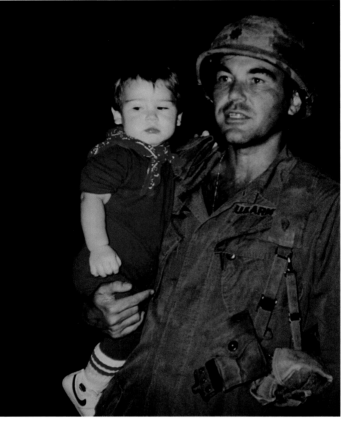

||

We hit a consciousness of some kind, a collective consciousness.

||

talk about 2001, I'm talking as a military person, saying that I think it's an overresponse. But I see it all the time. I see it in documentaries on Afghanistan. These guys are yelling and screaming and categorizing things right away, and they don't know what they're talking about. All of a sudden, it becomes about, "Man down!" and then they're freaked out, and before you know it, two more guys trying to get this man down become wounded, and that makes it even worse. Instead of letting things lie; sometimes you just don't send people. All this mythology about getting the wounded man out . . .

"Never leave a man behind."

You get more people killed that way! That is movie talk. It's like MIA—they go crazy when they leave a man behind, but that's war! People get left behind! People disappear! All through every war! World War II has tons of missing soldiers! Korea!

But they oversentimentalized it in the Vietnam thing, and they became so crazy politically that we became a crazy country. Two thousand one is an overreaction, and as a combat vet, you've got to be cool. Somebody blows up something; you've got to be cool. Watch, find, look, listen, go after Bin Laden, but *find him*. Don't go scream and shout and commit ground troops in two

wars and then find the fucker ten, fifteen years later, from some local informant, at the end of the day.

It's just crazy, the way we react to gunfire! We're fear-ridden. I put that in *Untold History*, and I just want to emphasize that, because I saw it again and again in Vietnam. Every time a man faced fire, if they were in a unit that thought like this, they overreacted. And they'd kill something, and they were not thinking about it, because they thought it was justified.

I saw that sort of thing time and again, and I, in my core experience of my life, know it's true. It's part of the problem we have as a country.

With *Platoon*, you got a lot of flak, even at the time, for the morality play aspect of the screenplay, and for the idea that, particularly, in the end we didn't fight the enemy, we fought ourselves. I think a lot of people interpreted it to mean, "The war was all about us," which begs the question, "Hey, what about the land and people of Vietnam—and if we fought ourselves, who were those people shooting at us?"

Well, obviously, that wasn't what I meant.

What were you trying to say?

What do you think I was trying to say?

I felt like what you were getting at in that line was that our decision to go into Vietnam was the result of a long-standing inability to address certain flaws in our national character.

That's absolutely correct. Our involvement in Vietnam was based on a flawed perception of Communism, the domino effect, and the fear of Third World countries turning Communist. That was the official narrative.

Which is something you come back to in *Born on the Fourth of July*. And you got this kid, Ron Kovic, who's swallowing that narrative, this story that if we don't support South Vietnam, all the dominos are gonna fall. He's watching Kennedy's address and he wants to go enlist.

The Vietnamese civil war! They call it a civil war, but it's not a civil war. It's America propping up one class of people against the whole country that was a united country, in 1954, when the French were defeated, finally. We should've backed the Vietnamese in '48. We didn't. But after '54, Eisenhower never allowed that election to happen. They cut off that election in '55 because, Eisenhower himself wrote—we cover this in *Untold History*—Ho Chi Minh would've won 90 percent, 80 percent, and we couldn't let that happen.

172

This idea of an "official narrative": There's an official narrative of Vietnam—

Of the world! *(Laughs)*

There's an official narrative of the history of the American military, and democracy, there's an official narrative of American capitalism, and you make movies like *Platoon* and *Salvador* to challenge that narrative?

Yes.

That wasn't where the country was, psychologically, in 1986, though.

Given that, why do you think *Platoon* was so well received in the United States? Why was it a hit? Why was it on the cover of *Time*?

I can't tell you. I just know I went from the guy whose phone calls they don't return, to Orion looking at the picture in October or November and saying, *Yeah, we'll release it.* They released it in New York, and maybe seventeen other cities, maybe more. But they were not prepared for what happened. It was a landmine.

Maybe the country wasn't ready for *Platoon* politically, but they were ready for it emotionally?

Maybe. We got a lot of publicity from the get-go, but I have to say, it wasn't critic oriented, it was audience oriented. Its success came from the audience. Whoever saw it reacted. We hit a consciousness of some kind, a collective consciousness. I think the veterans might have driven it. They were lining up at the Astor Plaza on Forty-fourth—veterans from all over New York.

I will never forget seeing *Platoon* at the Northpark 1 and 2 Cinemas in Dallas in early 1987. Guys who were in their late thirties or early forties, the right age to have served, were crying.

In Los Angeles, our marketing adviser was calling us, saying, *They have to book faster!* We were getting Oscar buzz right away, right? Orion was rushing prints! I mean, I don't think they went wide till January 15 in those days.

You know, because Orion had turned down *Salvador*, they were totally unprepared for the success of this one. They did a catch-up marketing job—also they changed the poster, and got a lot more theaters. But even then, it was slow. In the end, I guess it made most of its money in late January, February, as they got bigger and bigger.

***Platoon* was one of the most successful movies of the 1980s, and it won four Oscars: for picture, director, editing, and sound mixing. How did your life change after all that?**

It was night and day. I can't even describe the excitement at the change in my life, how golden it suddenly got, from being a criticized person to being loved a bit. It was unbelievable. So many people from all over the world still remember that movie. Older men come to me, and also young people, men and women, come to me and tell me they saw it, and it meant something. And maybe in hindsight you could say it was a highlight of my life. Maybe I didn't enjoy the roses enough, because I was insecure.

FINAL OUTCOME

1	CHRIS TAYLOR	wounded
2	BARNES	dead
3	ELIAS	dead
4	DOC	wounded
5	GARDNER	dead
6	BUNNY	dead
7	KING	a.o.k.
8	TUBBS	wounded
9	SAL	dead
10	FRANCIS	wounded
11	LERNER	wounded
12	TEX	wounded
13	JUNIOR	dead
14	BIG HAROLD	wounded
15	CRAWFORD	wounded
16	ACE	wounded
17	SGT O'NEILL	a.o.k.
18	SGT WARREN	wounded
19	LT WOLFE	dead
20	FLASH	dead
21	RHAH	a.o.k.
22	TONY	missing in action
23	FU SHENG	dead
24	RODRIGUEZ	wounded
25	HOYT	wounded
26	MANNY	dead
27	MOREHOUSE	dead
28	HUFFMEISTER	wounded
29	PARKER	dead
30	SANDERSON	dead
31	CAPT HARRIS	wounded

BODY COUNT:

Dead	13
Wounded	14
M.I.A.	1
Survivors	3

Total Accounted For: 31

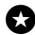

OLIVER STONE BRINGS HIS EXPERIENCES IN VIETNAM TO THE SCREEN WITH INCREDIBLE FORCE IN 'PLATOON' BY FRED SCHRUERS

PATRICK DOWNS / Los Angeles Times

e, Best Director, with their Oscars at the ceremonies.

Stock as Do

Yen at Rec Level Desp Bank's Eff

By SAM JAMESON,
Times Staff Writer

TOKYO—Reacting to sions in U.S.-Japan econ tions, the dollar Monday another all-time low a yen on the Tokyo Fo change Market despite tervention by the Bank o

In less than 30 minute ing, the dollar fell to 1 down 4.3 points from Fri of 149 yen. The Bank bought about $2-billion dollars in a vain attempt decline.

Although the dollar re its own without central b vention in the afternoon, trading at 146.20 yen, a n a closing price. Its one amounted to 1.9% in $ worth of trading.

Cites Fears

Finance Minister Kiicl wa said for the first time of a "free fall" of the emerged.

"The [U.S.] Federal Bank is beginning to w that. I think the other co engaging in a broad-sc vention because there is Miyazawa told a news co

Continuing the interve cool down speculators finance minister said, he want to decide what actio be taken on the basis during "a day or two."

"I would like to watch a little longer" before c any appeal to other adv tions for new action to exchange marts, Miyazaw

"If this condition con long, it would be extrem sirable," he added.

Please see YE

ollywood **REPORTER**

03/23/88

CA 90069

wood Wednesday, April 1, 1987 Vol. CCXCVI, No. 31 75 Cents

Hemdale celebrates 'Platoon' Oscar with plans for sequel

By MARTIN A. GROVE

Hemdale Film Corp. has a sequel to "Platoon" on its drawing board, chairman and CEO John Daly told The Hollywood Reporter at the post-Oscars victory celebration for the Arnold Kopelson production.

Films that win Best Picture typically do not spawn sequels. A "Platoon" sequel would put it in a small distinguished group that includes 1971's "The French Connection," 1972's "The Godfather" and 1975's "Rocky."

Shortly after "Platoon" captured Oscars for Best Picture, Director, Film Editing and Sound, Daly was asked if a sequel was in the cards. "For sure," Daly told THR at Hemdale's jam-packed gala Monday night at La Scala in Beverly Hills. "We have one already in mind and Oliver's been paid to write it. You may want to ask him, has he started writing it?"

Would distribution of the sequel be done through Orion? "I'm not sure yet," Daly said. "It's not contracted. It doesn't have to go. But let's get the (sequel's) story right first."

A mood of great jubilation prevailed as Hemdale celebrated not only its success with "Platoon" but also the nominations that went to its productions "Salvador" and "Hoosiers." In all, Hemdale films received 12 Oscar nominations (eight for "Platoon," two for "Salvador" and two for "Hoosiers").

"Platoon" producer Arnold Kopelson, the man of the hour, arrived with his wife Anne Kopelson (who is co-chairman with Arnold of Inter-Ocean Film Sales Ltd.) after making an appearance at the Governors Ball at the Beverly Hilton.

"I am terribly excited," he acknowledged, clutching his Oscar as he tried to make his way through the overflow crowd at La Scala. "This is the greatest day of my life. I'm thrilled beyond belief because we were made to feel that we were right. We fought for a project — Oliver fought for so long and I fought —

ders ecord

D Refuseniks us Freedom

'Platoon' Is Top Film; Newman Is Best Actor

By JAY SHARBUTT,
Times Staff Writer

On a night Oliver Stone's "Pla-named best and a best actress award went to Ma le stain, a hearing-impaired young actress who made her film debut in "Children of a Lesser God," actor Paul Newman finally won his first Oscar Monday after seven tries, winning as best actor for his role in "The Color of Money."

Woody Allen, already a two-

emigration and their be free to go to Israel with the exception of ich national security egitimately be made," who took part in talks officials in Moscow kend. Edgar M. Bronf t of the World Jewish so participated in the

OLIVER STONE WIN

Could Slow Econ

Interest

THE TRINITY ALUM REVIEW

A MEMBER OF THE PLATOON

Oliver Stone who attended Trinity in grades two through eight, before leaving in June, 1960 for The Hill (boarding) School has recently been getting quite a lot of media coverage, and deservedly so, for his recently released, and already successful, film *Platoon*.

On Saturday, January 31 *Platoon* was awarded two Golden Globe awards, one for best dramatic movie of 1986 and one for best director. In his acceptance of the award Stone told the Beverly Hills, Calif. audience "Through this award you acknowledge the Vietnam Veteran, and you say you understand

Entertainment

Rolling

PLATOON DIRECTOR OLIVER STONE GUNS FOR THE OSCARS

'I NEVER REALIZED WHAT WAS GOING O

Hope changes view after seeing Platoo

'It was such a v

NEW YORK — No, hell hasn't frozen over. Bob Hope and Abbie Hoffman really do see eye-to-eye on a film about the Vietnam War and to some extent on the war itself.

Yesterday you read here about members of the infamous '60s radical group, The Chicago Eight, who reunited to face the press to tout the Home Box Office movie of their 1969 riot trial.

While his motor was running, ex-defendant Hoffman singled out the Oscar-nominated anti-war film *Platoon* for praise, calling filmmaker Oliver Stone "a great American."

This week a spry Bob Hope appeared at the same Waldorf Astoria that had earlier housed aging yippies. He, too, had shows to sell — an April 19 Easter special and a May 25 84th birthday special, both on NBC.

And it happens that Hope — who spent the '60s angrily defending the U.S. role in the war and entertaining the troops overseas — had also just *toon*. There wer cracks in his o review.

"It got me stirr says. "I never what was going there behind o

"Platoon" Viciously Smears White Southerners

"PLATOON" - Cunning Movie Slanders Southerners and Vietnam Veterans

The Academy Award for Best Picture of 1986 is already odds-on favorite to go to **Platoon** by Jew Oliver Stone. Yes, even the Communist Party has endorsed the film. The chief villain is not the Red Viet-Cong - IT IS A WHITE SOUTHERNER!!!

Movies / David Denby

A FEW WEEKS AGO, AT THE Berlin Film Festival, I attended a tumultuous screening of *Platoon*. Part of the audience was obviously impressed, but there were also groans and complaints and cries of "*Scheisse!*" ("shit"). The insult was pronounced strangely, with a drooping, dragging intonation: "*Shei-suhhhh...*". The way the word was spoken implied that *Platoon* was just another piece of Hollywood junk, not worth bothering about.

GUILD OF AMERICA

1986 DGA AWARD FOR 'PLATOON'

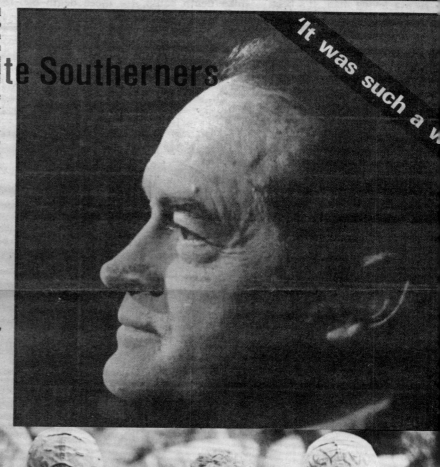

プラトーン

文／川口敦子

Sragow tells why 'Platoon's' the Oscar favorite

国のために戦う。そして自分自身をみつめなおしてみたい……。
安易な道を選ばずに大学を飛び出してベトナムに志願した青年クリス。
彼が泥沼と化した戦場に見た真実とは……

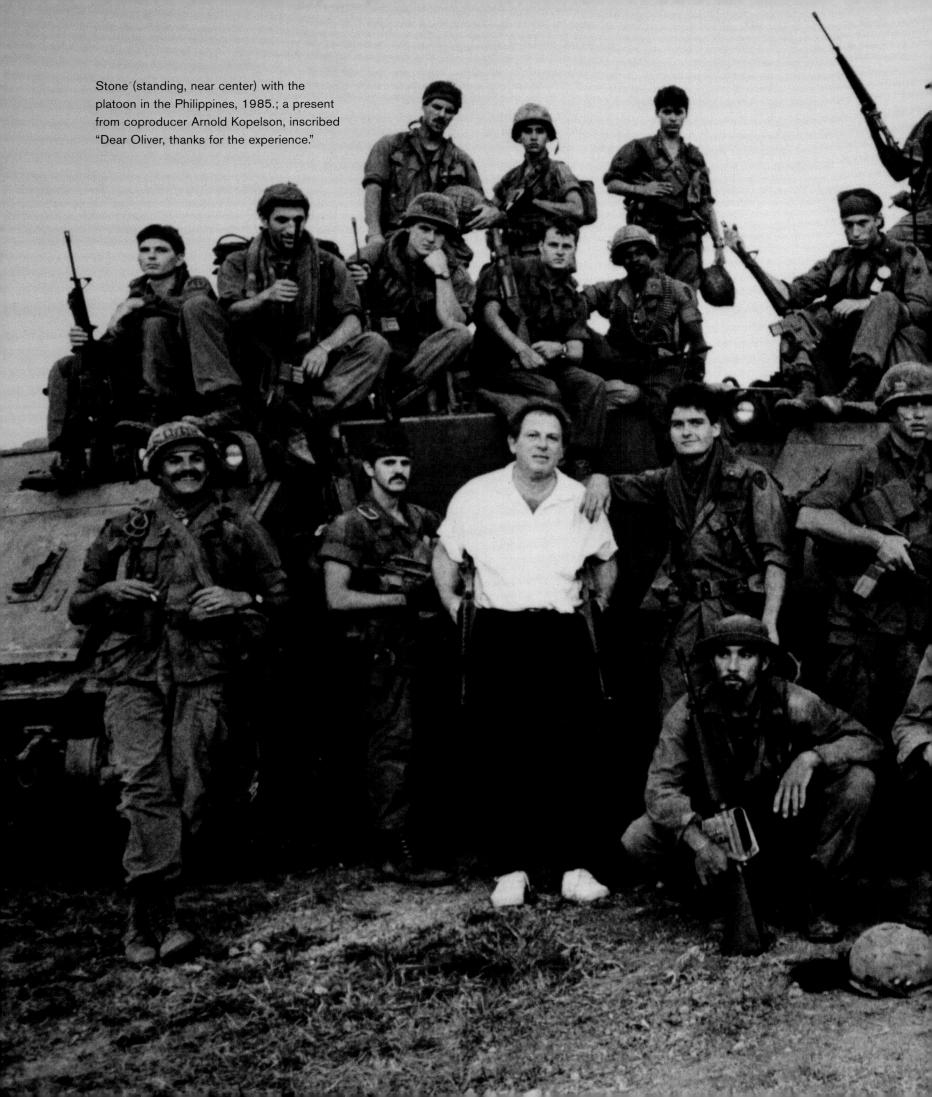

Stone (standing, near center) with the platoon in the Philippines, 1985.; a present from coproducer Arnold Kopelson, inscribed "Dear Oliver, thanks for the experience."

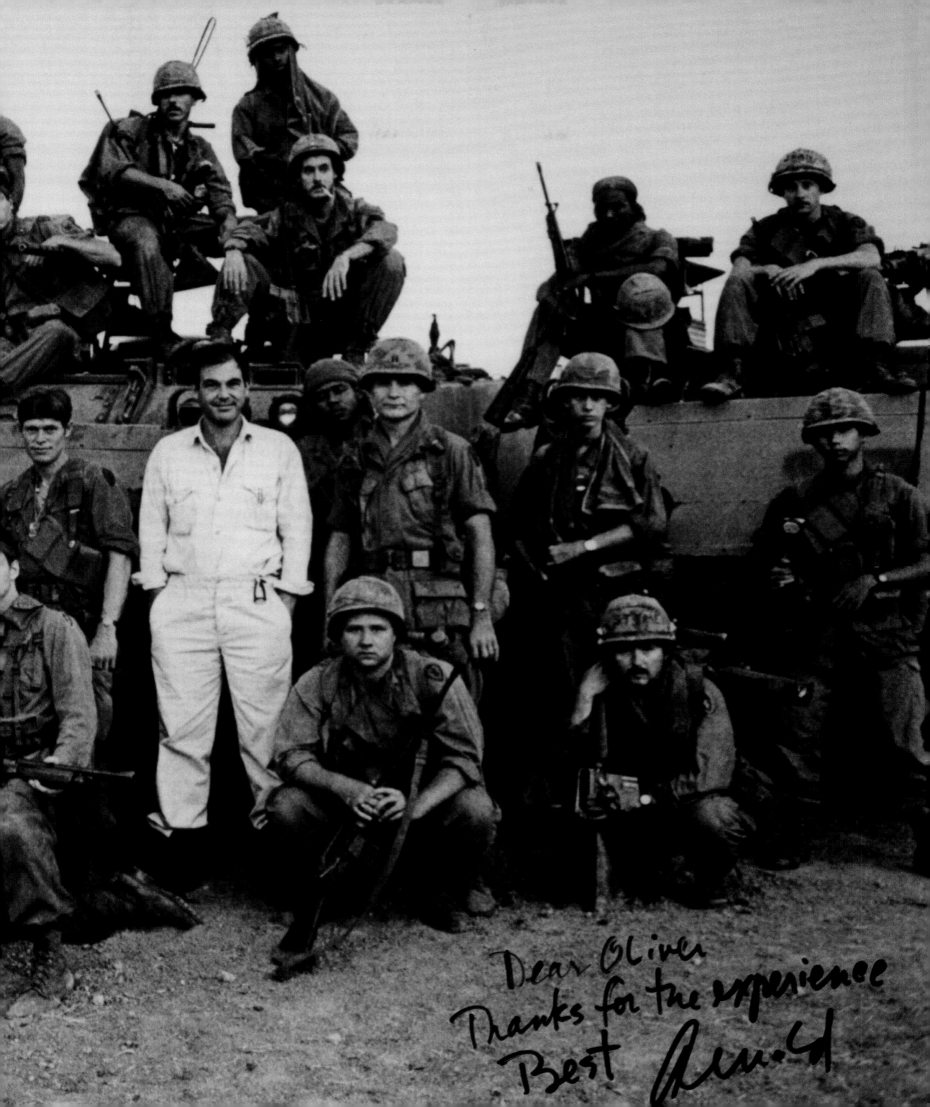

Dear Oliver
Thanks for the experience
Best
Arnold

Sense Memory

Jim Beaver

Platoon Through a Veteran's Eyes

I remember sitting very still. Not moving at all. From the blackness arose, quickly, an unconscionable bright light. I sensed, dully, around me, some vague, vaporous semblance of the real world, of people moving, speaking mutedly with each other, of motion and sound. Yet it was at a great remove, and it seemed separated from me and my thoughts and feelings, the way conversations and arguments bleeding dully through a wall from a neighbor's apartment are at once heard, but isolated from one's own existence. I sensed the presence on my right of my friend Tom and, on my left, of my wife, Cecily, both of them silent, unmoving, attentive but desperately unobtrusive. I sat for a very long time. Two minutes? Ten? Twenty? I don't know.

I had just seen *Platoon* for the first time.

I joined the US Marine Corps in 1968. I was sent to Vietnam as an infantry radio operator in 1970. My tour of duty in country lasted from June of that year until April of the next. I came home with my body intact, save for a small scar on my hand from where I'd been bayoneted accidentally by an idiot from Corbin, Kentucky, who was trying to kill a rat. My time in Vietnam was largely a mild time. The old saying about war being long periods of boredom interrupted by occasional flashes of terror was true: some early transits through enemy-rich territory, a few times when rockets came closer than comfortable, a night alert when the entire valley leading into a pass outside Da Nang lit up with a thousand parachute flares to illuminate the hordes of attacking VC who never got around to showing up, and a firefight when sappers were discovered in the wire at a battalion command post on an isolated hill. The rest of my war, insofar as the terror/tedium ratio went, was exclusively tedious.

Far more disturbing than my own brushes with combat were my experiences visiting a boyhood friend at a nearby marine medical unit. During almost every visit, our conversations and low-level carousing were interrupted by medevac choppers coming in with loads of

(*opposite*) 1987 Polish poster for *Platoon*, celebrating the film's post-Oscar march through Europe.

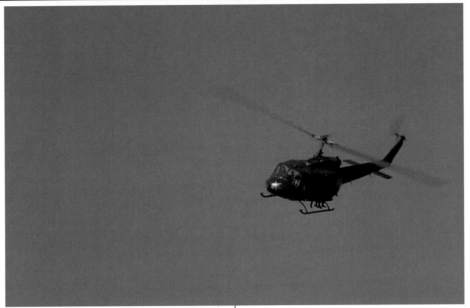

freshly wounded and dead. At such times, it was all hands on deck, base personnel and visitors alike, unloading the choppers, and my experiences of the screams and blood and horror in Vietnam were largely confined to the Landing Zone at First Med Battalion. Stretcher after stretcher went either left off the LZ to triage or straight ahead to Graves Registration.

The night before I departed for marine boot camp in '68, I left the marine recruiting station in downtown Dallas and caught a movie before heading home. The picture was John Wayne's much-reviled but naively well-intentioned Vietnam movie, *The Green Berets*. The night before I left for Vietnam two years later, I finished reading Dalton Trumbo's horrifying antiwar classic, *Johnny Got His Gun*. My timing was less than impeccable, but the ironies were not lost on me. By 1986, there had been better movies about the Vietnam War than Wayne's, but not many. *Apocalypse Now* and *The Deer Hunter* exquisitely caught the madness of the war without being terribly revelatory about what it was like on a realistic basis. *The Boys in Company C* captured marine boot camp wonderfully, but when its characters moved on to the killing fields of Vietnam, it seemed a far cry from the Vietnam I knew about. Only the under-seen *Go Tell the Spartans* (about the earliest days of American involvement in the war) and the TV movie *A Rumor of War* came remotely close to depicting something of the actualities experienced by combat infantrymen in that conflict.

Then came *Platoon*.

I knew a little about the film beforehand. My wife, Cecily, an actress and casting director, had worked on a film in the Philippines at the same time *Platoon* was shooting there, and she spent time with many of the largely (then) unknown actors

in that film. She had reported to me their stories of their training in remarkably arduous conditions for the film, and she said that they all believed they were involved with something special. Well, my own film career was just beginning at that time, but even I knew that *everybody* thinks they're working on something "special." Although I was skeptical that any movie could encapsulate the experience of that war, I was happy to learn that a Vietnam veteran was directing this one. I hadn't seen any of Oliver Stone's work, but I knew that the failings of most previous films about Vietnam were due in part to the filmmakers' guessing what the war was like instead of knowing from experience. With *Platoon*, I hoped Stone would get a few things right.

He did.

The opening scene of fresh meat coming off the plane while old meat is laid out on the tarmac for shipment home was more dramatic than my own arrival in Vietnam, but it expressed a fear that gripped all of us at the beginnings of our first tours. No one tells you anything about what to expect when you're about to land in Vietnam, and the tension and fear that our plane would be blown up before we had a chance to get off it were no

less palpable for being based on a false impression. The blast of fear and isolation and sickness we felt stepping off that plane matched the massive blast of heat and smells that accompanied it. The sudden awareness that nothing you've been taught or trained to do feels sufficient for your needs, the withering consciousness that everyone you meet hates you on sight because you're ignorant and, thus, a danger to them all: These Stone captures perfectly, as he does the sense of the countryside, the heat, and even, somehow, the smells. There was a smell in Vietnam that took over your clothes. It was probably some kind of exotic mildew from always being wet, from sweat or rain. It was a stench I never encountered before Vietnam, and one I never smelled again after I left—until the night I saw *Platoon*. I remember the smell of rotting clothes come over me in waves as I watched the actors drenched in perspiration. Sense memory, I suppose, but no other film has ever made me smell something from the other side of the world, a decade and a half later. I know what rifle fire sounds like, up close and from a distance, and I've seen the orange tracers going out and the green ones coming in, and forty-five years

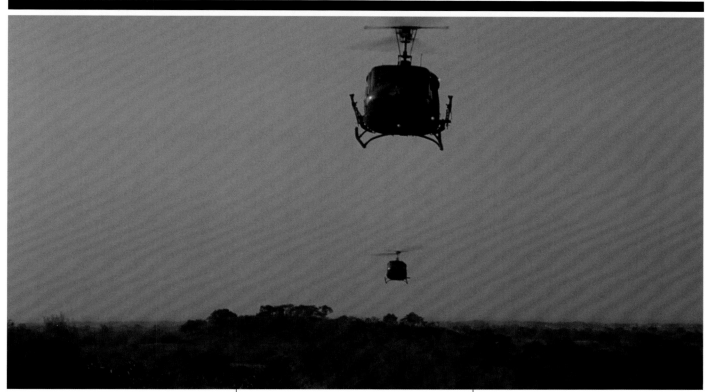

later, the sounds of certain helicopters catch at some place far deeper than my inner ear. *Platoon* reproduced these sensory impressions better than any film up till then ever had. Only *Forrest Gump*, a picture I'm not particularly fond of, did a better job of nailing the sounds of the war.

But authenticity of time and place and sight and sound, while vital, are not the most vital goals for a film that hopes to paint a true picture of Vietnam's heart of darkness. Where Stone's genius and his daring most reveal themselves is in his delineation of the characters and transformations of the people who form a combat unit in a war as infinitely flawed and misunderstood as was the war in Vietnam. In spite of the unity suggested by the term "United States," a deadly diversity afflicted America's military personnel in Vietnam. Gaps of wealth, of education, of race, of political inclination, of conscience, and in an understanding and consciousness of our national goals (whatever they actually were) undermined unit cohesion in a way they did not seem

to do in prior wars. Stone covers every base in his portrayal of how men of presumed like intent splinter under the pressures of war when the goals and reasons for that war are unclear.

My experience mirrors that of the men in Stone's cinematic platoon. The greater the pressure, the greater the divisions. Stoners, rednecks, scholars, idiots, patriots, cowards, ghetto kids, psychopaths, mentors, drunks, layabouts, hard-chargers: Every possible variation on human behavior gets a chance to reveal itself in blinding clarity in the cauldron of war, and in Stone's film, he not only depicts it, he realizes that these isolating divisions between people create and exacerbate the possibilities for failure, whether for a nation or for a small group of men. The Vietnam War was spoiled and rotting before Americans ever stumbled into it, and its putrefaction not only pulled apart the nation, it ripped at the fabric that created in earlier wars the bond of bands of brothers. It is a mark of Stone's insight as a filmmaker and his courage as an artist that he confronted

this inconvenient truth. Certainly there was (and remains) a brotherhood of warriors who fought and survived the Vietnam War. But by confronting the collapse of unity and commonality of purpose among the soldiers characterized in his film, Stone is able to confront the larger issue of the collapse of unity in the American nation as inflamed by the central conflict of his generation, and to do so in a more concrete and unambiguous way than such exercises in deadly surrealism as *The Deer Hunter* and *Apocalypse Now* could approach. And that, beyond even the magnificently authentic re-creation of the details of life in a combat unit, is why I believe *Platoon* to be the greatest and most important film about the Vietnam War to date.

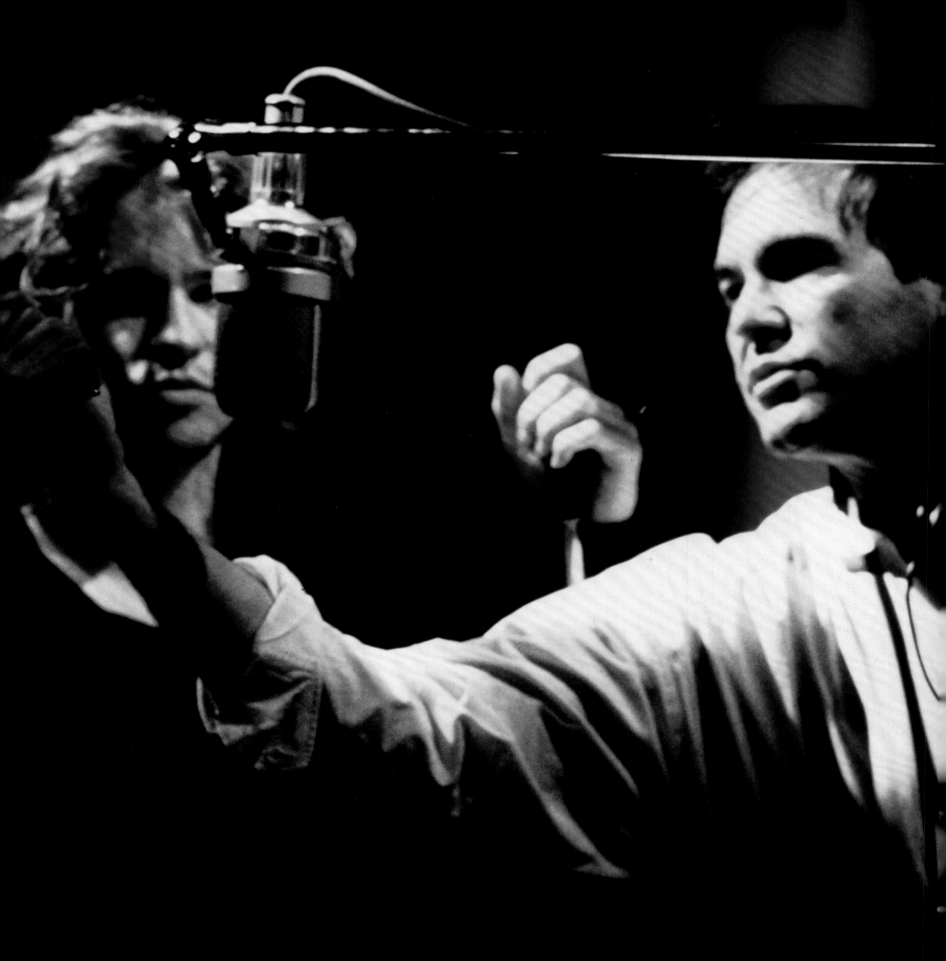

𝕿hrough

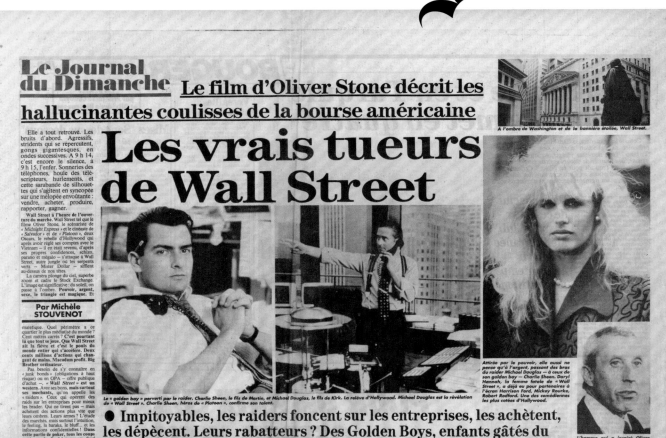

Le Journal du Dimanche

Le film d'Oliver Stone décrit les hallucinantes coulisses de la bourse américaine

Elle a tout retrouvé. Les bruits d'abord. Agressifs, stridents qui se repercutent, gongs gigantesques, en ondes successives. A 9 h 14, c'est encore le silence, à 9 h 15, l'enfer. Sonneries des téléphones, houle des téléscripteurs, hurlements, et cette sarabande de silhouettes qui s'agitent en syncopée sur une mélopée envoûtante : vendre, acheter, produire, rapporter, gagner.

Wall Street à l'heure de l'ouverture du marché. Wall Street tel que le filme Oliver Stone, le scénariste de « Midnight Express » et le cinéaste de « Salvador » et de « Platoon », deux Oscars, le rebelle d'Hollywood qui après avoir réglé ses comptes avec le Vietnam – il en était revenu, d'après ses propres confidences, schizo, paranio et mégalo – s'attaque à Wall Street, autre jungle où les serpents verts – Mister Dollar – sifflent au-dessus de nos têtes.

La caméra plonge du ciel, superbe zoom et cadre le Stock Exchange. L'image est significative : du soleil, on passe à l'ombre. Pouvoir, argent, sexe, le triangle est magique. Et

Par Michèle STOUVENOT

maléfique. Quel périmètre a ce quartier le plus médiatisé du monde ? Cent mètres carrés ! C'est pourtant là que tout se joue. Que Wall Street ait la fièvre et c'est le pouls du monde entier qui s'accélère. Deux cents millions d'actions qui changent de mains. Macadam profit. Big Brother ordinateur.

Pas besoin de s'y connaître en « junk bonds » obligations à haut risque) ou en OPA – offre publique d'achat –, « Wall Street » est un western. Avec ses bons, mais surtout ses méchants, qu'on appelle les « raiders ». Ceux qui opèrent des raids sur les entreprises pour mieux les brader. Qui ne tirent pas – mais achètent des actions plus vite que leurs coeurs. Leurs armes ? L'étude des marchés, mais surtout l'intuition, le feeling, la baraka, le bluff... et les informations confidentielles ! Dans cette partie de poker, tous les coups sont permis. Sauf les erreurs. Seul perdre. Sauf se faire prendre. Ces raiders, on les appelle aussi les prédateurs, prêts à tout pour se procurer l'information qui leur

Les vrais tueurs de Wall Street

Le « golden boy » perverti par le raider. Charlie Sheen, le fils de Martin, et Michael Douglas, le fils de Kirk. La relève d'Hollywood. Michael Douglas est la révélation de « Wall Street ». Charlie Sheen, héros de « Platoon », confirme son talent.

A l'ombre de Washington et de la bannière étoilée, Wall Street.

Attirée par le pouvoir, elle aussi ne pense qu'à l'argent, passant des bras du raider Michael Douglas – à ceux de son golden boy – Charlie Sheen. Daryl Hannah, la femme fatale de « Wall Street », a déjà eu pour partenaires à l'écran Harrison Ford, Mickey Rourke, Robert Redford. Une des comédiennes les plus cotées d'Hollywood.

● **Impitoyables, les raiders foncent sur les entreprises, les achètent, les dépècent. Leurs rabatteurs ? Des Golden Boys, enfants gâtés du capitalisme boursier** ● **A trente ans, ils gagnent 280.000 F par mois**

L'homme qui a inspiré Oliver Stone, Ivan Boesky, surnommé « le Terrible », raider célèbre pour sa limousine noire et sa Rolls rose. Milliardaire et escroc. Condamné, il a payé cash une

(previous spread) Production still of Oliver Stone directing Val Kilmer during the shooting of *The Doors* (1991).

(above) 1987 story from *Le Journal du Dimanche* about *Wall Street* as a critique of American-style capitalism.

"**G**reed, for lack of a better word, is good," *Wall Street* antihero Gordon Gekko (Michael Douglas) tells a roomful of Teldar Paper stockholders in the 1987 drama's most famous scene. "Greed is right. Greed *works*." Gekko is speaking on behalf of himself, but also—via Oliver Stone and his cowriter, Stanley Weiser—on behalf of the United States. In the eighties, many Americans had accepted the gospel of trickle-down economics and Ayn Randian uber-selfishness, and embraced the notion that Vietnam and Watergate were hiccups on the road to empire. Gekko's arrogance embodied the era. He was ascendant yuppie values incarnate: a slick-haired thug in Armani suits, buying companies to dismantle them for profit, and dismissing the plight of laid-off employees as collateral damage. "I am not a destroyer of companies," he proclaims. "I am a liberator of them!"

Stone's first movie after *Platoon*—and his first major studio picture, with Twentieth Century Fox—initially seemed like an odd fit, but the film's keen grasp of the capitalist mentality synced up with the anti-logic espoused by the Pentagon in Vietnam: a war that was run like a corporate expansion, adding new bombing targets and free-fire zones with the bland inevitability of Coca-Cola or McDonald's entering new markets. Gekko's Teldar monologue is not far removed from a statement made to the Associated Press by a US Army major in Vietnam almost twenty years earlier, after ordering the bombardment of Ben Tre city to root out Viet Cong believed to be hiding there: "It became necessary to destroy the town to save it."

Charlie Sheen's presence in the role of ambitious junior stockbroker Bud Fox, who appeases his surrogate daddy, Gekko, by selling out his working-class biological father

(Martin Sheen), felt inevitable and correct. His father, Martin Sheen, had starred in Francis Ford Coppola's *Apocalypse Now*; *Wall Street* is another kind of war story, and by a fluke of timing, its casualties were sitting in the audience watching the film. The movie opened on December 11, 1987, less than two months after the so-called Black Monday crash, the largest one-day decline in the history of the Dow Jones Industrial Average. This coincidence helped *Wall Street* become an editorial-page headline generator as well as a modest hit; it might have helped put Douglas over the top to win an Oscar; and it catapulted Stone into the ranks of auteurs who were asked for their opinions on politics and society as well as cinema. When you saw Stone's gap-toothed grin in an eight-page *Premiere* interview, you sensed how bold he'd become in the wake of *Platoon*'s success. A year into his celebrity, he was already starting to look and sound like the heir to his old NYU professor, Martin Scorsese—or better yet, Francis Ford Coppola, a director as rock star whose seventies classics were as much statements as they were stories. It didn't matter much that *Wall Street* was an unabashed crowd-pleasing melodrama that boldfaced its points, had little use for women, and unwittingly glamorized the same foulmouthed men whom its screenplay depicted as economic vampires. Stone was plugged into the zeitgeist now. Each new film was a chapter in the tale of his march into the pantheon.

If there were any doubts that Stone's rabble-rousing hero-heels were refracted shards of himself, *Talk Radio* erased it. The movie was shot in 1988 for a pittance in Dallas, mainly as a logistical warm-up to *Born on the Fourth of July*. It adapted and expanded on the play by Eric Bogosian, who cowrote the script with Stone and brilliantly reinvented his role as Barry Champlain, a left-wing Jewish radio host bonding with fellow eccentrics and ridiculing redneck flag-wavers[1] on a Dallas late-night show that's about to go national. It was what a concert pianist might call a five-finger exercise, but Stone still gave a virtuoso performance as director. Roughly four-fifths of *Talk Radio* unfolds in and around a single set, the radio station, and Barry is seated for much of it.

Despite these constraints—and notwithstanding unnecessary scenes away from the station, and awkward seventies flashbacks charting Barry's rise to fame and the collapse of his marriage to his now ex-wife (Ellen Greene)—it's furiously kinetic, suggesting Barry's depression, paranoia, and

narcissism not just through dialogue and performance but sound design, music, expressionistic lighting, and bold camerawork. There are moments when Barry seems to think he's Howard Beale, the "Mad Prophet of the Airwaves" in Sidney Lumet and Paddy Chayefsky's 1976 media satire *Network*, exorcising his demons by telling his audience harsh truths they never thought they'd hear. But at his most sweatily desperate, he evokes Lonesome Rhodes, the drawling demagogue played by Andy Griffith in Elia Kazan's 1957 cautionary tale *A Face in the Crowd*. The climax, filmed in a single take on a rotating set, reproduces a go-for-broke monologue from Bogosian's play. It indicts the entertainer's (and the filmmaker's) sadomasochistic, hypocritical relationship with an audience that dares him to be outrageous and then excoriates him for becoming a caricature of himself, that craves both intimacy and distance, and that prizes sensation over sense. "You're happiest when others are in pain!" he rants. "And that's where I come in, isn't it? . . . I'm here to lead you by the hand through the dark forest of your own hatred and anger and humiliation. . . . I'm providing a public service! You're so scared! You're like the little child under the covers. You're afraid of the boogeyman, but you can't live without him."

As in stage productions, which root the hero to his desk and pipe the callers in through speakers, the phrase "theater of the mind" truly applies. Every stranger who reaches out to Barry is at once an instantly defined character (sweet, lost, confused, hostile) and a stand-in for some aspect of Barry's personality, as well as confirmation of the fame-fueled oblivion trip he's been on since his twenties. If other people don't hear him, he doesn't exist.

Platoon was about one soldier's experience in Vietnam. With his second Vietnam picture, *Born on the Fourth of July*, Stone widened his vision to examine the political, religious, and social machinery that manufactures soldiers, then breaks and discards them. Stone's adaptation of the antiwar activist Ron Kovic's memoir is an epic of disillusionment—about a man raised on a diet of militaristic propaganda who realized, too late, that it was poison. Stone's cinematographer, Robert Richardson, shot the opening section in golden tones reminiscent of *Life* magazine covers and Norman Rockwell paintings, but it's an apple pie laced with arsenic. *Born* is filled with rituals and gatherings meant to reproduce ideology—particularly the notion that America is a selfless warrior nation that rewards

winners who never quit. Tom Cruise, who had become an international superstar after starring in the gung ho Cold War melodrama *Top Gun*, was the perfect lead actor for a film that sought to interrogate the very assumptions that make blockbusters like *Top Gun* possible. Kovic's blind faith in authority and obsession with belonging are fortified by denial and repression—perfect traits for a soldier who is expected to do as he's told and never ask why.

In Vietnam, this good soldier pays a terrible price. He lets himself be bullied into accepting faulty battlefield intelligence, participates in a botched raid on a nonexistent enemy stronghold that kills civilians, and then accepts his superiors' cover story. The result is a chain of moral compromises and tragic mishaps—including Kovic's accidental shooting of a fellow soldier, an act that he denies and represses under orders. His war experience exposes the lies on which his identity and his country's self-image are based. Channeling a depressive rage that audiences hadn't seen before, Cruise incarnated the disillusioned "Yankee-Doodle boy." Kovic marched not for Lady Liberty and Uncle Sam but for the Beast, and came home in a chair. "You look great, Ronnie," his family and friends tell him. He doesn't. He looks like a ghost on wheels, haunting a life that no longer seems real, and maybe never was. Only his father (Raymond J. Barry) recognizes the profundity of Kovic's loss, but is powerless to salve his pain.

"The first time I was hit, I was shot in the foot," Kovic later reflects while sitting in his parents' backyard with a fellow vet. "Who gives a fuck now whether I was a hero or not? I was paralyzed, castrated that day. Why?" Kovic answers that question by facing facts he'd previously denied, voicing thoughts he'd once repressed, and speaking truth to power. The young soldier's rebellion starts out small-scale and personal, as evidenced by a mortifying scene in which Kovic blasts his mother (Caroline Kava) for inundating him with religious and political propaganda, then pulls out his catheter and demands that she not only acknowledge his impotence, but the sexuality that his Catholic upbringing suppressed.

With each subsequent scene, Kovic's rebellion becomes more daring, forceful, and public. He visits the family of the soldier he shot, erasing the official narrative of the young man's death and dragging his survivors into Kovic's turmoil. In the movie's audacious climax, Kovic leads a phalanx of Vietnam Veterans Against the War (many of them paraplegic) into the 1972 Republican convention; after

security dumps Kovic and his crew onto the pavement, the hero reconnects, more sensibly this time, with his inner John Wayne and inspires his buddies to regroup and "take back the hall." The following sequence—perhaps the film's only straightforwardly rousing set piece—is a dynamic analogue for Stone's directorial strategy. Throughout, Stone subverts patriotic iconography to enable viewers to recognize it, see through it,[2] and rebel against it. *Born* is antiwar in the deepest, most basic sense. It shows how the Beast uses words and images as psychological weapons, and then turns those same weapons against it.

Born was a surprising financial success, considering its dire subject matter. It won acclaim for Cruise's career-reinventing lead performance, Stone's punchy yet meticulous direction, and his script with Kovic, which had been simmering on the back burner for ten years. It nabbed Stone a second Oscar as Best Director, against stiff competition—the feel-good race-relations drama *Driving Miss Daisy* took Best Picture—and proved that he could revisit proven dramatic terrain and still break new ground. Most important, it reasserted that Stone was as much a polemicist as a storyteller, as well as a stealth memoirist who could see himself in each new subject. In *Born*, he merges his own privileged narrative with the working-class Kovic's, but without warping the latter's essence.

The Mexico sequences, in particular, seem especially dear to him. He had finished his first draft of *A Child's Night Dream* in Mexico, right after he returned from the merchant marine, then got busted for drugs a few years later, just across the border—an event that transformed his suspicion of authority into generalized resentment. The mix of brute fascination and romantic idealization with which Kovic regards the prostitutes at the veterans' colony mirrors passages from the director's novel (it feels more Stone than Kovic, really). And the heat in Kovic's first postwar tryst seems to sum up Stone's conflicted vision of woman as lover/mother/redeemer/Other, and sex workers as both detached professionals and romanticized mates: nonjudgmental, enveloping, then gone.

The Doors, **which was released in February 1991, is ultimately a classically styled movie, structured not too differently from** Born on the Fourth of July. There are times when it feels like the flip side of *Born*; set in roughly the same time period, it could be

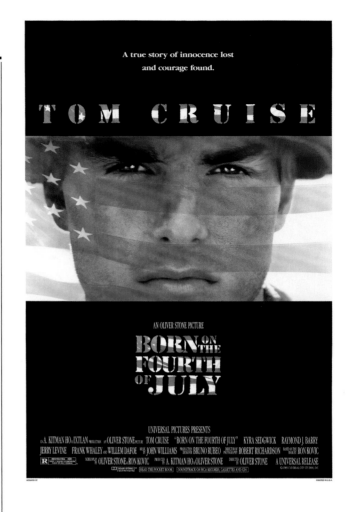

the postwar Kovic's imagining of the freedom, debauchery, and cultural chaos he missed out on because he'd enlisted in the US Marines. Stone drew the ire of some Doors fans when he put Jim Morrison at the center of the film, and turned him into a drug-addled voyager exploring his interior. *The Doors* is not a deep biography of Morrison, his bandmates (Kyle MacLachlan, Kevin Dillon, Frank Whaley), or his girlfriend Pamela (Meg Ryan, well cast as a woman too hip to be square, too square to be hip); but it's not really trying to be, the date-stamped concert sequences and allusions to then-current events notwithstanding. Stone, who sent his first feature-length script "Break" to Morrison right before the singer's death and modeled *Platoon*'s Elias on him, has said in many interviews that it is his fantasy of the rock star as an embodiment of Dionysian fearlessness—a dream figure who carried the emotional arc of the sixties counterculture within him, moving from utopian rebellion and feral boldness to booze-soaked depression, withdrawal, and oblivion. The film showcases Val Kilmer's richest performance—few stars are so adept at letting themselves be treated as sculptural objects while still allowing us to share their characters' feelings—as well as some of Stone and Richardson's most arresting images: a diving hawk seeming to merge with a lens flare; the LSD-tripping Morrison climbing atop a car roof on LA's Sunset Strip, his beaming face haloed by stars; Pam in the background of a wide shot of a Paris bathroom, contemplating Morrison's out-of-focus corpse.

These dazzling moments never arrange themselves into a clear statement, but considering the intuitive way Stone approached the subject, perhaps there's no way they could have. *The Doors* is in some ways his most minimalist picture, in others his most excessive. One long scene bleeds into another long scene that bleeds into a montage, creating a sequence. The entire movie plays (by design) like one of those swoony double albums that rock bands used to release in the sixties and seventies when everyone was trying to outdo the Beatles. The sequence built around the Doors' masterpiece "The End" is one of Stone's grandest, beginning in the sunbaked desert, diving into Morrison's psychedelic/oedipal visions like Dave Bowman entering the monolith at the end of *2001*, and emerging into a concert hall where the song is being performed live; like the other musical sequences, it's so voluptuously imagined and drawn out—the better to study the psychic tremors passing between singer and audience—that it feels like a continuation of Morrison's peyote trip. The whole film is Morrison's trip, and Stone's.[3]

1 Stone: "Now see, here you go again with making [*Talk Radio*] into part of my political evolution. You keep writing about it this way, but I think it's all in your head. This is Eric [Bogosian]'s play, I'm the interpreter, I'm trying to be true to the story, and it's not the story you see in your head. This story is not about politics. It's about emptiness and love and talking yourself to death. I've been on so many talk radio shows . . . you talk yourself out and you hate yourself afterward because it's like, *What am I talking about?* You're filling air and you have a self-loathing about it. . . . it's like I told an interviewer recently, if you only probe for the truth and don't have a heart you're lost. That's really the theme of the movie, and it's a warning perhaps to myself."

2 At times literally—note the shot in the 1970 Independence Day sequence, showing an American flag rendered transparent by the sun.

3 Stone: "I don't see this film as a death trip at all. Jim Morrison was exploring the frontiers of experience, and for me, that oblivion you say Morrison and the movie are seeking is the final transformation."

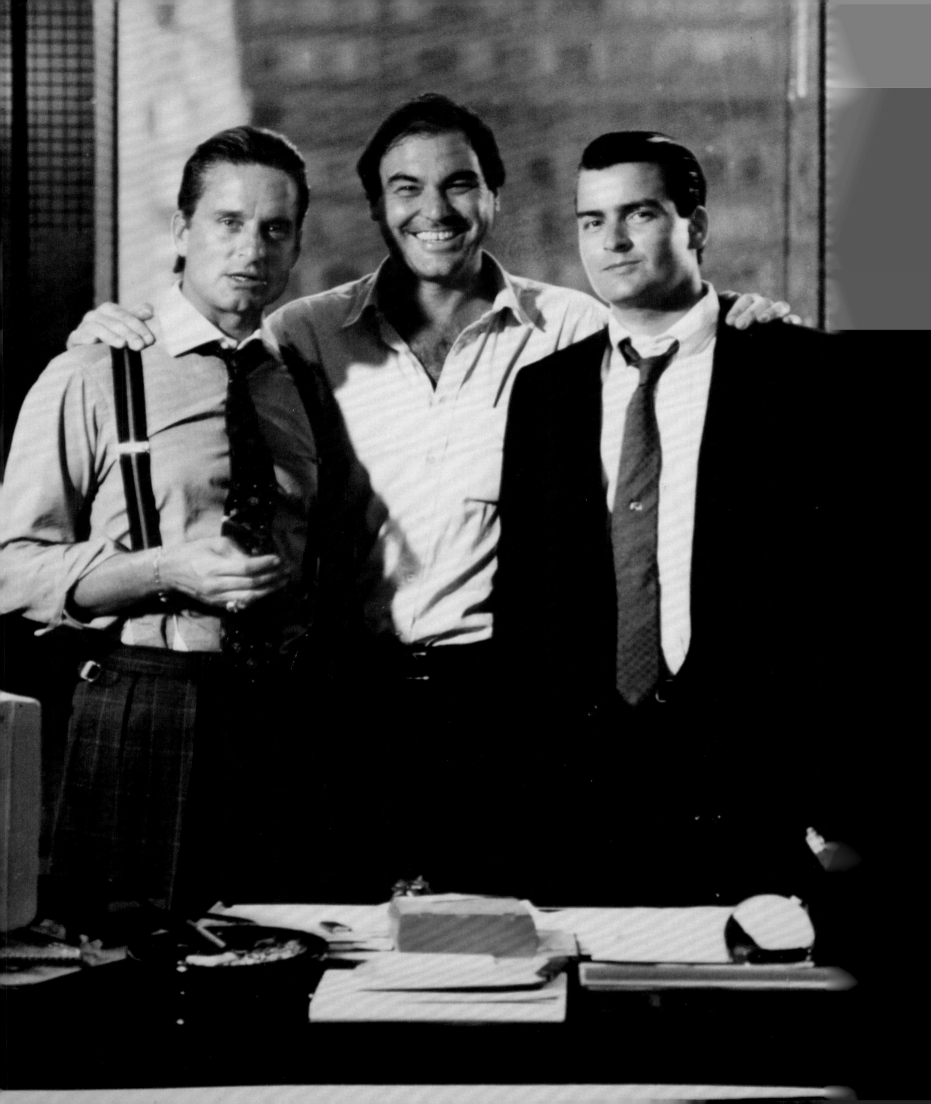

MATT ZOLLER SEITZ So you go to the jungle twice, then you come home to New York. That's what happened in your own life, and that's what happened in your filmography after *Salvador* and *Platoon*, which are, respectively, about another Vietnam, and Vietnam.

But your next movie after that is *Wall Street*. It's a melodrama about a young broker trying to curry favor with a corporate raider by helping him buy the airline that his dad works for. And it turned out to be another iconic movie for you.

OLIVER STONE *Wall Street* was a chance to shoot in New York City, my hometown, and a chance to do a studio film, because they'd backed me to the tune of about eighteen million dollars at that time, which was pretty big money in 1987. But it's important that you know: There was no conscious political motivation to do *Wall Street*. I did it mainly because I was curious about my dad. It was really an exploration of my father's world, which I found fascinating atmospherically, and I wanted to get back to where I'd been in the 1950s, when my father would take me down to Wall Street, with the lighting and those offices. The dark spaces . . . if you look at the movie, it's shot pretty dark.

It is, except for the trading floor and the brokerage houses, which are very unnervingly bright. And the camera is flying through it—it's like it's a shark.

Yeah, but those are bigger rooms. I like the small-room effects, too; those are small-room effects.

Anyway, my father was buried into Martin Sheen's character, the hero's father, as well as Hal Holbrook.[1]

The veteran at the firm. The guy who still has some conscience.

Some of those lines from Hal Holbrook would've been right out of my father's mouth, you know? He liked epigrams, and Martin Sheen and the son, all the stuff about the son borrowing small sums of money from the dad. My dad told me one time, *Kiddo, I got you a start and a college education, but I don't have a lot of money left to give you. But I had fun spending it. I had a great life!*

Wall Street was a really personal movie. It was disguised biography.

But the rejection of that movie by the critics was so heavy. I mean, so nasty, I thought. Except for a few. Roger Ebert was nice to it [END 1], but for me, the response was devastating. I knew I could never be a good guy with these people because *Platoon* was too commercially successful and *Wall Street* . . . they kind of sliced it up, you know.

You got hammered, even in the positive reviews of *Platoon*, over the narration, and over the character of Chris Taylor as being too naive, and the symbolism being too basic: Jesus and the devil fighting for the hero's soul. *Wall Street* got a lot of the same criticisms: *He's moralizing. He's a sentimentalist. He's too on-the-nose.*

Yeah. But so what? I always said, it's *The Pilgrim's Progress*.[2] It's a medieval play. Let it be. So what that the guy's naive and the story is larger than life?

But it didn't matter. The most popular critical film that year, of that genre, was *Broadcast News*,[3] which, for my bad luck, had to come out from Twentieth Century Fox in December, before our movie, and it got all the play! I remember [Barry] Diller,[4] he didn't like this movie, *Wall Street*, and he was dumping it out. How many theaters did it open? Seven hundred theaters in one day? In those days, that was a huge amount of theaters—but Walton, Florida? That's not a first-run market! You don't open this movie in places like Walton, Florida. There was no way we could build on that.

And there was no respect for the movie. Michael Douglas did get a bump from it, because film industry people liked the performance, but they didn't really look at the movie. James Brooks had seven Oscar nominations for *Broadcast News*? We had one? Why was *Wall Street* ignored, except for Michael Douglas? No Oscar nominations for anything, including the writing or anything? Two years later, *Working Girl*[5] is nominated!

Look at the hypocrisy in that! What's so threatening about *Wall Street* but not about Michael Douglas's performance?

I think they were responding to his personal narrative of being the actor who had never found himself as a star, who was always seen as the son of Kirk Douglas, and here he was playing a role his dad would've played, as well as Kirk Douglas could've played it.

It was disguised biography.

Yes, in the part, in the movie, he surprised people. There's no question that in the first one, the surprise is partly what led to the Oscar, I believe. It was so against what they expected of him. He'd achieved some reputation as the protagonist of *Streets of San Francisco*[6] and as the dashing hero of *Romancing the Stone*[7]—he was excellent in

1 *Wall Street* is dedicated to Stone's father, Louis, who died shortly before the film came out.

2 Religious allegory written by John Bunyan, published February 1678, and never out of print; follows an everyman named Christian as he journeys from his hometown (metaphorically: "this world") to "that which is to come," in other words, heaven.

3 A 1987 comedy-drama-romance written and directed by James L. Brooks about rivalries (romantic and otherwise) at a television news station; stars William Hurt, Albert Brooks, and Holly Hunter; nominated for seven Academy Awards.

4 Chairman and chief executive officer of Fox Inc. from October 1984 to April 1992.

5 A 1988 romantic comedy directed by Mike Nichols about a secretary (Melanie Griffith) working her way up in the mergers and acquisitions department of a Wall Street investment bank.

6 A 1972–77 television series about a seasoned cop (Karl Malden) teamed with a rookie inspector (Michael Douglas) to solve crimes in San Francisco.

7 A 1984 romance-adventure directed by Robert Zemeckis; Michael Douglas plays a dashing hero who guides a romance writer (Kathleen Turner) through Colombia.

that. And he created a persona: handsome young daredevil. He'd been in several movies by that time but had never had the success of his father at that point in his career, and I think that was a very important movie for him. His ferocity came out of nowhere, in the sense that it wasn't expected. Michael had a financial mind, and had lived on the East Coast and was interested in Wall Street, so I felt like he could do it. ███████████████████████████ ███████████████████████████ ███████████████████████████

███████████████████████████[8]

It was a very dialogue-heavy movie, and the model for it, for me, was *Sweet Smell of Success*.[9] People would boast a bit, talk like the way Burt Lancaster had, that great confidence about himself. I liked that aspect of it. ███████████████████████████ ███████████████████████████ ███████████████████████████ ███████████████████████████ ███████████████████████████ ███████████████████████████ ███████████████████████████[10]

Did it seem that being able to play a heel liberated Michael Douglas?

I think to some degree, yeah. I think he was more comfortable, but I think Michael struggles for comfort levels. I mean, he's not comfortable per se, he's always looking.[11] If you notice, he moves his shoulders a lot. When he's misused, which he sometimes is in films, that cockiness of Gekko can be irritating, smarmy, in the wrong roles. But I like Michael when he's doing it in good movies, with good material. I liked him in *Wall Street* very much, and in certain other roles very much, like the one Danny DeVito did about divorce, *War of the Roses*. That's a bleak piece of work. I loved him in that. He and Kathleen Turner had wonderful chemistry. So there are moments when he approaches the old William Powell, or even Cary Grant, mode. He's debonair, and he can also do middle class, as he does in *Fatal Attraction*.

Same year as *Wall Street*.

So there you go. The new Michael may have emerged from that as well, but he was more the put-upon, yuppie husband in that one. He was growing into that role, the yuppie, which Gordon Gekko is a kind of offshoot of— although a weird offshoot. Yuppies love money, that's always the issue: They're a money-oriented ideology. A yuppie has no principle. The only principles Gekko has relate to money, the deal, win or lose, in or out. *It's a zero-sum game, pal!*

So much of his dialogue in *Wall Street* is about physically hurting people, ripping them new orifices, making them bleed.

8 Redacted.
9 Acidic, sharp-tongued 1957 tale of a powerful Broadway columnist, J. J. Hunsecker (Burt Lancaster), who manipulates a press agent (Tony Curtis) to do his bidding.
10 Redacted.
11 According to an interview with Douglas on the twentieth anniversary DVD of *Wall Street*, Stone denied Douglas his "comfort level" by playing on his "repressed anger," at one point stopping by his trailer between takes and asking him if he was doing drugs because "you look like you haven't acted before."

It's a zero-sum game, pal!

Yeah, and it's not all figurative. He does punch Charlie out at the end. He punches him out!

You got to work with Martin Sheen, finally, after almost working with him on *Salvador*.

Yes. Martin I always think of as a fine actor, and his handling of the dialogue with Charlie was very touching to me as an example of a father-son relationship. I love the scene where Martin confronts Gekko at the union meeting, the way he plays an iconic, working-class father in his mannerisms and moods. The man is a mechanic; you see it at his work and in various places. I always found Martin authentic and honest. Maybe he wasn't a movie star, you know, he was more perhaps in some ways like Arthur Kennedy[12] was in his day, just that great, dependable second.

A very handsome character actor?

I would say so, yeah. And I don't think he wanted the stardom. Even in *Apocalypse Now*, which he's great in, he seemed to shy away from it. He wasn't comfortable in that aura. He was a hell of a father and raised fine children: Emilio, certainly. And the other children—well, I can't say Charlie is a specimen, a product that would make his dad proud—well, I think there are issues with Charlie.

You saw something in him early on, though. A lot of people thought you were grooming him for a Scorsese–De Niro type of collaboration.

Well . . . You see, Charlie, to me, when I did *Platoon*, was a wonderful potential movie star. That was a surprise, because he didn't have those kind of ordinary movie star looks, but he had a certain quality that came from Martin: honesty of expression.

We played with it in *Platoon* and also *Wall Street*, but by the time the latter was ending as a film, Charlie was . . . definitely more interested in money, and being in the Wall Street world certainly sharpened his appetites. So after that, I felt like he took a series of films, one right after the other, really without much thought as to what they were saying. It seemed to me he was on a path to make the big money, because he wasn't paid a lot for those two movies with me, you know? It was beginners' wages, so to speak, and now he wanted to score.

Do you think that drew him away from exploring his talent?

I think Charlie never developed his intellect that much. I mean, he had great instincts, but growing up as the child of an actor, you fall into these patterns, and you don't think about it sometimes. You just assume it. So you can act, but you don't think about why, and sometimes . . . sometimes I feel Charlie was ignoring those principles, and was just insensitive to himself.

The principles that his father exemplified?

The principles of his father, yes, but it's kind of like that dynamic between the father and son in *Wall Street*, where you see that play off of, *I want to make money, I want the girls, the fun, the glamour, I don't want to be stuck in Long Island with a wife*.

12 Premier character actor in American film and theater who often worked with the director Elia Kazan; originated the role of Biff in the original stage production of Arthur Miller's *Death of a Salesman* (1949).

191

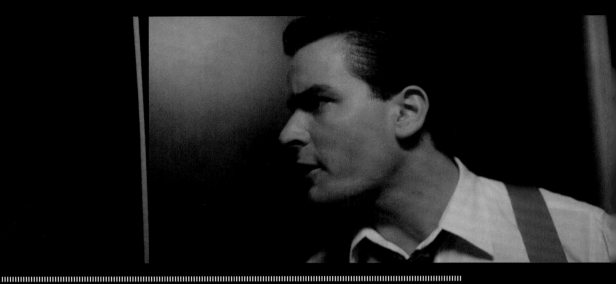

That's interesting, because everybody who saw the scenes between the two of them assume there was some real-life father-son psychodrama happening underneath the dialogue, and you seem to be saying that something of themselves really is coming through.

I didn't notice it at the time, but yeah. I knew we had something. I mean, it was my idea that they would play opposite each other. But . . . I had gone through similar things with my father, so I was seeing that aspect of it, too. I was listening for the lines, because you're in the moment. I did the same thing in the scenes with Martin and Charlie in *Wall Street*, but I was being honest to my father and me, and if it was a parallel between the two of them, well, I didn't know their relationship and didn't claim to. I just knew that they had something together.

That scene in the elevator, that was my favorite moment: when we were panning back and forth.

That's all one take. There's no cut in that.

In the elevator, right. I thought: Why not? It was too tight a space to go for coverage, and it builds tension. It's a good scene.

I want to reiterate, for readers, what an intense and short period this was for you. Between spring of 1986 and December of 1987, you released three major features: *Salvador*, *Platoon*, and *Wall Street*. The upside and the downside of your success in that two-year period was, you were immediately not just seen as a major filmmaker, but as a major filmmaker everybody had formed an opinion on. That almost never happens! Usually it takes three, four, five movies before it gets to the point where critics and the general public feel they need to have an opinion on a director.

And yet the film became iconic!

That's true.

But people felt they needed to have an opinion on Oliver Stone *right now*. And then, coming right on the heels of that, there's a sense of, *Who's this filmmaker who's suddenly being forced on me? I must resist!* I was rereading, for example, reviews of *Salvador* and *Platoon* in Pauline Kael's collection. She was complimentary, for the most part, to *Salvador*. But I sensed a bit of a backlash already in her review of *Platoon*. Those reviews were separated by just a few months.

Yeah.

And I remember reading think pieces about *Platoon* at that time, on editorial pages, and I was struck by the fact that a movie had spilled off the entertainment pages and was on the editorial pages. As a young student journalist, it did not escape my attention that you had become an issue. Your movies were an issue, and you were an issue.

And also, there was an attempt to discredit me. You mustn't forget, it was very hurtful. The day *Platoon*, there was this torrent of phone calls from people asking if I was aware of this story starting to go around that I had never served in Vietnam. Dale Dye alerted me quickly to that, and it was a story going around that I had never been in Vietnam, based on the fact that there was no record of an Oliver Stone.

So you were swift-boated?

I was about to be! No, I just said, *That's bullshit—first of all, it's William Oliver Stone*. And then Dale went back for the files and found them. I did have a record that they couldn't expunge.

But in general, I felt like there was a backlash at that point, and on *Wall Street* especially, the writing was dismissed, everything was dismissed. I was hurt by Vincent Canby in the *New York Times* **[END 2]** and Sheila Benson in the *LA Times* **[END 3]** . . . snarky, snarky stuff. It's devastating to feel that there's no support for the work.

The irony is the film did work out, over time, to be more resonant than *Broadcast News*—I'm not saying it's a better film, it's just different, a different film, but one with more resonance. And so many young people were moved by it. They came and told me so. In *Broadcast News* they're all cynical—that's the point. It's a good film, and I enjoyed it, but it's the kind of film that appeals to the literati more so than the naïveté of *Pilgrim's Progress* on Wall Street.

And yet the film became iconic! We didn't expect that. Remember, the Wall Street movie hadn't been a very successful genre. We grossed the same amount of money as *Broadcast News* at the end of the day, about forty-seven million dollars, and Fox spent a fortune, a *fortune*, promoting Brooks's film and dumped us. But we survived, at one level or another. No one could stop *Wall Street*. At the end of the day, the critics could not destroy it. And it had popularity everywhere.

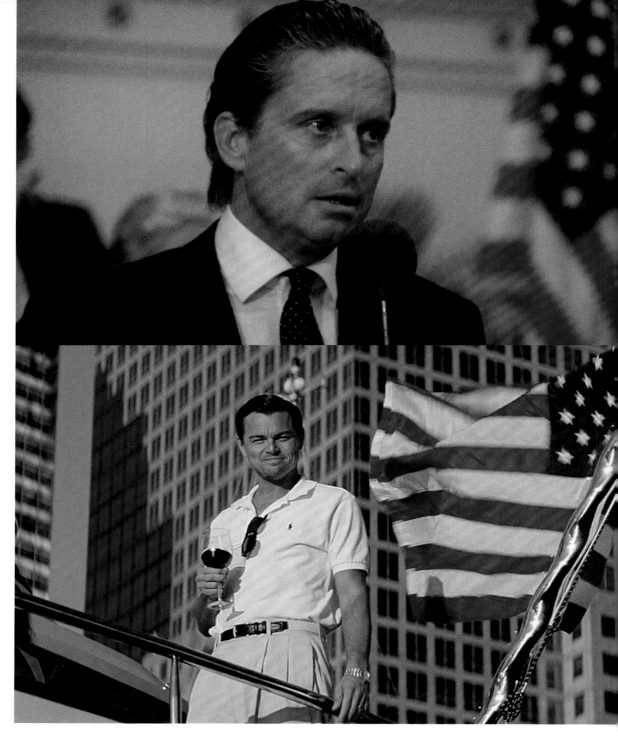

(clockwise from top left) Different ironic uses of patriotic imagery in films by Oliver Stone and Martin Scorsese: Michael Douglas in *Wall Street*; Daniel Day-Lewis as Bill the Butcher in Scorsese's *Gangs of New York* (2002); Tom Cruise as Ron Kovic in Stone's *Born on the Fourth of July* (1989); Leonardo DiCaprio as disgraced trader Jordan Belfort in Scorsese's *The Wolf of Wall Street* (2013).

You mention *Pilgrim's Progress*, and I want to zero in on that. There's a sense of this film, indeed most of your films, as morality plays.

Nothing wrong with that, if you believe in it.

You're often criticized for that, though: giving audiences a sermon. *Wall Street* is extremely clear about what you thought we were doing wrong as a country.

(*Stone laughs.*) That's always been true. It's still true. I was pretty blunt in *Untold History*, too. Come on, I laid it all out! I think I became much clearer by *Untold History*. *Wall Street* was a stumbling exercise. You know, I figured out more about Wall Street itself in the second movie than I knew the first time out! You understand, it was like intuitive, I just felt like . . . Did you know we were going to make a movie about the quiz show scandals, a *Quiz Show* kind of movie, like the one Redford ended up doing?[13]

No.

This was around that time, the mid-eighties. I was shocked by what happened on *The $64,000 Question*, the whole scandal, and I wanted to do that as a movie. Stanley Weiser wrote a first draft at my suggestion, and it wasn't good, and I just said, *This is boring. Let's go to Wall Street*, and I turned the whole project around in one day. I whipped up a story and said, *Let's do* Pilgrim's Progress, to Stanley. We went back and forth on the script throughout that process of cutting *Platoon*.

Well, I thought I knew Wall Street, but what I knew was Wall Street during my father's time. Then I walk the story into the eighties, and here it is—these people are new! They're not my father's generation! These guys are new! They're talking a tougher language; they're less gracious. Money was never talked about during my father's time. Money in the old days . . . was whispered. It was a gentleman's business. You cared about the client. You were responsible for the client. You see Jordan Belfort in *The Wolf of Wall Street*,[14] it's ridiculous! There's no client!

But we were talking about sermons. I wanted to ask you a question. You say people think of me as a guy who does sermons. Marty's always said he almost went into the priesthood, and he's referenced the priesthood several times to explain his interest in the church. You've seen his films. Does Marty sermonize? Do you think he's a priest who sermonizes?

No. I think he always remains a member of the congregation. It's interesting, though: *The Wolf of Wall Street* and *Wall Street*. I hadn't thought about it until you said Scorsese's name, but you could definitely pair those up. There are similar situations, similar ethical issues.

That would make an interesting essay. You should write it!

But Marty: Sermonizer? Not a sermonizer? Is *The Wolf of Wall Street* a sermon?

In *Wolf*, I think Scorsese definitely has an opinion about this guy Belfort, but because of how he expresses it—subtly, a kind of subtlety that's hard to see because the film is so loud and broad—I think that Scorsese was misunderstood and vilified, mainly by people who couldn't accept that depiction doesn't constitute endorsement. Not that it made a dent in the film's box office, because it did very well, and I like the fact that a seventy-one-year-old man could make people that pissed off, but got a lot of heat for it.

13 1994 drama directed by Robert Redford, starring Ralph Fiennes, John Turturro, and Rob Morrow, about the fifties scandal that revealed that the hugely popular TV game show *Twenty One* was rigged to provide the most dramatic and audience-pleasing outcome.

14 A 2013 comedy-drama by Martin Scorsese about a real-life stockbroker Jordan Belfort (Leonardo DiCaprio), who makes a fortune selling junk stocks.

But I never felt there was any doubt that Scorsese felt as much repulsion as attraction to those brokers. I felt like he was putting it in our laps and saying, *This is the culture that you have. This is what you had been living with for the last ten, fifteen years. This is how America still views these kinds of people.* And that final shot, I feel, implicates the audience: We've been watching these scumbags for three hours, that means they're interesting enough to hold our attention, so on some level we're still in awe of their kind of bullshit.

So yeah, maybe it's a sermon, in a roundabout way. The kind of sermon where you have to figure out the moral.

I think Marty, in a certain way, in many ways, is repressed sexually. I think he's always watched his step, and I think he's letting out a bit through the hero in this movie, like he's having some fun. He's having all his sex fantasies at seventy-one that he couldn't have at fifty or forty. That's what he was doing in a lot of that movie, and I think he had a ball, and I think he decided to paint the most impressionistic colors, doing what I did on *The Doors*, and on *Natural Born Killers*: reaching for a new dimension, trying to have fun with it!

I think Belfort is devilish. I don't think Belfort has any sense of responsibility about the victims, and I don't think Marty cares about the real Wall Street. Anybody who was serious on Wall Street would tell you that this guy Belfort was never taken seriously, nobody would return his phone calls. He was just a criminal, ▮▮▮▮▮▮▮▮▮▮▮▮▮▮▮▮▮▮▮▮▮▮▮▮▮[15] But it works, because people like that are fun to watch in movies. And it's good he did it.

It's funny: I don't think Marty has a political bone in his body. I mean, to him, it's kind of like, *They're all gangsters, the system's kind of fucked up, and we're here, and we're just going to rip it up as best we can.* Be smart. Live inside the fucking system, benefit from it . . . the tribe is a rapist tribe, a predatory tribe. Marty's world is a cruel world. I see a little bit of Little Italy in that point of view.

Gangsterism as a metaphor for life, yeah. Every mentality is the tribal mentality for Scorsese, not just in his Mob films but also in films like *The Age*

15 Redacted.

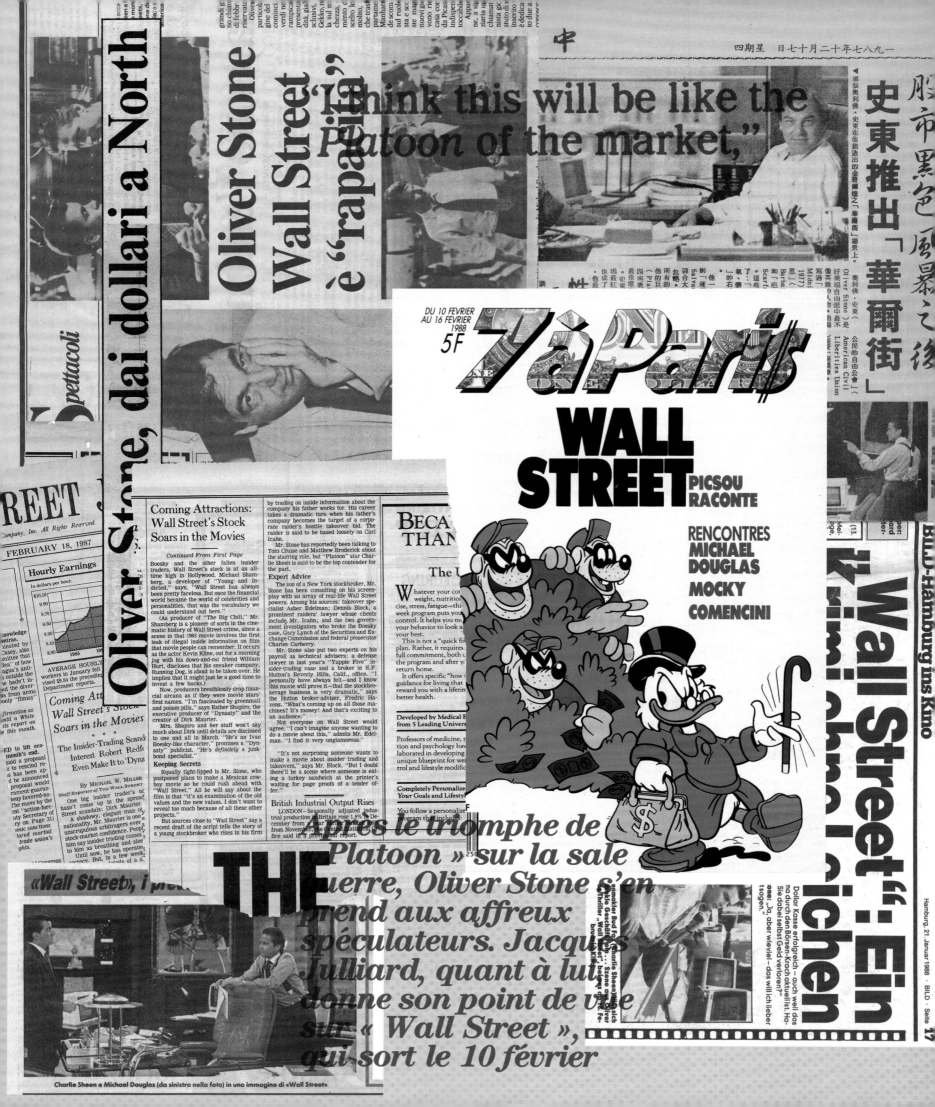

of Innocence, where you see New York high society in the 1880s acting like a bunch of gangsters.

Yeah, and *Gangs of New York*.

Yeah: The city in that film is rotten from top to bottom. And his plots often come down to secret tribunals taking down renegades for the good of the tribe.

Well he's probably right about that. I'm just asking you: Is there a larger picture? Is there something we can do about that mentality?

Maybe there's not. Maybe I'm crazy. I want to get back to this idea of sermons. I like the idea of sermons. Do you think *Wall Street* is a sermon?

Sure.

Do you think *Untold History* is a sermon?

I do.

But what does a sermon mean? Does it mean I'm a priest?

Yeah. You're a priest, you're a preacher.

A priest does sermons. He's supposed to do sermons. Is it bad to be a preacher?

The critical consensus seems to be that sermons are boring.

Bad sermons are boring. But what if it's thunder and lightning? Prophesy, prophesy!

Moving on: In between two studio films, *Wall Street* and *Born on the Fourth of July*, you made another small movie, *Talk Radio*. Eric Bogosian starred, based on his own play about this left-wing radio host. The play folds in details from the life of the Denver talk show host Alan Berg, who was killed by Anti-semetic extremists.[13] It's very much a self-loathing antihero sort of drama, about a guy being consumed by his own demons, but Berg's murder hovers over all of that.

That was in 1984, wasn't it? Berg was shot by a member of a right-wing militant group. I think he was killed in a downstairs parking garage, but we moved it onto the roof.

Yeah, the issue was, I was preparing *Born*, but I had to wait for Tom Cruise[14] to finish *Rain Man*. *Born* was set to go in September of 1988 or something like that, and I think because we were in Dallas preparing for *Born* and I was young and impatient and had just finished *Wall Street*, I didn't really want to take nine months to prep. So we knocked off *Talk Radio* sometime that late spring. There was another factor: We'd just done *Wall Street* in New York, our first big studio movie. The two movies before that, *Salvador* and *Platoon*, were John Daly specials: independent, smaller, faster. Because we were preparing to shoot *Born* in Dallas, and it was a big movie, we thought if we shot another movie there, it'd be a good way to get to know Dallas. And more importantly, it would allow us to concentrate on how to shoot claustrophobically, in a tight radio station that would

13 Members of the anti-Semitic white supremacist group the Order killed the talk show host Alan Berg on June 18, 1984, in the driveway of his Denver town house.

14 1962– ; pure will.

① Big Masters. diopters, reflections
knock off large chunks of dialogue
only way to make it

② Nykvist - Lightness of Being. [RSAL]

③ Diopters! split 2A w/possible
 Heightening of
④ STEADICAM + LUMA. Shadow ACT 3.

⑤ REAR SHOTS BARRY. a
⑥ BOOMS UP AND Down - "TAXI DRIVER"

TALK RADIO

Screenplay by Eric Bogosian and Oliver Stone

⑦ Dissolves inside scenes as talking. Save time,
conversation!

⑧ SHOOT LIGHTBULBS. COLORS. FLASHING - intercuts
on calls.

⑨ SUPERIMPOSITIONS - Images via glass.
 S/len - LINDA. DIETZ -
 DAN.

⑩ ACT 3. Dietz pacing - TRACK - over train onto
Barry. tension.

March 6, 1988 *

⑪ TIME - TENSION - CLOCK CUTS
HANDS, DIALS, BLINKING LIGHTS

CHOICES STUDIO A.

① [Dolly] moving on Barry
② [Diopter] STATICS — on Barry ALL 3 B.G. WINDOWS

③ LOOKING OUT FROM BARRY TO
3 B.G. WINDOWS — [REFLECTION] OF BARRY.
IN STUDIO A.

④ LOOKING AT BARRY FROM 3 WINDOWS
[REFLEXION] OF PERSON LOOKING
④A DIOPTER STATIC. ~~W/no Reflexion~~

⑤ LONG LENSES ON BARRY (ACT 3)

⑥ OVERHEADS.

ⓐ HALF FOLLOWS - GODARDIAN
Barry to WINDOW
ONTO STV in window
B. EXITS -
B. COMES BACK. talking - leads US
back to desk,
OR 2D WINDOW etc

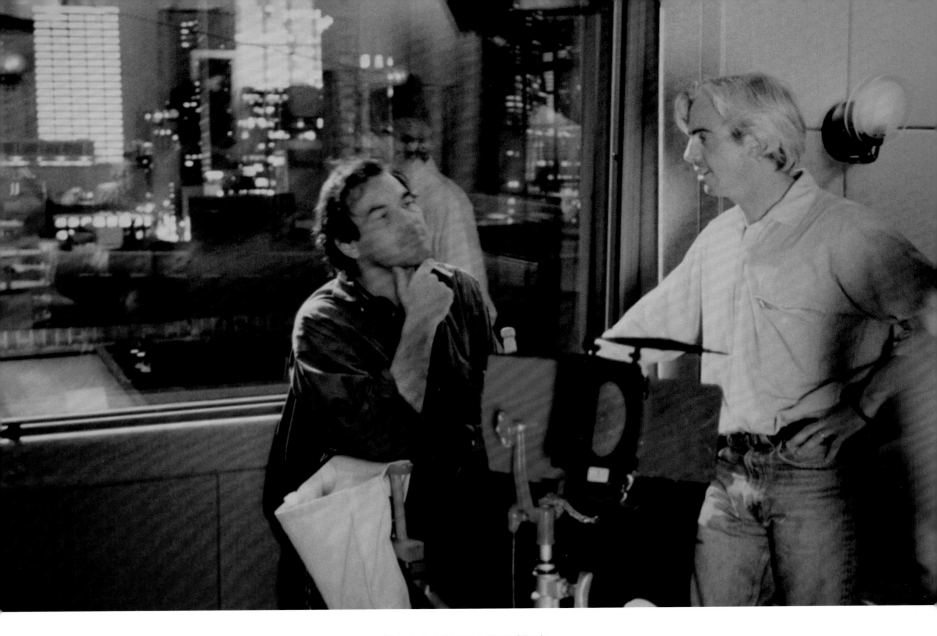

approximate the problems posed by shooting Ron Kovic in a wheelchair. *Get small. Shoot small. How do we do it?*

You shot three movies in Dallas, practically on top of one another: *Talk Radio*, *Born on the Fourth of July*, and then *JFK* a couple years after that. And you returned to Dallas to shoot parts of *Any Given Sunday*. I was raised in Dallas, and I was in college when you were making these movies, and I remember thinking it was tremendously exciting, this big American filmmaker shooting movies there.

Ed Pressman had his canny way. He had produced *Wall Street*, and he wanted to keep in business with me. He had seen this play with Bogosian, bought the play, and wanted me to produce it with him, supervise the adaptation, and supervise Eric. I was not interested to the degree of wanting to just direct a film version of the play, but I said, *Listen, it's a small movie, but it's interesting, I'll go with you, here's a deal.* I'd been approached by Garth Drabinsky, who was a Canadian entrepreneur ▆▆▆▆▆▆▆▆▆▆

▆▆▆▆▆▆▆▆▆▆▆▆▆▆▆▆▆▆▆▆
▆▆▆▆▆▆▆▆▆▆▆▆▆▆▆▆▆▆▆▆
▆▆▆▆▆▆▆▆▆▆▆▆▆▆▆▆▆▆▆▆
▆▆▆▆▆▆▆▆▆▆▆▆,[16] *Talk Radio* was another of my movies that ended up in bankruptcy, because it was released by Cineplex Odeon, the distribution arm of the theater chain. Cineplex Odeon is still in business, it's a nice outfit up in Canada, but the distribution business went down.

Anyway, we made a good deal with Garth; we all benefited. Garth paid, up front, 10 million dollars. We made the movie for 3 million, roughly, maybe less, maybe a bit more, 3.2, 3.8—I don't remember, but we had the profit in advance. Pressman and I divided fifty-fifty. Good deal. And I knew we could make this movie in thirty-some days. We assembled the picture: It was one set onstage, and it took place all in one night, if I remember right, but I opened the story up. Have you seen the play?

Yeah. I like it a lot. I've seen it produced on the stage a few times.

I have, too, twice. I've seen it with Eric, and with Liev Schreiber,[17] a great actor who had a different energy. Eric was very intense, the whole play. Well, I wanted to add the middle section with Ellen Greene[18] and his past, and open up the movie to get out of the studio, because staying in the studio for the whole movie would've choked us out. The play was essentially one diatribe after another with the callers. Some of them had dark humor, some of them were not so dark, but we didn't want it to become monotonous on-screen. We wanted to design it, make it cinematic, give it a look. The idea was, as the story goes on, we're

16 Redacted.

17 1970– ; film, TV and voice-over actor; *Ransom* (1996), *Spring Forward* (1999), *The Manchurian Candidate* (2004), *Pawn Sacrifice* (2014); directed *Everything Is Illuminated* (2005).

18 1951– ; actress in *Next Stop, Greenwich Village* (1976); Audrey in *Little Shop of Horrors* (1986, after originating the role onstage); *Naked Gun 33 1/2: The Final Insult* and *Leon: The Professional* (both 1994); *The Cooler* (2003).

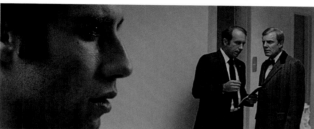

tightening the screws, so the lighting would tighten down. And with Bob Richardson and Bruno Rubeo, we built a really incredible set. It was a revolving thing with windows. It was about windows, mirrors, glass. There were four sides to the set, all these windows, and outside the window was a view of Dallas. Of course, it was all on a soundstage so you weren't really looking out at Dallas. We put that on a transparent screen. We shot it at Las Colinas, which was a new studio outside Dallas, a virgin kind of studio, very clean and kind of sterile.

Whenever I make a movie, I always find some new thing that turns me on, but on that movie in particular, it was the split diopter, which allows you to have foreground focus and

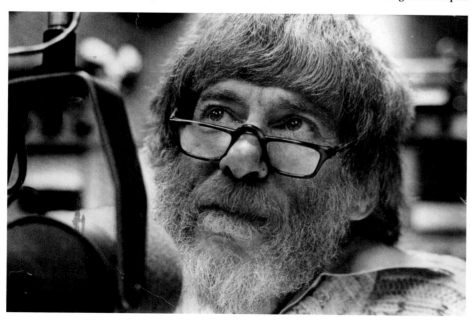

deep background focus, but the middle ground is a little soft. I fell in love with split diopter shots. Bob Richardson and I went to extremes on that, and I had to push Bob, because he wasn't as fond of the diopter as I was.

To clarify, for readers who may not know what we're talking about: You can recognize a split diopter shot because you've usually got the screen divided so that it almost looks like two panels stitched together. There's two planes of action. You're seeing something in the extreme foreground and something in the deep background playing out simultaneously, and it has this feeling of collapsed space. A lot of people's first exposure to this kind of shot was in *Citizen Kane*, but there are lots of other great examples

after that. Your old teacher Mr. Scorsese and your colleague Brian De Palma are masters of the split diopter shot, and Tarantino did a lot of good ones.

In this film you've got a lot of shots like that, where you might see Bogosian in the foreground, talking into the microphone, and then you see people in the booth or in the background.

I liked that kind of shot, and I thought it worked for the picture. We hoped it would give you a sense of Barry being in his own world. It was a way to make visual this sense of how incredibly egotistical he was. He lives his show. The whole world revolves around Barry Champlain. We're in Barry's head. That's why we did the diopter, and all these wild angles.

Some of the shots we pulled off are unbelievable when you look back at them. One that I really like is the spinning dolly shot—you know the one I'm talking about?

That's my favorite shot in the movie: a three, three-and-a-half-minute monologue, all one shot, and we're with Barry as the world starts literally revolving around him as he's basically having a breakdown.

Yeah, he's rotating 360 degrees! I forgot exactly how we did it, but it's like we're corkscrewing into his mind!

I remember that the whole film was tricky to light, because we shot it in a studio filled with all this glass. You have to be careful lighting a set like that; otherwise you'd see the stands, you'd see the lights, reflected in the glass, and the crew. You want to see the actors, but not the crew! There were a lot of angles, but because we had a lot of free time in that

201

112

68 CONT:

Hangs up. Barry leans into the mic, starts softly, then louder with growing anger.

 BARRY
 Believe it or not, you make perfect sense to
 me, you're right -- I <u>should</u> hang. I'm a
 hypocrite. I ask for sincerity and I lie. I
 denounce the system as I make love to it. I
 want power and money and prestige. I want
 ratings and success and I don't care about
 you or the world. And that's the truth...
 And for this I could say I'm sorry, but I
 won't... Why should I, who the hell are
 <u>you</u> anyway, "The audience" -- you're on me
 like a pack of wolves every night, because
 you can't stand facing what it is you are and
 what you've made... Yes, the world is a
 terrible place! Yes, cancer and garbage
 disposals will get you! Yes, a war is
 coming. Yes, the world is shot to hell and
 you're all goners... Everything's screwed up
 and you like it that way! Don't you?
 You're fascinated by the gory details..
 you're mesmerized by your own fear! You
 revel in floods and car accidents and
 unstoppable diseases...you're happiest when
 others are in pain!... That's where I come
 in, isn't it?... I'm here to lead you by the
 hand through the dark forest of your own
 hatred and anger and humiliation. I'm
 providing a public service. You're so
 scared, like a little child under the covers,
 you're afraid of the boogie man, but you
 can't live without him... Your fear, your
 own lives have become your entertainment!...
 Next month, millions of people will be
 listening to this show. <u>AND YOU HAVE NOTHING
 TO TALK ABOUT!</u> Marvelous technology is at
 our disposal and instead of reaching up to
 new heights, we try to see how far down we
 can go, how deep into the muck we can immerse
 ourselves! What do you want to talk about?
 Baseball scores? Your pet? Orgasms? Your
 loony prophecies?... You're pathetic, I
 despise each and every one of you... You've
 got nothing. No brains. No power. No
 future. No hope. No god. The only thing
 you believe in is me. What are you if you
 don't have me?

Linda has come in and stands next to Stu, listening.

 BARRY
 I'm not afraid. I come up here every night
 and I make my case. I make my point.
 (MORE)

 BARRY (cont'd)
 I say what I believe in. I have to, I have
 no choice. You frighten me! I come up here
 every night and I tear into you, I abuse you,
 I insult you...and you keep calling. Why do
 you keep coming back? What's wrong with you?
 I don't want to hear any more. I've had
 enough! Stop talking. Don't call anymore!
 Go away!.. Bunch of yellow-bellied,
 spineless, bigoted, quivering, drunken,
 insomniatic, paranoid, disgusting, perverted,
 voyeuristic little obscene phone callers.
 That's what you are. Well to hell with you!
 I don't need your fear and your stupidity.
 You don't get it. It's wasted on you.
 Pearls before swine...

The computer screen and the lights on the phone have been lighting
up as he talks. People are still calling in!

 BARRY
 ...If _one person_ out there has any idea
 what I'm talking about, I...

69 INT. STUDIO - (VARIOUS CALLERS) 69

He suddenly starts taking callers again...

 BARRY
 Fred, you're on!

 FRED
 Oh...hello...yes...well, you see Barry...I
 know it's depressing that so many people
 don't understand that you're just joking! I
 remember...

 BARRY
 (cutting Fred off)
 Jackie, you're on!

 JACKIE
 I've been listening for years and I find you
 a warm and intelligent voice in the...

 BARRY
 (cutting off Jackie)
 Arnold!

 ARNOLD
 What you were saying before about loneliness,
 I'm an electrical engineer and...

 (CONTINUED)

studio space, Bob was able to pre-light much of that set, and that was very important because it allowed us to rush through the film and get it done fast. It was a very draining kind of movie, probably like Hitchcock doing *Rope*,[19] where you're returning to the same set day after day, and you have to be constantly focused.

Meanwhile, this experience was getting us wet for *Born*, introducing us to all these little stores and places where we ended up shooting the next picture. That was important for the crew: to break them in, to get to where they'd know my style and I would know their style.[20]

So you worked with a lot of the same people on *Talk Radio* and *Born*?

Yeah, a lot of the same crew. This is really a Texas movie. We got to know a lot of people in Texas.

We also had Anath White [END 4] on set as our consultant, who had worked with Alan Berg in Denver. She was really helpful as far as showing us how things were done in radio.

And Eric Bogosian[21] and I really did a lot of work on the script, opened up his play, gave you some of Barry's background, who he was before.

Some fans of the play didn't like that you did that.

You could accuse me of screwing up the movie; I don't think I did, though Vincent Canby did [END 5]! Sometimes he was off the air, he had an outside life, he had relationships; he wasn't just in the studio the whole time.

So I pushed and pushed Eric to open it up more, and we kept adding new things. The Ellen Greene character, for instance. She was good.

It's an impressive bunch of actors, none of whom were terribly well known to moviegoers at that point, including Bogosian. He'd only had one major part by then, playing the prosecutor in Robert Altman's TV version of *The Caine Mutiny Court-Martial*. He's a great actor.

With Eric, we had to train him, because even though he understood acting for the camera, he'd never done a movie with shots like this one. One shot we did was so difficult: He not only had to walk with a camera on him weighing on his chest—a Steadicam, kind of—he had to talk and hit his lines, and I think we might have put him on a dolly, too, for part of the shot! It was so difficult! The first days were a training course.

But he learned fast. He's very smart, Eric. By day fifteen, he started to get it all down. ███████████████████████████ ███████████████████████████ ███████████████████████████ ███████████████████████████ ███████████████████.[22] I'm talking about the dolly moves and how to deal with the camera when you're acting, which is another art form. Eric got it. He was good. All the actors were good. And don't forget Alec Baldwin. He was terrific as Barry's boss. Alec was a young rising actor then, not much film work, always in a rush, but he was good in the movie, very good as Dan. That was a big year for Alec.

That's right. He was also in *Working Girl* as Melanie Griffith's boyfriend, and several others. That was a big year for him, 1988.[23]

And we also had John McGinley[24] from *Platoon*, as well as *Wall Street*, playing the engineer, Stu.

He's a versatile actor, sort of a utility infielder, I guess you could say. How many films has he done with you?

He's briefly in *Born*, so that's four. And *Nixon*, that's five. And he's in *Any Given Sunday*, that's six! I like John. He's a hale, hearty—an Irish soul, a straight shooter.

He once told me, "If you see Oliver again, remind him that I'm his good-luck charm."

(*Stone laughs*) Yeah! Maybe I should get him back! I need to make a note about that.

When I watch the film now, I associate Barry with Oliver Stone, the half-Jewish East Coast liberal coming to Texas and stirring things up. Not long after that, *JFK* comes out and kind of makes that official for you: this carpetbagger, Oliver Stone, picking at Dallas's scabs.

Well, you may read all that into it, but you know, we never felt that when we were shooting. Remember, Dallas may have been more conservative than New York, but it was much more liberal than most of the area, and there was humor there, and it was a great hub for actors and extras. There are a lot of exhibitionists in Texas, you know. So it's no surprise that we found a lot of good actors down there.

We needed a city with a local talent pool because we had all these voice parts to cast. There were a lot of callers in the movie. Doing voices is a very hard thing. People don't realize how hard it can be. Every caller is a definite personality, so that is an actor's role, but you don't ever see the person!

There were a lot of voice-only characters—sixteen, eighteen, I'm not sure. Some of the voice actors were so talented that we could have one of them doing two or three different parts. Those callers are the costars of the movie, and they're invisible. You feel like you know them, but you never know them.

19 A 1948 Alfred Hitchcock thriller about two young aesthetes who murder an acquaintance and then hold a dinner party in the room where his body is hidden; primarily filmed on a single set in what appears to be a single uninterrupted shot.

20 In a December 3, 2015, interview with Jim Hemphill, publisher of the blog *Focal Point*, Stone said, "At the time I felt that *Talk Radio* was the furthest movie from me . . . the provenance was Eric's play, and what I responded to in that was the fury of his performance. I wasn't thinking of it so much as 'my' movie as a chance to develop technique. Remember, I was a young director looking for new ways to express myself on film, and one of the things that was on my mind was the question of how to depict the claustrophobia of being in a wheelchair—*Born on the Fourth of July* loomed like a huge mountain in front of me. Shooting a movie where the hero is castrated and in a wheelchair, living a confined existence for the second half of the picture, seemed like an enormous technical and emotional problem, and I didn't feel comfortable with it. I had rehearsed the movie ten years earlier with [Al] Pacino when it was almost made and knew the challenges that lay ahead of me. I knew that I had to really prep, because I had so much respect for Ron and his story . . . I didn't want to fuck it up."

21 1953– ; playwright and actor, often projecting acerbic intelligence in his own self-written plays and films (including 1991's *Sex, Drugs, Rock & Roll*) and in character parts (1997's *Deconstructing Harry*, 2014's *Listen Up Phillip*).

22 Redacted.

23 1958– ; *Glengarry Glen Ross* (1992), *Malice* (1993), *The Edge* (1997), *Outside Providence* (1999), *The Cooler* (2003), *30 Rock* (2006–2013). In 1988, the year of *Talk Radio*'s release, Baldwin also acted in *Beetlejuice*, *Working Girl*, *She's Having a Baby*, and *Married to the Mob*.

24 1959– ; *Point Break* (1991); *A Midnight Clear* and *Article 99* (both 1992); *The Rock* (1996); *Office Space* (1999); *Scrubs* (2001–2010).

How did the film do?

Not well.

I wonder if the subject matter, the tone, the politics of this movie doomed it? I was in college then, I was becoming aware of both cinema and politics, and I remember thinking even then that this didn't feel like a 1988 movie. Like a lot of your films, it felt like a seventies movie. It was very much about this raging undercurrent of resentment that Barry taps into by needling conservatives in his audience. Nixon's so-called silent majority, those are the people who listen to Barry. Hate-listen, I guess you could say.

I met [Michael] Dukakis[25] in that period. I liked him very much and I tried to support him.

Then the Willie Horton ad appeared. Bush's team scapegoated Dukakis as a wimp and made fun of him for driving around in that tank.

He got wiped out.

Don't you feel that the eighties were an extraordinarily conservative time, though, culturally as well as politically, in America? Hollywood movies in the eighties were not generally liberal. Your friend Michael Douglas built a career on understanding that; a lot of his big hits are about fear of women, fear of gays and minorities, fear of the Japanese, the white worker being displaced.[26] There were all these revisionist post-Vietnam movies, which we've talked about. And there was a lot of hate radio—and unlike Barry Champlain in this film, a lot of the hosts were right wing. Their success set the stage for the rise of Fox News Channel in 1996.

And then a year after the presidential election, in '89, Bush attacked Noriega.[27]

And suddenly we were in Panama.

And in 1990 Saddam Hussein attacked Kuwait, and we manufactured that crisis into a war. And that's all too bad, because in other parts of the world, the late eighties were a liberal time.

I remember when Gorbachev broke the ice with Reagan in '86, and the breaking up of the Communist world, and then the fall of the Berlin Wall in '89 . . . the perestroika.[28] I thought it was a great time. For Eastern Europe it was! Every city was breaking out into joy.

We go into this in *Untold History*. It was beautiful for me, in terms of, *Wow, the world is changing*.

Did these changes abroad have personal significance to you?

Oh, for me, yes! I was happy for the world! It just felt right.

Mikhail Gorbachev was a dream. I met him back then, and I just thought he was the cat's pajamas.

When did you meet Gorbachev?

Eighty-nine, ninety, that period. He was in the United States for some tour. Lovely man. His English was not great, but he had a translator. He had just a lovely persona, radiant health, and happiness and joy, and honesty. It was . . . everything opposite of [Leonid Ilyich] Brezhnev.[29] It was not the closed, dark, cold persona we were accustomed to in Soviet premiers. He was just an optimist and an outgoing man.

But politically, it wasn't pretty in the US, you're right.

Garth, being a showman, wanted to bring the picture out in December of '88. And it seemed to me it should've been in theaters in February or March of '89. But no, no, he was very confident: *I'm gonna spend a lot of dough, I'm gonna* make *this, it's an Oliver Stone movie!* You know?

But the problem was, it's also a really *dark* little movie! Christmas is a different kind of season. Big-event movies come out, and some of them are dark, but Oscar dark isn't dark, you know? This was *dark*.

And the end is brutal.

But Garth was looking for Oscar bait, so we came out in December, and we died. We folded. The movie made like three million dollars. Garth moved on to other escapades. The reviews were kind of tough, as I remember—at least the mainstream reviews; they were not friendly. I don't remember much that was positive being said about it. It was so heartbreaking, heartbreaking, because a lot of work had gone into it. But I love that film, and it does play, in its own way. It's a cult film.

But by that point I was preparing *Born*.

It's ironic that *Platoon* was written in '76, and *Born on the Fourth*'s screenplay was completed in '79. Both films were done

exactly ten years after their screenplays were written for other directors. I was a screenplay writer working for those directors, Billy Friedkin and Dan Petrie. And in the case of *Platoon*, the supposed original director was Sidney Lumet, whom I met in '76.

But I wrote *Born* for Friedkin.

25 Governor of Massachusetts in 1975–79 and 1983–91; Democratic nominee for president in 1988; he lost to the Republican nominee, Ronald Regan's two-term vice president George H. W. Bush. Bush's campaign strategists successfully portrayed Dukakis as too liberal to hold national office, politically oblivious, and soft on crime; the latter charge was driven home in a now-legendary 1988 attack ad blaming Dukakis for the rampage of Massachusetts inmate Willie Horton, who committed armed robbery, assault, and rape while on a weekend furlough from prison. Another ad made comic use of video footage of Dukakis riding in an M1A1 Abrams Main Battle Tank during a campaign visit to a General Dynamics facility in Sterling, Michigan, that was supposed to make him look like Commander-in-Chief material. It didn't.

26 Respectively, in *Fatal Attraction* (1987), *Basic Instinct* (1992), and *Disclosure* (1994) (fear of women); *Black Rain* (1989, fear of the Japanese) and *Falling Down* (1994, fear of white working men becoming marginalized by women and minorities).

27 In December 1989, the United States invaded Panama and deposed its military dictator, General Manuel Noriega, after Noriega voided results of the May election on grounds that the US government had covertly interfered in it; operation code-named Just Cause. The invasion was presented as as response to local harassment of US civilians in Panama and as a necessary action to protect access to the Panama Canal.

28 Mikhail Gorbachev's program of economic, political, and social restructuring that eventually dismantled the Communist state in the USSR.

29 General secretary of the Central Committee of the Communist Party of the Soviet Union; presided over the USSR from 1964 until 1982, expanding the country's world influence and military actions, but also ushering in an era of economic stagnation and social unrest.

Excerpt

Born on the Fourth of July

Ron Kovic

(above) Still-frame from *Born on the Fourth of July* (1989): Ron Kovic's hand clutches dry grass after he is shot and paralyzed in a firefight.

They came for him early that morning, walking up the wooden ramp and knocking on the front door of his house. He could hear them in the living room talking to his mom and dad about the parade and how important it was to have him marching with them on Memorial Day in his wheelchair.

"Parade time," his father said, walking into his room.

"I'll be right with you, Dad," he said, looking up from his bed. "I've got to get my pants on."

It was always hard getting dressed, but he was getting better at it. He turned from his back to his stomach, grabbing his pants and pulling them up until they reached his waist. Turning on his back again, he

207

buckled his belt. Then he pushed himself with both hands in back of him until he was sitting up in the bed next to his wheelchair. He grabbed the chair with one hand, dragging his body across in a quick sweeping motion until he was seated, his legs still up on the bed.

Now his father knew it was time to help. He took each leg, carefully lowering them one at a time to the chair, spreading them apart to make sure the rubber tube wasn't twisted.

"Ready?" shouted the boy.

"Ready!" said his dad. And his father went in back of the chair as he always did and lifted him up underneath his arms so that he could pull his pants up again.

"Good," said the boy.

His father let him slowly down back onto the cushion and he turned around in his wheelchair to face the door and pushed his chair down the long, narrow hallway to the living room. His mom was there with a tall man he immediately remembered from the hospital; right next to him was a heavy guy. Both of them had on their American Legion uniforms with special caps placed smartly on their heads. He sat as straight in his chair as he could, holding on with one hand so he wouldn't lose his balance. He shook hands with the tall commander and with the heavy guy who stood beside him.

"You sure look great," said the tall commander, stepping forward. "Same tough marine we visited in the hospital," he said, smiling. "You know, Mr. Kovic"—he was looking at his father now—"this kid of yours sure has a lot of guts."

"We're really proud of him," said the heavy guy.

"The whole town's proud of him and what he did," said the tall commander, smiling again.

"He's sacrificed a lot," said the heavy guy, putting his hand on the boy's shoulder.

"And we're gonna make certain," the tall commander said, "we're gonna make certain that his sacrifice and any of the others weren't in vain. We're still in that war to win," he said, looking at the boy's father. His father nodded his head up and down, showing the commander he understood.

It was time to go. The heavy guy had grabbed the back handles of the chair. Acting very confident, he reminded the boy that he had worked in the naval hospital.

The boy said goodbye to his mom and dad, and the heavy guy eased the wheelchair down the long wooden ramp to the sidewalk in front of the house. "I've been pushin' you boys around for almost two years now," he said.

The boy listened as the heavy guy and the commander stood for a moment in the front yard trying to figure out how they were going to get him into the backseat of the Cadillac convertible.

"You're goin' in style today," shouted the commander.

"Nothing but the best," said the heavy guy.

"I haven't learned how to . . ."

"We know, we understand," said the commander.

And before he could say another word, the heavy guy who had worked at the hospital lifted him out of the chair in one smooth motion. Opening the door with a kick of his foot, he carefully placed him in the backseat of the big open car.

"All right, Mr. Grand Marshal." The heavy guy patted him on the shoulder, then jumped into the car with the commander, beeping the horn all the way down Toronto Avenue.

"We're goin' to Eddie Dugan's house," said the commander, turning his head. "Ya know Eddie?" He was talking very fast now. "Good boy," said the commander. "Lost both legs like you. Got plastic ones. Doin' great, isn't he?" He jabbed the heavy man with his fist.

"Got a lot of guts, that kid Eddie Dugan," the heavy man said.

"I remember him . . ." The

commander was turning the corner now, driving slowly down the street. "Yeah, I remember Eddie way back when he was . . . when he was playin' on the Little Leagues. And as God is my witness," said the commander, turning his head back toward him again, "as God is my witness, I seen Eddie hit a home run on his birthday. He was nine or ten, something like that back then." The commander was laughing now. "I was coaching with his dad and it was Eddie's birthday. A lot of you guys got messed up over there." He was still talking very fast.

"Remember Clasternack? You heard of Clasternack, didn't you? He got killed. They got a street over in the park named after him." He paused for a long time. "Yeah . . . he got killed. He was the first of you kids to get it. And there were others too," said the commander. "That little guy, what was his name? Yeah I got it . . . Johnny Heanon . . . little Johnny Heanon . . . he used to play in the Little League with you guys."

He remembered Johnny Heanon.

"He tripped a land mine or something and died on the hospital ship during the operation. I see his folks every once in a while. They live down by the old high school. Fine kid," said the commander.

"He used to deliver my paper," said the heavy guy.

"There was the Peters family too . . . both brothers . . . ," said the commander again, pausing for a long time. "Both of them got killed in the same week. And Alan Grady . . . did you know Alan Grady? He used to go to the boy scouts when you kids was growing up."

The boy in the back seat nodded. He knew Alan Grady too.

"He drowned," said the commander.

"Funny thing," said the heavy guy. "I mean, terrible way to go. He was on R and R or something and he drowned one afternoon when he was swimming."

"And Billy Morris," said the commander, "he used to get in all

sorts of trouble down at the high school. He got killed too. There was a land mine or something he got hit in the head with a tree. Isn't that crazy?" The commander was laughing almost hysterically now.

"He goes all the way over there and gets killed by a fucking tree."

"We've lost a lot of good boys," the heavy guy said. "We've been hit pretty bad. The whole town's changed."

"And it's been goin' on a long time." The commander was very angry now. "If those bastards in Washington would stop fiddlefucking around and drop a couple of big ones in the right places, we could get that whole thing over with next week. We would win that goddamn thing and get all our kids out of there."

When they got to Eddie Dugan's house, both of the men got out, leaving him in the back seat, and ran up to Eddie's doorstep. A few minutes passed, then Eddie came out of the front door rocking back and forth across the lawn like a clown on his crutches until he had worked himself to the car door.

"I can do it," Eddie said.

"Sure," said the taller commander, smiling.

They watched as Eddie stretched leaning on his crutches, then swung into the car seat.

"Not bad," said the commander.

The commander and the heavy guy jumped back into the car and the boy could feel the warm spring air blowing on his face as they moved down Eddie's block. The leaves on the trees had blossomed full. They glistened in the sun, covering the streets in patches of morning shadow.

"You're not going to believe this," Eddie said to him, looking down at his legs. "I got hit by our own mortars." He was almost laughing now. "It was on a night patrol . . . And you?" he asked.

"I got paralyzed from the chest down. I can't move or feel anything."

He showed Eddie with his hands how far up he could not feel and then showed him the bag on the side of his leg. Usually he didn't like telling people how bad he had been hurt, but for some reason it was different with Eddie.

Eddie looked at the bag and shook his head, saying nothing.

"Let me see your new legs," he said to Eddie.

Eddie pulled up his trousers, showing his new plastic legs. "You see," he said, tapping them with his knuckles. He was very sarcastic. "As good as new."

They got to the place where the march was to begin and he saw the cub scouts and the girl scouts, the marching bands, the fathers in their Legion caps and uniforms, the mothers from the Legion's auxiliary, the pretty drum majorettes. The street was a sea of red, white, and blue. He remembered how he and all the rest of the kids on the block had put on their cub scout uniforms and marched every Memorial Day down these same streets. He remembered the hundreds of people lining the sidewalks, everyone standing and cheering and waving their small flags, his mother standing with the other mothers on the block shouting for him to keep in step. "There's my Yankee Doodle boy!" he'd hear her shouting, and he'd feel embarrassed, pulling his cap over his eyes like he always did.

There were scouts decorating the Cadillac now with red, white, and blue crepe paper and long paper banners that read WELCOME HOME RON KOVIC AND EDDIE DUGAN and SUPPORT OUR BOYS IN VIETNAM. There was a small sign, too, that read: OUR WOUNDED VIETNAM VETS . . . EDDIE DUGAN AND RON KOVIC.

When the scouts were finished, the commander came running over to the car with a can of beer in his hand. "Let's go!" he shouted, jumping back in with the heavy guy.

They drove slowly through the crowd until they were all the way up in the front of the parade. He could hear the horns and drums behind him and he looked out and watched the pretty drum majorettes and clowns dancing in the street. He looked out onto the sidewalks where the people from his town had gathered just like when he was a kid.

But it was different. He couldn't tell at first exactly what it was, but something was not the same, they weren't waving and they just seemed to be standing staring at Eddie Dugan and himself like they weren't even there. It was as if they were ghosts like little Johnny Heanon or Billy Morris come back from the dead. And he couldn't understand what was happening.

Maybe, he thought, the banners, the one the boy scouts and their fathers had put up, the ones telling the whole town who Eddie Dugan and he were, maybe, he thought, they had dropped off into the street and no one knew who they were and that's why no one was waving.

If the signs had been there, they'd have been flooding into the streets, stomping their feet and screaming and cheering the way they did for him and Eddie at the Little League games. They'd have been swelling into the streets, trying to shake their hands just like in the movies, when the boys had come home from the other wars and everyone went crazy throwing streamers of paper and confetti and hugging their sweethearts, sweeping them off their feet and kissing them for what seemed forever. If they really knew who they were, he thought, they'd be roaring and clapping and shouting. But they were quiet and all he heard whenever the band stopped playing was the soft purr of the American Legion's big Cadillac as it moved slowly down the street.

Even though it seemed very difficult acting like heroes, he and Eddie tried waving a couple of times, but after a while he realized that the

staring faces weren't going to change and he couldn't help but feel like he was some kind of animal in a zoo or that he and Eddie were on display in some trophy case. And the more he thought about it, the more he wanted to get the hell out of the backseat of the Cadillac and go back home to his room where he knew it was safe and warm. The parade had hardly begun but already he felt trapped, just like in the hospital.

The tall commander turned down Broadway now, past Sparky the barber's place, then down to Massapequa Avenue, past the American Legion hall where the cannon they had played on as kids sat right across from the Long Island Railroad station. He thought of the times he and Bobby and Richie Castiglia used to sit on that thing with their plastic machine guns and army-navy store canteens full of lemonade; they'd sit and wait until a train pulled into the Massapequa station, and then they'd all scream "Ambush!" with Castiglia standing up bravely on the cannon barrel, riddling the train's windows.

He was beginning to feel very lonely. He kept looking over at Eddie. Why hadn't they waved, he thought. Eddie had lost both of his legs and he had come home with almost no body left, and no one seemed to care.

When they came to where the speakers' platform had been erected, he watched Eddie push himself out of the backseat, then up on his crutches while the heavy guy helped him with the door. The commander was opening the trunk, bringing the wheelchair to the side of the car. He was lifted out by the heavy guy and he saw the people around him watching, and it bothered him because he didn't want them to see how badly he had been hurt and how helpless he was, having to be carried out of the car into the chair like a baby. He tried to block out what he was feeling by smiling and waving to the people around him, making jokes about the chair to ease

the tension, but it was very difficult being there at all and the more he felt stared at and gawked at like some strange object in a museum, the more difficult it became and the more he wanted to get the hell out of there.

He pushed himself to the back of the platform where two strong members of the Legion were waiting to lift him up in the chair. "How do you lift this goddamn thing?" shouted one of the men, suddenly staggering, almost dropping him. He tried to tell them how to lift it properly, the way they had shown him in the hospital, but they wanted to do it their own way and almost dropped him a second time.

They finally carried him up the steps of the stage where he was wheeled up front next to Eddie, who sat with his crutches by his side. They sat together watching the big crowd and listening to one speaker after the other, including the mayor and all the town's dignitaries; each one spoke very beautiful words about sacrifice and patriotism and God, crying out to the crowd to support the boys in the war so that their brave sacrifices would not have to be in vain.

And then it was the tall commander's turn to speak. He walked up to the microphone slowly, measuring his steps carefully, then jutted his head up and looked directly at the crown. "I believe in America!" shouted the commander, shaking his fist in the air. "And I believe in Americanism!" The crowd was cheering now. "And most of all . . . most of all, I believe in victory for America!" He was very emotional. Then he shouted that the whole country had to come together and support the boys in the war. He told how he and the boys' fathers before them had fought in Korea and World War II, and how the whole country had been behind them back then and how they had won a great victory for freedom. Almost crying now, he shouted to the crowd that they couldn't give up in Vietnam. "We

have to win . . . ," he said, his voice still shaking; then pausing, he pointed his finger at him and Eddie Dugan, " . . . because of them!"

Suddenly it was very quiet and he could feel them looking right at him, sitting there in his wheelchair with Eddie all alone. It seemed everyone—the cub scouts, the boy scouts, the mothers, the fathers, the whole town—had their eyes on them and now he bent his head and stared into his lap.

The commander left the podium to great applause and the speeches continued, but the more they spoke, the more restless and uncomfortable he became, until he felt like he was going to jump out of his paralyzed body and scream. He was confused, then proud, then all of a sudden confused again. He wanted to listen and believe everything they were saying, but he kept thinking of all the things that had happened that day and now he wondered why he and Eddie hadn't even been given the chance to speak. They had just sat there all day long, like he had been sitting in his chair for weeks and months in the hospital and at home in his room alone, and he wondered now why he had allowed them to make him a hero and the grand marshal of the parade with Eddie, why he had let them take him all over town in that Cadillac when they hadn't even asked him to speak.

These people had never been to his war, and they had been talking like they knew everything, like they were experts on the whole goddamn thing, like he and Eddie didn't know how to speak for themselves because there was something wrong now with both of them. They couldn't speak because of the war and had to have others define for them with their lovely words what they didn't know anything about.

He sat back, watching the men who ran the town as they walked back and forth on the speakers' platform in their suits and ties, drinking their

beer and talking about patriotism. It reminded him of the time in church a few Sundays before, when Father Bradley had suddenly pointed to him during the middle of the sermon, telling everyone he was a hero and a patriot in the eyes of God and his country for going to fight the Communists. "We must pray for brave boys like Ron Kovic," said the priest. "And most of all," he said, "we must pray for victory in Vietnam and peace throughout the world." And when the service was over, people came to shake his hand and thank him for all he had done for God and his country, and he left the church feeling very sick and threw up in the parking lot.

After all the speeches, they carried him back down the steps of the platform and the crowd started clapping and now he felt more embarrassed than ever. He didn't deserve this, he didn't want this shit. All he could think of was getting out there and going back home. He just wanted to get out of this place and go back right away.

But now someone in the crowd was calling his name. "Ronnie! Ronnie!" Over and over again he heard someone shouting. And finally he saw who it was. It was little Tommy Law, who had grown up on Hamilton Avenue with all the rest of the guys. He used to hit home runs over Tommy's hedge. Tommy had been one of his best friends like Richie and Bobby Zimmer. He hadn't seen him for years, not since high school. Tommy had joined the marines too, and he'd heard something about him being wounded in a rocket attack in the DMZ. No one had told him he was back from the war. And now Tommy was hugging him and they were crying, both of them at the bottom of the stairs, hugging each other and crying in front of all of them that day. He wanted to pull away in embarrassment and hold back his feelings that seemed to be pouring out of him, but he could not and he cried even harder now, hugging his friend until he felt his arms go numb.

It was so wonderful, so good, to see Tommy again. He seemed to bring back something wonderfully happy in his past and he didn't want to let go. They held on to each other for a long time. And when Tommy finally pulled away, his face was bright red and covered with tears and pain. Tommy held his head with his hands still shaking, looking at him sitting there in disbelief. He looked up at Tommy's face and he could see that he was very sad.

The crowd had gathered now watching the two friends almost with curiosity. He tried wiping the tears from his eyes, still trying to laugh and make Tommy and himself and all the others feel more at ease, but Tommy would not smile and he kept holding his head. Still crying, he shook his head back and forth. And now, looking up at Tommy's face, he could see the thin scar that ran along his hairline, the same kind of scar he'd seen on the heads of the vegetables who had had their brains blown out, where plates had been put in to replace part of the skull.

But Tommy didn't want to talk about what had happened to him. "Let's get out of here," he said. He grabbed the back handles of the chair and began pushing him through the crowd. He pushed him through the town past the Long Island Railroad station to the American Legion hall. They sat in the corner of the bar, watching the mayor and all the politicians. And Tommy tried to keep the drunken Legion members from hanging all over him and telling him their war stories.

The tall commander, who was now very drunk, came over asking Tommy and him if they wanted a ride back home in the Cadillac. Tommy said they were walking home, and they left the American Legion hall and the drunks in the bar, with Tommy pushing his wheelchair, walking back through the town where they had grown up, past the baseball field at Parkside School where they had played as kids, back to Hamilton

Avenue, where they sat together in front of Peter Weber's house almost all night, still not believing they were together again.

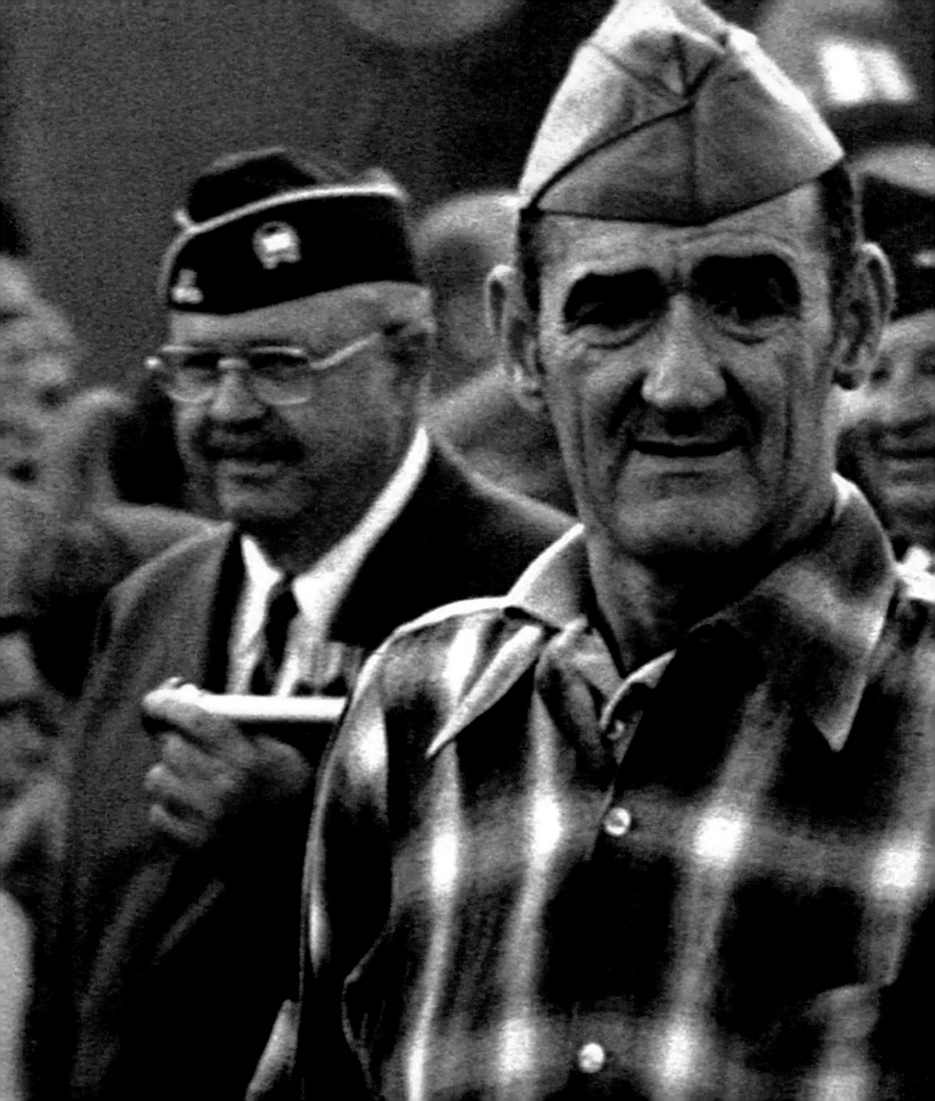

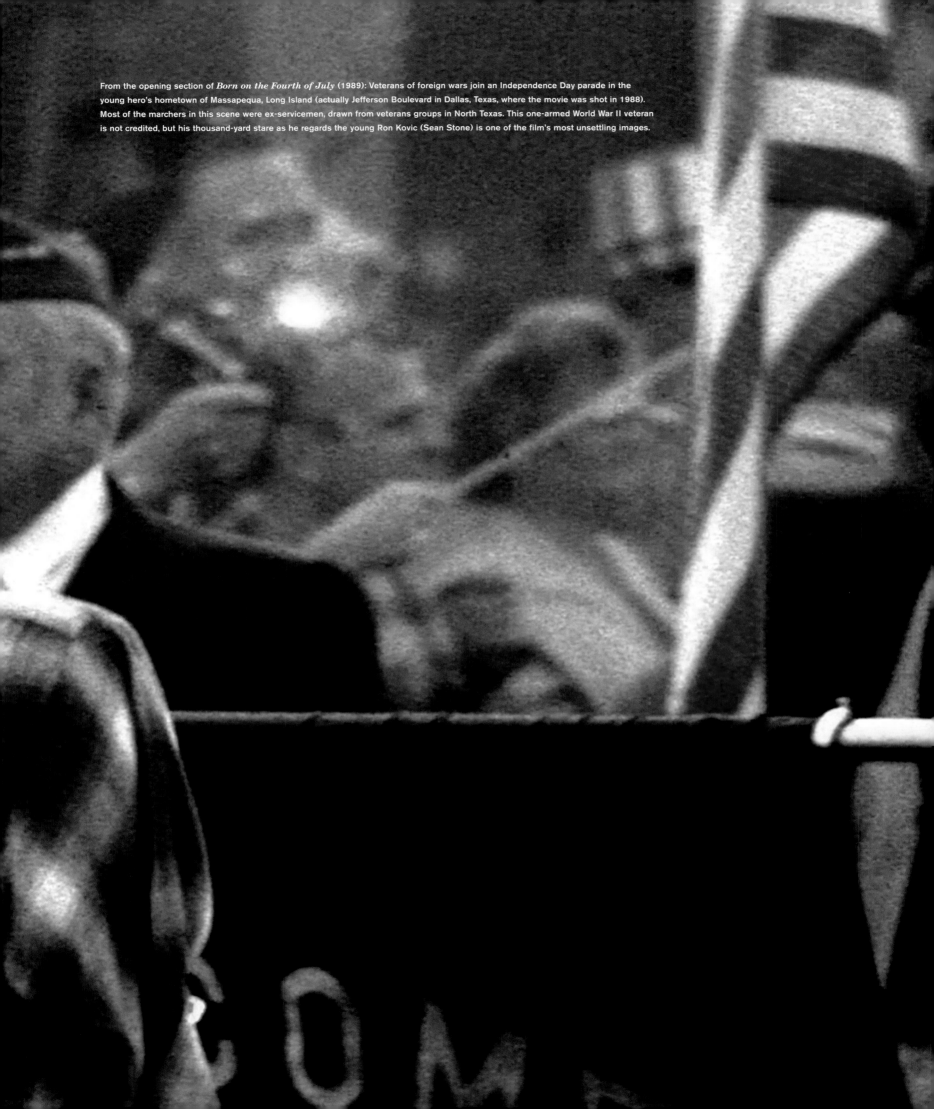

From the opening section of *Born on the Fourth of July* (1989): Veterans of foreign wars join an Independence Day parade in the young hero's hometown of Massapequa, Long Island (actually Jefferson Boulevard in Dallas, Texas, where the movie was shot in 1988). Most of the marchers in this scene were ex-servicemen, drawn from veterans groups in North Texas. This one-armed World War II veteran is not credited, but his thousand-yard stare as he regards the young Ron Kovic (Sean Stone) is one of the film's most unsettling images.

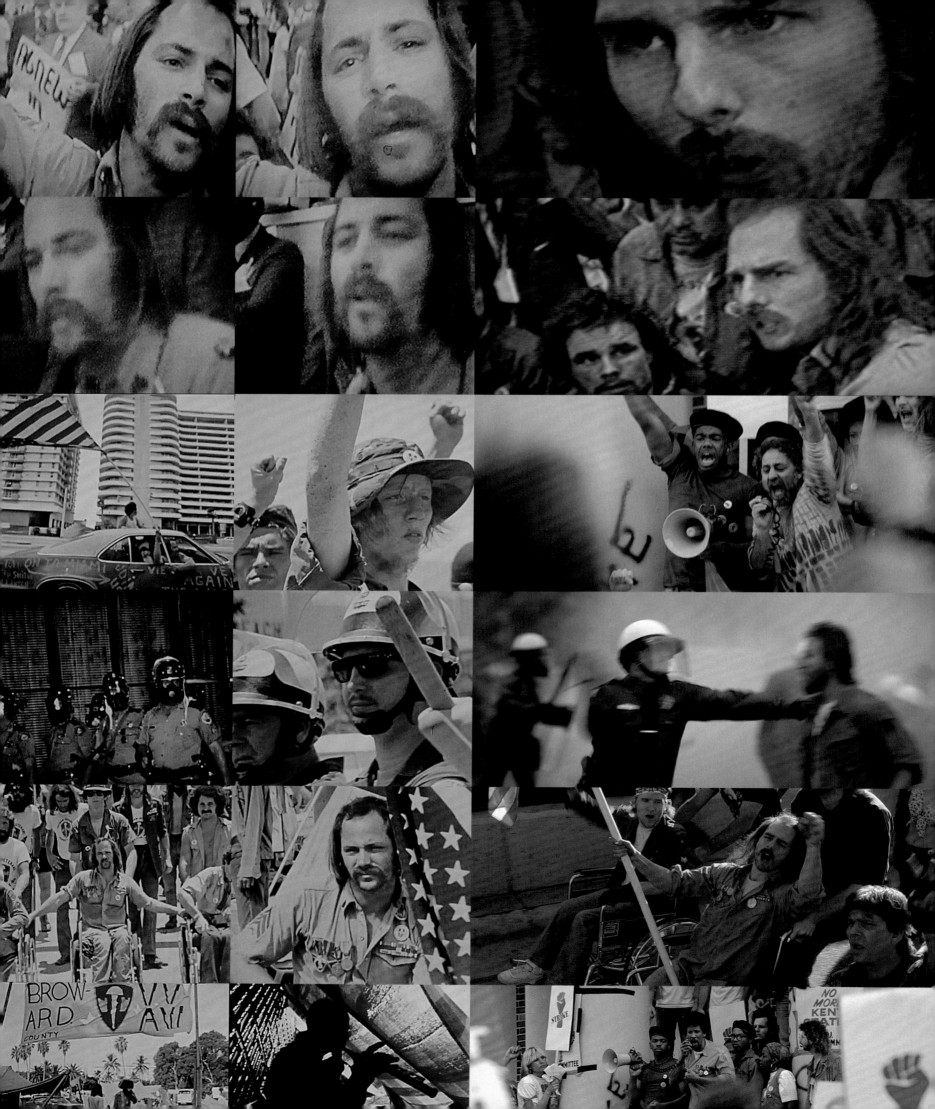

(opposite) Collage juxtaposing images from *Born on the Fourth of July* (1989) with images from Loretta Smith's nonfiction film *Operation: Last Patrol* (1972), a record of Ron Kovic traveling to the 1972 Republican National Convention in Miami. Certain shots and scenes in Stone's film mirror moments captured in Smith's documentary.
(below) Memo from the completion bondsman of *Born* to producer Alex Ho, chastising them for cost overruns.
(following spread) Still-frames from Stanley Kubrick's *2001: A Space Odyssey* (1968) and Oliver Stone's *Born on the Fourth of July*. The mirroring is quite exact; both sequences are shot in slow motion and cut from a person throwing an object in the air to a close-up of the object tumbling against the sky. In Kubrick's film the shot of the bone used to kill an enemy hard-cuts into an image of an orbital nuclear weapons platform, showing how violence and technological advancement have been intertwined throughout history. The baton toss in *Born* adds a layer to Kubrick's formulation, suggesting that ideology can also be a weapon.

This is the second chapter in what you would later call your Vietnam trilogy, the third chapter being *Heaven & Earth*. *Born on the Fourth of July* did very well with critics and audiences, and it was nominated for several Oscars, including best actor, picture, adapted screenplay, and direction. For a story about a man embracing the counterculture, it's very classical, even conventional, you might say. It tells a very linear story framed as a flashback, like something from an old movie. It starts with a voice-over, and then, at the end of the story, the hero goes off to give the speech at the 1976 Democratic convention, and there's a moment that almost looks like his life is flashing before his eyes.

But it's not as conventional as it seems. You're using these classical filmmaking techniques for politically radical ends. One of the things I love about this movie, besides the emotional power of it, is the rhetorical beauty of the statement that it makes, and how it makes its statement. It's about a guy who realizes that he's been programmed from birth by the state to obey orders and go kill. He systematically deprograms himself over the course of the movie. Even though your own political deprogramming, you might say, was in its middle stages when you made the movie, I sense an autobiographical component to Ron's journey. The character is going through something like what you were going through, or would go through. You're looking at patriotic imagery and language in a skeptical or bitter way, and showing how it conditions people to obey the state.

I have to say, you have reminded me that the book ends with him being wounded, an event that's shown at the 40 percent mark in the movie. I was thinking of what Friedkin had said at the time—he had done *The French Connection* and *The Exorcist*, and was one of the hottest directors—because there had been an earlier screenplay by another writer, which was all over the place in terms of structure, and kind of mimicked the book. He said, *Forget this nonsense, this is good corn. Keep it that way. Make it straight through, write it straight through, and you'll see the power that it'll pick up.*

When you two first started work on this in the seventies, did Ron Kovic write the script and then you rewrote it? Or did you work on it at the same time? Walk me through that process.

Well, I write alone, but we spent a lot of time with Ron in hotel rooms, talking and talking. Ron talked, I wrote. He was so excited about Al Pacino, because he was a big star. It was heartbreaking to see this fall apart! And we had a moment in Venice Beach, where he was chasing me down the boardwalk like Charlie, played by Willem Dafoe, does in the Mexico sequence of the picture. Ron wanted to kill me, because, you understand, his rage was so immense: *Why couldn't we do this movie?* And I said to him—he quotes this story—*Ron, I swear to you, if I ever make it in Hollywood, I will come back and make this movie. I swear.* And he remembered that, because life takes its very strange winds.

And so *Platoon* gets made ten years later in '86, it's an international success, and that sets the tone for this film—that it was able to get made. This, and Tom Cruise signing on—he was at that time certainly the biggest young star in Hollywood.

It still was tough. Universal was tough with the budget. We did go over budget, about two or three million dollars. We reshot the ending with Ron at the Democratic convention. It was quite a struggle, even with Cruise as box-office insurance.

FILM FINANCES, INC.
SUITE 808
9000 SUNSET BOULEVARD
LOS ANGELES, CALIFORNIA 90069

TELEPHONE (213) 275-7323
TELEX: 183-205
ANSWER BACK: FILFNS INC LSA
TELECOPIER: (213) 275-1706

TO: Alex Ho

FROM: Kurt Woolner

DATE: December 8, 1988

RE: "Born on the Fourth of July"

Dear Alex:

 I am truly shocked by the most recent cost report. The overage is far in excess of what you had indicated when we last reviewed the costs.

 What is equally distressing is that this cost report does not allow for any revisions to the Philippine budget which I feel will be light by $200,000 based on your current plans.

 As such, the actual overage at this time is closer to $1,300,000.

 Please advise me immediately what steps you are taking:

(A) to insure that the cost reports you publish are, in fact, accurate;

(B) to reduce the overage to date;

(C) what you are doing to revise the plans for the Philippines shoot to align with the original budget which you approved and submitted to us.

Tom Cruise was then, and still is, one of the biggest stars in the world, but back then he was certainly the youngest big star in the world, aside from Eddie Murphy. And his biggest movie up to that point had been *Top Gun*, which came out the same year as *Platoon*, 1986. I got such an enormous kick out of seeing Maverick from *Top Gun* in this part, because the casting itself is a provocation. You're practically vandalizing a monument. You might as well have thrown the Statue of Liberty facedown in the mud.

215

DAVID HERMAN
ANDREW LAUER
TOM SIZEMORE

Oh, *Top Gun*! The young guys, the Mavericks, going to World War III with the Russians and exalting about it! That's the ending of *Top Gun*, it's exactly the opposite message from our movie, and it made far more money than *Platoon*. It cleaned up at the box office!

It was one of the biggest movies of that year.

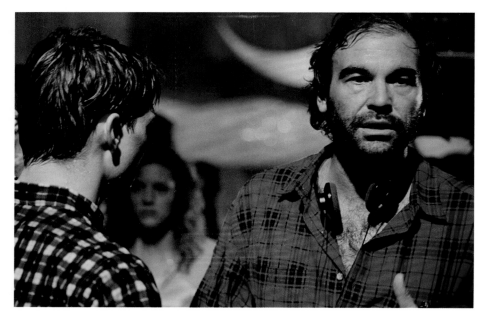

Almost one hundred eighty million dollars domestic. We made about seventy-five million dollars, and we were lucky. We opened that horrible week we invaded Panama!

Listen, this movie—when I see all the rage on the screen today, with some distance, I'm kind of shocked. It's still there; you can feel it. It's raw anger, and it comes mostly from Ron, because by the time we wrote it

together, I had made my peace with the war, or so I thought. It was Ron who activated my anger, and I was living through Ron at this point. I was not doing my own story, although there's something of my own personal return in this movie.

But still—it's so angry, it shocks me. And it doesn't let up! Watching it again, I thought, *God, this fucking movie doesn't end! This hell! I cannot be here anymore!* But you have to understand, this guy is living in hell.

Young people rejected the film. Tom Cruise is castrated in the movie—this was not easy at that time. We did not do the business of *Platoon* partly because young people, young women especially, didn't want to see that.

I imagine young guys weren't too thrilled about it, either.

No! It did not become a date movie, I have to tell you! So we lost out.

However, it does have a quality, and people stuck with it, and it did very well overseas. In fact, it's one of the highest-grossing movies I've ever been involved with, and it continues to do well, so I hope it lasts.

There was a wonderful line in Pauline Kael's review of *Top Gun*: The movie "is a recruiting

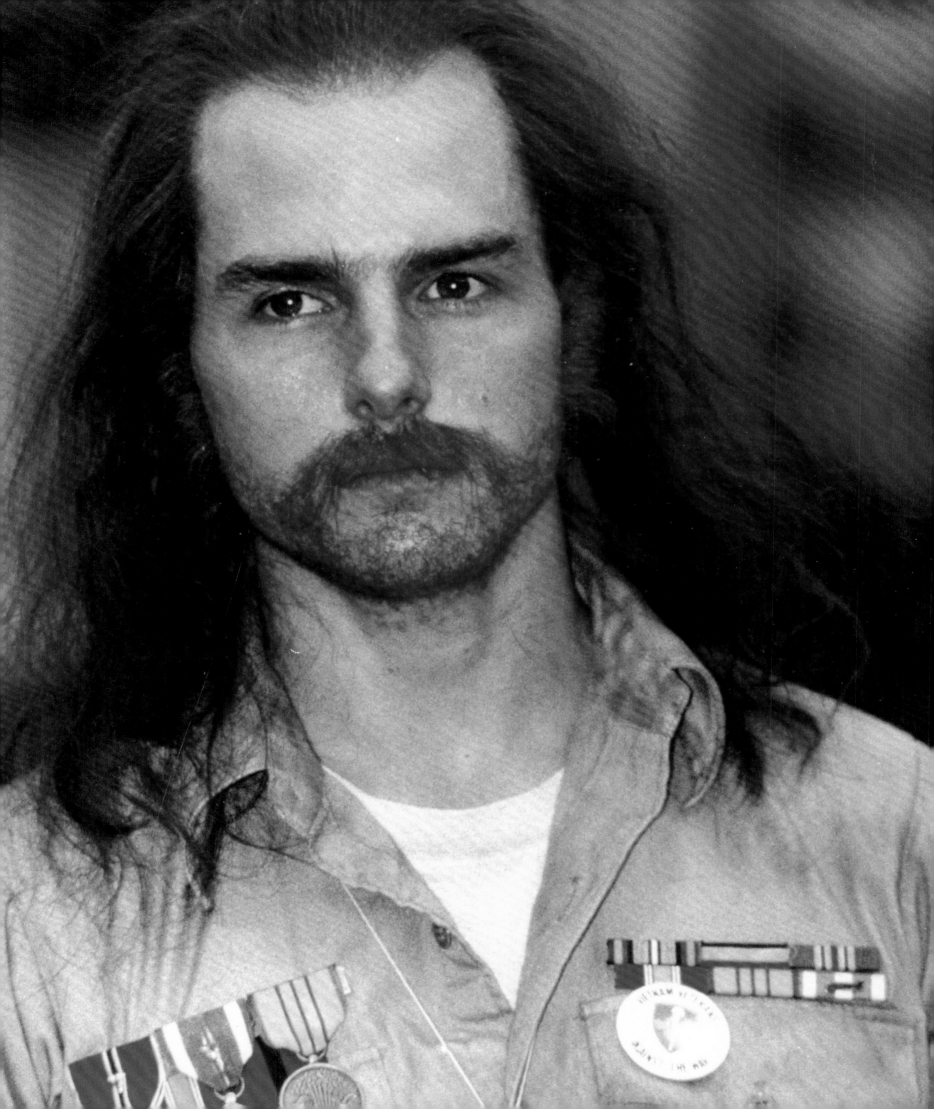

BORN ON THE 4TH OF JULY

TO: OLIVER STONE
FM: ALEX HO
RE: EXPRESSIONS FROM THE 60's
DT: OCTOBER 5, 1988

"...reachable only through the language of power and violence..."

Repression turns demonstration protests into wars.

...we as the guerillas attacking the shrines of authority...

The street is the stage. You are the star of the show.

"politics is how you live."

..."nonviolence has the power to win tangible victories."

right on	groovy	pigs
dig it	turn-on	gettin' high
cool	foxy lady	comin' down
cool it, man	bummer	free love
Peace, man	bummed out	love-in
rip-off	freaks	sock it to me
outtasight	freakin' out	love power
far-out	right wingers	working class
reefer	get it together	
SDS	getting off	
Bro	head	
spare change	pothead	
tripping	acidhead	
what a trip	acid	
daytripping	revolution	
groovin'	flashback	

FOURTH OF JULY PRODUCTIONS INCORPORATED
2927 Maple Avenue Suite 308 Dallas, Texas 75201 · 214-720-7797 · FAX 214-871-7039

BORN ON THE 4TH OF JULY

```
TO:  OLIVER STONE
FM:  ALEX HO
RE:  MORE '60s EXPRESSIONS
DT:  OCTOBER 7, 1988
```

Summer of Love

"...more fists than V's..."

get it on

heal

bread

blown away

do your thing

it's your bag

get down

love generation

peace and love

psychedelic

counterculture

anti-establishment

mod

FOURTH OF JULY PRODUCTIONS INCORPORATED
2927 Maple Avenue Suite 308 Dallas, Texas 75201·214-720-7797·FAX 214-871-7039

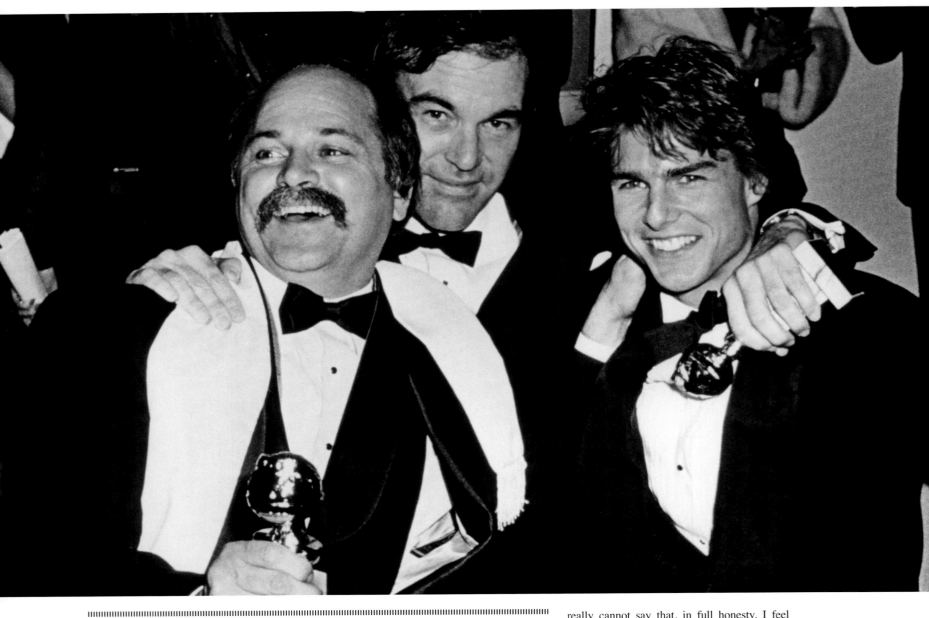

I don't know if the country learned **anything** from this movie.

poster that is not concerned with recruiting but with being a poster." I thought about that again while rewatching *Born*, because this movie is very much a critical look at the recruiting poster mentality.

Everything in this film, from the very beginning, is about conditioning people to go to war. There's a scene in *JFK*, the famous scene on the park bench with Jim Garrison and Mr. X, who says, "The organizing principle of any society, Mr. Garrison, is for war."[30] People who've seen *JFK* might think about that moment when Tom

Berenger's marine officer comes to talk to the high school kids, and he talks about Iwo Jima, and the frozen Chosin Reservoir, and everything about that early part of the movie screams "conditioning": the Fourth of July parade, the fireworks, the cheerleader tossing her baton in the air that looks like the ape throwing its bone into the air in *2001*.

I don't know if the country learned anything from this movie, though, or from Vietnam. I

really cannot say that, in full honesty. I feel very frustrated and depressed, as you know from my *Untold History*, that this system is in place, and this blind patriotism remains to this day. There was a recent poll done by Gallup: Believe it or not (my colleague on *Untold History*, Peter Kuznick, told me this story): 51 percent of the sixteen- to twenty-eight-year-olds in this country—*51 percent!*—believe that the Vietnam War was a good war. The people that I know, the veterans, we're divided. But many of them were very depressed during the

30 For more about the military-industrial complex as portrayed in Stone's work, see *JFK* in chapter 6, pages 244–76; *Nixon* in chapter 7, pages 321–39; and *The Untold History of the United States* in chapter 9, pages 444–47.

2002 to 2008 period. I know I was. It was the worst time. To live through this again, and not having learned, was infinitely depressing.

I was at the University of Wisconsin talking to students, and it was very clear, talking to Alfred McCoy, our host and the man who wrote *The Politics of Heroin*. He said to me that in his classes and among his fellow teachers, that this generation, those born in the 1990s, Vietnam is basically under the bridge, it's forgotten, much like World War I would've been to my generation, and World War II to the Iraq generation. So Vietnam has become "the war before the last war."

The way that you portray this conditioning, and how Ron eventually comes to see through it—can you talk about how that's conveyed in the look and feel of the film? There's almost a *Life* magazine sort of feeling to it: the textures, the colors, and all these patriotic symbols, this kind of apple pie laced with arsenic you've got going on in the movie.

Those were very deliberate choices. The production team—Bob Richardson, our DP; Bruno Rubeo, our production designer—we knew this was our most epic film to date. This was done in anamorphic widescreen, it was our first film in anamorphic, and to fill that screen you have to spend money, so obviously the producers were saying, "You realize, Oliver, you're doing 2.35 to 1, you have to have more props, everything's going to be period, and it's going to cost x amount more!" And I'd say, "Yeah, but it's worth it!"

Bob laid out the *Life* magazine three-color strips that they used to do, and he wanted to get that look as much as possible. If you notice that the first parade—and the whole early part of the film, which is optimistic and certainly patriotic—is very much based on *Life* magazine photos from the fifties and sixties. Beautiful colors, by the way.

And of course, in Vietnam, we did another look: We didn't do the *Platoon* look, we did a bleached, dirty, hazy, hot hell look, and yellow.

That's in the book, too. It happened to him on the beach—he describes the dunes.

That's where Ron was stationed, in First Corps. The marines were working a lot of the

beach areas, and inland, too. I was up there on the second part of my tour, First Cavalry. We replaced the marines up in the north at Camp Evans. But it was that dirty, hazy look, very scary in its own way, different from the jungle.

But the third part of the film is that horrible hospital, which was hell to shoot, and that was based on Ron's criticism of a Bronx VA. I think a lot of good people work at the VA, but this was a hellhole, no question about it.

There's a great sadness in that sequence, and it's not just because of the pain Ron is going through, but also because the people who work in the hospital are at wit's end. Some of them seem to have given up. You got a lot of criticism for pretty much everything in that sequence: the black orderlies [31] who treat it as just another job, the white doctors who can't do anything or don't care anymore, the filth, the sores, the rats.

Ron was honest. Ron was telling me about these characters, and he has a great memory. Sometimes he'd remember exact dialogues, which helped me a lot to get those crazy expressions that people say sometimes.

And then, of course, the Massapequa sequence, to me, the return—and that second parade sums it up, the second parade being the opposite of the fifties parade. It's a seventies, "Up, Up, and Away" parade with glare-y

Vietnam has become "the war before the last war."

over-saturated colors. It reminds you of much of the early seventies films, which were, frankly, horrible looking, but very realistic—really dirty, washed-out colors.

There's a shot of the American flag in that seventies parade sequence, and it's transparent, and you can see through it. You've got a lot of flags in the film, many of them used ironically. It's like you're reclaiming patriotism from the right wing in this movie. This is a movie that looks like—if you're watching it with the sound off, just the first half of it, you might think it was *Top Gun*, but set in the fifties. It's got that look to it—very sunny and very optimistic. At first, anyway. And then that same imagery begins to seem ominous as Ron starts to dig into himself and figure out how he ended up in that wheelchair.

The awkwardness of the young man—I mean, he is so shy with women! I love that he's so awkward, and that's Ron in the book. He very much idealized a young, vague girl, a high school girl, in his book, whom I made concrete in the film as Donna. In the movie he goes back to see her, and after he spends a few hours

with her and sees the protests and all that, he begins to understand that she's no longer the woman he thought she was. She's a nice woman, a good woman, but he's moved on, and she's moved on—more or less, she's moved on. And he's had a hard time moving on. But it was difficult for him to relate to women, and he had a strong mother—a wonderfully tough, fucking tough mother—and a father who was somewhat passive.

These events more or less happened, in the sense that he did have to leave the house to go to Mexico, and in Mexico we have a false paradise. We created a false paradise, and I think the film gets juiced in the last three-quarters of an hour by Willem Dafoe's entry. You need that kind of push in a movie sometimes. Willem brings this new energy to it, and I think it powers it.

And, of course, Georgia never happened.

31 For a detailed discussion of the portrayal of African Americans in Stone's films, see the section on *Any Given Sunday* on pages 359–65 of chapter 7.

Georgia—you mean the scene where Ron apologizes to the family of the marine he killed in Vietnam?

Yes. The Georgia sequence was much contested, and I was criticized for it. But you know, in the book it was very clear, if you pay close attention, that shooting Wilson affected Ron deeply and he never could recover from a sense of guilt. He had to confess. He tried to do it with a marine officer in Vietnam but the facts were denied.

I was going to say, in fact, I was rereading the book in preparation for this, and there are a number of major scenes in the movie that are not in the book—and yet they *are* in the book. The scene where he goes to confess to the soldier's family is one example; there's no scene in the book where that actually happens.

But the entire book is a confession. Essentially, Ron is telling the readers what happened to him and what he did. And there are sections of Ron's description of the shooting that are integrated into the dialogue in the Georgia scene.

That's exactly why we did it. And I made that choice. But I was much criticized for it. My whole point was that it's a public confession in his book. He never looked up the family, never found them. Don't ask me why. It's a hard thing

to do. Maybe the information was not available. But the whole thing is pitched as a confession, and it's naked. And that scene has to be done.

It's a 210-page book, and it's not until the last 5 pages that he talks about the massacre, and the shooting, the accidental shooting, of the fellow soldier. He takes the entire book building up the nerve to tell you what happened.

Exactly. It's a good point: It takes him the whole book to tell us that. But I don't know if that structure would have worked for this movie. You can disagree with me. *Johnny Got His Gun* was Ron's model, Dalton Trumbo's wonderful book.[32] He was moved, because of Trumbo's book, to write this book, I think. *All Quiet on the Western Front*,[33] too, was a major influence for him.

But I think Friedkin said the right thing: It was good corn. Do a Capra film with heart, but go straight through. Don't get fancy with it. Because with a lot of films later in my career, the time structure changes!

You mentioned earlier when you were working on adapting the book with Ron, that a lot of it was him recalling his past, but that there were some details that come from your experience, and I was wondering if you'd give an example of what some of those details might be.

That's a tough one. I'm in there, in some ways, but by that point I had already done *Platoon*. I was supposed to do a movie called "Second Life," which I had written about a man's return from Vietnam, but I thought that because I went back to a relatively privileged New York family, that I was not in touch with the pulse of the country [END 6]. Ron came from the heartland. The Massapequas had put up most of the boys in this war—the suburbs and small towns and inner-city neighborhoods—and so I thought it would be more honest and accurate to tell Ron's story. And I just thought Ron had a greater story than my story, so I went with his story. It delayed gratification for me, but I was really happy doing that.

Let's talk about *The Doors*.

The Doors grew out of exuberance. It was a wonderfully freeing, Dionysian film. I

32 A 1939 antiwar novel by Dalton Trumbo about a World War I soldier who has lost his arms, legs, and face due to an exploding artillery shell.

33 A 1929 novel by Erich Maria Remarque that looks at the trauma of war from the German perspective; the first film version, directed by Lewis Milestone and starring Lew Ayres, was made in 1930.

remember coming right off of *Born*—I'm telling you, *Born* was such a straitjacket in a sense, because it was such a tough film to make, with the concepts of paralysis and castration. It was our first anamorphic film, an image with a ratio of 2.35 to 1. You see guys in a wheelchair, and the frame goes this way. *(Holds arms out to indicate a wider frame.)* Isn't it crazy? It has the opposite effect that you'd expect. Do you want to tighten up? No! We go wide. And we swing, and we see giant rooms, but they're small. So anamorphic clutters it another way. And we built that set, and I remember cracking down on the dimensions; I kept pushing our production designer, Bruno Rubeo: *Tighter, tighter.* The camera always wants to be free, but I wanted to make it so the camera could barely squeeze down the hall; you'd need a Steadicam.[34] It was a breakthrough use of anamorphic lenses with Steadicam equipment. Normally you would try to stabilize that kind of lens, but here we were flying around with it. We also spent a lot of money, and that was another issue budget-wise. With 2.35, more money is required for your props. You have to build your sets bigger, have more things in there, more actors . . . everything has to conform to the larger frame, so if you do a parade down Main Street in Massapequa, you're going to see more! So my producer, Alex Ho,[35] says, *You're going to have to build that fucking facade of the bank to fill the frame! Don't shoot anamorphic! Shoot 1.85!* That's where you have one of those little battles that just goes on all the time.

But we learned how to shoot in the 2.35 format, and we continued on into *The Doors*, which had always been my dream band. After Vietnam, they affected me more than anyone, although I loved a lot of the music of that period. For some reason, Morrison was different. He was this so-called erotic poet. He used the word Dionysian.[36] He loved being different, and I remember they didn't quite fit in. There was a lucidity to Jim, and his lyrics were so clear, which was a contrast to some other lyrics from the period, which could be more obscure. Jim laid things out pretty clearly. And as a literary person, too, I appreciated that. The poetry was called juvenile by some, but I thought it was spectacular, Rimbaud-like poetry. And Rimbaud[37] in his era could be laughed at, too, but his poetry meant something.

What qualities did Morrison and Rimbaud share that you think people might laugh at?

Freedom. Freedom! Breaking through to the other side. I didn't know Jim, but I sent him a script of "Break," which you read. They found it when he died, in his apartment in Paris. Bill Siddons[38] sent it to me via his wife several years later. He said, *This was in his apartment among his possessions when he died.* He was reading it, I guess. You saw "Break," so you understand the symbolism of that, and the Doors songs were in that draft I sent you. So that's why I sent the script to Jim, with the idea of him being the star.

But he never contacted you?

No. He died in '71, so that would've been probably two years after I wrote the script, I think.

He represented freedom. I was doing acid, breaking through to the other side, trying to get beyond the war, get past the war, get on to my own life, but I really believed in that dream, and I thought anarchy would come. I thought I was seeing it as a police state—Patty Hearst, all the ugliness of America with decay, I was starting to buy into. And it wasn't like a conscious reaction to Vietnam, I wasn't really linking those two, I was just, *Why are the cops busting everybody? Why are the cops busting young people?*

When I got back from Vietnam and I went to jail for smuggling—the cops were ugly to me. Nixon . . . law and order, you know? It was wrong. I thought that anarchy had to rule. I really thought we needed to free up America, and I didn't make this political; it was just unconscious knowledge that this system was venal, and it wasn't working. It was militaristic, ugly . . . And then movies, there was a lot of this kind of sentiment. *Easy Rider* was very important.[39] Jack Nicholson on the back of the motorcycle going, *Fuck you, man! Pigs!* And I wasn't saying *pigs*, but . . . I just agreed with it.

Jim was in that vanguard, and he died in '71, and it was pathetic. . . . With Jim and Jimi Hendrix and Janis Joplin dying,[40] it's not like some conspiracy was going on, but—I couldn't link all the dots on the chain. So I was always interested in a Doors movie, and it

had been around. I heard De Palma worked on a script with John Travolta for a long time, which wasn't working.[41]

After *Platoon* and *Born*, I was hot . . . very kind of heavy, heavy. I didn't realize how heavy I was in terms of the business. Then Brian Grazer[42] had come to me and

Mario wanted to make this into a Fellini movie. It's a wonderful thing to be supported by a producer like that. He had big money.

said, "Do you want to make *The Doors*?" and I said yes. Brian was not a powerhouse at that

34 Camera stabilizer invented by Garrett Brown in 1975 that allows for a smooth shot even when moving over an uneven surface.

35 A. Kitman Ho, 1950– ; producer of seven Stone films, stretching from *Platoon* through *Heaven & Earth*, plus *On Deadly Ground* (1991), and *Ali* (2001).

36 In Greek mythology, Dionysus is the god of the grape harvest, winemaking and wine, intoxication, ritual madness, and religious ecstasy, as well as fertility and theater; Roman name is Bacchus, from which the word "bacchanal" is derived.

37 1854–1891; French poet known for his genius with verse and his libertine appetites, sexual and otherwise.

38 1948– ; managed the Doors from 1968–72; arranged Jim Morrison's funeral and burial in Paris.

39 Landmark countercultural road movie from 1969.

40 Stone is grouping together three events from 1969 to 1970: the Tate-LaBianca murders in August 1969, under the direction of cult leader Charles Manson; Hendrix's death on September 18, 1970, after asphyxiating on his own vomit during an overdose of barbiturates; and Joplin's death on October 4, 1970, from an overdose of heroin compounded by alcohol use.

41 In 1981, John Travolta briefly tried to package a Morrison project to star in, with De Palma directing, based on the book *No One Here Gets Out Alive*, by *Rolling Stone* writer Jerry Hopkins and former Doors publicist Jerry Sugerman; William Friedkin succeeded De Palma, but the project collapsed in 1982.

42 1955– ; cofounder of Imagine Entertainment with director Ron Howard; coproducer of *Splash* (1984), *Apollo 13* (1995), *A Beautiful Mind* (2001), and *Frost/Nixon* (2008).

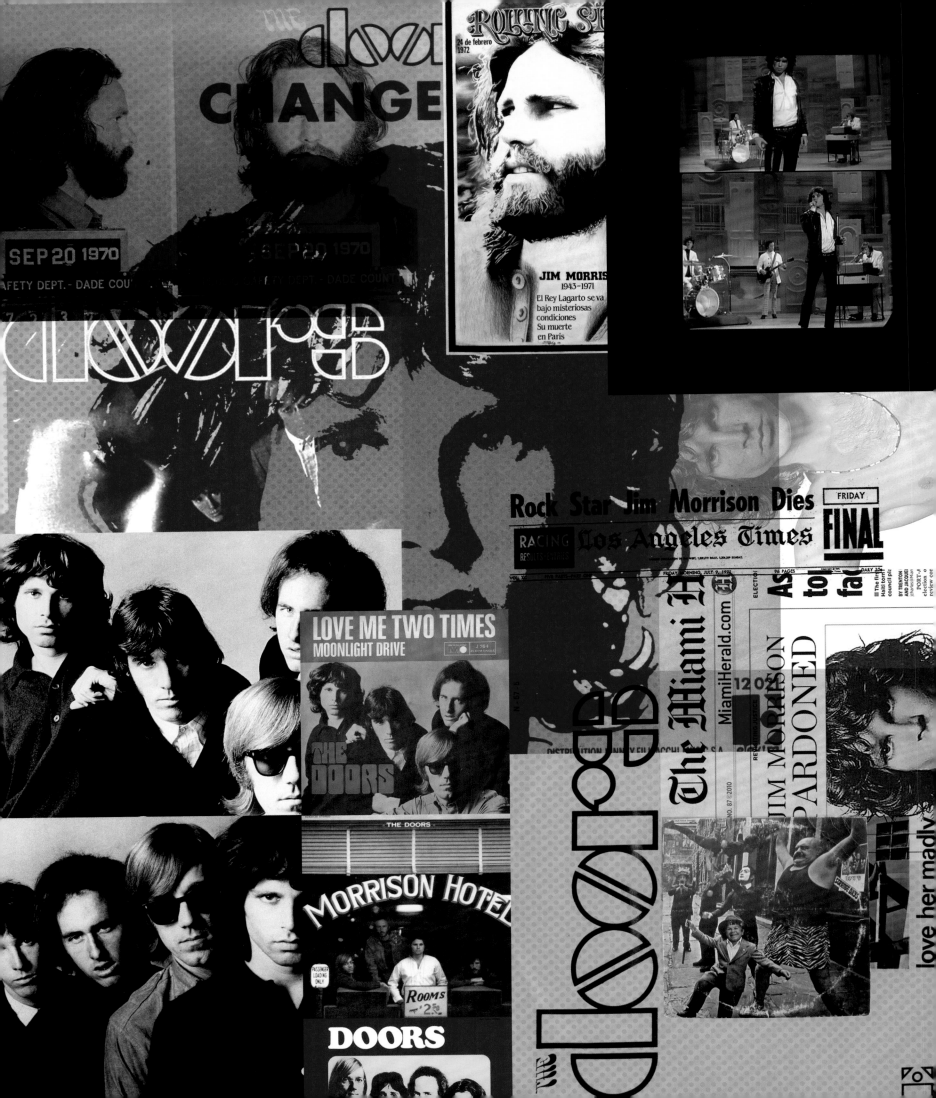

time; he and Ron Howard[43] had a company, but it was kind of rocky. I linked them up with Mario Kassar,[44] who was the ultimate bandit but a wonderful man, also in the vein of big spenders. He was Carolco; he had *Rambo*. Mario loved Fellini and he wanted to make this into a Fellini movie.[45] It's a wonderful thing to be supported by a producer like that. He had big money.

Mario gave the thirty-three million we budgeted at, because we were shooting in Los Angeles. I did it with Alex Ho. That was one of my first films where we underbudgeted it. It was our first picture in LA. It's like shooting in another world, LA. The location rentals alone were enormous, and frankly a bit extravagant, because that was the nature of the movie. We wanted to take on the Roxy and the Sunset Strip, but we didn't realize the costs of doing all this in Hollywood, renting out a whole street for two or three nights. Wow. These bills run big, because everyone in LA was gouging us at this point.

Everybody's jaded about movies being shot there.

Totally. We shot in the actual Roxy. We did "The End," where he breaks out, says, "Fuck you." We did as many of the real locations as possible. We had a whole, I mean, so many scandals on that movie, it was just one thing after the other. It was also my first big-budget film. I realized . . . we'd gone beyond thirty-three, thirty-four—I think we got up to thirty-six million, I'm not sure. I felt bad about it, but on the other hand, Mario said, *Go for it. This is Fellini time*. He wanted it to be this big movie, and it was symphonic. Paul Rothchild had been the Doors' producer and he brought on the mixer Bruce Botnick, and we had the cooperation of John Densmore and Robby Krieger;[46] they were involved in the movie and shooting it. Later on they differed.

Ray Manzarek was always a divisive force from the get-go. He fought me on the script: He wanted me to do the script he had from somebody else, which was, I thought, a bad movie. I rewrote the Randall Jahnson[47] script I did have. My concept was to set the story to the songs. The song would set the scene, like we did later in *Natural Born Killers*. There'd be a song that'd be the mood, and it was written.

Like tracks on an album.

Yes. But it would be in the chronology of Jim's life as much as possible, so it would be the early stuff gradually turning into *L.A. Woman* at the end. And the *American Prayer* album became the bookends of the films, so I did it as a time-travel piece, as the older Morrison was fatter and wanted to be a writer in Paris, and wanted to give this up, so he's telling his story through song, and he's the shaman now. So it was a beautiful idea.

You have to realize at this point I'm doing dream sequences. I love dream sequences. We generated the most footage of anything we'd done up to that point. We shot five concerts. Five concerts, maybe fourteen, fifteen songs, maybe twelve. I loved shooting

43 1954– ; actor in *The Andy Griffith Show* (1960–68), *American Graffiti* (1973), *Happy Days* (1974–84), *Arrested Development* (2003–); director of *Splash* (1983), *Cocoon* (1988), *Apollo 13* (1995), *A Beautiful Mind* (2001); cofounder of Imagine Entertainment with Brian Grazer.

44 1951– ; cofounder with Andrew G. Vanja of Carolco Pictures, which released all four of John Rambo's adventures, plus *Total Recall* (1990), *Terminator 2: Judgment Day* (1991), *Chaplin* (1992), and *Showgirls* (1994).

45 Italian director; originally a Neorealist but later known at times for films of extravagance and fantasy; most famous works include *La strada* (1954), *La dolce vita* (1960), and *8¹/₂* (1963).

46 Rothchild and then Botnick produced the Doors' albums; Krieger was the band's guitarist, playing alongside Morrison, keyboardist Ray Manzarek, and drummer John Densmore.

47 1959– ; screenwriter of *Dudes* (1987), *The Doors* (1991), episodes of *Tales from the Crypt* (1989–1996); cofounder of Blue Yonder Sounds, an independent record label.

good

sand and rub our toes in the ocean and we're gonna have a good time. Are you ready? Are you _readddddyyyy! ARRR yew rreeeadYY!!_ Are you ready? Are . . . are . . . a-r-e yewwwwwww . . . _Wowowowowooo . . . Aahhhhwwwoooooo suck . . . Aahhhh suck . . ._"

The band was crashing into the opening of a familiar song from the first album, "Back Door Man."

"_Louder! Come on, band! Get it louder! Come on!_ Yeahhh. Yay-ehhh. Ahhhmmm uh _back door mannn . . ._"

Four lines into the song Jim stopped singing and began talking again. He sounded apologetic. Was he speaking to Pamela as well as to the crowd?

"Hey listen," he shouted, "I'm lonely. I need some love, you all. Come on. I need some good times. I want some love-a, love-ah. Ain't nobody gonna love my ass? Come on."

The crowd gasped.

"I need ya. There's so many of ya out there and nobody's gonna love me, sweetheart, come on. I need it, I need it, I need it, need ya, need ya, need ya, need ya. _Come on!_ Yeah! I love ya. Come on. Nobody gonna come up here and love me, huh? All right for you, baby. That's too bad. I'll get somebody else."

The musicians were barely hanging in through most of the plea. When Jim paused, they began "Five to One" and he picked it up, singing the first verse fairly coherently. Then he made another speech, inspired by the greed of the promoters in jamming so many people together, but also by _Paradise Now._

"You're all a bunch of fuckin' idiots!"

Again the crowd gasped.

"Lettin' people tell you what you're gonna do! Lettin' people push you around. How long do you think it's gonna last? How long are you gonna let 'em push you around? How long? Maybe you love it, maybe you love gettin' your face stuck in the shit . . ."

Jim was taunting them, just as the actors in the Living

Theatre taunted their spectators, trying to shatter their lethargy.

"You're all a bunch of slaves!" Jim shouted. "What are you gonna do about it, what are you gonna do, what are you gonna do?" His voice was a hoarse shout. Then he resumed singing: "Your ballroom days over over, bayyy-beeee/Night is drawing near."

Somehow the song was concluded and Jim began to talk again. "I'm not talkin' about no revolution, I'm not talkin' about no demonstration. I'm not talkin' about getting out in the streets. I'm talkin' about havin' some fun. I'm talkin' about dancin'. I'm talkin' about love yer neighbor. I'm talkin' about grab yer friend. I'm talkin' above love. I'm talkin' about some love. Love love love love love love love. Grab yer . . . fuckin' friend and love him. Come _ooooooaaannnn. Yeahhhhhh!_

Then, as if to set an example, Jim pulled his shirt over his head and threw it into the audience, where it disappeared like meat thrown to a pack of ravenous dogs. As he watched, he hooked his thumbs into the top of his pants and started playing with the buckle. This was the moment that Jim had been planning since seeing _Paradise Now._ He had prepared for it carefully. But he hadn't said anything to anyone in the band.

Ray called for "Touch Me," hoping to draw Jim's attention back to the music. Jim sang two lines and stopped.

"_Heyyyyyy,_ wait a minute, wait a minute. Hey wait a minute, this is all fucked up—no, wait a minute, wait a minute, wait a minute! You blew it, you blew it, you blew it, now _come oannnn. Wait a minute! I'm not gonna take this shit! Fuck you!_" he hollered.

He was red-faced, his voice a bellowing growl, the microphone rammed into his mouth.

"_Bullshit!_"

The crowd roared.

Jim began to unbuckle the belt. Ray called to Vince, "Vince, Vince, stop him! Don't let him do it!"

it. So many extras were in that movie, I can't tell you. We had limited digital effects then; all the extras were real people. You have to understand the amount of people it took in those days to fill a concert. And we found these incredible places, we made every space count, we filled them with extras in period costume, and all these people come up to me still to this day and say, _I was in your Doors movie! I was at that concert! Man, were we ripped!_ So we asked one day, at the last concert, the AD asked, _Who wants to take your clothes off? Go over there!_ All these hands shoot up! We had too many volunteers to take their clothes off, because they were on LSD! We didn't know! They were doing drugs, living the seventies vibe again! And they were all young enough—some of them were old enough to remember that, too. There were older guys and women, too. It was an amazing journey.

We went up to San Francisco to do the fourth concert. Jesus Christ! Every one of those concerts is like a football game in _Any Given Sunday._[48] That amount of detail . . .

huge, huge set pieces. Wow. I loved making that movie. I was wild and free. I finally felt more the director than anything. It was amazing, just an amazing experience. Of course, there were a lot of affairs going on at this time.

On the set?

Off and on, yeah. I was insane. It was a wonderful experience. If anything, I wish I'd slowed it down, because I released the film quickly. I was cutting _The Doors_ and preparing _JFK,_ and I was in this frenzy, and we released the film in March of '91. I was in a rush. I wanted to make two films that year and get out with _JFK,_ which I didn't realize was going to be another monstrosity in size. So I made two movies in one year to release—it just staggers me to this day. You realize the size of _The Doors,_ if you really look at it, the amount of scenes, maybe one million feet of film at that time, which is enormous for me. Paul Rothchild[49] was indispensable. I say that again because Paul was a lovely man who knew a lot about Jim

and told me a lot of stories. I say this because there was so much crap written about that movie from the get-go, I didn't realize the subject was so controversial. So many people knew Jim, but I actually had access through the kindness of [Jerry] Hopkins,[50] who wrote _No One Here Gets Out Alive,_ and the book was good. I enjoyed it—I don't know if we optioned it. But Hopkins did give me 120-some transcripts he'd collected to prepare. He'd done these interviews with 120 different people who'd known Jim through the years, from grade school to the very end, and some of these stories are insane. So these transcripts were invaluable.

And when Ray Manzarek was coming out and going on with his shit about how I'm

48 Stone likens the structure of _Any Given Sunday_ to that of _The Doors_ on page 357 of chapter 7.

49 1935–95; produced the Doors' first five albums and Janis Joplin's final album, _Pearl._

50 1935– ; contributor and editor for _Rolling Stone_; author of 1971's _Elvis: A Biography,_ among other books about rock history.

between Apollonian and Dionysian impulses, the desire to explore or conquer new frontiers, the internal journey being mirrored by the images on-screen.

A statue of Alexander appears in *The Doors*. Do you remember that?

No!

You have to look for it, it's in a montage. Bizarre.

But I just want to say again that the picture was one of the greatest experiences of my life. I wish I'd had more time to enjoy it, because I *really* enjoyed it. The editing was rushed, I think, but we did a good job. It may have been flawed in some ways, I haven't seen it in a while, but I love the movie. People get into it. It's always survived through word of mouth.

Critics were mostly cruel, although Janet Maslin was wonderful, gave it a great review [END 7]. But they were scared to go that way. It was just too wild, too extreme at that time. But it was a wild experiment for me, gave me a lot of confidence.

I only wish I'd enjoyed it more, because we had to rush it out for March 1991, when it got a release date. We did a very good opening weekend and then it wilted, and that has to be word of mouth, because we had an opening. But it only made some thirty-some million in the end, and I think it cost that. But overseas I'm sure it did well. Mario never regretted it; he loved the movie.

It was just disappointing because it really was . . . to make two movies of that size in one year, it's a shame because I rushed it. I wish I'd taken another year, the next year. But—I don't know why, I was in a rush, a fever, to take on big things, and the biggest thing that was next was *JFK*. So you can imagine going from *The*

distorting things,[51] well, he's wrong, and I wouldn't do that. I mean, obviously you have to condense. I made five, six girls into one girl. But Manzarek, who I don't believe ever saw Hopkins' transcripts, was outrageous in what he said, outrageous and totally mean-minded. But the thing that really bothers me is that Manzarek, if you really go over [Hopkins's] transcripts, doesn't figure prominently, except as a musical coworker with

despite the hostility of the press reception. He was everywhere, doing counter-publicity everywhere. It was ugly.

I probably made Morrison more dangerous than he wanted him to be, but I think Ray was pretty straight and boring. I read those transcripts. What was going on sexually: the impotence, this and that, all kinds of issues. I met his parents, I met Pamela's parents. . . . It was a journey to get permission!

Kill the father, fuck the mother.

him. He's Jim's colleague and all that, it's very important at the beginning, but after the first album you sense Manzarek was a complete opposite to Jim. Everything with Jim is free; Manzarek is control. [Manzerek] is the authority figure, the voice, the way he closes down on every situation. I was choking with him, and resented his constant interference. I tried to work with him, but then I gave up after he gave me his screenplay—which was ridiculous. He hated my screenplay, *hated* it. He was like an Iago figure to me.

But the movie was not about the Doors as much as it was about Jim, and the Doors' reception. So the four lead actors were very good, and Kyle MacLachlan[52] is very good, but at a certain point Jim is definitely on his own. He has another life. He never really had a social life with Ray anyway. They were UCLA film students together. So Manzarek made up his own myth, and carried it on

Bill Graham was on the film, and he was instrumental. He was crucial at getting us in with Jim's family, which we had to do to get their participation and blessing for certain aspects of this project. He was the guy who put the permissions together, and Pamela's parents came to LA and I interviewed them, and I had to go to San Diego to meet Jim's parents, the admiral and his wife. His dad was an admiral, the head of the Pacific Fleet, at one point, during the Vietnam War. So you can imagine Jim's antipathies! "The End," you know: Kill the father, fuck the mother.

Jim was a strong influence, and there's a lot of that in *Alexander* as well. I think you see the same thing, the concept of breaking on through and destroying the father.

There are a lot of similarities, I think, thematically and stylistically, between *The Doors* and *Alexander*, now that you mention it. The boy torn

51 In a March 17, 1991, *Los Angeles Times* article, Manzarek said, "Oliver Stone has assassinated Jim Morrison." He accused the director of numerous errors of fact and omission and said the project was made "from the entirely wrong philosophical base. The Doors were about idealism and the '60s quest for freedom and brotherhood. But the film isn't based on love. It's based in madness and chaos. Oliver has made Jim into an agent of destruction."

52 1959– ; star of *Blue Velvet* (1986), *Twin Peaks* (1990–91 and 2017), *Showgirls* (1995), and *Portlandia* (2011–2016); Calvin Sabo on *Agents of Shield* (2015–).

Doors, which is a gigantic film, five concerts, all that period, right into another period film of the same era. We're going from Morrison, late sixties, to Garrison. It's very funny. Garrison the straight man, Morrison the wild man.

Very much so.

And I said to one critic, to several of these critics, *You guys keep classifying me, but what kind of guy would I be if I'm this guy? How can I be Nixon and Morrison at the same time?* You have to understand, I'm different people. I'm *several* different people! I've led a lot of different lives! I'm not going to be restricted into being this political agitator . . . Give me a break, you know?

I mean, fucking Morrison is a free, wild animal. I love that character. Val Kilmer[53] impersonated him to a T, singing 75 to 90 percent of the vocals in Jim's live stage appearances. We had to use Jim's recordings on the soundtrack because there's no way Val could fake those vocals; everybody knows what they sound like on record, and Jim just had his own unique voice. Paul was the arbiter, he knew Ray very well and just dismissed him, said Ray just had a hard-on about this. It was an ego issue with Ray, too. Anyway, he

talked Robby and John into joining him. . . . He was an evil motherfucker, they both kind of dissed the film, but John came back. Robbie, I don't know where he is. They're all in the movie. But there was so much bullshit politics surrounding the film for me—who's with the film, who's against the film—it became too much of that shit.

When you mentioned Fellini, a lot of things clicked into place for me, because structurally, *The Doors* seems to flow beautifully off of *Born*, because it's a series of self-contained scenes or tableaux, almost. It is structurally and visually as controlled a film as *Born*. And yet the story that it tells is much wilder and more impressionistic in the way that, say, Fellini's *8½* is.

Or *La dolce vita*, which takes place in some eight nights, seven nights, or something, and it's all constructed very nicely.

I wrote it up in Santa Barbara, and I loved writing it, but that's the only time I wrote purely to music. I'd put a song on, and I'd be in that mood, and I'd write that scene.

Were you straight when you wrote the script?

I forgot. How would I remember?

(Seitz laughs.)

I couldn't go through *JFK* on whatever I did. Imagine the reams of information I had to get on that one? Stacks of books like that, you know? *(Holds hand up to indicate a stack nearly two feet high.)* Pictures, autopsies, all that! It was pretty tough. I mean, I can't be *that* stoned and write this shit!

Absolutely not!

I loved every second of *The Doors*. I just wish I could've slowed down and enjoyed it more, because it would've been really fun to edit for six, seven months, eight months, you know? That would've been great, living in that world.

There's a lot of spite of the LA rock scene, the LA music scene. Too much spite. There's a lot of spite in the world.

Well, I'm sure that a lot of the people you portrayed in the film felt they were the ones who should be telling the story.

53 1959– ; *Top Secret!* (1984), *Real Genius* (1985), *Tombstone* and *True Romance* (both 1993), *Batman Forever* (1995), *Kiss Kiss Bang Bang* (1995), *The Bad Lieutenant: Port of Call New Orleans* (2009).

233

████████████████████████████████
████████████████████████████████
████████████████████████████████
████████████████████████████████
████████████████████████████████
████████████████████████████████
████████████████████████████████[54] I was reading about the end in Paris . . . all these Paris people. Agnès Varda[55] knew him, and then the people in the early part of his life, in Florida. I had the whole 120 transcripts: It's like *Citizen Kane*, you understand.

Hopkins did me a huge favor with those transcripts. He gave me all of them. How many girls fucked him, his impotence. These are oral transcripts. The blood-ritual thing was true—I mean, all kinds of shit. He'd try stuff. He actually wasn't doing that much drugs in the end. It was more booze than anything.

That's a big part of the movie, and something that really jumped out at me when I watched it again. Jim Morrison was an *alcoholic* at the end. With a capital *A*.

I don't know how much. . . . Paul implied that. He wasn't that . . . sex-driven as much as he was, the idea . . . and you know, Pamela's a pretty straight woman, kind of boring in a way, ████████████████████████████████
████████████████████████████████
████████████████████████████████
████████████████████████████████
████████████████████████████████
████████████████████████████████
████████████████████████████████
████████████████████████████████
████████████████████████████████
████████████████████████████████[56] But in other words, I don't see Pamela as some exotic drug hippie chick. No, I find her to be kind of bland, and I think Jim liked that, in a strange way. I think he was so outrageous that he wanted the opposite. So Meg Ryan[57] was not bad in the part, although she's strange, and you know, she's . . .

You mean as a person?

A very strange lady, yeah. It wasn't the way Pam was, but she would probably be happy with Meg. I think we got away with Meg.

That's a very good performance by her that I don't think gets the credit it deserves.

But she . . . like, the scene where she covers her tit right away, that was Meg Ryan as opposed to . . . She was trying to be Meg Ryan, to keep that image, like Blake Lively would try to be Blake Lively when we were making *Savages*.

Meg Ryan was nine months out of *When Harry Met Sally . . .* when she appeared in *The Doors*, so that was a bit of a stretch for the audience.

She was a star, and Val was not a star. But Val is the difference in the movie, in terms of . . . he committed totally. He's so much taller, and more Norwegian or whatever he is—Swedish? But my God, he had charisma, he was handsome, and Val's a very good actor. He went to Juilliard and all that, but he'd done a fair amount of theater by the time he did this. If anything, it was a difficult performance.

He told me—he broke my heart at the end of this, and he knows this now—at the end of the shoot, he said, *You don't know how to direct*, at the last wrap party. That's a nice way to end the film! But it made me feel bad, you know? He was not easy.

He ran huge massage bills up every day. We'd have to pull him out of the trailer, with thousands on our budget. He was always tired, because it was exhausting to do that role, I grant you that, but he was always difficult, and the producers had a hard time with him.

Do you feel he was worth it in the end, though?

Yeah! I used him again on *Alexander*. I'd absolutely do it again with Val, like Billy Wilder said about Marilyn Monroe.[58] I would do it again in a second.

But what an experience that film was. There was so much sensuality, and I'm not kidding. Oh my God, what fun, what fun it was to direct!

54 Redacted.

55 Central figure in the French New Wave cinema movement; director of *La Pointe Courte* (1955), *Cleo from 5 to 7* (1962), *Far from Vietnam* (1967), *Vagabond* (1985), and *The Gleaners and I* (2000), among others.

56 Redacted.

57 1961– ; *D.O.A.* (1988), *When Harry Met Sally . . .* (1989), *Sleepless in Seattle* (1993), *Courage Under Fire* (1995), *Proof of Life* (2000).

58 Of the experience of directing a pill-addicted, forgetful, chronically late Monroe on 1959's *Some Like It Hot*, Wilder said, "I have discussed this with my doctor and my psychiatrist and they tell me I'm too old and too rich to go through this again." But he also said, "My aunt Minnie would always be punctual and never hold up production, but who would pay to see my aunt Minnie?"

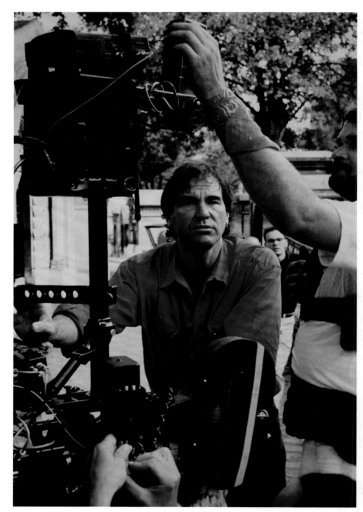

Essay

A Matter of Character

Kim Morgan

There's a scene in Oliver Stone's *W.* that is as absurdly surreal as it is vividly realistic. Beginning with Alan Jackson's chirpy song "Chattahoochee,"[1] the camera moves to George W. Bush and his inner circle at Bush's ranch, discussing strategies to invade Iraq. Bush is comfortable—this is *his* domain; he is used to the oppressively hot sun and the cow shit and walking in boots and presumably eating pork rinds (even if that belies his upper-crust upbringing). Nevertheless, he misses the side road and sets himself and his cronies adrift. Colin Powell (a terrific Jeffrey Wright) is wary of starting this war; a smiling Donald Rumsfeld (Scott Glenn) expresses the term "shock and awe"; Condoleezza Rice (Thandie Newton) struggles in her non-sensible shoes, her head bobbing around like a dislocated doll's, hiding her obvious annoyance; Karl Rove (Toby Jones) pops into the scene looking like he's just landed on Mars; and Dick Cheney (Richard Dreyfuss) struggles with real pain. The guy's had three heart attacks, after all—he needs a goddamn car.

A nice little walk is one thing; losing one's way with half a mile or more to go while talking about the invasion is another. Everyone treads along, flies buzzing around them, all overheated and miserable and pretending not to be miserable (though you get the feeling nothing bothers Rumsfeld—the man doesn't even sweat). But the scene is both *so* odd and *so* obvious, it works. All of them, including Bush, begin to take on freakish characteristics—they look like a cluster of sad Muppets straggling along the dirt road, discussing one of the most serious issues of our time. If Sam the Eagle jumped in to discuss exit strategy, we'd think nothing of it. That is how absurd it becomes. But then, that's probably what they would look like from afar, struggling along the dusty trails of the ranch, lost and uncomfortable—freakish and absurd.

George W. getting his cabinet lost is both subtle and unsubtle, much like the prowess of other writ-large Stone characters: Anthony Hopkins's Tricky Dick (in *Nixon*) beseeching his wife, Pat (Joan Allen)—"Buddy!"—in such a jarringly entertaining way that it sticks in our minds. Or John Candy playing the Southern-fried lawyer Dean Andrews like a hepcat daddy-o in sunglasses, sent to represent Lee Harvey Oswald in *JFK*. Stone directs actors with look-at-me gusto, and yet you aren't so distracted that you forget what they represent. Think of the series of weirdos in the filthy little neo-noirish peculiarity *U-Turn*, some of them so stupid that Sean Penn's character, lost in this town of freaks, even points out how dumb they are. Joaquin Phoenix's one-note country tough boy tries to threaten

Sean Penn's Bobby: "I don't think you know who I am: Toby N. Tucker. People round here call me TNT. You know why?" Bobby answers, "Um . . . they're not very imaginative?" Or think of the purposely, crazily off-the-wall moments in *Natural Born Killers* with the eye-poppingly wonderful Tommy Lee Jones as the demented, delightfully punitive Warden Dwight McClusky, walking along with his guards and Tom Sizemore's Detective Jack Scagnetti and uttering to him, "Mickey and Mallory Knox are without a doubt the most twisted depraved pair of shitfucks it has ever been my displeasure to lay my goddamn eyes on. I tell you these two motherfuckers are a walking reminder of just how fucked up this system really is."

Stone pulls both the preposterous and the grindingly real out of many of his actors and reveals what many of us see when we look in the mirror. *What is this silly thing? How lost am I? Who am I?* Charlie Sheen utters the latter question as a melodramatic entreaty in *Wall Street*. It's a laughable scene because it *is* kind of silly. And yet, it's sincere. Who hasn't asked such a question, or at least thought it? Who hasn't been overdramatic, privately playing the reality show that is his or her life? *Who the hell am I? And am I brave enough to, as Jim Morrison sang, break on through to the other side?*

In the case of Stone, the most compelling characters try to break on through via crime, drugs, greed, and corruption, yet they rarely make it to that other side. Even Morrison, for all of his poetry and ride-the-snake performance sexiness and leather pants and "penetrate the evening that the city sleeps to hide" lyrics, couldn't make it either, despite how freely he tried to live his life. Morrison died, which is a kind of freedom (especially from drink and drugs), but probably not the kind he was seeking in life. He didn't have

a death wish. But even as Stone seems to revere the iconic sixties rock god (played by a transformative Val Kilmer, bravely digging into Morrison and all of his Jim-ness—he could have come off really, really pretentious and silly), he also gets his humor as well. In a short moment of sublime ridiculousness, the end credits begin with Morrison, all bearded and burly, recording one of his best songs, "L.A. Woman"—while sitting on a toilet. That really happened, and anyone who knows the history of Morrison is delighted to see that moment. Following the scene where he slips into the bathtub emitting his last gasp, and the famous headstone marking his grave in Paris, it's a much more powerful and effective way to end the movie. This is Morrison being extraordinary and absurd—we love that the sexy son of Dionysus recorded "L.A. Woman" while sitting on the john. And he's in control here. But that won't last.

Stone's preoccupation with those who seek control but are truly lost swirls through his movies. Watching them is like trying to get a handle on a bad (or sometimes good) acid trip. Film stocks alternate, cuts are unexpected, music is either completely obvious or completely startling. The people frequently are, to varied degrees, grotesques. As Jim Garrison in *JFK*, Kevin Costner's Gary Cooper–like steadiness keeps the calm amid a cavalcade of terrific character actors (Kevin Bacon, Joe Pesci, John Candy, Gary Oldman) playing vivid oddballs—even though Garrison himself was in real life something of an oddity. And in *Nixon*, a brilliant Anthony Hopkins seems more subdued than the real-life, "Sock it to me," sweaty Nixon. This isn't rubber-mask Tricky Dick; this is a haunted man, remembering life with Mom while enduring (or deservedly suffering) his almost psychotic paranoia. He was a person, after all, and Stone interprets him as

Shakespeare might have chronicled a corrupt, fallen king.

Lost souls and power trips and those warring factors in powerful men (mostly men, though Angelina Jolie in *Alexander* and Cameron Diaz in *Any Given Sunday* compete with similar issues in a man's world) are nothing new in cinema or any other kind of art, but there's something about how Stone depicts such struggles that resonates with actors. You see it in *Talk Radio*, *Platoon*, *Savages*—all of his films, but certain performances just pop out among these pictures with such riveting panache that you can't stop watching, to the point where you might feel those warring factions within yourself. He even titled one of his documentaries on Castro a search: *Looking for Fidel*.

"Greed is good," Michael Douglas's Gordon Gekko famously says (which has been picked up as an almost Patrick Bateman–like inspiration to business majors and salesmen everywhere), but where do the power and greed lead? To Josh Brolin's fantastically powerful performance as George W. Bush, a guy who probably just wanted to run a baseball team, that's where. Stone is not letting George W. off the hook, but there's sympathy in the weird combination of wiliness and simplicity that he finds in this strange man. Foreseeing George W.'s own post-presidential art career, in which the blandness of his self-portraits in the tub and banal paintings of dogs have riveted some people, we find ourselves reading signs of something ("help"?) into those paintings and George W. that may or may not be there. It's that range and reach—like smoking some mellow weed between dropping five tabs of orange sunshine—that Stone and his actors love showing on-screen. George W. laughs and acts smug and at times looks like a lost puppy dog while working with some of the most dangerous people

in the world. But hey, he's just a regular guy. Is he? Of course not. It's interesting to look at that character compared to one of Stone's most iconic creations, Tony Montana from *Scarface*. After loudly insulting and lurching at his coke-addled, but ultimately sad and fragile, wife/arm candy (Michelle Pfeiffer) in a public restaurant, Montana just spells it out to a horrified diner—and, in turn, to the audience, too:

What you lookin' at? You all a bunch of fuckin' assholes. You know why? You don't have the guts to be what you wanna be. You need people like me. You need people like me so you can point your fuckin' fingers and say, "That's the bad guy." So . . . what that make you? Good? You're not good. You just know how to hide, how to lie. Me, I don't have that problem. Me, I always tell the truth. Even when I lie. So say good night to the bad guy! Come on. The last time you gonna see a bad guy like this again, let me tell you. Come on. Make way for the bad guy. There's a bad guy comin' through! Better get outta his way!

Trouble is, when Stone and actors are working on all cylinders, we can't get out of the way. We don't want to.

And we have to wonder why. Are we glamorizing them? Are we rooting for Mickey and Mallory? Are we too soft on Nixon? What he hell is going on in George W. Bush's brain? So we watch. We make way. We say hello. And, sometimes, we say hello to ourselves, and realize that we're *all* a bunch of sick shitfucks.

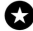

THROUGH THE
Looking Glass

★ ★ ★ ★ ★ ★ ★ ★ ★ ★ ★ ★

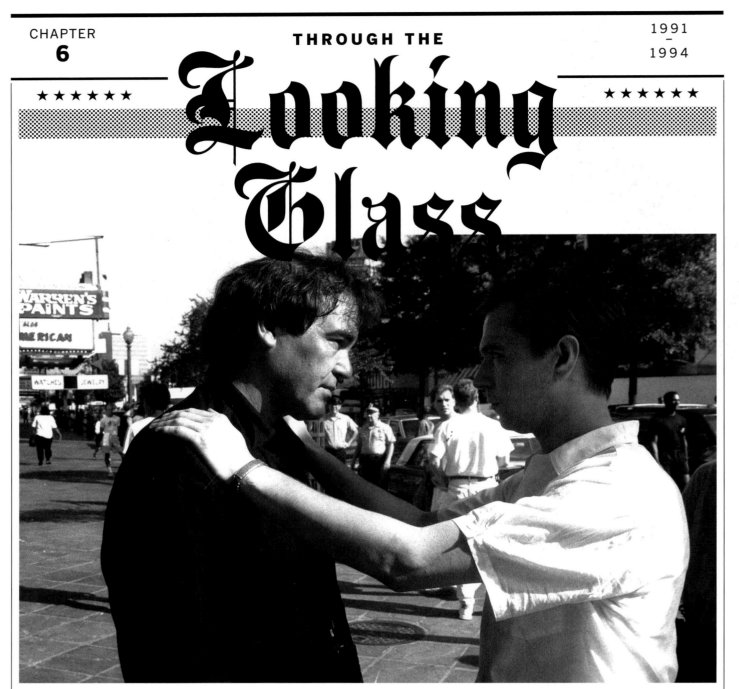

(previous spread) **Set photo from *JFK* (1991): Oliver Stone (center, on tiptoes) shows Gary Oldman (left) how accused assassin Lee Harvey Oswald should stand while having his mugshot taken by Dallas police.**

(above) **) Press kit photo: Oliver Stone and Gary Oldman outside the Texas Theater in Oak Cliff, Dallas, Texas, where Lee Harvey Oswald was arrested**

The years 1991–95 represent Oliver Stone at the peak of his artistic power, cultural influence, and productivity. In particular, 1991 stands as a high-water mark: the year of *The Doors* and *JFK*. Although Stone had released two features in one year once before (1986's *Salvador* and *Platoon*), the pair that he produced five years later dwarfed them in complexity and scale. They are also more divergent stylistically than the earlier two, confirming Stone's increased assurance and skill. *The Doors* is a visually and tonally sophisticated but classically structured drama about

a musician's life and times. *JFK*, which arrived in theaters ten months later, is a triumph of a different order of magnitude: one of the most stylistically innovative and politically provocative big-budget films to originate at a major studio (Warner Bros.). For the editing experiments it emboldened, the arguments it sparked, the media hysteria it caused, and the legislation it inspired (including the President John F. Kennedy Assassination Records Collection Act of 1992 and the creation of the Assassination Records Review Board), it should be considered one of the most important films ever made.

The narrative backbone of *JFK* is a hybrid of genres: the conspiracy thriller, the detective story, and the crusading do-gooder fable. The screenplay, credited to Stone and New York University history professor Zachary Sklar, is a Frankensteinian patchwork of sources. Its core is the New Orleans district attorney Jim Garrison's book *On the Trail of the Assassins*, a self-aggrandizing account of his nonetheless indisputable distinction: He was the only person to bring criminal charges related to the murder of President John F. Kennedy. The film idealizes and abstracts the real Garrison, who has been accused by various critics of reckless narcissism, mental illness, and far worse; Stone told me he considers all these charges groundless and thinks many of Garrison's harshest detractors are deeply compromised in one way or another. He says he got to know the real Garrison, who died shortly after the film's release, while writing and shooting the movie, and thought he was "an honorable man"—though admittedly "a womanizer"—who was "attacked on every front possible" for daring to question the official conclusions of the Warren Commission. "He was alive and he was consulting with us, and I think we told the story along the lines that he set out," Stone told me, adding, "There'd be no *JFK* at all if it hadn't been for Jim, and I wasn't misled. I checked his bona fides. I talked to so many people who were on his side. . . . He did fuck up a lot, but only because there was so much pressure on him."

In the end, though, Stone and Sklar's version of Garrison is less a representational sketch than an information delivery device in a suit. The character is incarnated by Kevin Costner as a drawling lawyer cousin of his Eliot Ness in *The Untouchables*, and written as if he were the second coming of Gregory Peck in *To Kill a Mockingbird*; there's even a scene where he sits in a porch swing with his kids and explains why his mission is so urgent. Garrison is Stone's squarest leading man (at least until the one-two punch of *World Trade Center* and *W.*); the film surrounding him is conventional in the way that it separates characters into conspirators, enablers, oblivious sheep, and crusaders for truth. It is an impassioned, deliberately incendiary film that demands audiences to pick a side: the approved account of the assassination, or something else, anything else.

The film's commercial-friendly trappings, including its conventionally idealized vision of its hero, are the film's strategic masterstroke; they let Stone sneak several major JFK conspiracy theories into a star-packed, forty-million-dollar-plus motion picture. They also let him create aggressively free-associative sequences that bring editing techniques pioneered by Sergei Eisenstein and perfected by Jean-Luc Godard into the mainstream.

That the film's boldest editing is functional—in service of delivering as much information as possible, as quickly as possible—makes its mix of lyricism and sinister force seem all the more impressive. When we watch, say, Mr. X (Donald Sutherland) break down the sequence of events before and after the murder, or Garrison lay out the geography and timing of his multi-shooter scenario as prelude to showing Abraham Zapruder's 8 mm film in court, we're seeing chapters of a textbook delivered with the passion and force of an aria. When coupled with Wylie Stateman's horror film–inflected sound design and John Williams's martial drums, dread-soaked brass, and shrieking violins, the images don't merely flash on-screen: They pierce and tear. Stone, his editors Joe Hutshing, Pietro Scalia, Hank Corwin, and his cinematographer Robert Richardson assault the viewer with volley after volley of inflammatory allegations and unnerving suppositions; meanwhile, the use of dialogue as stealth narration puts a comprehensible frame around what might otherwise have seemed like a shrapnel bomb unleashed by a newsreel warehouse explosion. Name a major player in JFK lore, and there's a chance they're represented in the movie: the Joint Chiefs of Staff and the Pentagon; the defense contractors that stood to benefit from the United States escalating its involvement in Vietnam; JFK's successor, President Lyndon Johnson; anti-Castro agitators based in the United States; the assassins and commandos (both Cuban and American) working to further their cause.

Contrary to many of *JFK*'s detractors, the film does not present any single theory as definitive, much less suggest that all of the forces Stone name-checks joined hands to murder the president. This is a film that tells you how you should watch it. Every flashback is yoked to a particular story told by a particular character to Jim Garrison. The "flashbacks"—a blizzard of dramatic re-creations, TV and newsreel images, and still photos, captured in a variety of black-and-white and color film stocks—are the "mind movies" Garrison sees as he spitballs theories and interrogates witnesses. There are, inevitably, inconsistencies, contradictions, fuzzy areas. These, too, are accounted for. Stone has spoken of his desire to create a countermyth to answer what he saw as the inadequacies of the Warren

Commission Report, which concluded that there was no organized conspiracy to kill the president, and that accused assassin Lee Harvey Oswald (played in the film by Gary Oldman) acted alone. The dialogue is filled with repeated admissions that what we're seeing are riffs on a history-altering narrative that Stone believes was warped by ineptitude or deception and sealed off from scrutiny until 2017, when 3,600 classified documents related to the case were set to be released in accordance with the JFK records act of 1992.

Beneath the factual and speculative particulars is a bedrock of dread. Once you dig into it, you realize that the Kennedy assassination is, incredibly, mere means to Stone's larger end: to warn the viewer that since the end of World War II, the United States has not truly been a democracy, in the sense that school textbooks idealistically claim, but a whey-faced dictatorship run by the military-industrial complex—a loose consortium of interests linked by the desire to acquire and hold power by generating public fear of "enemies" within and without, then generate profits by selling arms and munitions to the US military in order to defend against those same enemies.

The five-minute prologue is essentially a paranoid's version of the "March of Time" newsreel at the start of *Citizen Kane*. It kicks off with Kennedy's Republican predecessor, the onetime five-star US Army general Dwight D. Eisenhower, warning citizens to "guard against the acquisition of unwarranted influence, whether sought or unsought, by the military-industrial complex." The speech, Eisenhower's farewell, was delivered in January 1961. In less than three years, Eisenhower's successor would be murdered, and the events laid out after the Eisenhower snippet (including the Cuban Missile Crisis, the so-called domino effect abroad, and the prelude to JFK's murder at Dealey Plaza) beg for a cause-and-effect interpretation: Somehow, the military-industrial complex killed him.[1]

The film encourages this interpretation, particularly during Garrison's long pretrial interview of X—a sequence that, in its relative brevity, variety of data, and clarity of expression, must be considered one of the great expository montages. It's a phantasmagorical info dump that puts us inside Garrison's head as he puts himself inside X's, imagining sinister conversations that might have occurred behind closed doors, then going on to ask not just what was said and done, but why. "The organizing principle of any society, Mr. Garrison, is for war," X intones, as the Washington Monument looms over them. "The authority of the state over its people resides in its war powers. Kennedy wanted to end the Cold War in his second term. He wanted to call off the moon race and cooperate with the Soviets. He signed a treaty to ban nuclear testing. He refused to invade Cuba in 1962. He set out to withdraw from Vietnam. But all that ended on the twenty-second of November, 1963."

Stone's foes ridiculed the idea of JFK as some kind of pro-hippie peacenik: He legendarily tried to out-macho his opponent in the presidential race, Eisenhower's vice president, Richard Nixon, and got the United States involved in foreign adventures, including sending combat advisers to Vietnam. But in later years, assertions by Stone that many dismissed as ludicrous in 1991 were proved right—in particular, his claim that JFK wanted to de-escalate or end US involvement in Vietnam, rather than put boots on the ground as Johnson eventually did.[2] *JFK* doesn't profess to offer specific answers to most of the questions that it raises. But it does insist that its darkest question—could a coup d'état happen in this country?—is valid, or at least understandable, considering the deficiencies of the Warren Commission's presentation and the veil of secrecy draped over its methods. As Thomas Oliphant, one of the film's defenders, wrote in a 1992 *Boston Globe* editorial, "His point of view is clearly that President Kennedy's murder originated in military-intelligence opposition to post-Cuban-missile-crisis changes in policy away from the Cold War, against a second invasion of Castro's Cuba, and, above all, against Vietnam. However, Stone leaves one free to accept all or none of his suggestions; only elitist Washington would assume a mass audience of zombies, incapable of viewing a political film carefully and critically."[3]

The film also insists, just as valuably, that to ask such questions is to invite the participation of storytellers who are often written off as undesirable, untrustworthy, or insane. In Dallas and New Orleans, Garrison and his team pass through a Lewis Carroll–like "looking glass" in which "white is black, black is white"; the most important players on the ground are outwardly respectable but secretly violent small businessmen, pro- and anti-Castro Cubans, sex hustlers (represented by Kevin Bacon's Willie O'Keefe, a composite of three real sex workers), a drug runner and prostitute (a composite character played by Sally Kirkland, glimpsed being tossed from a moving car), black ops gargoyles (including Joe Pesci's manic David Ferrie), and a prominent closeted

New Orleans businessman, Clay Shaw (Tommy Lee Jones), who holds orgies in which participants dress as mythological or historical figures.

In this way, *JFK* represents a culmination of Stone's career-long fascination with validating the life experiences of people whom many Americans would rather not think about, much less listen to. The narrative of the assassination was decided by the most powerful of "respectable" Americans: Supreme Court justices, a sitting president and Congress, generals, FBI and CIA officers, police chiefs. In the film, Garrison, himself a sworn representative of the Powers That Be, invests his own aura of respectability in the search to uncover an alternate narrative. This requires Garrison and his investigators to seek out marginalized or reviled Americans, listen to them, take their stories seriously, and enter their statements into the public record. By spearheading such a search, Garrison becomes disreputable: a traitor to his class and in some eyes, to his country. "I had no idea Kennedy was so dangerous to the Establishment," Garrison tells X, unknowingly foretelling the campaign of sabotage and smears that he's about to endure himself. Garrison's team is followed, wiretapped, and hamstrung by legal and illegal inventions throughout their investigation. In a scene drawn from Garrison's own life (deleted from the theatrical cut but restored for home video), he's set up for solicitation in an airport men's room.

The film sparked controversy of another kind when the Gay and Lesbian Alliance Against Defamation charged it with sensationalizing its gay characters, and making it seem as if a cabal of sordid homosexuals had killed the president. Stone's protestations that these incidents and images were also drawn from Garrison's interviews don't wash. The hero's visualization of the orgies, while brief, are creepy enough to make Shaw seem like a queer devil opposite the hero's white-bread straightness; if Stone meant to suggest that his lead character was projecting unacknowledged homophobia onto his quarry, it doesn't come through, and as a result, these scenes themselves are charged with horror and disgust, not at what Shaw allegedly did to the president, but what he and his guests are doing behind closed doors. There's nothing else in Stone's filmography to suggest that he shares such retrograde attitudes—this is, after all, the same filmmaker who has spoken of human sexuality as a spectrum of possibilities beyond definition or judgment; wrote a gay relationship into *Midnight Express* because he

thought the film needed "a little tenderness," and directed the most expensive film ever made about a bisexual, 2004's *Alexander*. Nevertheless, those images were inflammatory, and Stone's tabloid sensibilities and brusque manner left him open to attacks. And so *JFK* was bundled together with two other features released around that time, 1991's *The Silence of the Lambs* and 1992's *Basic Instinct*, in feature articles about Hollywood's negative images of gays and lesbians; and Stone's plans to produce a film adaptation of Randy Shilts's book *The Mayor of Castro Street*, about the life and death of Harvey Milk, San Francisco's first openly gay city councilman and supervisor, were derailed.[4]

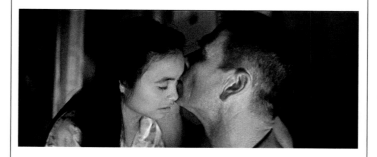

By that point, ironically, Stone was already in production on a film that would partly rehabilitate another thorny aspect of his reputation: the not-undeserved charges that he was indifferent or hostile to women's stories. *Heaven & Earth* is based on two memoirs by Le Ly Haslip that charted her journey from Vietnam to the United States and back again. As flowing and lyrical as *JFK* was dissonant and assaultive, the movie gave Stone a chance to work in the vein of one of his heroes, the mainstream epic maker David Lean (*Lawrence of Arabia*), and of Lean's regular screenwriter Robert Bolt, who had been a mentor to Stone in the 1970s. It stars the Vietnamese American newcomer Hiep Thi Le, with a formidable supporting cast of actors drawn from other Asian film industries (including China's Joan Chen, fresh off her success in *Twin Peaks*, and Cambodian actor Haing S. Ngor, who had won an Oscar for *The Killing Fields*). The only American actors of note in the cast were Tommy Lee Jones, who played the heroine's American GI husband, and Debbie Reynolds, who played his hopelessly suburban-bourgeois mother. Concessions were made to the English-language market, and to the complexities of pan-Asian

casting; the actors spoke in English rather than Vietnamese, and the voice-over narration papered over storytelling gaps. In its determination to give American viewers a brief history of Western intervention in Vietnam (including France's blundering), the film leaned hard on expository dialogue.

And yet, remarkably, *Heaven & Earth* carries itself with a heft normally afforded only to films with Anglo casts, balancing viciousness and compassion. Le Ly is separated from her family, humiliated, imprisoned, tortured, beaten, raped, and made to prostitute herself to feed her children; even when she escapes to America, hell still follows her. It turns out that her would-be savior, Steve, is a murderous man-child who can't live without war. He implodes in withdrawal, spiraling into psychosis and menacing Le Ly and their kids. Still, she gets through it, by meditating, channeling the experiences of her relatives, and following the teachings of the Buddha. No American filmmaker had ever tried to present such a philosophical, peaceful response to war, imperialism, and cruelty, and few male directors of Stone's stature have made movies so visibly overcome with sorrow for the evil that men do. "I am insulted at the insolence of men," Le Ly says. "They don't respect women. I cannot believe such men have known a mother's love."

Critical reaction was indifferent. At least some of this might have stemmed from the tendency to misrepresent the heroine's point of view—that of a middle-aged writer looking back on a difficult life through the lens of Buddhist teachings—as passive. But time has been kind to *Heaven & Earth*. It is one of Stone's most confounding and surprising films, and certainly his warmest, even as it makes room for satiric jabs at postwar American gluttony and shallowness, conveyed through shots of tacky suburban homes and featureless strip malls standing in for paradise, and of canned and frozen foods unveiled by Steve's sister as if they were the grandest of feasts.

Heaven **&** **Earth** **came out two years after** **JFK,** **Stone's second-biggest commercial success** **and a multiple Oscar nominee[7]; a true labor of** **love, its box office failure blunted the momentum that** **Stone's conspiracy thriller had managed to generate.** *Natural Born Killers*, Stone's ultraviolent satire about mass-murdering sweethearts, restored some of that luster and landed on a number of ten-best lists, though there were points when he must have wondered if the agitation was

worth it. Loosely based on a screenplay by Quentin Tarantino, whose drawer full of unproduced scripts became hot properties after his 1992 directorial debut, *Reservoir Dogs*, the film prompted battles with the ratings board and Stone's releasing studio, Warner Bros., over content and "tone," and it became the centerpiece of a lawsuit accusing it of inspiring copycat murders.

Even Stone's ardent defenders were troubled by the film, which seemed to represent an about-face from his earlier tendency to treat violence as something to be scrutinized, acknowledged as awful spectacle, but not glamorized. *NBK*'s brutality was hyperbolic, at times knowingly ridiculous: The opening bloodbath in the diner, where Mickey and Mallory Knox (Woody Harrelson and Juliette Lewis) kill three people whose only sin is being present, includes shots from the points of view of a pistol barrel and a Buck Knife flipping end over end, and the visuals only get wilder from there. The nonlinear edits placed in service of exposition in *JFK* are deployed here to purely disorienting ends. Stone's rear-screen projections, Robert Richardson's array of film stocks and heat-lamp gels, and lead editor Hank Corwin's madcap juxtapositions fuse to create a vortex of sound and light. The film itself seems unmoored not just from commercial storytelling conventions, but from reason. It is the only film directed by Stone about which one can reasonably ask if he is indulging in shock for shock's sake. The answer is yes. *NBK*'s audiovisual barrage is a satire on the nineties mainstreaming of tabloid sensibilities, an indictment of individual narcissism and ambition and an anarchist's spray-painted screed against the corruption and stupidity of modern media, justice and life itself.

The film is not coherent; Mickey tacitly admits as much when he tells Wayne, "Killing you and what you represent is a statement. . . . I'm not a hundred percent sure exactly what it's about." But considering *NBK*'s formal daring and the connections it draws between personal and national pathology, its very essence is unstable. Parts of it are the closest the director has come to making abstract art, and it might capture the experience of listening to music while stoned better than any other Stone picture, *The Doors* included. And if you can stomach repeat viewings, it can seem as compassionate, in its counterintuitive way, as *Heaven & Earth*. Mickey and Mallory are abusers and abuse survivors, the plague and the cure, nature and nurture, human beings and animals, natural born killers just like everybody else. ("You

(below) Still-frames from *Natural Born Killers* (1994): Mickey and Mallory turn a roadside diner into a crime scene.
(following spread) Still-frame from *JFK*: an assassin takes aim at the president's motorcade from behind a fence on the grassy knoll in Dealey Plaza, Dallas, Texas, on November 22, 1963.

can't hide from your shadow," Mickey says.) They are cackling bullies, but their love for each other is real. The jailhouse visitation scene set to Bob Dylan's "You Belong to Me," which cuts between Mickey and Mallory and other couples separated by the state, suggests what *Midnight Express* might have looked like if Stone had directed it. It is possible to hold contradictory thoughts in your head at the same time; *NBK*, more than any Hollywood film of the nineties, demands it.

1 This section is narrated by Martin Sheen, who played JFK in the 1983 miniseries of the same name (and seven years later would play a Kennedy-like liberal president on *The West Wing*). For viewers of a certain age who associated Sheen with the president, it was as if Kennedy himself were speaking from beyond the grave, like Hamlet's uncle, and entreating the viewer to solve his slaying.

2 In *JFK*, Stone singles out Kennedy's National Security Action Memo 273 as a smoking gun, proving that the president thought the war was a potential quagmire and wanted out. After the film's release, John M. Newman's book *JFK and Vietnam: Deception, Intrigue, and the Struggle for Power* (New York: Warner Books, 1992) changed historians' perception that Kennedy never intended to withdraw from Vietnam—that, indeed, it was not a matter of whether to do it, but when and how. In a 2003 article published in the *Boston Review*, James K. Galbraith wrote that a phased withdrawal from Vietnam would have been "part of a larger strategy, of a sequence that included the Laos and Berlin settlements in 1961, the non-invasion of Cuba in 1962, the Test Ban Treaty in 1963. Kennedy subordinated the timing of these events to politics: He was quite prepared to leave soldiers in harm's way until after his own reelection. His larger goal after that was to settle the Cold War, without either victory or defeat—a strategic vision laid out in JFK's commencement speech at American University on June 10, 1963."

3 Thomas Oliphant, editorial, *Boston Globe*, December 30, 1991.

4 Screenwriter David Franzoni adapted Shilts's book in 1991, and it was set to go before cameras in summer 1992, with Robin Williams playing Harvey Milk, who was assassinated, along with San Francisco mayor George Moscone, by Dan White, a city councilman who had resigned but wanted his job back.

5 *JFK* became one of Stone's highest-grossing theatrical release (over seventy million dollars) alongside *Platoon*, *Born on the Fourth of July*, *World Trade Center*, and *Any Given Sunday*, and was nominated for eight Oscars. It won for Best Film Editing and Best Cinematography, though not for Best Picture, Best Director, Best Adapted Screenplay, Best Supporting Actor, Best Sound Editing, or Best Original Score.

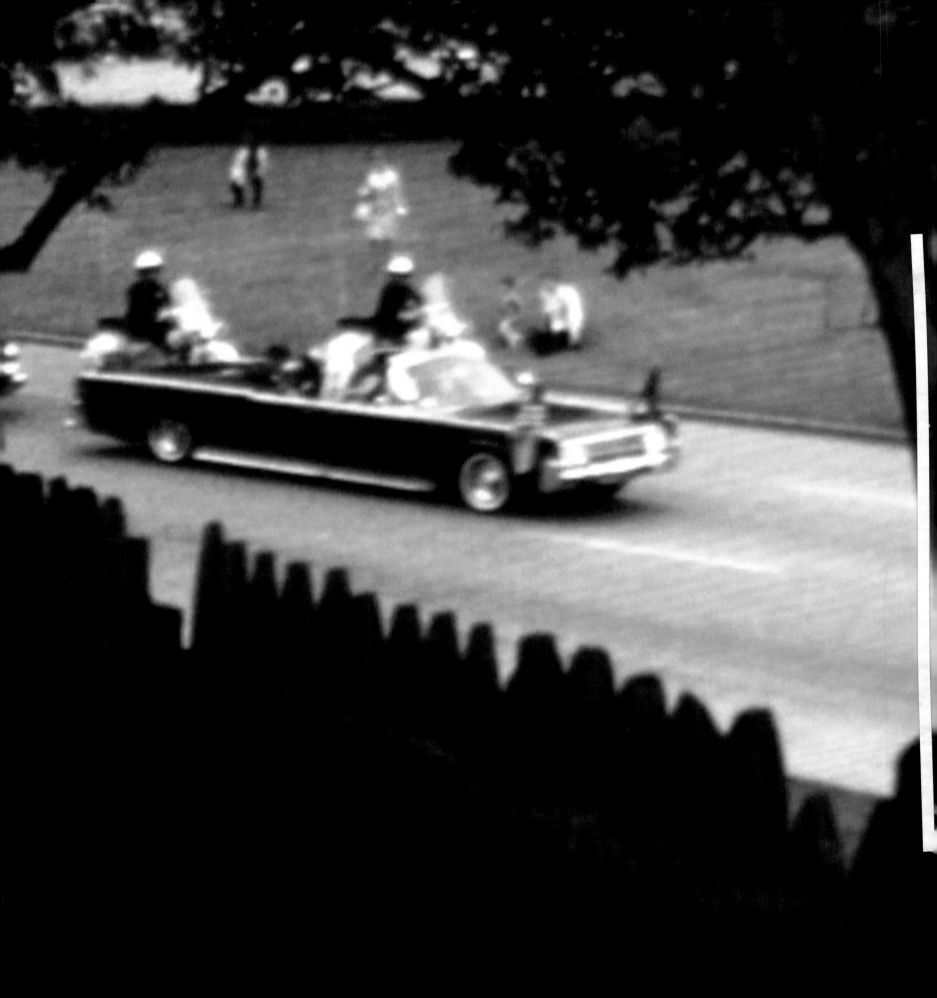

The Dallas Morning

Texas' Leading Newspaper © 1991, The Dallas Morning News Dallas, Texas, Monday, April 15, 1991

Lights, camera ... delays

Downtown prepares for disruptions as filming of 'JFK' movie begins today

By Al Brumley
Staff Writer of The Dallas Morning News

James Jones points toward the picket fence above the grassy knoll and laughs a knowing laugh.

■ Street closings map. **9A**

town where the shooting occurred. They are unofficial tour guides for people curious about the event.

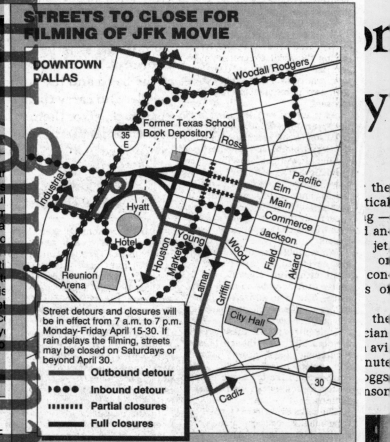

STREETS TO CLOSE FOR FILMING OF JFK MOVIE

DOWNTOWN DALLAS

Former Texas School Book Depository

Street detours and closures will be in effect from 7 a.m. to 7 p.m. Monday-Friday April 15-30. If rain delays the filming, streets may be closed on Saturdays or beyond April 30.

— Outbound detour
◖◖◖◖ Inbound detour
||||||| Partial closures
— Full closures

The Dallas Morning News

ring rescues save the rainy d

DALLAS WARY OF ROLLING STONE

As Academy Award-winning director Oliver Stone prepares to shoot his movie on the assassination of John F. Kennedy, some fear it may again cause America to see Dallas as "The City of Hate."

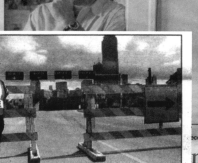

Police officer Jessie Williams braces Tuesday for the onslaught.

ive
ead
icer

incident
ry behind

Rose
AFF

once spotted
ruins of Grand
Wax was shot
morning by an

become the nation's chief film chronicler of the 1960s.

Mark Graham/Dallas Times Herald

memories with film

Page A-19
tic David Kronke
Page G-1

nd even after
s, some people
ply troubling.
said, boils down

the Nov. 22,
uch of America
d "The City of
ight-wingers so
words of busi-

ness leader Stanley Marcus, they made "John Birchers look like raving liberals."

Now, as Stone prepares to kick off five weeks of local shooting Monday on the movie tentatively titled "JFK," some fear that the specter of Dallas' supposed responsibility — the idea that the city fostered a climate conducive to the murder of a liberal-minded chief executive — could be raised once more on celluloid.

Please see **STONE, A-19**

3 women's memories surface at JFK assassination filming

By Mark Potok
OF THE TIMES HERALD STAFF

Anne Adams was standing on the motorcade route, a small child throwing confetti at the Democratic president her Republican parents pulled her out of school to see.

Jacqueline Edwards was waiting at the Trade Mart, one of dozens of waitresses who were to serve the presidential party lunch after the parade.

cult to explain as director Oliver Stone's film crew re-enacted the assassination during its second day of filming.

"I just wanted to see how they portrayed it," said Anne Adams, 35, as she stood with her family near the Old Red Courthouse, where hundreds of Dallas residents and tourists gathered to gaze at the motorcade of classic 1960s cars and a film star or two.

"The likeness is amazing."

Mark Williams/Dallas Times Herald

Soggy resid
hope dry fo
will wring t

By Mede Nix
OF THE TIMES HERALD STAFF

Flood-weary residents across N
stood a third day of heavy thunde
with hope for clearing skies today.

On the heels of massive stor
heavy rains and spawned tornad
County, another thunderstorm sy
ahead of a cold front Saturday m
as much as 5 inches of rain in the

The torrential down-
pours led to more than 50
water rescues from auto-
mobiles and one by boat
by Dallas firefighters, but
others decided to engineer their ow
Robert Darby leaped from a D
up to an underpass at South Cen
after he saw a car drive into flood
come submerged. Darby swam to
Sue Cozine of Pleasant Grove, and
said a witness, Marie Hernandez.

"He didn't wait a second," said
man was so courageous. He could
then

Firefighters used a boat to rescu
who lives on Alcalde Street in Ea
flooding made many streets impr
morning, fire department spokes
Garcia said.

At Prestige Ford at LBJ Free
Road, owner Randall Reed said/du
flooding, employees rescued mo
cars trapped in front of the dealers

"It started raining real hard an
hit the 3-foot mark," Reed sai
driving through and got stuck in
hoods.

Sales manager Rusty Gates we
water to bring out the occupants
another employee was sent out
drive vehicle.

"There were some kids and so
the cars who didn't see the wate
high enough that cars were floatin
them out, we brought them in and
chocolate and Prestige Ford T-shir
out. I got a few people here

The dealership lost about 30 car
last year, and Reed said the past tw

Please se

■ Tor
Vista.
■ Dal
motori

Disruptions expected as movie f

Continued from Page 1A.

from two blocks away.
the western portion of down-
Dallas, Mr. Stone's movie soon
e causing similar daily disrup-

From the closing of key tho-
fares to the refinishing of his-
buildings, Mr. Stone has had
d will continue to have — his
with Dallas for the next two
s.

ost business owners and city
als say they don't mind the in-
enience. Not everyone, how-
, welcomes the film company
open arms.

Well, no, I don't like it, but I
there's nothing I can do about
r. Jones said. "On a good day, I
make $25 to $40 out here. But I'll
out. I got a few people here
l help me out."

y traffic officials hope motor-
ill help each other by using al-
te routes into and out of down-
during the two weeks of film-

ginning Monday and lasting
April 30, the triple underpass,
all other streets and freeway
points will be closed week-
rom 7 a.m. and 7 p.m.

Dallas' upscale topless
put new face on old bus

By Scott Baradell
OF THE TIMES HERALD STAFF

In a time of recession, it's the

stage by women f
been for ages. But
upscale trappings, a
an air of legitimacy

The Arts

JFK movie may use at least five sniper sites

© 1991, The Dallas Morning News

Q. What might the film accomplish?

A. I think it would be great if it reopened the case, but I doubt that would happen because so much of the evidence has been destroyed, so many witnesses are dead.

Q. How have you incorporated the memories of people who were involved?

A. Every time I meet somebody else, I hear another version. . . . People come in here and lie a lot to me. Not so much in Dallas, more in New Orleans. . . . I take all my instincts through the years and I judge people. And those I believe I incorporate into the story, and those I don't, I don't.

The Dallas Morning News: Milton Hinnant

School Book Depository site for the Oliver Stone film about the John F. Kennedy assassination. Filming begins Monday.

Utility workers Cotton Bailey and Nick Pesiha work above Elm Street on Friday as they remove a street light at the Texas

THE MYSTERY BECOMES THE MOVIE

JFK

Director Oliver Stone tells why he tackled the big story of his time

In a rare interview during film production — just a week before shooting was to begin on JFK in Dealey Plaza — Oscar-winning director Oliver Stone talked to staff writer Jane Sumner about his decision to take on a subject, the John F. Kennedy assassination, that has consumed researchers for almost 28 years.

Q: The Kennedy assassination is probably the most mythical event of our time. Why did you take on a project of such magnitude and complexity?

A: I suppose it combines the mythic with the whodunit. For me, it was the seminal event of my generation. It shaped the '60s because Kennedy was my godfather. He

INTERVIEW

came into office, and he promised change. He was about to deliver it when he was cut down.

As a result of that murder, it's my belief that Vietnam came about. If Kennedy had been in office, Vietnam would not have happened. And as you know, I was swept up into Vietnam, as were many other people. It shaped America as it is today.

In addition to Vietnam, we had in the wake of his death an enormous amount of crime and violence. We had race riots and wars and the hippie protest movement in reaction to the war. We had rebellion all around the world in the '60s — in Czechoslovakia and France.

In reaction, then, we had almost the repression of the '50s return. In a sense, '68 led to Nixon and to his elec-

Please see STONE on Page 8C.

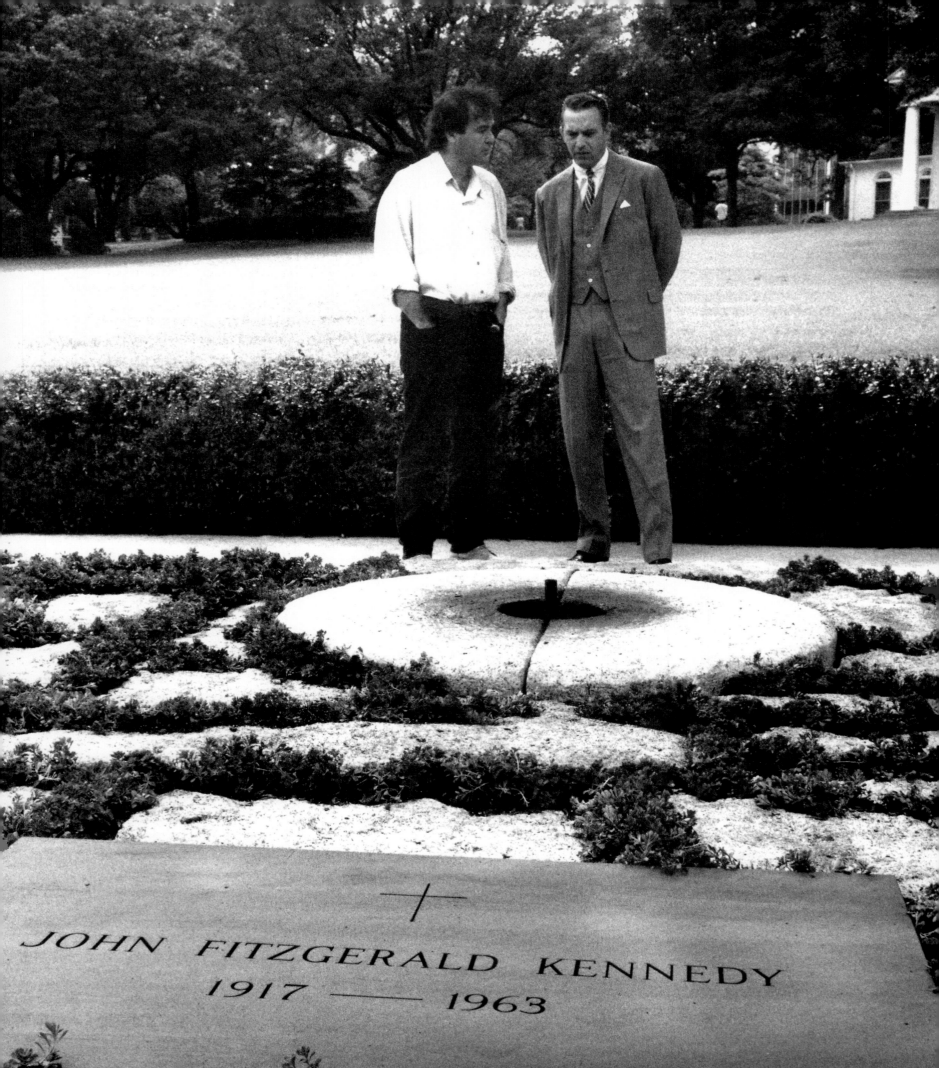

MATT ZOLLER SEITZ Tell me about Jim Garrison, the New Orleans district attorney who tried to prove a criminal conspiracy to assassinate President John F. Kennedy.[1] You made him the hero of *JFK*, but that choice didn't sit right with some people. A lot of people thought he was a crank. A lot of them still do. Why him?

OLIVER STONE I read Jim Garrison's book *On the Trail of the Assassins* in '89 when I was in the Philippines making *Born on the Fourth of July*. I'd been offered a lot

You have to understand that we know now—we didn't know then—the CIA went after Garrison with everything it had. They took him very seriously and they bugged his offices, stole his files, and had informers all over his place. If you look at the film, it's pretty accurate, actually! I got a lot of criticism for making Garrison the hero, but in the second act, you see how weak Garrison's case is! He knows his case is very thin.

Several witnesses died or disappeared, or folded when pressure was brought on their

of the benefit of the doubt. It seemed like the entire point of Carson having him on there was to set him up in order to knock him down.

There was so much worse than that—anything to make him look like a kook. And we know much more about it because of the things that have come out since the movie: The Assassination Records Review Board lasted

We know now the CIA went after Garrison with everything it had.

of things, but when I read this, I thought it was a hell of a thriller. I thought, *Here is an official crime that happens, we show it conventionally at the beginning, and a bit like in Z,[2] we go and peel it back.* The prosecutor goes after the guys the investigation points him to, but finds out there are fascist thugs working for the government. He peels back the onion and finds some government element is deeply involved in this murder. He brings the cases—and of course, at the end, they're all destroyed because the government lets everybody go and destroys the case. Garrison started that case and he was destroyed, but he's the only public official who went there. And he should not be derided. Garrison should be lionized as a guy who challenged the official version of the assassination that said Lee Harvey Oswald acted alone, brought into the public light so much we did not know, including the [Abraham] Zapruder film **[END 1]**. Garrison was talking about this in the book, and he saw the big picture. He goes out in the ocean, he catches a big fish, but by the time he gets back to shore, the sharks have eaten it.

You have to rethink Garrison in light of how difficult it is to bring a case against covert branches of a government operation. Can you imagine trying to be the district attorney of New Orleans, and hanging in there on a rocky ride? There are odd parallels here to the character of Edward Snowden, who in recent times saw and revealed too much and was chased out of the country for it.

testimony. Most of his witnesses had street records and were tough people. Garrison lost David Ferrie, he lost Eladio [del Valle] and [William Guy] Banister, to death—those three all died under mysterious circumstances, including Banister.[3] None of his subpoenas were honored, which was rare for a DA of that stature. He'd always had cooperation of other states in bringing these subpoenas. Additionally, the subpoenas on Allen Dulles and the CIA characters were all denied. There was no help for Garrison, except for his small, loyal staff and the drop-ins who besieged his office. He was attacked broadly by local and national press, especially by an NBC special report in which the CIA was heavily involved. Richard Helms, later the director, ran the case on Garrison. And then there was Johnny Carson.

I just watched the entirety of Jim Garrison's appearance on *The Tonight Show Starring Johnny Carson* on YouTube. To me it seemed a textbook example of how consensus is enforced by the media in this country, but in a very subtle way [END 2].

It's subtle and benign.

Johnny Carson, in that particular appearance, presents it as a case of simply trying to be even-handed. But what you have here is a guy, Jim Garrison, who is beleaguered, presenting clearly a minority opinion at a time that's very hostile to anybody who's trying to do that. Watching it now, we may feel he should have been given more

1 District attorney of Orleans Parish, Louisiana, from 1962 to 1973; in late 1966 he began an investigation into the John F. Kennedy assassination, which resulted in the arrest and trial of a New Orleans businessman, Clay Shaw, who was acquitted by the jury; wrote three books on the assassination: *A Heritage of Stone* (1970), a fictional account called *The Star Spangled Contract* (1976), and the bestselling *On the Trail of the Assassins* (1988).

2 1969 political thriller cowritten and directed by Costa-Gavras; thinly fictionalized account of the events surrounding the assassination of the Greek politician Grigoris Lambrakis in 1963.

3 David Ferrie, Eladio del Valle, and William Guy Bannister are the three men Stone is referencing. David Ferrie was an American pilot who, Garrison alleged, knew Lee Harvey Oswald and was one of the main conspirators in the Kennedy assassination. Right after Garrison's investigation was announced, Ferrie was found dead in his apartment, an apparent suicide, though the pathologist later ruled that Ferrie died of a cerebral hemorrhage due to an aneurysm. Eladio del Valle, a Cuban congressman and supporter of the Cuban dictator Fulgencio Batista, went into exile right before Fidel Castro took power. Del Valle was active with the Free Cuba committee in Florida and, Garrison claimed, was a friend of Ferrie's. Garrison wanted to interview him about Clay Shaw but could not find him. Del Valle was murdered on February 22, 1967—apparently only hours after Ferrie died—in what was determined to be an extended torture session. William Guy Banister was a retired FBI agent and a private detective in New Orleans who did work with Ferrie and whose office was in the same building as del Valle's and other militant anti-Castro groups. On the afternoon of the assassination, Banister argued with one of his investigators, Jack Martin, and injured him. Martin then started accusing his boss of having played a role in the assassination, along with Ferrie. By the time Garrison learned about him, however, Banister had died, in June 1964, of coronary thrombosis.

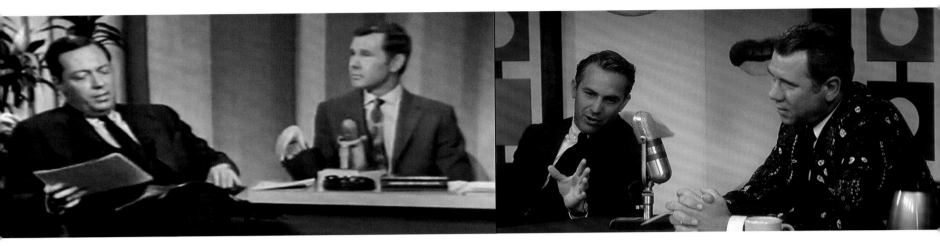

Suppose and *might* were very important words.

till 1998, and although they didn't make conclusions, there are six million pages.

When I looked at the movie again, what struck me was that the weaknesses of Garrison's case were very clear. He had a case, he had witnesses, he had that much that we'd shown, but he was ultimately diminished and defeated. We show the ridiculousness, and the press turning on him—it's not like we hid anything at the trial, is my point.

I think what's solid about the movie and really holds up, to me, is the hard evidence. The best evidence in this case is the Zapruder film, the shooting sequence, and the forensics, the botched autopsy, and what happened at Parkland Hospital, where the president was taken after the shooting. If you really look at this, just put on your Sherlock Holmes cap, and see how you can fire three shots from this cheap bolt-action weapon, this Mannlicher-Carcano,[4] in less than six seconds, out of that sixth-floor window, through a tree, at a moving target—it's just physically impossible. Every combat infantryman would know that, and the FBI tried! That's what was so nutty— they couldn't do it! Two teams tried it. CBS did a special—nobody could match that rifle without some kind of cheating [END 3]!

One of the things that struck me when re-viewing the film recently is that you got a lot of flak for presenting a scenario or scenarios that were supposed to be interpreted as some kind of verifiable, objective truth. And yet when you watch the film, it seems to me it's very carefully coded, almost to the point of footnoting it. When you suddenly go into this feverish envisioning of what

may have happened, you are pretty clearly in the consciousness of Jim Garrison. It's not meant to be an objective truth, a pseudo-documentary representation of reality. Somebody starts to talk to Garrison, and then we cut to an envisioning of how things may have happened.

Suppose and *might* were very important words.

"Let's just for a moment speculate, shall we?" That's what Garrison says at the start of one flashback sequence, and it sort of sums up the movie.

The movie holds up for me. As a dramatist I would have a little issue with a few scenes, because I think they were clunky.

What scenes?

I wasn't happy with the Bill Boxley scene—I think I was trying to cram too much into that scene when he turns.[5] Because the picture was three hours and nine minutes,[6] I was trying to do a lot fast. And Sissy Spacek [as Liz Garrison]—I like her early scenes, but I think after the Robert Kennedy scene when he tries to connect with her, it was a little rushed. As a dramatist, those bother me. And the scene on the porch with his kids: the son, Jasper— who's played by my son, Sean—is over-sentimentalized. I think the courtroom stuff and the early stuff, all the buildup to the first act through the intermission, is terrific.

There should've been an intermission after the Donald Sutherland[7] scene, though, because it was all too much to take in two hours into a three-hour film. And then, in the

very next scene, rushed into the Clay Shaw arrest. You don't have a chance to breathe, and I put one in the DVD.

Did you know there were originally two scenes with X, Donald Sutherland's character, one in the middle and one at the end, a wrap-up? When we edited it, and we were rushing the edit, too, to make it to December, I thought, *It's not working*. So we combined the two scenes and put it in the middle, and I don't remember what I exactly did, we dubbed some lines and stitched two different scenes together. It was a complicated re-edit, but it had to be done and I think we succeeded. It was never intended to be so long, but we were blessed by the speed of Donald Sutherland's delivery.

The style of the film was radical for you, technically, rhythmically radical for you; radical, period. The photography of the film, by Robert

4 The Warren Commission and others since then concluded that Lee Harvey Oswald fired all the shots at President Kennedy using a World War II–era 6.5 mm Carcano Model 91/38 Italian carbine that he purchased via mail order earlier in 1963.

5 In the film, one of Garrison's investigators, Bill Boxley, is renamed Bill Broussard. Played by Michael Rooker, he tends to counter Garrison and his team on every one of their assertions, and it's implied that he may be working with the federal government to undermine his boss.

6 This is the theatrical running time; for home video, Stone assembled a director's cut that runs 206 minutes (3 hours 26 minutes).

7 1935– ; one of the greatest voices in movie history, as well as one of the most reassuring faces, even when playing disturbed or disturbing characters; *Don't Look Now* (1973), *Invasion of the Body Snatchers* (1978), *Ordinary People* (1980), *Six Degrees of Separation* (1993), the *Hunger Games* franchise (2012–2015); father of Kiefer.

(below) *JFK* cinematographer Robert Richardson on location in Dealey Plaza in Dallas, Texas.

(right) From Stone's extensive handwritten notes on the writing and production of *JFK*: "Dawson . . . one. Black & white experiment . . . evokes memory rewind—tos [Military acronym for 'terminate on sight'] . . . can anyone's . . . 2. title end tos—

OLIVER STONE

Richardson, and the editing, by Joe Hutshing[8] and Pietro Scalia[9] and Hank Corwin,[10] were huge, huge deals. Even people who had political or moral or journalistic issues with the movie had to admit it was innovative technically.

That's true.

You had started going down this road a little bit in *Born on the Fourth of July*, with those jagged flashbacks of Kovic in Vietnam, and you went a little further with it in *The Doors*, but this was a pretty incredible flowering of a new style for you. It took trends in editing that had been building up in different international cinemas for a couple of decades, with directors like Alain Resnais and Sam Peckinpah and Bob Fosse and Nicolas Roeg, and the true-crime shows on TV, and music videos, and it put them in service of speculative fiction. And then the next few films you made after this one felt like attempts to refine this language.

Did you go into this movie thinking you needed a different kind of film language to tell this story? Or a refinement of existing language?

No. It's funny, people say that—that it was innovative, we were doing new things, this was something new. But we didn't set out to be innovative. There was no theory behind any of this. It was a response to the demands of the story. There were a lot of characters, a lot of plot, a lot of information to get across to the audience without confusing them, but we also had to make a film of reasonable length so it could play in theaters. So yes, I did take the lessons I learned on this film later on, and I tried to do other things with it. But I have to stress, we didn't set out to invent or reinvent anything. It was a response to realizing you couldn't do flashbacks in a traditional way with a story like this, because if you did . . .

The film would be twelve hours long?

Well, six! So Garrison talks about this person or that event, we cut to it while he's still talking, we go back and forth while he's talking. And you're compacting it all. I'm grateful for any compliments people pay to

the style, but it started as a practical solution to a storytelling problem wherein word and image are too often in conflict.

It was a neo-*Rashomon* approach.[11] You don't know what the truth is. It's all shaky. You have this murder that's official, we see it at the beginning. We don't show you the hit

8 1957– ; editor on *Talk Radio* (1988), *Born on the Fourth of July* (1989; with David Brenner), *The Doors* (1991; with Brenner), *W.* (2008), and *Savages* (2012).

9 1960– ; editor on *JFK* (1991), *The Quick and the Dead* (1995), *Gladiator* (2000), and *The Martian* (2015), among others.

10 Editor on *Natural Born Killers* (1995), *Nixon* (1995), *U-Turn* (1997), *The New World* (2005), *The Tree of Life* (2011), and *The Big Short* (2015); credited "additional editor" on *JFK*.

11 Famous, widely acclaimed 1950 Japanese film directed by Akira Kurosawa in which a group of characters provide varying perspectives on the same incident, the murder of a samurai and the rape of his wife.

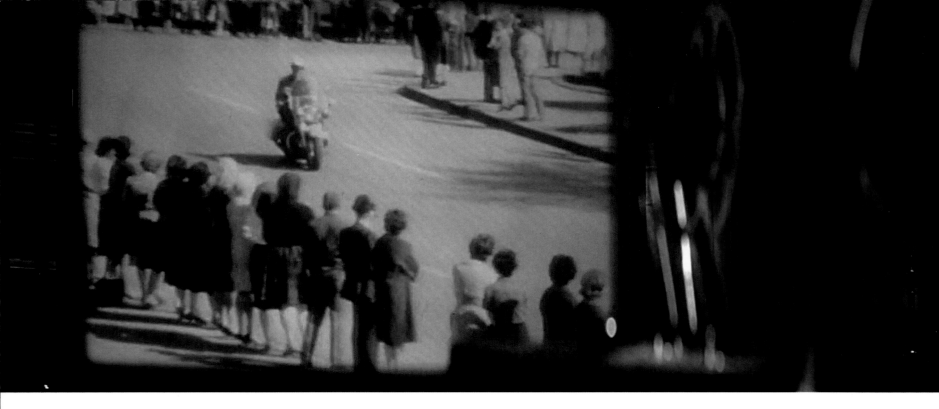

on Kennedy, because the Zapruder film wasn't public at the time. He just drives, then you see the pigeons and hear the shots, and Walter Cronkite is on the CBS News special report telling you what happened. The pigeons are sadly poetic, but nobody knew what happened in the immediate period that followed, and everyone bought the story, including me and Garrison. And then Garrison calls in flight instructor David Ferrie, and then the case is thrown out—and that's a big interesting thing, that the FBI makes a special announcement to blame that on Garrison.

You're talking about *Rashomon*, but the film that *JFK*'s editing most reminds me of is another Akira Kurosawa film, *High and Low*,¹² specifically the scene where the policemen are telling the lead investigator what they've learned about the kidnapping. The cops come forward, and you hear

them reporting on what they did out in the field, and then Kurosawa cuts to a visual representation of what they did, but their dialogue continues to play out over the flashbacks, in what I like to call "stealth voice-over." So the movie is giving you the present tense and the flashback at the same time, doing hard cuts between past and present, very quickly. It's telling but also showing. That was very ahead of its time, that style. It's basically taking the innovative flash cuts in Alain Resnais's *Hiroshima mon amour*¹³ from a couple of years earlier and applying them to a crime drama.

You do that same kind of thing in *JFK*, but you take it to the next level; it's almost like you're folding and refolding a samurai sword, there's so much going on in these sequences. You've got people delivering a lot of verbal information, in the old-fashioned way, and at the same time you've got these very intricate, very quickly edited—for 1991—flashbacks.

Yes, but there's one very important difference between the editing in *High and Low* and the editing in *JFK*: Sometimes the "stealth narration," as you call it, matches up with the action, but other times the images you see directly contradict official testimony.

12 1963 Japanese police procedural directed by Akira Kurosawa in which a botched kidnapping affects the lives of a wealthy businessman (Toshiro Mifune) and the police detective (Tatsuya Nakadai) investigating the crime.

13 Stylistically influential 1959 French drama directed by Alain Resnais and written by Marguerite Duras, told in a highly elliptical style; follows a pair of lovers, a French actress (Emmanuelle Riva) and a Japanese architect (Eiji Okada), as they wander through post–World War II Tokyo and reflect on the recent past.

The most powerful part of the film was the back-and-to-the-left sequence. And frankly, having talked to Bob Groden,[14] and Gary Aguilar,[15] a physicist who's rebutted Vincent Bugliosi[16]—Bugliosi's the single biggest hack on the defense of the Oswald theory; he cannot, will not, debate Groden or Aguilar—and Josiah Thompson, who wrote *Six Seconds*,[17] it's never changed, even with the House Select Committee.

Kennedy. You can see in the film that Connally's still holding his Stetson. He's not taken the same shot as Kennedy at that point, there's a separation. Then Connally takes a separate shot, probably from the rear, or from the back, OK? So Kennedy gets hit, Connally gets hit. That's at least three shots right there.

Then you have this fourth shot, which is the big hit from the front—it's really the fifth

in Dealey Plaza, where are you going to kill the president? If you're going to shoot him out of a sixth-floor window, you'd better shoot him as he comes up the street toward you, because if it's just one gunman, you can get two shots, maybe three shots off, and by then maybe the car has gone around the bend and moved away from you—and you're shooting through the branches of a tree. A tree that, by the way, was immediately cut down after the murder!

Imagine you have two teams in the back, you have a good angle from the Dal-Tex Building,[21] and a real shot from the sixth floor—now you need a third position, but a triangulated ambush zone as it was taught in

We didn't set out to be innovative. There was no theory behind any of this.

That shot in the Zapruder film: Look at the results. Look at the film as it exists. You cannot make a case for a single shooter because there are five shots at least, and probably six. And then there's the throat shot. It's a frontal shot, the first one that hits him, and you see him do this (*mimes the famous movement with his hands*). The second shot is in his back. It goes through his back, out his throat, hits Connally's left wrist, bounces off his knee, and out comes this pristine bullet—you know, that one bullet that supposedly passed through seven wounds, wounding both Kennedy and Connally. We won't even go into the pristine bullet. It's the path of the bullet that bothers me, because it just doesn't make sense.

I remember seeing two things that purported to prove the lone-bullet theory. One was a computer simulation of a body in spasm: Being shot and then turning around in a car could've resulted in those trajectories, with the bullet passing through Connally's wrist and so forth. The point being that such a thing might have been unlikely, but it was not impossible.

I'm not going to argue with that, but I can also show you a computer simulation of an elephant hanging off a cliff![18]

The other thing was the notion of that particular shot—the back-and-to-the-left shot that you deconstruct in the film—not necessarily being proof positive of a second shooter, because that neurological spasm of the bullet's impact could've forced his head to jerk in that way. I gather you think this a case where the obvious explanation is the correct one?

Yes. Combat common sense.

In that amount of time, there's no way Connally takes the hit at the same time as

shot because there was a guy down at the overpass who got hit, James Tague.[19] There are also many people who believe there was a sixth shot because that was the one that missed completely. There was a backfire that Kennedy heard, you see Kennedy turning to a backfire—that's depicted in the film, I don't remember exactly the sequencing.

You see people panicking, and backfire before the shooting.

The kill shot comes after Connally does his reaction. I talked to Connally, who himself told me it wasn't that way—he said he wasn't hit by the same bullet, and he was there. The kill shot—which is maybe the fifth or the sixth shot, when you see Kennedy blowing back and to the left, and the scalp blows out—the issue is the back of his head.

That becomes a huge issue, because when you get hit from the front, the maximum impact is out the back of your head. We have numerous eyewitnesses at Parkland, including Dr. [Robert] McClelland,[20] who said, when they were trying to save Kennedy's life and doing the tracheotomy, apparently the bullet went through his throat, it was a soft wound. There were two bullet holes in the bone in the pictures that I've seen, so that indicates the exit of that. They're trying to save his life with a tracheotomy, and the guy was there for eighteen minutes, he said, and he was staring down at Kennedy: right at the head, the whole cerebellum had gone out! Most of it had disappeared out of his skull! It had been blasted! So the brains pour out this way! He repeated this. There were twenty-five to thirty witnesses at Parkland Hospital who attest to this massive exit wound.

That is a fucking basic shot from the front, and that's the kill shot! If you stand there

14 American photo technician and major critic of the Warren Commission who has written or cowritten numerous books on JFK conspiracy theories.

15 Ophthalmologist specializing in plastic and reconstructive surgery who was permitted by the Kennedy family to examine autopsy and other medical evidence related to the JFK assassination.

16 Best known during his eight years in the Los Angeles County district attorney's office for prosecuting the serial killer Charles Manson; Bugliosi's many books include *Reclaiming History* (2007), which analyzes the events surrounding the Kennedy assassination and supports the official lone-gunman theory implicating Lee Harvey Oswald.

17 In *Six Seconds in Dallas: A Micro-Study of the Kennedy Assassination* (1967), private investigator Josiah Thompson argues that there was a conspiracy involving three gunmen at separate locations.

18 Stone is paraphrasing a line Garrison says in the film: "The FBI says they can prove it through physics in a nuclear laboratory. Of course they can prove it. Theoretical physics can also prove that an elephant can hang off a cliff with its tail tied to a daisy! But use your eyes, your common sense."

19 Was driving to downtown Dallas to have lunch with a friend when a traffic jam caused by the presidential motorcade stopped his car. Stepping out to investigate, he heard, and was slightly injured, by the shots that killed Kennedy.

20 One of the physicians attending to Kennedy at Parkland Memorial Hospital; stood at the head of the gurney and witnessed the full scope of the president's head wound, which convinced him that the fatal bullet had to have come from somewhere in front of the president.

21 Seven-story office building on the northeast corner of Elm and North Houston Streets in downtown Dallas, across the street from the Texas Book Depository.

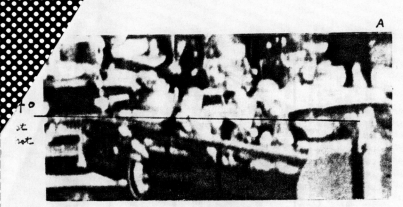

A

B

Z-188 1/18 sec before back throat shot
Shot by Oswald on front steps of TSBD with .38
After bullet transited struck front windshield near
rear view mirror. 21 yards

C

D

+21°

2nd
shot

Z-238 Connally shot
Shot at about 200ft from TSBD 6th floor

E

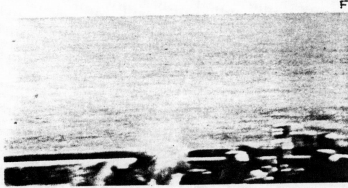

F

Z 312 Shot at 265ft from TSBD 6th floor

Z 313 Fatal Head Shot - Greer
Copyright March '89

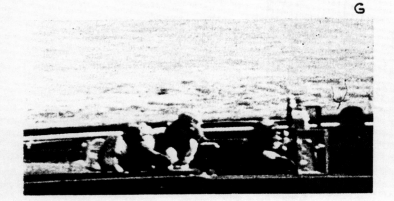

G

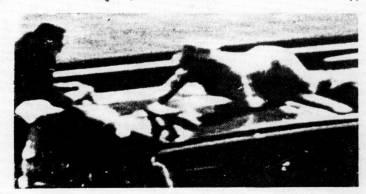

H

Z 332

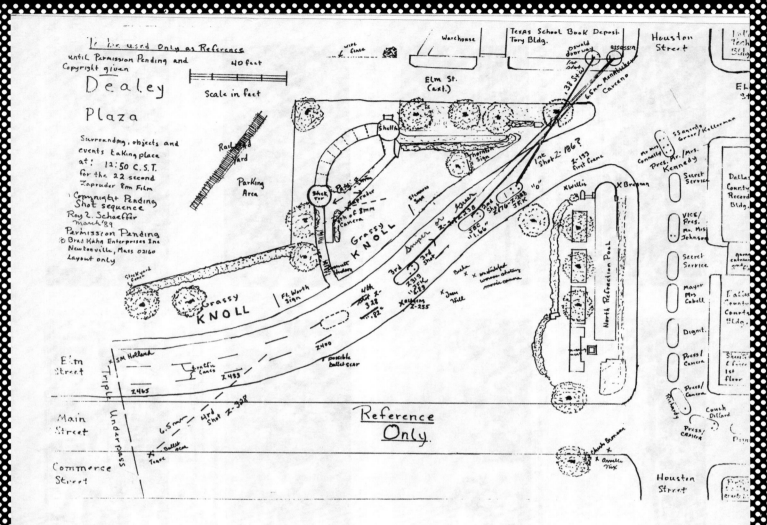

REMEMBER WHOSE OFFICE THIS WAS IN '63?
A study in flashback cinema, *JFK*-style

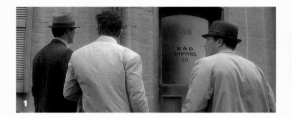 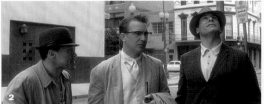 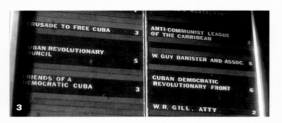

Garrison takes his men on a tour **(1)** of New Orleans locations he believes are significant in building the case for conspiracy. "Remember whose office this was in '63?" he says **(2)**, as they stand in front of a particular building. "Sure," replies Lou Ivon, one of Garrison's men. "Guy Banister. Ex-FBI man. Died a couple of years ago." **(3)**

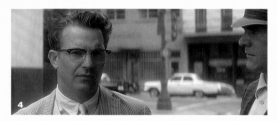

The camera slowly pushes in to Garrison's face, **(4)** signifying (in a quite old-fashioned way, for such an innovatively edited movie) that we're about to enter the hero's mind. The film then cuts quickly between shots of Garrison and his team and a shot of Banister in the past, **(5)** emerging from the same door the heroes are regarding in the present. Garrison talks about his history with Banister. **(6)** Garrison: "Banister headed the Chicago office. When he retired, he became a private eye here. I used to have lunch with him. John Birch Society, Minutemen. Slightly to the right of Attila the Hun. He used to recruit college students to infiltrate radical organizations on campus. Headed the Anti-Communist League of the Caribbean. All out of this office. Come around here, I want to show you something."

 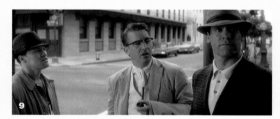

Garrison: "See that? Now take a look here. 544 Camp Street. **(7)** 532 Lafayette Street. **(8)** Same building, right? But with different addresses and different entrances. Both going to the offices upstairs. Guess who used this address? Lee Harvey Oswald." **(9)**

 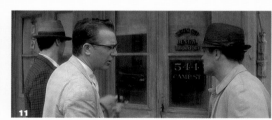

Next we see a slow-motion close-up of Lee Harvey Oswald **(10)** exiting the building. The scene switches between Garrison **(11)** telling what he knows about Oswald's history in New Orleans and newsreel-type images **(12, 13)** visualizing his

words. "Now, how do we know he was here? Because this office address was stamped **(14)** on the pro-Castro leaflets he was handing out in the summer of '63 down on Canal Street. Now, these are the same leaflets they found in his garage in Dallas." "What's this?" Banister demands in the speculative flashback, **(15)** dialogue that might be what Garrison hears in his own head or what one of the men imagines Banister saying as they hear Garrison talk. "What the hell is this doing on this piece of paper?" Garrison: "After the arrest, 544 Camp Street never appeared on the pamphlets again." Banister growls at Oswald, "Asshole."

We return to the present. **(16)** "[Oswald] was arrested that day for fighting with some anti-Castro Cubans," Garrison says. Then we go back to the past, **(17)** with black-and-white and color newsreel-type images showing Oswald scuffling on the street with Cubans who object to his handing out the leaflets, then being arrested. "But actually he had contacted them a few days earlier as an ex-marine trying to join their anti-Castro crusade," Garrison clarifies. "When they heard he was now pro-Castro, they paid him a visit." The flashback sequence includes a brief shot of Clay Shaw, **(18)** the New Orleans businessman who will prove central to Garrison's case, even though Garrison's narration never mentions Shaw, a touch that adds one more layer of paranoia to an already unsettling sequence.

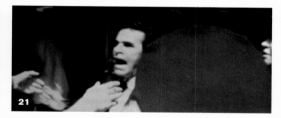

"What is this Fidel shit?" an angry Cuban man in horn-rimmed glasses tells Oswald in the "newsreel" images. "You lied to me, you hypocrite! This is Communist propaganda, you piece of shit! Liar, son of a bitch! People, do not take this paper, this is Communist propaganda!" The man's rant is accompanied by a brief, rather mysterious close-up **(19)** of a man in sunglasses whose relationship to Oswald and his attacker is unknown—yet another layer of menace. "If you want to hit me, hit me," Oswald says. "You pinko shit!" the man in the horn-rimmed glasses **(20)** shouts at Oswald. "Go back to Moscow! Communist!" "There was no real fight," Garrison tells his men in voice-over, "and the arresting lieutenant later said he felt it was a staged incident." **(21)**

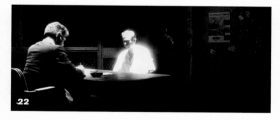

"In jail, Oswald has a special session with agent John Quigley of the FBI," Garrison continues over shots of Oswald in jail, haloed from above by a shaft of harsh white light. **(22)** "Oswald is released, and Quigley destroys his notes from the interview. **(23)** The arrest gets him a lot of publicity, and as a result, Oswald appears on a local TV debate." The sequence cuts to a black-and-white static shot of Oswald debating the Cuban situation with the same man who was seen shoving him in the "leaflets" flashback. **(24)** As Oswald protests that the man is not a Communist but a "Marxist-Leninist," he identifies his TV opponent as "Mr. Bringuier." "You are not a Communist, but you are a Marxist-Leninist? What is the difference?" Bringuier challenges Oswald.

> JIM (OVER CONT)
> of them think they're policemen with rifles

109.E. EXT. TEXAS BOOK DEPOSITORY -DAY (1963) 109.E

Houston Street POV up at the Sixth Floor SHOOTERS moving around.

ARNOLD ROWLAND pointing out the shooter to his WIFE.

> ARNOLD (under)
> ...probably a security agent.

109.F. INT. JAIL CELL - DALLAS COUNTY JAIL - SIXTH FLOOR (1963) 109.F.

JOHNNY POWELL is one of many convicts housed on the sixth floor -- the same height. The POV *
across to the Texas Depository is seen through cell bars. He and various CELLMATES are watching
TWO MEN in the sixth floor of the Depository.

> JIM (OVER)
> John Powell, a prisoner on the sixth floor of the Dallas County Jail, *
> *also* sees them.

> POWELL (UNDER)
> ...quite a few of us saw them. Everybody was hollering and yelling
> and all that. We thought it was security guys...

> JIM (OVER) *
> ...they don't shoot him coming up Houston, which is the easiest for
> a single shooter in the Book Depository, but they wait 'till he gets to
> the killing zone between three rifles. Kennedy makes the final turn
> from Houston onto Elm, slowing down to some 11mph.

All the SHOOTERS all across the two positions tightening, taking aim. A tense moment. 109.G

> JIM (OVER, dramatic)
> ...~~all~~ the shooters ~~all~~ across Dealey Plaza tighten, taking their aim
> across their top-grade telescopic sights...waiting for the radio to say
> "Green Green!" or "Abort Abort!"

 109.H

109.H. MONTAGE:

On KENNEDY waving. A MONTAGE follows -- all the faces in the SQUARE that we've
introduced in the movie now appear one after the other -- watching, the killers, the man with the
umbrella, the Newman family, Mary Moorman photographing, Jean Hill, Abraham Zapruder
filming it, Gordon Arnold filming it, Beverly Oliver, S. M. Holland, Patrolman Harkness...

INTERCUT with the ZAPRUDER & NIX films on JFK in the final seconds, coming *
abreast of the Stemmons Freeway sign.

> JIM (OVER)
> ~~The scenario was one bullet in the back of the head and you and I~~
> ~~wouldn't be here.~~ The first shot rings out.

109.J. FLASH -- the SIXTH FLOOR SHOOTER fires. 109.J

109B. EXT. COURTS BUILDING - DAY (1963) **109B**

> JIM (OVER)
> A second shooter, B team, one rifleman with a headset, with access
> to the building, moves into a high floor or rooftop of the Criminal
> ~~Courts Building -- a beautiful long shot down Elm, the wind is your~~
> ~~only enemy.~~ This man is probably calling all the shots on a radio to
> the two other teams. He has the best overall view -- the "God" spot. ∧
> *there*

A COP, Sheriff's Department, is already in place. Alone, with a take-down weapon with
scope, he's white, redneck-looking, a hunter. His POV down Elm Street.

109C. EXT. PICKET FENCE - DAY 1963 **109C**

 *

TWO PICKET FENCE SHOOTERS with a TWO SPOTTERS move around, one of them
in a Dallas police uniform, climbing on the fender of a vehicle, aiming up Elm.
His SPOTTER has a radio to his ear. The OTHER MAN in a secret service suit moves
further down the fence with his spotter.

> JIM (OVER) *and*
> The third team, the C team, moves in behind the picket fence above
> the Grassy Knoll, where the two shooters, two spotters are first
> seen by the late Lee Bowers in the Watch Tower of the Railyard.
> ~~They're wearing a combination of police uniforms, workclothes,~~
> ~~and suits -- just like secret service men.~~ They have the best position
> of all. Kennedy is close and on a flat low trajectory. ~~They don't~~
> ~~need scopes; iron sights are better at this range...~~ Part of this team is
> a coordinator who's flashed security credentials at several people
> chasing them out of the parking lot area.

An "AGENT" in tie and suit moving on the UNDERPASS, keeping an eye out

109.D. EXT. ELM STREET CROWD - DAY (1963) **109.D***

 *

Brief glimpses of the UMBRELLA MAN and the CUBAN in the CROWD, neither of them
watching Kennedy, both looking around to their teams. There is a THIRD MAN, heavyset, in a
construction helmet.

> JIM (OVER)
> ...Probably two to three more men are down in the crowd on Elm, ~~the~~
> ~~Cuban and the Umbrella Man.~~ Ten to twelve men...three teams, four
> shooters. The triangulation of fire Clay Shaw and David Ferrie
> discussed two months before. They've walked the Plaza, they know
> every inch. They've calibrated their sights, practiced on moving
> targets, ~~they've all performed foreign assassinations before.~~ They're
> ready. It's going to be a turkey shoot. Kennedy's motorcade makes
> the turn from Main onto Houston.

JFK waves and turns -- SLOW MO

> JIM (OVER) *...Six witnesses*
> ...~~witnesses~~ Caroline Walther, Arnold Rowland, Richard Carr,
> Ronald Fischer, Ruby Henderson and Norman Similas ~~all~~ see two
> gunmen on the 6th floor of the Depository, moving around. Some

PIGEONS, seen once again, fly off the ROOFTOP of the BOOK DEPOSITORY. 109.T

110. INT. COURTROOM - DAY (1969) SC.110

> JIM
> What happens then? Pandemonium. The shooters quickly disassemble
> their various weapons, all except the Oswald rifle.

110.A. FLASH -- SIXTH FLOOR SPOTTER dumping the Mannlicher-Carcano in a 110.A.
corner as he leaves.

110B. FLASH -- The ROOFTOP SHOOTER stays at his position, a cop on duty. 110.B

110C. FLASH -- the SPOTTERS with the FENCE SHOOTERS quickly break down their 110.C*
weapons, throwing them in the trunk of a car parked at the fence. They walk away.

110D. FLASH -- the UMBRELLA MAN and the CUBAN sit quietly together on the 110.D
north side of the curb of Elm.

110E. FLASH -- PEOPLE, stunned, confused, some lying on the ground, some running 110.E
for the Grassy Knoll.

111. INT. COURTROOM - DAY (1969) SC.111

PATROLMAN JOE SMITH is on the stand.

> JIM (OVER)
> Patrolman Joe Smith rushed into the parking lot behind the fence.
> He smelled gunpowder.

FLASHBACK TO:
111.A. EXT. PICKET FENCE - DAY (1963) 111.A*

His gun drawn, SMITH rushes across a MAN standing by a car who reacts quickly, producing
credentials. He is one of the HOBOS. A strange moment between Smith's eyes and the man's *
fingernails.

> SMITH (OVER)
> ...the character produces credentials from his pocket which showed
> him to be Secret Service. So I accepted that and let him go and
> continued our search. But I regretted it, 'cause this guy looked like
> an auto mechanic. He had on a sports shirt and pants, but he had
> dirty fingernails. Afterwards it didn't ring true, but at the time we
> were so pressed for time.

> JIM (OVER)
> Yet, all Secret Servicemen in Dallas that day are accounted for. None
> were on foot before or after, till Forrest Sorrels returned at 12:50.

 TIME CUT TO:

112 SC.112
RESEARCHER on stand with a blowup of the MOORMAN PHOTOGRAPH. He uses a pointer.

109.K. FLASH -- HIS POV -- through the sight on the back of Kennedy's head (stand-in) Kennedy reacts in the ZAPRUDER film.

 109.K

> JIM (OVER)
> But strange as it seems, it misses completely. The ammunition in the mannlicher is old and unreliable. The cheap cartridge possibly splitting in two, sounding like a backfire... ricochets off James Tague's cheek at the underpass...

109L. FLASH -- JAMES TAGUE at the underpass, bloodied, startled...

 109.L
 *

Everything goes off very fast now. REPEATING INTERCUTS slowed down with KENNEDY reacting in the Zapruder film.

 *

> JIM (OVER)
> ...the second shot hits Kennedy in the throat from the front. Here he raises his arms to his throat.

109M. FLASH -- the 1st FENCE SHOOTER hitting him from the Fence. His POV-JFK (stand-in) in the man's telescopic sight. JFK clutches his throat in the ZAPRUDER film

 109.M

> JIM
> ...the third shot hits him in the back, drawing him downward and forward.

109N. FLASH -- the SHOOTER on the COURTS ROOFTOP firing -- his POV on Kennedy, hitting Connally (stand-in). The ZAPRUDER film slowed.

 109.N

 *

> JIM
> ...the fourth shot from the 6th floor, misses Kennedy and takes Connally in the back. He is hit, yells out, "my God, they're going to kill us all"... Here...

109P. FLASH -- THE SIXTH FLOOR SHOOTER firing rapidly --

 109.P

> JIM
> ...the umbrella man is signalling, he's not dead. Keep shooting.

109Q. FLASHES -- the UMBRELLA MAN is pumping his umbrella. The CUBAN is looking off. The man on the curb in the construction helmet is looking not at JFK but up at the Book Depository.

 109.Q

> JIM
> ... the fifth and fatal shot takes Kennedy in the head from the front...

109R. FLASH -- the 2nd FENCE SHOOTER -- his POV -- firing -- JFK from the ZAPRUDER film flying backwards and to his left in a ferocious, conclusive spray of blood and brain tissue. The car speeding off. Jackie a crawling animal in a pillbox hat on the back of the car speeding off.

 109R*

THE PEOPLE on the other side of the UNDERPASS waving innocently as the Car speeds through with it's horrifying contents.

 109.S

Vietnam. So you need the kill position at the fence in front, the so-called grassy knoll. In a triangle like this, you've got two shots from the rear and side and you've got the third shot from the front. The key is, the guy at the fence cannot miss. I think there probably was a fourth shooter behind the overpass in case the car got through that kill zone.

The fact that the fence shooter hit Kennedy in the throat first shows us that he was aiming right from the beginning. He almost got him there. The throat wound is pretty serious; I mean, [to figure out who fired the shot], as Walter Matthau's[22] character Senator Long says in the movie, I'd round up the hundred best sharpshooters in the world and see who was in Dallas that day. It's good shooting—you have to have good shooting, and here we see the guy from the front get him right off with the throat shot and then finish him off with the kill shot to the head. Back and to the left.

And what's Jackie chasing? She's chasing a piece of brain out the back, because that's where it goes. There was something that came out and she was looking for it—there was something visual that blew out. There were too many doctors who saw this.

Now, they take the body illegally to Washington, DC, four hours on the airplane,

they don't do the autopsy right away. I don't think they did it until eight o'clock that night. All these details have been written, but the autopsy photos have always been weird. They patched up the back of the head—how did that happen? They're photographing this and presenting this as evidence! Like that's all the proof you need!

And as you know, the autopsy is dominated by military officers. Kennedy, as we showed, is stripped naked in front of his enemies, in a sense, cut up like that. But they're telling the doctors what not to look for: *Don't go too far in the throat, or the exit wound in his back*, etc. It was just a manufactured autopsy that was questioned by many eyewitnesses there, including two FBI men who say the photos that the Warren Commission issued did not resemble what they saw with their own eyes! The truth is, there were too many eyewitnesses who were honest.

Why is it so hard for people to believe that a conspiracy like the one depicted in your film could be possible?

Most people do believe that there were two shooters.

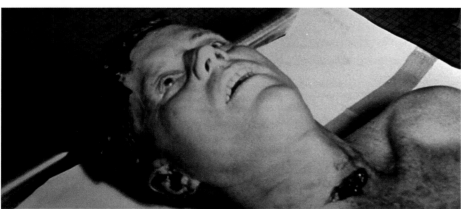

I think a lot of people believe that something happened that day, other than what the official story claims. But what I'd like to know is, why do you think people are so unwilling to go as dark as you did in considering the implications of these scenarios, with fascistic elements in our own government and industry killing a president, when it happens in other countries all the time? There's always been reluctance to think of it as a coup d'état on American soil. Why?

There were too many eyewitnesses who were honest.

Well that's why we went back into the history in *Untold History*, which I think is important. Chapter 6 of *Untold History*, "JFK: To the Brink," does not go into the assassination. We make it very clear: We're not going back and beating a dead horse—we think we did our job in 1991. Well, we did, and *Untold History* is giving you motivation and context for the assassination. We're showing you that there was an old man in office, Dwight Eisenhower, who'd built up a giant military security beast from 1947 and 1960. The thirteen-year span between the last year of Harry Truman's first term and the two terms by Eisenhower.

Here's this young "punk," all his chiefs of staff are older men, World War II veterans—they distrust Kennedy. Nixon was supposed to be president. And then Kennedy decides he won't go into Laos; he makes peace in Berlin—figuring, as he put it, that a wall is better than a war—and after the Cuban Missile Crisis of '62, he talks peace with the Russians, and he starts to rethink Vietnam.

After his death, we head into the Johnson era, and what Johnson does right away is go back in the direction of Eisenhower: complete national security state; intervention in Third World countries including Brazil in '64; Indonesia in '65—the destabilization of Indonesia is a major coup that nobody talks about. That is the most successful CIA operation ever and nobody can know about it, but they're very proud of it. McGeorge Bundy[23]

22 1920–2000; *A Face in the Crowd* (1977), *The Fortune Cookie* (1966), *The Odd Couple* (1967), *The Taking of Pelham One Two Three* (1975), *Grumpy Old Men* (1993).

23 National security adviser to presidents John F. Kennedy and Lyndon B. Johnson, from 1961 through 1965.

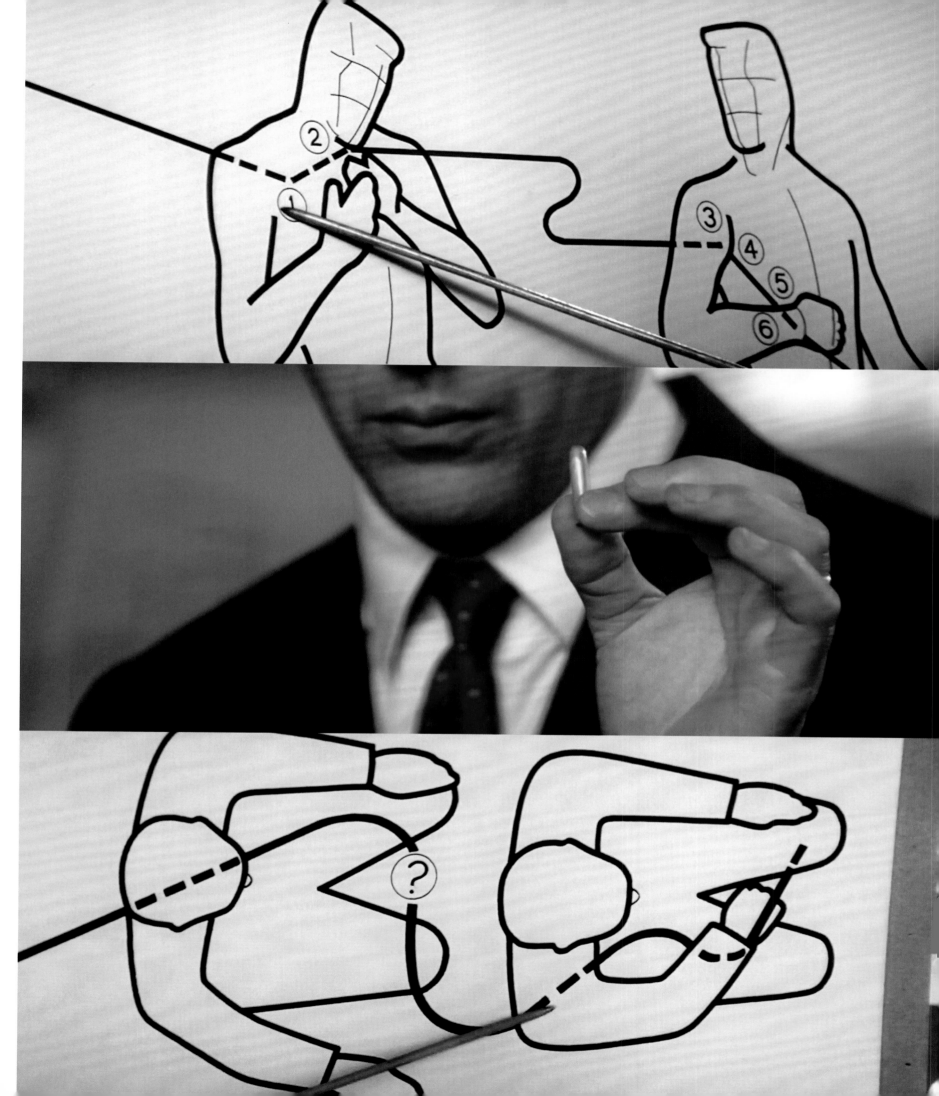

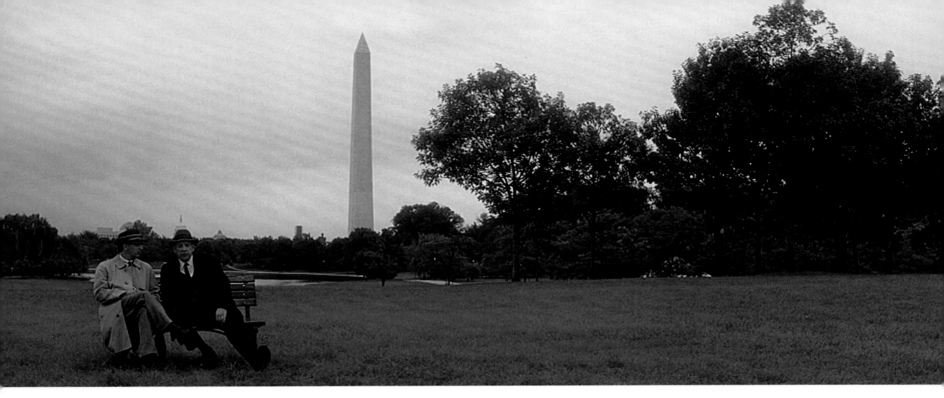

himself, who's a smart guy, says, *I never understood why we pushed into Vietnam when we had Indonesia, it was the richest area in that region. We had the goods. Vietnam was much less wealthy.*

But they pushed into Vietnam.

Why did they push into Vietnam?

I think it's because it was a step-by-step process. Eisenhower had sent the first ones, but he did that to support the French. But Eisenhower was not around in '65 when Johnson started to make the big moves, sending in combat troops eventually numbering over 500,000.

Kennedy, in contrast, issued an order in 1963 to withdraw American troops from Vietnam when there were only about 15,000 of them. That was a big issue, much bigger than people remember now. What Kennedy did in Vietnam was resist sending combat troops. He sent noncombatant advisers. He did not send troops into Laos, as was requested by the Pentagon. And he resisted the kind of big moves that Johnson made in Vietnam.

Obviously there were other issues for Kennedy besides Vietnam. There was the Bay of Pigs and the embarassing aftermath of that, and from many documents we know the Pentagon wanted to invade Cuba [END 4]. We had a huge crisis in Berlin, in Germany; as you know, we had supported an independent West Germany ever since '47, '48—there were tremendous problems there, and we almost had a nuclear war at the end of 1961 over the Berlin Wall [END 5]. Kennedy famously allowed that it wasn't a very nice solution, but a wall is a hell of a lot better than a war. People don't remember, but it was *that* close.

We had a huge, huge nuclear superiority over the Soviet Union. The idea was *hit them now, and they can't retaliate that badly. We're not going to lose that many people*. It's

Dr. Strangelove [END 6]. They had meetings about this stuff. Kennedy would walk out and say, in essence, *I'm disgusted . . . these people are not talking about human beings, they're talking about the Soviets as the implacable enemy who must be destroyed now, not later.*

Somewhat in *Platoon*, definitely in *Born on the Fourth of July*, and absolutely in *JFK* and *Nixon*, I see you evolving this unifying theory of US history being built around war, a war machine, a war industry, that that is our primary export. Is that fair to say?

I think money, capitalism, is the primary driver of our society, and obviously these weapons bring a lot of money in. We reached a place where war became dominant, and now we're certainly in that place where it revolves around money.

Eisenhower went further than you think. Eisenhower, who had been against the bomb, but over that '47 to '52 period, believed more and more in the bomb. In fact, he thought the bomb should be a first-use weapon. Eisenhower, in fact, threatened North Korea with nukes. He called this "The Madman Theory."

You can only threaten to use a weapon like that if nobody else has one.

That's why Nixon, once he became president, without Eisenhower around, thought the madman theory worked—he convinced the other side you could be barbaric.

But we dropped atomic bombs on Hiroshima and Nagasaki when we didn't have to. We dropped the bombs without a blink and congratulated ourselves for winning the war! The world got the message that the United States was capable of the greatest barbarism of all. As we see from what we did in Korea, what we did with the napalming, plus Vietnam, the world knew by the 1960s that the US was capable of doing anything without remorse.

So this movie is not solely a representation of Jim Garrison's case, it's also about another subject that's of great interest to you: the American

The idea was *hit them now, and they can't retaliate that badly. We're not going to lose that many people. It's Dr. Strangelove.*

war machine and how it dictates the course of our history. To that end, you're bringing in a lot of other elements besides just Garrison's case. You've got the speculations of the sensibilities of one of your advisers on the film, [Leroy] Fletcher Prouty—aka Mr. X, Donald Sutherland's character[24]—and we've previously discussed how you brought in the Mafia and the Cubans, which doesn't strictly come from Garrison, it comes from a lot of other sources.

24 Leroy Fletcher Prouty served as chief of special operations for the Joint Chiefs of Staff under President Kennedy. He had considerable inside knowledge of US foreign policy, was a critic of the CIA, and believed that the Kennedy assassination was a CIA coup d'état against presidential interference after the Bay of Pigs failure, aided by elements in the military. Prouty was the inspiration for Garrison's informant, Mr. X, played in *JFK* by Donald Sutherland.

I think money, capitalism, is the primary driver of our society

It was a hodgepodge, yes. I didn't feel limited by Garrison's book, even though he was an adviser.

It's important to realize that the *Strangelove* scenario is born in the aftermath of World War II, when we had the bomb and the Soviets didn't. Eisenhower loosened up the bomb. He loosened up that whole process, because he gave battlefield authority to initiate dropping the bomb, as well as sub-commanders. So that's where you can get these Jack D. Rippers.

So Ripper's based on a real thing—something that could have actually happened?

Of course! Look at what happened during the Missile Crisis in 1962 with General Thomas Power.[25]

Kennedy realized in the thirteen days of the Cuban Missile Crisis that he could no longer control the military, and he told that message to his brother [Attorney General Robert F. Kennedy], who told it to Soviet ambassador Anatoly Dobrynin, who told it to [Soviet Premier Nikita] Khrushchev. Kennedy and Khrushchev were not communicating effectively—they didn't have the hotline in those days. But he got through at the last second.

There were all these little hair-trigger incidents.

We built the bomb, so we thought: *We have such superiority, we can blow these motherfuckers off the face of the earth! They can't really hurt us! They may take out a few hundred thousand of us, but we're going to win!* That was the attitude. And the civilians didn't know what the fuck was going on, they're told the Soviets are trying to take over Cuba, offensive missiles.

I use Eisenhower's farewell speech at the beginning of *JFK*.[26]

This puts a frame around the entire story.

But it's a real statement of guilt from Eisenhower. Of remorse.

I interpreted it as Dr. Frankenstein telling everyone he created a monster.

But he seemed to feel bad about it! He left a psyops plan that called for the deaths of six hundred million people. Eisenhower, in some way, did not want to go to conventional war again, because he'd been through one, and he said famously that it was a shame they had to drop this weapon on the Japanese to end this war. In his gut he knew it was the wrong choice. All the five-star generals did, including [Douglas] MacArthur, who ended up loving the bomb, too. But Ike left in place a war

plan to basically avoid a conventional war. We'd go to a nuclear option very quickly.

It's fascinating to think of you preparing to make *JFK* in the late eighties—after eight years of Reagan and then Bush the elder. There were covert wars going on left and right. There were even hearings about them in 1987, Iran-Contra, and yet there was also this triumphal sensibility in the country, a sense that we could do no wrong, the specter of Vietnam had been defeated, and we were these jolly green giants walking the earth. How in the hell did you get up the gumption to make a movie like *JFK*, which is a critique of all that?

25 Thomas Sarsfield Power was commander in chief of the Strategic Air Command during the Cuban Missile Crisis, and a proponent of striking Soviet cities first should war break out. Powers is notorious for flouting the DEFCON system (short for Defense Readiness Condition), which prescribes five levels of readiness, and states of alert for the US military in times of crisis. DEFCON 5 indicates a normal state of peacetime readiness; DEFCON 1 is the most severe state, signaling maximum force readiness in the event of imminent nuclear war. On October 24, 1962, Power broadcast a notice of the military entering DEFCON 2 mode "in the clear," where the Soviets could hear it—an act that some interpreted as an attempt to intimidate the enemy.

26 Delivered January 17, 1961, Eisenhower's farewell speech warned, "We must guard against the acquisition of unwarranted influence, whether sought or unsought, by the military-industrial complex. The potential for the disastrous rise of misplaced power exists and will persist."

So — who was trying to **kill** who **first** —? Write and ask me!! the ~~true~~ untold story is gotowards to be released!!!?

Hello Oliver,

I don't know how much time I have left ——— I recently had a tail on me that was extremely covert.

Today, more than ten years after the shooting of Ronald Reagan, George Bush has finaly gotten his wish, to be President of the United States of America. I think a closer look should be taken to see if he got into office legitimately.

A few minutes into your movie "JFK" I began to relive a little of the grief I experienced those days immediately after the assassination.. I commend you for using your talent and resources to persue something that should have been persued sometime ago.

Sincerely,

A Concerned Citizen

I PRAY THIS MOVIE IS — RIGHT! We WERE AN ugly CITY in THAT TIME of '63. I Am STILL ASHAMED OF THAT ugliNESS AND REMAIN ANGRY AT SS WHO ACTED UPON THAT SICKNESS. I FIRMLY

I am unaware of your attitude, or knowledge, towards the subject of UFOs, therefore, please bear with me.

discovered something freeze framed that proves cons

Oliver

My 14 year old son has discovered something extrodinary on the original J.T.K assassination newsreel film. (the zapruder film) It is important to contact someone not connected with the government. If what, he has freeze framed, is indeed ~~test money bad the mrbirment~~ proves a conspiracy solved the case in 1968. By 1975, all these critics had enough money to print 10,000 copies of their own book using these photos. By 1980, they had the autopsy photos which showed the ~~sense~~ malicious destruction of Kennedy's head by the autopsists and the generals. At least 12 shots were fired in Dealey Plaza, and at least several hundred U.S. employees were involved in the coup. As I said in my letter, this treason leads to Israel's Last War. I've finished a draft on JFK's murder 20-25 pages text - that's how simple it is!

Was there also conspiracy at Pearl Harbor? My analytical mind said yes then, and says now, yes, yes, absolutely yes!

Did I have proof then? No. Do I have proof now? Due to a very strange occurance on Dec. 4, 1991 I firmly believe I do. Skeptical Mr. Stone? I don't blame you

Oliver, may the Angels of God guide you and guard you as you continue to pursue the truth.

I have interviewed a former CIA agent who claims he can locate the missing 18 minute gap on the White House tapes that reveals Nixon & Bush's role in the murder.

When JFK was shot, Lee Harvey Oswald was the Horrible Bad Man who was the lone assassin. He did it. He senselessly robbed us of our hero. There was no one else to

Now the big question is, where was George?

eginning in May of 1963, he supposedly spent every weekend into November n the state of Florida at some type of camp, training with others for articipation in what he referred to as an "assassination team" - extremely onfidential. Over the following months he phoned me a few times on the eekends saying that he was calling from Florida, and the background noises eard corresponded with what he told me.

I believe that the Mafia and/or Cuban emigrés who were rying to frame Oswald invited him to bring his rifle from rving under some pretext or other, possibly to practice arget-shooting. I believe it is a matter of record that he rought the rifle into Dallas wrapped in brown paper, and

South Bottom...

Fan letter:
RE: Martha Mitchell in "JF

Dear Mr. Stone,

I'm writing to you in regards to your movie of JFK. It was well made and brought back many memories. I would like to know why you never included Martha Mitchell or commented on her sudden death and her allegations of making public what she knew about JFK's assassination. I remember reading about a book she was writing with the help of her secretary concerning this revelation. What ever happened to all her information?

I'm sure she was murdered

coincidence!!!

Was our 10,000 day war with North Vietnam really designed to create a super drug market in the United States? Turn all of the returning GI's into users?

YOU ARE ON THE RIGHT TRACK.

Watching the film was a much more interesting way to learn about American History than listening to a teacher lecture or watching a thirty year old filmstrip.

clearly visible with the naked eye.

1-17-92

Dear Oliver, I have written the six key Representatives that I have spoke about introducing a bill to open the secret govt. files asking that they proceed. I saw you on Arsenio and heard you on NPR's Nat. Press Club.

"THE GREATEST PURVEYOR OF VIOLENCE IN THE WORLD TODAY."

12/21/91 MY FRIEND--OLIVER STONE,
THE SOLUTION TO THE MYSTERY LIES IN THE SHIP'S LOG OF THE USS IWO JIMA. USING THE FREEDOM OF INFORMAT-

I didn't think of it in those terms. I didn't see the whole pattern of how history was made until we made *Untold History*. I had done specific histories in my films, but at that time I didn't see the whole pattern that stretched from World War II onward. With *Untold History*, I wanted to go back to the 1940s, the decade when I was born, and ask, *Why are we acting like this constantly?* Progressivism came about a little bit slowly for me.

Circling back to Vietnam, yes, I got more enlightened when I returned to the United States, but it took my trips to Honduras, Guatemala, Salvador, and Nicaragua with Richard Boyle in 1984–85 to really start me down the road to realizing *We're doing it again!* I saw the soldiers in Honduras, kids with the same uniforms that I wore, men and women. It was terrible what we did in Guatemala, too, and in Salvador—death squads decimated the reform movements.

Is it fair to say that you didn't become politically radicalized until the mid- to late eighties?

That's correct, I voted for Reagan in 1980.

I never would've thought that!

But I voted for Carter in '76. The reform spirit was in the air after Watergate. There was the feeling that Carter was gonna change everything. But after he was in office for a couple of years, all of that turned south. Carter continued the Military-Industrial Complex policy.

Why did you believe that Reagan was a better alternative to Carter in 1980?

I thought he was the spirit of hope. Reagan had a good aura—he had harmony in his face,

OLIVER STONE

||

It's so bizarre, the reaction of the media and how they closed so quickly around their stories. It bothers me so deeply to this day.

||

he looked like a grandfather type. I didn't realize how bad, how brutal, and how disinvolved he could be!

Anyway, I voted for him and—listen, I learned late in life, but once I learned, I think I *learned*. I didn't see the system in its totality, historically, until 2008. It wasn't until then that I really started to understand who's running this place.

The movie made money. But the media, by and large, were not kind to you.

It's so bizarre, the reaction of the media and how they closed so quickly around their stories. It bothers me so deeply to this day. Seemingly intelligent people just dismiss the conspiracy people as a tribe of lunatics or theorists. And they all say the same thing:

Time has elapsed, history is showing Oswald did it alone. Have you ever read Robert Groden, or *JFK and the Unspeakable* by James Douglass, and the all-important Jim D'Eugenio's *Reclaiming Parkland*? There are some good books, some essential books, respectable books, that support a lot of what I'm saying, and there's a section of *Reclaiming Parkland*, thirteen pages, where he goes through *JFK* and concludes that a lot of it is essentially accurate, despite what was said about it at the time. Or have you looked at any of the Groden photographs? Not one of the writers supporting a lone gunman theory has taken the time to read a serious book questioning this consensus. Why? It's so bizarre to me. Instead they write about these bland books

that go on about this fallen president. And now, many of them start to admit that Kennedy was moving on Vietnam, and if he hadn't died, we never would've gotten so involved, and that he's much more than a tragic, young, flawed president.

As I've said to you, I didn't see the bigger picture until 2008–13. I don't call myself a historian. I call myself a dramatist trying to dramatize what the history professor Peter

O'Keefe and David Ferrie, and the shots of the orgy, made it look like evil homosexuals killed the president.

I think I countered the GLAAD argument. Those scenes were necessary. The point of them was to show that Clay Shaw was not the person he represented himself to be. Clay Shaw's being gay was the reason for his other name, Clay Bertrand.

What was it about Harvey Milk's story that spoke to you?

Come on! It has all the elements. Outsider, honest, trying to change the world, getting shot down by this crazy man, along with the mayor. It was just a heartbreaking story. I guess it had all the elements of an underdog film.

And that he was gay, again . . . it wouldn't have been *black, gay, a woman*. I see a character as a *person*. I don't see him as a movement. And I suppose that gets me into trouble.

I don't call myself a historian.
I call myself a **dramatist.**

Kuznick has been teaching. The media have a pro-America, triumphalist point of view, and the Cold War is very important in their doctrine, that we had to fight against Soviet aggression, that we had a containment policy that came out of a belief that we didn't need to go through another world war. The essential truth here is, the biggest risk of World War III was us: We'd built ourselves up. The greatest enemy we have is ourselves, and I say it in *Platoon*. I would not have said that it was that true about American history until now, but it's very clear to me after these last five years, the period of working on *Untold History*.

With *JFK*, do you think I went from being a hero for the war films to being a bad guy? Or a target?

I think so, to a degree. You wanted to make a film about Harvey Milk, and that fell apart, largely because of *JFK*. You were accused of being homophobic.

Right. I talked to Robin Williams about doing it, I saw him in San Francisco. He was very interested, very likeable. I thought he could do it. There was no script at that time. I wasn't working on the script but I was involved with the two men who made the film eventually, the two producers. They wanted me to direct. There was a drumbeat about being who I was, whether I should be able to direct the movie, or if it should be done by gay people. It's the same thing they always come up with: You have to be gay to do a gay movie, or Indian to do an Indian movie. It's a drumbeat.

The Gay and Lesbian Alliance Against Defamation? They came after you hard because of *JFK*. They said the scenes with Clay Shaw and Willie

What effect did the GLAAD protests have on the Milk movie?

With the Harvey Milk project, I had a producing deal at Warners with Arnon Milchan, and I wanted to make the Milk movie through that deal, and I got Terry [Semel][27] on board. But at a certain point, I decided to back out of the movie as a director, and I went to Gus Van Sant to direct it. I believe it was budgeted around fourteen million, which was low for the kind of movie they were talking about making, but remember, we're talking about a gay-themed film in 1992, when not many gay-themed films were being made at the studio level. It was an anomaly. Still is.

I said, *Gus, you can make this movie, you know?* Becky Johnston[28] had written the script and it was a decent script, I liked it. I don't remember exactly but I said, *You can do what you want with it, but you go, get this money and make the movie*. And Gus surprised me, because he went out and wrote a script that no one wanted to make at that time, something like *My Own Private Idaho*. I don't even know what it was about . . . it was so out of this planet that there was no way Terry would make the movie. It wasn't in the spirit of reality. And unfortunately, Gus wouldn't back down, and that ended my involvement with that.[29] But I believed in Gus and he could've done it with . . . well, I don't remember if Robin was still interested at that point, but it was certainly a doable movie.

But then I lost interest, and it went away. And years later they did it for the same amount of money, probably less, with Gus and Sean [Penn]! But it had a different script at that point.

You also got some flak for the way that *Midnight Express* danced around the relationship that Billy Hayes had with a fellow prisoner, Erich. What's left in the film is one scene in the steam room between him and another inmate, which seems like it's about to turn into sex but then doesn't.

We had a very tender scene that was cut down considerably by Columbia, because they wouldn't have allowed it to be more explicit at that time.

If it was such a problem, why didn't you cut the scene out entirely?

It's in there because we sensed there was a need for tenderness.

27 Chairman and chief executive officer (with Bob Daly) of Warner Bros. from 1981 to 1997.

28 Screenwriter; *Under the Cherry Moon* (1985), *The Prince of Tides* (1996), *Seven Years in Tibet* (1997).

29 In a November 12, 2008, *Willamette Week* profile of Gus Van Sant, the director said he was "fired" from the Stone project. "Van Sant was concerned that Stone's version would avoid the personal and stick to the political. 'It was about city politics without any flavor of the actual place. It was too boring,' he says about a script he didn't write, and that didn't show the lead character kissing his boyfriend until page 45. 'I wasn't a good stand-in for Oliver.' He added, 'I don't feel like I own Harvey Milk's story.'"

Then in 2004, you go and make *Alexander*. In light of the problems you've had with gay characters and gay sex in your movies, that's an interesting development.

Alexander was shit on, too! Though not for that reason.

I don't think I've done a very good job of communicating, Matt. I just don't get it. I don't get the art of communication.

I think you're better at it than you think you are.

I appreciate you saying it, but I don't know if it's true! I worry about being misunderstood again. All my life. I'm doing the best I can, but it's a heavy feeling, a miasma around you. Or else, are people really stupid? I wonder.

You feel *JFK* did you as much harm as good, then?

I never got a fair shake after *JFK* in terms of the movies. I think the rest of my movies were judged in the light of *JFK*.

They were. You became "Oliver Stone, conspiracy nut."

That hurts.

Well, it's true. That was the brush they tarred you with from that point on. But I wonder, do you think the main idea you were putting forth was that radical—that there are sinister forces at play behind the United States government?

Why does that bother people so much? Because it could be true that their government is a monster? That there's a malignancy in our military-industrial-security complex that has grown so much more immense now, with the George W. Bush administration?

And Obama.

Obama drank the Kool-Aid, man.

Should I leave the country? Should I give up? This is a new question in my life, because many battles have been fought and lost now, or they left me wounded. I just can't get anything out there clean.

When I went to the Academy Awards with *JFK*, we had eight nominations, but we only won two, both technical: cinematography and editing. It was really hard because I felt the pulse of the room when I was there, and I felt a sigh of relief when we didn't win Best

Picture. It was like, Thank God we have *The Silence of the Lambs* to rally around. That was an easy-to-digest horror film.

It's a sensationally effective film, but it's not doing what *JFK* is doing.

No. And then, *Heaven & Earth* was brutal, the reception, as you know, brutal, and it didn't do anything at the box office. And of course, it could be the subject matter, too, but I loved that movie.

Why did you want to tell the story of *Heaven & Earth*? You'd never told a woman's story before this point. At this stage of your career you were known, for a lot of reasons, as a very male sort of director.

I read the book by Le Ly Hayslip, which was very, very moving. Then she gave me the second book she'd written, which is not as moving but which was a continuation of the first story, and the scope of that story was everything I could want to say at that point in my life.[30]

Not that I remember every review, but I do remember Janet Maslin saying something in the *New York Times*. She was a very powerful influence at the time. She said that from the get-go this film was like an elephant wearing ballerina shoes or something, and that I

find the wife who's interesting, played by Caroline Kava,[31] who played the mother in *Born*! She's very good. *(Laughs)* [32]

You've talked to me about my sexist worldview: That is bizarre! I didn't think about it, but I know that I cared about women. It's not like I was a hard-ass. I know what a hard-ass guy can be. I know men who talk about women with other men in a certain way, and I try never to do that. I'm just not that type of person, and I was always trying, you know? Whatever they say about me, I was trying.

In *Midnight Express*, the hero had a girlfriend and cared about her. Maybe that's Alan Parker's domain, whether he did it or not, but the actress in that film, Irene Miracle,[33] became a bit of a sensation at that time. And in *Scarface*, of course, there's Michelle Pfeiffer's role, but it doesn't mean she's just a hooker: She's a classy call girl, and she's smart! She's a little lazy, but smart. And the other character in that film is the sister—that's a strange relationship between her and Tony, I agree, but it's a relationship that was there from the original,

Why does that bother people so much? Because it could be true that their government is a monster?

was a suspect person to tell this kind of a story [END 7].

With that kind of thing being written about you, how can you make your art, how can you make your life? You have to go your way, you know?

I made the film because I wanted to make the film. I had to go that way. I wanted to go that way.

You're very sensitive about that: the issue of how women are portrayed in your films.

Well, people have an impression of me from *Conan*, *Scarface*, *Midnight Express*, and *Year of the Dragon*, of having a male orientation. But even in *Dragon*, which is very male, you

and Mary Elizabeth Mastrantonio was lauded for her performance, as sensitive.

But it's not like I'm avoiding women, making men-only films. I like women!

30 The two memoirs are *When Heaven and Earth Changed Places: A Vietnamese Woman's Journey from War to Peace* (1989) and *Child of War, Woman of Peace* (1993). The former tells of Le Ly Hayslip's childhood in Vietnam; the latter describes Hayslip's experiences adjusting to life in the United States near the end of the Vietnam War.

31 *Heaven's Gate* (1980), *Little Nikita* (1988), *Snow Falling on Cedars* (1999), *Final* (2001).

32 Redacted.

33 American actress; *Last Stop on the Night Train* (1975), *La Portiera Nuda* (1976).

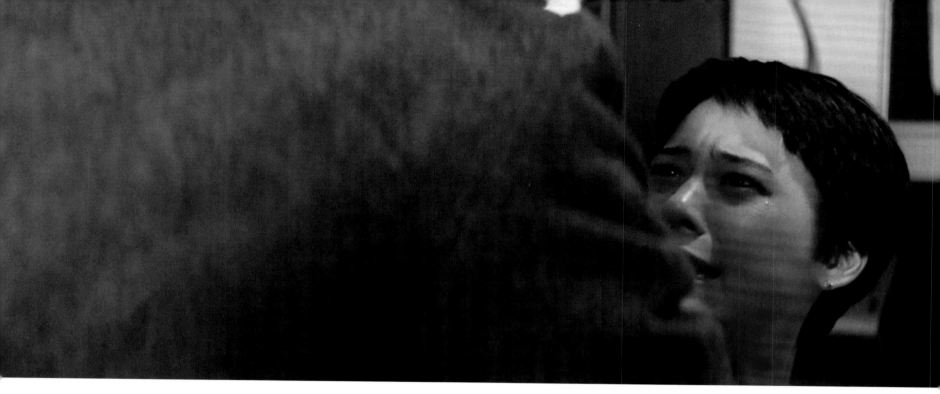

They're also fun to be around. It's also not only that, they're enlightening to be around, and they can also be a source of great love sometimes. But sometimes they can be destructive. Sometimes a mother can be corrupt. And that's an issue I've been wrestling with. At least I *hope* you sense that.

It's right there in your work, the idea of the mother and father pulling people apart psychically, sometimes literally.

It is there, and it's something that came to me through drama. I would never have gone there and thought that, but I realize now that's where my films have gone, and the screenplays have gone there, no? If you read my screenplay "Break" from back in 1969, the father is a strange character. You don't see him. He's in a painting, I think. And the mother is an extravagant woman, and there's no family life. It's like the hero is completely alone in the world. And that's the first screenplay I wrote.

So I think that mother-father thing is evident in my work from the beginning. *Alexander* is also a culmination of the mother-father thing. The screenplay I've been working on recently is about all that, and how these kinds of feelings about women get passed down from generation to generation.

In looking at your earlier films and looking at your later films, I've noticed a difference in how women are portrayed, and in how the relationships between men and women are portrayed. You've made more space for women in the second half of your career, and it seems to me that it started in a big way with *Heaven & Earth* in 1993. I wonder about the timing of that, and I wonder about how you feel about my saying that to you: if there's any validity to the idea that your women have deepened? And I wonder if, in hindsight, you think there might have been something

to the complaints early on in your career: that some of the characterizations were sexist, and that in general, you just didn't have much use for women in your films?

Well, in *Salvador*, if you remember, Elpidia Carrillo [34] did have a role, whether you liked the characterization or not; she had a huge role in that movie, because it was her character who brought Boyle around to some form of grace, right? He was trying to save her ass, and he was becoming something he was not; so she plays a crucial role. In *Platoon* there's no women because there were none, so it's a function of the movie. Then you go to *Wall Street*, also a very male world.

Sean Young [35] did not have a good experience on *Wall Street*, to put it mildly.

She was a handful for me. I made the original mistake—she would've been better in Daryl Hannah's [36] role. Daryl Hannah was not happy in that role, but she never did anything about it, never took a proactive role. She just projected unhappiness. Sean Young was after Daryl's part from day one, just saying, hinting, that she should do it instead of Daryl. She would've been very good for the sophisticated, young New York woman.

I see that in hindsight, but at the time, I hired Daryl because she was a fantasy. I like her in the movie, but she was resisting the whole time, torturing herself. She didn't want to be that role. She didn't want to be the woman in this modern age that was dependent on the super-mogul, which a lot of women still are. A lot of women in those social circles that travel are there to be noticed, to be married, to find a husband, to score. They look good, they're sexy. They're trophy wives. Feminist critics would get on that case and say, *He doesn't like women, blah blah blah,*

and it's crap! I mean, you're being realistic to what's going on!

So Sean did not have enough to do, and she was a very talented actress, but she made a pain in the ass out of herself for everybody. It was difficult. Charlie didn't like her, and there's some very funny stuff about that that you can probably read somewhere.

Well, I don't know about "funny." One time Charlie Sheen put a sign on her back that said "I am the biggest cunt in the world."

OK, well—you saw that stuff! And then there was the day that . . . man, there were so many problems. ███████████████████████ ███████████████████████████ ███████████████████████████ ███████████████████████████ ███████████████████████████ ███████████████████████████ ███████████████████████████ ███████████████████████████ █████████ [37] Could she have played Daryl's

34 1961– ; *The Border* (1980), *Predator* (1988), *My Family* (1995), *Solaris* (2002), *Mother and Child* (2010).

35 1959– ; *Blade Runner* and *Young Doctors in Love* (both 1982), *The Boost* (1988), *Fatal Instinct* and *Even Cowgirls Get the Blues* (both 1993), *The Drop* (2006), *Bone Tomahawk* (2015).

36 1960– ; *Splash, Reckless, The Pope of Greenwich Village* (all 1984); *Roxanne* (1987), *Steel Magnolias* (1989), *The Last Days of Frankie the Fly* (1996), *Kill Bill Vol. 2* (2003), *Sense8* (2015–).

37 Redacted.

38 1972– ; *The Mask* (1994), *My Best Friend's Wedding* (1995), *Fear and Loathing in Las Vegas* (1998), *Charlie's Angels* (2000), *Shrek* (2001), *Gangs of New York* (2002), *The Counselor* (2013).

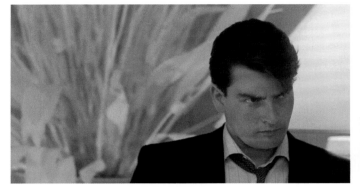
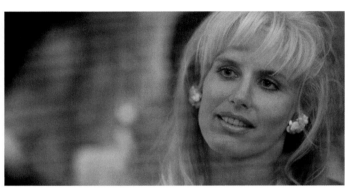

role? Yes. It could've been a different interpretation, than Daryl did. It was a dream thing. Daryl is a dream. I'd seen her in *Splash*, a bit of that, the blond girl that dreamed of the working-class boy, right?

Yeah. The hero acquires her. She's like a spoil.

She wasn't happy with it.

I wish I'd had Cameron Diaz[38] back then. She would've killed in that role, like she killed in *Any Given Sunday*.

Cameron Diaz in *Any Given Sunday* changed the way I looked at her. Because she'd done so many comedies, I would not have thought that she could play a role like that, much less play it as well as she did.

She was good because she has some steel in her. She's a girl who's been around, she knows the score. She'd been a model, been treated like a bauble in the Jim Carrey picture *The Mask*—a bit of that. But she was smart. If only Daryl had had Cameron Diaz's sense of humor, her career really would've gone far, ████████████ ████████████████████████████ ██████████████████ [39]

But the whole bit with Daryl's character that I thought was nice was that she was not just the girl from the street, she came from a wealthy family, she came from money and lost it. When she leaves Charlie, she says, *You don't know what it's like to have money and lose it and be where I am*. It was an interesting little speech, and it was a character thing that's very special to that person, a person who's had money and lost it. In movies they simplify it. No one does that [kind of] character very much. That was the original character I had in

Scarface, but Michelle Pfeiffer was not the kind of person I'd originally seen in that role, so I just went back the other way and made her a girl from the streets who was just pretending to be upscale.

But as far as Daryl Hannah's character in *Wall Street*: You can fault me, or the actors, or whatever, but I still feel like when Charlie blows up at her, it's an effective scene. She played a role in that movie that was very important. She also put the apartment together, you know? But she was very much a rich man's New York woman, and beautiful to boot, as they are. You see seventy-year-old men marrying thirty-year-old beautiful women. The way she's a fashion designer, and talks about the right apartments, very much describes that awful thing I hate about New York, the snobbery.

I would say yes, you may be right about what you're saying about that particular characterization in that particular film. And yet you still find yourself needing to defend that characterization, you know, Oliver? Whereas the women of *Nixon*, *World Trade Center*, and *Heaven & Earth* require no defense.

I think a shallow movie critic would say something like that. It's a cheap shot, because the earlier films were macho kinds of movies, but women were always in there, and you know

the women that were in my life. Maybe I wasn't working it all out, but I mean, I had a feeling for them, a tremendous feeling for them. When I did *Talk Radio*, the Ellen Greene character is an addition to the play, which I put

I think a shallow movie critic would say something like that. It's a cheap shot.

in. I was using women in the early films, it's not like I was ignoring them in the universe, except for *Platoon* and *Born*—well, *Born* is an interesting story because Ron Kovic was very virginal. The mother is the crucial female role in *Born*.

And you left out Donna. She's idealized in Ron's mind, but she's an interesting character. He goes to Syracuse after he gets back from the war with these romantic notions about her, and he realizes that he can never be with her. His heart is disappointed, but he realizes his expectations are unrealistic. And Kyra Sedgwick[40] is very, very good in the part. And then there's, in *NBK*, oh my God! *(Laughs)* That woman! Mickey and Mallory are equal, they're lovers, and young people love that movie because they get it! They're lovers—and love conquers all, right?

(Matt laughs.) **Right.**

39 Redacted.

40 1965– ; *Mr. and Mrs. Bridge* (1990), *Something to Talk About* (1995), *Personal Velocity* (2002), *Something the Lord Made* (2004); *The Closer* (2005–2012).

(opposite) Still-frames from *Wall Street* (1987): Trader Bud Fox (Charlie Sheen) checks out interior decorator Darien Taylor (Daryl Hannah) as she pitches a redesign of his apartment.

They may be paste-ups, but they're valid cartoons. Cartoon is not the best word; they're iconic figures. They're supposed to be bigger than life.

I want to dig into this a little more, because you and I have talked about it lot, and yet I've never really felt like I've gotten a satisfactory answer from you about the issue of the portrayal of women in your movies—and it has been an issue, throughout your career. I'm not telling you anything you haven't heard. But whenever I broach the topic with you, you get fixated on the criticisms of women in your earlier movies and you start defending them, and what I'm interested in is whether you think your understanding of women and your portrayal of women in your movies has improved over time.

What do you think?

Yes. *Heaven & Earth* seems like a turning point to me. And in a way, also, *Natural Born Killers*, somewhere around in there is where I think the change started, maybe. There's a great deal of ugliness toward women in that film, but it's committed by ugly men, and the ugliest character of all is Mallory's stepfather, who's sexually abusing her. Then, in *Any Given Sunday*, you have Cameron Diaz as a lead character, and the movie's sensitive to her being a woman who's in a male world, and she's treated like an interloper even though she has real power.

And then you've got a female drug dealer in *Savages*, and in *World Trade Center*, *Alexander*, and *W.*, and *Nixon*, some interesting women in believable marriages.

Oliver, I mention all this because every time you come out with a new movie, people find a reason to get into the issue of misogyny again, and I believe there's a body of evidence there contradicting it—not in your earlier movies, but in your later movies. But I feel like you don't want to really *examine* that body of evidence. And I wonder why that is.

Why do you think it is?

I think it's because if you agree with detractors who say the women in your later movies are more interesting, that means you have to admit those earlier women weren't as interesting.

When you put it into a male-female gender thing, I'm not comfortable with that, because I'm just into individuals, Matt. I never felt this feminist thing—that's about politics and economics, I understand. That's about voting, getting money, equality in sports, this and that. But in life, no: There's no equality at all.

Women are treated unequally in life, and you're just being true to that?

Equal before the law, unequal in life. But then everyone has to make their way anyway, and have a splash.

My mother is a case in point: She is a woman who is totally, frankly impressive, and if she walks into a room, you remember her. She got away with an act all her life, strong as Olympias in her own way, but not as politically smart. My mother was a party girl at the end of the day. That's what she was! She never put her brains to work trying to advance herself—well, certainly socially, but not to make money. She was a character, as was my father, who's also very strong, by the way. It was not like a weak father with a strong mother.

I'm trying to justify that each one of them is a character.

Then we go to *JFK*. Sissy Spacek[42] played this woman I met, Liz Garrison, not as a Southern caricature, but a Southern woman who exists. So I always argue that yeah, Liz Garrison didn't go out and distinguish herself, but her characterization is about realism, it's about staying true to the person. To have made Liz Garrison into more than she was would've been a mistake at that time. I also want to point out that there were no women on Jim Garrison's staff, but I put the Laurie Metcalf[43] character in there, because I didn't want it to be all guys. I'm not a guy who cuts my cloth to fit the fashion, but I did that.

By the time you get to Le Ly Hayslip and Mallory Knox and Pat Nixon, though, it's a different ball game, wouldn't you agree?

Cartoon is not the best word; they're iconic figures. They're supposed to be bigger than life.

The lack of a sister plays a role in who I am. It was very important to me to have not had a sister. I told you I was not around women as a young man. I was in the army, I was a merchant marine. I mean, I wasn't used to being around women.

And I told you the story that when I went to Southeast Asia, that was a whole other ball game. I crossed over a curtain, the partition, and I saw women in a different way. And people take the easy way out and say, *Oh yeah—he sees them all as Asian hookers*. Well, that's simplistic, because every Asian hooker is different, and every Asian hooker has a story! The deeper you go into their stories, it becomes . . . everyone is a novel. That's why *Of Human Bondage* is an interesting story.[41]

I'm a storyteller, and if you think I missed it on *Wall Street* with Daryl Hannah or Sean Young, you can say that! But to me they were characters. I understood them as characters, and that's how I wrote them. The speech about Daryl Hannah's character losing the money is important. It may not work for some people, maybe the acting was stiff, but I took it seriously.

But see, here we go again! You're still talking about your earlier movies!

Well, Pat Nixon, yeah—but again, I have to say: That's just who she was, in my opinion. She was just more complex than Liz Garrison. Pat Nixon has a whole life of her own. She was a model before she got married. She married a man who I think she had to force herself to come to love. There are all sorts of levels with Pat Nixon, and Joan Allen[44] is a great actress, but it was written. It was *written*!

41 1915 novel written by W. Somerset Maugham that follows Philip Carey, a young man with artistic ambitions whose life is mostly a series of disappointments; made into a film three times: in 1934 with Leslie Howard and Bette Davis, in 1946 with Paul Henreid and Eleanor Parker, and in 1964 with Laurence Harvey and Kim Novak.

42 1949– ; *Badlands* (1973), *Carrie* (1976), *3 Women* (1977), *Coal Miner's Daughter* (1980), *Crimes of the Heart* (1986), *Affliction* (1997), *In the Bedroom* (2001), *Get Low* (2009).

43 1955– ; *Desperately Seeking Susan* (1985), *Internal Affairs* (1990), *Leaving Las Vegas* (1995), *U-Turn* (1997), *Stop-Loss* (2008); the *Toy Story* series (1995, 1999, 2010).

44 1956– ; *Manhunter* (1986), *The Crucible* (1996), *The Ice Storm* (1997), *The Contender* (2000), *The Bourne Supremacy* (2004), *Room* (2015).

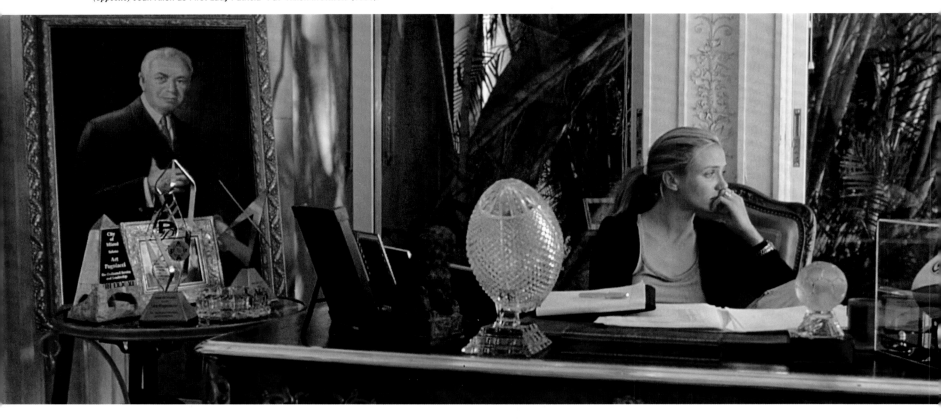

Also Laura Bush, Condoleezza Rice. The women in *W*. are not to be trifled with.

Well, again, we're being true to those women. Who was Laura Bush? Why did she sublimate to this man? She was intelligent, she was a teacher. We went around, coscreenwriter Stanley Weiser and I, on this, we went around quite a bit. It wasn't like we were trying to make her independent or feisty or anything like that. That's just the way she came out, based on our reading of history and research.

I liked Laura very much for her sauciness, but that character was still not a feminist by any means. If anything, she was Liz Garrison twenty years later. You get what I'm saying?

It's not like I've become—I've always respected women and I've had my fights with women. But I've had fights with men, too. I don't see the difference anymore. I've had many, many affairs, I appreciate women very much. At the same time, I'm not going to say I've fallen. There's no veil, there's no illusion about women. When you have a daughter, it changes your whole relationship to women, too. You see them from another side. You know that from your own experience! So let's just stick to realism, about keeping it real between people.

The Snowden movie is interesting because perhaps—and this can only be judged in the end—Shailene Woodley,[45] if it

goes the way I think, will bring another dimension to this movie that is not readily apparent in the way that the real woman, a fitness instructor–amateur photographer named Lindsay Mills, is perceived in the press. I think we really have a character who's a warmer, realer person, who is actually the opposite of Ed, and opposites attract. We're working on . . . that one perhaps has less reality, because we're dealing with what works as drama. He's a spy, he's hidden. She's a public figure, she's on Facebook and does everything the new generation does, she puts herself out there.

I'm glad my female characters got richer for you, but you know, perhaps the scripts got richer, and the people got richer.

All right, Oliver!

Ay yi yi! I'm getting deeper in the shit hole every time I speak to you!

Okay, back to *Heaven & Earth*. This is a biography of the writer and refugee Le Ly Hayslip. It didn't do well with critics or audiences. But I think it's one of your masterpieces.

Its message of forgiveness is personal for the heroine, but it also has a national and even global application. It's not just America versus South Vietnam or North Vietnam, and it's not just North Vietnam versus South Vietnam. You can extend the message to everyone: Through forgiveness comes peace.

There's one scene that I love, when she says to Steve, "Different skin, same suffering." It's lovely.

By the time I made the movie, I'd gone back to visit Vietnam maybe twice. I was finding out more and more. But it wasn't until I worked with Peter Kuznick on *Untold History* that I found out the actual civilian rate of death that was listed by the defense secretary, Robert McNamara, was close to 3.8 million, though he didn't have exact figures. Three point eight million civilians! Back in '93, I had no idea of the scope of it. I sensed the size of the destruction—and remember, I'd been to Salvador in Central America, too, by that stage, so I knew that civilians paid the highest price in war. But I didn't have the same knowledge of Vietnam then that I got later.

You've also got this embedded critique of American culture in the movie, in the sequences where Le Ly comes to the United States with Steve. I was kind of horrified by the frozen and canned food, and the way they're cooking food by just sort of twisting a dial. And the way everything has been mechanized, industrialized, processed—we sense all that from just the way she's looking at her environment.

45 1991– ; *The Descendants* (2001), *The Spectacular Now* (2013), the *Divergent* series (2015–2016).

Yeah, you may be right. The relationships between American family members are shocking to her, too.

You became a student of Buddhism at some point during production of that film, yes? I ask because I read somewhere that you said one goal in making the film was to illustrate the principles of Buddhism to a Western audience. That's not

suffering on women. And it's only through forgiveness that she can move on, and live her life.

The heroine of the story was a Buddhist. I had been studying Buddhism with Richard Rutowski, who had been a Buddhist, or whatever a Western Buddhist is called. The confluence of Vietnamese and Tibetan Buddhism was important. I started to study and practice it from

as if Le Ly meets her husband's hatred with love, and when he realizes what a monster he's become, he's so ashamed that he kills himself.

(Stone quotes the shaman.) "He changed a lot."

Right! "He changed a lot." I love that.

"Have to leave."

There's a wonderful scene I cut from the movie, and I really regret it: At the end, after Steve dies, after the scene in the temple with the shaman, there's a scene where Le Ly goes back and has a scene with Steve's mother, Debbie Reynolds,[46] and his sister, Conchata Ferrell.[47] They want Steve's ashes back. You see that Le Ly has a whole Buddhist version of the death ritual, but the Americans have a completely materialistic version, worrying about how to cut up the will! It's a wonderful contrast.

And then Le Ly talks like the shaman does, and says: "He's here, Steve is here, his spirit is with us," and you feel it in the scene. I forgot how we did it. "We feel the spirit is with us," she says. And Steve's mom looks at her like she thinks she's nuts.

I'm not saying I'm a good Buddhist — but it's good to give yourself that reflection.

something most Hollywood movies would try to do, to put it mildly, but you do it through the heroine. There's scene after scene where Le Ly is suffering injustice, in some cases physical harm—being raped, tortured. Then, just when she thinks she's escaped into the arms of this American soldier, Steve, and goes back to the United States with him, that relationship turns to shit, too. He becomes abusive and controlling.

She gets through it all through meditation. You actually see her meditating and thinking. The filmmaking shows us leaving her present circumstance and becoming focused and free. Le Ly suffers so much in this movie, and it's not just suffering inflicted by a political establishment or a particular military. There's also an element of men inflicting

1993 on, and to basically meditate every day. I'm not saying I'm a good Buddhist—but it's good to give yourself that space for reflection.

In the scene in the temple after Steve dies, the movie, which always had hints of magic realism, goes for broke. You see an orb of light moving through the room illuminating his window and the shaman, and there's a point-of-view camera that seems to be representing Steve's spirit. This is the kind of thing I'm talking about when I tell people that *Heaven & Earth* is a spiritual or even religious film. This is not metaphorical, what's happening in the scene in the temple with Le Ly and the shaman and Steve is all really happening. And the way you tell the story, it makes it seem

46 1932– ; over seventy years' worth of performances, stretching from *Singin' in the Rain* (1952) and *The Tender Trap* (1955) through *Mother* (1995) and *Behind the Candelabra* (2013).

47 1943– ; *L.A. Law* (1988–1992); *Hearts Afire* (1992–1995), *Two-and-a-Half Men* (2003–2015).

HEAVEN AND EARTH

SCREENPLAY BY OLIVER STONE

Based on the autobiographical books "WHEN
HEAVEN AND EARTH CHANGED PLACES"
and "CHILD OF WAR, WOMAN OF PEACE"
by Le Ly Hayslip with Jay Wurtz.

5TH DRAFT
MAY 15, 1992

IXTLAN INC.
3110 MAIN ST. 3RD FLOOR
SANTA MONICA, CA 90405
(310) 399-2550

COPYRIGHT IXTLAN/REGENCY FILMS

Handwritten annotations:

OLIVER COPY 1.

MONSIEUR OLIVER STONE

Rely on location - read all V.O.s as 90 %

(B) L.J. - makes it sexy interesting then wind the wind into the movie - the flaky and what will he do for her - the American characters believe ultimately chem + believe her. But pad in his because don't identify them what Stew (A.B) is going to do about.

(P) Steve (T.R/J.)
① Blond hair, buzz cut, sunburned.
② Money to Steve - desperation, LE Ly succeeds -
③ his relationship Vietnams as terrorists -
④ go to Dale - how not USMC.

you have, yet you don't / you don't / you do"

NOTE:
"REPUBLICANS → NATIONALISTS!"
5th DRAFT (REVISED JULY)

(5) Desaturating at different OS strengths all the way to San Diego - first time
① CAMERA ANGLES Now -
(1A) Low frames - also MAN LOW IN FRAMES beside Nature
② Dogs, birds in cages, to use each frame as needed

Songs in Vietnamese. Superior. All dialogue Vietnamese. fractured English
2R à la last

Ly's POVs à la Cruise wheelchair
(A) Low angle sc
(B) Low floor. STATIC + CRABBING. A. RISE. YES. But

③ I THINK VIETs SHOULD SPEAK IN VIET + English only when 2 CONTEXT + REAL!!! - LIKE "DANCES" & "CLOCKWORK ORANGE" THE RESULT WILL GIVE US A FASCINATING DUALITY FEEL - 2 CULTURES AT ODDS. the POWER of American Language FEEL

(6 children OK)
④ PLAY MOM AT 30 When Ly Born, 45-50 during action - + prosthetics only at 60-70.

2R 6/92

OS. YOU REALIZE WRITTEN IN SHOTS AS IS.

WL = WIDE LONG MW = MODERN WIDE

MIKE BUTLER, STEVE WILSON

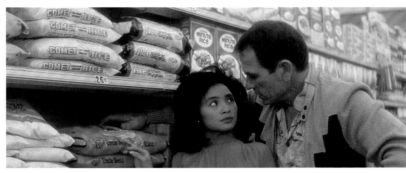

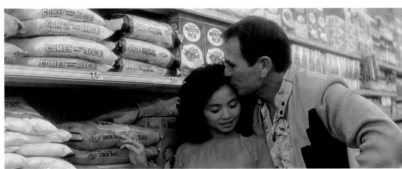

This movie is not presenting the tenets of Buddhism in an abstract way. It really seems to believe in the idea that there is a spirit world, that there's karma.

This is not exactly Buddhism, though. A lot of times what you're seeing in the film is shamanism. It's a combination of tribal shamanism and Buddhism. The Vietnamese are not educated as much in Buddhism in the way that you're thinking. It's also Theravada, which is a different vehicle than the Mahayanas [END 8]. But Buddhists are a very down-to-earth, very primal kind of cultural society.

And then after that, the movie returns to Vietnam. It also seems to me that the film is walking a very interesting tightrope between wanting to be true to the experience of this one Vietnamese woman and at the same time being aware of itself as a Hollywood movie that wants to educate American audiences. There are a lot of basic facts in the dialogue about our involvement in Vietnam, and the involvement of France before us, and the involvement of Japan and China. That's all stuff that I don't remember ever seeing in an American movie made at this budget level. Or maybe ever.

It's all colonialism.

I also sensed there was an aspect in which the movie could be seen as your apology to the Vietnamese people.

Yes—there was a sense of atonement.

Where did you discover Hiep Thi Le?

At that time I had the power to say, "I want to find a young Vietnamese woman who can speak English and make her the lead." So we put the word out, and we looked in six cities: Houston, San Francisco, San Jose, LA, New York, and Washington, DC. And we had tremendous turnouts in all these places.

It was in San Jose, where this UC Davis girl walks in with a friend! I think she wasn't taking it too seriously. This was like something from the old days, like an Otto Preminger casting search,[48] thousands of people, and we found this young woman, who I think did a commendable job. I loved her in the movie. She looks exactly like a young Le Ly. She's got a great, beautiful, little face. She's four foot eleven. Le Ly's tiny, too. You can see it when they're standing next to each other in pictures.

Why did you have actors from different Asian countries playing Vietnamese people?

First of all, a lot of the Vietnamese actors we saw just didn't speak English well enough to carry a movie like this in English. We put Joan Chen, who's Chinese, in the part of the mom because we couldn't find the right mom. Same with the dad, who ended up being cast with the Cambodian actor Haing S. Ngor from *The Killing Fields*. It was hard!

I was very proud of the film. Unfortunately, we spent too much money making it, because I was hot and I knew I had power.

I was very proud of the film. Unfortunately, we spent too much money making it, because I was hot coming off *JFK*, and I knew I had power. It was a complex production because we built an entire village on Phuket Island off the mainland of Thailand. The production designer, Victor Kempster,[49] did a

48 Stone is alluding to Preminger's search for an unknown actress to play the lead in his 1957 adaptation of Georger Bernard Shaw's *St. Joan*; he eventually settled on Jean Seberg.

49 Production designer on six Stone films, from *JFK* (1991) through *Any Given Sunday* (1991); also *Bamboozled* (2000), *Miami Vice* (2006), and *Charlie Wilson's War* (2007).

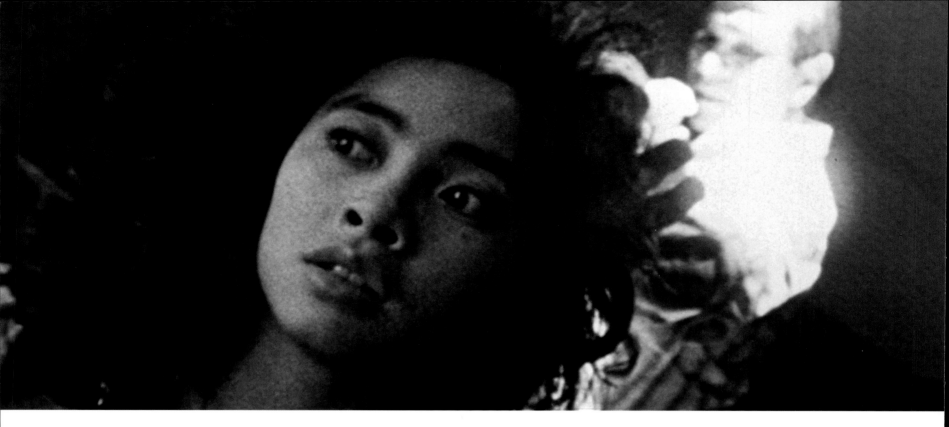

great job. So much detail, and Le Ly was with us the whole way and brought implements from Vietnam. The details were great, because Vietnamese agriculture is different from Thai: how to grow the rice! God, we had time to get into all those cycles we shot.

There was no way this thing would get through the system today. I didn't realize at the time how anti-Asian sentiments were, in our country. The concept of the Vietnamese getting fair justice in this case is still not an idea that's relevant to a lot of people. America is very isolated by these two oceans. They cannot understand, most of them, the suffering of the Vietnamese. They cannot. They don't want to even think about it. They cannot understand the suffering of the Russians during World War II. They cannot understand what World War II really was, because they don't know what war is! I've been up against this wall in *Untold History* as well.

We had a broad opening, December 25. It was a beautiful film on-screen. I went to the Ziegfeld and saw it there, on Fifty-fourth and Broadway. The theater was maybe one-third full. I knew in my heart what was going to happen to it. I knew this one was going to be a long shot.

To this day I can't tell you how many Asian women come up to me and say, "I saw *Heaven & Earth*," which really warms my heart.

How can people say I just don't like females? God, there's so much love in this movie. You can feel it.

It wasn't until you were several films into your career that you started to really let women into the stories, though, Oliver. They were much more male-oriented before that.

But at the same time, I should say that there's also a self-awareness about what you

might call "the mask of masculinity"—men feeling that they need to be hard and tough, treat women as property, conquer, and all of that.

Give me an example.

For one, the way the soldiers in this film, from all of the armies, talk about women, about prostitutes, the different levels of prostitutes, and how much they're worth as commodities. You're experiencing their ugliness and their privilege entirely through the heroine's eyes. The specific language these guys use doesn't come from the sourcebooks. The slang that they use, the sexually objectifying language, the slurs: That all struck me as something that's the product of research, i.e., Oliver Stone having been a soldier, or spent time in places like that.

Well, I had my share of that kind of thing.

Prostitution, in Vietnam? Like what, the bit that you read aloud to me from *A Child's Night Dream*?

Yeah.

That's soldier talk they're talking in that *Heaven & Earth* scene, right?

It's earth talk, yeah! Vietnam was a tremendously erotic place, a place of love and death. To them, sex is more like eating. A function of life. It's not a big deal, like it is in puritan societies. And I kind of grew up on that.

The movie seems horrified by the sexual violence, though.

The rape was shown pretty graphically, though, wasn't it?

Well, yes and no. We actually don't see as much of the act as we maybe think we do. We're in Le Ly's mind as it's happening; the shots of the rapist are what she sees.[50]

50 "We tried to do it as tenderly as possible. I built prosthetic breasts for her, so she would not feel naked in the rape scene, and that was helpful. But we shot in the rain all night and we were wet and miserable and cold. She had a hard time dealing with it." Oliver Stone as quoted by Gregg Kilday in *Entertainment Weekly*, January 14, 1994.

And later, the moment when she has to decide whether or not to sleep with the American soldiers to get that nest egg of cash for her kids—you don't see the resolution of that, which is that she went ahead and slept with the soldiers because she needed the money. The resolution is offscreen.

Yes, that's right.

You've never seemed more disgusted as a film-maker than when you're showing sadism, and yet that's also the point in a lot of your movies when they seem the most intense and involving.[51] In *Heaven & Earth* there's a lot of cruelty. I'm thinking particularly of that guard in the prison camp who sticks the snakes down the female prisoners' shirts while they're tied up. You make a point of showing us his laughter in close-up. It's hideous, a condemnation.

Oh, that face!

It's almost like a death mask laugh that he's got. He looks like a skull.

That was a horrible day, the day we shot that scene. But that guy was very good in the scene. They were all good. She's a brave girl, Le Ly, in that scene. That shot of the torturer—he enjoys it. He totally enjoys it. It's not fake. Actually, you smile sometimes when you see people suffer, so . . . there but for the grace of God go I.

Which in colloquial terms means, "Better me than the other guy!"

Sometimes when things are really, insanely crazy, you're laughing! I've seen that reaction in myself! When things are so bad, you laugh. That's what humorists do, right, in a sense?

But just when the scene starts to become unbearable, you cut out of it.

Well, it's over. There's no point in making it *more* horrible. After that, she's let go, right? Because her mother made a deal to get her out of prison.

Her mother bribed somebody in the prison.

Right, right.

And they think it means she's a VC sympathizer, and that leads to her rape, when they're going to throw her in the open grave?

The VC think she's collaborated with the South Vietnamese government to get out of jail. That's a big situation. Can you imagine being caught in the middle of that? That's what I was trying to show. I mean, it was impossible for her. It's like what's going on in Iraq or Afghanistan now! Civilians cannot get away from it. If you have no money and you can't protect yourself, you're stuck in a war. It's a horror show.

Was it that bright young critic, that kid Guarnieri, who said that because I'd been to war and I'd actually killed people, my relationship to crime and violence was different than Marty [Scorsese]'s and a lot of other directors'?

Yes. And I was going to ask you about that piece, Michael Guarnieri's essay "The World Belongs to Savages."[52] It was one of the more original pieces I've read about your films. Also interesting was a comment that a reader made on that piece—that your next film after one of your official Vietnam movies, *Heaven & Earth*, was *Natural Born Killers*, and in a way that's a Vietnam movie, too, because it's about life in a landscape where law, order, and morality basically mean nothing. It's just kill or be killed.

And *U-Turn*, too? The piece talked about the vultures: The vultures get ya.

51 From the same *EW* story, Stone responds to reports of audiences walking out of *Heaven & Earth* after the prison camp torture scenes by saying that the images were "so minor compared to what people go through when they're being tortured. I'm amazed that Americans would be so squeamish. What wimps! How can you deny life? What we're going to get as a result of that is a lot of PG *Jurassic Park*s. We're going to live in a PG fucking world. Macaulay Culkin will be our next Clark Gable."

52 Reprinted on page 310.

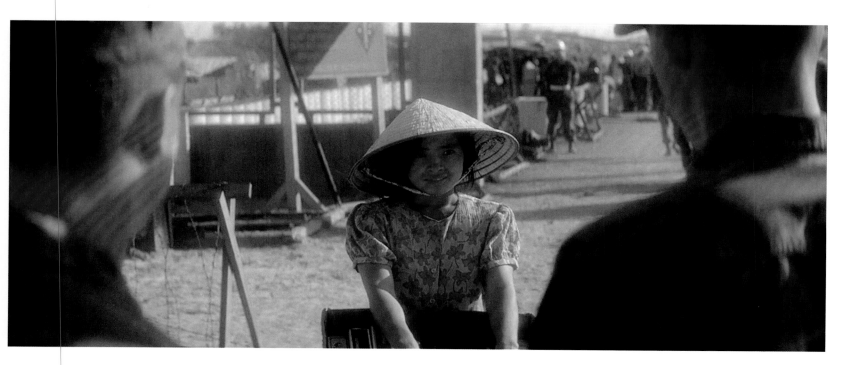

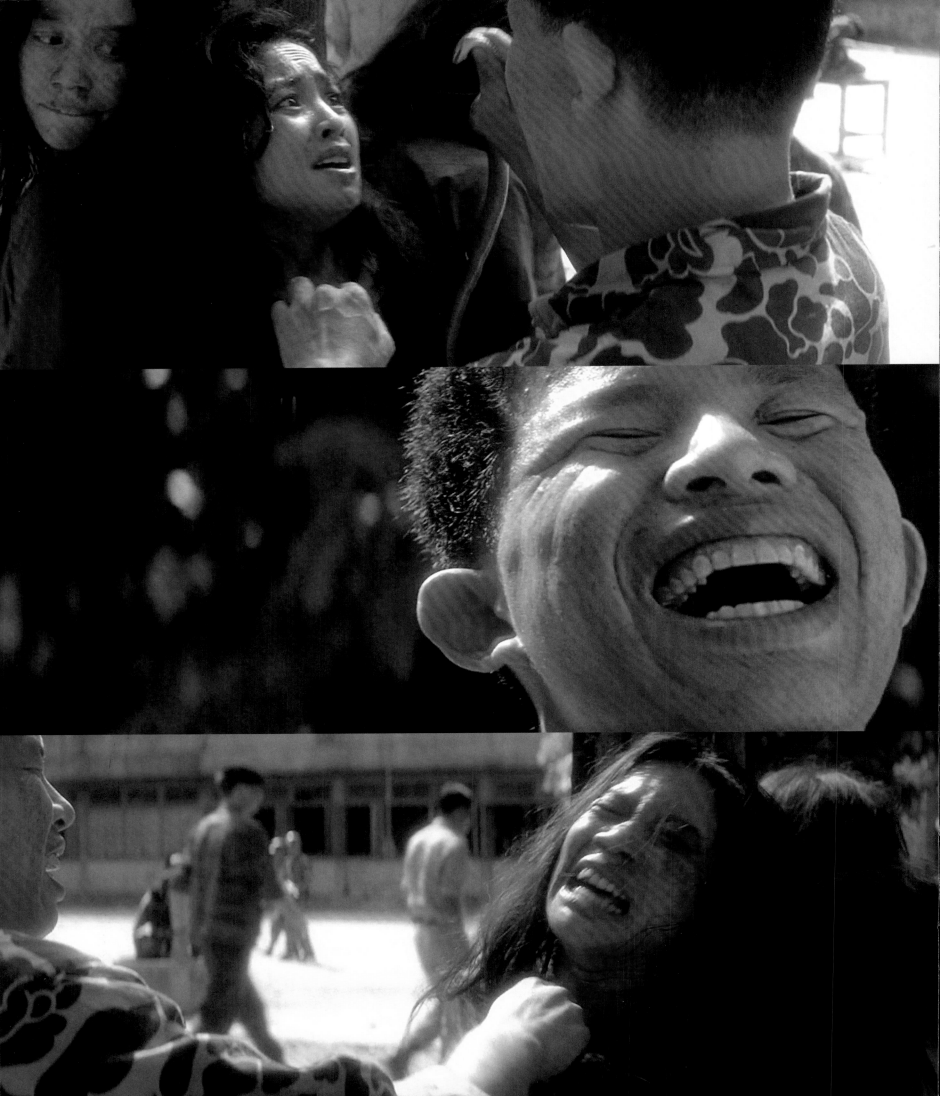

Is that a fair assessment, to suggest a lot of your movies that aren't specifically *about* Vietnam are still about things you experienced in Vietnam, and thought about because you served in Vietnam?

I don't know. I think it's a worldview. I don't think it comes *only* from Vietnam. I think it starts before Vietnam, as a kid. In some way, I was sensitive to cruelty, and I was cruel, too. I was cruel to my dog at one point because he

[REDACTED]53

So, back to the response by critics and the public: You at that point had won Best Picture for *Platoon*, two Oscars for directing, nominations

That's the only redeeming trait they've got. They kill *a lot* of people.

But when they kill the Indian, they feel bad!

They do, and everything turns to shit after that.

And they know it.

My point is, you don't have anybody there to be the audience surrogate in that movie.

I don't know what an audience surrogate is. Explain that to me.

The person who represents the average person.

I don't know what the "average person" is.

I don't, either, but Hollywood seems to care very much about that idea. And the parties who brought an incitement lawsuit against you for *NBK* were very much concerned with how the film relates to the average person. They thought the film might drive the average person to murder [END 10].

That's a horrible story. No support from Hollywood on that at all. Every filmmaker would be imperiled by a product liability claim on a film. Nobody would be able to make films! Everybody would be suable for suggesting it's a product, like a vacuum cleaner or a washing machine, that you have to get a warranty on. That was the basis of the suit.

Why was there no support, any support, at the time? It was like I'd done something bad. Like I'd caused fifty-five murders or something!

What was the issue? Lay it out for the reader, if you can.

John Grisham's[54] friend was killed by two young people who supposedly said they were influenced by it. But when the actual evidence finally came out, there was no indication that they were moved by the film to kill.

Stanley Kubrick ran into similar problems with *A Clockwork Orange* [END 11].

And Kubrick withdrew it.

Don't underestimate schoolyard cruelty! I mean, kids are cruel!

was shitting all over the place, and I hated him for that because it was just a mess, but he was bleeding out. I didn't realize—nor did my parents, who were kind of stupid about it—that he was bleeding to death because he had bowel cancer or something.

How old were you?

I was very young. Seven, six. I mean, it was all kinds of cruelty. But I saw cruelty in school, too. Don't underestimate schoolyard cruelty! I mean, kids are cruel! I don't forget that shit. I think cruelty is a way of life. I felt it, I saw it, even on my first tour to Vietnam. When I was a civilian, a merchant mariner and teacher, I saw cruelty of people to people. It's always shocked me.

It wasn't because I killed in Vietnam, it was because I *see* things. Look, in Vietnam, it was confirmation. It wasn't a revelation of any kind, it was a confirmation of what I learned in the schoolyard, that in a sense, people behave badly and they still do, and you sense the vigilante mentality ganging up on villagers because they're weaker. You sense the desire for rape, to kill anybody at a certain point because you're pissed . . . casual cruelty. And I saw plenty of that.

and awards for your writing, and actors you'd directed in your movies had been nominated for, or won, awards. And you'd just come off one of your biggest box office successes, *JFK*. Then *Nixon* comes out, makes thirteen million, costs forty million, and it seems like everybody just flipped a switch and suddenly you weren't allowed to make that kind of movie anymore.

Who knows why? *NBK*? Perhaps *JFK*? Realize, there was a lot of bad blood on *JFK*, a lot of enemies. Don't forget, [Motion Picture Association of America president Jack] Valenti called *JFK* a hoax [END 9]. All the cynics said, "I don't believe that, the guy's making it up, all the fact-changing."

Maybe I am off the wall, because who goes from *JFK* to *NBK*? I mean, think about how different those movies are! In one I'm trying to be responsible, and the other is kind of irresponsible because I'm letting the killers kill everybody!

Why did people find the violence so unsettling?

It wasn't supposed to be that way in *NBK*. It was supposed to be, *Relax! This is ridiculous!* Every murder in that movie is ridiculous, don't you think?

Yes.

Why did people take it literally?

Maybe because there are no good guys in the movie. There are no nice people in the movie.

What about Mickey and Mallory? They're lovers!

53 Redacted.

54 Bestselling author of legal thrillers, many of them made into hit movies, such as *The Firm* (1993) and *The Client* (1995).

Yes, he withdrew it from circulation in England, where the problem was.

We were banned in Ireland for several years, and also we had huge problems in England. Jesus Christ, I went to France, there were murders in France—everywhere I went, there was a murder reported, practically.

I had to take a deposition in LA, it was a four- or five-hour thing. I had to prepare for it. Warner Bros. paid for a deposition lawyer. These are specialty experts. They tell you how to speak in a deposition. It was a long, drawn-out process. Then these guys came up from Louisiana, very serious lawyers representing Grisham's friend, and . . . wow! They had such a circumstantial case, and they never presented direct evidence, like, "I saw *NBK*, man, what a great movie! It turned me on!" There was nothing like that. Wasn't even close.

And on top of it, well, those two kids were fucked up. I felt sorry for them, but they were doing some heavy, heavy drugs right before, I think it was LSD-type stuff, and they also had rough backgrounds.

In the end, you never withdrew the film from circulation, like Kubrick did with *A Clockwork Orange*.

Right. I didn't withdraw the cut.

Why not?

I felt no guilt about the murders. On the contrary, it was a satire, and was pointed directly at this concept of American violence, of this mentality that embraces violence for money and news, or whatever you want to call it, and embraces sensationalism, and how sensationalism attracts violence. So when you get two attractive morons like Mickey and Mallory, and you get Robert Downey's[55] character, Wayne Gale, selling them on his TV show, and you get an insane prison system run plantation style by Dwight McClusky, the Tommy Lee Jones[56] character, and a homicidal cop who strangles hookers, played by Tom Sizemore,[57] the whole system is insane.

What's worse? The two killers who love each other, who at least have some love in their life, some kind of affection? Or these monsters we've created?

The idea that there's a direct, one-to-one correlation between someone watching a movie and going out and killing people, I think, is silly, but I feel like I have to ask you: Do you think if movies can be a force for good or social change, doesn't it logically follow that they can also be a negative force?

Yeah, sure.

How do you navigate that as an artist?

That's your responsibility as a viewer. You take your life in your hands when you see a film. You take responsibility for each and every film, an ad hoc decision.

some issue back when,[59] so there was bad blood, and he came and saw me one day, Tarantino, and I thought I'd make the peace pipe between them. But there was no peace pipe to be had. Tarantino walked out of the office, went right to the press, and started blabbing about me, and them, and started saying horrible things about me and how bad *Born on the Fourth* was—I remember some comments on it, just below-the-belt stuff, because he compared me to a wonderful film-maker, a guy who's been totally knocked and

Every murder in that movie is ridiculous, don't you think?

And I don't think I am an accessory, because in every single one of these cases, when they actually got searched out in France, England, US, none of the kids said it was the reason. There were preconditions at work: jealousy, hatred, drugs. It's like the kid who killed John Lennon saying, "Why don't you blame the Bible?" [END 12] Come on.

But I don't think *NBK* is that film. To a stupid person it could be. To me, they're lovers. That's the best part of it, they're lovers, and they stay lovers, and everybody else around them is corrupt, everybody—the prison system, justice, law, and the media, the most corrupt of all.

We went to court for seven or eight years! That was expensive for Warners and myself, because I essentially had to take my own lawyer, apart from them. They were defending me, I'm not saying they weren't, because I was covered by their protective suit, but at the end of the day there is a lot of detail in a lawsuit. It went to the Supreme Court, bounced back, went through several appeals courts.

Tarantino's original script describes Mickey and Mallory as "predatory animals who have created this psychotic little bubble, and anything that intrudes upon that bubble must die." I feel like part of that, at least, got preserved in the movie, although they're different animals from what Tarantino wrote.

That whole relationship between you and the original writer, Quentin Tarantino,[58] is a powder keg, so I don't know if you want to get into it, but . . .

[Producers] Jane Hamsher, and [Don] Murphy had a huge falling out with Tarantino over

undervalued, Stanley Kramer, and I thought that was such a cheap shot, because not only was he shooting me down, he was shooting Stanley Kramer down!

55 1965– ; sardonic and self-aware leading man; *Less Than Zero* (1987); *Chaplin* (1992), *Short Cuts* (1993), *Wonder Boys* (2000), *Tropic Thunder* (2008); the once and future *Iron Man*.

56 1946– ; craggy-faced Texan character actor and director whose sheer likability made him a star; *The Executioner's Song* (1975), *Coal Miner's Daughter* (1980), *Blue Sky* (1990), *The Fugitive* (1993), *Men in Black* (1997), *No Country for Old Men* (2007).

57 1961– ; affable, menacing leading man with a flair for volatility and sleaziness; *Heat* and *Strange Days* (both 1995); *Saving Private Ryan* (1998); *Robbery Homicide Division* (2000).

58 1962– ; endlessly controversial writer and director, from 1992's *Reservoir Dogs* through 2015's *The Hateful Eight*; script doctor on *Crimson Tide* (1995) and *The Rock* (1996), among other films.

59 After Tarantino unexpectedly hit it big with his directorial debut *Reservoir Dogs*, he wanted Hamsher and Murphy to sell *Natural Born Killers* to somebody other than Ixtlan. When the option to make *NBK* ran out during Stone's production of *Heaven & Earth*, they refused to seek another buyer, saying they'd made an agreement with Stone to direct and were sticking with him. Tarantino also strongly objected to Stone's alterations and additions to his screenplay. Stone: "Hugely rewritten. Tarantino made the biggest money of his life. Jane and Don could've gotten out of it, but I insisted on paying it." And there were disagreements over who owned the rights to publish the screenplay in paperback.

FDC 50202

96 PAGES! MORE BANG FOR YOUR BU

FILM THREAT

THE OTHER MOVIE MAGAZINE

FILM THREAT

ALMODOVAR • CRISPIN • LYDON • HOUSTON • CANNES • MORE

Natural Born Killers

BLOOD FROM A STONE:
ON THE SET WITH OLIVER

HONEST REVIEWS

Issue 18 · Oct. 1994
$4.99 U.S./Can. · £2.95 U.K.

0 74666 50202 4

10

|||

You take your life in your hands when you see a film. You take responsibility for each and every film.

|||

Stanley Kramer's name is still a pejorative, though.

Not to real people who see movies. He's one of the greatest, most successful filmmakers in the world. More people have seen *Judgment at Nuremberg*, or the other one he made, *The Defiant Ones*, and *On the Beach*, than will ever see most of Tarantino! Even today, you can watch *Judgment at Nuremberg*, sit through all of it, and it's a brilliant movie! So is *On the Beach*. Maybe it's long here and there, but so is every movie when you see it a few times.

I love that you're defending Stanley Kramer. What did you learn from him, or what did you apply from watching his movies?

You could be moved. You could move a universal audience with a good, noble theme. There was something socially uplifting in his movies. It's true, I got to know him in the very twilight of his career, when his luck had turned and he was not able to make a movie. But he maintained his dignity and his intentions. *The Defiant Ones* was one of the first big movies about blacks and whites in America, with Tony Curtis[60] and Sidney Poitier.[61] Every kid who grew up in the fifties had to see that movie. Wow! I mean, it's not like, *Now I'm going to run out and love a black man,* but it treated black people as equals. It portrayed the black man with dignity, in a lead role, at a time when most Hollywood movies weren't showing black people at all, or putting them in subservient roles. I was not a fan of *Guess Who's Coming to Dinner*, but when you look at it again, it's a very well-made, noble film. [Katharine] Hepburn[62] is good, [Spencer] Tracy's[63] great. *Judgment at Nuremberg*, I think, is a classic. It's talky, but it's Abby Mann's[64] script, too, and it's a great script. Abby Mann I got to know. I produced an HBO film about the McMartin trial with Abby, which is a great story, about the witch hunt for the teachers in California. *Indictment: The McMartin Trial*, it was called; Jimmy Woods starred in it. Abby wrote the script with his wife Myra Mann. You know, Abby's script on *Judgment* is a brilliant script. It was a 1961 TV play originally, broadcast live on *Playhouse 90*, and as a movie it still holds up. It has a large cast full of movie stars who are all acting, really giving terrific performances. Spencer Tracy's superb in that movie.

Tracy's judge has a very long summation, like Kevin Costner in *JFK*.

Yes, and I think it's beautifully done. When Burt Lancaster's[65] German comes forward and says, *We're all guilty, because we broke all the laws on an ordinary basis, and it made all of us criminals,* Kramer shows that he gets it! That's what happens in a society. That's how it breaks down. It will happen in our society, too, when we no longer feel any shame or guilt about condoning torture or abandoning the Fourth Amendment or giving up our privacy rights. Germany in World War II will happen again. It will happen all over again! That's what Abby Mann and Stanley Kramer were warning us about, and that's a more important story than anything most filmmakers do.

So when Tarantino bad-mouthed Stanley Kramer, that was it for you?

(Stone laughs.) I mean, what are you gonna do? It's embarrassing, because you know, I'm trying to sell a film and not only is he bad-mouthing me, he's just damaging the possibility at the same time for us to make money. Theoretically, if we'd sued him, it would've been more colorful with all that crap. But it was a horrible experience.

I didn't realize it was a tidal wave. Tarantino was a holy god at that point. He could do no wrong. He had the biggest fan club in the world, every fucking critic! The Tarantinites, or whatever they're called, they were so insane! They were like the guys you'd see on the Internet defending right-wingers in Venezuela! They're the kind who tell you, *You dirty shit, go back and die, eat shit and die*—I mean, awful! These were the guys who took umbrage if you attacked their god Quentin [END 13]. I tried to let it go by, but it did hurt the film, no question.

They're two very different approaches to the same material, his original script and your movie.

It's also much more of a Roger Corman film, Tarantino's. As I remember, it's a one-themed film, which is *Love you, love you.* I think it works, but I don't think it had the dimensions we added with Wayne Gale, Tommy Lee, and the whole concept of what the prison was. But I liked his sense of humor and his insanity, and I liked *Reservoir Dogs*, and so I bought the script.

We were turned down by Cannes. That hurt badly. [Cannes festival director] Gilles Jacob said it was too violent. But they had Tarantino there with *Pulp Fiction* that year. They said, "We already have enough violent fare with *Pulp Fiction*, we can't do two of these type of things," and blah blah blah.

The Venice [International] Film Festival, though, was a whole amazing other story. We'd gotten a standing ovation, a wonderful reception. The director Gillo Pontecorvo, a kind man, called me right before I was going to leave and said, *Please stay an extra two days, because it looks like you're going to get the top prize, the Golden Lion.*[66] So the pro-

60 1925–2010; over 130 film and TV credits, stretching from 1949's *Criss Cross* and 1958's *The Sweet Smell of Success* through 1968's *The Boston Strangler*, 1985's *Insignificance*, and 1999's *Play it to the Bone.*

61 1927– ; actor, social activist, director, and the first leading man of color to become a reliable box office attraction; *Blackboard Jungle* (1957), *A Raisin in the Sun* (1961), *Lilies of the Field* (1963), *To Sir, with Love* and *Guess Who's Coming to Dinner* (both 1967), *Sneakers* (1992).

62 1907–2003; independent-minded, prolific, durable American actress, on her own or in tandem with Spencer Tracy; sixty-six years worth of film and TV credits, including *Bringing Up Baby* (1938), *The African Queen* (1951), *The Lion in Winter* (1968), and *On Golden Pond* (1981).

63 1900–67; perhaps the greatest example of a character actor becoming a leading man through sheer mastery of craft and force of personality; often paired with Katharine Hepburn, with whom he had an ongoing affair for over a decade; *Boys' Town* (1938), *Adam's Rib* (1949), *Father of the Bride* (1950), *Inherit the Wind* (1960).

64 Socially aware American screenwriter; *Ship of Fools* (1965), *Report to the Commissioner* (1975), TV's *King*, about Martin Luther King (1978); *Teamster Boss: The Jackie Presser Story* (1992).

65 1915–95; acrobatic, muscular, macho leading man who aspired to be taken seriously as a character actor and got his wish; *The Killers* (1946), *The Flame and the Arrow* (1950), *Sweet Smell of Success* (1957), *Elmer Gantry* (1960), *The Train* (1964), *Go Tell the Spartans* (1978), *Atlantic City* (1980).

66 Pontecorvo was an Italian filmmaker best known for his cinéma vérité war drama *The Battle of Algiers* (1966) and the slave rebellion drama *Queimada (Burn!)* (1969).

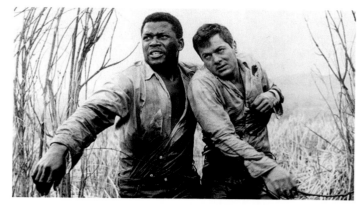

Sight and Sound

Bodysnatchers:
Siegel to Ferrara
Zhang Yimou's new film:
exclusive set report
Interview: Yuri Norstein's
dark animation
Post-Jurassic Europe:
'Germinal' and the stars
Monika Treut on
Fassbinder's men
Andy Medhurst on
Queer books

PLUS 33
PAGES OF
FILM AND
VIDEO
REVIEWS

The director of
'Reservoir Dogs'
on his new movie
'Pulp Fiction'
Plus pulp from
'The Maltese Falcon'
to 'Romeo is Bleeding'

Tarantino

ducer and I stay, and sure enough, the decision comes down and he says, *No, I'm sorry, Oliver, they decided to give it the Jury Prize instead.* This was after Mario Vargas Llosa,[67] who's another gasbag—he was on the jury, the jury's supposed to be silent until they make a decision—goes to the press; I see the headline on Saturday morning one day before the jury is supposed to decide, and it's something like: "Over My Dead Body—Vargas-Llosa!" And there was all this talk about how Uma Thurman[68] was on the jury, and she was in *Pulp Fiction*. David Lynch[69] was the chairman . . . I don't know. That hurt.

But you know, all that's minor compared to the lawsuits, the murders, the fallout with Warner Bros. that made the Warner Bros. relationship uncomfortable over the next couple of years.

And the ratings board! All those cuts changed the rhythm. We went back to the ratings board several times—that was always a hassle. We'd say, *What's wrong? What's wrong?* And they'd say, *We don't know what's wrong! Chaotic. It's just chaotic.*

I couldn't get past that word, because I had tried to create chaos deliberately.

Did they ever say they objected to specific acts of violence?

Some, but mostly it was about the way the film was cut, the way it was balled together. They said there was something disturbing about it, so make it less disturbing! I don't

know! What the fuck? I had done it to be a satire, shocking to the eye! That's the point of a movie like this! So having to make it *less offensive* to, excuse me, a bunch of puritans, or whatever the fuck they call themselves, was tougher. Really hard!

But I didn't like the cut, the rhythm of some of the cuts, that I had to make. I had to make 155 cuts to get an R rating! I mean, it was OK because I did it; certainly the prison riot and the music worked. I eventually did one of those side deals, and I forced Warner Bros. to give me back the cut, and then I finally got it out [on DVD] unrated in 2007 or something like that.

But I didn't want to back down. I didn't think it was right.

Tarantino's script was, in terms of narrative structure, more experimental than your movie—because that's his thing, shuffling narrative around. You go, for the most part, with a more

67 Peruvian writer who received the 2010 Nobel Prize in Literature; novels include (with the dates of the original publications in Spanish) *The Time of the Hero* (1963), *The Green House* (1966), and *Conversation in the Cathedral* (1969).

68 1970– ; *Dangerous Liasons* (1988), *Pulp Fiction* (1995), *Kill Bill Vol. 1* and *2* (2003–2004); *Motherhood* (2009); *The Slap* (2015).

69 1946– ; painter turned influential surrealist filmmaker; *Eraserhead* (1977), *Blue Velvet* (1986), *Twin Peaks* (1990), *Mulholland Dr.* (2001), among others.

BOB DOLE

*In Boston, a young murder suspect brags to
his girlfriend about the murder.*

*He said "Haven't you ever seen "Natural Born Killers"
before?"*

The implication is that murder is glamorous. . .

. . .it's just like the movies.

Dear Friend,

I just watched all I could stand of "Natural Born Killers."

It's about two young people becoming celebrities by committing a series of murders.

I kept thinking, with our streets under siege and our values decaying, why would anyone make a movie in which the heroes are twisted lovers on a killing binge?

Do you agree?

Are you tired of movies and songs "glamorizing" rape, murder and drug abuse?

I am.

As I campaign for President, violence and sex in entertainment is what parents and grandparents talk of most. They are tired of movies and music oozing blood and sex.

But, too many of those who profit from these movies and songs claim their products are not part of the problem — that they are not influential to our young.

That is conveniently self-serving and horribly wrong.

Let there be no mistake: televisions and movie screens, "boomboxes" and headsets are windows on the adult world for our children. Kids know firsthand what they see in their families, their schools, their immediate communities. But our popular culture shapes their view of the "real world". Our children believe those pictures on film are reflections of reality. But I don't recognize America in much of what I see.

July 2, 1996

VIA MESSENGER

Mr. Terry Semel
Warner Brothers

Dear Terry:

I don't know whether you saw the report of ABC News on Friday night regarding the suit that has been filed against myself and Warner Brothers regarding "Natural Born Killers", but I want to express my concern that we handle the suit in a serious and strategic way.

I believe that this suit, though wholly without merit, will gain both a great deal of publicity as well as a great deal of sympathy for the victim -- especially in Louisiana where it has been filed. I think that our legal approach has to be savvy -- not only in terms of the legal issues, but in terms of the media and political ramifications.

Rather than leave this solely to insurance company attorneys, I believe we must involve a prominent, First Amendment attorney to represent our interests in this matter. I would recommend Floyd Abrams, who was interviewed on ABC and in the Vanity Fair article and took a position that was supportive of our situation. He is perhaps the most prominent and respected (especially by the media) First Amendment attorney in the country. He represented The New York Times in the Pentagon Papers case.

I am sure that this suit is going to continue to receive a significant amount of media attention, and I would not be surprised if Bob Dole and others decided to weigh in as well. I think we must be prepared for the worst and arm ourselves accordingly with the best legal advisors possible. I hope you agree and look forward to hearing your thoughts.

Sincerely

Oliver

201 Santa Monica Blvd. ▲ # 610 ▲ Santa Monica, CA 90401 ▲ 310/395-0525 ▲ FAX 310/395-1536

linear narrative. **But visually, sonically, musically, cut for cut, it's much more aggressive, much more alienating, than anything Tarantino has ever directed. I've joked to people that this is the only thirty-plus-million-dollar experimental film I can think of that was released by a major studio.**

That is a high number, for an experimental film, basically, yes! *(Laughs)* I don't know that Warner Bros. knew what they had. They certainly didn't expect it, and they were not ready to sell it.

I think they were shocked and repelled by the film in some way, because of all the issues and controversies. And yet, in spite of everything, it made like forty-eight million dollars, and it did very well abroad.

But back to what you're asking: the idea behind it? Chaos. You have to remember what was happening in this country in 1991, '92, '93, with the Tonya Harding–Nancy Kerrigan thing,[70] and Lorena Bobbitt,[71] the woman who cut off the husband's penis, and TV coverage of the O. J. Simpson trial—I mean, I've never seen so much attention paid to a murder! It was a new kind of coverage.[72] I mean, I'd seen coverage of scandals in New York, there were all kinds of shootings, this, that, and of course it makes the *Post*, the *Daily News*, but this was a national sickness, this obsession with "did he or did he not do it?" "The black man did this, the black man did that." It was somehow revolting to me.

Why did TV news take a turn toward this sort of tabloid material, and bring it into the mainstream?

Network television sold the news out in the eighties, or whatever was left of the news. Before, it had been treated as a public trust, and there was supposed to be a Fairness Doctrine,[73] but that went out the window with Reagan. And there was an issue with [President and CEO Laurence] Tisch[74] at CBS, where he said, "Now the news has to make money. It's a new division. It's a profit-making division." It was never supposed to have that responsibility before. Now there was this feeling that news can no longer be for the public good, and now it was, *Fuck you, it's on us, we have to make money.*

It was a complete whoring-out of our civilization, which is what these kids [Mickey and Mallory] sensed. They were just disgusted and numbed by it all, and they were the product of a numbed-out civilization.

It's like that quote by Octavio Paz: "The ancients had visions, we have television" [END

14]. I wanted to spin this idea that Tarantino had started, about filming yourself, into something that would take on this new world that I was seeing around me. It was my homage to the end of American civilization as I once knew it.

And I wanted to make it a crime movie, on top of it. And make it a love story! And actually, it's one of my better love stories, because the truth is, I think. And I was criticized for it, because of course they get away with it. People were criticizing that aspect, but I said, "It is a love story and it doesn't have to end tragically, and I'd like to know that they're good people compared to the other 'good people' in the movie."

And of course, I got killed for that because the characters killed fifty-five people, or something like that; therefore, how could you say, "Well, look at society?" I'm saying, look at the cop, the prison system, this guy Wayne Gale. What's worse, you know? What's worse? Is it worse to kill people who actually fuck with you, or is it worse if you kill them spiritually, with what Wayne Gale does with the excretion that he mutters every night?

So this is a movie that's about an entire civilization of murderers, in one sense or another.

Yeah, spirit killers. The situation has gotten worse. A culture of confusion, distraction, and corruption.

Well, talking about destabilization, let's talk about the style. The very first sequence in the movie—which is one of the only sequences where it's a fairly faithful transcription of that original Tarantino draft, the diner scene—the grammar of it, the visual grammar of it, is very disorienting, because you start not with an exterior shot of the diner, which would've been the traditional way to start, but with a close-up of a television set. And the waitress is futzing with the television.

What's the first TV image?

In the film proper? It's *Leave It to Beaver*.[75]

Right.

And the image rolls, and we follow the waitress as she walks over, and then Mickey is revealed in close-up, Mallory is revealed as he's looking at her from across the room, and she's playing the song on the jukebox, and we don't get an establishing shot until like a dozen shots into the sequence. *Then* you cut to the exterior shot.

As a car rolls up.

Right. And there's a lot of this, sort of like . . . you know what they call "word salad" in print? You're almost making "visual salad" with this movie. The normal grammar that we are taught from a lifetime of watching movies and TV doesn't apply here. It's like you've thrown the alphabet up in the air.

We were in trouble from day one on that one. Did you know my three editors walked out on that scene?

No!

They'd had enough of this other editor, this brilliant guy named Hank Corwin, who

70 American figure skater Tonya Harding hired an ex-bodyguard to break the leg of her main competition, Nancy Kerrigan, in the 1994 Winter Olympics.

71 On June 30, 1993, Manassas, Virginia, resident Lorena Bobbitt took revenge on her husband, John Wayne Bobbitt, whom she accused of raping her, by cutting off his penis with a knife.

72 After being accused of murdering his wife Nicole Brown Simpson and her friend Ronald Goldman, former football star O.J. Simpson led police in a low-speed chase in his white Bronco that was covered live by every major broadcast network. The subsequent 1995 criminal trial, which ended in acquittal for Simpson, was covered for 134 days, and generated approximately 2,700 hours of national TV news coverage.

73 Policy introduced in 1949 by the US Federal Communications Commission, that required any holders of broadcast licenses to present contrasting views on a range of controversial issues of public importance and to do so in an honest and balanced manner (without mandating a strictly equal amount of time for each point of view, as was sometimes inferred). Abolished in August 1987, as advocated by President Ronald Reagan, after the FCC decided that the policy—which the Supreme Court held was constitutional but not mandatory—was an unconstitutional violation of free speech.

74 American billionaire; president and CEO of CBS from 1986 to 1995.

75 Popular American sitcom that ran from 1957 to 1963; starred Jerry Mathers as the title character, a young boy named Theodore "the Beaver" Cleaver, who had a number of adventures and mishaps around his neighborhood. The show was often pointed to as a prime representation of the ideal American suburban family.

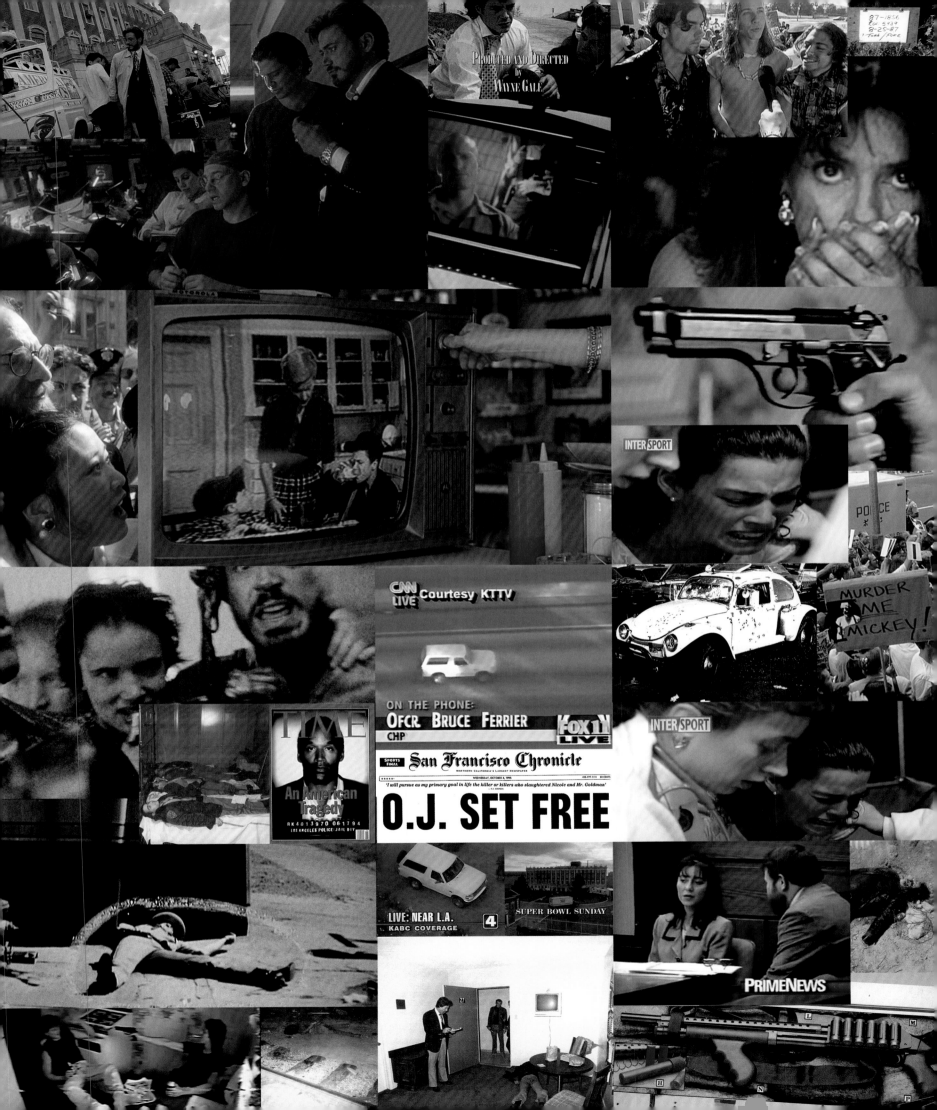

L E V E N S O N & H I L L

WARNER BROS.
SCREENING REPORT

JL

TO: Stu Gottesman SUBMITTED BY: Susan Clarke

FILM: NATURAL BORN KILLERS

CITY: El Paso

DATE: Tuesday, August 23, 1994 TIME: 7:30 p.m.

TYPE OF SCREENING: Radio promotional

PROMOTIONAL OUTLET: KAMZ-FM (AOR)

THEATRE: GCC The Park SEATING CAPACITY: 326

ACTUAL ATTENDANCE: 311 % OVERBOOKED: 275%

DEMOGRAPHICS (%):

% UNDER 18 20% WHITE: 40%

% 18-24 30% BLACK: 5%

% 25-34 30% HISPANIC: 55%

% 35-54 15% OTHER: 0%

% 55+ 5% WALKOUTS: 3

M/F RATIO: 40/60

600 North Pearl Street
Suite 910
Dallas, Texas
75201
214/880-0200
Metro
214/263-4145

P.O. Box 219051
Dallas, Texas
75221-9051

mp michael palver associates, inc./1800 peachtree st/suite 333/atlanta, georgia 30309/(404)586-8880/fax(404)351-2786

WARNER BROS. SCREENING REPORT

OVERALL RESPONSE: GOOD TO VERY GOOD

TO: STU GOTTESMAN SUBMITTED BY: DEBRA FALGON

FILM: NATURAL BORN KILLERS

CITY: ATLANTA, GA

DATE: 8/23/94 TIME: 8:00 P.M.

TYPE OF SCREENING: RADIO PROMOTION, PRESS AND WORD OF MOUTH GROUPS

PROMOTIONAL OUTLET: WNNX-FM

THEATER: LENOX SQUARE THEATERS SEATING CAPACITY: 500

ACTUAL ATTENDANCE: 475 % OVERBOOKED: 100 %

DEMOGRAPHICS (%)

UNDER 18: NONE WHITE: 90%

18 - 24: 45% BLACK: 10%

25 - 34: 40% HISPANIC:

35 - 54: 5% OTHER:

55+ : NONE WALKOUTS: NONE

M/F RATIO: 55 M / 45 F

WEATHER: CLEAR, BEAUTIFUL

REACTION: EXCELLENT:___ VERY GOOD: X GOOD: X FAIR:___ POOR:___

SCREENING REPORT

TO: STU GOTTESMAN/RON MACPHEE SUBMITTED BY: D. COPELAND

FILM: NBK

CITY: MIAMI

DATE: 8/23/94 TIME: 7:30 PM

TYPE OF SCREENING: RADIO/WSHE-FM

THEATRE: AMC SHERIDAN 12 SEATING CAPACITY: 495

ACTUAL ATTENDANCE: 450 % OVERBOOKED: 125%

DEMOGRAPHICS (%):

% UNDER 18 10% WHITE: 90%

% 18-24 60% BLACK:

% 25-34 20% HISPANIC: 10%

% 35-54 10% OTHER:

%55+ WALKOUTS: 50

M/F RATIO: 50/50 WEATHER: FAIR

REACTION: EXCELLENT___ VERY GOOD___ GOOD X FAIR___ POOR___

COMMENTS: RENE RODRIGUEZ OF THE MIAMI HERALD HAS NOW SEEN THE MOVIE FOR THE 3RD TIME. THREE OTHER HERALD CRITICS ATTENDED WITH HIM (INCLUDING MUSIC CRITIC). RENE SAYS HE WILL GIVE THE MOVIE 4 STARS THIS FRIDAY. ALL WALKOUTS SKEWED OLDER. MANY PEOPLE CLUMPED TOGETHER TO WATCH THE CREDITS INCLUDING THE OTHER CRITICS

(partial document, right edge)

...ARDS THE MOVIE –
...IT WAS KIND OF DISTUR-
...HE MEDIA DOES PORTRAY
... TO SEEING THE KILLING
...AS THE CONCEPT BEHIND
... THE SCENE WHEN THE
... THE ROOM WAS SICK'
... (OVERHEARD BETWEEN TWO
...?'

...RY/ATLANTA JOURNAL: BOB
... JOURNAL: BETSY PICKLE/
...ACH BUZZ': ARON SIEGAL/
... PATRONS OF

SLAY (communications inc.)

SCREENING REPORT

OVERALL REACTION GOOD

TO: Stu Gottesman SUBMITTED BY: Valerie Surico

FILM: NATURAL BORN KILLERS

CITY: PHOENIX

DATE: 8/22/94 TIME: 8pm

TYPE OF SCREENING: RADIO PROMOTIONAL

PROMOTIONAL OUTLET: KEDJ-FM (THE EDGE)

THEATRE: HARKINS CENTERPOINT SEATING CAPACITY: 383

ACTUAL ATTENDANCE: 360 % OVERBOOKED: 200

DEMOGRAPHICS (%)

% UNDER 18: 05% WHITE: 98%

% 18-24: 44% BLACK: 01%

% 25-34: 36% HISPANIC: 01%

% 35-54: 15% OTHER: 0

% 55+: 00% WALKOUTS: 2 MALE/FEMALE RATIO:

56male/44female

WEATHER: clear and 100 DEGREES

REACTION: EXCELLENT: 28% VERY GOOD: 18% GOOD: 15% FAIR: 21% POOR: 18%

Audience Reactions: Audience reacted to the following scenes: The TV show family. Demons inside them and face distortion. When Brigham Young rides across the plains on a white buffalo. When Mickey decides not to kill anyone on their wedding day. When beginning the prison riot scene and Mickey throws the doughnut and the guard drops it. Moans when chick is tied up in... hotel room. Malory sh...

and humping on TV. ...

"Sick, stupid and distur...

"A very different outloo...

"Not enough killing or ...

Phoenix Gazette, Ma...

Lovejoy KNIX-FM Co...

Angie Chuang -AZ Rep...

3550 N. Central, Suite 915 ▲ Phoenix...

NBK Martels

WB WARNER BROS.

Inter-Office Memo

To: NANCY KIRKPATRICK From: STU GOTTESMAN Ext:

Subject: "NATURAL BORN KILLERS" RADIO PROMOTED SCREENINGS

Date: August 25, 1994 Copies To: M. JOYCE, B. KUTCHER

Dear Nancy,

We held radio promoted screenings for "Natural Born Killers" in our A, B, and C markets this week with good results. Attendance averaged 90% and the reaction breaks down as follows:

Excellent Reaction	5 Screening
Very Good Reaction	12 Screenings
Good Reaction	12 Screenings
Mixed Reaction	7 Screenings
Fair Reaction	16 Screenings
Poor Reaction	3 Screenings
Total:	57 Screenings

Regards,

Stu Gottesman

DISTRIBUTION:

L. Anreder J. Jacobs
S. Blake R. Kallet
D. Buckley C. Kandel
R. Del Belso M. Murphy
L. Drazen B. Reardon
D. Fellman C. Samrock
S. Finkel N. Sams
R. Friedman

FRANK CHILLE ASSOCIATES
PUBLICITY, PROMOTION & PUBLIC RELATIONS

P.O. Box 307, Blackwood, NJ 08012
Telephone (609) 227-8425
FAX (609) 227-0074

MR. STU GOTTESMAN SCREENING REPORT

TO:

 SUBMITTED BY: FRANK CHILLE

FILM: NATURAL BORN KILLERS

CITY: PHILADELPHIA

DATE: 8-23-94 TIME: 7:30 PM

TYPE OF SCREENING: RADIO PROMOTION

PROMOTIONAL OUTLET: WMMR-FM

THEATRE: RITZ 5 CINEMA SEATING CAPACITY: 350

ACTUAL ATTENDANCE: 100% % OVERBOOKED: 50%

DEMOGRAPHICS (%):

% UNDER 18 5% WHITE: 85%

% 18-24 40% BLACK: 15%

% 25-34 25% HISPANIC:

% 35-54 20% OTHER:

% 55+ 10% WALKOUTS: 8

M/F RATIO: 50-50

WEATHER: WARM, CLEAR

REACTION: EXCELLENT:___ VERY GOOD___ GOOD___ FAIR X POOR___

COMMENTS: "I WOULD NOT PAY TO SEE THIS FILM"

"VERY ARTISTIC. THE BEST STONE FILM I HAVE EVER SEEN"

"WAY TOO VIOLENT"

"THIS FILM COULD CAUSE PROBLEMS"

"WOODY IS ONE HELL OF A GOOD ACTOR"

"I'M REALLY STUNNED"

It's like that quote by Octavio Paz: "The ancients had visions, we have television."

worked with me on *JFK*. Hank had been this really funny character. Odd, awkward, weird. He just didn't fit in with anybody. He could never work on a team. So he doesn't follow the same rules we do. We'd ask him to do it this way, he won't do it that way, he's too disorganized. But he was a brilliant commercial editor. We brought him in to edit, and from the beginning, he was tuned in to it! And the other three quit, to my chagrin. I worked with them again, all three—I'm not going to mention their names, they were part of my group, they'd been there a long time. And Bob [Richardson] was going insane at this point, too. I was going through a divorce myself, this horribly painful process with losing my child and my wife,[76] ██████████████████ ████████████████████████████ ████████████████████████████████ ████.[77]

Hank went on, and I brought other very talented editors on, including Brian Berdan.[78]

It was a mess to put that editing department together again, and maybe that's a part of the reason why it took almost a year to edit that film. It was a complicated edit. But Hank was always a prominent editor, the first editor, and I have to say he did a marvelous job, and he certainly had a vision of the world. He later worked with Terrence Malick on *Tree of Life*. I just want to give him credit, because I think he's amazing.

Also, Bob Richardson did an amazing job at working with Hank, myself, and the production designer, Victor Kempster, who is a lovely man, a very gentle soul. Victor was the assistant to Bruno Rubeo, who worked with me a long time.

That was an amazing partnership you had with Robert Richardson, maybe one of the greatest director-cinematographer pairings in American movies. What happened to make you stop working together?

Bob divorced me in '97 with *U-Turn*. Divorced me! That's our last film together. And I say that because he thought I was too violent! With *NBK*, the divide started to get bigger and bigger.

It started a bit on *The Doors*, the divide.

How were you crazy?

I remember one scene, it was like, a wedding scene in Malibu, it's in the film, in the montage. The fog set in and Bob really didn't want to shoot it, because the light was down. And I shot the fog for the wedding, and I put it in the movie, I liked it. But he refused to shoot it, walked away, which you don't do on a movie, and his gaffer walked away, too—his grip was very loyal to him. So . . . for me that was not a good thing, but I shot it with somebody else, and it's in the movie. Things like that sort of happened.

Bob had his own craziness, though, like on *Platoon* in the helicopter one day, he was almost suicidal with me. He was like, rocking the helicopter, he wanted to wrestle with me inside—it was crazy! And I have vertigo, so I'm not wild about helicopters. But he was fucking with me, stuff like that.

76 Stone filed for divorce from his second wife, Elizabeth, nee Burkit Cox, in 1994.

77 Redacted.

78 After apprenticing with David Lynch on *Blue Velvet* (1986), *Wild at Heart* (1990), and *Twin Peaks* (1990).

No blue screen tech.
Just overlap edges – let it fall where will. *OI – 3rd person*

② *corridor –*
a pass –
who are they?

Dear Oliver,

Short
with 3
projectors
same time

Stylistically there are so many ways to go on your upcoming film,
<u>Natural Born Killers</u>. What it comes down to is perception; how does
Mickey perceive the world, how do we perceive Mickey, the nature
of the interaction between Mickey and Mallory, etc. What I need is
some definition of how you see the story. Then, instead of spewing
out ideas, perhaps I can give you some valid suggestions.

③ *Mickey on cot.*
blue screen

Is the film is a farce. As in "Candide", is it an indictment of the
fractured nature of our times. Told satirically.

3 screens
Ⓐ *mall. Mallory father*
Ⓑ *house murders*
Mickey 4.

on one level
a dirty little
movie,
rough
and on
the level
do seq.

Voltaire or Jonathan Swift?

Maybe there has to be a magical element. Mickey and Mallory have
to be enchanted and bestowed with special powers. Do they have an
aura, as in Kirilian photography? Occasionally do they have visions
like Jerry Uselman's photography?

Ⓒ *Mallory*
sleeping in
cell (present)

Fisher Price
Toy camera 2.6 yrs
ago
P.D.Vicon –
gram size}
eyeballs
Video channel

When Mickey is in his cell writing to Mallory(p.19), where he's
reminiscing about their idyllic times together, we should either be
projecting different images against him, or doing in <u>camera double</u>
exposures.

One thing to examine. Can we explore the first person singular, that
is, Mickey's POV. And what would his POV be like? I see his
perception as being very quick and peripatetic. His free-associations
could be wondrous, perhaps even magical. This is as opposed to
portraying him as a plodding and methodical killing machine.

8t person –
were seeing him!
2nd – him.
seeing

If we stay in the third person singular, or plural, we as an audience
can only view the events with an unrequited sense of horror. Magic
dies and numbness remains, soon to be followed by boredom.

new monitor +
rephotograph it
in 35 mm off
monitor
30 x 60
ROM video.
multiple screens
split screen
Mickey Mallory

Unlike <u>Reservoir Dogs</u>, there doesn't seem to be realistic character
development in this script. Both Mickey and Mallory are almost
cartoonish in their outlooks. This is not a bad thing necessarily, But
as an editor, it seems to me that we have to know whether we're
going for pathos or bathos. That sort of stuff

his life like on
his level
pure love
to keep for her
next page.

And then there's Mallory. She seems to be blessed with super-
human strength, as well as being a bit of a dingdong. How did she
develop these endowments? Did she receive them from Mickey?

Mickey + magical visions – a totem.
(a snake)

– something
before
associated with X
on before violence.
synapse.

– glow around Mallory – (pull
another neg – an IP – blowup
by Mallory.)
X Kirilian photog.
– Eyeball – 3 screens

① eyeball - center screen. 3 screens
before violence.

Let's briefly discuss technique. If we want to highlight a scene, perhaps we should be thinking in terms of the planes of action. If Mickey is reminiscing wistfully in his cell, this might become the principle plane of action. Perhaps we create a translucent mortise of his eyeball in the center of the screen.

TOTEM Mallory

And juxtaposed next to the eyeball is Mickey's perception of Mallory. Perhaps he sees her as life-giving blood running through a vascular system, or maybe she's his little kangaroo rat. Or a bird.

Prospero's Books?

I like the idea of translucence, with the density values determined by the relative importance of each plate.

what she's thinking is in frame —

As in JFK, I would recommend using multiple formats, including 65mm, which might, in some instances, make for real trashy juxtapositions with Super 8.

density would control what see.

If we use a center screen mortise, perhaps the background and the foreground action should be opposed to each other.

face on page?

Another idea is to use rear-screen and front-screen projection. Project Mallory's smiling face next to a projection of some macro of her killing her father. Overlapped by a projection of Mallory in her father's home movies. Etc.etc.

in camera double + triple exposures

The problem is, Oliver, that I'm not sure of the tone of the piece, so I can't help figure out what the juxtapositions would be. You know, pathos or bathos...

I'll be in LA starting tomorrow (Tuesday) for about a week. I'll call the office and set up an appointment with you. If you want to talk sooner, you can reach me at home there at
(310) 455-4265.

Man
Face
The page across his face —
(different density)

Regards,

Hank Corwin

IXTLAN

April 4, 1994

Richard Heffner
MPAA
1133 Avenue of the Americas
32nd floor
New York, NY 10036

Dear Dick:

The following are the specific areas of "Natural Born Killers" addressed in response to the screening for the MPAA on March 23.

Opening Café Fight

Removed second punch after Mallory breaks bottle out of dancing cowboy's hand.
Removed Mallory breaking plate over cowboy's head.
Removed full shot of Mallory kicking cowboy in groin.
Removed rapid cuts of face and groin kicks after cowboy falls over railing.
Removed first shot of Mickey knifing older cowboy which most looked like he was cutting his throat, rather than his chest.
Replaced two close-ups of knifing with one WS black and white, which has more of a comedic tableau tone.
Recut female cook's death with cartoon-like humor (bullet stops in front of her).
Trimmed following shot of blood hitting wall.
Trimmed sequence of knife through window to not show knife in cowboy's back.
Trimmed shot of Mallory jumping on cowboy's back.
Trimmed shot of Mallory breaking cowboy's neck (offscreen action)
Trimmed shooting of waitress with coffeepot. Substantially shortened screams.

Killing Mallory's Parents

Replaced sound effect of Mickey's first face hit to sound like slap, not punch.
Removed sequence where Mickey hits Dad in face as he stands against wall.
Replaced sound effect of Mickey hitting Dad on back to sound like slap.
Trimmed shot so as not to see Mickey hit Dad in the head in fish tank.
Removed gloating closeup of Mickey saying "Hi mom!"
Removed two shots of Mickey spraying Mom with lighter fluid.
Trimmed remaining shot of Mickey spraying Mom.
Replaced intense area of music track with more cartoon music.

Detective Scagnetti Murders Hooker

Hooker no longer removes her bra to minimize connection of sex and violence.
Trimmed closeups of strangling on bed.

Mickey Shoots Pharmacist

Trimmed first shot of Pharmacist getting shot.
Removed second shot of Pharmacist getting shot and falling to floor.
Removed shot of blood hitting mirror.

Police Capture Mickey and Mallory

Removed first close shot of Mallory being hit across face.
Removed Scagnetti loudly saying "fuck you" to Mickey as tazer men run forward.
Removed closeup of female cop kicking Mickey.
Trimmed WS of beating of Mickey
Removed Scagnetti's "Beat that motherfucker's ass"
Trimmed MS of Mickey on ground

Prison Riot First Begins

Trimmed tail of guard being brought down into washing machine.
Removed shot of closing washing machine door, losing him beginning to spin.

Mickey's Shootout in Interview Room

Replaced MS of guard being shot to remove squib explosion.
Trimmed woman shot against wall to remove squib and fall (from 50 to 18 frames).

Scagnetti Maces Mallory

Removed two closeups of Scagnetti yelling and macing.
Removed MCU of Mallory writhing on the ground.

Mallory Stabs Scagnetti in Neck

Removed one (of doublecut) of Mallory stabbing Scagnetti.
Trimmed remaining shot.
Trimmed head and tail off Scagnetti grabbing his throat as Mallory leaves him.
Removed later CS of Scagnetti grabbing throat.
Replaced shot of Scagnetti on ground after kissing sequence with less graphic shot.
Trimmed three shots of Scagnetti struggling before he is shot by Mallory.

Prison Riot

Trimmed tail off shot of guard thrown in oven as door closes- no struggling.
Removed one shot of couple on couch watching television.
Trimmed shot of guard thrown off railing.
Removed flash cut of demon.
Removed prisoner beating hanged guard.
Removed prisoner beating another guard.

He was a wild man, too, and I liked that, because we're both wild, and when we hit it, we were dancing, it was great, because we knew each other's steps. I'd push him, he'd push me, I'd push him, he'd push me. OK?[79]

So . . . well, on *NBK* he criticized the script. He didn't want to do it. He thought it was a pointless script, immoral, and so forth. He said it was evil, I remember some word like that, something evil about it. And it was: It had evil in it, it was not some phony dualistic movie, it was what I felt. But he didn't feel that, and I had to talk him into it. It took some doing.

I worked on the script with Richard Rutowski and David Veloz.[80] Let's put it this way: Once I read the script and we bought it, I always had a tearing-down plan, and I assigned certain sections out, because I was working still on *Heaven & Earth*. So David came in, and I think he punched out one of the first rewrites. The sitcom idea, *I Love Mallory*, grew out of this thing that he did.

Tell me about Richard Rutowski.

Richard was always a presence in my life, very Buddhist, very natural, what do you call, beatnik?

He has been described as your procurer.

Well! I liked him, because he was always fun to be with. I always thought of Richard as a fifties beat, like a guy who had been there before me, one of those California beatniks, a Jack Kerouac type, definitely that Jack Nicholson feeling. Somehow older than me, and definitely wiser in the ways of the world. Richard hooked up with me for a few years, and was a good partner, and we were close, no question about it. And of course, many women crossed our paths.

And so you and Veloz and Rutowski got the script where you wanted it, and you shot the movie. What was that like? I heard it was wild.

I was going through a divorce, so it was freeing—a letting go of the skin, too. I'd been carrying film after film after film, financial obligation after obligation, and so many people were approaching me; you have no idea the amount of devouring that goes on when you have success of that order and you're relatively naive about it. If you'd been a Spielberg you have more experience with having a team around you, but I was still trying to figure out who the best people were for me. There were a lot of questions, and people were using my name to try and make deals without kind of . . . you know, people use you. That's just the nature of things.

So I was losing the layers of a snakeskin, so to speak, and I was feeling a new freedom, and in that freedom was chaos, a lot of chaos. I'm talking about, obviously, my amorous life, which was insane.

There were a lot of reports all over the media and in *Killer Instinct* about drugs on the set.

No, no—drugs on the set are not a good idea.

I did cocaine on *The Hand*. I did it in the back room here and there, and I will say this—I've never said this before—but I saw the deleterious effects that it had, and crew members did, too. So when I quit cocaine

before writing *Scarface*, I really quit, and cold-turkeyed it, and I never went back. When you're doing research for a script like that, you have to do it when somebody offers it to you, otherwise the people with the knowledge you want won't trust you; but once I got beyond that, no, that was basically it for me.

You know, people use you. That's just the nature of things.

I'll tell you the honest truth: On *Natural Born Killers*, I smoked grass off set in my own private time, when I wanted to, and there may have been a few pills, but not many. There was definitely psilocybin. But that was only on special occasions. Indian stuff, peyote stuff, as

79 In a 2012 interview with BlogTalkRadio, Richardson spoke of the extremes to which Stone would push him. He said he broke his hand during the shoot and suffered a black eye "the size of a golf ball" while shooting the prison riot sequence of *Natural Born Killers* when his camera slammed into a cell door, driving the camera's eyepiece into his eye socket. "Oliver looked at me, and he just started laughing. . . . I was so fucking pissed off at him! I said, 'Give me a goddamn knife, let's slice [my eye] and let's shoot. And they slit it. And I shot."

80 Veloz was brought in by *Natural Born Killers* coproducers Jane Hamsher and Don Murphy to rewite Quentin Tarantino's script to incorporate Stone's changes. He went on to adapt the Hollywood drug memoir *Permanent Midnight* (1998) and the survival drama *Behind Enemy Lines* (2001).

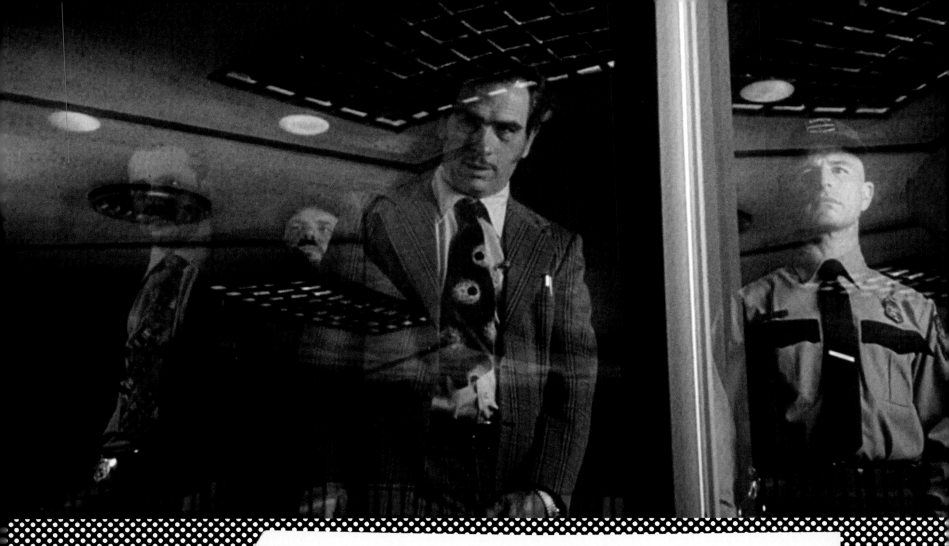

cont. (2)

2) Rotating knife is mounted on matte box of camera to
 provide "over the shoulder" on the knife as it tra-
 vels thru the window, breaking it. For travel beyond
 the window, either the camera must be mounted on a
 boom extending in front of the dolly, or the wall
 around the window must be removed and the window glass
 supported on C stands

3) Knife on wire imbeds in Earl's back. Knife will not be
 rotating. Good only for instant of impact and beyond.
 ½ knife on wire.

BALSA WIRE

PRONGS O
TO STICK INTO BALSA
PLATE IN EARL'S BACK

Mabel shot thru coffee pot: Breakaway coffee pot, partially
full, squibbed, wire up her arm. Blood bag squib bullet
hit on her.

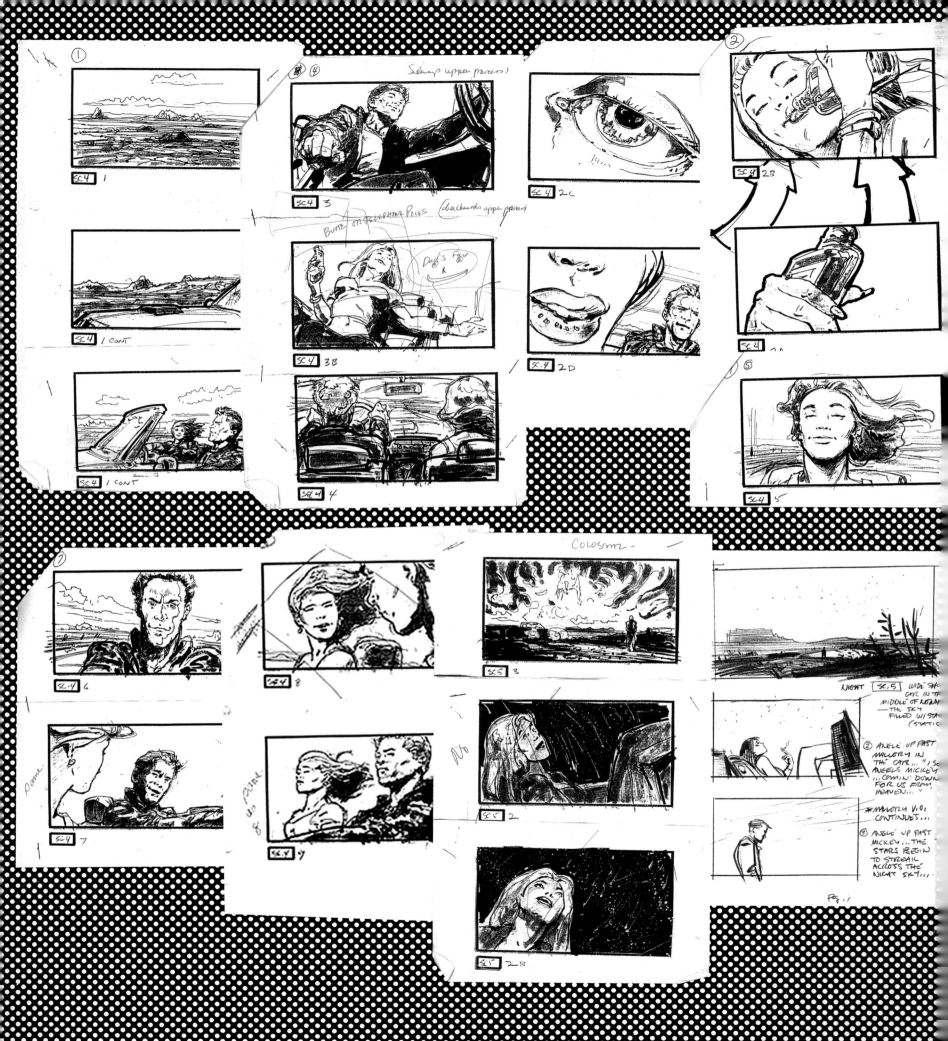

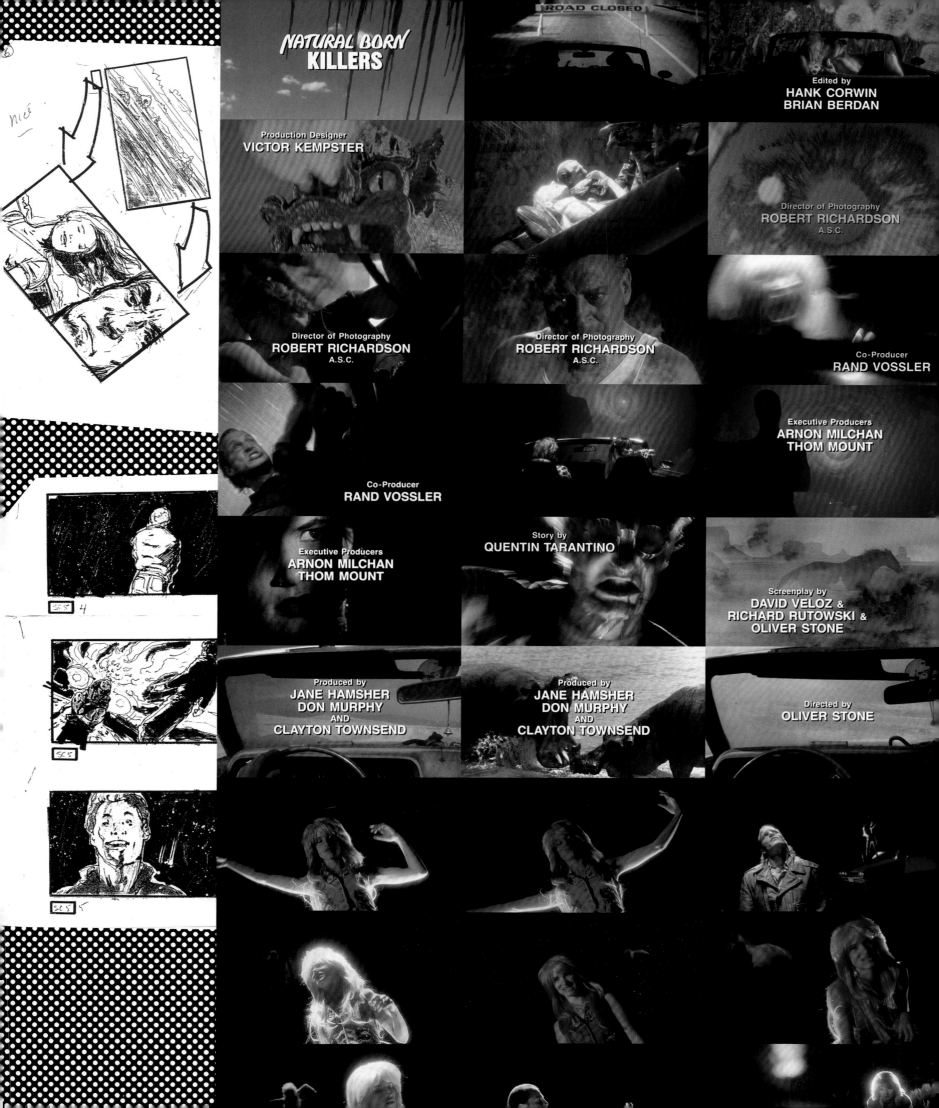

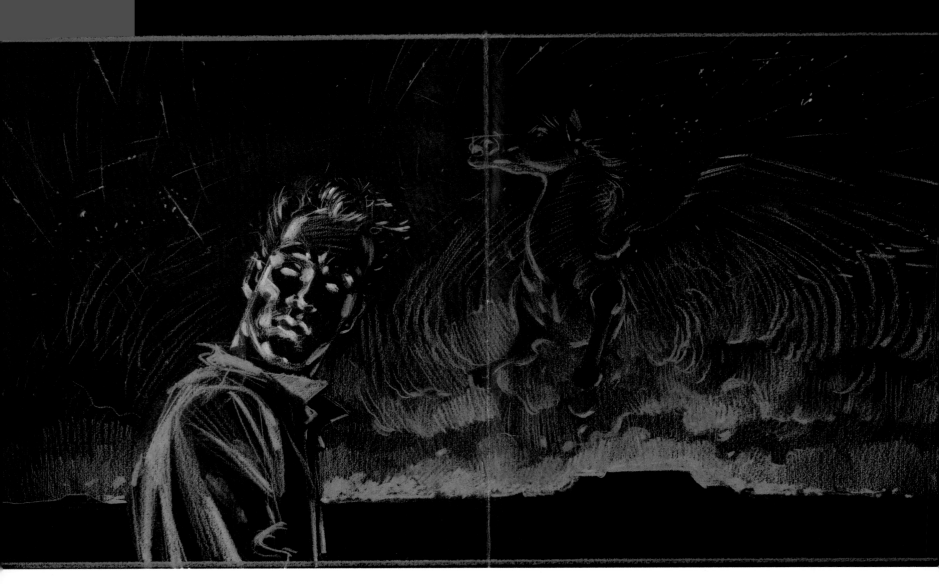

well as mushrooms—sure, mushrooms, what, are you kidding me? We had a mushroom scene in the movie! How could I do a mushroom scene without knowing about it? *(Laughs)* But I'd done a few mushrooms at that point, not a lot. But this is not on the set!

But when I'm on the set, I'm fucking directing a movie, in whatever it was, fifty-four days, and it's a very complicated movie, and I'm trying to keep focus, so if anything, I'm the most sane person there, trying to rat-catch five actors who are pretty crazy! You know, they're like cats in the same cage. I mean,

every one of them is an interesting character, and different. Everything was shot sober, but this feeling that they were all on something came from within each of these characters.

Robert [Downey Jr.] had his own off-camera issues later. He was fun during the shoot. He was always a party animal. I had no problem shooting with him. I loved him **[END 15]**. I loved Sizemore, he was hilarious! His problems got worse later, not with me **[END 16]**. And I loved Juliette [Lewis].**81**

Woody [Harrelson]**82** was pretty normal, except he was crazy-normal, insofar as he loves

grass—we all know that—and yoga. And he loves natural gas! And he always would tell fart jokes, and I hate fart jokes! But he was always cracking me up. Woody would come onto the set and he'd have this yogurt face, like *(imitates Harrelson)*, *Hi, buddy, how's it going? You taking good care of yourself today? You do the natural thing, you know?* And fucking Juliette would go, *SHUT THE FUCK UP!* Smoking a cigarette. She loved everything artificial and unnatural, stayed up all night, and was tense, and Woody's Mr. Relaxed! But they were playing lovers, so it worked.

Why did you think a guy who was best known for *Cheers* and who had just been in *White Men Can't Jump* was the right guy to play a murderous hillbilly psychopath?

Juliette has added approximately 4.235 lbs of muscle to her already lean frame. Since her body weight has essentially stayed the same, we can conclude that she has lost some body fat. This is recognized in the fact that some measurements are smaller. With continued training, we can improve on these impressive results.

If you have any questions or comments, please feel free to call me at ▮▮▮▮▮▮▮▮

Sincerely,

▮▮▮▮▮▮▮

81 1973– ; insinuating, wickedly funny leading lady and rock singer; *Cape Fear* (1991), *What's Eating Gilbert Grape* (1993), *Strange Days* (1995); voice of "Juliette" in *Grand Theft Auto IV* (2008).

82 1961– ; Woody the bartender on *Cheers* (1984–93); *White Men Can't Jump* (1992); *The People vs. Larry Flint* (1995); *Kingpin* (1996); *Rampart* (2011); *True Detective*, season one (2014); the redneck Olivier.

19 original

18

9

27

Frankly, he had that American, trashy look. There's something about Woody that evokes Kentucky or white trash. For me, there was no question about him. And Juliette, despite her accolades in *Cape Fear*, I felt could pull off white trash, too. Juliette has malice in her eyes. She's got adorable eyes, but they jump and they gleam.

I just felt they were right. They didn't feel like they were upper-class people.

Did you know Woody Harrelson's dad had been a hit man when you cast him?

I knew that at some point in time, that he'd killed that judge, yeah [END 17]. I knew that, I think other people knew that, but I have to say, it certainly worked in Woody's favor for that role, because I believed there was an element of criminality to him.

And he had that great smile. It wasn't used right in *Indecent Proposal*: too sweet, too bland. Woody's not bland. He's got a smile of a wicked baby, you know?

And Russell Means![83] He was a cool, cool guy, but he also had a reputation as a tough guy. I know he was with the American Indian Movement. He came from a whole tradition that was about not trusting the white man.

Did you know we couldn't shoot the scene with Woody and Juliette and Russell Means on an actual Navajo reservation because we were doing peyote in the scene with the snakes? That was a problem, because the whole scene with Russell Means is based on that, the idea of magic mushrooms, peyote.

Did you hire a snake wrangler?

Oh sure, several! We had rattlesnakes, but unfortunately they were nice creatures. I was terrified of having to work with them, but they

83 Russell Charles Means (1939–2012) was a Native American activist and actor who was a prominent member of the American Indian Movement (AIM). He was involved in many well-publicized protests for Indian rights, including the seizure and occupation of Wounded Knee, South Dakota, by AIM members and two hundred Oglala Lakota supporters for more than two months in 1973, following the failure to impeach tribal president Richard Wilson on corruption charges. Means began his acting career in 1992, appearing in Michael Mann's historical romance *The Last of the Mohicans*. He was also the voice of Pocahontas's father in the Disney film *Pocahontas* (1995).

307

sewed up their mouths, which I'm sorry about, but maybe that's the way it was done in that time. They ended up falling asleep anyway because it was two o'clock in the morning, and it was so cold on the floor of the desert that we'd put the snakes on the ground and we could walk through them without exciting them because they were asleep. So we ended

following its own internal logic. Like the whole peyote sequence in the teepee: the lead-up to that, where you see the flock of sheep, and there's that one sheep that looks like, I don't know what . . . like, these strange horns coming out of its head?

The ram, yeah.

Well, that was more choreographed.

Even the way it forms a question mark as it's falling?

No—that, you can't control. But that happens in movies. That happens when you get an actor, props, whatever, the wind that day, the light, and there are magic moments, and I think that's the gravy, that's truly the gravy. If you have a good script and you've prepared, you get those magic things that happen like you just described.

Woody's not bland. He's got a smile of a wicked baby, you know?

up putting rubber snakes in and wire as much as possible. We had real snakes and rubber snakes, so we created the illusion of a lot of them, and some of the snakes were active, but certainly the one Russell handled that day would've been a live snake, and that was a wired snake. I mean he had his mouth shut, but that was definitely a snake.

When you describe *NBK* to me, you have certain things that you keep hitting on, like the idea of the satire, and the bankruptcy of the media, and the sort of soul-murder of society. Those are all present. But I also see a very mysterious, intuitive, dreamlike kind of film, like David Lynch makes, and like the kind of film that one of your heroes, Luis Buñuel, used to make, where it's

And the music that's playing, and the expressions on Mickey's and Mallory's faces. I was really moved by it. That caught me by surprise, and I don't know why I was moved.

How do you produce effects like that? Those aren't coming from the politics or the messages or the satire. I feel like they're coming from someplace deeper.

That kind of thing can't be planned in the script, no. That's associative editing. We were shooting Super 8 mm out there in the desert and we caught a moment.

There's a lot of that sort of thing in the film: caught moments. Like on the bridge, where you see the wedding veil falling into the canyon.

Mallory has a line in the teepee scene where she says, "There are no accidents, Mickey."

You're talking about the unconscious, which is always there. I run into Robert Downey Jr. or Woody Harrelson or Juliette Lewis and I'm excited to find an outlet through them. They become stand-ins for my unconscious desires. It's what your children are, in a sense: your unconscious desires. So you pour into them what you think is your conscious side, but what's coming through is also your unconscious side.

I've had vivid dreams recently, in the last year or two, vivid. Which is a good thing, I suppose.

Essay

The World Belongs to Savages

The Oliver Stone Crime Film

Michael Guarnieri

Oliver Stone is best known for political films like *JFK*, *Born on the Fourth of July*, and *Nixon*—movies that attempt to take the major symbols of late twentieth-century history and reconfigure (some would say revise) them into epic tales of the battle for America's soul, putting these events into the framework of recognizable genres. The Kennedy assassination becomes the basis for a suspenseful murder mystery. The Vietnam War is the setting for a young man's journey from innocent to victim to hero, using Frank Capra–esque conservative iconography for leftist, subversive purposes. Watergate becomes the act of hamartia that leads to the downfall of a president in the tragedy of Richard Nixon. "Political filmmaker Oliver Stone" is still a common construction on editorial pages as well as in film sections. So is "provocateur Oliver Stone," because he is a polarizing figure with incendiary opinions on current events as well as history.

There is another way, however, of looking at Stone that's less common, but in some ways more revealing: as a crime filmmaker.

I'm going to talk about four films here. They are 1983's *Scarface*, a Brian De Palma film from an Oliver Stone screenplay, and three Stone-directed features: 1994's *Natural Born Killers*, written by Quentin Tarantino and rewritten by Stone; 1997's *U-Turn*, adapted by John Ridley from his novel; and 2012's *Savages*, adapted by Shane Salerno, Don Winslow, and Stone from Winslow's novel. All differ wildly in setting, subject matter, and origin (though all were adapted from another source, whether it be a novel or a previously published screenplay). They all exhibit a tremendous amount of connectivity in aesthetic and worldview. They are violent and appallingly funny, and suffused with cynicism and paranoia, and they have a different tone and point of view from Stone's overtly political movies.

Still, there's a lot of overlap between Stone the political filmmaker and Stone the crime filmmaker. That's because his political dramas are subsets of the crime film, only the political dramas tell of the crimes that

go unprosecuted. It's just as Kevin Costner's Jim Garrison tells the courtroom in *JFK*, quoting the Elizabethan John Harrington:[1] "Treason doth never prosper. What's the reason? For if it prosper, none dare call it treason." The connection between these two types of filmmaker, and the contrast between the two, becomes clear when you watch Stone's political films through the prism of his crime films, which are much smaller and bleaker and, in stark contrast to his political films, largely devoid of hope.

Stone's political films are fearful of the sabotage of the democratic process on behalf of a powerful and influential elite, and of the encroachment on peace and prosperity by the military-industrial complex. In films like *JFK* and *Nixon*, black-suited men sit in dark, smoky rooms and plot the future of the Western world, conspire to feed lies to an unsuspecting public, and order invasions and assassinations the way most people order coffee. Such Stone films do not end in unambiguous triumph. Clay Shaw is found not guilty of assassinating President Kennedy and walks free. Ron Kovic finds his purpose in life as an antiwar activist, uncovering the ways in which ideology turns idealistic Americans into compliant soldiers in questionable wars, but there is still much work ahead of him. Nixon leaves office, but "the Beast" that put him there is still active. But the point of view is ultimately idealistic, even quixotic. Stone wants you to come away from the theater feeling invigorated, convinced that something can be done. At the end of *JFK*, Jim Garrison walks off toward sunlight, head unbowed, while the following text rolls on-screen: "Dedicated to the young, in whose spirit the search for truth marches on."

Stone's films about street-level crime lose the idealism. Their bleak nastiness is as foreign to most mainstream American films as the explicit political consciousness of other Stone movies. *Scarface* and *Savages* are about drug dealers; *Natural Born Killers* is about murderers; and *U-Turn* is a sunbaked noir about a man asked to kill for cash. They're united by their conviction that no one is making it out alive, and it's a fool who tries.

Consider *U-Turn*, about a gambler and crook (Sean Penn) whose car breaks down in a Southwestern town. He entrusts the car to a questionable mechanic, various mishaps prevent him from leaving, and he becomes entangled in a plot that involves murder and incest. In the final scene, having outlived both the femme fatale he adores (Jennifer Lopez) and the repulsive husband (Nick Nolte) who hired him to kill her, a badly injured Penn makes his way to his car and gleefully starts the ignition—only to find that the radiator hose has burst yet again, leaving him stranded and bleeding in the desert. The film's closing moment is the defining image of Stone's crime films: a pack of hungry vultures eyeing a dying and bloody Penn. You may outlive your enemies, but at the end of the day, you're stuck in a car that ain't movin', and soon you'll be lunch.

In *Scarface*, the gangster protagonist rises to the top of Miami's drug game by killing every rival and superior who stands in his way and alienating everyone he cares about. In the end, Tony Montana is truly at home only when he stands alone in his mansion, firing round after countless round at his attackers. Every major character dies, and very bloodily. As the smoke clears, and a pool of blood forms around Montana, a neon sign mocks his character's ambition, and the very idea of ambition, ironically proclaiming: THE WORLD IS YOURS.

Stone's screenplay makes a notable departure from the 1932 original by having its "hero," who in both incarnations dies in a hail of bullets, meet his end at the hands of rival dealers, not the police. In Stone's world, the representatives of law and order have no hopes of taking down Tony. They might not even exist. The police are largely absent from Stone's crime films, and when you do meet them, they're corrupt. In *Natural Born Killers* they're either killers themselves, like Tom Sizemore's prostitute-murdering detective, or sadistic, buffoonish martinets like Tommy Lee Jones's prison warden. Powers Boothe's small-town sheriff in *U-Turn* is an easily duped stooge. In *Savages*, John Travolta plays a corrupt, paid-off DEA agent who protects a pair of drug dealers in exchange for money, then swoops into a deal to position himself as a media hero.

It's important to note, however, that these aren't "heroic outlaw versus evil copper" stories. The criminals in Stone's films are vicious, even sadistic, and have no impetus for their crimes other than an all-consuming greed and hunger for more: more money, more drugs, more blood. The drug cartels in *Savages* are shadowy, unrepentant, ruthless killers with a taste for the theatrical. They will decapitate people just to make a point, and they seem to derive special pleasure from forcing people to push beyond their own established boundaries for committing violence. When Taylor Kitsch and Aaron Taylor-Johnson, beach bums and pot dealers, try to make a deal with the cartels, they're forced to show their trustworthiness by torturing and immolating, while he still breathes, a lawyer. It is a nasty, hard-to-watch scene. No one comes out of it looking good.

Benicio Del Toro's cartel hit man, Lado, might come closest to summarizing the film's worldview in one scene late in the film. Throughout the film, Lado has been training a young protégé in the ways of murder. Near the climax, Lado tells him with a shrug, "It didn't work out. You're too sensitive," and shoots him.

There is no room for kindness in Stone's crime movies. Nice people won't even make it to the climax. The world belongs to the savages.

These films contain more cruelty than even jaded audiences tend to be capable of handling. The characters of Stone's crime films are vicious, nasty, self-interested, sadistic, and above all, cruel. When you compare them to the characters presented in the crime films of the most acclaimed cinematic poet of American gangsterism, Stone's old teacher, Martin Scorsese, Stone's characters come off far worse. A closer examination reveals why.

In *Mean Streets*, the central character is a guilt-ridden, morally conflicted small-time criminal, and the characters around him are, at worst, stupid and impatient. In *Goodfellas*, Henry, the narrator, never kills anyone and is mostly just too lazy to get an honest job, while his mentor, Jimmy, and his bosses kill out of self-preservation from prosecution, and for business reasons. Their behavior is ruthless, but the audience understands it. Only Tommy, Joe Pesci's scene stealer of a trigger-happy crook, kills for seemingly irrational reasons, often from insecurity. The portrayal of gangsters in *Casino* is similar to that of *Goodfellas*, although the criminals have more power and money and greater aspirations. *Gangs of New York* features a young orphan seeking revenge for his father's murder, a motivation that most Hollywood films present as heroic. In *The Departed*, cops battle gangsters, and some of the cops are corrupt and some of the gangsters have admirable qualities. In all of Scorsese's gangster films, there are moments of extreme sadism, but we always know why they're happening, and they makes sense in the context of the world the film has created. A mailman in *Goodfellas* gets his head shoved into a pizza oven because the crew doesn't want truancy notices being delivered to then-young Henry's house, and a clubhouse waiter named Spider gets his toe shot off because he was disrespectful to Tommy. In *Casino*, Robert De Niro's casino boss takes two men into a back room and breaks one's hand and squeezes another's head in a vise until one of his eyes pops out. It's horrific, but they shouldn't have tried to cheat the house.

Oliver Stone's criminals are scarier, more mysterious, and more infuriating—they are often people who enjoy killing. They kill with a smile. They kill to bring others down to their level. They kill for no good reason. They kill because "murder is pure."

It's easy to see why audiences trained to react to certain values and forms of morality in provoked and safe responses would find films like these to be beyond our traditional sense of reason. *U-Turn* and *Scarface* are filled with unimaginable brutality, as well as moments that encourage us to see ourselves in the criminals, to cheer when they triumph over their enemies, and to laugh when they let themselves be deceived and bleed for their dumb mistakes. The films roll credits with most of the main characters having shuffled off this mortal coil, but there is no sense that good has won and balance has been restored to the universe, because the universe consists, as Stone has described *U-Turn*, of scorpions in a bucket.

Natural Born Killers and *Savages* offer something even more disturbing: a seeming conviction that every human being has the capacity to be coldly greedy, sexually vicious, sadistic, even murderous, and that for some people, it's normal. Such people can terrorize, torture, rape, and kill people and still experience friendship and love. The films don't merely present such behavior; they often seem to show us the world through the eyes of people who behave that way—through savage eyes.

Mickey and Mallory, a pair of married serial killers who drive around the country committing mass murders for no particular reason, accidentally kill a Native American healer, which sparks introspection and regret about the path they've chosen. Then they have to kill even more people to escape from prison and chase the possibility of a better future. At the end, they finish off Robert Downey Jr.'s slimy TV reporter by assuring him that they'll spare one victim—his camera. Over the credits, the lovers are seen driving an RV around the country with a brood of kids, while Leonard Cohen's song "The Future" plays. "I have seen the future, brother," the lyric goes. "It is murder." Do Mickey and Mallory, who say that they have "evolved" to the point where they perceive murder to be pure, really intend to spend the rest of their life living as a kind of Partridge Family for the Jerry Springer age? Are they a new breed of humans who exist in a realm beyond our mere mortal capacity for understanding? Do we not even have the vocabulary to talk about who they are and where they're going? This ending is deeply disturbing, and by Hollywood standards, baffling. It seems like the sort of happy ending that mass murderers might imagine for themselves.

Likewise, *Savages* turns bourgeois morality on its head, and slices it from crotch to chin. Ben and Chon share a mutual girlfriend, nicknamed O, who gets kidnapped when they decline an offer to sell their weed business to a Mexican cartel. All three go on a journey through darkness, getting in touch with the ugliest and most evil parts of themselves. Ben—a pacifist and Buddhist, like Stone—allows himself to become a murderer to get back the woman he and his best friend love equally. O, who narrates the film, initially presents us with an ending in which all three characters get pulled into a literal Mexican standoff and die, beaten and bloodied, in each other's arms. Then O and Stone reveal that what we saw is not what happened, but O's fantasy. The real

ending is Ben and Chon getting arrested by the US Drug Enforcement Administration, spending a few weeks in jail due to their status as confidential informants, then moving to an unnamed Third World country with O and living, as she puts it, as "savages": "cruel, crippled, regressed back to a primal state of being." The film closes over shots of the trio living out on the edge of the world, in a seeming tropical paradise, while O's narration intones: "One day, maybe, we'll be back. For now, we live like savages. Beautiful savages."

Is this a true escape? What does it mean when O says that the first ending was just her "imagination"? Was it a hopeful imagining, or a fearful one? In the last scene, O doubts if three people can remain equally in love forever, hinting that perhaps one day Ben, Chon, and O will drift apart, and their love, the one pure thing in the film, will die. Is that truly preferable to the three perishing in each other's arms? Is it better to end up like Tony Montana than Mickey and Mallory, or Ben and Chon and O? Stone leaves us wondering, and the inscrutable look that the actress Blake Lively, as O, gives the camera at the end leaves open many possibilities.

These films are impossible to evaluate within the moral framework provided by most commercial Hollywood features, even most crime movies. The chainsaw scene in *Scarface* has been the bane of the squeamish moviegoer for more than thirty years, and its hero's boastful and profane maxims are still emblazoned on posters and T-shirts, quoted in rap lyrics, and burned into flesh via tattoos. I saw *Savages* twice in theaters, and both times I could sense the audience becoming progressively standoffish and even hostile to the film, particularly during the torture and immolation scene, which showed the alleged heroes acting like villains.

In *Chinatown*, the villain Noah Cross tells the hero that in the right time and place, people are capable of almost anything. Stone's crime films accept this as a given. That's why they're so hard to watch. The casualness of death and the sheer pervasiveness of cruelty are subjects few filmmakers ever try to deal with, and Stone's attitude is one that few filmmakers take: that this world is a world of natural born killers and hungry vultures. You might find your place of tranquillity, your peace at the center, however briefly, but there will always be vultures circling the canyon, and it's their world, not yours.

1　　　Sir John Harington (also spelled Harrington) (1561–1612); courtier, author, translator, and member of Queen Elizabeth I's court; also the inventor of the flush toilet.

313

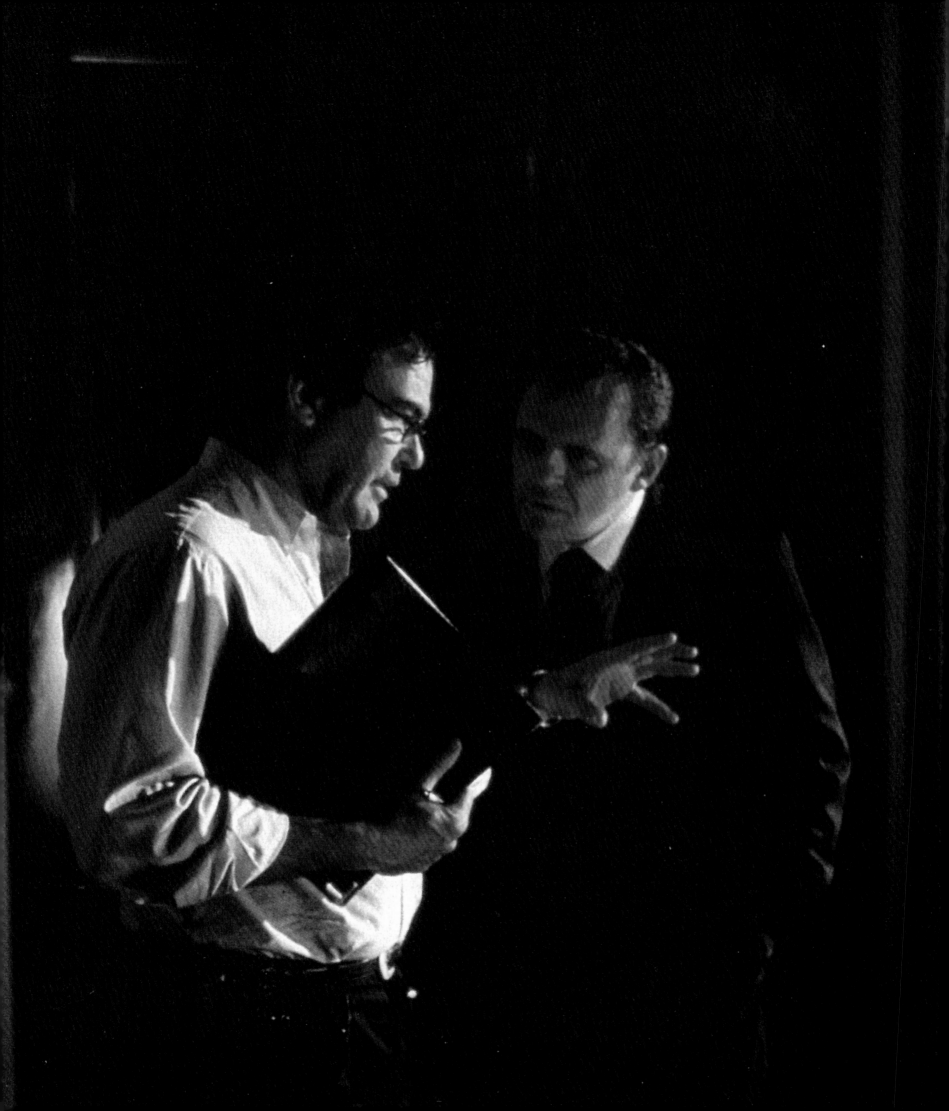

★ ★ ★ ★ ★ ★ # Darkness ★ ★ ★ ★ ★ ★

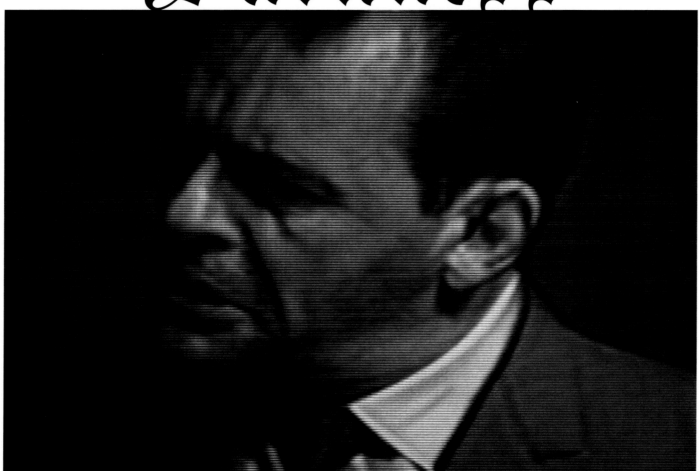

(previous spread) Oliver Stone and Anthony Hopkins on the Oval Office set of *Nixon* (1995); taken from the interior of a "For Your Consideration" booklet sent out to members of the Academy of Motion Picture Arts and Sciences.

(above) Anthony Hopkins as President Richard Nixon in the Kennedy-Nixon debate sequence of Stone's biographical drama.

Nixon **is one of Oliver Stone's greatest films, and the one that marks the end of his ten-year, ten-film streak.** A sprawling amalgam of *Death of a Salesman*, *Citizen Kane*, Freudian psychoanalysis, and fifty years' worth of headlines and transcripts, it feels less like a biography than an autobiography, colored by Richard Nixon's paranoia and self-loathing. Its opening scene finds the Watergate burglars preparing for their fateful break-in at the Democratic Party's Washington headquarters while watching a training film about how to be a good salesman (a true-life detail, Stone says). The prelude hints at what's to come: a dark drama about a man of substance who was uncomfortable in his skin, enslaved by influences and impulses that his repressive conditioning wouldn't permit him to investigate, and determined to overcome them by repackaging himself, until the public finally realized that he was always the same needy, destructive liar. Anthony Hopkins sounds only faintly like the real Nixon, but his skill at playing repressed men (including the butler in *Remains of the Day*, the role that inspired Stone to cast him) delivers something deeper than a superficially accurate impersonation. He brings a pained awareness of the man's limitations to every scene. This enriches an epic biography bookended by Nixon's nadir: his resignation on the cusp of impeachment.

The movie's empathy for Nixon surprised everyone. It was presumed that Stone, a counterculture sympathizer

whose Vietnam service coincided with Nixon's rise to the White House, would skewer the man as a panderer to red-state reactionaries, a demagogue who pursued power for power's sake, and an enabler and exemplar of the military-industrial complex. Yet the movie is no hit job, as evidenced by the sequence that follows Nixon's oddly psychoanalytical China trip with a harshly editorializing account of the Christmas bombing of Hanoi that no early seventies broadcast news outlet would have allowed. This newscast, like all the newscasts in the film—indeed, like the whole of *Nixon*—doesn't present itself as "the News," but as a naysaying chorus that Nixon hears in his mind.[1] When he reads a newspaper or watches TV, it's as if he's seeing what Nixon *thinks* the world thinks of Nixon. In the sequence following his defeat in the 1962 California governor's race, we enter the room with Nixon, then feel his frustration as he gives what he wrongly believes will be his final speech. As he talks, Stone cuts to reporters transcribing Nixon's emotionally naked statements, and newsreel cameras seeking to frame Nixon as unflatteringly as possible, even zeroing in on his signature upper-lip sweat.

Nixon's mind is a Freudian stew. There are idealized flashbacks to his Quaker upbringing, showing how he idolized his older brother (Tony Goldwyn) and mother (Mary Steenburgen) but feared his disciplinarian father (Tom Bower). We sense that Nixon absorbed their prejudices, aspired to their clarity—and remembered their admonition to never give up, no matter what.

The "reality" of Nixon's life is often overlaid with, or interrupted by, still photographs, headlines, or footage from newsreels or TV cameras. Sometimes these elements reduce his accomplishments to historical footnotes, as if Nixon is thinking, "Nobody will remember how long I worked to do this, only that it happened." We're inside Nixon's head as he tries to make a case for himself, while trying and failing to suppress his fear that journalism—the first draft of history—has already diminished him through pop psychoanalysis, leftist posturing, and petty cruelty. The film re-creates Nixon's 1960 presidential debate with John F. Kennedy, whose good looks, charisma, and TV makeup made Nixon look like a moist troll. The premature death of Nixon's older brother is conflated, in Nixon's imagination, with the killing of John F. Kennedy, a man whose star quality seemed a reproach to Nixon's very existence. That JFK's star was snuffed so quickly only amplifies Nixon's feelings of unworthiness. The free-floating

guilt he feels over the assassination (and perhaps over his own brother's death—could JFK's death represent the fulfillment of a horrible secret wish?) is confounding; but because this is a film by Stone, the director of *JFK* and an increasingly psychoanalytical dramatist, it is also expected.

Stone theorizes that the eighteen minutes Nixon removed from his White House tapes confirmed the president's role in the creation of a national security state, referred to as "the Beast"—a monster that he endorsed for patriotic reasons, but which grew out of control, killing JFK and subjecting America to a version of the trauma Nixon felt at losing his brother. The gap on the tape is Nixon's own Rosebud. Stone, to his credit, leaves its exact meaning as mysterious and irreducible as that of Charles Foster Kane's own talisman.[2] It's a pretext for free association, for fantasy—for Nixon's, and Stone's, dreams and nightmares of America.

The images of Nixon taping himself, then claiming as he listens to the recordings that he never said this or that, and running the tape back as if to reverse and then rerecord history, are Stone's storytelling in microcosm. There's a gap between what Nixon said and did and what he wishes he had said and done; between Nixon's aspirations to greatness and the verdicts of the media, the public, and history. The essence of Stone's approach is telegraphed by an image in the prologue—a slow tracking shot around a projector, ending with the bulb shining into the viewer's eyes. The film is multi-planed projection: Nixon projecting his goals and fears onto America, and America returning the favor.

In the arc of Stone's career, *U-Turn* bears the same relationship to *Nixon* as *Natural Born Killers* did to *Heaven & Earth*: It's a deep dive into crime, violence, and scathing satire, following on the heels of an introspective, tenderhearted biography. Which is another way of saying that it's an attempt to make a somewhat more commercial film than the one that preceded it, as insurance against studios writing him off as uncommercial. It's filled with touches that fans had come to associate with the Oliver Stone Film: the whirling and tilting and plunging camera; the rapid cutting between film stocks, with inserts that suggest a filmic equivalent of parenthetical details in a novel; the merging of personal psychodrama with satire, mythology, and dream images; the soundtrack mixing orchestral music and pop songs with an editorial bent.[3] *U-Turn* was only slightly more successful at the box office

than *Nixon*, a film that made Stone persona non grata as a big-budget director; in retrospect, its story of a maimed pariah fleeing Los Angeles only to suffer and die in the desert feels like a prophecy of Stone's forthcoming period of wandering the showbiz wilderness.[4]

Time has been kind to *U-Turn*, though; in fact, for a "disappointing" film, it sure does show up on a lot of lists of essential Stone films—deservedly so. For all its gore and cruelty and desperate screwing and superheated film noir and pulp thriller flourishes, it is ultimately a comedy about the universe's indifference to our wants. Stone directs as if channeling the children in the opening of *The Wild Bunch*, watching a scorpion fend off wave after wave of ants and then setting the whole pile ablaze.[5]

The drifter hero, Bobby (Sean Penn), keeps trying and failing to escape a miserable little Arizona town while romancing Grace (Jennifer Lopez), wife of Grace's snarling, cowboy-hatted husband, Jake (Nick Nolte), and getting drawn into a series of half-assed criminal plots. Bobby plays so many angles that his desperation becomes a running gag. Somewhere around the halfway mark, *U-Turn* becomes a sunburned American counterpart to a classic by one of Stone's favorite directors, Luis Buñuel: 1962's *The Exterminating Angel*, about dinner party guests who can't leave the house and end up devouring one another.

U-Turn's screenplay, adapted by John Ridley from his novel *Stray Dogs* and substantially rewritten by Stone, is part film noir, part western, part shaggy-dog joke. It is serene in its bleakness. There is no comfort in the movie, no mercy, no hope. The thirst for redemption that fuels many of the film's characters, and ties *U-Turn* to other Stone pictures, becomes a sick joke here.[6] Stone's characters can't win for losing, and they're mostly so scummy that they probably don't deserve to win anyway. The movie's unexpected yet somehow welcome spiritual undercurrents (Jon Voight's blind Native American seer; time-lapse shots of scudding clouds; vulture's-eye views of tormented antagonists) mark it as a twisted religious picture. The flashbacks to Bobby's beating and disfigurement by L.A. loan sharks feel like visions not merely of the past, but of a past life. Bobby doesn't realize it yet, but he's in Superior, Arizona, to reinvent himself. Some of the other characters—including Grace, the dimwit lovers Toby N. Tucker (Joaquin Phoenix) and Jenny (Claire Danes), the sheriff (Powers Boothe), and even Jake—are all reaching for their own version of redemption, one that lies tragically beyond their grasp.

Penn was only thirty-seven when he acted in *U-Turn*, but he carries himself with such despairing cynicism that the character seems ancient. Lopez was twenty-eight but reads as much younger—a curvy half-Mexican, half–Native American Lolita whose soul has been abraded by her secret. The only parts of the film that aren't hideously funny are the scenes between Bobby and Grace (whose name is so loaded that it, too, plays as a joke). Ennio Morricone's score slows down whenever they're together: Its woodwinds seem to inhale and exhale like lovers reveling in each other's presence; at times it seems to be moaning, or sighing. The characters' mutual intoxication gums up what might otherwise have been a rote, James M. Cain[7]–style narrative of a small-town femme fatale entrapping a big-city stud. Like the relationship between Mickey and Mallory in *Natural Born Killers*, this relationship feels so true to the lived experience of attraction that it confounds the film's cartoonish stylizations. Monsters need love, too.

Stone's final studio picture in the 1990s, the NFL football drama *Any Given Sunday*, is in many ways the most conventional movie of his career. It includes almost every cliché of the sports film genre, and because the movie is unified by its obsession with change and evolution, it collects more than you expect. The characters are laid out in old guard/young guard juxtapositions. The brilliant, volatile, fifty-something head coach of the Miami Sharks, Tony D'Amato (Al Pacino), who prizes intuition and improvisation, but is being forced out over too many losses; his heir apparent, cool-headed offensive coordinator Nick Crozier (Aaron Eckhart), is an affable company man who works out plays on a laptop. There's a veteran quarterback, Cap Rooney (Dennis Quaid), who's too beaten up to keep playing but stays on the field because he fears what'll happen once he leaves it, and a showboating younger quarterback, "Steamin'" Willie Beamen (Jamie Foxx), who must learn humility. There's Harvey

Mandrake (James Woods), an experienced team doctor and company man, who lets injured players play because he wants his championship bonus, and an internist named Ollie Powers (Matthew Modine) whose ethics incline toward whistle-blowing. In the skybox, we have Christina Pagniacci (Cameron Diaz), who inherited the Sharks from her dad and has the will to restore the team's greatness, but must struggle to be taken seriously in a testosterone-soaked league. Looming over her is the crusty old league commissioner (Charlton Heston), who never liked Christina or her team and sabotages her maneuvers. This helmets-and-shoulder pads ensemble rewrite of *All About Eve*[8] climaxes in a championship that the Sharks win by working through their animosities and finding common ground.

Within this nearly machine-tooled storytelling template, Stone and his coscreenwriters sneak aesthetic and narrative surprises, and inject elements that connect sports movie fantasy to sports page realities. Drawing on several books and voluminous research, the script deals with medical ethics; corporate sexism; racial tension between black and white players, and the differences in their cultures; the back-scratching and palm-greasing required to keep a local team local; and the skybox Machiavellianism that pits league executives, team owners, coaches, and players against one another in a fight to control what happens on the field. The supporting cast blends actors and athletes in a way that lets one type of artist legitimize the other: Foxx, Quaid, and rapper-actor LL Cool J share screen space with former New York Giant Lawrence Taylor and the great Jim Brown, who was nearly as significant to movies as he was to football.[9] The players' wives and girlfriends are among Stone's toughest, fieriest women. Lela Rochon, Lauren Holly, and Elizabeth Berkley know the men better than they know themselves, and they brook no bullshit. Ann-Margret briefly appears as Christina's mother, a giggling, poodle-toting eccentric who knows nothing of football after all these years, and whose coquettish passivity represents everything her daughter is rebelling against.

The film is overstuffed and overreaching—an electric jumble of bone-rattling hits and scabrous humor, scored to rock and rap, and loosely woven around a series of big games, wild parties, and private moments of doubt and despair. Its nearly three-hour running time feels like two if you share Stone's interest in minutiae, six if you hate his style or don't like the sport. The photography (by Salvatore Totino)

and editing (by a four-man wrecking crew) pushes *JFK*'s everywhere-at-once aesthetic into yet another direction. The cutting enriches the film's *Godfather*-like fascination with an old era continuing to resonate even as it passes from living memory. When Willie and his coach discuss race relations and gridiron philosophy, Stone flash-cuts to sepia-toned images of their football ancestors (all white); roiling thunderclouds and lightning strikes (the football gods shaping mortal destiny); and scenes from *Ben-Hur* (likening the players to gladiator-slaves, and the team owners to masters). It's bizarre and wonderful: Jean-Luc Godard doing *North Dallas Forty*.[10]

1 Stone: "This is an interesting reading, and I'm not going to argue with you if that's what you got out of it. But it's like what I told you about the editing in *JFK*: I'm grateful when people read some deeper strategy into it, but at the time I was just thinking, 'How can we pack as much biographical information about Nixon as we can into this movie without it being eight hours long,' and the 'news' montages were one way of doing that."

2 Lucy: "'Rosebud' was his sled." Linus: "Aaugh!" Charles Schulz, *Peanuts*, December 9, 1973.

3 The opening song, "It's a Good Day"—performed by Peggy Lee and Dave Barbour and His Orchestra—might be the sickest of Stone's sick musical jokes, considering that *U-Turn*'s hero is driving toward his final resting place.

4 Stone: "OK, you're doing it again here, the find-the-biography-in-the-work thing, but this time you're not totally wrong."

5 On p. 347, Stone refers to *U-Turn*'s characters as "scorpions in a bucket."

6 The film features a shot of a scorpion resting in the mouth of a tap water spigot.

7 James M. Cain (1982–1977) was the author of influential hardboiled novels, many with a strong component of forbidden sexuality; *The Postman Always Rings Twice* (1934) and *Double Indemnity* (1943) both tell superheated tales of a dissatisfied wife who wants her husband dead and entices a cynical lover to help kill him.

8 In Joseph L. Mankiewicz's backstage comedy-drama, a scheming young actress (Ann Baxter) plots to dethrone and replace a Broadway legend (Bette Davis), who's already self-conscious enough about her age.

9 For more on Brown's legacy, see pp. 360–62

10 Director Ted Kotcheff's 1979 adaptation of the novel by Peter Gent, about a fictional Dallas Cowboy–type football team in the 1970s. Has many storytelling similarities to *Any Given Sunday*, including an emphasis on the players' off-gridiron partying, and a central conflict about whether sports is a pursuit and a physical art or a business that can be scientifically quantified and improved. "Every time I call it a game, you call it a business. And every time I call it a business, you call it a game," a player (Jon Matuszak) tells a coach (Charles Durning).

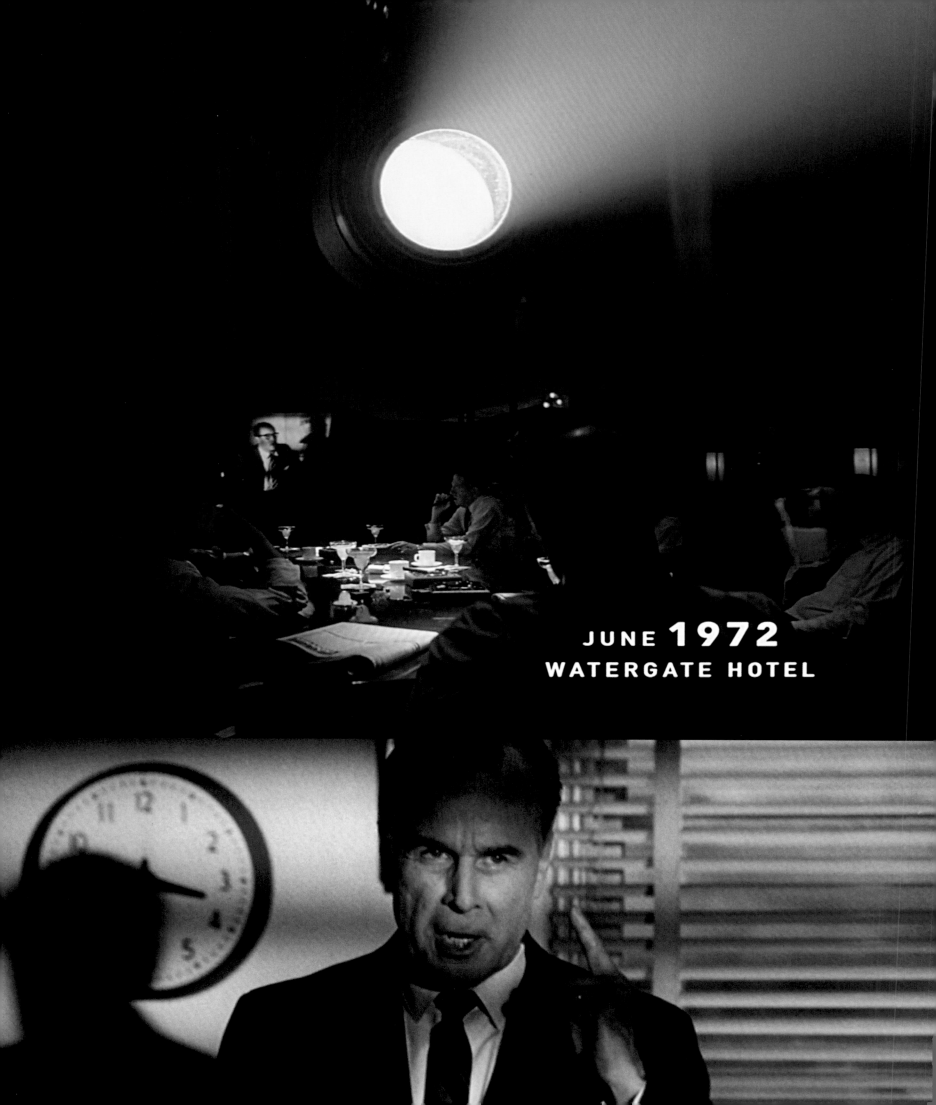

JUNE **1972**
WATERGATE HOTEL

MATT ZOLLER SEITZ So: *Nixon*.

OLIVER STONE It was doomed, this movie. Here's a white guy with all these other white guys, bad haircuts, bad suits, sitting around in rooms talking! I was fucked! *(Laughs)* I had success with *JFK*, but this film didn't have the kind of action that *JFK* did, with all those gangsters and crooks. And Richard Nixon was not the same kind of man that John F. Kennedy was.

There's a line that Nixon says, in the scene where he looks up at the statue of Kennedy: "When they look at you, they see what they want to be, and when they look at me, they see what they are." It's one of many instances where you take observations that journalists and historians have made *about* your characters and put them in the characters' mouths. You told *Film Comment* in 1996, "That was never said in Nixon's lifetime, but it was suggested by Tom Wicker in his 1991 book *One of Us: Richard Nixon and the American Dream*. It's a complete invention. It's beautiful. It brings out the 'man on the street' side of Nixon, his many frustrations."

Well, Wicker's right. Nixon embodied everything bourgeois and Main Street, Sinclair Lewis, *Babbitt*,[1] about America. The bad, small, isolated, anti-Communist, crazy America. Absolutely right.

opens with G. Gordon Liddy[5] and his men preparing for the Watergate burglary, and what are they watching? A documentary about salesmen.

That's the larger story in *Nixon*, the salesman's story.

You could have called this movie *Life of a Salesman*.

You know, they really were watching a business film like that before the burglary. I don't remember why, but I didn't make that detail up. I read the reason somewhere, and it's bizarre.

they thought. We were frayed. Nixon presented himself as the bourgeois. Adolf Hitler came along like that in his own way in Germany. I'm not saying Nixon is exactly Hitler, but Hitler said, *We have to get our pride back, we're being destroyed economically every which way, pride, German pride!* That's what Nixon sort of said: *We can be good again!* Every politician does that: sells pride.

He embraced the concept of the silent majority, and his people were the architect of the so-called Southern strategy,[6] which went hand in hand with that.

The hippies scared the nation.

The movie's about people like that, who unironically believe in "sell, sell, sell" and "get ahead" and "fight, fight, fight" and "never give up" and "you can do anything if you put your mind to it," and it's about how those mantras are serving the people who secretly and truly run things, people who've rigged and manipulated the system and all the people living and working in the system. This is a subject that's been explored in a lot of classic American films and plays and novels, including *Death of a Salesman*,[2] the documentary *Salesman*,[3] and *Glengarry Glen Ross*.[4]

What do you think? It's a cliché, but a true one, no?

It is true, and it's also the American story, and you kind of establish that right up front. Your movie

Even Eisenhower had problems with Nixon, right? Eisenhower was very cold with him.

And yet, despite this, Nixon almost won the presidency against JFK in 1960. Then he challenged the incumbent California governor Pat Brown two years later and lost. And then he was sort of exiled into the wilderness. Then he came back six years later and won the presidency. Then four years later he won reelection—and on the basis of what, do you think? Not charisma?

Nixon won the presidency in 1968 because the situation got so disastrous under his predecessor, Lyndon Johnson, that he could position himself as the alternative, the law-and-order candidate. The hippies scared the nation. Vietnam was tearing apart the social fabric,

1 1922 novel in which the title character, a small-town realtor, Babbitt, expends a great deal of energy trying to be a noncomformist—even dabbling in socialist politics and having an affair—only to return to his middle-class lifestyle.

2 Arthur Miller, 1948; stage drama about the mediocrity and moral failures of a middle-class salesman.

3 1968 documentary by Albert and David Maysles about door-to-door bible salesmen.

4 David Mamet, 1984; New York City real estate salesmen undercut and destroy each other in a sales competition.

5 Chief operative of Nixon's "plumbers"; convicted of conspiracy, burglary, and illegal wiretapping for his role in the Watergate scandal; remade himself as a campus speaker and pundit in the nineties, then a radio host.

6 Republican party strategy, refined in the sixties, to sway once-solidly Democratic white voters in the former Confederate states by stoking racist sentiments with "dog whistle" euphemisms.

321

Horrible. I mean, we're still living that, aren't we?

You were pro-Nixon when you were younger, though. We talked about that: At NYU film school, you were a closeted Republican.

Well, that's oversimplifying it a bit. I don't want to give people the wrong impression. I was torn between rebellion and conformity at NYU. I'd been more sympathetic to my father's values a few years earlier. When Nixon was Eisenhower's vice president, I was for Nixon, in the 1960 election, like my father. But I didn't know shit. I was too young to vote, my saying I was for Eisenhower and Nixon was just a reflexive gesture toward my father. He was a conservative who preferred Eisenhower to Nixon, but didn't question Nixon's authenticity or his anti-Communist

credentials. That was business America: Kennedy was seen at that time as a newfangled liberal, kind of fucked with businessmen. My father and his friends were businessmen. They were the kind of guys who'd watch a football game with suits on. My father was a Republican who didn't like Democrats because he thought they were always antibusiness! That's what you call the Roosevelt curse.

But then, look: In '68 it was confusing. [The Democratic presidential nominee] Hubert Humphrey was known as a "wimp" because he'd been a sheepdog for Johnson, so how could you vote for Humphrey? And there was just nobody else the Democrats could've run, as far as I know!

I wasn't in the country the first time Nixon ran for president, in '68. I wasn't paying close attention. Before the election itself, I was con-

fused. If I'd registered and had the ability to vote, I would've voted for Nixon in '68. Maybe he really had a plan to end this war like he said he did! I didn't know what I wanted!

At NYU we protested Nixon, but that was later. By '70, at NYU, after the Cambodian invasion [END 1], we went after Nixon for sure. It wasn't about politics as much as I was shaken by my classmates' radical ideas, you know? When I got there, I wasn't buying yet that people were underprivileged. I'd been with the guys in Vietnam, but I never understood the economic structure I'd inherited from my father.

Why did you dedicate *Nixon* to your father?

I felt there was something in this character of Nixon that drew me in, and I figured out it was me identifying Nixon with my father. I

felt like I knew him in some way, that I'd lived with him in my life.

Maybe a part of me was in Nixon, too. I think in all of us, there's a low-self-esteem, external blamer—a guy who is paranoid about certain things. It's true about everybody to some degree. But Nixon was super-paranoid, and I didn't realize how crude he was until I heard those tapes later on.[7]

Let's talk about the tapes for a second, and in connection with that, Orson Welles's *Citizen Kane*, which is a movie that obviously means a lot to you. Your fondness for *Kane* comes through very strongly in *Nixon*, where you photograph the White House like it's Xanadu.

The gap in the tapes seems to be Nixon's Rosebud in the context of this movie: the absent presence that's driving our curiosity. We watch the movie thinking: *What's on the tapes?* We wonder if it'll explain the source of Nixon's paranoia, his guilt—if it contains the key that will explain him to us, the way the reporter in Welles's movie hoped that Rosebud would explain Kane.

Is that driving the movie, you think? The gap?

I think it is. You keep seeing the tapes rewinding and playing and rewinding and playing.

Going in reverse.

And at one point, Nixon listens to himself on tape, captured by a recording system that he installed himself, and insists, "I didn't say that!"

Yeah, that was a funny scene!

What about the scene where Alexander Haig, played by Powers Boothe, says, "Sir, you talked about opening up the whole Bay of Pigs thing again . . . on that June 20 tape, the one with an eighteen-and-a-half-minute gap. . . . You mentioned it several times. Sooner or later they're

|||

I'd been with the guys in Vietnam, but I never understood the economic structure I'd inherited from my father.

|||

going to want to know what that means." And then he suggests that bit wasn't really deleted, that maybe there's a second tape.

Haig's purpose here is to tell Nixon, "It's over—get out, because unless we pull off a military coup, you can't stay in power."

He's trying to put the fear of God into Nixon in this scene, and then he hands him the resignation. And Nixon can't even look at the paper.

That's right.

Do you think there was really a second tape, or that somebody has copies of the tapes?

They were always taping something in that White House. Don't you think people make copies of tapes? I don't think the eighteen and a half minutes were just deleted by Rose Mary Woods.[8] I think there's another copy. I really do.

Really?

Yeah. In that vast archive, in the cloud that never will come out.

In the opening of the film, you have a newsreel, like in *Kane*, and then the shot of the palace, the haunted castle: the White House, Richard Nixon's own Xanadu. And the music's almost like horror film music, like Bernard Herrmann's score for *Kane*. And you've got a shot where the camera travels through the front gate that's sort of your version of Welles's shot craning up over the gates of Xanadu.

How did we do that shot? I don't remember exactly. Obviously there's an optical in there. We couldn't shoot at the real White House. And obviously it's bold, as you know. It's a *Kane* shot. The White House is a castle. Like a dark castle. I love the opening.

And then you've got these tilted angles, and those very low angles, and the harsh shadows, like something out of a German Expressionist film. All the White House stuff is very German Expressionist–film noir–Orson Welles.

Also the Russian silents. There's a lot of Sergei Eisenstein in there—in the editing but also just the look.

7 When the House Judiciary Committee, which investigated the Watergate scandal, ordered the president to hand over the contents of the White House's audio tapes, Nixon gave them transcripts in which instances of profanity had been replaced by the phrase "[EXPLETIVE DELETED]." The president could also be heard making racial, ethnic, and anti-Semitic comments.

8 Richard Nixon's fiercely loyal secretary from 1951 until the end of his political career; claimed (but was generally not believed) that she was inadvertently responsible for deleting a crucial portion of a tape secretly recorded in the Oval Office early in the cover-up of the Watergate scandal.

Ivan the Terrible?[9]

Absolutely. We even painted the ceilings.

The scene late in the movie where Nixon and Kissinger go down to pray together is one of the funniest and saddest scenes you've directed.

"Pray with me, Henry."

Where did that scene come from?

Kissinger mentioned it, and it was written about in *The Final Days*,[10] among other places. Obviously we interpreted what was going on in the prayer. We don't really know what it was like. It could've been, I guess, an innocuous supermarket prayer: "God help this country." But I don't believe that. In any case, it's a good moment dramatically.

The sense of humor in the film is often absurdist. I wonder how much work you had to do to make it absurd?

Not much. A lot of the lines are taken from real dialogue.
 I want to tell you something that annoys me: the people who say, *It plods like a biopic*. It's the opposite of a traditional biographical film! It's the most structured of all my films, except maybe for *Alexander*, and the structure is intricate. For instance, you might start with the tapes in 1973. And then you might slip back to the 1960 election with Kennedy, then back to the 1930s where he's courting

Pat. So by that point we're in a third-stage flashback. We're operating on three levels.

There seem to be moments where Nixon remembers remembering things. We also see flashbacks to when he's growing up in Whittier, California, and those are in black and white.

I thought the black and white was well used, and I loved Mary Steenburgen[11] as Nixon's mom, and I thought Tom Bower,[12] who played his father, Francis, was very good, too. I like the concept of the two brothers becoming intertwined in Nixon's mind with the Kennedy brothers: His brother Harold, the Tony Goldwyn[13] character, whom Nixon idealized, and who died of tuberculosis when he was twenty-three, became John F. Kennedy in his mind, later in time. The younger brother, Edward Nixon, became Robert Kennedy.
 Robert Kennedy would've run against Nixon if he hadn't been assassinated. Robert would've beaten him in '68, most likely. There's no question in my mind that Nixon thinks he benefited from the deaths of his own two brothers as well as from the deaths of the Kennedy brothers.

And you've also got this theme likening what was happening in the US in the early sixties and early seventies to the Civil War just over a century before. I didn't even notice it until I watched the film again before this interview, but you've got the shot in one of those early scenes, a close-up of the portrait of President Abraham Lincoln up on the wall, who was also himself assassinated

|||

Nobody's written about the structure.

|||

during the Civil War, and as we dolly in on that, Nixon is talking about "the violence, the tear-gassing, burning the draft cards" and so on. Then, later on, in a moment of doubt, Nixon visits the Lincoln Memorial, and he talks to an antiwar protester. That period from about 1965 to Nix-

9 Two-part historical epic about Ivan IV of Russia; Sergei Eisenstein released *Part I* in 1944, but *Part II* didn't get released until 1958 because Soviet Premier Josef Stalin was offended by the filmmakers' portrayal of Ivan as a ruthless destroyer of his enemies. Eisenstein wanted to make a *Part III*, but its production was halted after Stalin banned *Part II*. The films' meticulous repetitions of symbols and patterns is a clear inspiration on *Nixon*, which often returns to Nixon's tape recorder, paintings and sculptures of JFK and Abraham Lincoln, and various architectural and propaganda motifs.

10 1976 nonfiction book by *Washington Post* journalists Bob Woodward and Carl Bernstein that looks at the final months of the Nixon presidency.

11 1953– ; *Melvin and Howard* (1980), *Miss Firecracker* (1989), *What's Eating Gilbert Grape* (1993), *Elf* (2003), *The Help* (2011).

12 1938– ; *Die Hard 2* (1990), *Georgia* (1995), *Pollock* (2000).

13 1963– ; *Tarzan* (voice; 1999); *The Sixth Day* (2000); *Romance and Cigarettes* (2010); President Fitz on *Scandal* (2012–).

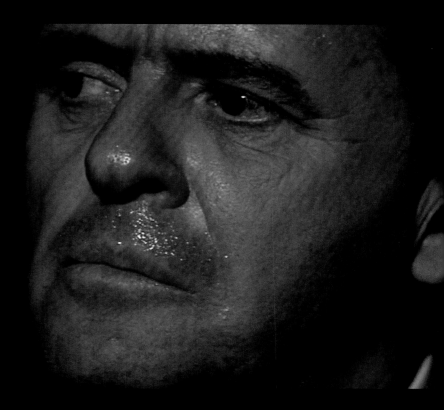

on's resignation is treated here like it's a second Civil War, but without as many shots fired.

You're drawing a lot of parallels here. Nixon versus Kennedy is, in a metaphorical sense, brother against brother, which is how people described the Civil War. It's a real dip into the primordial American unconscious. It's very complex.

There's some truth to that. It's an amazingly structured film! Nobody's written about the structure. But if you think the movie works, the structure of the script, which I wrote with Christopher Wilkinson and Steven J. Rivele,[14] is really something. The problems were enormous, but you realize how bold it is.

The flashback to the Kennedy-Nixon election takes us back to the '60 defeat, to Joan Allen[15] [as Pat Nixon] the night he loses, and then it takes us into the past. Then we come back into the middle of '62.

You also use shifting film stocks again here, a technique you embraced in a big way on *JFK*, then used to somewhat different ends in *Heaven & Earth* and *Natural Born Killers*. I think in some ways your use of it here might be your subtlest, because it's used in an almost completely interior way, to explore the contents of one man's mind, or life. You really feel like you're seeing a person's psyche dropped and shattered like a glass orb, and the pieces are all over

the screen. The *Entertainment Weekly* critic Owen Gleiberman, who chose *Nixon* as the best film of 1995, wrote: "More than any director before him, with a turbulent, hallucinogenic style [Stone] has captured the violent free-associated rhythms of a jagged, feral modern mind."

Yeah, yeah. . . . I'd done that with *JFK*, too, but there the story itself was fractured. It was

14 Wilkinson (1950–) and Rivele (1949–) are a screenwriter team who also worked on *Ali* (2001), *Pawn Sacrifice* (2014), and *Miles Ahead* (story; 2015).

15 See chapter 6, p. 279.

Still-frames from the re-creation of the 1960 debate between Democratic presidential candidate John F. Kennedy (represented by the real Kennedy) and Republican challenger Richard Nixon (Hopkins).

the whole story of how JFK was murdered. I kept the style here because Nixon was a disturbed, warped individual.

You have a lot of scenes where you integrate actors into existing historical footage.

That's hard, technically, to make work.

In the 1960 presidential debate, you have to match actual footage of John F. Kennedy with footage of Anthony Hopkins as Nixon and make it feel seamless. Sometimes when you see Kennedy from the back, it's a stand-in, right?

Yes. Those were complicated shots.

You've got flashbacks within flashbacks, and projections, and all sorts of psychic rumblings throughout the movie. But it's especially complicated as you get us to that moment where Nixon loses the debate to Kennedy. Our framing device for the whole story is Nixon on the eve of his resignation, with everything turning to shit, and then he has a struggle with the pill bottles, and then he flashes back to this 1960 debate, at which point you introduce his wife, Pat.

In the debate, Kennedy hauls out information about Fidel Castro and the anti-Castro Cuban forces in exile that he got from a security briefing. He uses them, thinking Nixon won't call him out for violating national security—and Nixon doesn't. He kind of freezes, and you see the sweat on the upper lip. And then we see that moment where he's fumbling around on live television, and then suddenly we see television footage of Kennedy's inauguration the following January.

It's so complex, because Nixon is leading that operation against Cuba and he has to deny it! And that's the secret that comes back when he talks about the Bay of Pigs.

Of course, Nixon could not picture Kennedy's *actual* inauguration in 1960. So, what are we seeing at that moment in the film, when Nixon seems to be watching Kennedy being inaugurated three months after the debate? Is this Nixon on the eve of his resignation in 1974, thinking back on the 1960 debate and realizing, *Yeah, that's the moment I lost the election*?

No, no—it's the moment where Nixon in 1960 flashes ahead, and foresees the victory of Kennedy.

So that's Nixon in 1974 remembering the moment in 1960 when he *foresaw* losing the debate.

That's right.

It's all in his psychology. It's like the same moment with the pills: *Why don't they just fucking shoot me?* Nixon the self-victimizer. He has this issue through the whole movie, an inferiority complex. He sees it again and again as it emerges. His father is a failure, the concept of the two brothers dying. . . . He has to succeed in spite of failure. This gives him that iron mentality that he can do anything. JFK is willing to cheat and lie on national security and break the promise in the debate. Nixon's the better man at that point. Or he *feels* he's the better man.

Failure! My father . . . come on, the

salesman? *I'm failing!* The father failing. You'll see throughout the movie the repetition of the concept of the word "failure."

You also return over and over to Nixon's envy of Kennedy, and people like Kennedy: the WASPs, the rich, people born with silver spoons in their mouths, or so he thinks. There's a lot of class envy in Nixon.

Oh, of course. But what's important is, Nixon wills his own end, just like he does in that debate scene. You can become a victim of that: the feeling of being wedded to failure.

We talked about this in the context of *JFK*: the idea of the CIA as the secret author of American history in the twentieth century. Nixon seems terrified of the CIA throughout this whole movie, like it's a rabid dog he doesn't want to provoke.

Nixon knew all this shit that was going on against Castro, including the assassination attempts, which had been set in motion by Eisenhower.

I wish I'd left that scene where he goes to see Richard Helms in the theatrical cut!

Sam Waterston[16] as the CIA director, tending his orchids. One of the greatest performances ever left on the cutting-room floor, maybe.

16 1940– ; *The Great Gatsby* (1974), *The Killing Fields* (1984), *Hannah and Her Sisters* (1986), *Crimes and Misdemeanors* (1989), *Law & Order* (1994–2010).

In one of *Nixon*'s signature images, the president (Anthony Hopkins) is literally as well as figuratively being pushed out of the picture by tapes of his secret wrongdoing.

Well, we did put him back in the extended cut [on DVD]. Helms seems to have equality with Nixon, to put it that way. He's a keeper of secrets.

What sort of conversations did you have with Anthony Hopkins[17] about his performance in this movie? Did he come into the project knowing a lot about Nixon?

No, he came into it scared. He thought he could never do it. Nixon is not an attractive figure. But we made him tense. You feel the tension in him. Hopkins's performance is marvelous, the energy he radiates. The dialogue is very good, it keeps snapping and moving, and you don't have to know what it all means; you get the sense of it. The film has one of John Williams's best scores, I think. It's a subtle score. And I think stylistically the film is interesting. It makes this period, some of which predates the period of *Mad Men*, just come back alive for me.

There's an overwhelming sense of loss at the end of *Nixon*, even as Nixon finds some measure of greatness in his farewell speech to his staff.

You know, his farewell speech is his best fucking speech. It's an unbelievable speech! It's so compassionate! It's what he should've done years before.[18]

There are so many details in this film. You have points where it seems like even Nixon doesn't know what's going on.

He has a lot on his mind. You have to remember, he's the president of the United States, there are twenty things a day, so many things going on, it's hard to remember what you approved. Let's say someone else comes up with a plan; they pass it by you in a way you don't remember saying yes, and it's a big decision. You just say, "OK." Or maybe you never said, "OK"! You're busy.

You were attacked for suggesting that Nixon felt guilt over Kennedy's death. Some people said you were doing *JFK 2*, and trying to say Nixon killed Kennedy. But I don't get the impression you're suggesting that Nixon was directly involved. It seems more like he feels connected to it in an oblique way, maybe through the Cubans who were involved in the Bay of Pigs. The Cuban element is mentioned in *JFK*, as one ingredient in the gumbo.

The Bay of Pigs was talked about on the tape that we show Nixon listening to, right before [the Helms scene], and somehow I forgot all the anecdotes about it, but this scenario seems likely to me, because of Helms's CIA, and how it got dirty with that, too, and maybe it led to the Kennedy murder. Nixon doesn't want to be involved in that.

I'm not suggesting he killed him, but that he's *part* of the machine. "The Beast," he calls it.

You can become a victim of that: the feeling of being wedded to failure.

You never come out and say it, but there's a strong implication that, while Nixon himself didn't have anything to do with Kennedy's assassination, the black ops arm of the military that may have been involved was enabled by Nixon—that Nixon was somehow passively complicit in the murder, because he helped create all of that when he served under Eisenhower.

Nixon was out of office, out of touch, in 1963. Allen Dulles would not have talked to him. Kennedy was an issue; they weren't thinking

17 1937– ; *Hamlet* (1969), *Magic* (1978), *The Elephant Man* (1980), *The Silence of the Lambs* (1991), *The Remains of the Day* (1993), *Amistad* (1997).

18 Not to be confused with Richard Nixon's televised resignation speech of August 8, 1974. Stone is referring here to the speech Nixon made to White House staff the following day. It includes many moving passages that *Nixon* lifts for its closing credits montage, including, "Always give your best, never get discouraged, never be petty; always remember, others may hate you, but those who hate you don't win unless you hate them, and then you destroy yourself."

329

about Nixon. Nixon was dead to their eyes. I don't think Nixon plays any direct role, no.

Although Nixon was in Dallas that day, that morning, talking . . . which is ironic.

Nixon was actually there that day, in Dallas?

Yes. And the night before, too, addressing a business convention in Texas. He flew out that morning. We show that scene in the film [END 2].

And when you refer to the business convention, you mean the scene with Larry Hagman,[19] playing sort of a J. R. Ewing from hell?

Yeah. It's a symbolic scene. He's a composite of different oil guys. But the scene is based on

an actual trip Nixon took to Texas right before the assassination.

Admittedly, we made Nixon a bit more important than he actually was at that point in his career. We wanted to show that he was out of power, but he was hanging around the edges still—he still had the bug, he still wanted to keep his hand in national politics.

You've got this low-level fear and paranoia throughout—Nixon fearing the CIA and the military-industrial complex, and referring to it as the Beast. It connects with the statement Eisenhower made when he left office, the one you open *JFK* with: this concern that the government has created a thing that they can't control anymore.

No one can control it.

I just feel like we wanted to make this point, because I do feel sorry for the country, that it had come to this. It saddens me that America got to this place through bad policy and bad leadership since World War II. This country was doomed on this cycle. Nixon called it the Beast, and it's beyond any president by this point. After it killed Kennedy, I really believe that it couldn't be tamed. And I believe that Kennedy was the fulcrum point of the Beast. It took over. Say I'm nuts all you want, but it—the assassination—makes no rational sense and there's no proof, evidence by evidence. Just read DiEugenio's book, *Reclaiming Parkland*, and go back to the first impressions, the first evidence collected. Everything is fucked up. Something's screwy in the whole thing.

I do feel after that point, and especially after Watergate, we're doomed. There's no coming back from wars, aggression, the Beast. Reagan fed the Beast. Carter tried temporarily to soothe the Beast, but it didn't work, we were back at it. Obama's the same. Nothing changes.

19 1931–2012; American TV star, equally adept at projecting earnestness and menace; *I Dream of Jeannie* (1965–70); two incarnations of *Dallas* (1978–91 and 2012–14), the second of which continued briefly after his death.

Still-frame from *Nixon*: Re-creation of Richard Nixon's concession speech after losing the 1962 California governor's race; the press corp becomes a shadowy, inhuman mass of illegible faces.

The Beast is only getting bigger, and worse. It's on the Russian border, the Chinese periphery, drones everywhere, basically trying to dominate the world, control the resources, own the resources of the world, of Eurasia. Like in *Alexander*, everyone went to the East. As we say in *Alexander*, you go east to make your fortune, and you loot the place, and bring it back to the West. The Crusaders did it, Alexander did it—though he never looted, he cohabited, and that was what was brilliant about Alexander.

But essentially, the Beast wants the world, and we want our system to not only dominate, but *control* the world. Ever since '91, when the Russian Empire fell away, we've just crept up in strangulation mode.

So do you see what's happening in *Nixon* as kind of a karmic blowback? The way you're talking about the Beast, you're making me think of the Buddhist strain throughout *Heaven & Earth*. Are you saying there's a spiritual and moral dimension to politics?

Absolutely. And I don't know if we can continue. The Vietnamese dead, the ghosts, the ghosts of Vietnam, Iraq, Afghanistan . . . There's a price to be paid. I can't see us slipping away from this thing.

Do you think our karma is irrevocably fucked?

"Irrevocably" is a tough word. I can't tell. But it seems that we're skating on the thinnest ice right now. The Beast is trying to hold it together, and it can't. The world is always messy and disordered and leaking, and I do think that Nixon made a good point: *I made peace with Russia, I opened China, I ended the war*. That last one you can argue. But Nixon really did do some good things, like create the Environmental Protection Agency.[20] He did some liberal stuff as president. He tried! But of course, he couldn't get elected without being caught up in the Beast.

Can anybody get elected without being caught up in the Beast?

I don't think so. That's what worries me.

We built the Beast up after World War II. During World War II, we became a military state, and we never broke it down. With the A-bomb and military buildup in Korea, and with the bases all around the world, we never turned away. Eisenhower became the ultimate agent for this buildup, going from 1,000 nuclear weapons to 30,000 weapons by the end of the budget cycle in '61. He brought the military-industrial Beast, and he apologized for it in a strange way, in that speech that we put at the start of *JFK*.

But I think Kennedy was the last hope to turn it back. Since then, nothing has truly changed in America. Life is more comfortable for us, but at a price. The price is karma. The price is soul-deadness, or whatever you want to call it.

There is a balance in the world. There always has been.

And we have reached Roman Empire grotesquerie. The change of leadership means nothing; the new emperors mean nothing. They're wrestling with greater and greater scandals, more distracting things. There'll be a thousand Fergusons. There'll be a thousand ISISes, groups that are essentially our creation. There'll be messes everywhere, and we'll be fighting with them. We can't even get judges appointed. Gridlock has reached the point of Roman corruption madness. How do you come out of that?

Hopefully, for us, it'll be a slow decline. The barbarians, so to speak, came into Rome and extended it another seven hundred years.

Is it possible that the resistance to political content in a lot of your movies comes from people

20 After public concern about air and water pollution, hazardous waste, endangered species, and other environmental problems during the sixties, President Nixon signed an executive order creating the Environmental Protection Agency (EPA) to protect human health and the environment by proposing congressional legislation and enforcing regulations.

NK Pub

IXTLAN

February 29, 1996

Editor
Chronicle of Higher Education
New York, NY

To the Editor:

I applaud Anna K. Nelson's call to open the Nixon papers. I would add that the Nixon tapes should be opened as well. As I point out at the end of my film, only 60 out of 4,000 hours of Nixon tapes have so far been made public. I was very pleased that my film JFK helped prod Congress to pass legislation resulting in the release of over 1 million pages of previously classified documents. I hope that NIXON can have the same effect.

However, I must dispute Ms. Nelson's characterization of my film. She says that I show Nixon as a "paranoid, foul-mouthed alcoholic". This is a distortion of a complex and nuanced characterization of the man based on many interviews and extensive research. Perhaps Ms. Nelson has not seen the book of the film which we published, containing hundreds of references documenting the scenes in the film.

Evidently she is not aware of the work of more respected historians such as Arthur Schlesinger, Jr., Michael Beschloss, and Fawn Brodie, who have documented Nixon's key role in assassination plots against Castro as Vice President. As H.R. Haldeman suggested, Nixon was referring to these plots and their link to the JFK assassination when he talked about opening up "the whole Bay of Pigs thing" on the "smoking gun" tape of June 23, 1972.

Rather than "putting words in the mouths of historical figures", we have used Nixon's actual words from the Watergate tapes so frequently that one commentator suggested we should give a screenwriting credit to Richard Nixon. It is Ms. Nelson, not I, who is creating "fiction". Even an "adjunct professor" should be required to do her homework.

Sincerely,

Oliver Stone

201 Santa Monica Blvd. ▲ # 610 ▲ Santa Monica, CA 90401 ▲ 310/395-0525 ▲ FAX 310/395-1536

rejecting the idea that they are passively complicit in the Beast?

Absolutely.

So you think audiences can't face their own complicity in all that? You think they don't want to go to movies that make them feel guilty?

Well, they didn't go to *this* movie.

Are you still crushed by what happened to *Nixon*?

I've accepted it. I've come around. I realized this rejection happened, and it was hard at the time.

The thing is, I've managed to shift my concentration to the positive. I used to wake up in the morning and that was the hardest time: *Why start another film? There's no reason they'll open it or give it a break*. But it's my desire to make a film that's more important than whatever the reception is going to be. Sometimes it's predetermined, isn't it?

The mere fact of *Nixon*'s existence strikes me as pretty remarkable. It struck me as remarkable in 1995.

I think it was doomed in the sense that people were out to get me. There was the *JFK* issue with me, and I had a high visibility still. I also had gone across political boundaries, saying things. *JFK* was a big crossover point, as we've discussed.

You kidded that perception when you acted in *Dave*, that Kevin Kline movie where he plays this look-alike, secretly impersonating a sitting president. You were playing the public perception of Oliver Stone: the paranoid conspiracy theorist.

(Laughs) Yeah—and I'm the only one who knows the truth![21]

Nixon is the end of a roll. I'd made a Promethean effort to get all those films out. Ten films in ten years is a race. The film wasn't badly received—it got Oscar nominations for Hopkins, Allen, the script, and for John Williams' music—but it didn't make money because people were not interested in Nixon that way. He had just died two years earlier. And there was a darkness associated with the film. It just never crossed over.

It was also the end of my relationship with Warner Bros. at that time. I'd made the previous three films with them, and my contract with Arnon Milchan was to make this

this movie as long as I made a certain budget number, which I did. Warner Bros. passed on it, which they had a right to, and Milchan wouldn't honor his contract with me, so it turned into quite an ugly situation that would've been a lawsuit. But because of Hopkins's window of availability, I waived all my rights to pursue the lawsuit in order to make the film on Hopkins's schedule. A lawsuit would've tied up the rights for years. At that point, Andy Vajna stepped in with his independent company and produced it through Disney. But it marked the end of my period at Warner Bros., which I valued far more than my association with Milchan.

Well, something happened to my psyche at that point. And I said, "OK, this race is over for now," because basically the mojo ran out.

Would you consider yourself depressed at that point?

Yes. Psychically or subconsciously, I felt a bit like Nixon, like, "Why do they hate me?"

I did get offered *Mission Impossible 2* somewhere during that period, and I did work on it, but it wasn't really doable for me. It was a good idea, but I didn't write it. So there were some friends and allies out there, but I didn't feel it. The town is rough.

That period, to me, is like this extraordinary window of opportunity where you're just reaching through and grabbing one amazing thing after another.

Then the window closes.

It always does, except in very rare cases, like Steven Spielberg's. The magic window has stayed open for Spielberg for forty years.

Well that's because he made his own money and created a financial empire that couldn't be stopped. I don't think it *could* be stopped.

Spielberg was a wise man. I never thought about the money.

But people do remember *Nixon*, so that's something. It has grown in awareness, right?

21 In Ivan Reitman's comedy *Dave* (1993), a presidential look-alike (Kevin Kline) assumes the highest office in the land after the real president of the United States (called POTUS by insiders) is incapacitated. Stone plays himself, being interviewed by CNN talk show host Larry King and insisting that the president has been replaced by an imposter.

Hopkins brings Nixon to life—untarnished and un...ished

Lights, Camera, Nixon!

ANTHONY HOPKINS HAS MADE A SERIAL KILLER SEEM someone you'd want to talk to at a party, so his cu... role ought to be a snap. But when Oliver Sto... him to star in "Nixon," Hopkins hesitated. "I said me 24 hours to think about it, because I'm very impulsiv... tend to jump in up to my neck in trouble." That night... Stone to accept. "I thought I'd be insane to turn it do... probably insane to do it." Now, despite the Welsh... initial concerns about playing such a famous—an... American, Hopkins is on the set, committed to g... president his due. "I've neutralized myself from the polit... aspects of it," he says. "As an actor I have to find a deep co... empathy with him." He also denies reports that the film t... Nixon to a plot against JFK. "That's not in the script at al... There's no tarnishing of Nixon's image, but it's certainly r... whitewash." In other words, there is no cover-up.

A Wild, Tragic Ride

If you can't resist the second-gunman theory and get caught up in tales of the grassy knoll, director Oliver Stone has got the conspiracy theory movie for you: "Nix... on."

NIXON

MOVIE of the YEAR

1

OLIVER STONE PUSHES his hell-bent propulsive sensibility into a new realm of manic truth-telling. In his brilliant, kaleidoscopic dramatization of the life of Richard Nixon, he shows us the Nixon we all know in our bones—the sweaty, stiff-backed paranoiac, his heart black with self-pity—and then lays bare how Nixon's pathology, his belief that deliverance was attainable through lies, served and finally extended a sinister shadow government. Using the vertiginous multimedia style he developed in *JFK* and *Natural Born Killers*, Stone layers 50 years of images into Nixon's snakelike voyage through the corridors of power. He turns history itself into a hypnotic Black Mass, anatomizing the space between public perception and backroom reality, until the notion of "cover-up" takes on dimensions of mystical unease. And Anthony Hopkins, in a towering performance, puts us right inside Nixon's skin. His squirmy masochistic righteousness becomes the stuff of high tragedy, as he locks himself off, Kane-like,

2 Crumb It would be hard to think of a movie experience more memorable than the two hours I spent getting to know the underground-comics artist Robert Crumb and his supremely warped family. Crumb, in his ecstatically exhibitionistic cartoons, draws on the convulsions of his own id, turning his most scandalous fantasies into a trippy grunge burlesque of American life. In Terry Zwigoff's great documentary, he appears before us as a razor-tongued contradiction (imagine Howard

MOVIE

...WHAT A SHAME. HE WAS A RARE TALENT, BUT HIS BITTERNESS AND PARANOIA GOT THE BEST OF HIM...

RICHARD NIXON?

OLIVER STONE.

OLIVER STONE'S NIXON

Hollywood's most controversial director Oliver

Stone takes on our most controversial president Richard Nixon

NIXON

BY STRYKER MCGUIRE AND DAVID ANSEN

THE FALL OF RICHARD Milhous Nixon has begun. Watergate has exploded. John Dean is testifying before a Senate committee. Haldeman and Ehrlichman, his closest aides, have been ordered to resign and White House aide Alexander Butterfield has just revealed the existence of secret tapes. And now we see Nixon for the first time. It's late at night in a deserted White House, and there he is, sitting like a trapped animal in a corner of the Lincoln Sitting Room, a tumbler of Scotch by his side. The 5 o'clock shadow. The sweaty upper lip. The face

ashen from lack of sleep. He gulps his drink and fumbles with the tapes. Alexander Haig presents him, a man on unfamiliar terms with his own body. "Nixon's never been good with these things," he tells Haig, as if the president. And then he launches into a rant of self-justification. "We never got our side of the story out. Al. People've forgotten. I mean, f--k you, Tricia, f--k you, Juliet"... The teargassing, the riots, the burning, the draft cards, Black Panthers—we fixed it. Al. And they hate me for it—the double-dealing bastards.

WE NEVER IMPLY THAT NIXON HAD ANYTHING TO [DO WI]TH THE DEATHS OF THE KENNEDYS. IN FACT WE SHOW THAT HE GRIEV[ED O]VER THEM."

ROLLING WITH STONE: The director rehearses with Anthony Hopkins, who was terrified, Stone says, by the extraordinary demands of the role: "Even into the fifth or sixth day of shooting the picture, he was shaken."

own childhood, when two of his brothers, whom he loved very much died young. If there is a [conspiracy] theory in this film, it's that Nixon undid himself. If it hadn't been Watergate, it would have been something else.

PREMIERE: John Ehrlichman has said that there are two schools of thought on Nixon: the John Dean school, which sees him as the villain, and the Silent Coup school, which sees him as a victim, and that your film reflects the Dean view.

Stone: The Silent Coup theory is that the military wanted Nixon out because he was close with the Soviet Union. It charged that [reporter Bob] Woodward was an agent, that he was a Navy guy who was tied to [Alexander] Haig, and part of the CIA, and to get rid of Nixon. But to say that Nixon is to excuse him from responsibility, and that segues into the Republican view that he was destroyed by the press. Which is saying that American soldiers in Vietnam were defeated by the media, or like Hitler said after World War I that Germany was stabbed in the back by the politicians. Historically, it doesn't wash. You can't excuse Nixon over Watergate. A man as powerful as he was, as goal-oriented as he was, certainly had to know much more than he ever admitted to. To this day one, Nixon was covering up. So all in all, I don't agree that one theory is opposite the other. To characterize a human be...

victim or a villain is to miss the point of Shakespeare's plays, in which villain and victim are combined in the same person.

PREMIERE: Was Dean an adviser on the film?

Stone: He just read the script with a fine eye toward the actual language that was used.

PREMIERE: In many ways you go easy on Nixon—Watergate is almost small potatoes.

Stone: There's forgiveness, but I don't think Watergate is small potatoes. I think that corruption is corruption. It all leads to Watergate.

Milchan and Warner Bros. cochairmen Bob Daly and Terry Semel, who financed *JFK* and *Natural Born Killers*. *Nixon* is at Disney. What happened?

Stone: The truth is, Warner's and Milchan never really wanted to make this movie. Warner's felt that Nixon is an older white male, that the picture would have a lot of guys in suits talking, not much action, less appeal to younger people. Not like *JFK*, which was a murder story. The cost, given the requirements of a period piece and the size of the film, was also a problem. They started at $28 million and they ended up offering me $36 million. I said, "Gentlemen, I can't make the film at that price. That's the bottom line." And they wanted me to put up the overage. At the time, they were making *Assassins*. That's the kind of movie they want, a sure thing. But *Assassins* was not a sure thing, was it? You see, when you're with somebody for three pictures, I suppose they start to take you for granted. I think that Milchan presumed that I was there for hire, to do *A Time to Kill* or something. I'm not that way. This picture came very close to not being made. Maybe some people will say that's good [*Laughs*], but we were right on the edge.

PREMIERE: Did you make money for Warner's?

Stone: *JFK* did about $200 million worldwide, and *Natural Born Killers* did about $100 million, and that doesn't count cassettes or TV.

PREMIERE: Was the fact that you brought down all the flak on the studio for NBK a factor?

Stone: Certainly my relationship with Warner's degenerated over NBK. Having to go back...

it would just go away, I would end up doing something more commercial. When I saw *The Remains of the Day* and *Shadowlands*, I realized that Hopkins had the balance I needed. In *Remains of the Day* he had a sadness that I felt in Nixon. And in *Shadowlands* he had a warmth and emotion that I also thought were necessary. Tony, meanwhile, was overwhelmed that I had offered him the role. He said that he would love to do it, and then he got scared and passed on it six or seven days later. I went over to London and had breakfast with him. I was joking around, and I said, "What do you think of Gary Oldman?" He said, "Gary, yes, he would be very good." And at that point he said, "Fuck it, I'm going to do it myself."

PREMIERE: How was he once he took the plunge?

Stone: We had about five weeks until the shoot, the fastest prep I'd ever done. He was going through hell studying Nixon, working on his accent every day, doubting his ability to do it. Paul Sorvino went down in the elevator...

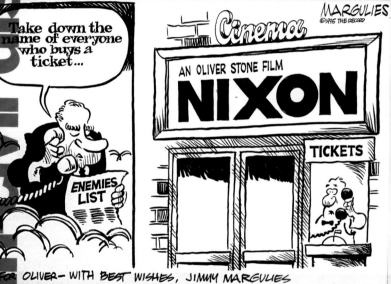

MARGULIES ©1995 THE RECORD

Take down the name of everyone who buys a ticket...

ENEMIES LIST

Cinema

AN OLIVER STONE FILM

NIXON

TICKETS

FOR OLIVER— WITH BEST WISHES, JIMMY MARGULIES

Daily Variety March 14, 1995

ROLLING STONE: It's no surprise that Oliver Stone is on more than one enemy list. One foe has been actively dispersing early script drafts of "Nixon" to magazines everywhere, trying to sabotage the director with bad publicity. While some wondered if he generated the leaks to heighten expectations, sources say Stone was blindsided by them and hardly wanted to debate the politics of a work-in-progress months before it begins shooting.

In a statement, Stone criticized an Associated Press story Monday, saying that the notion "that we have Nixon organizing a hit squad that killed JFK is ridiculous."

Stone

This week's *Variety* reveals some of "Nixon," including a plot line that suggested involvement in a coup attempt could have tied Nixon to the assassination. In the script Dish read, he was an unwitting participant at best, with no advance knowledge.

C 18 ESPECTACULOS EL MERCURIO — Jueves 8 de Junio de 1995

Los dos Richard Nixon; el que interpreta Anthony Hopkins y el de la vida real, el que salió tras el escándalo Watergate.

Oliver Stone Ve a Nixon como Demoníaco y Trágico

HOLLYWOOD— Mientras las cámaras de cine trabajan bajo la atenta mirada del director Oliver Stone, Richard M. Nixon, interpretado por Anthony Hopkins, reacciona a la prime...

● Anthony Hopkins es el protagonista de la película que se filma en Hollywood sobre la vida del fallecido Presidente de Estados Unidos. Ex asesores del...

Muriel, que visitó la Biblioteca Nixon, ubicada en Yorba Linda, California, con su hijo.

El actor, que recibió un Oscar como mejor actor por su trabajo en El silen...

"CHINATOWN" OLIVER COPY.

① OS The heat, postma—
— sex, crime.

② All dialog secondary to image
Throw away one key shots, O,
may not scrawl — go for utterance simple
one dialog, a killer by

A DAY IN HELL SLEEPING DOG GOD

STRAY DOGS
by
John Ridley

SCORPIONS TOWN DUST DOG

DEAD END U TURN

OS A TALK FAST SIERRA
SLEEPING DOGS

① Town. a little bigger
reaction the killing,
for jewelry store.

② OS. keeping it
simple

③ Alter 90-95 min.
"Detour" simple

④ change name Sierra
to Scorpion, Arizona

⑤ SHOW STRIP MINE
(mention 70)

⑥ 2 DUSTS
P72—
P1—
P85

July 11, 1996 Grace (D.C.)

I was gonna quote a *Nixon* line back to you, from Kissinger: "History will treat you far more kindly than your contemporaries."
That's a generous thought.

Did you make *U-Turn* after *Nixon* because you wanted to work small, or because you had no choice but to work small?

I gave up.

I mean, I didn't give *up* . . . I just went to do another thing for a while. I published the book, *A Child's Night Dream*, which, as you know, was important to me. It was a break; writing that book was very hard. I mean, not *writing* it: organizing it, while retaining the voice of the nineteen-year-old who wrote it. It

a novel, *Stray Dogs*, and the novelist, John Ridley,[22] did a draft for me. It came together as a low-budget film. The film was financed at a decent price by [Mike] Medavoy.[23]

I came at the end of that Coen brothers/ Tarantino thing, where everyone felt they had already seen that kind of movie, and so it was judged by critics not unto itself, but like, *Here's another one*. It was compared to *Red Rock West*.[24] I think you'd know better.

I did sense there was something different about *U-Turn*: mainly that it's not a cool film, it's a hot film. It's cruelly funny, like certain films by Tarantino and the Coens, but those directors rarely have anything like the overheated melodrama you bring to the love story. And they don't get into these

book by Ridley, but we made it into something even beyond that. We made into more of a—whaddaya call it? Spaghetti noir.

Well, you do have Ennio Morricone[25] doing the score!

Or . . . what did I once call it? I think "sol noir," did I?

22 1965– ; wrote *12 Years a Slave* (2013) and created the dramatic anthology series *American Crime* (2015–)

23 1941– ; film producer and executive who cofounded Orion Pictures and Phoenix Pictures, and also worked in top positions at United Artists and TriStar.

24 1993 neo-noir directed and cowritten by John Dahl, starring Nicolas Cage as a drifter who runs afoul of a hit man played by Dennis Hopper.

25 Composer of scores for innumerable classic movies, including films by Sergio Leone (the Dollars trilogy; *Once Upon a Time in America*), Brian De Palma (*The Untouchables, Casualties of War*), and Giuseppe Tornatore (*Cinema Paradiso*). He came out of retirement to score *Hateful Eight* (2015) by Quentin Tarantino, who had used snippets of Morricone's preexisting western scores in four earlier films.

It was judged by critics not unto itself, but like, *Here's another one.*

was not organized. It was just a bunch of pages. I had to put it all back together, so that was a lot of work.

I developed *U-Turn* with Richard Rutowski somewhere in there. Richard and I worked on it very extensively. It was originally

kinds of hippie visions, these kinda peyote-like explorations. That seems like a Stone thing.

It was original, of its own, you know? We didn't copy anything, certainly not *Red Rock West*, which I barely saw. We went off the

It conforms to the basics of film noir: Everyone gets killed! Dark, dark, dark!

Yeah, "sunshine noir," I think.

It conforms to the basics of film noir: Everyone gets killed! Dark, dark, dark!

Do you see it as essentially a comedy?

Yeah, a grim comedy. But comedy's a big word, because it's not a lot of open laughs. But I think it's funny. I find it very funny.

You use a lot of wide lenses, low angles, extreme angles. It's bordering on a cartoon a lot of the time.

I kept telling Morricone, *Take it further, make it bigger.* It's also beautifully shot by Bob Richardson. It's a wild stock that he used, a reversal stock. You don't know quite what you're going to get when you shoot reversal film, so that's fun; it's not as controlled. It was an interesting look. We did too much of that triple-exposure stuff. But I think some of it's good. I went maybe too far?

The movie, at times, seems to be having a nervous breakdown.

Yeah, it's too jaggy for me at times, like, *Calm down, man! What do you want?* But I committed to that kind of boing-boing style. I wanted to . . . What was I thinking? The Ridley book is more serious, I believe. Have you read it?

Yes, I have, and it's not as grotesque, not as exaggerated, as your film.

Every book is a springboard for the movie. I go forward. I don't even know what's in the book at the end, it gets confusing. *Savages* was the same kind of thing.
 What did you once say to me about this movie? That it's secretly a Christian movie?

Well, it's funny: That's not what I said, but it is that, in its way. It's a Christian film, but it's also a Buddhist film. There's a spiritual aspect.

Ghosts?

Yeah.

All those lines are from Buddhism, or from Rutowski. *Nothing is nothing, everything is everything.* That's Richard. He'd talk like that, you know? He had that California guru fifties talk, which was so funny. I loved it, and it fit that film the best, although I used some of his dialogue in *Natural Born Killers*, too.

Given your interest in Buddhism and the concept of karma, it almost seems like Sean Penn's character is being punished for something.

He's a hungry ghost. He doesn't have much of a chance. But he's not interested, you see. He's kind of, like, blithe—like most people go through the world trying to make a buck any way they can, not thinking about the consequences too much.

He wants to get out of this town, but he can't, and he keeps coming close and then the chance is always snatched away from him. Fate snatches it away from him.

Like the bus ticket.

Yes, Joaquin Phoenix ripping up the bus ticket in his face!

And then he eats it!

He looks like he's about to cry—Sean Penn!

And then he goes lower! When he has to beg for his life from Nick Nolte, and J-Lo is hearing it! I mean, he's totally ashamed! And then digging for the money over Nick's body, making love to—come on! You see, he has no shame! He has nothing! He's so humiliated through this whole movie.

This town is a microcosm. It's divorced from reality, and yet it also represents reality.

To me it does. I once told you my experiences in the incest part of it, in smaller towns.

You told me you encountered some of these people during scouting trips: people you suspected were inbred.

I can't believe that situations like the one between the J-Lo and Nolte characters don't exist. Some of the people live strange lives back in America. You see the effects of it. I was in Mississippi once, in a county that was all incestuous. I mean, everybody! And you felt like you were in a zombie film. It's bizarre, so overt. You'd miss it unless you were paying attention, and if you were, you'd feel as if people were intermarrying each other.

But you also give us a sense of ordinary working people in the town.

You see Mexicans and Indians.

And poor whites. And they're all at each other's throats, snarling over money. And in the meantime, there's this handful of rich people lording it over the town, and the police are doing their bidding. It's very much an Oliver Stone take on this kind of story.
 And the ultimate evil is the patriarch who's committed the ultimate crime.

The incest got me into trouble. I think Medavoy told me it was too brutal, and that may have turned him off, too.

There are a number of bold graphic images in

Yeah, it's too jaggy for me at times, like, *Calm down, man! What do you want?* But I committed to that kind of boing-boing style.

U-Turn, inserts that almost look as if they could be silk-screened prints: the close-ups of the dripping faucets, scorpions, snakes, signs, crosses, cactuses, mesas, and some of these helicopter shots going over the land. I wanted to ask you about what I feel is your affinity for the American Southwest.

There's a quote in this section of Jane Hamsher's book *Killer Instinct*,[26] about the making of *Natural Born Killers*, where she talks about taking a trip into the desert looking for places to shoot, after you'd scouted locations for the prison riot sequence in Illinois. She writes, "After Oliver had his fill of Chicago, we moved on to the Southwest, where I think Oliver's heart really lay." She also writes, "He has a sixties glamorization of Indian deserts and spirituality that he wanted to integrate into the film."

I thought that last part was especially interesting given your fascination with Native Americans as figures of higher consciousness, or of the white man's original sin. Ben Stiller even poked fun at you for that on *The Ben Stiller Show*, in a fake ad for the "Oliver Stoneland" amusement park. He's got a Native American in there saying, "I'm an Indian, but I also represent death!"

(Stone laughs.) Well . . . I think that as a city boy from New York City, with the cold winters of Pennsylvania and all that, I think I bloomed in the California desert. I bloomed in this area here. So I like the desert, and I like the hotness and the colors. My first big film was in Mexico: *Salvador*. I also like the Philippines, I like the tropic feel. And I love Carlos Castaneda: *The Teachings of Don Juan*,[27] all that.

And *Journey to Ixtlan*, which jumps out because, of course, your production company is named Ixtlan.

I met Carlos. Carlos was very nice to me. I have the feeling he wanted me to make those books into movies.

Castaneda is very much of the sixties, but he goes on a very interesting spiritual journey, and it still applies to Buddhism, too. There's a sort of belief in natural gods, natural things, and peyote. I'd always loved peyote since I took it. I went to several peyote ceremonies. So *Natural Born Killers* was done there, in the Southwest. The colors were beautiful. It was also the road, the beauty of the empty highway. Highway 666. The towns are different there, they're very unique. Some of them are

26 Broadway Books, 1997; from the *Entertainment Weekly* review: "Stone is painted as a hard-partying womanizer who pits his underlings against each other and plays mind games. Take this description of how he worked his charms on *NBK*'s second screenwriter, Dave Veloz. 'It only took two weeks for Oliver Stone to reduce Dave Veloz from a stable, reliable churchgoing Mormon to a borderline psychotic Pepsi-swilling mess, rolling around the floor in his boxer shorts and wondering if he'd ever be able to do anything right again for the rest of his life.' Tarantino gets off less easily. Hamsher charges that he betrayed her and Murphy by going behind their backs to keep them from making *Natural Born Killers*. She also calls Tarantino a 'one-trick pony' [and] 'a wildly overrated director.' "

27 1968 book written by the author and anthropologist Carlos Castaneda; documents his personal exploration of shamanism and experiences with hallucinogens in the company of a Yaqui Indian spiritual guide from Mexico.

There was no typical white-girl resistance to being in this negligee in the middle of the desert.

Apache culture is an important theme in the movie, mainly for Jennifer Lopez's character. That's why I cast Jennifer, because she had this half-Spanish, half-Indian feel.

The film is very much a story of cultural exploitation, too.

Yes. Jon Voight's[28] character says that they killed all the Indians off.

The Native American is literally being raped by the white man in the movie.

Yeah! I feel like I don't have much to say beyond that!

Does any aspect of your fascination with the American Southwest and Latin America come from watching westerns when you were younger?

Yes. I always liked the Apache movies, and John Ford, and Robert Aldrich's movie *Ulzana's Raid*, and Howard Hawks's *Red River* [END 3]. I liked that there's something harsh, brutal, and savage about cactus—impending doom. You're alone in the universe. The Mexican border, that's always tough. Mexico: a brutality place. Charm, but brutality. I think the American South, too, interests me, but in another way.

I just have an affinity for the desert. I used to take long rides there. I used to go with my wife—my second wife, now ex-wife—and Rutowski. We'd go down to Arizona and New Mexico and some of West Texas. I loved Mexico; I always went there.

And you know I used to like to ride horses. I was in Colorado for a while. I had a ranch there once. Different country. I was good on horseback. I rode on the East Coast when I was growing up, so I was taught riding, and I rode a lot, but I got used to the western saddle in Colorado, which is a whole different ballgame, because I was really riding hell-bent for leather. I enjoyed horses. I had a few. But I sold them, you know. It was just too much maintenance.

You know, I was very lucky to have gotten all the actors that I got for this movie. They all did it for very little. It wasn't a big-salary movie or a big studio movie at all.

28 1938– ; versatile leading man, later eccentric character actor; *Midnight Cowboy* (1978), *Deliverance* (1974), *Coming Home* (1978), *Runaway Train* (1985), *Anaconda* (1997), *Ali* (2001), *The General* (1998), *Ray Donovan* (2013–).

(below) Still-frame of Bobby (Sean Penn) lifting Grace (Jennifer Lopez) down after helping her hang the drapes, which amazingly is not a euphemism.

(opposite) Still-frame from *U-Turn*: Powers Boothe's Sheriff Potter (right) examines the body of Grace's mother in a flashback.

J-Lo[28] had just been in *Money Train*, in which I liked her very much, and thought, *Wow, this girl's a babe. She can act, she has a sense of humor, she's sexy, and she fits this role*. And of course she wasn't noticed for *U-Turn*, though she was noticed right after that, with *Out of Sight*. But I thought she did a terrific job for me. That was so outrageous, her hanging off the cliff! And then all the murder scenes at the end, going around and crawling at night.

She was fun. She was hungry to make a name for herself. There was no typical white-girl resistance to being in this negligee in the middle of the desert or some crap like that. She told me, when I talked to her years later and she'd turned into a bit of a superstar, *Let's go make another* U-Turn! *Let's do something like that again!*

The relationship between her and Sean Penn's[29] character is the only aspect of the movie that is not essentially comedic.

No, that part is a love story.

I mean, it's like one of the grimmest roles ever, right?

And it's a serious one. She wants to enlist him in a murder plot; he's originally going to murder her. But there's also a real connection between them: She tells him in that first bedroom scene, "There's something in your past . . . Something . . . There's a pain," and she touches his face, and he says, "You can tell all that by my face?" And she says, "I can tell what everybody's face tells me, that you have a past." And he senses the pain in her, too. You feel this tug of chemistry between them, and it overwhelms everything else. As soon as they get anywhere near each other, they start fucking!

(Stone laughs.) But you know, he doesn't come the first time! He masturbates behind the tree, which is hilarious! I love her expression during that scene. She won't let him come—it's the classic delay!—until she enlists him in her plot. She's been used by so many people that

she doesn't give in to him. The one guy who really wants to fuck her is just another guy.

She wants to get out of town, but she's got the sheriff on the line, Powers Boothe.[30] She's telling lies to everybody, but my favorite is when they get pulled over on the highway,

28 aka Jennifer Lopez, 1969– ; actress, singer, dancer, producer; *Selena* (1997), *Out of Sight* (1998), *The Cell* (2000), *Home* (voice, 2015).

29 1960– ; mercurial Method lead; *Fast Times at Ridgemont High* (1982), *Bad Boys* (1983); *At Close Range* (1987); *Dead Man Walking* (1995), *The Thin Red Line* (1998), *Sweet and Lowdown* (1999), *Milk* (2008), *Tree of Life* (2011).

30 1948– ; character actor known for menacing roles; *Guyana Tragedy: The Story of Jim Jones* (1980), *Philip Marlowe, Private Eye* (1983–86), *Red Dawn* (1984); *Tombstone* (1993), *Deadwood* (2004–2006).

and all that double play—the whole scene is double entendres. She's trying to get him off the case, but she made a deal with him, too, with Powers. After she kills Powers Boothe, she says, *Bobby, I did it for us. He was going to fuck us over.* And prior to that, a few hours earlier, Sean's in the poolroom, begging for his life: *I'll kill her! I'll fucking kill her!*

She's an interesting twist on the femme fatale archetype, because there's a core of innocence to her. And it's through her character that you kind of turn all your western imagery inside out. She's half Apache. She tells him the story about the suicide of her mom, who was raped by a white man, who turns out to be Nolte's character, and she ends it with, "Whatcha gonna do, life, right?" Then she asks him if he's ever been to California, which is where white people go in westerns to get away from their own pasts.

Also, she doesn't seem calculating, at least not immediately.

That character has been so brutalized that I don't know that she *doesn't* calculate, you know? Maybe she is calculating, in a strange way. But maybe in another way she's not. She's a child, right?

On the inside, probably. She's victim of incest.

They know each other, in a way, but they're still attracted to each other. My favorite scene in the whole movie is when they're fucking with Nolte's dead body in the background. That's so fucking wild! They get the money, they killed the guy, they got away with it, and then they have sex! What's the question he asks her? "Can we close his eyes?" She says, "No, let him watch!"

Yeah!

"Let him watch," she says, in that accent of hers! *(Laughs)*

Penn really has that beaten-down, grimy, been there, done that feeling in this movie.

Sean, at that time, was smoking a lot. He's never been a clean-cut boy, either. And who knows what else he was doing? But he was in a dour space. He saved our film, because the other guy pulled out.

You mean, you'd cast another actor in that part?

Bill Paxton.[31] He pulled out right before because . . . I don't know why. That was a strange thing. He pulled out with about ten, fifteen days to go. We'd had rehearsals, we were doing a production meeting, and I heard it then. Sean, thank God, stepped in, because he'd looked at it and there was something else in his life that was going on, and I think that resonated with the story. I had the sense that he was in a rocky marriage at that time with Robin Wright.[32] And he was opening a club in

31 1954– ; *Aliens* (1996), *Near Dark* (1987), *Twister* (1996), *A Simple Plan* (1998), *Big Love* (2006–2011).

32 1966– ; *The Princess Bride* (1987); *State of Grace* (1990, opposite Penn); *Forrest Gump* (1994), *Unbreakable* (2000), *Moneyball* (2011), *House of Cards* (2013–).

||

I always called *U-Turn* a "scorpions in a bucket" movie: Nobody would rise out of there.

||

Santa Monica. His life was busy.

I thought he was perfect for the role. He had a great face and a great feeling. He worked, and he did his job. Nothing fazed him. Sean Penn has a certain allure, and I thought I used him well in the context. It wasn't easy, because he had to fall apart the whole movie. I mean, it's like one of the grimmest roles ever, right? (*Laughs*) I liked his attitude.

You beat the shit out of him in this movie.

I thought metaphorically I did, but it was just the nature of that script! It was a funny story that way. That's why Sean was in a bad mood toward the end of the shoot! It's hard to get dressed in those same shitty clothes every day, come out, and fall apart more and more! Can you imagine all that shit? How you'd feel as an actor? You're completely mutilated by the end of this movie!

I love the way he deals with people in the film. Even when he's being told to his face by Voight, "Look out, this is a tricky situation," he says, "See you later, old man." He never heeds any signal. The first signal with the garage guy, the guy's telling him what the deal is, and he treats the guy like shit, right? *I gotta be out of here, I'm just driving through.*

There's a sense in which he deserves everything that happens to him. Like the cosmos is punishing him for being such an asshole.

Yeah. I'm not going to say no to that.

I always called *U-Turn* a "scorpions in a bucket" movie: Nobody would rise out of there. And that was why I referred to it as a kind of film noir. I mean, it was!

In a sense, though, there is also a closeness between this film and *Natural Born Killers*, because the two protagonists care for each other—except it's darker in *U-Turn*. Well, they're both dark films, but in *U-Turn* they're both betraying each other at the same time that they're in love with each other, or desiring each other. The lovers don't do that in *NBK*. They're locked together. It's a love bond. They're like the white trash couple in *U-Turn*, Toby N. Tucker and Jenny. That relationship is more like Mickey and Mallory, but they're smaller characters in this movie.

We should talk about Nick Nolte,[33] who is scary as hell in this.

I'd always liked Nick. I'd met him and his second wife, Legs [Sharyn Haddad]—she was his girlfriend then—and knew them socially.

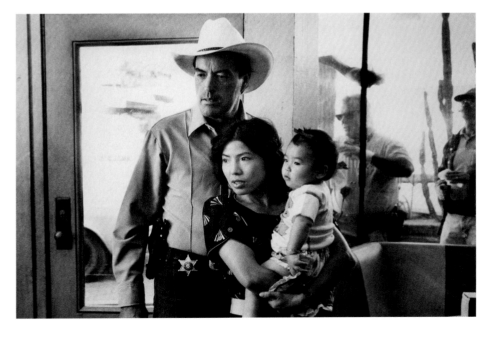

He was a fun character because he was a wild man. What were some of his early movies?

He was in *Who'll Stop the Rain*[34] from Robert Stone's novel—which has certain similarities to *Savages*, now that I think of it.

He got nominated for supporting for that one, the Streisand picture, at the Oscars?

No, lead, actually. And he was nominated again for *Affliction*, the Paul Schrader movie.

Well, it's funny: I'm not relating any one movie star role to him.

That's true, and he's always had that problem, because he's a chameleon. He's an incredibly good-looking guy, but he never had a particular "thing" that he did, in the way that somebody like Pacino or Nicholson did, or Michael Douglas.

I guess I'd always wanted to work with Nick. But this was a chance, and I offered him the role. He took it right away, and he had fun. I mean, he came up with the beard, the look, the whole thing. He worked on it, he cared about it, and he was a ball on location, a real ball. He's a guy who people go hang out with in his trailer. He had a whole group hang around with him, including some interesting women, that kind of thing. And he was always fun.

It's a crazy story with Nick, because he's so affable. People love him, and then he kind of disappears back into his Malibu world. I always liked him. In fact, I recommended my doctor to him, and Nick ended up seeing my doctor for a long time. I think it helped him a lot, because there were issues with Nick, but I don't remember quite what they were. Smoking j's? That's fine, I don't care, not an issue. I guess cocaine at some point.

Alcohol.[35]

33 1940– ; gravel-voiced icon of self-destructive macho; *48 Hrs.* (1982), *Under Fire* (1984), *Extreme Prejudice* (1987, opposite Powers Boothe), *New York Stories* (1989), *Cape Fear* and *The Prince of Tides* (both 1991); *The Thin Red Line* and *Affliction* (both 1998); *Warrior* (2011).

34 1978; directed by Karel Reisz.

35 Nolte has battled addiction to alcohol and drugs throughout his adult life. "You never overcome any of these defects of character forever," he told the *Los Angeles Times* in 2012. "They're always with you. You have to learn to live with them."

I was very lucky to get Nick Nolte, and he gave his all.

Was it alcohol? With Nick you never knew, because he had kind of a crazy life. I'd say that Nick, like Rutowski, had that California, Malibu, surf-side, fifties, sixties, Kerouac[36] thing. He's got that thing, and he's great at it, but he never was able to deliver it in a way that he could cash in on.

Hey, that was it! He was in the Kerouac picture! That's where I first paid attention to him.

Oh, right. *Heart Beat*, from 1980.[37]

I remember visiting him on the set and getting to know him. He was playing Neal Cassady, with Sissy Spacek as Carolyn Cassady and John Heard as Jack Kerouac and Ed Pressman producing. Nick missed with that picture, which is too bad, because that would've been the right one for him. That was the character he was, you see. That was the role. He was also in my friend David Ward's *Cannery Row*

in 1982, and that flopped, too, so he didn't have much luck there. But he was definitely a great character actor.

I was very lucky to get Nick Nolte, and he gave his all. He reminds me of Walter Huston[38] a bit, a lot of that grit he's got. He plays that role in *U-Turn*, of the tough guy. Walter Huston is a nasty fucker in *The Furies*.[39] He hangs Gilbert Roland, right? That's a great moment. And of course *The Treasure of the Sierra Madre*,[40] where he came into his last glory.

Even though Nolte's character in this is really horribly scummy, he also seems to be a man who's not in control of his own impulses. There's as much of a helpless quality to him as there is to the other characters.

I love the scene where he's fucking his daughter-wife or whatever, and he's so into it, and she's bored, because she's a tool, she's being used. But

he hears the door, and he hears Sean Penn coming in, and he goes, "What was that?"

But before that, he goes into this whole thing with her, calling her all these names, abusing her: *Your mama, blah blah blah.* Making her go through all this pain and suffering, and then he hallucinates her mother and her, and he freezes up, with those great eyes and long teeth—I don't know if we added teeth or not—and he's crying, and he dives right into her muff like nothing happened!

36 Jack Kerouac, 1922–1969; pioneering writer of the Beat generation, along with William S. Burroughs and Allen Ginsberg; *On the Road* (1957), *The Dharma Bums* (1958), *Desolation Angels* (1963).

37 Drama from writer-director John Byrum.

38 1883-1950; *The Maltese Falcon* and *The Devil and Daniel Webster* (both 1941), *Duel in the Sun* (1946); father of writer-director John Huston, grandfather of actors Anjelica and Danny Huston, and great-grandfather of *Boardwalk Empire*'s Jack Huston.

39 1950 revenge western, directed by Anthony Mann.

40 1948 Western, directed by John Huston, from B. Traven's novel, about two Americans, played by Humphrey Bogart and Tim Holt, who hire Huston's grizzled prospector to help them find buried gold.

"You're a man without scruples, I can smell it on ya!"

It's like he wants to be reborn or something!

Yes! And he becomes a baby again! And then he hears the fucking noise, and he looks up like that! After all this emotion, he's still like a lupine animal, and he grabs a gun right away. That transition from making love is very well done. That's what an actor can do. It was written, yeah. It's a mad scene in a mad script. But Nick really brought that thing to life with great energy.

Also, I love the first scene where he picks up Sean Penn and he turns the conversation: *I bet you just wanted to kill her. . . . Would ya? . . . You're a man without scruples, I can smell it on ya!* And I love how Sean Penn is like, *Hey, man*—a very weak protest! That's a great scene.

I love that contrast between Penn and him. Penn is having a really fucking bad day. He has a headache, he's walking on the side of the road, and now he's being offered a deal

to kill this woman we just met? He can't believe it! Everybody's crazy in this town! "Is everyone in this town on drugs?" he says in the café.

When you think about *U-Turn*, when you think back, what are the first images that spring to mind, or experiences that spring to mind? Or sensations?

I see a horseshoe, the "U." I mean, it's hot. Cactus, sun, drenched in sun. I remember coming up with the title in the Moroccan desert, in the middle of nowhere.

Billy Bob [Thornton].[41] Sean Penn in his face. Jennifer coming out of the store with the red dress. So many images, you know. Everything's very vivid. I have very fond memories of it.

So, let's situate your next movie, *Any Given Sunday*, in the timeline of your career. The magic

window opened for you after *Platoon*. It stayed open for ten years. And then you made *Nixon*—a personal film that's now generally recognized as one of your major works—and it wasn't a hit. You once told me that when *Nixon* bombed, it suddenly became impossible to get the studios to directly fund the big historical dramas you were known for. You changed course by making *U-Turn*, a smaller movie, and closer in spirit to your earlier films.

And that was rejected, too. The corporate attitude that was so cold came from that period, too. I think by that period, the entertainment corporations were getting so big. In some naive way, I thought the NFL would see that *Any Given Sunday* had a very positive respect for the game of football. I *hoped* that they would see that.

But they didn't, as we'll discuss.

41 Wickedly funny, unnervingly charismatic character actor and filmmaker; *One False Move* (1992), *Sling Blade* (1996), *A Simple Plan* (1998), *The Man Who Wasn't There* and *Monster's Ball* (both 2001), *Bad Santa* (2003), TV's *Fargo* (2014).

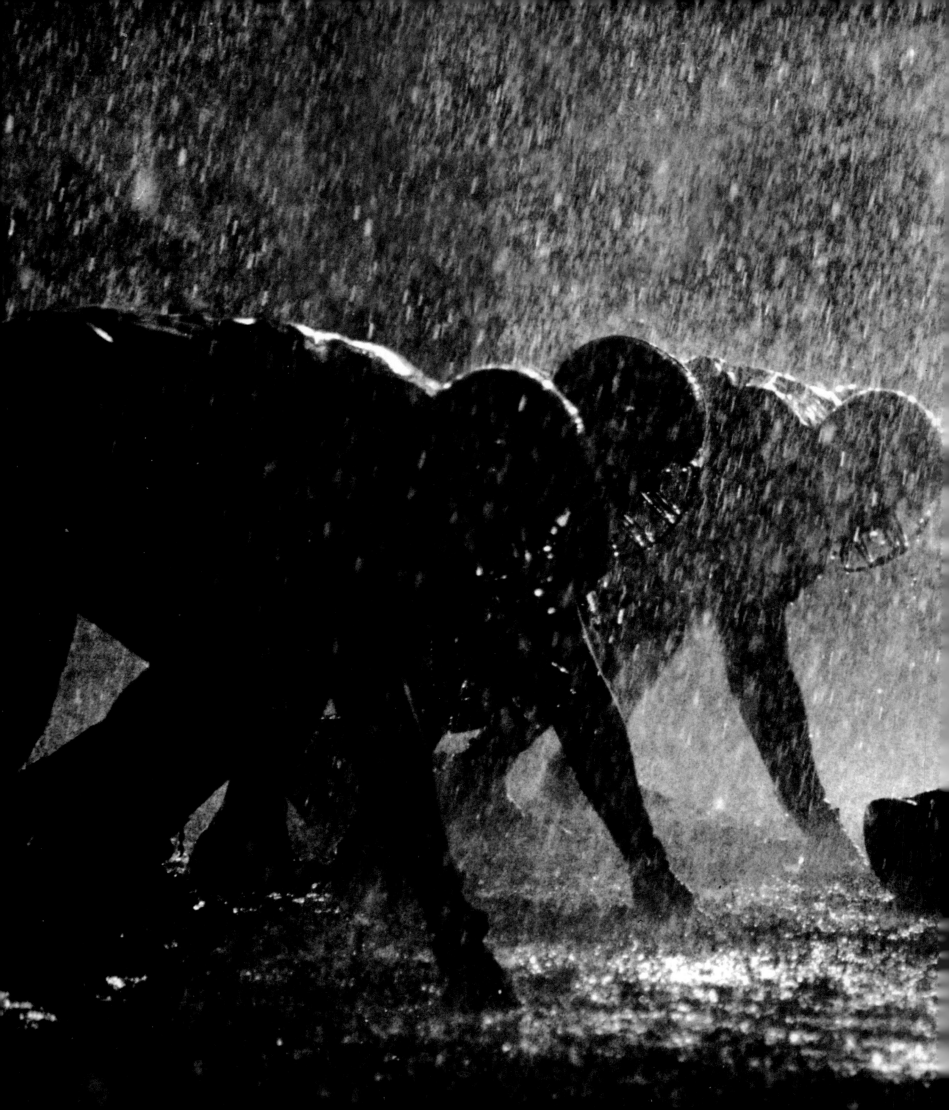

(opposite and left) Publicity still of Jamie Foxx as Miami Sharks quarterback "Steamin'" Willie Beamen from *Any Given Sunday* (1999), in a pose inspired by the 1950s-era football cards (such as the Ollie Matson card at left) that Oliver Stone collected as a child. *(below)* Stone as a sportcaster in *Any Given Sunday*.

No, they didn't.

What was your relationship with football growing up?

I played football in elementary school. I was a left halfback and linebacker. I was a good one. I think I liked the violence of the game. And then I went to freshman year at Hill School, where they made me fullback, which was a big mistake: The coach was not a good coach, he made me fullback, and I wasn't big yet! I mean, what the fuck? So I ended up as a linebacker, but then I gave it up and turned to cross-country sophomore year: varsity cross-country in my senior year. But yeah, I've loved football since I was a boy. I was a lonely child, and I had free time, so I started a fantasy football thing for myself. I collected football cards—the early cards, in the 1950s: Ollie Matson,[42] those guys. I loved those guys! They had great football cards back then, very expressive. Guys would make faces, like they were all doing individual heroic poses, you know, like this— *(He stretches back in his chair with his arm behind his head, like a quarterback about to throw a pass, and grimaces.)*

And so I devised a game, which I really enjoyed, where I'd take all these old football cards, put my teams together—I don't know if I had the full number of teams; in those days there were fewer teams. I think I only played the game inside the seasons, or close to it.

Can you describe how the card game was played?

I would have a physical side, I mean, really physical, just sort of slamming these cards together. *(He mimes smashing playing cards together in his hands, like football players colliding.)* That part of the game was based on whim and force, and it was half the game. The other 50 percent of the game was dice. So it was an interesting combination of luck and will. Let's say I wanted one team to win. Well, who knows what happens if you put more force one way? I broke it down pretty interestingly, and I kept logs of all the teams: wins, losses, and so forth. I had fun, but over the course of that year, the log grew into this monstrosity! From what I know of fantasy football now, it's somewhat along the same lines, only more sophisticated.

So you were into football before football became corporatized? Before television came in?

That's right. Football was not televised [bigtime] until 1958, you know. *(Grins)* Alan Ameche![43] Ah, yeah! I remember that '58 championship game with Ameche and the [Baltimore] Colts against the [New York] Giants vividly, and I remember Frank Gifford[44] of the Giants. I got disgusted with the Giants in the mid-'50s, so I became a 49ers fan, largely because of Y.A. Tittle.[45]

I wrote a Facebook post about the 49ers, and about their coach [from 2011 through 2014], Jim Harbaugh. There's something wrong with him! He concentrates all the time on strength and force. You can see it in Harbaugh's expressions on the sidelines: He's always looking at the game like this— *(His eyes narrow, and his face assumes a rocklike stare.)* He's always crouched, and he wears khakis like a kid, and he always has goofy expressions, and looks like he's trying to will things to happen. He talked in an interview about putting the team through pain to make them a great team. That's not going to work in football, because they're all tough guys. Harbaugh's not in the same class with the really good coaches, like [New England Patriots coach Bill] Belichick, or the smart ones, like Bill Walsh of the 49ers, who's my hero, and Bruce Arians of the [Arizona] Cardinals, Mike McCarthy of the [Green Bay] Packers.

Hearing the way you talk, I'm not at all surprised that your cameo in *AGS* is as a sportscaster.

I wish I could've been a sportscaster, but I don't know if I could handle the grind.

Can you talk some more about the role of willpower in a game: the idea of trying to will things to happen, or forcing them to happen?

42 Pro football running back who played in the National Football League in 1952 and then from 1954 to 1966.

43 Fullback for the Baltimore Colts; nicknamed "the Iron Horse."

44 1930–2015; after 12 years as a running back and flanker for the Giants, became a commentator for ABC; husband of TV personality Kathie Lee Gifford.

45 1926– ; quarterback for the Baltimore Colts, San Francisco 49ers, and New York Giants.

That's what the classic fan does. The fan sits there on a Sunday afternoon and goes, *Come on! Come on!* He wills it, right? Gave up on that theory a while ago!

It's almost like a mass prayer, except everybody's screaming.

(*Laughs*) Intelligence and game planning make a winning team. Football is a complex game, but it's not that complex. You see a lot of sloppiness when the receivers go up in the air: They juggle. You have all that thinking, all that strategy, in football, but in the end you just go out there and throw the ball—and these days, when you do that, half the time you get a penalty, or the guy changes something in the middle because somebody ran into his path, or because something else happened. Still, there's a madcap quality to football that's fun. It's like what I had as a kid, with the dice and the force.

You push that idea to an almost horrific, comic degree in *Any Given Sunday*. Some of the hits in the movie are so huge, just enormous. The sounds are immense, absolutely immense, like someone's throwing a sack of potatoes at a wall. And in one game, you've got a guy losing an eye, Oliver! He gets tackled so hard that his eyeball

Intelligence and game planning make a winning team.

pops right out of his head, and the medics put it in a cooler!

(*Laughs*) Some people didn't like that, they told me. And it's true: I did go too far.

The eyeball wasn't in the original theatrical release, but it ended up on the DVD.

That was one of those movies where I wanted to finish the theatrical cut, the DVD people needed it right away, I couldn't quite finish, and I said, *Fuck it, put this film on the DVD*, which we did, and that was the version with the eye. But then fans kept writing me and saying, *Why hasn't the theatrical release been on DVD?* So I went back this year and released one without the eye to DVD, the theatrical print. The theatrical cut is shorter. There are a lot of differences, but most of them are small. For example, in that part where they did the hands-around sweep, I always wanted to have the sound of a buffalo herd in the mix, so I think we added buffalo sounds.

You have a lot of sound that's ultimately more expressionistic than strictly realistic. In this movie you have sounds of exploding bombs mixed into a scene, and you've got another scene where a bunch of players suddenly drop down on the field, like a pratfall, and you hear a machine-gun noise, as if they got mowed down with bullets.[46]

Yeah! And there are subtle animal sounds in there, too, throughout. Tigers, lions—I remember early in the first game, there was a tiger sound. The agony, the clashing—I think there were a lot of jungle sounds. And when that buffalo herd comes around, you hear the ground shake. There are a thousand tricks like that.

You've got a lot of different subcultures in this movie, and a lot of characters representing different

46 *New York Daily News* film critic Jack Mathews complained, "the sensation we get from the blizzard of images and teeth-jarring sound effects is of having our head used as the football."

(below top) Stone, Cameron Diaz, and James Woods in the Miami Sharks locker room. Diaz's surprised expression is not an act; Stone asked her to cover her eyes before entering the locker room, and when she uncovered them, she found herself among naked or partially naked actors. "She was cool as a cucumber, though," Stone says.
(below bottom) One of many images in *Any Given Sunday* of nonchalant male nudity.
(opposite top) Al Pacino and Oliver Stone in Coach Tony D'Amato's office.
(opposite bottom) Personal photo from Stone's Los Angeles home office with him and Charlton Heston on the set of *Any Given Sunday*.

Yeah. There was nobody like that—no female owners, none. But I wanted a woman. Cameron, I thought, delivered. I thought she was good. She proved she was a dramatic actress, too. Pacino didn't trust her at first, and was really against it, because Al's tough, you know: *I don't know if she can do this*. The first day was rough, too. She was nervous with him, and he was tough. But she got into it. Man, she was good. Wow!

But there was so much indecision in post-production. It was all really complicated, and I couldn't make up my mind on a few things. It was a race to the finish. Shannon Leigh Olds[48] was the visual effects supervisor, and there must've been one hundred opticals.

You mean like all those dissolves?

There was nobody like that—no female owners. But I wanted a woman.

aspects of those subcultures, or different attitudes within them. Throughout the film, there's this sense that people need to be team players without changing or being untrue to their code. You see that with Matthew Modine's[47] character, the doctor who wants some accountability on the medical end of things and is being shouted down by the senior doctor, the James Woods character, who just wants to "patch 'em up and put 'em back on the field." And you see it with Cameron Diaz, too.

The biggest problem for me on this movie was simply having so many actors who were very good, and trying to give everybody equal time—with the exception of Al [Pacino], who demands the most time: He was the star, you understand, so that was always the equation.

Was Cameron Diaz's character originally a woman in the script?

47 Modine (1959–) is a lanky, reflective leading man best known for *Vision Quest* (1985), *Full Metal Jacket* (1987), *Short Cuts* and *And the Band Played On* (both 1993), and *The Dark Knight Rises* (2012). Modine's character, Dr. Ollie Powers, is partly modeled on Robert Huizenga, former LA Raiders team doctor and author of *You're OK, It's Just a Bruise—A Doctor's Sideline Secrets about Pro-Football's Most Outrageous Team*, which sparked a national argument about sports-enhancing drugs and steroid use. Huizenga sued Warner Bros. over screenwriter and source-material credit and won an undisclosed settlement.

48 Visual effects editor on over 20 feature films, including *Strange Days* (1995), *Starship Troopers*, (1997) and *Moulin Rouge* (2001).

Yeah, all kinds of shit. And of course, the crowds, you know, were all digital—obviously you can't book 60,000 people, so you book sometimes 1,000, sometimes 500, sometimes 2,000 on certain days. We did go over budget in overtime, because there were huge deals, where you have a lot of people who work fifteen, sixteen, seventeen hours. You're paying for it. And rigging the stadiums! The last stadium was open to the sky. I'll never forget when we tried to light it! The rigging was so expensive that it totally covered the top, and the wind blew it off! It was gone! We had to shoot the scenes fast, because when the shadows come, increasingly smaller pieces of field were available to us. So we'd be on the 50-yard line and we had to move to the 10 in order to get a shot.

So you're changing screen direction a lot during the games, and hoping nobody notices?

Yeah! Constantly tricking the audience. This was one of the trickiest shoots I've ever been on. You had to remember a hundred things at one time, technically. I have to say, it was intense for me, and I probably did smoke too much grass. I was very tense. I just had to relax. I got a DUI at that point, too, in '99.[49] I don't think my health was in the best shape at the end of that film.

There's a lot of intercutting in the movie—too much, in hindsight. I'm thinking that the *Ben-Hur* scene, I got it, though. I also like that bit with him grabbing the ball and turning it in slow motion, and that moment of the hand gripping the dirt, and him standing in the rain. I don't know why I had so many shots of Heston in the scene, maybe because Heston is in the movie.

It's funny to see Charlton Heston on the coach's TV playing *Ben-Hur* and then see the actual Charlton Heston: Ben Hur, The Omega Man, Moses from *The Ten Commandments*.

Of course, an actor like him would become commissioner of football! It would be a Ronald Reagan type. But he was a wonderful, charming, and dignified man. And he was great in the role.

Heston was a conservative. He was even the spokesperson for the National Rifle Association for a long time. Did he give you any grief for being Oliver Stone?

No. I had cast him in the movie partly because he'd said in the press something like: *People like Oliver Stone would never hire me, because the liberals run Hollywood.* I wrote him a nice

note and said, *I admire you very much.* I hired him, and I kidded him, as if to say, *You complained, and I wanted to show you that I love your films!* I mean, we don't agree politically, but he meant so much to me, you have no idea! He was so gracious, and he had bad arthritis. I could see the pain he was in, and he had to work long hours. We were working sixteen-hour days. One time we finished at four in the morning, and he was standing up there.

This is a long film with a lot of story, and a lot of football.

Five games! Each game represents a period, a turn in events. First game, second game—each one has a meaning to me. I think the games are doing in this story what the concerts did in *The Doors*. If you compare the five games in *Any Given Sunday* to the five concerts in *The Doors*, you'll see some parallels. Each one of those concerts represents another stage of Jim's journey, as do these games for Pacino and Jamie Foxx,[50] and the team.

49 Stone was arrested in May 1999 for driving drunk, as well as for possessing marijuana and a small amount of Hydrocodone (a pain medication) and possession of fenfluramine and phentermine (the ingredients of the dieting drug fen-phen) and was ordered into a rehabilitation program. He was arrested again in August 2005 at a police checkpoint on Sunset Boulevard in Los Angeles on suspicion of drug possession and driving while intoxicated; he pled no contest and was fined $100.

50 1967– ; actor and singer; *In Living Color* (1991–94); *Ali* (2001), *Collateral* (2004), *Ray* (2004), *Miami Vice* and *Dreamgirls* (both 2006), *Django Unchained* (2012).

And throughout it all, you've got this sense of history and myth, where the ghosts are constantly, at times almost literally, intruding on the movie. You see the silhouettes, the images of the great players from the days of leather helmets. It's like the present-day characters are being psychically oppressed, in the way your version of Alexander the Great is oppressed by tales of his ancestors.

Except Jamie Foxx's character didn't believe in the ghosts until that very last play, when he hears them. So there is tradition to me. That's what the coach kept talking about: the tradition. And you have to hear it. *You have to hear it.* Just like as a director you have to hear the old filmmakers in your head, and combine the old and the new, on your terms.

Do you see yourself in Pacino's coach, Tony D'Amato?

Very much so, especially at that moment in time, when I wasn't sure about the future. It was the end of the century, and there were so many dire predictions at that point about the new world, and all this computer business was starting to happen. There was a dot-com explosion, and all this fear of the Y2K virus. It was a very uncertain moment in history.

It was an uncertain moment for you, too. A lot of the Coach D'Amato scenes in *Any Given Sunday* are about him pushing back against the people who write the checks, and who want to second-guess him and tell him how to do his job.

You've worked for a lot of different studios. Universal did *Born on the Fourth*. TriStar did *The Doors*. *Any Given Sunday* was funded by Warner Bros., a studio that also funded *Heaven & Earth*, which was not a hit, and *Natural Born Killers*, which was.

I think good filmmakers are like coaches. They just get shuffled around. By the time I did this movie, Warner Bros. had changed a lot. There was new management. New kids were coming in. It wasn't about the movies anymore, it was about, *What's the box office?* It wasn't about the game, it was about, *How many passes can you throw? How many star quarterbacks can you get?* (Sighs) That becomes a very painful way to do business.

In this film, though, the coach and the quarterback are able to reconcile those forces: will and dice, the material and the spiritual. And they're rewarded with a happy ending. The team wins.

Yes. But I think until Willie Beamen learns that lesson in some way—until he becomes less materialist and more spiritual—he doesn't become a grand leader. And I think that's the leadership quality, always, for directors and quarterbacks and coaches.

But the issues are not entirely resolved. The anger is always there. You can see it still. But at least it's reflected, and his relationship with his fiancée, Vanessa, Lela Rochon's[51] character, is amazingly volatile. I remember we had some pretty good dialogue there where she lets loose.

After the reception, where she sees him flirting with other women, yeah: They fight about class, and the perception of class, after Cindy Rooney, the wife of the white quarterback, Cap Rooney, condescends to her at the reception. She kind of pushes her out of their little white sewing circle. Vanessa says, "She made me feel like a field hand!"

I love those scenes. I think they deserved recognition: two black people talking to each other about some down-and-dirty shit.

Willie Beamen's journey seems to be the thread that takes us through that world. That thread is mainly about a talented black man trying to succeed and define himself in a white-owned world. There are many, many sections in that movie where he is at odds with Al Pacino's character, Tony D'Amato, the coach of the Sharks.

The coach is having issues with the establishment, too. He's trying to keep his freedom.

True—but even though he's still a white man in his fifties, and even though he hates thinking of it this way, he's representing the owners when he's dealing with his players, most of whom are black. And his interaction with Foxx is condescending at first. I'm thinking in particular of the scene on the airplane where Coach D'Amato is trying to school Willie on the giants of jazz. The music Willie is listening to through headphones is rap, and he has to take his earbuds out to indulge the coach. Then he invites Willie over for lunch to try to rein him in, and Willie asserts his individuality instead. You cut the whole conversation together

with scenes from *Ben-Hur*, which is playing on the coach's TV, and also with these dreamlike flashes of football's early days, when the players were white.

The gladiator thing is major. All through the movie you liken these mostly black football players to gladiators, and it's not lost on the audience that the men in the arena were slaves. It's not lost on Tony or Willie, either—Willie refers to the

If you compare the five games in *Any Given Sunday* to the five concerts in *The Doors*, you'll see some parallels.

black players as "field hands," and Tony warns him not to play the "race card." And in another scene you've got the team owner, Christina Pagniacci—Cameron Diaz's character—walking into the locker room, wading through all these guys, like she's a rancher visiting a cattle pen. She shakes hands with this one black player who's naked, and you can tell by how blasé everyone is that this is just the way things are.

Yeah, that's right. I'm trying to remember the origins of all that!

I know the script was kind of a hybrid of different sources, and it went through different drafts, different versions, and the WGA arbitration ended up with ten names on it, including yours. Weren't you originally developing a football script called "Monday Night," by Jamie Williams, a tight end for the San Francisco 49ers?[52]

Yes. I [spent time with] with the 49ers for a while, and Jamie Williams ended up on the film as my adviser, along with his wonderful cowriter on that script, Richard Weiner, who wrote about football for *USA Today*. And then

51 1964– ; *The Chamber* (1996), *Gang Related* (1997), *Why Do Fools Fall in Love* (1998), *Brooklyn's Finest* (2009).

52 As of May 1, 1999, the screenplay's cover page listed the following writers: original draft by Jamie Williams and Richard Weiner, John Logan, Daniel Pyne; subsequent revisions by Gary Ross; revisions by Raynold Gideon and Bruce A. Evans; revisions by John Logan; revisions by Lisa Amsterdam and Robert Huizenga; latest revisions by Oliver Stone.

(*below*) Stone with Dennis Quaid, who plays fading Sharks quarterback Cap Rooney.

(*opposite*) While the football stadium, locker room, and executive suites are ruled by whites, *Any Given Sunday* shows that in the wider world, black athletes set the cultural standards; the party sequence 30 minutes into the movie establishes this with images that emphasize the players' bold sense of style (epitomized by the red suit, hat, and gold jersey-number ring sported by LL Cool J's Julian Washington.

John Logan,[53] a really excellent writer, did a screenplay called "On Any Sunday," which is more about a coach; I don't remember that one having a lot of stuff about what life is like for the black players. But I bought Logan's script and combined it with a book by Robert Huizenga, a team doctor who worked for the Oakland Raiders in the eighties, with the wilder guys; he talked a lot about what passes for medical treatment in the NFL.[54]

Where did the race stuff come from, though? I think it may have snuck in there through Jamie Williams and Huizenga; they were a great duo, and they really helped me a lot.

Did they help you get into the cultural differences between the black and white players? There's a lot of material in the movie about that. At one point Willie's on an ESPN-type talk show, and he says that young black men are raised to think of themselves as individuals, and then you get them into football, suddenly they have to keep a lid on that. He also tells the white host that the NFL is 70 percent black players but there are no black owners, few black coaches, and only two black quarterbacks, including him; the league in the film is fictional, but at the time those numbers came straight from NFL stats.

And then some other elements in the movie remind me of a great book by the culture critic and filmmaker Nelson George called *Elevating the Game*. That's about how African American players changed pro basketball—how they had great success, but they also found themselves pushing against traditionally white concepts of what it means to be a good athlete: subordinating yourself to the institution, tamping down on your personality so nobody could say you were trivial or vain [END 4].

And then you've also got the LL Cool J[55] character, J-Man Washington, who wants more play time because it means more money. All that stuff got honed over time, and that whole ego versus the needs of the team element, and expressing it by contrasting the white quarterback and the black quarterback—that's great stuff, and it plays well, it's fun.

And Dennis Quaid's[56] character, Cap Rooney, is a model of that strong, silent white man thing, which is still a thing in sports. I love Quaid in that part: He's got that great face, that authentic face of the fading quarterback, just a wonderful character.

And he's juxtaposed against Willie, who's so exuberant and young.

Willie Beamen! What a character! Jamie was a natural quarterback from Texas. And what a great performance he gave! He brought so much to the part. Willie Beamen's attitude, the brashness, was always in the script before, but certainly Jamie added to it. Jamie was good. Al intimidated him, but he was *good*, and he brought a lot of himself to that character, a lot of authenticity to that character. Honestly, a lot of the good stuff from Willie comes from Jamie. And any of the other black players who seem authentic or believable, same thing: That comes from me going to the actors and saying, *Look, I need you to take this scene and run with it. Make it sound right, make yourself comfortable, make it believable*.

Jim Brown loved the movie, too, and he's a big influence on it, because he's very conscious of the black player. His character definitely represented the older point of view

on that experience. So did Lawrence Taylor,[57] who was there as well.

I wanted to ask you about Brown specifically, because he's a walking repository of not just football history but Hollywood history. He had the first interracial sex scene in a major motion picture in *100 Rifles*, and he was one of the first honest-to-God black leading men in American cinema: an action hero. And here he is in this movie, playing a wise older man, a counterpart to Pacino. Did you talk to Jim Brown about his football career?

Sure. He told me the game had moved on since his time. He talked about his time, the sixties. It was that moment when Cassius Clay became Muhammad Ali, that moment when these black athletes were starting to really rise into the national consciousness and assert themselves. Jim was part of that moment, and that was where he had problems, because he seemed aggressive and threatening to some white people. He and Ali alarmed whites because they were outspoken black men at a time when white people weren't used to seeing that kind of black man. Brown and Ali were men who didn't feel the need to accommodate, didn't feel the need to assimilate.

That attitude was also scary to a lot of white people. I remember this from my immersion in Vietnam: A lot of the black soldiers would disappear when we got back to base camp and hung out with themselves, in their hooch. They had hooches of their own, like the equivalent of having a lounge where

53 1961– ; *Gladiator* (2000), *The Aviator* (2004), *Rango, Coriolanus,* and *Hugo* (all 2011), *Penny Dreadful* (2014–).

54 For more about Huizenga, see footnotes on pages 356 and 359.

55 1968– ; rapper and actor; *Krush Groove* (1985), *Anaconda* (1996), *Deep Blue Sea* (1999), *NCIS: Los Angeles* (2009–); cowrote and performed closing credits songs for *Deep Blue Sea* and *Any Given Sunday* that lodge in the brain so deeply that not even surgery can remove them.

56 1954– ; energetic leading man with a killer smile; *Breaking Away* (1979), *The Right Stuff* (1983), *The Big Easy* (1987), *Wyatt Earp* (1994), *Far from Heaven* (2002).

57 New York Giants linebacker, 1981–93; battled drug problems throughout his adult life and pled guilty in 2011 to sexual misconduct involving a sixteen-year-old girl; considered one of the sport's greats and is one of only two defensive players to win the NFL MVP award.

you could smoke dope and listen to music. Their music was great: jazz, beautiful soul music, the Motown you hear in *Platoon*. Jimi Hendrix was very new then. I can't say he was popular with the black soldiers, though one or two of the guys I knew really liked him. Rock music generally, not so much, except some of the psychedelic stuff. The black soldiers weren't into the Doors, you know, or country, a lot of rock. That was for the whites.

There's an echo of those scenes in *AGS* in the locker room where you've got this low-level running battle over what kind of music gets played. The default is R&B or hip-hop, but then the white linebackers will come in and crank up their metal.

Some of that was improvised. I mean, this was an active movie. I was taking from everywhere, but I had real good people there, too. Holy cow! A lot of influences, you're right, not just in the songs, but the score. The composers were multi-varied. Remember, we had [Richard] Horowitz, Robbie Robertson, and three or four others weaving in and out.

You haven't dealt with black-white relations at length in any film besides this one, though it does show up in your other work—like the portrayal of the African American soldiers in *Platoon*. You got some flak for treating them stereotypically, but if you look at them in relation to the white characters, particularly Chris and Barnes and Barnes's people, there's a statement being made about this idea that innocence is something that really only white people can lose in America. I'm thinking mainly of Keith David's character, King: He represents a kind of skeptical or cynical understanding of the military, and of the country that the military represents in microcosm—an understanding that the white hero doesn't have yet.

And then in *Born on the Fourth of July*, you've got Ron Kovic getting helped up by black men twice. It happens in Vietnam, when he gets shot and paralyzed: A black soldier slings him over his shoulder and carries him to safety. At the Republican convention, Ron gets dumped out of his wheelchair by cops, and another black man comes to his rescue.

As to the black soldier who picked Ron up, that was true to life, true to the book. The guy at the end of the film who helps him up, though—he's a composite, because I think Ron got thrown out of his chair on Wilshire Boulevard in LA, by a police informer; who-

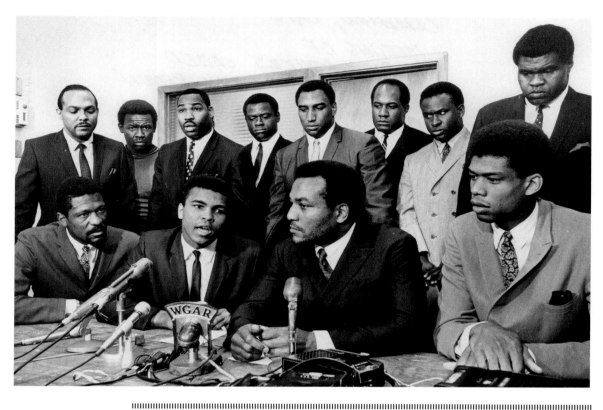

I'm a white man: That's a privilege.
I was scared of black people
before I went to Vietnam.

ever actually picked him up, I don't know what race he was. But that moment in the film seemed like a bookend to me, and to make sure people got the point, we went ahead and made it a bookend. Ron was saved by compassionate black men in tough situations twice.

But then somewhere in the middle of *Born*, there's a whole section when Ron is in the hospital: You see all these black nurses and orderlies who have an extremely cynical, sometimes dismissive, even grimly comedic attitude toward the suffering in the rehab ward, and to all the political arguments happening in the ward. You got some flak for that from some viewers, because there are times when those black characters seem insensitive to suffering, like it's just another job to them.

Well, for them it is. That's the way Ron wrote it in his book. That was the reality. Those characters in the hospital are of a different type than the other guys you mention, the ones that help Ron. You see that attitude in Poker Willie, the leader of the group, the guy who hoses Kovic down: *Whatcha want now, Kovic?*

But you know, the orderlies and nurses in the ward were not mistreating white men as much as they were overworked and overstressed, probably, and their facilities were low budget, and there was tension. And it was just an angry time. There was this anger in the air about the system. Racism was permeating the American environment, and you saw the rise of the new black man, represented by

Muhammad Ali and Jimi Hendrix and the Black Panthers, all coming forward. None of them had been shown much mercy in life.

If you listen to how the hospital staffers talk, and contrast it with the conservative kind of patriotism or idealism that Ron has, you get the sense that this white kid from the suburbs is coming to a realization that the black nurses and orderlies probably had from a young age.

Yeah—and there was one character, played by Rocky Carroll, who did make all of that stuff conscious. Like, *What are you going overseas for? There's a war at home*. He was talking very bluntly to Ron. Ron did not hear him in that scene, but I think he did hear him subconsciously.

I should say, obviously, I lived a privileged life. I'm a white man: That's a privilege. I grew up comfortable: That's another privilege. I was scared of black people before I went to Vietnam. When I ran into them in New York, sometimes they'd be in gangs—and remember, this is New York in the fifties and sixties, so there were white Irish gangs that were tough, too, and Puerto Ricans, so anybody in groups like that, I'd be scared of them. I was a city kid, but not the kind of city kid that a lot of these other kids were. I wasn't used to fighting. So I would say to you that I had a limited viewpoint on all of this.

And then I went to Vietnam, and suddenly I was in the infantry with black men, in

units that were maybe 30 percent black. I learned where my friends were, in a way, because it was a necessity.

Why, in Vietnam, did you gravitate toward black GIs, and toward the white stoners, or people with more counterculture sensibilities who also were friends with black soldiers? Was it because of that desire we talked about earlier: to lose yourself, to start over? The rich white boy sentimentalizing the common man?

Sure. But it was also about wanting to be around men who had heart and a soul, still. War dehumanizes everybody, but the black soldiers seemed to be able to resist it a little bit more. That's a generalization, but to me it seemed true. When I was smoking dope in the rear areas, I was hanging out with black soldiers because they had a little bit of life still left in them, as we showed in *Platoon*. When I was with them, there was a sense that life goes on. That life was not just this war we were in. That war was an unfortunate aspect of life—but that life is more important than war.

And that's a very important thing, you see, because a lot of people lose that perspective, like the Barnes character. There are certain people who just get way too deep into the war thing, and are relentless, and who embrace war, and dehumanize themselves in the pursuit of war.

A lot of white people seem to like violence, especially firearm violence. I've noticed that a lot. It's a small-town mentality, a tribal mentality, but it's everywhere—in cities, too. It's especially scary if you're living in Ferguson, or any of these fucking places. I know it's tough to be a policeman in New York and other big cities, but there's places in the country where there's just nothing going on, and yet they have huge police departments that are equipped and uniformed like an occupying army, and they just constantly harass people: black people especially, but they're scary to whites, too. If you have surveillance on a national level at this degree, it means you have a police state.

I've seen it as I've gone through life: It's a rough place, America. This country is a place where it's still natural to believe in might, to believe in force, to believe that force trumps law, that it trumps peace treaties, and so forth.

Maybe it comes from our genes, you know? Or maybe we just kept acting that way, and over time, it got embedded in our

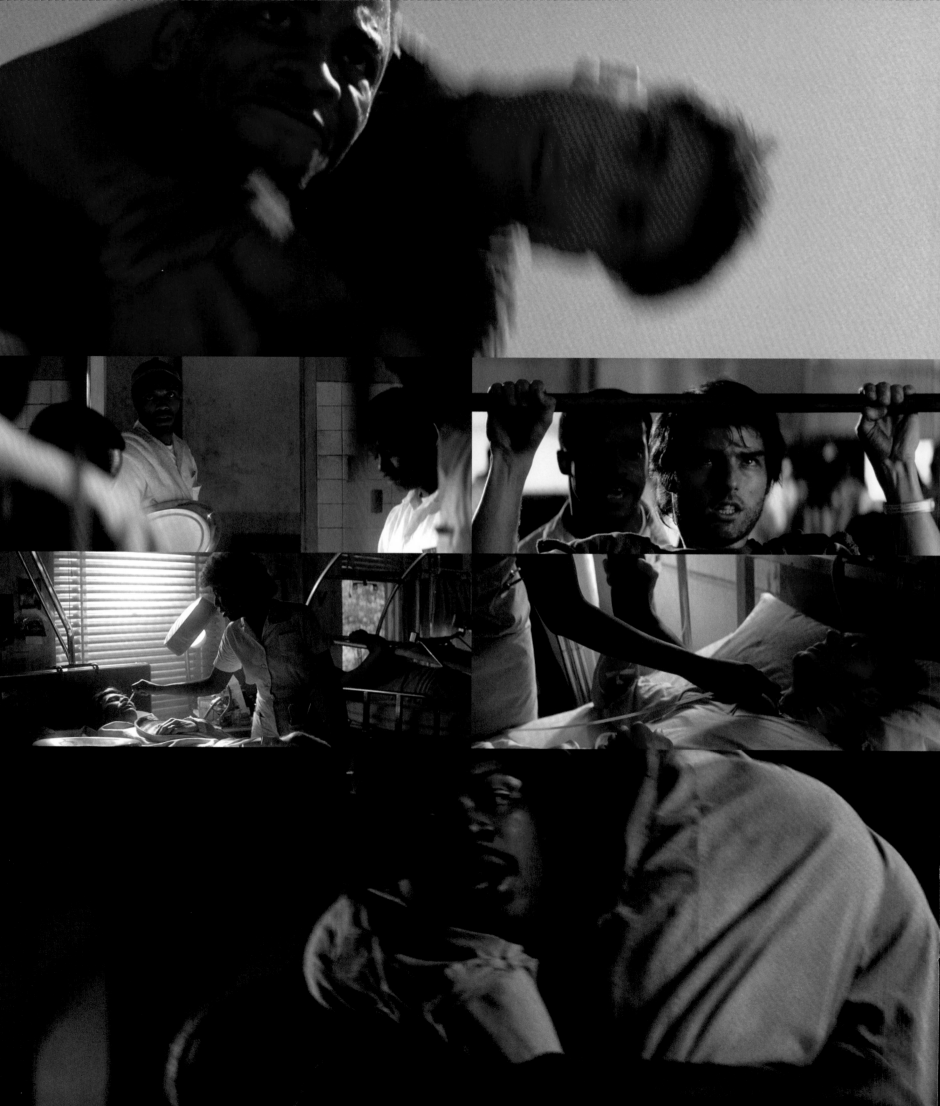

What's a white guy doing with this story?

genes. We're a pretty violent people, white people, especially when you look at the way we subjugated the Indians and the slaves, too. The Indian wars, slavery. The Civil War, the bloodiest war of all: We fought each other.

It's a pretty rough culture we come from. Maybe it's a part of us, or it's become a part of us, maybe it's passed down.

You executive-produced the indie film *Zebrahead*, which is about an interracial romance, and you helped out Spike Lee with JFK motorcade footage when he was making *Malcolm X*; but during that post-*Platoon*, pre-*Nixon* period, there were a lot of movies being made about black characters, some of them with racial themes, and you didn't direct them. Why?

Because there was already good stuff being done by black filmmakers, and because I didn't feel comfortable going there.

Why didn't you feel comfortable going there? Because you're a white guy?

Yeah. That's an issue. I ran into it again after I finished writing *MLK* in December of 2013.

The biography of Martin Luther King. That was going to be done with the cooperation of the King estate, with Jamie Foxx as King, right? Why didn't that happen?

A lot of reasons. But one was, there was this drumbeat of, *What's a white guy doing with this story?* And then Oprah Winfrey was making noise about doing a Selma movie, and wanting a young black director. Even on Facebook, I got that question: *What are you doing on this story?* But I did have a great King story, and I wanted to tell that story.

What did you think of Selma?

It's a great movie. It's about different warring factions within the civil rights movement, and then the FBI and the White House way up above them, and people within all those groups who agree in the abstract about what their goals are, but can't agree how to get there.

I think it was a safe movie to deal with King in Selma. He was a hero to the press. But that film doesn't get into the wider issues I got into in my King script. After 1965, the King story gets really rough, but no one wants to go there in American public life. And that's what I put into in the King script that you read.

No, you're right. *Selma* is a very intimate, on-the-ground story—not like how you described your Martin Luther King project to me, as an epic, the story of the American Jesus Christ—somebody who's indicting an entire way of life, a whole society, on a lot of different levels.

He was something very close to that. I think Lincoln was, too, to some degree, and he also got assassinated. King was a wonderful man who devoted himself entirely to this goal of civil rights, then expanded it at great risk to himself to make it a universal goal, more in the Mahatma Gandhi sense, of going after the war in Vietnam, going after the root causes of racism, economics, poverty, the war machine, our aggressiveness.

You do this a lot in your work: You tie these individual, political stories to larger, often sinister forces. There's always a bigger oppressive force up there, behind whatever we can see. It's never just a matter of, "This white person hates me because I'm black," or, "This redneck or Native American hates me because whatever." At the end of it all, there's always money and power. And that's true of your "MLK" script: this notion that the real enemy is aggression, and those who profit from aggression.

The older I get, the more sense it makes. I mean, I don't see any way out for this country. It just seems that there's a war machine that needs money, and they keep getting it. The definition of fascism is a police state at home, and a corporate state economically, and expansion abroad: imperial overreach.

Essay

Surrender to the Primordial

Oliver Stone, Poet of the Id

Walter Chaw

Oliver Stone is not just a historian or an entertainer. He is a mythmaker and dream weaver, contemplating the forces that drive individuals and nations. He senses portents. He is a seer of signs. He works in the unconscious, where archetypes swim. Even in films that are rooted in biographical fact, there are scenes or moments when his characters become dream protagonists, wandering through apocalyptic landscapes invoked by abandoning rational thought. Whether he is reimagining history or working in established commercial genres (such as the horror film, the crime thriller, or the sports movie), his films regularly abandon "realism" for the figurative, expressionistic, or surreal. His films often have a spine rather than a head. No surprise, then, that he puts so many snakes in his films: Snakes are all spine, and they'll bite you even when they're dead.

To experience his work is to surrender to the primordial, the uncanny. Watching his films is like walking into a Francis Bacon painting, or through an Anne Sexton poem where the inside is turned out and distorted. Even in "realistic" mode, he takes images that are commonly employed for comfort and familiarity and perverts them. Think of the way he poisons patriotic iconography throughout *Born on the Fourth of July*, to show how propaganda shaped its hero into an compliant killer; when Ron Kovic returns from Vietnam in a wheelchair after accidentally killing women, children, and one of his own men, there's an image of a tattered flag, made transparent by the sun shining through it. And in more overtly expressionistic works, the stylization is more extreme than Hollywood films typically allow. In *Natural Born Killers*, the American TV sitcom is reconstituted as an X-rated nightmare: laugh track, interrogation room lighting, crude blocking, abuse, molestation, patricide. Stone's most potent images make us shudder and recoil. They are as jarring as finding a roach in a cereal box or a lump in a breast. Time and again, he serves up the familiar and then introduces the arcane. In *U-Turn*, a diner waitress is confrontational and rude with the

hero and then suddenly flirts with him—and after that, her cat reads his thoughts and thwarts a petty robbery. His characters often seem to be enacting prophecies or living out curses: hence the interpolation of Peggy Lee's jaunty "It's a Good Day" as our hero drives toward his karmic comeuppance in *U-Turn*; the closing chessboard of *The Hand*; and the moment in *Nixon* where the soon-to-be president delivers a law-and-order speech at the 1968 Republican convention, and Stone cuts to a wide shot that shows him addressing an obviously rear-screen projected image of riot cops amassed like centurions.

In casting his leads, Stone often gravitates toward wiry, nervous, solipsistic James Woods, Sean Penn, Al Pacino, Val Kilmer, Taylor Kitsch types—men whose screen personas speak to lives lived in thrall to insensate reflex action. While these types of men often use drugs, they don't always appear to require them. The live-wire Stone hero often seems to exist half in a dream state, regardless. But Stone's more clean-cut, "square" protagonists—Richard Nixon, Charlie Sheen in *Platoon* and *Wall Street*, Ron Kovic in *Born on the Fourth of July*, Jim Garrison in *JFK*, the Port Authority cops in *World Trade Center*—also abandon the rational or

mathematical, by choice or necessity, sometimes at the behest of a wilder friend or a shaman figure, and depart the measurable world, and flow in and out of reveries brought on by alcohol, drugs, near-death experiences, obsession, or despair. They are on vision quests whether they realize it or not, and whether they want it or not. Stone's movies pull the viewer into the experience of ecstasy, in the ecclesiastical sense: the *ekstasis*, the standing outside of the self. "The worm has definitely turned for you, man," says Willem Dafoe's Sergeant Elias in *Platoon*, after feeding the hero a massive pot hit through a rifle barrel. "We're through the looking glass, people," Garrison tells his team as they investigate the conspiracy in *JFK*, invoking Lewis Carroll. "White is black, black is white."

His films find spiritual kinship in those of Shohei Imamura and Werner Herzog. There's no morality in his universe apart from that which individuals choose to exercise, and when Stone characters invoke morality as a justification for action, it's often a cover for enacting unconscious wishes, or satisfying greedy, sadistic, fearful, or lustful impulses. The only constant throughout his films is ugly, chaotic violence. In film after film we see

images of castration, mutilation, stigmata, disfigurement. The hero of *The Hand* loses a hand, Ron Kovic loses the use of his legs and penis, drug dealers in *Scarface* and *Savages* lose arms and heads and chunks of flesh, grunts in *Platoon* and *Born* are torn apart by rifle fire and mine explosions, soldiers in *Alexander* are stabbed and hacked, trampled by horses and gored by elephants. Their missing or destroyed parts can never been reattached or healed. Sometimes they can't even be found.

Stone digs deeper into male fear, rage, and desire than any American filmmaker since Sam Peckinpah, and he's just as fearless about revealing the caveman in outwardly civilized heroes. Think of the sequence in *The Hand* where Jon loses his hand: It's presented as a castration. It happens during an argument, when his inconstant wife suggests a separation. At the moment of his maiming, Jon is riding in the passenger seat in a convertible driven by a woman; from the outset there's a sense of unease, and we grasp that Jon is unhappy because men are supposed to be behind the wheels of their lives. In *The Hand*, the first glimpse of Jon's comic strip under the opening credits finds the artist's avatar, Mandro, telling his lady fair, "Now that I

369

control you, I must consider how you can best serve me." Jon never controls his wife, and she never serves him—and that's why the hand wants to murder her. The first appearance of Jon's reanimated member occurs after an eruption of jealousy: A beetle is riding it like a jockey.

There are images like this strewn throughout Stone's filmography: of men fearing loss of potency, or mourning their inability to set the terms of love or sex, and lashing out or imploding. In *Heaven & Earth*, Tommy Lee Jones's veteran fails to reintegrate with domestic life, fails to tell his wife Le Ly Hayslip the truth about his past, fails to create a new future for the both of them, fails their children, then turns ugly and abusive before finally blowing his own brains out; his spirit is seen roaming through a shaman's house like a will-o'-the-wisp. If Stone's filmography can be summarized, it is the return of the repressed: the *unheimlich* come home to roost. In *Born*, when Ron performs cunnilingus for the first time after his paralysis, Stone shifts the perspective in such a way as to present his partner, a prostitute, as intimidating, looming over Ron like a succubus. Ron can give sexual pleasure but not receive it. In the hospital he feared he could never be made whole again, and sexually, at least, he's proved right.

In *The Hand* there's a shower sequence in which Jon's hot-water tap turns into a tiny steel hand. Cocteau's *Beauty and the Beast*, the source for this image, is a retelling in part of the myth of Amor and Psyche, in which the heroine is secreted away to a castle where the servants are disembodied hands. In Stone's *U-Turn*, the hero in the shower contemplates lost fingers and flashes back to the moment of their separation. In *NBK*, Robert Downey Jr.'s smarmy exploitation-TV jock gets a hole blown in his hand in a scabrous intimation of the Passion. The scenes leading up to Mickey's Big House interview are scored with Peter

Gabriel's music for *The Last Temptation of Christ*. The shower, in the Val Lewton–produced, Mark Robson–directed *Seventh Victim* and Hitchcock's *Psycho* (and De Palma's *Dressed to Kill*), is a private place, sexualized by voyeurism. For Stone, this intimate space has a shamanistic element. His treatment of it evokes the Oracle at Delphi, a woman who squatted over a steam vent so that chthonic wisdom would rise in her, fertilize her, and be born as foreknowledge. Stone sees the shower as a mundane equivalent of a Native American sweat lodge, a visionary place where a man enters, naked, to revisit scenes of his physical and emotional mutilation.

Submersion for Stone is baptism in the uncanny. Inexplicable, irrational transformations happen in downpours, in the water, at night, and from deep shadow. He is not laying out blueprints for us, saying this equals this and that equals that; the films are reports from dreamland, accounts of sensations felt in the spine, and lower. The personal becomes political, the intimate becomes national, the real becomes unreal, the factual becomes the mythic. In the animated sequence on the bridge in *Natural Born Killers*, as Mickey and Mallory cut their palms and join them together, their intermingled blood becomes snakes twining into the river. The lovers are elevated, as all of Stone's protagonists are elevated, into mythology, but their desires are primal, bestial, universal. For Jung, Greek mythology is the language of the unconscious. The image of the snakes in *NBK* suggests the blind seer Tiresias, who comes upon two snakes copulating, strikes them in disgust, and is turned into a woman for seven years. Tiresias is perhaps better known for being struck blind for his impertinence to a goddess and being compensated with the gift of prophecy by a god. In the Oedipus play, Tiresias warns the hero's father

that he'll be slain by his son, then warns the son, the play's hero, that he will marry his mother. ("Father," Jim Morrison sings in "The End," "I want to kill you. Mother . . .") No one listens to Tiresias until it's too late.

Stone upsets the war movie this way as well, and the noir, and the youth-on-the-run picture, and the epic—every genre he attempts. He takes scenarios that are merely reenacted or tossed off in other movies, and makes them shock and baffle us by plugging them into the subconscious. Just before Downey's faux-journo is murdered in the woods in *NBK*, the point of view jumps to footage captured by a camera discarded on the ground. Mickey recognizes that camera as the documentarian and addresses it, and us, directly. Before Stone kills off the couple's chronicler, he offers a flash of Downey dressed in a store-bought devil costume. We come into *Natural Born Killers* expecting *Bonnie and Clyde*—and Stone gives us layered visions and spirit animals, allusions to Greek mythology and the Bible, and violence so visceral that the ratings board demanded it be recut and recut again and again because they found every frame upsetting. What does it say that each subsequent revisiting of the piece finds it more prescient and, unexpectedly, more . . . tender?

Stone's filthy, carnal noir *U-Turn* is a retelling of Sophocles's *Oedipus Rex* set in an infernal Arizona desert town named—not ironically, I think—Superior. The story connects with the mythic fascinations of *The Hand* so strongly that the latter feels like an elaboration on the former. Late in *The Hand*, Jon is told that the murderous functions of his id are the product of "an old rage, Jon, an ancient rage." Late in *U-Turn*, the disgusting hero, Bobby (Sean Penn), is told by a blind, homeless, Tiresian Native American (Jon Voight) that "your lies are old, but you tell them pretty good." Native Americans are, for Stone, representatives of the uncontrolled, the

uncontrollable really: the essence of man. They are his and Jim Morrison's connection to the eternal, and the invisible enemy to white determinism in the West. If Stone's films are, as he has claimed, about righting karmic imbalances, few figures are as greatly wronged as Native Americans. Their existence in Stone's films is a warning and a reminder.

Mickey's murder of the Navajo medicine man during the peyote trip sequence of *NBK* causes Mallory to shriek, "Bad, bad, bad!" and leads to her snakebite, which leads to the scene in the drugstore where Mickey tries to steal antivenin and is caught by police, which in turn lands them both in prison: a guilt-and-punishment cause-and-effect chain that causes the murderous hero to understand that he has a demon inside him, and only love can kill it. Stone shoots the scenes of the couple's capture in a sick, poisoned green. The world has turned. *U-Turn*'s fatale, Grace, is a "half-breed," a tragic heroine of a film set at a metaphoric as well as geographic crossroads. *U-Turn* is composed of a series of violations predicted by Bobby's breaking of planes: crossing roads, penetrating thresholds. The blind Native American functions as the chorus of the film, similar to the director's cameo in *The Hand*, playing a homeless man with one hand who recognizes a kindred spirit in the maimed hero, but is rudely shoved aside.

U-Turn is a myth of the United States steeped in sex, greed, and blood. Stone identifies that noir is at its essence a vacuum of morality rather than a restoration of civilization. There are no "good" characters peopling Stone's sunshine noir. All of the major characters are driven by lust or are products of lust, performers endlessly acting out their roles, Sisyphean in their labors. A young girl named Jenny (Claire Danes) uses the hero as a catalyst in rescue fantasies that she continuously reenacts with her thuggish boyfriend, TNT (Joaquin Phoenix). Their relationship is a microcosm of the tale that Grace's husband, Jake (Nick Nolte), tells of himself and Grace's dead Indian mother. Jenny and TNT are last seen writhing on a dusty street like the twining cartoon serpents of *NBK*. We are reminded yet again that this director has an affinity for chthonic creatures. Scorpions, snakes, carrion birds: bottom-feeders all, echoing the baser desires of the characters. Jake's murder in *U-Turn* is intercut with shots of a crow. The film opens and closes with vultures. The images of carrion birds stalking roadkill become metaphors for people who've paid to watch films about mayhem.

It's Francis Bacon's meat captured on 35 mm film: the underneath, the essential self, and the inevitable end as food for others. The whole town seems to be in stasis. Its inhabitants are America, and the id, and eternal in their way. If Bobby is the detective, and Oedipus is the first detective story, then Bobby is the "child" of Jake and Grace, fated to kill the father and fuck the "mother" whose own mother Jake fucked. In Stone's America, we're all the products of Jake and Grace. Jake is the white oppressor; Grace is the "savage Other." Robin Wood's essay "An Introduction to the American Horror Film"[1] talks about how Puritans projected their own sexual repression onto the "Other" of the Native American. For the children of manifest destiny, Indians were literal children of the devil: unfettered libido, unfettered id, and successfully demonized as Other, ripe for eradication. The story of Jake and Grace (and Mickey and Mallory) gains resonance because it's incestuous. The incest depicted in *NBK*'s sitcom sequence is played out in Mickey and Mallory's union of like kinds. Stone's creation myth for America turns the Puritan myth back on its ancestors, in much the same way that *Born on the Fourth*, *JFK*, and *Nixon* take patriotic symbols claimed by the American right wing and make them seem untrustworthy, even sinister. In Stone's *U-Turn* countermyth to manifest destiny, Americans are the product of an incestuous union between repressed id and id: the offspring of two snakes fucking.

Where does Stone's searing vision come from? Even he doesn't seem sure. He smokes, he drinks, he reads, he writes, he dreams, he makes films, but there is always a sense that, like all artists—but perhaps more so than most—Stone would rather ride the snake to the lake than take orders from his waking mind. There's a telling moment early in *The Hand*, when the daughter of the film's cartoonist hero, Jon (Michael Caine), finds a discarded lizard tail twitching in the grass. She asks how the tail knows she's there. The father says, "He doesn't know, it's just a reflex." The line suggests not only that men are helpless to resist the tides that drive them, but that each component part of a living being is as much "he" or "she" as the rest, and driven by the same strange frequencies. Later, Jon describes his comic creation Mandro, an adventurer somewhere between Conan and Prince Valiant, as a being that "doesn't think," right at the moment when he rounds a corner and comes face to face with the homeless, one-handed drunk played by none other than Oliver Stone. "Hey," the drunk says, "you got no hand!" Jon denies it and pushes him away. He doesn't know why; it's just a reflex. Later on, Jon's hand returns and strangles the drunk: the artist murdered by his alter ego. "It's all up there," says Jon's only real friend in *The Hand*, pointing to his head, "and you'll never know who the fuck you really are."

1 From *The American Nightmare: Essays on the Horror Film*, Robin Wood and Richard Lippe, eds. (Toronto: Festival of Festivals, 1979).

Late Ed

New York: Today, su noon clouds. High 77. more humid. Low 65. then clouds. High 81. 81, low 63. Weather

ws
Print",

The New York Times

NEW YORK, WEDNESDAY, SEPTEMBER 12, 2001

Copyright © 2001 The New York Times

$1 beyond the greater New York metropolitan area.

,874

U.S. ATTACKED

HIJACKED JETS DESTROY TWIN TOWERS

AND HIT PENTAGON IN DAY OF TERROR

President vows to E

CELEBRATING
100
YEARS

SPECIAL ED

NEW YORK

LATE CITY FINA

Wednesday, September 12, 2001 / Sunny, 80 / Weather: Page 76 ★★

ACT OF WAR

World Trade Center destroyed; many dead

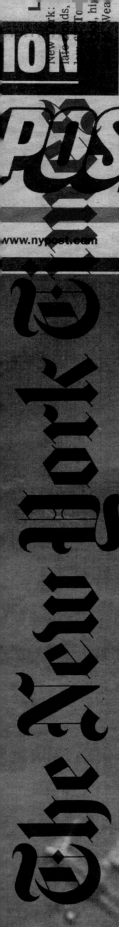

NEW YORK POST

www.nypost.com

$1 beyond the greater New York metropolitan area.

25¢

The New York Times

"All the News That's Fit to Print"

NEW YORK, THURSDAY, SEPTEMBER 13, 2001

Copyright © 2001 The New York Times

CL...No. 51,875

...TUNNED RESCUERS COMB ATTACK S...

...UT THOUSANDS ARE PRES...MED D...

F.B.I. TRACKING HIJACKERS' MOVEME...

THE WALL STREET JOUR...

© 2001 Dow Jones & Company, Inc. All Rights Reserved.

WEDNESDAY, SEPTEMBER 12, 2001

VOL. CCXXXVIII NO. 51 ★★ EE/CP

...RRORISTS DESTROY WORLD TRA...

...T PENTAGON IN RAID WITH HIJAC...

...gave proof through the night

that our flag was still there

BY STEEL AND BY

Suffering

★ ★ ★ ★ ★ ★ ★ ★ ★ ★ ★ ★

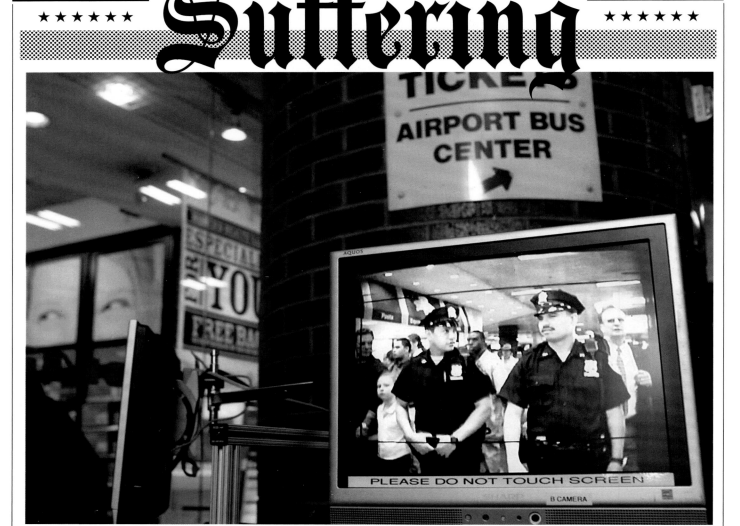

(*previous spread*) Oliver Stone (silhouetted, in baseball cap) directs *World Trade Center* on the "Ground Zero" set in Los Angeles, 2005.

(*above*) *World Trade Center* castmembers Jay Hernandez (left) and Michael Peña (right) on location at the Port Authority Bus Terminal in New York City.

By all rights, the aughts should have been the Oliver Stone decade. The contested 2000 presidential election that handed George W. Bush the presidency; the catastrophe of 9/11; the US-led retaliatory invasion of Afghanistan and the preemptive war in Iraq; the White House's embrace of torture as an intelligence-gathering tool; the elusiveness of Al Qaeda figurehead Osama Bin Laden, the reputed mastermind of the attacks; the financial meltdown of 2008 and the worldwide recession that followed: These developments and others felt like something out of a nonexistent Oliver Stone fantasy about the collapse of late capitalist America.

Unfortunately, Stone was never able to address present-tense troubles or their historical roots as grandly

as he had in the eighties and nineties. Some of this was a consequence of the ebb and flow of career making: To give just one example, after 1997's *U-Turn*, Stone lost one of his most important collaborators, his regular director of photography, Robert Richardson, and while subsequent cinematographers did fine work for him, none seemed to amplify Stone with the same vigor. More important, though, it was a touchy time. Aside from outliers like *United 93* and *Green Zone*, most of the notable films that addressed the era head-on were documentaries: Michael Moore's *Fahrenheit 9/11*, Charles Ferguson's *No End in Sight*, Alex Gibney's *Taxi to the Dark Side* and *Enron: The Smartest Guys in the Room*. On those rare occasions when Hollywood dramas dealt with current events, they leaned on metaphor: Steven Spielberg's

trifecta of *The Terminal*, *War of the Worlds*, and *Munich* are especially vivid examples.

The aughts found studios chasing properties that could be sequelized and merchandised, and that were aimed at children of all ages; the *Star Wars* prequels were already rolling out by that point, and the industry was just seven years away from the superhero gold rush ushered in by *The Dark Knight* and *Iron Man*. Stone's work never lent itself to action figures, video games, and theme park rides (although Fox's *The Ben Stiller Show* did hilariously imagine an "Oliver Stoneland," "where the objective is not to escape, but to confront").

The only spot on studio release schedules for Stone's brand of adult blockbuster was the window between Thanksgiving and New Year's, when awards-baiting "serious" epics were released in hopes of nabbing end-of-the-year critics' awards and generating Oscar momentum. Only a handful of directors were still allowed to make those kinds of pictures on a huge scale: Martin Scorsese and Steven Spielberg, mainly. Stone was no longer a part of that club. In the first few years of the decade, he had struggled to mount another feature, and kept his hand in by making documentaries about contemporary political leaders (these are discussed in the next chapter, along with his TV series *Untold History*).

Alexander, the fulfillment of a lifelong dream that Stone describes as "my *film maudit*,"[1] was his first feature since *Any Given Sunday*—and his most expensive yet. In its way, it was a 9/11 film—the first of three in a row by Stone. The screenplay, credited to Stone, Christopher Kyle, and Laeta Kalogridis, took Western civilization back to the dawn of its ongoing obsession with subduing Asia. Its omnisexual Macedonian visionary hero (Colin Farrell) builds his forward-thinking social experiments on a foundation of military adventures, first in Babylon (successful, up to a point) and later in India (catastrophic).

The film's existence seems a miracle when you consider the factors arrayed against it. It was one of two competing *Alexander* projects in the works at that time; the other, a Baz Luhrmann project that would have starred Leonardo DiCaprio, collapsed when it became clear that Stone's movie would beat it to the marketplace. And, despite a self-aware framing device in which Ptolemy (Anthony Hopkins) speaks of manufacturing the myth of Alexander, it was an unfashionably stately historical epic in the vein of *Lawrence of Arabia* and *Doctor Zhivago*. In the

end, it was a disappointment in relation to cost, earning $167 million against a $155 million budget cobbled from various international sources. Critics mocked its length and earnestness and took potshots at Alexander's startling blond hair and the exotic accent sported by the hero's mother (Angelina Jolie). Few noticed what the film was actually doing, or trying to do.

Stone is a serial reviser who released different cuts of *JFK*, *Nixon*, *Natural Born Killers*, and *Any Given Sunday* to home video. He would release four versions of *Alexander*, a personal record. The second was not hugely different from the 175-minute version released to theaters, cutting 19 minutes and restoring 9, and shifting both present-tense scenes and flashbacks to new places in the story. Both cuts moved through the hero's life in a more or less linear fashion. The 2007 *Alexander Revisited: The Final Unrated Cut*, however, is a different film from the same material, running 214 minutes, plus intermission. It arranges highlights of the hero's life in nonlinear order, introducing him at the battle of Gaugamela (arguably the peak of his charisma), flashing back to his childhood and adolescence, then moving back and forth through time in a leisurely, intuitive way. The third cut better illustrates the notion that the film's Alexander is a construct of Ptolemy; at times the movie seems not to unfold, but to ruminate. Five years later there would be an *Ultimate Final Cut* for DVD that ran 167 minutes, inspired when Stone watched the third cut at a festival and decided he'd put too much back in. In any version, *Alexander* deserves to be seen. It is a consummate Stone picture that takes us further back in world history than any of his prior features, yet resonates with then-current events (when the first cut came out, an American boy prince had sent his own army to the Middle East). And it will be of interest to Stone-ologists intrigued by how the director smuggles autobiographical touches into historical dramas. Stone's script visualizes Alexander as a pampered only child raised mainly by men. In adulthood, the hero brazenly seeks out new experiences, including war, international travel, and sex with partners of different nationalities, races, amd sexual identities. Throughout his life, he strives both to please and to resist a mother (Jolie's Queen Olympias) and father (Val Kilmer's King Philip II) whose attraction is palpable even when they're threatening to kill each other. *Alexander* is also a key Stone historical drama that's about what it says it's about while also being about history as fabricated narrative. (There are times

when Ptolemy seems a stand-in for Stone, an aging warrior puttering around his study, contemplating murals, globes, and texts.) Last but not least, it is, for all the "tasteful" elisions forced on Stone by homophobic test-screening audiences, remarkably advanced for the nonjudgmental, empathetic way in which it portrays the hero's sexuality. Ptolemy describes a world of robust male-male relationships (between boys and boys, men and boys, men and men), as well as heterosexual marriages and side action with eunuchs; this is all presented not in a self-congratulatory or condemnatory way, but as an observation of how things (probably) were. It is clear by the end that the hero has a far deeper connection with Hephaistion (Jared Leto) than he ever did with his Bactrian wife, Roxana (Rosario Dawson); but this, too, is depicted as one more biographical supposition among many that will surely be revised as time rolls on.

World *Trade Center* **is Stone's most quietly surprising movie.** Based on a script by Andrea Berloff, with uncredited revisions by Stone, it portrays the most politically important violent act of the twenty-first century to date. But surprisingly (for Stone) it avoids politics, focusing on a handful of Port Authority police officers (Nicolas Cage, Michael Peña, Jon Bernthal, and Jay Hernandez) trying to survive under wreckage at Ground Zero. It gives nearly equal time to the frustration and terror of the officers' loved ones, most of whom are female (Maria Bello, Maggie Gyllenhaal, Donna Murphy), and portrays their suburban-domestic world as a loving place gone suddenly dark and cold. It is Stone's altogether warmest and most optimistic movie, despite the wrenching predicament at its core. It depicts the relationships between friends and lovers with a reverence bordering on the mystical. And it refuses to corrupt the power of collective memory by making a spectacle of terror. The hellish flashes that we do see (citizens bloodied by broken glass and falling rubble; blurry speck of a jumper) are painful but brief: audiovisual bee stings.

Repeat viewings of the film reveal its artful construction. Like *Born on the Fourth of July*, *The Doors*, and all four cuts of *Alexander*, it eschews razzle-dazzle montage in favor of real-time scenes in which the locus of interest is behavior rather than explanation. The whole cast is superb, but the most striking performances are Cage's and Bello's as John and Donna McLaughlin. They are middle-class, East Coast Americans separated by tragedy in 2001, but the way

they talk about and remember each other turns them into fit subjects for a Romantic poem: a yearning husband trapped in hell, psychically reaching out to a wife who can sense his life force.

World Trade Center stirred up a lot of advance publicity, much of it ranging from skeptical to alarmist. The media thinks of Stone, not without reason, as an auteur whose specialty is ripping the scabs off national wounds. His remarks in the weeks after 9/11 suggesting that the attacks were karmic payback for foreign policy sins gave viewers reason to expect a rant. The emphasis on healing threw everyone for a loop. It was odd to see trade publications worriedly asking if Oliver Stone was going to view the attacks through the lenses of leftist polemics or paranoid fantasy, then read critics grousing that the film was too square. It earned $162 million worldwide.

It seemed only a matter of time before Stone made a biography of George W. Bush, the president who pulled the United States into a sunbaked latter-day Vietnam, but no one thought it would hit theaters before Bush left office.** Written by Stone's *Wall Street* collaborator and former NYU film school classmate Stanley Weiser, *W.* was rushed through production in hopes of affecting the 2008 presidential election; it followed one of Stone's most disappointing near misses, *Pinkville*, a legal thriller about the investigation of the My Lai massacre that would have been his fourth Vietnam picture had the production not been canceled due to the 2007 Writers Guild of America strike and financiers' fears that a film about a massacre would be uncommercial. Despite its clear budgetary limitations and its inability to take the long view, *W.* is a surprising biopic—overreliant on Bush gaffes ("Is our children learning?") and thin overall, but terse and droll and light on its feet, with absurdist war room and Oval Office scenes that channel *Dr. Strangelove* by way of *Doonesbury*. "Funny, Dick, I remember you once agreeing that going all the way to Baghdad would be a mistake," Colin Powell (Jeffrey Wright) chides Vice President Dick Cheney (Richard Dreyfuss). "Well, I think you made a bigger boo-boo, Colin," Cheney replies. "You could have been president." Powell: "Fuck you."

Weiser's script, rewritten without screen credit by Stone, presents Bush (Josh Brolin) as stubborn, superstitious, and anti-intellectual, a bland demagogue. There are moments when the movie plays as a *Candide*-like

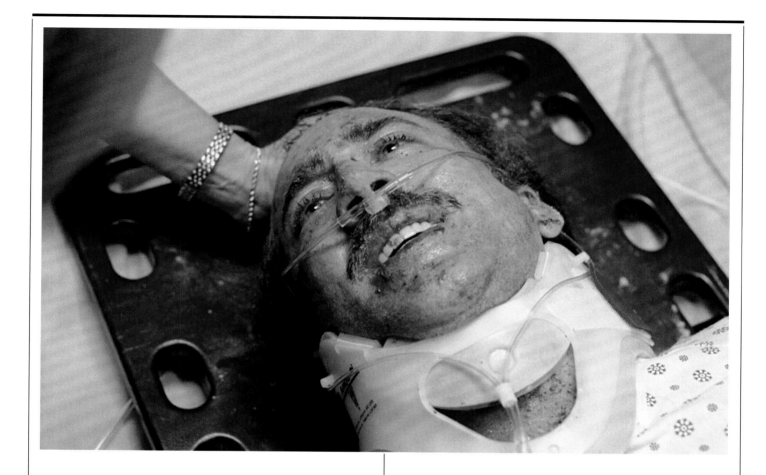

tall tale about a ninny who keeps failing upward. Bush's father, former CIA director and president George H. W. Bush (James Cromwell), looms over his son physically as well as intellectually, and their verbal sparring (which turns physical in a nightmare fistfight) channels Stone's desire to please and outshine his own father, as well as his unease about his childhood privilege.

Ultimately, though, *W.* seems to enjoy its title character—this despite Stone's documented disgust with the actual W., who attended Yale at the same time as the director. It also evinces respect for Bush's born-again Christianity (if only as a method of pulling himself out of a slow-motion tailspin), even as it shows how the president's faith hardened his delusions of grandeur. Its portrait of Bush's partnership with Laura (Elizabeth Banks) is as respectful and endearing as the marriage in *Nixon*. (W.: "Who's ever remembered the son of a president?" Laura: "John Quincy Adams!" W.: "Yeah, but that was, like, three hundred years ago, wasn't it?")

The film was dismissed by critics and ignored by audiences, because it was too sympathetic for liberals and too disrespectful for conservatives, or maybe because, by that late stage in Bush's presidency, no one wanted to pay to spend more time with him. But the movie's incredulous satire wears well. *W.* seems astonished that a presidency like this could have happened, much less that it could have gone on for eight years and led the United States so deeply into a quagmire. When Bush stands tall in an empty stadium and raises his arms in triumph, basking in the love of a nonexistent crowd, the film seems to throw its hands up, too.

1 "Cursed, or unfairly maligned." According to the website of the Harvard Film Archive, which mounted a Film Maudit festival in the summer of 2015, "The term *film maudit*—literally, 'cursed film'—was coined for the legendary 1949 Festival du Film Maudit in Biarritz for which a jury lead by Jean Cocteau curated and celebrated a group of films criminally overlooked and neglected at the time—a lineup that included such now-canonical pictures as *L'Atalante* (1934), *The Long Voyage Home* (1940), and *Les Dames du Bois de Bologne* (1945). A polemical landmark in the history of postwar French film culture, Cocteau's festival also designated as *films maudit* a number of deliberately shocking, outré, and bold films, such as *Fireworks* (1947) and *The Shanghai Gesture* (1941)."

SEPTEMBER 24, 2001

NEW YORK

SEPTEMBER 11, 2001

$2.99 (CANADA $3.99)

NEWYORKMETRO.COM

SEPTEMBER 24, 2001

MATT ZOLLER SEITZ What was the emotional experience of 9/11 for you? What was the physical experience? And as a historian, what were you thinking? Do you remember?

our response and do it intelligently, as they did. Because the people who did this were findable.

We were, comparatively speaking, new at this.

feeling that the world was going on a crusade. Maybe it was Bush's rhetoric.

The president did use the word "crusade" [END 4].

He did once, yes. I had a bad feeling. His true colors were coming out. So it was all downhill for the country. We never recovered. We're still under the onus of all that. And it's a crazy story, because really it's a chimera, in the classical Greek sense of the word: a weird, dragon-tailed chimera. It's just fear of fear, as Roosevelt said. Bin Laden and most of them would have been captured in some way. You

Bush was not my enemy at that point at all. He had been called upon to lead.

OLIVER STONE I was angry, as shocked as most people were. I was in Los Angeles, three hours behind, and I had slept a little bit late that morning. My wife woke me to tell me. And . . . I felt normal feelings of revenge. Normal, like, "God, who did this?"

And you know, Bush was not my enemy at that point at all. He had been called upon to lead. I didn't know about where Osama Bin Laden came from then; I didn't have that history, tracing him back to the Afghan war against the Soviets [END 1], and Bill Casey[1] arming the mujahideen, or Zbigniew Brzezinski's trap for the Russians in Afghanistan [END 2]. I didn't know about all that. I only saw the surface of things.

I remember having a discussion a few days afterward with Michael Caine, who was in LA at a dinner party, and I argued with him, and I remember him saying, "We have to react!" And that was definitely the reaction: We have to react! I actually wrote about it in my diary not long ago, I went back to that

Totally. And so our reaction to 9/11 was disproportionate.

And then, on October 6 of that year, I was on a panel."[3]

Yes. **"Making Movies That Matter: The Role of Cinema in the National Debate," at Avery Fisher Hall at Lincoln Center. With Christopher Hitchens** [END 3]. **The** *New Yorker* **got a "Talk of the Town" item out of it.**[4]

That's no good, it's an awful piece. That guy was not a very good reporter.

It darkened my honor. It darkened my life, and it changed . . . You know, it made me, in a way, want to get away from this argument with vigilantism, which I realized I could never win. In a sense, I went back to the world of Alexander to get out of the modern era!

When you say "It darkened me," what do you mean by "it"? Are you referring to this particular *New Yorker* **story?**

1 President Ronald Reagan's head of the Central Intelligence Agency from 1981 to 1987. He secretly flew to Pakistan in October 1984 to observe several Afghan mujahideen training camps near the border with Afghanistan. That visit and Casey's enthusiasm were instrumental in Reagan's decision to greatly increase military aid to the Islamic insurgents.

2 For more comments from Stone about overresponse as a motif in American history, and perhaps the American character, see page 168 of chapter 4.

3 Debate sponsored by the New York Film Festival and HBO, held at Avery Fisher Hall at Lincoln Center; alongside Hitchens and Stone were director Raoul Peck (*Lumumba*), feminist scholar bell hooks, former Universal Studios chief Tom Pollock, New Line Cinema founder Bob Shayel, and Killer Films producer Christine Vachon.

4 "Oliver Stone's Chaos Theory," by Tad Friend, October 22, 2001, is a portrait of Stone as a nervous, incoherent kook: "Although it seemed to most observers to be early afternoon, he twice observed that it was a wonderful night. . . . He explained how the World Bank, McDonald's, and the studios' response to the threat of a Writers Guild strike last year were all manifestations of the new global conspiracy of order." The *New York Observer*'s October 15 story about the panel was no less withering: "'I made a movie in which the President's head gets blown off in the middle of Dealey Plaza, and it was entertaining because it was a thriller!' he said in a voice as loud as his pink socks."

5 Author, critic, and journalist known for his leftist views. However, after the attacks on September 11, 2001, his views shifted to an interventionist stance that many detractors termed "neoconservative," a label Hitchens disputed.

America's corporate advertising mentality says, *We are fighting a war against evil!* I mean, what the fuck? Are you crazy?

moment, and one thing I remember was that, pretty soon thereafter, I started to see this idea settling into the American media. At that point, I said—and remember, that was not long after—"Why do we have to react this way?" Or something to that effect.[2]

I argued my theory with Michael. My thought was that Britain, France, Italy, Germany, Spain had all dealt with terrorism for many years, and that we should monitor

I'm talking about the whole mentality of people like Christopher Hitchens,[5] who—well, he became neoconservative, correct?

In some ways. Certainly in terms of his views on foreign policy during that time. He popularized "Islamofascists" [END 3].

I'm talking about the embrace of this whole attitude of vigilantism. There was this weird

don't have to declare "war on evil" and go after the whole world, but that's a very American, political, brand-consciousness kind of approach, and that's what we did. America's corporate advertising mentality says, *We are fighting a war against evil!* I mean, what the fuck? Are you crazy? There's been a war against evil since the beginning of time! Who are you? Are you insane? This is an advertising slogan to you? You've declared permanent war, putting sixty countries on the potential suspect list. It's crazy! It's like a war beyond conception. That's what's scary about America to me: It grows.

What grows? The response?

Yes.

Back in the fifties, when I was growing up, in '58, for Eisenhower to send troops to Beirut was a huge deal [END 5], because that was a time when sending troops abroad was rare! And then they got withdrawn shortly after. Reagan sent troops to Beirut and it was a huge deal. His administration got killed after the bombing [END 6].

But then he went to Grenada a few weeks later And he won reelection by a huge margin in 1984.

Five hundred thousand went to Vietnam, and Bush's father sends half a million troops to Kuwait, Saudi Arabia, Qatar, during the Gulf War in '91.[6] It just becomes larger and larger. And then his son, who's a moron, says, "We're gonna fight a war against evil!" *(Laughs)* We're under an illusion! It's a chimera! We are really crazy! I feel like a one-eyed man in the kingdom of the blind.[7]

I see all these different theories attached to you, floating online, many of them associated with this idea that you're Conspiracy Theorist Oliver Stone. Before we go any further down this road, can you tell me, for the record, what you actually believe about 9/11? The means, the motive, the details?

I'm always asked that question, and my son Sean has shown me lots of stuff. He believes it was a conspiracy, and the US government or CIA was somehow involved. I've read some of that stuff. The way I look at it, from my perspective, it's possible. It's hard to believe those buildings fell of their own accord like that. The bigger argument is about the links that existed before the attacks between the terrorists and our intelligence agencies. But

I'm not investigating another conspiracy. Not after what I went through after *JFK*.

I will say that whether it was a conspiracy or not, or whether it was the nineteen hijackers with ideological motives, like Al Qaeda said, doesn't matter, because our *reaction* is what matters. Our reaction.

And our reaction was enormous: immense and hysterical. And as a result, the world changed.

What we need to be doing now is documenting all the changes since then: the militarization of the police, the militarization of the world, the loss of national wealth, the loss of thinking, and the concept that security is achievable at any cost. And the rise of the surveillance state and the disruption of civil rights—the mentality that if you don't have anything to hide, you shouldn't have any secrets, that everything should be visible. The government has taken the role of our conscience. They tell us how to think, act, react, do. In the old days that was our business. That, to me, is the biggest issue of all. I didn't make *World Trade Center* for those reasons; we'll talk about that. But it's why I made *W*.

On that panel the *New Yorker* wrote about, I talk about a great bomb of energy, like a French Revolution moment, which I guess, in hindsight, 9/11 certainly was, because it changed the world.[8]

You said the message of the attacks was, "Fuck you, fuck your order."

I was on a stage and I was impassioned, but I meant those words. There's nothing false in what I said.

Everything I predicted back then about our response happened. The world got more fearful, the US ramped it up into an international jihad and created more jihad—honestly, these monsters would be gone by now, there'd be a few left and we'd have to live with some chaos, but right now it's *very* chaotic! We're following a neoconservative agenda, to not allow any rival to emerge.

A "rival" being defined as any country we think might someday challenge our status as the lone superpower.

Correct, which is a title we assigned to ourselves after the Cold War ended, and that no one else in the world agreed to. A rival is Iran, certainly. Or on a bigger scale, it's China and Russia. This is a policy that comes, in my opinion, from the false success of the 1990s—from saying, *Hey, we won the Cold War. We're the free market democracy that will work everywhere in the world.*

|||

This policy comes from the false success of the 1990s—from saying, *Hey, we won the Cold War. We're the free market democracy that will work everywhere in the world.*

|||

In chapter 10 of *Untold History*, the last one, we go into the neoconservative agenda from the late 1990s, the period when the neoconservatives are out of power and Bill Clinton's in power. I think the heart of it was drawn up in '98.

By the Project for a New American Century [END 7]. Later on, a lot of people who were affiliated with that group or supported it joined up with the Vulcans, the military and foreign policy people advising Bush in his first campaign.

The Vulcans, right—that's what they called themselves.

6 During the first Gulf War, which lasted from August 2, 1990, to February 28, 1991, President George H. W. Bush sent 540,000 American troops to Middle Eastern nations in response to Iraq's invasion of the neighboring country of Kuwait.

7 "In the land of the blind, the one-eyed man is king." Desiderius Erasmus (1466–1536), Dutch Renaissance humanist, theologian, and Catholic priest.

8 "The Arabs have a point, whether they did it right or not," Stone told the audience, "and they're going to be joined by the people from Seattle and by the 10 percent who disagree with everything." The *New Yorker* item quotes him telling the reporter, "This attack was pure chaos, and chaos is energy. All great changes have come from people or events that were initially misunderstood, and seemed frightening, like madmen."

You should have seen his face: "You want to do *Alexander*?"

They issued another report in September of 2000 laying out this plan to preserve and extend our lone superpower status, and advance democracy [END 8].

Which was cosigned by Paul Wolfowitz and that whole cabal, which included Cheney. Over time, their agenda came remarkably true. When Bush got into office, he and his people implemented that agenda, and they evolved it. One of the ideas was to knock over seven countries. They'd start with Iraq and then they'd go after six more: Syria, Lebanon, Libya, Iran, Somalia, and Sudan [END 9].

That plan is essentially the domino theory in reverse: We're going to make one domino fall, Iraq, and then all the others will fall, because people love freedom. I mean, they hate our freedoms—supposedly that's why we were attacked [END 10]. But at the same time, somehow, they also love our freedoms. They love our freedoms so much that they're going to want to be just like us, because they're going to see how well things turned out for Iraq.

The Bush administration excised so much of the 9/11 testimony that it seems as cockeyed

as the Warren Commission Report. Twenty-eight pages were redacted; information having to do with Saudi Arabia was removed [END 11]. It was a cover-up. Too many witnesses were ignored.

You said that after 9/11 you needed to escape into the past, but as I watch *Alexander*, which was a long time in the making, again I'm struck by how it resonates with what was happening in the world at that moment.

Alexander is my *film maudit*. We came out in 2004, right in the heart of the Iraq War, celebrating a man who'd invaded Babylon! I mean, how fucking weird is that? It's a strange fate to make your most grandiose picture in the heart of that shit.

How did you finally get the money to make it?

Moritz Borman[9] got a lot of money at one point and said, *Look, I've got some money, I've got this independent company, what would you like to do? What is your dream to do?* And honestly, I just looked at him and said, *Alexander*. And he said, "Oh fuck." You

should've have seen his face: *You want to do* Alexander?

Alexander is my favorite hero in history, and also the most problematic because of all the difficulties he faced and the way he lived, and the mysteries. I can't get enough of him, and I still read more stuff about him. When I was a kid, I read the Mary Renault romanticized versions. Mary Renault loved this character. She wrote three books about him.

Fire from Heaven, *Persian Boy*, and the first one was called *Funeral Games*, which is the post-Alexander period.

And in '74, Robin Lane Fox wrote a wonderful, massive book called *Alexander the Great*. Robin became a consultant on the project, and of course we took from all sources. We read all the ancient sources and everything we could, and of course there were many opposing points of view.

But in my heart, I'm the kid who's in the fantasy of Alexander the Great—this guy was

9 German television and film producer; worked with Stone on *Alexander* (2004), *World Trade Center* (2006), *W.* (2008), and *Snowden* (2016), as well as *K-19: The Widowmaker* (2002), *Nurse Betty* (2000), and *Terminator 3: Rise of the Machines* (2003).

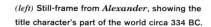

You wanted to be a hero, an adventurer, and you read all the great stories about him, and he was romanticized, no question. He's known all over the world, from Indochina to Iceland. Probably less in the US, but still, we got a dose of him here. Of course history has screwed him, and at the end of this movie you kind of have a sense that there's a historical perspective that is shifting all the time, because every one of these characters has been reseen by history, and then Ptolemy's library burns down on top of it.

There's the sense, and it's pretty much front and center in the movie, that this is Ptolemy's version of Alexander—which means it's another Oliver Stone movie about how history is a construct, a story, shaped to fit agendas.

It's our rendering of Ptolemy's version, but I would say it has a lot of currency.

What's beautiful about Alexander is that there was nobody like him up until that point. His father was an enormous, extraordinary man, who reshaped the whole Greek peninsula in Macedonia. Alexander went beyond all conceptions of what man could be, and that's why, in the ancient times, he was recognized by so many, because he actually *did* something.

So it's like what the kid says in the myths, when he says those myths about the East, going to Perseus and Theseus and Jason and Achilles, he asks, *But aren't the myths really true, because they get passed on?* And they did, Homer passed it on. Oral history's really important. There must have been, somewhere in time, an Achilles or a Jason . . . or Hercules.

Myth, of course, has been very important in your movies throughout your career, and you began *Platoon*, if I recall, with a quote from Ecclesiastes. In *Born on the Fourth of July*, you've got the scene where Tom Berenger's character comes and speaks to the high school kids and talks about the modern battles of the American armed forces, and he talks about them as though they're the ancient Greeks. Like, *these* are the mythological heroes. And it keeps going on, through *Nixon*, and through this film.

I think I remember that when *JFK* came out, you talked about that film as a countermyth. What is the currency of myth? How does it live in our lives even if we are perhaps not educated in it, or if it's not all around us all the time?

That's an excellent question, and I'm not sure I can answer it fully, but I can give you a very specific example. When I was in Vietnam, I

385

(*opposite*) In a deathbed scene with echoes of the opening of *Citizen Kane* (1941), Alexander (Colin Farrell) breathes his last and drops his ring.

(*below*) In a framing device, Alexander's story is told and reshaped by the historian Ptolemy (Anthony Hopkins, pictured here contemplating a bust of Alexander's father, Philip II of Macedon).

saw a lot of very graphic detail. It's in *Platoon*, but it's not the point of the movie—it wasn't done as a documentary. When I got back from Vietnam, I think I was, for lack of a better word, traumatized or freaked out, without knowing it internally. And I think that by mythologizing Vietnam, I made it into a story, as opposed to a brutal, day-by-day rendering of what I saw over there.

I think that by doing that, you keep a distance from it, you protect yourself from the memory of it, which is harsh, and sometimes it's without a point. Let's say you get out of Vietnam and you survive. What's the point of this thing? What we did over there was horrible. I think that the nature of man is to mythologize the experience. It makes it richer and better. I think there's an element of fear, too. Alexander felt dread. I felt his fear of life, and he did so much to overcome that fear by mythologizing it.

It's also got things in common with *Born* and *Nixon* and other Oliver Stone movies about how psychologies are shaped. For a man who wielded such power, he seemed very much a prisoner of the myths that shaped him, the forces that shaped him as a human being: his mother, his father, his civilization. This movie gets into all of that.

I think that's very true, but I think that what Ptolemy says at the end is an important line: "He's the freest man I've ever known." I think he was. When the father says to him, "When the gods change, men will change," I think Alexander was thinking, *That's bullshit. When*

men *change, the gods will change.* And that's what he did to the ancient world, because the Greeks were very pessimistic and very classically oriented by fear of the gods and the Titans. They were driven by that classic Greek pessimism, and that is what Alexander ruptured, and then said, *Man can make his fate!*

Alexander is not your typical strong, silent epic movie hero. He's not Russell Crowe in *Gladiator*. He's a prisoner of his conditioning, and these immense wellsprings of feeling just erupt from him, often at inopportune moments. And that's hard to take for people who are weaned on the other kind of epic hero. I was trying to think of another kind of hero in an epic film that is as emotionally delicate as this one—maybe *Lawrence of Arabia*?

Michael Wilmington said in the *Chicago Tribune* that it was *Lawrence of Arabia* in hell.[10]

You've got all these forces in opposition in this movie, but they never quite resolve in victory. You've got mother versus father, Macedonia versus Persia. And that line that you just quoted, "the freest man I've ever known"—immediately after that line is spoken, Ptolemy talks about

Alexander's loneliness and isolation, and how those feelings defined him, too.

Alexander is a man ahead of his time. He was outstripped and isolated because when Hephaistion died, that was the deal, wasn't it? That was the last Achilles-Patroclus myth.[11] He made the deal a long time ago at the tent in Gaugamela that he had to die with him. He had to keep his bargain. So I think Hephaistion was killed, and I think the murder of Alexander—I believe he was murdered—is the murder of Hephaistion first. It's the key murder because it happens so fast, and it's such a strange murder. It sealed Alexander's

10 "It's as if a great psychological film spectacle such as David Lean's *Lawrence of Arabia* had abandoned all restraint, been stripped naked and fallen into hell," Wilmington wrote in his November 24, 2004, review.

11 The relationship between the Trojan War hero Achilles and his comrade Patroclus is a key element of the Greek and Roman myths. Some versions paint them as brotherly friends, others as devoted lovers. It is Patroclus's death that inspires Achilles to return to battle and, ultimately, meet his fate.

> # Alexander is my favorite hero in history, and also the most problematic because of all the difficulties he faced and the way he lived.

387

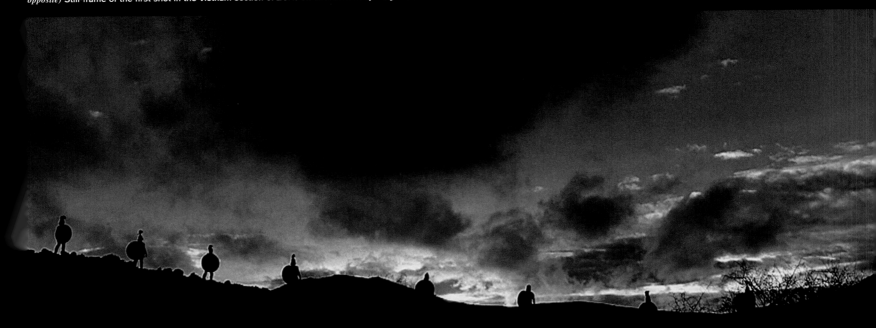

The nature of man is to mythologize the experience. It makes it richer and better.

ate, and he knew it. He's looking out the window, and he actually had these dreams of Arabia, he wanted to go out to Gibraltar, to Spain. He wanted to establish global centers all over the world.

But like a lot of Western adventurers, Asia proves to be his undoing. After India, he's done.

That last battle was a combination of the Hydaspes battle[12] and the Multan battle.[13] He was losing his first major battle. The army was fed up, they'd mutinied twice, and they just did not want to attack anymore. Alexander's pride was such that he actually threw himself over the wall—the walls were not huge, they were Indian mud walls—but he went in with two other men. Three men against hundreds of Indians, and he suffered his most grievous wound, the wound that we dramatized as an arrow through the horse. When he went over the wall, the Greek army, which was sick and tired of Alexander at that point, thought, *Oh shit, there he goes again!* And they went over the wall to save his ass and actually slaughtered the whole town!

Alexander never lost a battle. Never. But soon after his army conquered the Malli clans in what is now Multan, and he got seriously wounded by an arrow, he called it quits

and went home. But in calling it quits with that wound, I think he won his father's deepest respect, and that's why I brought the ghost of the father back on the hill. The father had prophesied, *By steel and by suffering you shall become a king. You will not be born a king, but you shall become a king.*

I think there, at that moment, whatever his mother had done to soil his name and kill his father, he redeemed. I think that's a key moment in Alexander's life, because then he can die. As he said on his deathbed to Bagoas, "'Tis done."

Alexander's deathbed scene may be one of the most uncomfortable, unsentimental deathbed scenes I've ever seen in a movie, if you're not looking at it from Alexander's perspective. In the people who have gathered around him watching him expire, there seems to be, of course, sadness, because this is someone they knew and perhaps loved. But there's also a sense of great relief and even impatience.

And then once he's gone, they're fighting like jackals. It all just falls apart.

There are a lot of bad feelings in that room. It's not your typical Hollywood good-bye.

I think the key line is Ptolemy again, when he says, "The dreamers exhaust us. They must die. We must stop them." It's great to have a dreamer. It's great to read about them, but my God, when you live with them they can drive you completely bonkers! *(Laughs)*

And you know, these guys are getting older: All these generals have been with him, traveling with him, for twelve years! They want to spend their money! They want to go back and buy that plasma TV! They want to buy that mansion! They don't give a shit about living in Babylon with a bunch of Asians, they want to go back to Macedonia and have a good time! Or else, take one of the colonies and exploit it!

Let's talk a little bit about the structure of *Alexander*. You've got so many elements of this movie that echo other movies that you've made up to this point. Alexander's mother says, "The world is yours," which is a line in the screenplay to the remake of *Scarface*, by way of the original *Scarface*.

And of course you've got a conspiracy, which is something you're known for. And you've got the conflict between East and West, and specifically, people from Western countries going to

12 Fought by Alexander's men in 326 BC against King Porus of the Paurava kingdom in the Punjab near Bhera, on the banks of the river Hydaspes (now called the Jhelum).

13 Fought by Alexander from November 326 to February 325 BC, against the Malli of the eastern Punjab.

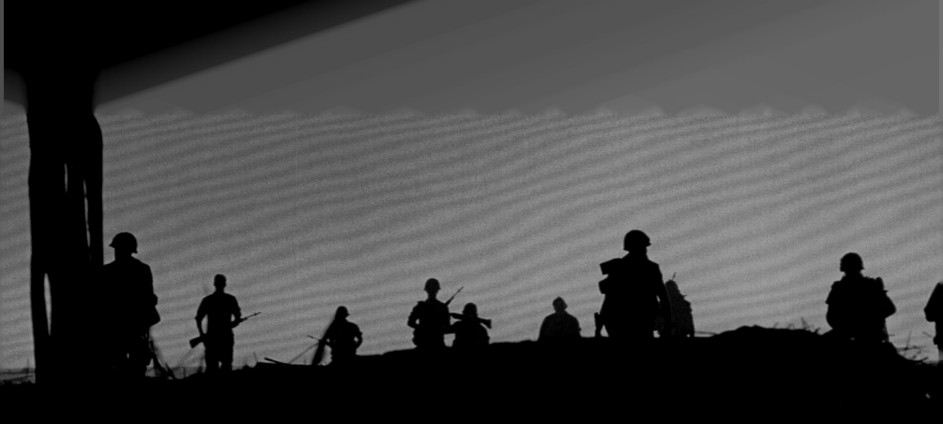

the East to escape their past. You've made three Vietnam films where that's an element. It's like one-stop shopping for Oliver Stone themes.

And there are four versions of it! The first two cuts are more linear, the third and fourth not so linear, and you've said the third and fourth ones are the versions you prefer. In those versions you've got this very intricate back-and-forth structure, and yet it's not all over the place, it's not a montage. You have these very self-contained, often very long, individual scenes. You've got two big battles in the movie, not a lot of small ones. You've got scenes in court, scenes where he's talking to his advisers that play out at length.

In some ways the film reminded me of *Born on the Fourth of July* and *The Doors*, which are classically self-contained in the way that they're structured, with a lot of long scenes that just play out in due course. But the way that you flash back and forth, it's like you see major events that define the myth, and then you go back and you see the things that made Alexander do those things. That's all very nineties Oliver Stone, that psychobiographical, past-and-present approach.

That was the intention, and that was always a difficulty integrating the two approaches in the first couple of versions. I couldn't solve the problem to my satisfaction, because you have the externalized action, but then the next scene should come from within; it should be the reason why you do this.

So yes, half of the film is this outward journey, and the other film is this inward jour-

ney into the past where we find out who he is. To balance those two is extremely difficult, and it took almost exactly three years after the film was released—and my son helped me a lot on that: Sean, who's in the film, but he gave me some great insight as a son, too.

The third version is the first one that really does justice to what Colin Farrell's[14] performance is. It establishes a hero at the beginning; he's strong. And then you see the vulnerability. In the earlier versions, he starts as a boy, and from then on, it's all just too linear for my taste.

Colin Farrell got a lot of flak for his performance.

I could see the weaknesses of it in the recutting. There are times he's not as good as he could've been. But there are wonderful moments when he comes alive, and by the end of the new cuts, I really believe the movie comes together. You've seen it with me twice, and I've seen it more times than that. I just think the overall wholeness of his performance is clear at the end, and I feel for him when he's dying. I feel very sad. He seems like a man who's larger than life. His spirit is equal to his life, if not bigger. I find that it grows and grows, and that's partly an editing thing. I think that some of the performance, when it was cut a certain way, was weak at the beginning, because Colin was playing younger and more timid. And that was the way it was cut, so that's where this preconception came in.

Also, the hair looks different when you cut it differently—when you cut the movie differently, in different time periods.

Overall, I don't think Colin ever got credit for how very hard it is to play that man. I don't know if anyone else could have captured that mix of sensuality and athleticism and Irish *pothos*, a Greek, Macedonian, word for "unfulfilled desire."

I love Colin in the movie, when in the death scene with Hephaistion, in the new cut, you see his heart is breaking when his lover dies. He's so emotional. There's nobody else!

Heath Ledger[15] was my first choice—I didn't know about Colin at that time—but I don't know if Heath would've been the same. Heath was more hidden. He didn't have Colin's outward Irishness, his lyricism. Heath turned me down because he said he didn't want to play an "imperialist." He wanted to pair off with Johnny Depp and play two mordant twins. Colin was lyrical and Irish and bold. He was right for it.

14 1976– ; roguish Irish actor who never seems more like a movie star than when his characters' hearts are being broken; *Tigerland* (2000), *Minority Report* (2002), *Phone Booth* (2003), *The New World* (2005), *Miami Vice* and *Ask the Dust* (both 2006), *In Bruges* (2008), *Miss Julie* (2014), *True Detective*, season 2 (2015).

15 1979–2008; perhaps the most tragically truncated career of any handsome young leading man since River Phoenix.

That iconic shot of Alexander facing down the Indian elephant, on horseback—how did you do that?

Colin did a lot of it, but we used a stuntman, too, because also Colin had broken his leg at that point. Then we had problems with the footage because it had been flashed at the airport for security reasons. So we had to go back and put Colin, with his splint, up on a horse. We tied him to the horse; it was really painful for him, but he's a real pro, and he's an athlete. He actually went through the rearing another time, in close-up, which was very painful.

The scene where the horses go up against the elephants was very difficult—horses are very difficult around elephants. Elephants are great, great actors. You know, they're smart, elephants. They know what "Action!" means. And they actually know what "Cut!" means.

But the horses get really nervous around the elephants. There were quite a few near accidents, and a couple accidents, but no one got killed.

In the last shot of the film, I let the elephants go: The one shot where the elephants are riding right to left, fifteen of them, the last shot, I said, "Go for it." I never said cut, and the elephants kept going through the forest! We drove the poor elephant handler insane! He was looking for those elephants for days! *Days*! He went all over the province! The elephants knew that the film was over.

Why did you decide to let Colin Farrell give the performance in his own Irish accent, and then have other actors try to match up with him?

I was thinking of doing that from the beginning. I love the Irish accent; I think it's charming.

And as long as it's intelligible—that's another issue, because a lot of Irish films are not.

But I felt like we were on the right track from the beginning. I never had doubts about it, and I heard criticism, but I liked the accent. If you're going to do an English-language version of Alexander's life, this is the best way to go: Irish as much as possible, with some English actors thrown in.

Angelina Jolie[16] was also criticized for her accent.

16 1975– ; darkly beautiful leading lady who displayed a Jack Nicholson–like intensity in early roles, notably *Girl, Interrupted* (1999), before gravitating toward somewhat more recessive or staid characters later; daughter of Jon Voight, wife of Brad Pitt, and increasingly distinguished film director (2014's *Unbroken*, 2015's *By the Sea*).

Angelina's accent is probably more accurate than people know, because it was of that Balkan era. Who knows what the hell she spoke? She was from Epirus, a place more Hellenized than the other barbaric areas. She played the character as an elegant queen, an elegant barbarian.

You worked with Val Kilmer again here, for the first time since *The Doors*.

What a fitting sequel! I thought it was a great idea, because on *The Doors* he was splendid, so surprising. I came back to him because I originally wanted Liam Neeson,[17] but that just seemed a bit predictable. Ralph Fiennes[18] read for it at one point and wore a costume for it in Pinewood. Poor Ralph: A wonderful actor, but he felt so uncomfortable in that outfit. You could tell he was not that charac-

ter, and he knew it. Val was always in the back of my mind and I grabbed him. I worried that Val was too young, but then I thought, *Why can't Philip be younger? Men die at forty-five, forty-six.*

Val's a little bit younger than that, but he's got red hair, the red beard, but he's not as tough as Liam Neeson—Liam's a fighter, and he'd be almost overwhelming when you put him next to Colin, you know what I mean?

Val Kilmer is very strong in the part, but there's also something incredibly sad about him.

Yeah, well, he's a poet. What was the sadness you detected?

A sense of . . . futility, I guess; a sort of inward depressive quality to certain scenes, particularly

when he's going into his drunken rages. He seems like he's imploding emotionally.

"You ten-titted harpy from hell!" Who can say lines of dialogue like that?

Not very many actors. It's verging on *Conan*.

But you know, I go there! I push the limits.

17 Neeson (1952–) played a string of fathers and fatherly mentors during this period, all tragic: *The Phantom Menace* (1999), *Gangs of New York* (2002), *The Chronicles of Narnia: The Lion, The Witch and the Wardrobe* and *Kingdom of Heaven* (both 2005).

18 1962– ; Amon Goeth in *Schindler's List* (1993), Voldemort in the Harry Potter films, and Eastern Europe's finest concierge in *The Grand Budapest Hotel* (2013).

You do. While there have been subtle performance in your movies, you do often encourage your actors to go big.

Well, I'm not going to make a Richard Linklater[19] film! He's more of a naturalist, and more power to him, but that's not me. The main actors, I push them. But I always have an alternative in the editing room. We're going big and then cutting. I am playing with the degrees. I just think a movie has to have some juice, some roar. Otherwise it gets boring and flat.

I like the performances. Parmenion was very good in the movie—John Kavanagh.[20] He was excellent. There are many good English and Irish and Australian character actors in it.

The film was an Anthony Hopkins reunion, too. He's Nixon worried about how history will write his story, and here is he in *Alexander* writing someone else's.

Anthony was very good as Ptolemy, but until the third and fourth cut, I wasn't happy with his performance.

What weren't you happy about?

The cutting. I didn't like the way it was done.

So it wasn't him, it was you?

That's right. His performance suffered from the cut, as did Christopher Plummer's[21] Aristotle, by the way. If you see the third and fourth cuts, you understand more what I'm going for, I think. You can't understand the efforts of the actors without them.

I want to ask you about some of the autobiographical aspects, with respect to Alexander's parents. Angelina Jolie and Val Kilmer are playing Mother with a capital M and Father with a capital F.

Yes. I'm going off all the research we did and what we know, and I added some with Roxana, Rosario Dawson's character. But the oedipal story that's there is not really historically mentioned that much. I remember that in the *Lives* of Plutarch, the power of the parents is mentioned, but it was never brought into this context. So obviously, I took some of my own life, yes.

But I went through it intuitively. I asked: Why? Why did Alexander behave the way he did after his father was assassinated? I believe there was some guilt, not for the murder itself but for taking his father's power. He had to prove himself twice over.

Why did he not invite his mother to Babylon, ever? Why did twelve years go by without ever seeing her again? The nature of that relationship . . . those issues haunt me. The relationship to Roxana: Why did he marry this woman? Why did he have a child with her when she was so politically insignificant? What was the relationship to the mother? She might have thought Roxana wasn't good enough for her son, or it may be my imagination.

But yes: It's Mother and Father with a capital M and F. Those are poignant scenes to me because they're all scheming. She's a woman in an age of men, and she's got to find her way and get a place for her son.

She reminds me of my mother. My mother never had that political sense, but my, she had that kind of charisma when she came into a room: the perfume, the snakes, the sense of something sexy. I'm not saying incest, but

19 1960– ; American writer-director in a Robert Altman-esque vein; *Slacker* (1991), *Boyhood* (2014), among others.

20 Steely-eyed Irish character actor, often in films and TV series requiring him to ride a horse, wield a blade, or both; *Into the West* (1993), *Braveheart* (1995), *The Tudors* (2007–2008); *Vikings* (2013–).

21 1929– ; imposing and seemingly indestructible character actor whose film career stretches from *The Fall of the Roman Empire* (1964) and *The Sound of Music* (1965) through *Danny Collins* (2015) and beyond; "Edelweiss, Edelweiss / Every morning you greet me / Small and white, clean and bright / You look happy to meet me."

there is a sense in which you're attracted to your mother.[22]

The beauty of Alexander is that he had a strong father and a strong mother, as you can see, and of course he's faced with patricide, guilt by association. No matter what you say, he is a man of great honor, and he feels shamed by his mother's celebration of his father's death/murder. At the same time, he has an obligation by Greek law to really prosecute his mother, and he says, "I should put you on trial for his murder." But he can't! So he's, in a way, responsible for *both* patricide and matricide!

What I was trying to do with this movie, I don't know that it's been done before. As Michael Wilmington said, the closest equivalent is maybe *Lawrence of Arabia*, because it's a big historical movie with stars, but it's dependent on psychology.

It's a parallel story, of Alexander going to explore the world while at the same time his inner life is being explored, and we begin to understand the parallels, and the control of his destiny, the way he acts.

It's almost like he's in therapy via the movie—which may be ironic, considering that this is a man who is not self-aware, in the twenty-first-century sense of the term.

Well, I don't know about that. The Greeks had their gods. They had various gods, and they externalized their inner beliefs through the gods. Alexander is torn between Dionysus and Zeus, and Apollo, too—Apollo is the god of reason, Dionysus is the god of emotion, according to Nietzsche. So you have these gods that are tearing Alexander apart. I love that he repeats his father's line, "Who knows these things?" I still don't think we know ourselves. I think we flatter ourselves. We go to psychiatrists and we *think* we know.

You were criticized in the United States and the United Kingdom for de-sexualizing Alexander's relationships with men, but in Greece some historians were mad at you for daring to imply that Alexander was into both men and women. A queer Alexander was too much for them.

I think, in some secret way, I knew I was doomed. I just don't think this film could ever have fit any possible category. I just felt, *Who would understand? Who's going to get this?* But you just go with it. This is one where you take a shot, maybe you overreach, and you pay with the rest of your life. I'm surprised I'm still working, to some degree.

The first sex scene between Alexander and Roxana is very blunt, and there's nudity from Colin Farrell and Rosario Dawson.[23] And yet I felt more of a connection between Hephaistion and Bagoas and Alexander than between Roxana and Alexander. There's a bit more heat in the sex scenes between men in the third and fourth cuts, but it's still pretty restrained.

22 In his biography, James Riordan wrote: "'She was like a fairy godmother,' Stone says today of his mother. 'When she was around, she trailed perfume, laughter, and smiles and beauty. And when she wasn't around, which was for long stretches sometimes, it was very cold. She was the life of the party and the light of my life. It was like she was either an extreme closeup or a longshot. Never just a two-shot.'" Riordan, *Stone, p. 11.*

23 1979– ; *Kids* (1995), *He Got Game* (1998), *The 25th Hour* (2002), *Sin City* (2005), *Death Proof* and *Descent* (both 2007), *Top Five* (2014). Though she's had memorable roles, few directors have permitted her to show as much charm and fire as she projects in even a substandard talk show appearance.

I don't think there was the same love between Alexander and Roxana as there was between him and the men in his life. I think . . . the flesh, the carnal part of his relationship with Roxana, was because of the mother. His mother was carnal, too, very fleshy—look at the first scene where the father tries to kill her! There was this visceral quality to the mother and the snakes, so I think with Roxana, there's kind of an unleashing of this fury with the mother.

Whereas with Hephaistion, Jared Leto's[24] character, the love illustrates a concept that Aristotle described: the love between men that would create the city-state. That was very much a Greek idea, by the way. Lust, as we think of it now, was looked down upon as immoderate in the Greek world. So people who behaved like some of the modern versions of gay men would have been anathema to the Greeks, and looked down upon!

You had that in the Persian behavior, but that became a third sex, the eunuch sex. The eunuch tradition is enormously refined in Persia. It was a specialty, you know. I don't think Alexander was with Hephaistion after a certain period, because it was all right for a young man to be together with an older man, but if men who were about the same age stayed lovers for too long a period, it was looked down upon, too. It was not condemned, but it was like: You had to move on.[25]

I don't really know if Alexander *had* relations with Hephaistion. We don't know that. It's always an assumption. But certainly they could have slept together without having relations. And there was that kind of boyhood relationship they had, too. We showed more than *Brokeback Mountain*,[26] though, didn't we?

Well, that one tent scene in *Brokeback* was more explicit than any of the sex involving men in *Alexander*, but I think if you totaled up the screen time, there would be more man-on-man action in *Alexander*. So maybe it's a tie?

Listen, the kiss between Bagoas and him has heat. There are two kisses I noticed were pretty long! But I had a hard time with all that in the first two cuts.

You mean you had a hard time with the studio? I read articles suggesting that there was pressure on you to temper the sexuality where Alexander and his men were concerned, because this was an expensive movie.

Bagoas was dead in the water from the get-go. I don't think it was really possible to do anything there. But you know, I fought as hard as I could to get everything in, including the Bagoas character, played by Francisco Bosch.[27] But we had a test screening with Warner Bros., and I remember there was disgust at that. It turned people off. In the South, you get killed for that!

I put the character back into *Alexander* for the third version, because I thought he was important.

Why was he important?

Alexander was not only bisexual, he was trisexual. I think that when he saw somebody to whom he was very attracted, it didn't matter to him whether he was male or female. He had children with females, but he had a thing for boys who were like girls. I think that makes him a very interesting man, because what I'm saying is that male becomes female, female becomes male, and there are shades of it. This happens, as you get older: You start to see the world that way. The female/male thing changes over time.

You've talked about the difficulty of getting a fix on Alexander, historically, about who he was, because the records are not really there in the way that we would like them to be. It seems like maybe you're acknowledging that difficulty by having the whole thing narrated by Ptolemy, who, even at the end, seems like he's still struggling with how to sum the man up.

Ptolemy is fascinating because he was the chief bodyguard. I love the ring at the end. He has a cracked ring. He knows it's a false kingship.

Ptolemy also admits, "The truth is, we did kill him . . . by silence, we consented. Because we couldn't go on." He doesn't say who did it, but by consent he allowed it to happen. By all rights as Alexander's bodyguard, he should not have let that happen. No matter how wounded he'd been, Alexander was still a strong young man, and people lived to old age in those days too! There's no reason he couldn't have continued, but he had already lost the inner core of his army. They were "tempted by all the things that destroy men," as he says at the riverbank.

Compared to *JFK* or *Nixon*, there are so many more things about Alexander that we don't know. How did that make things more difficult or complicate them for you, making this movie? Or make things easier?

He's one of the most written-about figures, and there are five or six actual sources, but none of them were closer than two hundred years. I can't answer that because I think that Robin Lane Fox's book[28] is trying to be objective about this stuff, to the extent that he can be. A lot is known, because oral history is passed on, and we got a lot of information through Persia and a lot through India, too.

I can't think of any other movies this big that have been released in four versions.

I can't, either!

Did Warner Bros. pay for the recuts?

Yes. I contributed my services for quite a period of time. It was the DVD division that allowed the third and fourth cuts to be made. I don't think the theatrical division would've made them.

And no one tried to have an intervention? Nobody said, "Oliver, stop"?

Thank God, no! No, it was very quietly done.

You have often gone back and made longer, expanded versions of your movies. I don't know if you'd agree with me on this, but some of the complaints that your movies get in their original theatrical release is that they're too relentless or too percussive, the characters are too broad, that the brushstrokes in general are too broad. Those complaints kind of get muted somewhat when you see longer versions.

We're living in a tough time, because there are no intermissions. They've taken that away, and the theaters don't like anything above a

24 1977– ; Jordan Catalano in *My So-Called Life*; *Prefontaine* (1997), *American Psycho* and *Requiem for a Dream* (both 2000), *Dallas Buyers' Club* (2013); that guy in every acting class who's just entirely too much and that everyone resents because they know he's going places.

25 There are suggestions that this might have referred to a strong bond of altruistic friendship rather than a physical love.

26 Classic same-sex modern western romance by director Ang Lee, adapted by Larry McMurtry and Diana Ossana from Annie Proulx's short story, "Brokeback Mountain."

27 1982– ; Spanish actor and dancer.

28 Fox's biography *Alexander the Great* was reissued in paperback by Penguin on October 5, 2004.

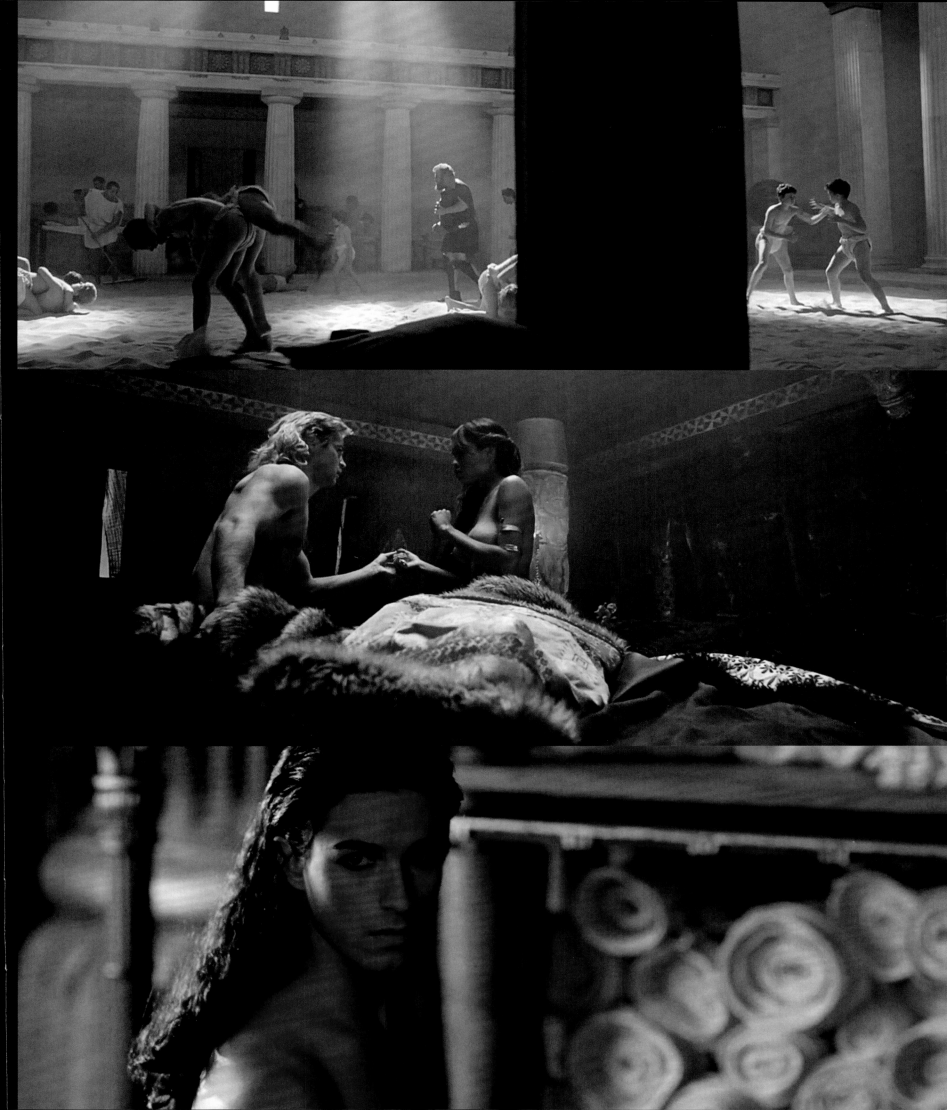

certain length. Audiences have shorter attention spans, they say. I don't know; I like intermissions, because I think you need time to get up. *JFK* should've had an intermission. Also *Nixon*, that's a very tough film to sit through for over three hours and absorb everything. People need to be able to get up during a film of that length, not just to stretch their legs or take a break, but to process what they've seen so far. In Holland, *Nixon* had an intermission.

It was so much of a joy to make this movie. It was difficult, no question, but you forget all the pain.

Are you done with *Alexander*?

Yes. I think so.

Really?

(Stone laughs.)

After *Alexander*, I'll say I was pretty down. The studio system had not been warm to me since all that shit went down with *NBK*—the legal problems, the battle over the rating, so I was always an "independent" kind of person. Michael Shamberg and Stacey Sher[29] called and asked if I'd be interested in making this script by Andrea Berloff,[30] *World Trade Center*, about these Port Authority policemen who got trapped under rubble after 9/11. Shamberg and

Sher were good, strong producers and had done a lot, good credits. I read the script and liked it very, very much. It was the right thing for me to do after *Alexander*, because it was more of an assignment. I'd have out-front people. I wouldn't be leading with my chin.

Also, because the story was so authentic—that's the second major reason I got involved, because John McLoughlin and Will Jimeno were two of the guys pulled from the twenty survivors, and their story, when you sat with them, was mesmerizing. Andrea's script reflected their story in a powerful way, but it had to be condensed. There had to be single, dramatic, powerful scenes. It couldn't keep going back and forth in time; some of that could be good, but the way it was, it was just too much. I wanted to keep the light in the dark: In other words, I wanted light scenes for the audience's eyes, and I wanted dark scenes. And there were a *lot* of dark scenes.

They're trapped in that rubble for quite a while.

It's a very authentic movie. We worked quite hard to get permission to shoot in New York City as much as possible. We had to go through PR issues in New York. People didn't want to talk about it. They didn't want to talk to us. Some did. The Port Authority was a great ally, but we had to get as close to the World Trade Center site as we could, and we

had limitations. I think we could only go three blocks up to it, which means we had to shoot the in-between streets in Los Angeles.

We also talked to many people who'd been there. And eventually, through the course of the movie, we assembled at least eighty people who came out to LA at the end: firefighters, people from all the different rescue teams that were involved in the rescue operation. They were wonderful people. Will and John helped us get to know all those people, and they didn't even know a lot of them before! It was great. It was a treat for me, to be with these firefighters in New Jersey, Long Island, and New York, and their families, going to their picnics and barbecues.

As I've rewatched the movie, I'm reminded that police officers and firefighters are basically paramilitary. They have rank. They have discipline. They have strict rules on how things should be done. Which means that, in a certain sense, what you're doing here is a movie about soldiers. I wondered if that's one of the reasons you seem to have an affinity for them?

29 Stacey Sher and Michael Shamberg's producing credits include *Pulp Fiction* (1994), *Gattaca* (1997), and *Django Unchained* (2012).

30 Andrea Berloff's other screen credits include *Straight Outta Compton* (2015), *Sleepless Night* (2016), and *Blood Father* (2016).

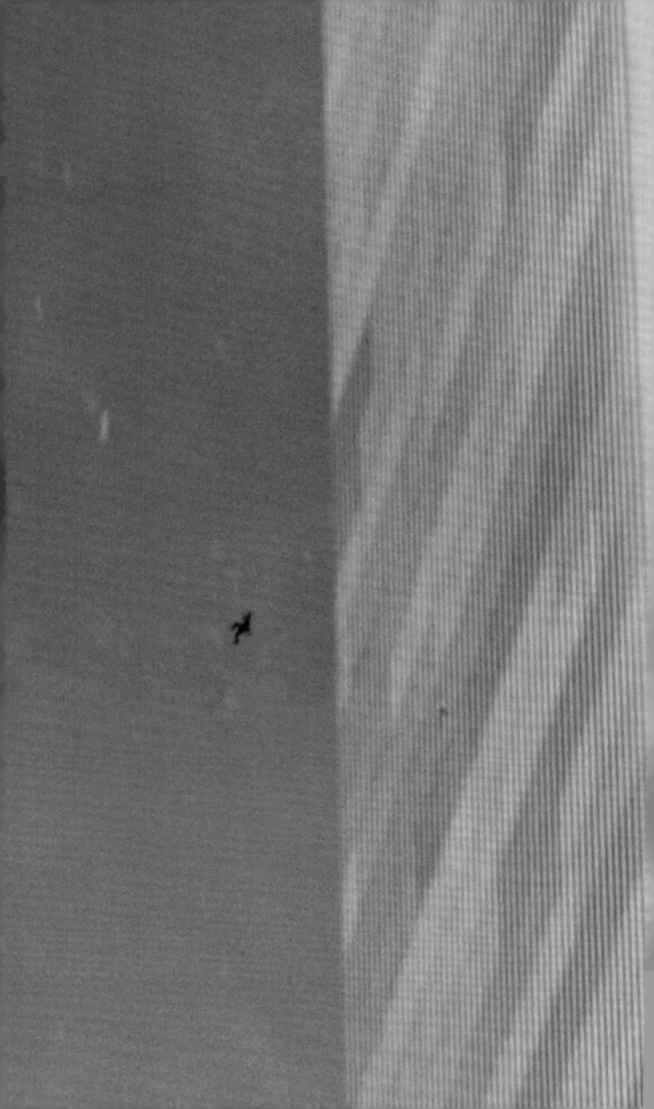

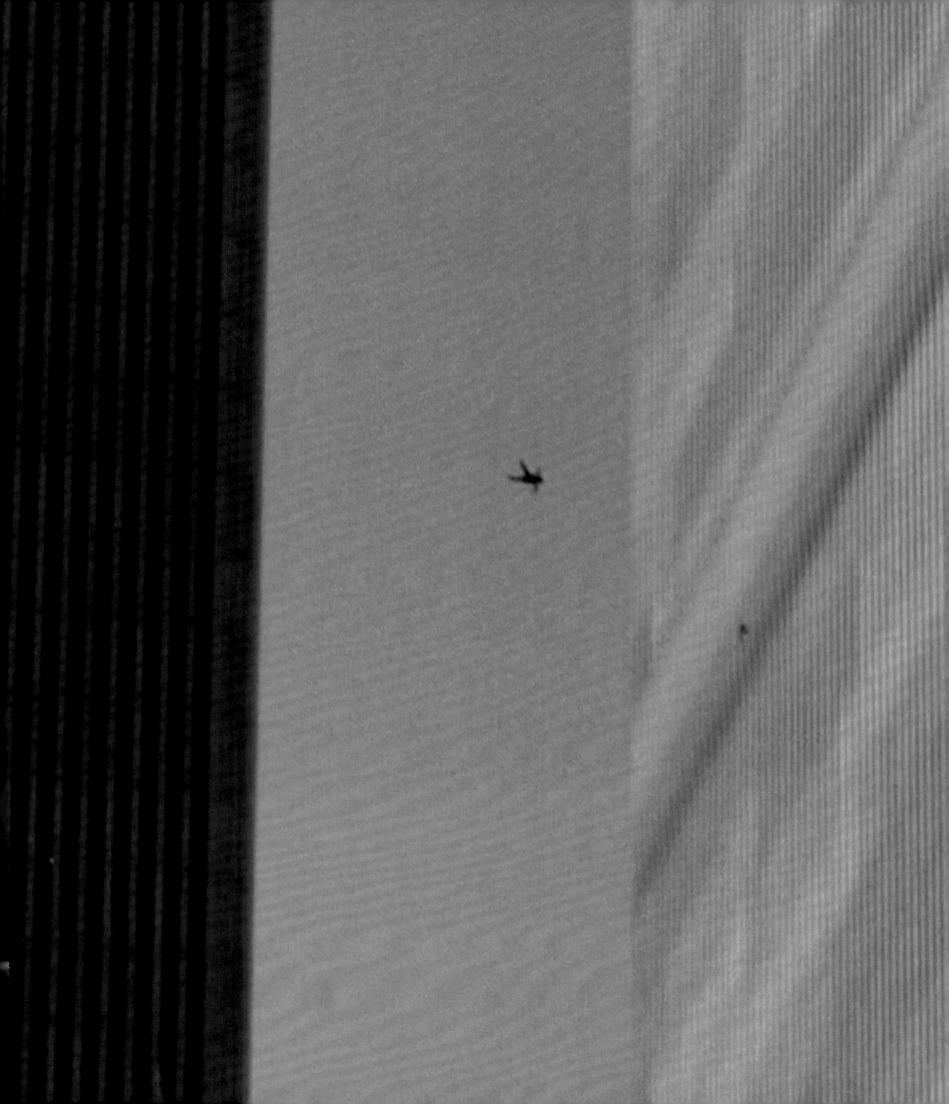

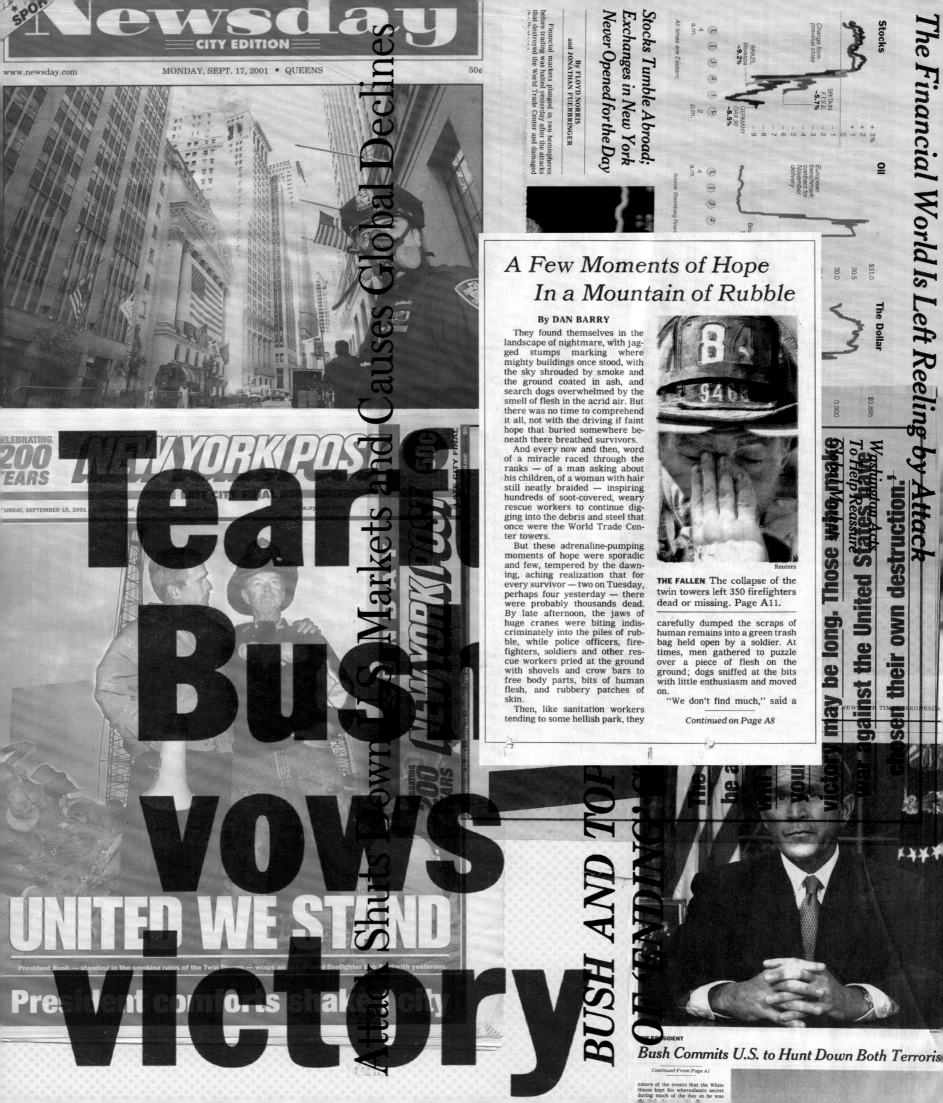

Stocks Tumble Abroad;
Exchanges in New York
Never Opened for the Day

By FLOYD NORRIS
and JONATHAN FUERBRINGER

Financial markets plunged in two hemispheres before trading was halted yesterday after the attacks that destroyed the World Trade Center and damaged

The Financial World Is Left Reeling by Attack

Stocks

Oil

The Dollar

BRITAIN FTSE −5.7%
GERMANY DAX 30 −5.5%
BRAZIL Bovespa −9.2%

A Few Moments of Hope
In a Mountain of Rubble

By DAN BARRY

They found themselves in the landscape of nightmare, with jagged stumps marking where mighty buildings once stood, with the sky shrouded by smoke and the ground coated in ash, and search dogs overwhelmed by the smell of flesh in the acrid air. But there was no time to comprehend it all, not with the driving if faint hope that buried somewhere beneath there breathed survivors.

And every now and then, word of a miracle raced through the ranks — of a man asking about his children, of a woman with hair still neatly braided — inspiring hundreds of soot-covered, weary rescue workers to continue digging into the debris and steel that once were the World Trade Center towers.

But these adrenaline-pumping moments of hope were sporadic and few, tempered by the dawning, aching realization that for every survivor — two on Tuesday, perhaps four yesterday — there were probably thousands dead. By late afternoon, the jaws of huge cranes were biting indiscriminately into the piles of rubble, while police officers, firefighters, soldiers and other rescue workers pried at the ground with shovels and crow bars to free body parts, bits of human flesh, and rubbery patches of skin.

Then, like sanitation workers tending to some hellish park, they

THE FALLEN The collapse of the twin towers left 350 firefighters dead or missing. Page A11.

carefully dumped the scraps of human remains into a green trash bag held open by a soldier. At times, men gathered to puzzle over a piece of flesh on the ground; dogs sniffed at the bits with little enthusiasm and moved on.

"We don't find much," said a

Continued on Page A8

Reuters

NEW YORK POST
CELEBRATING 200 YEARS

Tears, Bush vows victory

UNITED WE STAND

President Bush — standing in the smoking ruins of the Twin Towers — wraps an arm around firefighter Bob Beckwith yesterday.

President comforts shaken city

US Markets and Causes Global Declines

Attack Shuts Down

Washington Acts
To Help Reassure

victory may be long. Those
war against the United States
chosen their own destruction.

Bush Commits U.S. to Hunt Down Both Terroris

Continued From Page A1

nature of the events that the White House kept his whereabouts secret during much of the day as he was

(previous spread) Still-frames from *World Trade Center*: a digital re-creation of a man leaping to his death to escape death by fire; images like this, broadcast on live TV by news channels and captured in an infamously disturbing Associated Press photo, came to epitomize the horror of that day.

(opposite) Headlines about the real-life search for the trapped Port Authority police officers and the political context in which it occurred.

(below top) Still-frames from one of many quiet moments in *World Trade Center*: Allison Jimeno (Maggie Gyllenhaal) spends what feels like an eternity at a stoplight before leaving the car and walking away.

(below bottom) The August 7, 2006, cover of *Newsweek*, promoting a David Ansen cover story about the making of *World Trade Center*.

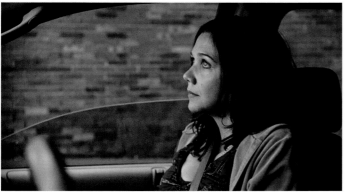

Most people would shy away from going into a burning building the way they did.

I certainly felt affinity for them, and I wanted to render them as wholly as I could, and as honestly as I could. These Port Authority police, let's face it, have tremendous courage. Most people would shy away from going into a burning building the way they did. You have to train yourself to do that. So there's a soldier aspect.

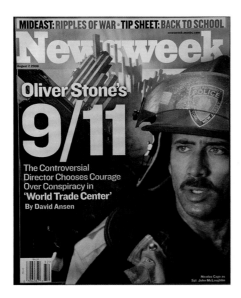

But at the same time, it's very important to differentiate, in my mind, soldiers from policemen. The Port Authority police may have qualities that soldiers have, but the Port Authority is not a militarized group in that sense. They're tunnel people, they're collectors. They're people who are maintenance engineers, and they have police training, but they're not supposed to use it. Since 9/11 we now have militarized policemen who are into this idea of seeing themselves as warriors, and we've forgotten something, which is that policemen are supposed to be there to serve the community. The Port Authority police understood that.

You see that in Nicolas Cage's [31] performance. It comes through. I like the humility of Cage's uniform, the way he handles himself, the way he slumps. There's an everyman quality to him, like with all the guys on the squad.

You've got a lot of great actors in this movie.

Yes! Maria Bello [32] is excellent. You read her completely—her character is real. Guys like Jon Bernthal, Michael Peña, Jay Hernandez, Nic Cage, they're real. Michael Shannon, Donna Murphy, Maggie Gyllenhaal, Frank Whaley, Stephen Dorff—they're all so real to me. Everybody gave their hearts.

Nic was very into it. He took a big pay cut to make this movie. He knew this script was good, and this part was good, and he infused the role with his personality. John Laughlin, Nic's character, is a very thorny guy, a tough guy, but he's kind. There are people like that, you know—good officers, good people in the social services, they're honest. But they're always obligated. They live their life under obligation. This is the way Nic played the role. The worry in his face is so real to me. If you ever meet John, you'll see he's a guy like that.

I have to say that technically, *World Trade Center* is one of the most difficult pictures I've ever done in my life. As tough as *Any Given Sunday*, *The Doors*, *Alexander*, *JFK*. God! You have to see the level of makeup, dust, dirt, shit! Working without flat [surfaces], you

know, you're always standing sideways! We're inside a very complicated set.

The ground zero set. The pit.

It's constructed, designed by Jan Roelfs, [33] who did *Alexander*, in a way so that it can break apart, but once you break it apart it takes a lot of time to put it back together, get it ready, and light it again. You have to light a dark hole! There is no light there! So you have to find your sources and make that work.

And there's the matter of separation—the men's positions. They were a certain distance from each other, but they were not able to see each other, so there's this weird communication that goes on between them—amazing lighting by Seamus McGarvey, beautifully done.

How were the sets constructed?

We built the interior sets to match what the rubble looked like. And we built the exterior completely, the wreckage where the rescuers come in. It's complicated to come out of the ground, as you saw at the end, but going in at night, coming out at night, in day—the set's like ancient Rome! You have to imagine the size of all these shredded chunks of metal and things sticking up on one set. There were different spheres we wanted, and we'd have to put Michael and Nic into place. Any time you

31 1964– ; expressive, often manic, always intensely physical actor who can be quite subtle in more earthbound roles; anyone who can play the leads in *Raising Arizona* (1987), *Vampire's Kiss* (1988), *It Can Happen to You* (1993), *Adaptation* (2002; dual role), and *Bad Lieutenant: Port of Call New Orleans* (2009) is an actor who should not be underestimated or pigeonholed.

32 1967– ; *ER* (1997–98), *The Cooler* (2003), *A History of Violence* (2005), the American *Prime Suspect* (2011–12), *Grown-Ups* (2010); Roberto Rosselini or Ingmar Bergman would have known how to cast her.

33 1957– ; Roelf's long career as a set designer includes *Prospero's Books* (1991), *Gattaca* (1997), *Alexander* (2004), and *47 Ronin* (2013).

There are people like that—good officers,
good people in the social services, they're
honest. But they're always obligated.
They live their life under obligation.

(above) Still-frames from *World Trade Center* suggesting the enormity of the Los Angeles
set where the wreckage of Ground Zero was re-created for Stone's film.
(opposite) Still-frame from *World Trade Center*, from the point of view of Port Authority police
officer John McLoughlin (Nicolas Cage) as he's finally lifted from the rubble: a resurrection image.

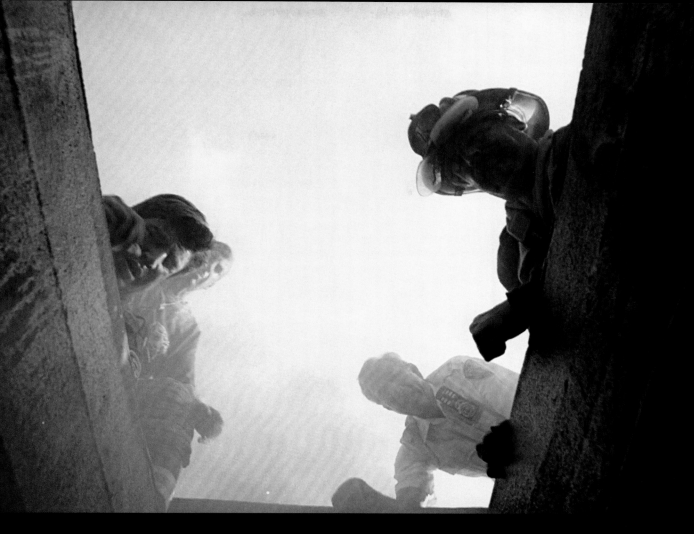

time and they have to stay there. If they have to take a bathroom break, it's a huge deal to go back and forth! You're looking at a long day.

Because parts of the rubble have to be lifted up off the actors?

which a lot of people are doing now, it'd be pretty simple to do that, I guess. You'd have them run across a green screen and do the rest. But the truth is, to really do it right, you've got to get into it, and marry the real with the movie element.

In a sense, I'm clearing the ground. I'm saying, "You're talking about 9/11, and all this fear and hysteria, let's go into it and look at the heart of the evil. These guys lived it. Go with them, live the story, absorb it, get over it."

Get over 9/11, is what I'm saying, in a weird way—get over it as in, exorcise it. But apparently the country was unable to, because as you know, we're still carrying that anger.

Every one of these fucking holes we had to construct and build and work in, and there's dirt on you constantly.

Oh yeah. And then there's the makeup, and the positioning—when you're squeezed into a place like that with a camera, it's not easy. God, in terms of standing on the sides of hills, this movie was as bad as *Salvador*, and this was going on every day, and we were *exhausted*. Every one of these fucking holes we had to construct and build and work in, and there's dirt on you constantly. We must've had a huge makeup bill.

I should also say, speaking of things that were technically horrific, having that crash in the beginning, with the twenty or something minutes where the building comes down, required an amazing amount of work. There was a lot of dust and dirt and special effects, but also visual effects. I think it was pretty authentic, in the end. It didn't feel like it was overdone. If you did a sloppy digital movie,

You were extremely judicious with what you show us from the attack itself. We never see a plane. We only see a shadow of a plane.

It was their story. It was from their POV. You can't cheat it. It had to be subjective.

We see a long shot of a person falling, a jumper, but it's only like a second and a half, just a flash of it. And we see a bleeding woman run past the camera, but that's brief, too. We don't see either of the planes hit. We don't see a lot of shots of people staring at the burning towers. Some, but not many, and it's brief.

You don't see anybody discussing politics, either. It's not about that. People misunderstood that. They wanted more from me, a discussion, but I was immersed in the details.

You could have changed the essence of this story to incorporate some of your political beliefs. A lot of people assumed you would. You didn't. Why?

It'd be like going into *Platoon* and having the guys talking about why the Vietnam War was shitty and they wanted to get out. I never heard any of that. I went pretty far in that direction with Elias, but I didn't have anybody else talking about the war in that way.

World Trade Center was like that. What we were showing was a microscopic view of the world—these policemen and their families. They were straight kinds of guys, pro-America, pro-baseball, pro–not thinking in any deep way about the interconnections between 9/11 and the War on Terror, or about the Christian–Muslim jihad–type thing. Their thinking was: These people came in, they blew us up, and now this is a time to heal, a time to get better, to pull together. The level these Port Authority officers were at when all this stuff was going on, they were just not

It was their story.
It was from their POV. You can't cheat it.
It had to be subjective.

going to get into the causes of 9/11. So why would you betray that?

Nevertheless, a lot of the same people who seemed to be dreading a politicized Oliver Stone movie about 9/11 seemed disappointed when you didn't give them one.

They expected something on *Nixon*, too. I'm so tired of their expectations! I should just live inside what I want to do, and create it! That was what I was good at, what I've *always* been good at. When I start to listen too much to expectations, I get thrown.

Survival stories are a genre. I like survival stories. I liked *Life of Pi*,[34] and the Redford movie *All Is Lost*—I liked that; *12 Years a Slave*[35] is a survival movie. They're all survival movies. This is a survival movie. It's a huge story, because they happened to be at the epicenter of disaster! The question is, will these guys survive? Will Dad come home?

There's no metaphorical dimension to this movie.

Well, that's not exactly true. There are two moments that are metaphorical. There's a beautiful moment when Will is about to crack and he sees Jesus, which he did. And there's another moment like that when John McLoughlin is about to crack, and his wife shows up as a ghost. Some people criticized me for going literal. But I wanted to go literal.

You cut to black, we stare at the black screen for a long time, and then Jesus appears, all blown out.

And then we to go to the white sheets, and then back to [Maria Bello]. . . . I think that's amazing.

You say that's a black screen, but that's not really accurate, because there's something happening inside that black, I don't even know what it is.

I know what you mean. It's subtle. It's almost like a solar flare.

It's beautiful. Had me fooled, because it feels like death. The Buddhists say when you're about to die, there's a flicker of candlelight, and that's what it looks like, that thing in the black. It looks like a candle for a moment—a very close to death experience.

And then the other scene is where McLoughlin's wife shows up. This is the edge-of-death stuff. He's wearing a mask, an oxygen mask. And then the mask is gone and

he's talking to her. And then the mask is back again. He's ready to give up. She appears. She comes to him. And then: Who's that? Who's there? It's the rescuer.

Later he tells her, "I'm alive because of you."

To me that's a powerful moment. It helps you understand that the men's survival depends on interconnectedness. The movie tries to show that again and again: that it's the need for each other, for family, that keeps them alive.

One of the many aspects of this movie that wasn't really remarked on is how it uses memories and flashbacks. They're not just attached to one person. The memories are passed between the men and the women like they're common property. For instance, in that scene we were talking about, where the cops have been trapped in the rubble for a day, John flashes back to when his wife, Donna, told him they were going to have another child. And then you come out of the flashback, and it's like *she's* remembering it. His flashback kind of becomes *her* flashback, like it's a shared memory. It gives us the idea that everybody is part of this one big organism, and the organism has been disrupted.

You know, when Nic was in the hole during the latter parts of the shooting, he asked me to read Buddhist texts, Tibetan texts, to him that we had talked about, because he was interested. And so I read to him sometimes, while we were doing some of these crazy shots, these reveries. I was reading *The Tibetan Book of the Dead*,[36] and he dug it. It really motivated him. If you think about getting close to death, the ghosts that you see—the images that are not real that come to you—are very important.

I get a kick out of the ending when he comes out of the earth. I love that scene.

He's rising up out of a coffin in that shot, and all these other people are helping him out of it.

It's like being born, the way he comes into the light after being, in a sense, dead. That's death. And he crossed over into this reborn spirit.

Near-death experiences happen a lot in your movies.

I guess I'm haunted by it. How are you going to die? Are you going to die alone, or connected? That's a big issue for everybody. As much as we think of ourselves as alone, through the experiences of life you can get yourself connected to the deeper, more valuable things of life. We're constantly rediscovering that through trial and error.

What is the importance of spiritual struggle in your work? You mentioned the "between states."

I read most of Thomas Mann[37] when I was younger. It seemed to me he was on the right track. He was asking: *Why are we here?* Viktor Frankl[38] raises that question, too. Buddhism raises it: *Why are we here?* I think that's a primal question. I don't think many people in the film business care about that one, though, because it's not commercial.

Well, that puts an earlier statement you made in context for me: the idea that ultimately it doesn't matter what exactly happened on 9/11, that perhaps the more important question is, where do we go from here?

How do you get past it? Stop talking about it! You know? You *have* to! We all have setbacks

34 Ang Lee, 2012; a young boy and a Bengal tiger survive a shipwreck.

35 2013; the story of a free man who becomes a slave and endures horrendous abuse and deprivation; directed by Steve McQueen from a screenplay by John Ridley, who wrote the novel that Stone's *U-Turn* is based on.

36 8th century text, kept from public view until the 14th century; intended to be read to people facing imminent death, to help them understand what they are seeing and hearing and prepare for a postmortem existence.

37 Nobel Prize–winning German novelist whose books include *Buddenbrooks* (1901), *The Magic Mountain* (1924), and the famous novella *Death in Venice* (1912), in which an older man falls in love, from afar, with a fourteen-year-old boy.

38 Austrian neurologist and psychiatrist who founded logotherapy, a form of existential analysis devoted to the idea that the most powerful motivating force in human existence is the search for meaning in life.

THE PRESIDENT

(*opposite*) Still-frames from W. depicting George W. Bush's spirituality. (*top*) Insert close-up of the Holy Bible on Bush's desk in the Texas governor's mansion. (*center grid*) Bush accepts Jesus Christ as his savior while in the company of the Rev. Earle Hudd (Stacy Keach), his eye twinning with the eye of Jesus as seen in a portrait on a nearby wall. (*bottom*) As president, Bush decides to invade Iraq, then leads his cabinet in prayer.

(*below*) Oliver Stone at a 1998 Republican breakfast fundraiser in Beverly Hills, California. He'd gone there at the invitation of a friend to hear George W. Bush speak because the latter was being discussed as a possible presidential contender and Stone "wanted to see what he was about." Bush didn't know that Stone, a Yale classmate, was in the room until somebody else told him. This picture was the inevitable result.

We all have setbacks in life with devastating consequences.

in life with devastating consequences. I suppose it's always going to be there, it's a scar, but you lose a child, you can pine over that child the rest of your life, but to bring harm to others who had nothing to do with the loss of that child, on top of all that, is compounding the bad karma.

It's kind of a beautiful continuation: *Alexander,* *WTC,* **and then** *W.* **They're all about 9/11 in a way.**

It's interesting: I did stay on the course of contemporary events during that period. I went right from *World Trade Center* to *W.* to *Wall Street: Money Never Sleeps*, you know. Three Ws in a row!

That's right! But there's another kind of continuity here as well. We were talking about the ideas of spirituality and karma in relation to 9/11, and this kind of idea of what goes around comes around, and that as a country, we put out so much negative energy into the world that some of it is going to come back. And in *W.*, **you have a touch of that as well. But you also have as your hero a simple or simplistic man who becomes a wartime president. And he's a religious man. And that complicates things.**

You treat George W. Bush's conversion to Christianity as the thing that made him a complete

person and gave him direction in life, for better or worse. There's positive value in it. But it's also what he invokes to justify war. He believed he was chosen by God to lead the nation after 9/11.

It's fascinating how straightforward you are in the moment where he comes to Jesus. He's praying with his AA sponsor, played by Stacy Keach,[39] and he looks up and sees the picture of Jesus on the wall, and there's a slow zoom on the eye in the painting of Jesus Christ, and then you go to George W. Bush's eye, and the two eyes merge. It's a very beautiful, poetic image. It's on par with the meditation scenes in *Heaven &* *Earth* **and the Catholic imagery in** *World Trade* *Center.*

Did you know there is a deleted scene where there's a first preacher? It's on the Blu-ray. The character is played by Michael Shannon,[40] who was in *World Trade Center*, and it's a very important scene. I hated cutting it out, but I had to because the movie was overlong and there were two of those scenes. Shannon plays a preacher who's carrying a cross. That's based on a true story, this guy carrying the cross around the world on his shoulders, playing Jesus. He's based on a real person.

But that scene you're talking about with Keach, it's a conversion.

So you do take W. at his word, about him being a spiritual man?

What I'm saying is, I don't know. Stanley Weiser worked on the the script with me, just as he did on the first *Wall Street*. And you know . . . I think Bush was to a degree phony. If you read his autobiography, I think you'd have some sincere doubts about his thinking. He's not a deeply dimensional man. He is not a spiritually deep man, he's a spiritually shallow man, and I think that's evident in the movie. I mean, he's completely violating the Constitution by making people pray with him in the fucking White House! Come on! He has no concept of history and the limits of his spirituality.

But he sold it—and he used it to get elected, too, by the way. And his father doesn't like it. Remember, his father makes that great comment—remember when W.

39 1941– ; Billy Tully in *Fat City* (1972), *American* *History X* (1998), *The Boxer* (2009); played Mike Hammer in three incarnations of a TV series based on Mickey Spillane's fiction (1984–87); brother of actor James Keach, with whom he acted in Walter Hill's 1980 *The Long Riders*, a western casting the siblings as outlaw brothers (Stacy played Frank James, James played Jesse).

40 1974– ; actor and musician; *Bug* (2006); *Shotgun* *Stories* (2007) and three more films for writer-director Jeff Nichols; *Revolutionary Road* (2009); *Bad Lieutenant: Port of Call New Orleans* (2009); General Zod in *Man of Steel* (2013).

407

brings George H. W. Bush the evangelists? I think that's hilarious, and after they leave him, the father is all patrician, like, *It's OK for politics, but let's not overdo it,* and you can see the disappointment in the son's face.

I love that scene. I love all their scenes together, Brolin and James Cromwell.[41]

But as for granting W. the sincerity of his religious beliefs, you have to. He believed it, the people around him believed it. When you're wearing a dramatist's shoes you have to empathize, not sympathize, with the character. You have to give him the benefit of the doubt.

Touches like that might be part of what complicated the public reaction to the movie, because, as we've mentioned, something like this happened to you with *Nixon* as well. Before the film came out, the audience thought, *Oliver Stone's doing a movie on George W. Bush, he's going to chop him up with a machete.* And then you didn't. In fact, you made him—well, I wouldn't say sympathetic, but you tried to understand him.

And I did it with Nixon, too! What's wrong with that? Isn't that what dramatists do? I don't think Shakespeare liked Richard III! But maybe he was fascinated by him, no?

I don't think it's a bad thing. I only bring it up because it ties back to this idea of having your art being accepted and engaged with on its own terms. We're not entirely sure how to take this character

on the screen. **If you disagree with his policies in real life, and with the way he sees the world, he's evil, but as a movie character, he seems like a nice guy who's just doing the best he can.**

Well, see—that's part of what I was trying to get at. I don't need this nice-guy culture, which was invented by America! George Bush got elected because a lot of people thought he was a nice guy. They thought they'd rather have a beer with him than Al Gore. That's how we think in this country. That's why I like the comedies where they play mean. I love *Wedding Crashers*.[42] I don't like nice-guy culture. It's like, in order to be a good American, you have to be a nice guy, and that means you have to be compliant, you have to agree, you can't oppose or question, you can't argue, you've got to show up at the football game, you've got to applaud when the military stands up, and you've got to kiss ass with the flag, and any war we fight, no matter what it's about, you have to agree it's about freedom! No matter

what, whether you go to Vietnam or Iraq, it's the same bullshit we heard back in the sixties and seventies! It's crap. Ours is not a nice-guy culture! We're a bad-guy culture! We're badasses! Like Elias says in *Platoon*, we kick ass all over the world. Loudly we kick ass, and quietly we kick ass! We squeeze other countries' throats economically and do anything we can to get our own way. And the whole time, we pretend that we're nice guys.

And then you've got this Powell Doctrine [END 12] of overwhelming force, which in our conversations you've criticized not just in relation to the first Gulf War, but also in the period right after 9/11. Also, this idea that whatever somebody does to

Ours is not a nice-guy culture! We're a bad-guy culture!
We're badasses!

41 1940– ; Jerome "Stretch" Cunningham on *All in the Family* (1973–78); *Babe* (1995), *L.A. Confidential* (1997), *Six Feet Under* (2003–2005); "That'll do, pig, that'll do."

42 2005, directed by David Dobkin; womanizers crash weddings hoping to get lucky.

us, we have to do it to them times a million. They killed five thousand of our citizens on 9/11, we invade two countries. That's also in the movie *W.*, implicitly.

You saw them working that out in the scene in *W.* where they're walking on the road.

At Bush's ranch, right. It's hovering on the edge of metaphor, and you don't push it over the line till the end.

When Powell says, "When you break it, you gotta keep it," right? The Pottery Barn rule.

Crawford, Texas, was easier to enter than it was to leave, apparently.

Yes! And they get lost at the ranch. They don't know how to get out! And the way they all talk in that kind of moving pastiche, it's very interesting.

Was Josh Brolin[43] always going to play the title character?

Yes, he was my first choice.

Was there a particular role that made you think he could be George W. Bush?

Yes. I liked Josh very much in Paul Haggis's movie *In the Valley of Elah*.[44] He had that western roughness, which is what Bush has. He has that cowboy dimension. He's got a ranch in California or something.

But he was shocked when I offered him the role. He said, *Me, George Bush?* And he was not keen about the idea, but I came back to him again and again, and he finally said, *Yeah*.

Then he got hives, because he was very nervous about the role! But we waited him out. It was scary. We lost key time on a tight budget because his face broke out.

There was nobody else, I think, [that I was] comfortable with. I really wanted him. I think Paul helped me get him. And I think he

did a great job because he was able to create the two-dimensional aspect. The character of W. is not a three-dimensional man. You know?

The film has a quieter score than you usually get in an Oliver Stone movie.

The score is influenced by *Nixon*, because there's a lot of framing music in that one. We work in a lot of folk melodies, and also religious music, because the composer Paul Cantelon's[45] father was an evangelical minister. He hadn't done much film work. He grew up on the circuit, playing piano for his father, so he had an understanding of revival tent Christian music. And I wanted those tunes. If you listen closely to the soundtrack, there's a lot of that.

You have a lot of the action carried by solo piano.

Yeah. That makes it a lighter film, I suppose, more of a comedy.

The cabinet scenes verge on *Dr. Strangelove.*

Yes! I love the national security scene. To me, that's one of the best condensations of the argument that goes on and on!

I wanted to get the movie out before the 2008 election, because I'd always felt national security would be the issue that decided it. John McCain versus Obama meant something, because McCain represented the old way: going back to war, fear, security over freedom. I thought that was the argument.

And what happened was the economic debacle, starting in September 2008, and it killed the movie, because at that point it was very clear the election was over and Obama was going to win for purely economic reasons. At least a lot of people attributed his victory to that.

Anyway, the movie did twice the business of *Nixon*, and *Nixon* is from a major studio, so that's better! *W.* made close to $25.5 million in the United States, versus $12.5 million domestic for *Nixon*.

Nevertheless, it's interesting that you've done two major films about Republican presidents whose policies you personally despised, but a lot of the time you feel for them, especially when they're down: George W. Bush choking on the pretzel, trying to define himself apart from his rich family, hallucinating his dad trying to box him in the Oval Office; Nixon praying with Kissinger, getting drunk, crying with Pat.

Ah, Nixon, Nixon. *(Laughs)* Who could like Nixon?

***You* like Nixon!**

I identified with him in some ways. I wanted to understand him. I love George W. Bush. He's a two-dimensional character, he doesn't have any depth at all, and he's quite happy that way.

43 Ruggedly handsome leading man who is starting to feel like the next-generation Nick Nolte as he ages; *Grindhouse* and *No Country for Old Men* (both 2007), *Milk* (2008), *Wall Street: Money Never Sleeps* (2010), *Inherent Vice* (2014, very Nolte-like); son of actor James Brolin.

44 2007; a military police veteran played by Tommy Lee Jones and his wife, played by Susan Sarandon, hunt for their son (Josh Brolin), whose murder and dismemberment is represented by authorities as being drug-related. Brolin honed his Tommy Lee Jones impression while working on this film, and it came in handy when he played the young incarnation of Jones's Agent K in *Men in Black 3* (2012).

45 Also the composer of scores for *Everything Is Illuminated* (2005), *The Diving Bell and the Butterfly* (2007), and many documentaries, including *Diana Vreeland: The Eye Has to Travel* (2011).

Essay

To Hell and Back

Alissa
Wilkinson

The Spiritual Cinema of Oliver Stone

I was never a religious person, but I became spiritual in Vietnam. Organized religion is for people who fear Hell, but true spirituality is for people who've been to hell. Possibly, I was saved for a reason. To do something. To write about the experience, maybe. To make a movie about it.

Oliver Stone, quoted in *Stone: The Controversies, Excesses, and Exploits of a Radical Filmmaker, 1995*

It's hard to imagine Oliver Stone topping any list of religious filmmakers. With the possible exception of *Heaven & Earth*, his movies don't blatantly proselytize on behalf of any organized system of belief. Plus, they're often bloody and violent, with graphic sex, profanity, and rampant drug use.

Yet for decades Stone has been making some of the most religious films in Hollywood. His movies obsessively work toward the fundamental questions of existence

that humans have always looked to religion to answer: Where did we come from? Does God, or something like god, exist? What does life mean? What is suffering for? Does anything happen after we die? Can we be saved, and if so, how?

Stone's characters often try to answer these sorts of questions audibly. "All my enemies reincarnated—you think Mandro believes in crap like that?" the maimed cartoonist Lansdale disgustedly asks his editor in *The*

411

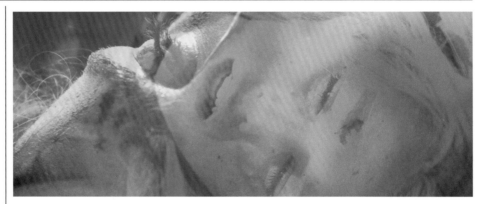

Hand. "There is no more God," Carlos says in *Salvador*. Ben in *Savages* subscribes to a "basically Buddhist" guiding philosophy: "Don't fuck with people." While nobody in particular listens, Stone's Richard Nixon asks the White House walls, "Who's helping us? Is it God? Or is it Death?"

In the drama he creates, Stone posits that suffering and mortality, both thoroughly corporeal concerns, are the primary experiences that shape us as humans. How we respond to suffering—our own and that of others—determines how we deal with death, and with whatever life might come after. "It is good to be exposed to suffering, not to run from it, not to keep it at arm's length through some expensive government program that we can ignore," Stone said in a 1994 commencement speech at the University of California, Berkeley. "It is good to make it part of your everyday life, like the Indians do in Calcutta."

A number of his movies juxtapose two perspectives: Catholicism, which stands for struggling against suffering, and Buddhism, which suggests that by letting go of the struggle, we can transcend suffering and really begin to live. He comes by this dichotomy honestly. Stone was born to a Jewish American father and a French Catholic mother, neither of whom was devout. He was raised white-bread Episcopalian without a deep connection to any religious practice, experienced his parents' acrimonious divorce, was wounded twice after volunteering for Vietnam, and after a half a minute's stopover in Scientology became a devout Tibetan Buddhist, a move he partly ascribes to his bond with Le Ly Hayslip, the protagonist of *Heaven & Earth*.

One dominant image in Buddhism—and in Stone's films—is the lotus flower, one of its "eight auspicious symbols." Lotuses crop up repeatedly, particularly in his Vietnam trilogy, but also in *Savages*, where it is Ben's nickname for O. Buddhism prizes the lotus for its growing pattern, which roots itself in mud, pushes its stem up through the water, and then blossoms above the surface of the water, where it floats. (Water, in lakes and oceans and fountains, also figures strongly in Stone's films, perhaps as an antidote to the fire that is everywhere.)

The implication is that the lotus starts in the muck and heads for the heavens, but first it has to get through the waters that might drown it. That drowning is the liminal space in which most of Stone's protagonists struggle—some succeeding, some not really making it. Stone himself has spoken repeatedly of suffering as the thing we must not flee, and how one deals with suffering—in Vietnam, in marriage, at work, on Wall Street—has everything to do with what happens next.

That may be because Buddhists also subscribe to the idea of rebirth, in which one's consciousness, conditioned by good or bad karma, returns to life on earth again and again as it evolves toward enlightenment. Death, then, isn't death in the Christian sense, when the soul moves toward either heaven or hell—or, in some traditions, purgatory—as much as it is rather another go at uprooting ignorance.

In the lotus's terms, life on earth is always another chance to grow out of the mud and through the water, out into the sunshine. That sunshine might be Indonesia or the ascent to truth in a courtroom or the stage of the 1976 Democratic Convention, but it all depends on how you deal with the challenges you encounter down here in the muck. Even the final act of *Natural Born Killers* gives us Mickey and Mallory making a last bloody go at escaping confinement and moving toward a sort of freedom: a life with children.

Mixing Buddhist concepts of rebirth into a Christian-inflected Western imagination lands Stone in an unusual place for a very American filmmaker: His films consistently and explicitly remap heaven, hell, and purgatory onto the here and now, with geographic locations and mental states taking on qualities and trajectories of the afterlife during life on earth. As such, his filmmaking over the past few decades has operated as his own exploratory ritual that constructs and reinforces his personal beliefs about where meaning lies: beyond the material.

Vietnam is most clearly the centerpiece of Stone's imagination, permeating all his work even into the present, and it most closely represents purgatory. It looms silent and shadowy over the experience of soldiers even into *World Trade Center* and *Savages*—it's the place where the innocent are tested and good men become bad men. It is where you might live and work and struggle, but if you get out alive, you're not quite sure if you're headed for heaven or hell. *Platoon*'s Chris

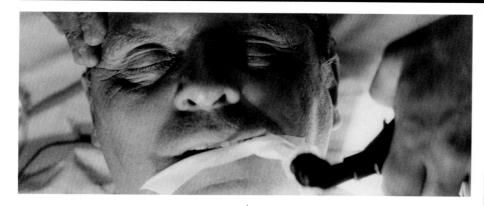

Taylor suggests in an early letter to his grandmother that it's basically a hell that lets its sufferers escape, a sentiment repeated by soldiers in different ways throughout the story. A character in *Born on the Fourth of July* says Vietnam is as hot as hell or, more likely, purgatory—"where the motherfucking devil at?" he demands. This is borne out in the experience of the film's protagonist, Ron Kovic: Vietnam was merely the preamble to years of suffering.

Kovic's experience is a competent lens onto Stone's sense of hell, firmly characterized as a thing we bring upon ourselves. And in Kovic's hell is the looming crucifix with the figure of a suffering Christ, hovering from his parents' Long Island home darkly and heavily over his drunken misery. In Stone's work there is, perhaps, no more miserable person than Kovic, who descends from clueless acceptance into almost life-destroying rage. But Kovic finds redemption in his post-Vietnam affliction after a turn in the desert—often the true point of eternal choice—and purges his demons, then resolves to rebuild himself and reach out to others rather than continuing on a self-annihilating path. As *Platoon*'s Chris Taylor narrates as the camera hovers over the Vietnam jungle:

I think now, looking back, we did not fight the enemy. We fought ourselves. And the enemy was in us. The war is over for me now, but it will always be there, for the rest of my days as I'm sure Elias will be, fighting with Barnes for what Rhah called possession of my soul. . . . Those of us who did make it have an obligation to build again, to teach to others what we know, and to try with what's left of our lives to find a goodness and a meaning to this life.

Stone is a filmmaker who sees politics as one big extension of the religious impulse. The most inexorably hellbound of all of Stone's characters is Richard Nixon. The former president's story seems reconcieved as that of a vampire, an eternally purgatory-bound creature, whose salvation is perhaps too late in coming, if it arrives at all. Stone also inserts blood references throughout the film, letting blood ooze from the steak on Nixon's plate as he discusses "dropping the big one" with his aides; lamenting that the press corps "smelled the blood on me"; complaining to his wife Pat that he could function "if I could just sleep."

So what vision of redemption does Stone offer? Nixon aside, it's fair to say that the most comforting and even beatific heroine of Stone's work is *Heaven & Earth*'s Le Ly Hayslip—a woman born into Buddhism, and borne toward enlightenment after her own suffering. But his most magnetic savior is still Jim Morrison, as immortalized in *The Doors*. Morrison is infatuated with death from the start; when his girlfriend Pam asks, "Do you love death?" he responds, "Life hurts a lot more. When you die, the pain's over."

In the film Morrison is a habitual drug user, but in Stone's universe that's barely related to his demise until, importantly, it becomes his substitute for real life—his swap-out for suffering. In interviews, Stone has drawn parallels between certain Native American tribes he has encountered and the Tibetan Buddhists he knows, suggesting in the Berkeley address that the drug-induced state is "a combination of fear and an act of faith at the same time, which is rare. . . . They give their flesh as offerings as Jesus did. We watch and we are moved by the sun dance's sacrifice, and after four days, we once again commit ourselves to things of the spirit."

Morrison sees drugs the same way, as a substance to elevate him into the stratosphere, and though it takes him a bit to get there, he eventually works through his suffering and reaches a state of enlightenment, accepting suffering as part of life before he departs it. Morrison's entombment in Père Lachaise is the elevation to cinematic saint, one of the few gravestones in Stone's work that's lingered over, sanctified.

For Stone, earth is one big place to work it all out, with drugs to help—"drugs," O repeats from Chon in *Savages,* "are a rational response to insanity." Cinema is a way to figure out where salvation lies. "I might be presumptuous," he told the Berkeley students, "but this is what I think movies are for in our culture, or at least what movies should aspire to: a coming together of our tribe. Drama as catharsis, as release, as reaffirmation of the power of the spirit."

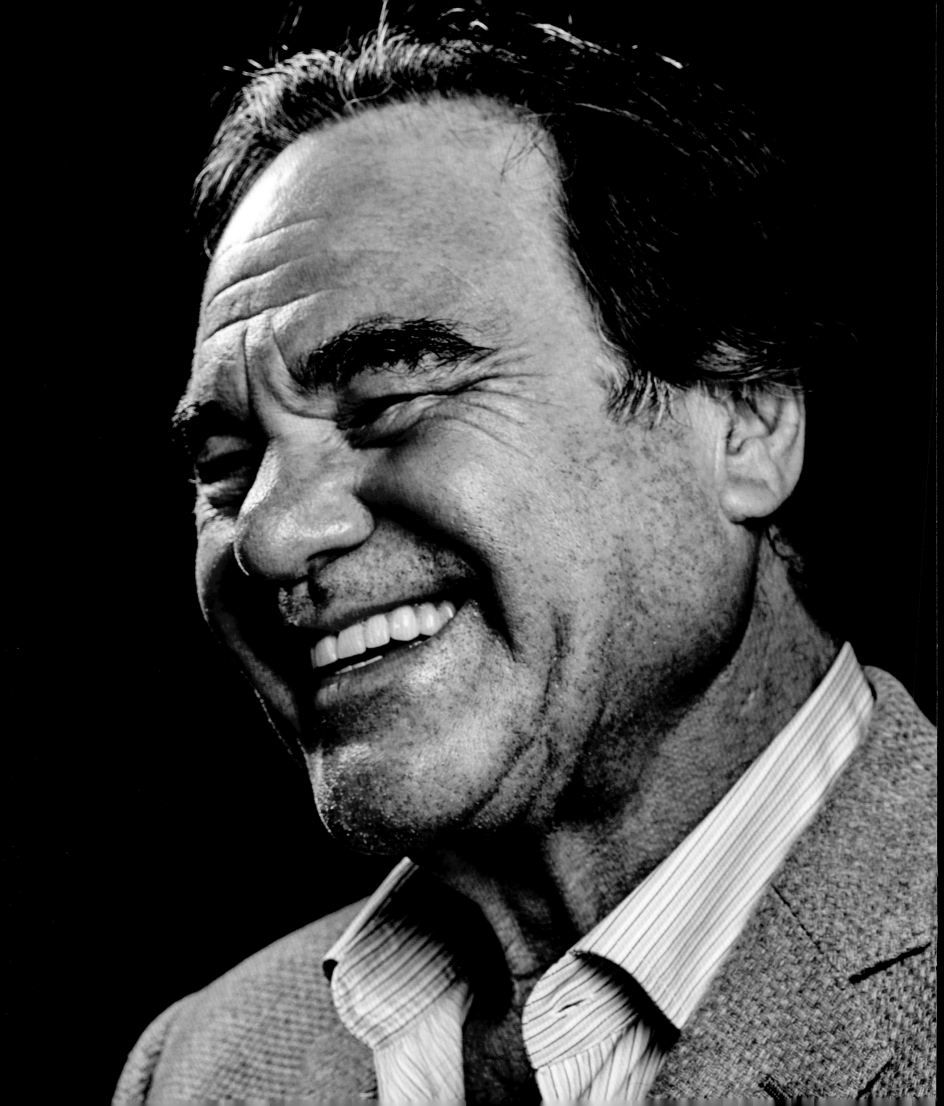

★ ★ ★ ★ ★ ★ *Freest* ★ ★ ★ ★ ★ ★

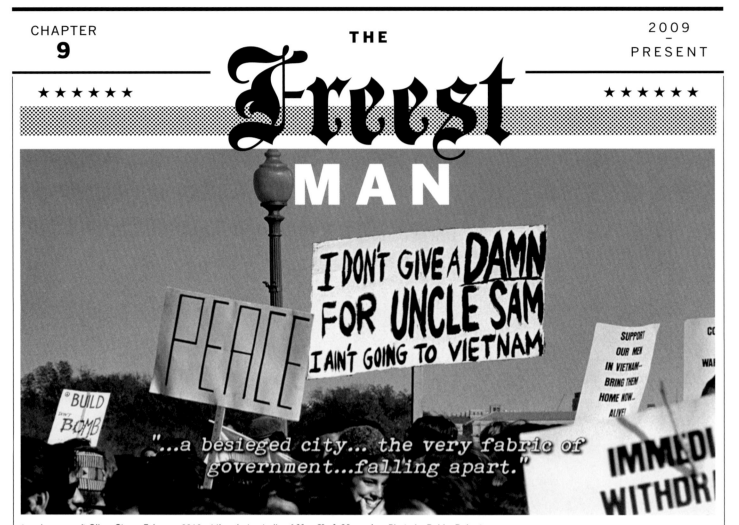

MAN

"...a besieged city... the very fabric of government...falling apart."

(*previous spread*) Oliver Stone, February 2016, at the photo studio of *New York Magazine*. Photo by Bobby Doherty.

(*above*) The seventh episode of Oliver Stone's *Untold History* contains a blast from his own past: an account of the wave of student protests that followed the invasion of Cambodia in 1970, when he was a student at New York University. For more about this period, see Chapter 1, pp. 72–78.

There must have been moments when Oliver Stone's fourth decade in the film business felt as difficult as his first. Although he still had access to stars and decent budgets, it was harder to secure either. Not even the worldwide success of *World Trade Center* could return him to the A list. He kept plugging away anyhow, but his first film during this rocky stretch, *Wall Street: Money Never Sleeps*, was not a success.

Like its predecessor, the sequel is a contemporary morality play, filled with big characters, corny dialogue, and commentary on then-recent events, in particular the financial meltdown that occurred in 2008 near the end of George W. Bush's second term. Gordon Gekko (Michael Douglas) gets out of prison after serving a sentence for insider trading—his returned goods include a phone the size of a combat boot— and tries to reenter both the financial world and the life of his daughter, Winnie (Carey Mulligan). We learn that these wishes are intertwined: The younger Gekko is sitting on a Swiss savings account that was supposed to stake Dad's

future endeavors, but she's cut him off following the suicide of her brother, Gordon's only son. Winnie's lover, Jake Moore (Shia LaBeouf)—the pilgrim of this *Pilgrim's Progress*, walking in Bud Fox's Italian shoe prints—doesn't know about the Swiss nest egg when he hooks up with the now allegedly reformed Gordon, who's repackaging himself as a reformer and hawking a book about the dangers of capitalism. Jake's looking for a mentor and ally. His firm was destroyed and absorbed by a bank led by Bretton James (Josh Brolin, Stone's W.), an icy, technocratic successor to Gordon. But for all Bretton's bland glowering, he's a side player here. The main trio is father, daughter, and prospective son-in-law. Each party's laudable desires—Winnie's wish to define herself apart from her dad's reputation; Jake's wish to spend the rest of his life with Winnie, and get rich without hurting anyone; Gordon's wish to get back into Winnie's good graces—are contaminated by the existence of the Swiss account.

The message is, "Money poisons everything." It's the literalist's answer to the first *Wall Street*'s "Greed is good," a

slogan that was meant as ironic and cautionary, but got taken at face value by Reagan-era yuppies and their descendants. Bud Fox was—like Sheen's character in *Platoon*—a male ingenue with appetite, torn between father figures, but for all its pained moralizing, *Wall Street* is mainly a white-collar crime thriller, with Gordon blustering like a WASP Tony Montana, and its outcome is decided in a series of deals: not just between brokers and brokerage houses, but between Bud and the Securities and Exchange Commission. Many viewers seemed to adore the posturing but miss the message: a classic gangster film conundrum. Tripped up morally by the swagger that made it a hit, *Wall Street* inadvertently showcased what it hoped to expose. *Money Never Sleeps* avoids this pitfall, but at the expense of audience involvement, and its penitent undertone never reconciles with the deals, schemes, and parties. It's a sackcloth-and-ashes domestic drama in a suit made of hundred-dollar bills, an incongruity that's more irksome than fascinating.

But in its circuitous, often stumbling way, the film is still a consummate Oliver Stone drama-as-warning—a bookend to *Wall Street* that reveals how much Stone has matured, or perhaps just aged, since the eighties. The structure of Allan Loeb and Stephen Schiff's script is as much a comment on the culture of moneymaking and what it does to families as any line of dialogue. Whenever the film threatens to get hopped up on money lust, Stone cuts to characters discussing everyday personal matters: *Can I win back my daughter's love? Can I trust my father again?* Even the most purely (and gratuitously) cinematic bit, Jake and Bretton racing bikes through woodland roads, ends sooner than you expect, and sets up Jake's condemnation of everything Bretton stands for. The film's most agonizing scene is Gordon begging his daughter to forgive him on the steps of the Metropolitan Museum of Art. The onetime Master of the Universe has been rendered helpless not by a subpoena or a jail sentence, but by the knowledge of what he lost and might not get back.

"**Just because I'm telling you this story doesn't mean I'm alive at the end of it,"** says O (Blake Lively), the narrator of the crime thriller *Savages*, based on Don Winslow's novel.** "This could all be prerecorded and I could be talking to you from the bottom of the ocean. Yeah, it's that kind of a story. Because things just got so out of control."

Things go out of control almost immediately for O and her two lovers, Chon (Taylor Kitsch) and Ben (Aaron Taylor-Johnson), who share a luxurious house in Laguna Beach, California, bought with profits from Chon and Ben's drug business. The men deal boutique marijuana grown in hydroponic tanks. Ben is a neo-hippie pacifist who seems to want to become the Steve Jobs of weed. Chon, an ex–US Navy SEAL and veteran of Afghanistan, is his best friend and muscle—a traumatized warrior who handles the scary aspects of the business. Their utopia is shattered by an e-mail with a video attachment showing some of their Mexican drug workers beheaded by chain saws. A Mexican drug cartel (run by a woman, Salma Hayek's Elena, who disguises her voice with a "male" filter) isn't just asking Ben and Chon to sell out, it's ordering them to. When the Californians balk, Elena sends her muscle to abduct O at a shopping mall and hold her captive. Things get darker and nastier, with O's lovers racing against the clock to save her and their business and becoming the sorts of expediently bloody characters that Ben held in contempt.

Once a rival enters the story, *Savages*' perspective opens and gives Elena, her own security chief, Lado (Benicio Del Toro), and the Mexican cartel nearly equal time with the Americans. Like an uglier, meaner answer to the TV series *Breaking Bad*, *Savages* frames the tactical maneuverings of the drug organizations in black-comedy terms. The characters dicker over money and worry about compensation, job titles, and respect. Ben and Chon are two halves of a controlling entrepreneurial mind-set: one half reaches for utopian statements, the other bullets. Elena and Lado and Dennis, a DEA agent (John Travolta), are corrupt and ruthless, and vastly more powerful than the gringos, but they have stronger bourgeois impulses. Lado urges his son toward baseball success (like Ron Kovic's parents in the opening of *Born*) and yells at his daughter for dressing provocatively; Elena wants her own daughter to have nothing to do with drugs, and worries that she's spoiled her; Dennis justifies his extralegal schemes on the grounds that his wife's cancer treatment is pricey and he doesn't want to have to sell their house. "Much of the fascination of *Savages*," Roger Ebert wrote, "comes through Stone's treatment of the negotiations, which involve percentages, sliding scales over three years, an ultimate payout, and other financial details that drugs have in common with big business. It's spellbinding to watch the two sides trying to outthink each other."[1] The film contains

some of Stone's bluntest violent imagery, including multiple scenes of torture and the immolation of a wrongly accused "rat" in Elena's organization (which Lado forces Ben to perform, while O watches from the sidelines), yet the film is circumspect about other kind of viciousness, including O's rape by Lado, which happens offscreen.

Chon and Ben pay Dennis three million dollars to reveal the location of Elena's daughter, Magda (Sandra Echeverría); then they kidnap her and engineer a climactic prisoner swap. We see this play out two ways. First comes a heroic-romantic-absurd ending—a literal Mexican standoff in which nearly every participant dies in a haze of gun smoke and blood mist. Then comes the deflating, unheroic second ending: Lado steals Dennis's car and escapes, ultimately forming his own cartel; Elena goes to prison; Dennis gets immunity for the partners after Ben threatens to release incriminating information about him; Ben, Chon, and O resettle in an unnamed tropical paradise. Which of the two endings is the "real" one? Probably the second; it has a feeling of "life goes on," so it is an older man's, rather than a young man's, ending, and therefore consistent with Stone's later output. But in interviews, Stone has seemed inclined to let them coexist.

Savages found a respectful audience outside the United States, earning $83 million internationally. But it was ignored or torn apart by major US critics (Ebert and the *New York Times*' A.O. Scott[2] being notable exceptions). Some wrote it off as Stone's attempt to outdo *Scarface*. A few of the reviews had a tone of gleefully obtuse mockery.[3] Many detractors seemed to read the two endings as an example of Stone's wanting to please everyone, or being unable to make up his mind. But they make the most sense as a statement on romantic fantasy versus the reality of adult compromise. They indicate where Stone's temperament has settled in this late stage of his career. But this is not the same thing as saying that he has become respectable. He remains intoxicated by characters who live beyond the boundaries of normalcy, however their societies define that word. Like *U-Turn*,

Savages takes its central love story seriously. Ignoring the bourgeois moral codes that most other American filmmakers would impose, Stone photographs Ben, Chon, and O's sex with admiration, reveling in their beauty and stamina. He never questions that they love each other equally, and that such an arrangement is not delusional or expedient, but a valid alternative to the usual. (Elena doesn't think so, though: "They may love you, but they will never love you as much as they love each other," she tells O. "Otherwise they wouldn't share you, would they?")

There's also a hint of metaphorical biography to *Savages*. You can see this expressed in the way that the drug trade (like the Hollywood movie business) enables a comfortable lifestyle until it intrudes upon, and in some cases destroys, lives (which links *Savages*, rather unexpectedly, to *Money Never Sleeps*). And there are moments when O, Ben, and Chon seem to express aspects of Stone's persona, or perhaps splinters of a dream of himself. O just wants to get high, get laid, and be loved and protected. Ben wants to revolutionize his business and make a fortune without hurting anybody or being swallowed up by a competitor that cares only for profit. Chon, played by an actor who resembles the twentysomething Stone, wants to get the war out of his system by smoking and fucking and enabling creativity (perhaps he is the "producer" to Ben's "director"); but there are moments where a soldier's skills and mind-set come in handy.[4] "You're already dead," Chon says. "You're dead from the moment you're born. If you can accept that, you can accept anything."

Why would anyone want to sit through *The Untold History of the United States*, a documentary series directed and narrated by Oliver Stone? In the nineties no one would have asked that question; back then, love him or hate him, Stone was an impossible-to-ignore filmmaker who pushed the medium forward. By the time his ten-part documentary about the seamy underbelly of America's official narrative debuted on Showtime, Stone had spent almost fifteen years being marginalized by the media as a fringe character, better known for his inflammatory quotes than for his movies. The outcry over his post-9/11 "Fuck you, fuck your order" sentiments never quite faded. His name became a dog whistle for anti–Hollywood liberal pile-ons at Fox News, Breitbart, and other conservative news outlets. He plugged gaps between

418

his dramatic features not with apolitical shoot-'em-ups or superhero movies or other cash-generating exercises, but with shoestring-budgeted documentaries about politicians who were despised in Stone's home country. *Persona Non Grata* tried to parse the endless conflict between Muslims and Jews in the Middle East, via interviews with politicians in the thick of it, including Prime Ministers Ehud Barak and Benjamin Netanyahu of Israel. *South of the Border* chronicled a left-wing reform movement by six presidents in Latin America, spearheaded by Venezuela's Hugo Chávez. Then there was a triptych of documentaries about Fidel Castro: *Comandante*, *Looking for Fidel*, and *Castro in Winter*.

These five nonfiction features—including *Comandante*, which was yanked from its scheduled 2003 HBO debut after Castro executed three men who hijacked a ferry to the United States and imprisoned more than 70 political dissidents—are covered in this chapter, out of sequence, because of how they resonate with the Showtime series *Untold History*, one of the director's most revealing works. Four years in the making and twelve hours long, it's a remarkable, if dense and difficult, program—at once the most stylistically stripped-down thing he has done and (somehow) the most Oliver Stone-y. If Mr. X, the *JFK* character who laid out the military-industrial conspiracy for Jim Garrison, got his own show, it might have felt a bit like this: ominous, seductive, verbose, apocalypse-left in its politics, filled with unflattering factoids about men for whom highways and monuments are named.

Coproduced by Peter Kuznick, an American University history professor—who collaborated with Stone on a same-titled, 784-page tie-in book—and cowritten by Stone, Kuznick, and Matt Graham, *Untold History* belongs to the tradition of alternative cultural criticism, journalism, and history. Its chapters echo Ida Tarbell, Upton Sinclair, John Reed, Noam Chomsky, Howard Zinn,[5] Norman Mailer, and the mid-century muckraker I. F. Stone (no relation). It adopts the house style of clip-job docs, only to subvert them by cutting to World War II cartoons of buck-toothed "Jap" soldiers or clips from *Invasion of the Body Snatchers* or *Twelve O'Clock High*. The montage-plus-narration style seems stylistically reactionary on first glance, a touch of Nonfiction 101—as if Stone the innovator had inexplicably defaulted to the mode of documentaries on the History Channel or PBS. Yet the style is gently subversive, integrating classic Hollywood movie clips and pointed,

intriguingly digressive asides about how American history is shaped to protect American triumphalists' designated heroes, and throw even more mud on their scapegoats. The voice is Stone's—literally. The director personally narrates the whole series, talking over newsreel snippets, photos, political cartoons, and movie clips; firing off dates and place-names; parsing the intergenerational tensions between labor unions and corporations, humanists and racists, doves and hawks. Some sections play like tales out of school that a charismatic but scruffy history professor might tell his favorite students in a bar after finals. (There are moments when Stone's East Coast boarding school elocutions oddly evoke the conservative columnist William F. Buckley; hear how he puts an "r" at the end of "idea.")

Untold History** would sit well on a double bill with *Born on the Fourth of July*, a left-wing film steeped in iconography that the American right has treated as their exclusive property since at least 1968.** Parts of the show are gonzo. Much of it is dire. The good guys keep losing. *Untold History*'s closest equivalent to an old-movie hero is Franklin Delano Roosevelt's third-term vice president, Henry Wallace, a humanist, socialist, and utopian who got thrown over for Harry S. Truman at the 1944 Democratic convention. Stone and Kuznick depict Wallace as a thwarted dreamer who might have steered the country toward a less paranoid and self-devouring postwar identity (and who, unlike Truman, might have resisted the urge to nuke Japan) had he replaced FDR. The bells of Frank Capra's Liberty Films production company logo ring throughout *Untold History*, to ironic effect: Mr. Smith goes to Washington—and Moscow, and Beijing—and gets curb-stomped, again and again.

Through Stone and Kuznick's eyes, religion and ideology play important roles in historical events, but not as important as history textbooks and pledge-week PBS docs

want us to think. The deeper causes of war, famine, poverty, genocide, and other momentous events are presented in a manner that Stone's detractors would call cynical, but that the left-leaning professors who advised Stone and Kuznick would call basic: Some person or company or political faction wanted more money or land or power, then pushed buttons on the national character to awaken established prejudices or reaffirm shared manias, producing the desired outcome.

It's through this contrarian but hardly outrageous vantage point that Stone and Kuznick view the last seventy-five years of US (and world) history. Because it starts in the late thirties and continues through President Obama's first term, *Untold History* ends up putting recent events in the context of the past, to spotlight recurring national tendencies, and to build a case for the idea that the United States of America has been the world's leading exporter of both covert and mechanized violence for at least a century. Patterns recur and bad karma keeps accruing. Post-9/11 anti-Muslim discrimination and anti-Japanese bigotry after Pearl Harbor are shown as iterations of a centuries-old white supremacist streak, which is also manifested in the Native American genocide, slavery, and Jim Crow. The ginned-up "Saddam has nukes!" panic that bum-rushed the US into Iraq feels like an uncredited remake of the 1964 Gulf of Tonkin incident, which led to the deployment of ground troops in Vietnam (and which was revealed in a 2005 report to have been distorted, to cover up intelligence errors). Stone and Kuznick present both incidents as manufactured pretexts for wars that benefited ideologues, military careerists, contractors, and CEOs (shades of *JFK*'s X) and that led to periods of hysteria (including the Cold War and the War on Terror) and epic acts of xenophobia (Hiroshima and Nagasaki; the carpet bombing of Southeast Asia).

Throughout the series, the United States regularly loses its innocence (to World War I, the Great Depression, World War II, JFK, MLK, Watergate, 9/11) and then seemingly hypnotizes itself into regaining it; *Untold History* suggests that the country never had much innocence to lose, while also declaring that, for all its hucksterism, it does stand for certain core principles, albeit more often in theory than practice. The series treats America's treasured self-image—a globe-trotting Galahad, blood-splattered but pure of heart—as a self-deluding reflection or an opportunistic facade. Stone says that when the nation does live up to its aspirations, it is a lovely anomaly, like a sunbeam cutting through overcast skies.

Edward Snowden was a sunbeam, at least the way Oliver Stone tells his story. And his story is close to a custom-tailored Oliver Stone film subject, ringing nearly every thematic and biographical bell that has fueled his art.

Snowden is about a politically conservative patriot who enters the military for righteously idealistic reasons (to fight terrorism after 9/11), washes out of the army after a training accident, joins the CIA and then the NSA as a hacker and cyber-security analyst, then becomes a disillusioned whistle-blower after learning that fear of terrorism is being used to justify blanket surveillance of people all over the world. It is based on Luke Harding's book *The Snowden Files: The Inside Story of the World's Most Wanted Man*, and on a novel about a Snowden-like figure, written by Snowden's Russian lawyer, the gatekeeper between Snowden and the media (and Stone). But much of the script is a work of reportage, based on Stone and cowriter Kieran Fitzgerald's conversations with Snowden at an undisclosed location in Moscow where the whistle-blower had lived in political asylum since his 2013 data dump. Stone is uncharacteristically cagey about what, if anything, Snowden contributed to the film's story, but he and Fitzgerald visited Snowden,[6] and the screenplay is filled with fresh information about Snowden. There are anecdotes about his epilepsy, his awkward attempts to be a CIA field agent, and his relationship with his girlfriend, Lindsay, an aerobics instructor and liberal whose political arguments with Snowden, in the film, push him to question received wisdom about the War on Terror. Stone and Fitzgerald started writing the script in early 2014, in consultation with intelligence and computer security experts, less than a year after Snowden revealed the National Security Agency's massive, illegal data trawl by leaking classified files to London's *Guardian* newspaper. The film was rushed into production to beat a similar drama being developed in association with the journalists Glenn Greenwald and Laura Poitras, who had facilitated Snowden's leak and had already told his story in their documentary *Citizenfour*. (Poitras and Greenwald appear in Stone's film as Snowden's questioners, in scenes that lead up to the *Guardian* series and put a frame around Snowden's backstory; they are played by Melissa Leo and Zachary Quinto.) Joseph Gordon-Levitt, a former child actor who grew up into a reactive leading man with opaque charisma, plays Snowden. Shailene Woodley, of *The Fault in Our Stars* and

the *Divergent* series, plays Lindsay. Their scenes together have (somewhat surprisingly) the feel of a romantic comedy about a spirited young woman who draws a melancholy lover out of his shell.

The result plays more like magic window–period Stone than anything the director has done since 1999's *Any Given Sunday*. The script is thick with technical details and dire in its political and moral warnings, but it is also essentially upbeat, because its informer hero is a man of conscience who challenged the National Security Agency and didn't get killed or sent to prison. Stone and his director of photography, Anthony Dod Mantle, modeled their compositions on Alan J. Pakula's trio of seventies paranoid thrillers, *Klute*, *The Parallax View*, and *All the President's Men*; the film's muted widescreen images favor negative space and use architecture to enfold or dwarf the characters and create feelings of unease. As played by Gordon-Levitt, Snowden's character could be a self-aware cousin of Ron Kovic from *Born*. He jokes in a final scene that he's often mistaken for a robot; if so, he's a robot that tore the wires from his motherboard once he realized that he was facilitating a slow-motion coup d'état against the nonmilitary world—one built on software and satellites rather than black ops scheming and assassins' bullets.

Lindsay's love for and influence upon Snowden anchors the story. While it would oversimplify Snowden to say he Did It All for Her, it feels true. The script presents Snowden as a reticent, awkward young man who only feels good when he's in his girlfriend's arms. Their tranquility is forever being destabilized by the Beast, which relocates Snowden to different states and countries and forbids him to tell Lindsay what he does. Not that he'd want to tell her: Deep down, he knows his data-trawling surveillance efforts are sinister and destructive, because they're more often in service of dominating foreign economic markets and controlling US citizens than stopping terrorist attacks. Snowden's allegiance to the Beast poisons an otherwise healthy relationship. In one of the most unnerving scenes, Snowden and Lindsay's comfort-sex is ruined when Snowden realizes that Lindsay has left her laptop open in the bedroom, which means the agency could use the computer's camera to watch them.

The film ends with a summation by Snowden, delivered by an encoded satellite feed to an audience in London. It restates themes that Stone has revisited throughout his career. Its inspirational tone, verging on Capra-cornball, suggests that the director, who turned seventy in the year of this book's publication, had not yet given up hope for his country. "America is not just a piece of land or a pot of money," Snowden says. "It's a set of ideas. The idea that we have a right to know what our leaders are doing in our name. That our communications and our private lives are protected by the Fourth Amendment, just like our homes and our property. And that if our government withholds information from us, we have the freedom to challenge it. Questioning authority is what we do. That's the principle our country was founded on."

1 Roger Ebert, review of *Savages*, *Chicago Sun-Times*, July 4, 2012, http://www.rogerebert.com/reviews/savages-2012.

2 "Mr. Stone's lush compositions and suave camera movements may surprise—and maybe offend—fans of [novelist Don] Winslow's lean, flinty prose, but the sumptuousness of the movie is among its chief delights," A.O. Scott wrote in the *New York Times*.

3 More than a few pans of *Savages* singled out "wargasms," a word occurring in O's voice-over description of Chon's lovemaking, as an example of Stone's propensity for inventing overripe dialogue, even though it appears in Winslow's novel and has been used by, among others, onetime secretary of state Robert McNamara, social critic Paul Goodman (in a takedown of Norman Mailer), and pop music critic Simon Reynolds (writing about military imagery in pop music).

4 Stone: "Okay, this is another one of those cases where I think you're a little bit full of shit but you're also right about some things."

5 Stone has cited *A People's History of the United States* as an influence on his official narrative-questioning worldview, and has enthusiastically recommended it to students.

6 *Snowden*'s director of photography, Anthony Dod Mantle, told me that one of his most cherished memories of the shoot was watching Stone travel from one country to another, always keeping his file boxes within his sight to prevent anyone outside the production from stealing them or rifling through them: "I wish everyone could see the extraordinary sight of this important American filmmaker pushing a cart piled up with boxes down hotel hallways and through airports."

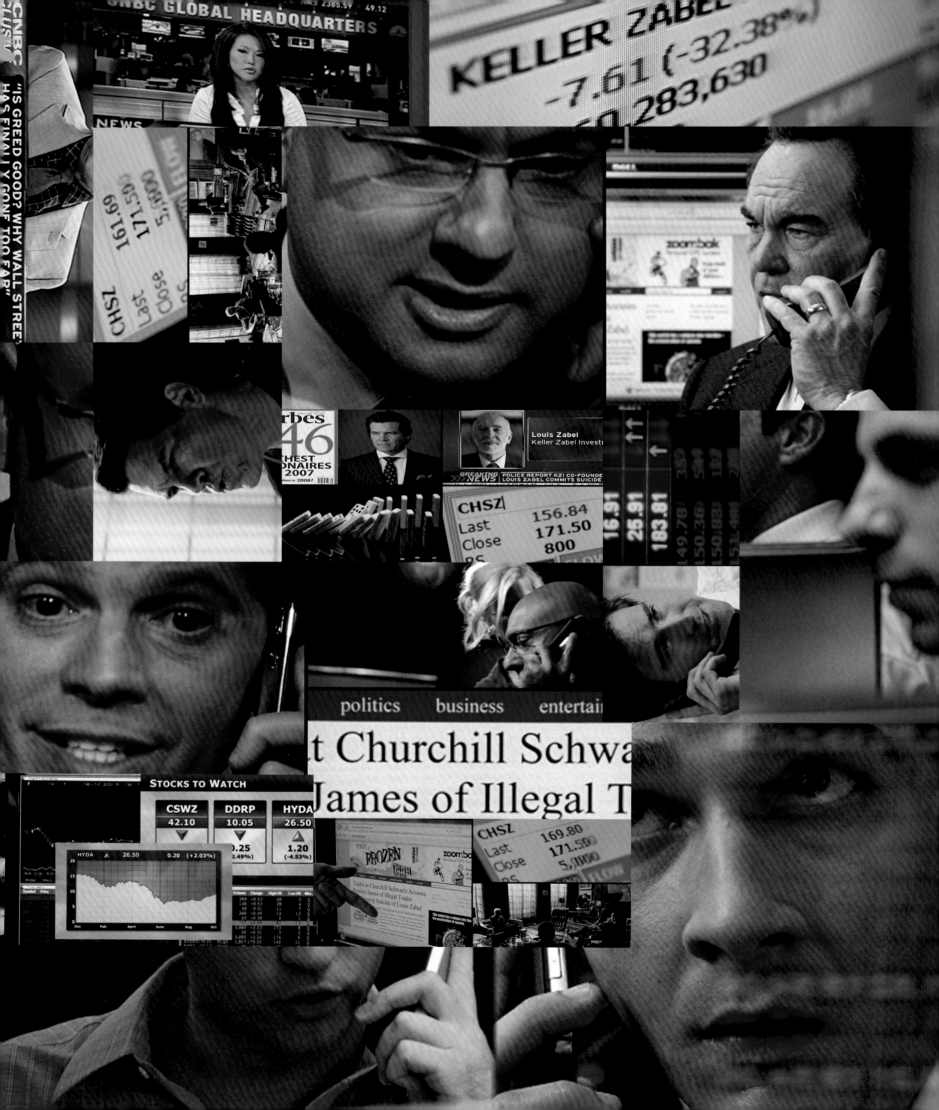

MATT ZOLLER SEITZ In 2010 you made your first sequel, *Wall Street: Money Never Sleeps*. What had changed in the culture of business, as you perceive it, between the first *Wall Street* and *Wall Street 2*, and how did that inform your approach to this story—a story in which there are continual references to what happened in the first film to establish the context?

OLIVER STONE The Gekkos were the raiders, they were the buccaneers—they came in, they cannibalized the companies, often for self-profit. Gekko masked it with a "greed is good" kind of revolutionary spirit, modernization act. But basically, they raped the place. And they created new wealth. The concept of one hundred million dollars for a company wasn't outrageous. One hundred million dollars used to be an enormous amount of money.

Now think back to 2008, when a billion dollars gets you into the game to buy a company. The trick is to overvalue, to hype, and that's what they did. But now there's no longer the buccaneers, they're gone—absorbed by the hedge funders. And the hedge funders in the nineties did what Gekko did. And more power to them. I have no beef with them, because you know what you're getting into with them. It's a risky business. But they made so much money and were so successful in that deregulated market of Reagan and Thatcher [END 1].

What happened was that the banks started to play the hedge fund game,[1] which was playing the Gekko game—so, essentially, Gekko became the bankers.

Josh Brolin plays the grandson, essentially the second-generation Gordon Gekko. But he's legal.

Watching Brolin's character on a financial news channel, Gekko says, "I'm small-time compared to these crooks."

Brolin's character is at the center of the system, whereas Gekko was a bad guy on the bad side of the system.

One of the things that surprised me about the second *Wall Street* is how different it felt in energy and tone from the original, and the more jaded way it looks at this culture of money. Whereas the first film had a lot of critical things to say about the mentalities that you've just described, it was also a movie that made the making of money and deals exciting.

Because it was new back then! There was a crisp business moving. Now you've had CNBC for twenty years, you've had books, you've had magazines.

But beyond that, it almost seems as though there are two movies going on simultaneously in *Wall Street 2*, and they're kind of intertwined, and in some ways it seems to me that they're canceling each other out. One of them is that exciting, "Are they going to make the deal or not?" movie, and that was at the heart of *Wall Street*: It was the spoonful of sugar that helped your medicine go down.

One hundred million dollars used to be an enormous amount of money.

But all that is contrasted with these very introverted, surprisingly tender domestic scenes that are about a husband and a wife, or a father and a daughter. And the message of those scenes is that money is what gets in the way of the stuff that really matters. And this sours the excitement of the moneymaking scenes, in a way that feels deliberate. You get the feeling that the obsession with money and profit is making it less likely that these characters can be happy.

Trust is an issue, isn't it? I mean, isn't the movie at a fundamental level like the old movie? It's the same story. It's about love and trust, greed and betrayal. In the first one, Charlie Sheen betrays his dad—that's the crux of the movie—and he betrays the labor union in order to advance himself and Gordon Gekko. And he realizes it at the end and he reforms, he faces the consequences.

This movie is no different. Everyone is tested. Shia LaBeouf:[2] good kid, idealistic, he's trying to start an alternative clean energy company—he brings the Chinese in, all that stuff. He's trying to help the world.

And make money.

Yeah. And he's twisted. He starts up false rumors, malicious rumors against Josh Brolin, because he wants to get revenge. That's completely illegal. Then he actually does not tell the truth to his fiancée twice, because he betrays her.

He's an honorable man when it suits him.

And so was Charlie in the first one. So I'm saying there's a tension between what money makes you do against your own family. She doesn't tell him the secrets of her own stash!

There's a line in the original where Martin Sheen says, "Money makes you do things you don't want to do." He also said, "Money is something you need to have in case you don't die tomorrow."

Were you thinking about your own dad when you were shooting the scenes with Frank Langella as the hero's mentor?

Yes and no. I think Frank Langella's[3] character was a much tougher guy than my dad. My dad was not a big shot. This guy was a *big* shot. He says early in the film, "They say a loss is a profit. I don't understand that shit." He comes from the day when at Lehman Brothers, the four partners would sit in the same fucking office to make sure nobody would steal the goddamn money. That was what he came from, so he was out of touch. And Brolin says, basically, *The guy knew how*

1 A hedge fund is a form of monetary investment that pools capital from a variety of sources; its name derives from a strategy—no longer followed by all such funds—of making certain kinds of investments to offset, or hedge against, the risks posed by other investments.

2 1986– ; film actor, music video director, graphic novel writer, and either performance artist or person with issues; *Transformers* (2007); *Indiana Jones and the Kingdom of the Crystal Skull* (2008); *Nymphomaniac* (2013).

3 1938– ; stage and film actor with a mellifluous baritone voice; *The Twelve Chairs* (1970), *Dracula* (1979), *Lolita* (1997), *Frost/Nixon* (2008).

WS²

JUNE 2008 - DEC 2008

June 3: Obama nominated

June 6: Worst Dow loss in a year.

June 9: Gas soars above $4/gal

June 26: Oil soars above $140/barrel
Dow drops 358 points.

July 11: Oil reaches all-time high of $146/barrel. ✗✗

July 24: Ford posts worst Q in history. Americans not buying trucks/SUVs

Aug 5: Oil falls below $120/barrel.

Aug 14: Highest inflation in 17 years

Aug 28: Obama accepts nomination.

Aug 29: McCain picks Palin ✓

Sept 4: Dow falls 344 ✗ ✗

Sept 5: Unemployment hits 5-yr high

Sept 7: Fannie & Freddie placed in govt. conservatorship

to run money, but you don't kill yourself. . . . You know, that was an astute observation on Brolin's part.

No, that's not my dad. He's a tough guy, but he could be closer to Hal Holbrook's character Mannheim in the first movie. He could have been a big shot, is what I'm trying to say. I don't see Langella necessarily as a good guy. He could have been a pig, but he was good to Shia because the kid was his caddy.

But all these guys are arrogant. When you get to the top, you're generally arrogant.

I think Gordon Gekko in the second *Wall Street* is closer to my dad, because Gekko to me is more torn, truly torn. I think the key scene is when he comes out of prison and his daughter's not there—there's nobody there, he's looking around. That says a lot. He references that later when he gets pissed in London at the kid. He says, *She wasn't there. I have a right to do what I'm doing. She promised me she would be there. It was my dough. She said she'd be there.*

So maybe this is the *Wall Street* version of *Nobody on their deathbed thinks, "Gee, I wish I'd spent more time at the office."*

Well, Gekko's divided that way, isn't he? He is pissed at his daughter, Winnie. He hates her for this. At the same time, he's on the steps of the museum begging her, convinced he needs her back in his life. So I don't think it's very simple for him. I think he's torn by money, torn by ego, desire to get back in the game, to be respected because he's an outsider looking

in. He's writing a book, he's kvetching about the system.

So when he gets back in London and he gets the hedge fund—and remember, the hedge fund can accelerate very fast in that period, because he's buying low; I checked that, I know hedge funders that can do that—he gets a billion bucks. So now he's going to give a hundred million dollars back, big deal. But he wants a grandson. That's part of an ego thing going on, too. He wants to have a male heir, I guess.

Gekko to me is a very nuanced, torn creature in this movie, unlike the old film, where he was a one-note. I loved him in that, but he was a superficial, son-of-a-bitch reptile. In this picture, you wonder, which way's he going to go? I kind of like that.

If you put both of the films together, they're over four hours' worth of running time, but the only scenes in either of those movies where Gekko is always on the defensive are the scenes with his daughter in the second film.

Michael Douglas does reflect that. He's lived a life. He's been through his son's thing.

You know, life does that to you. Life makes you humble.

I wanted to ask you about that, too—the scenes where the Gekko character talks about the suicide of his son, which was obviously the most important event of his personal life: To what extent did various drafts of the script draw on Michael Douglas's own personal problems?

Gekko to me is a very nuanced, torn creature, unlike the old film, where he was a one-note. I loved him in that, but he was a superficial, son-of-a-bitch reptile.

That material was already in the script. His son was busted for drugs right before we started shooting [END 2]. But by that point, we had committed to the story line. If anything, I thought Michael might want to change some things. He didn't. He went right with it.

Carey Mulligan[4] is very good, too, in the scene. She anchors the scene, because basically it's a job of convincing. He has to persuade her. And he does, so that at a certain point it's about her reaction shots. It's about persuasion. Seduction, too.

When you look at this movie and you think back on *Wall Street*, do you have a different perspective about what is important, where you want to put your energy as both a filmmaker and as a person?

It's been twenty-three years. I've been through two divorces and more life. I think I was a hungry young man and that was my first studio film, *Wall Street*, so I was excited, it was glamorous, and I remember being very proud of that. I'm shooting in New York with the studio money. I'd done low budget—*Salvador, Platoon*. Then I'm doing a ruthless, exotic world, and nobody had really done that kind of movie. So it was all fresh and new. I loved the story. It was *Pilgrim's Progress*—a young man corrupted by the world. But it wasn't as deep as this movie is, because this has more ambivalence.

Well, there's definitely skepticism about ideas of material success in this film, which there was not in the first one—at least not to the same degree.

Oh, but I think there was! The father, Martin Sheen, is to me a good guy, as well as Hal Holbrook. They're counterweights to Charlie's materialism. I think my dad was in Hal Holbrook, too, because I know I wrote some of those lines, the abyss and all that, they were my feelings at the time.

I've always felt, if you look back at my work, there is a spiritual side. Even back to *Platoon*, there were mystical concepts in it. I've always felt materialism has its limits. It's only deepened with time, frankly. It hasn't changed, it's deepened—more awareness about what money can do to people.

There is no middle class in this movie. The labor unions are gone now. They don't mean anything economically. The concept of a labor union striking in this country does not strike fear in anybody's heart. It doesn't work. The business of America is now finance.

And that kind of builds upon one of the motifs in the first *Wall Street*: that we're not making anything anymore except money. I remember at the time thinking, *Oh, that's a bit of an exaggeration*. But maybe it was just a little bit ahead of the curve?

So was *Natural Born Killers*, by the way. But I think TV has gotten worse than that since then. I thought that was the beginning of the end of this concept of truth. Larry Tisch[5]— you know that whole thing in the 1980s? He took the news and made it for profit.

I remember. But the example was set in the 1970s by *60 Minutes*, which was one of the most profitable shows on network television despite being a news program. And people looked at that and said, *Oh my God, we could make as much profit on this as we do on* Hawaii Five-0 *or* Gilligan's Island*, so why don't we remodel all of the news on this?*

Well, same thing with the movie business: *If* Jaws *can make that kind of money, we can do it this way.*

There's often a guns-blazing attack on any film you make that draws on real life, whether it's set long ago, recently, or right now. This kind of thing has been going on for a long time, and your response to it almost makes it seem like you've got a rapid-response team with a guy down in the boiler room working a LexisNexis account to find facts to refute people. I remember you started doing that when *JFK* came out. You published an annotated companion book for that, and you did

4 1985– ; utterly charming actress; *Pride and Prejudice* (2005), *An Education* and *Public Enemies* (both 2009); *Drive* and *Shame* (both 2011); *Inside Llewyn Davis* (2013).

5 The president and CEO of the CBS television network from 1986 to 1995. Under his tenure, the once dominant CBS, though very profitable, fell to third place in ratings behind NBC and ABC, and remained there. In unprecedented moves, he also slashed thirty million dollars from the news division's budget and fired nearly 20 percent of its twelve hundred employees.

(below) **Wall Street: Money Never Sleeps** continually reminds viewers, via close-up "inserts," of the financial and material matters that affect relationships.

(opposite) Cover of the August 2012 issue of **High Times**. Reprinted with permission of the publisher.

that with *Nixon* as well, and since the nineties you've been very swift and aggressive about responding to what you think are unfair or inaccurate attacks, whereas other filmmakers might be inclined to let that sort of thing slide a bit more.

What I want to know is, why do you think it is you, among the countless filmmakers who make films based on real life, that is subjected to this level of scrutiny nearly every time you make a movie? And secondly, why have you felt it was necessary to reply just as aggressively, and in detail, to the media and your detractors, rather than just saying, *Fuck it, let them say what they want to say?*

I've done that second thing, too. On *Nixon* there were some attacks. I remember Evan Thomas in *Newsweek*[6]—there were so many. I was tired. Sometimes you don't fight back. In the case of *JFK*, that was a monster for me, because we did publish a damn book, and nobody referenced it! And the book was as accurate as we could make it at that time. And we had a lot of footnotes in there and we covered a lot of bases. But detractors kept saying we made it up. We weren't hiding anything. But because we turned twenty-six characters into three, all of a sudden everything else has to be thrown out the window? Well, you can't throw the baby out with the bathwater. We were trying to stick to the spirit of the truth there.

But my role is a dramatist's role, and the dramatist's role is very hard to understand.

I made a comment somewhere that the dramatists came before the historians in Greek history, and when you think about it, maybe the dramatists do know something. Homer

Homer may not have been a great historian, but he certainly made the Trojan War have a meaning to us.

may not have been a great historian, I don't know, but he certainly made the Trojan War have a meaning to us. Perhaps it's been exaggerated, but the concept of overreach is very much present in Homer. And I think a dramatist can do the same thing with Vietnam or Afghanistan or whatever.

There's this refrain I hear, not just from you but also in the media, that things have gone downhill, we've lost our innocence, the bad guys are in control, the corporations run everything. But there are times when I read this sort of lament and think, well, when was that *not* true? Are things measurably worse in the United States, or in the world generally, than ten years ago, or twenty, or a hundred? Or do we have to, as a race, just keep relearning the same lessons over and over, and what we're experiencing is the natural stubbornness and cluelessness and blundering of the individual being played out at the level of nations?

I think that's a very valid question. I think we go through periods and cycles of reform. Sometimes there seems to be natural reform in the air. The bad guys don't always win—they win most of the time, it seems, yes. We've had mismanagement increase since World War II,

I think, and that's part of what our series *Untold History* is about. The mismanagement of the country is enormous at this point, and our policies are really askew. We will continue to intervene in foreign countries. The bigger issue is that after the Soviet Union fell, we just lost all control of ourselves, it seems. We think we can be the unilateral force in the world, the lone policeman. I think this is a huge, huge misconception that we're laboring under, that we have to be the lone superpower, we have to police the world.

The point is, we're on a death trip. We've overreached.

This is crazy. This is empire.

Well, I was just about to ask you if you think we are, in fact, the modern version of empire. And if so, are we in decline?

Of course we are. It's evident, self-evident, because we can't keep this up. The dollar is at

6 Thomas called the film a "credible effort" but added that "it seems . . . likely that Stone is projecting his own demons onto Nixon." Evan Thomas, "Whose Obsession Is It, Anyway?," *Newsweek*, December 10, 1995.

How to Grow Sativas Indoors

HIGH TIMES

August 439

Oliver Stone
On Pot, Politics & His New Movie Savages

The 10th Annual **Doobie Awards**

100,000-Watt Grow Op
Buds and Bulbs in B.C.

Die Antwoord's Smokeout

Cannabis in Colombia
Weed Farming in a War Zone

Pot, Inc.
Inside the Cannabusiness

Greenhouse Ganja Gardening
For Year-Round Success!

HIGHTIMES.COM

August 2012 USA $5.99 / FOR $5.99

the stretching point. It's an interesting con game that we have with the world, because they're still buying the US treasuries and they believe in the dollar. They will for a while, because something will happen eventually—we're completely borrowing, on borrowed time.

What role does the media play in all of this?

Blinding. The problem with the media is they're trying to make money, and I don't blame them. They're trying to make a profit, but they simply think about today—the tyranny of now. Any long-term point of view is very difficult to get across.

When you were on tour promoting *South of the Border*, you told the *London Times* that it was "Jewish domination of the media" that kept Adolf Hitler as villain, and there were other forces that deserved a lot of the blame for World War II deaths: "Hitler was a [Frankenstein's monster], but there was also a Dr. Frankenstein. German industrialists, the Americans and the British. He had a lot of support" [END 3].

The flap over the Hitler comments, do you think that was an example of "the tyranny of now?"

The point is, we're on a death trip. We've overreached.

I did say something inappropriate. I regret it, and I apologized for it.

I was in a discussion with the *London Times* about *Untold History*, and I was talking about a larger subject, which was the Israeli influence on US policy, not only in the Middle East, but also in the world. I said the wrong thing. My comments were blown up into this storm. It hurt me deeply, because I'm not that way. I'm not a provocateur.

You're often described that way, though—as a provocateur. And as a conspiracy theorist, or "the left-wing filmmaker Oliver Stone." There are all sorts of adjectives and phrases that get attached to you. How do you feel about them?

In *Wall Street* you see a guy who's a dramatist—you don't see a left wing or right wing. I think people from Wall Street can see the movie and enjoy it. Hey, how about *W.*? I love Michael Moore, but I was not Michael Moore there.

Whether I'm right or wrong, I feel like I'm screaming in the wilderness, "Be careful! You guys are crazy with what you're doing!"

Yeah, but if you're going to try to suggest that you haven't contributed at all to how people perceive you, well . . .

No! It sounds very pretentious, but—you mentioned Catholicism as an influence on me, because of my mother. Well, my father was Jewish, and there's a strain from my father of Jewish religion, of patriarchal religion, and in that religion there's Jeremiah, who was a famous prophet.[7] He predicted disasters for Jerusalem, and they came true! But nobody believed him. He had the Cassandra complex.[8] There is that aspect to me, too—of a prophet. Whether I'm right or wrong, I feel like I'm screaming in the wilderness, *Be careful! You guys are crazy with what you're doing!*

And now we travel from Wall Street to the California-Mexico border with *Savages*, from Don Winslow's novel. This is about a trio of California pot growers—Ben and Chon and O— and the Mexican cartel trying to take over their business. And it's all of a piece with other Oliver Stone screenplays and movies about the effect of drugs on society and the individual.

You have plenty of experience with drugs, as both a substance and a subject. You got your first Oscar for writing *Midnight Express*, about an American imprisoned for trying to smuggle hashish out of Turkey. In the script for *Scarface*, you created a comic metaphor for eighties excess in the image of Al Pacino's title character almost literally drowning in cocaine. Legal and illegal drugs also played important roles, on-screen and off, in *8 Million Ways to Die*, *Salvador*, *Platoon*, *The Doors*, and *Natural Born Killers*. And you've been quite frank over the years—in lots of interviews, including ones for this book—about your ingestion of various substances, and the aesthetic inspiration they've given you, and the legal and personal trouble they've gotten you into.

I wonder if that's why, twenty-four years after *Midnight Express*, there's no character in *Savages* who represents the so-called straight point of view on drugs and the war on drugs?

There's no moralizing about the war on drugs in the movie. Prohibition is not even mentioned. That's because, to me, prohibition is a joke. It doesn't work on any level.

The movie goes out of its way to show drugs as a business, and the people in the business as individuals striving to improve their social station. Benicio Del Toro's[9] character, the cartel enforcer Lado, grew up poor in Mexico, and now he goes to Little League games and complains that his daughter is dressing too provocatively.

Everyone changes in this movie. The only one who doesn't really fundamentally change is Taylor Kitsch's[10] character, Chon, who kind of returns to where he started, and that's because he was always psychologically grounded in the reality of the war.

And the drug war is a *war*. I always love that theme from Don Winslow's[11] book of bringing the Iraq War home to roost here. If you look at the statistics, the homicide rate in Ciudad Juárez was equivalent to Baghdad in 2007 or 2008. Most of the victims, according to statistics, were innocents, people in the middle. Now, we don't know exactly if some of those people might have had a cousin or

7 Jeremiah is one of the major prophets of the Hebrew Bible, traditionally credited with authoring the books of Jeremiah, 1 Kings, 2 Kings, and Lamentations. One of his most famous quotations is this: "The heart is deceitful above all things, and desperately wicked: who can know it?" Jeremiah 17:9 (King James Bible).

8 Psychological phenomenon in which an individual's accurate prediction of a crisis is ignored or dismissed. The term originates in Greek mythology: Cassandra was the daughter of Priam, king of Troy; the god Apollo fell in love with her and granted her the gift of prophecy, but when she refused his advances he cursed her so that thereafter, no one would believe her predictions.

9 1967– ; imposing character actor in a Lee Marvin vein; *License to Kill* (1989), *The Funeral* and *Basquiat* (both 1996), *Fear and Loathing in Las Vegas* (1998), *Traffic* (2000), *Che* (2008), *Inherent Vice* (2014), *Sicario* (2015).

10 1981– ; the strong, silent type, even when his characters talk a lot; TV's *Friday Night Lights* (2006–2012); *John Carter*, *Battleship*, and *Savages* (all 2012); *True Detective*, season two (2015).

11 1953– ; crime and mystery novelist; *The Life and Death of Bobby Z* (1997), *The Winter of Frankie Machine* (2005), *Satori* (2011), *The Cartel* (2015).

(below and opposite) Chon (Taylor Kitsch, left) and Ben (Aaron Taylor-Johnson) in combat armor and Day of the Dead-styled masks lead an ambush on Mexican cartel foot-soldiers.

Over time the drug money has legitimized itself, buying malls and land, not just in Mexico but in the United States.

somebody that was involved in the drug trade. That might have been true in some cases.

But in any case, it's a reality that things are quite violent down there right now, and they are violent because there's so much money to be made. It's bigger than tourism, bigger than oil. Drugs are a huge part of the economy of Mexico right now. Mexico would fall apart without drug money. Over time the drug money has legitimized itself, buying a lot of malls and land, not just in Mexico but in the United States as well.

How do you think the American point of view on drugs and drug prohibition has changed since the seventies?

I don't think America has learned much from the war on drugs. Sixty percent of our prison population is made up of nonviolent criminals, people who are behind bars because they ran afoul of the law by way of the marijuana trade, or the hard-drug trade. We have the largest per capita prison population in the world—bigger than China, bigger than Russia—and the drug war is the reason why. We can't afford it.

And we've criminalized a whole class of people and created a social chasm for young people. Per capita, there are ten times more blacks than whites in jail for drugs. It's the new Jim Crow [END 4]. On top of that you've got all these fucking prisoners in this prison system, prisons run both publicly and privately, for profit.

And you've told me before that you think the prison industry has no vested interest in reducing the incarceration rate, because it would take money out of the pockets of people who work in that industry.

That's the bottom line. This is not a war on drugs. This is a war *for* money. It's being fought in Mexico for money, and it's being fought in the United States for money—the United States being the biggest sap of all, because we give the most. It's an endless outflow of money and resources to Afghanistan, to Mexico—it doesn't matter. When George Soros tried to legalize marijuana in California [END 5], his toughest opposition came from the prison guards.

The idea that this is all ultimately about commerce gets driven home in *Savages* in a scene where Aaron Taylor-Johnson's[12] character Ben goes to one of his distribution associates and tries to explain the ins and outs of the cartel that's trying to buy their business. John Travolta's[13] corrupt DEA agent, Dennis, tells the weed-dealing heroes that the Mexican cartel is Walmart, and they want Ben and Chon in aisle 3.

This is a hypothetical fiction. The kind of drug violence depicted in *Savages*, with people getting killed by improvised explosive devices on US soil, hasn't happened yet. That comes from Don Winslow riffing. There's a line in the movie: "Five guys dead in the desert, that's huge news." Well, maybe in the United States in 2012 it's huge news, but not in Mexico.

Winslow has written about the drug war in the US, Mexico, Colombia, everywhere, in the sixties, the seventies, the eighties, and he's done a great job. This book is a whimsy. The truth is, the cartels are so big that their busi-

12 1990– ; earnest, slightly recessive leading man, always projecting wary intelligence; *Kick-Ass* (2010), *Captain America: The Winter Soldier* and *Godzilla* (both 2014), *Avengers: The Age of Ultron* (2015).

13 1954– ; actor, singer, dancer (when filmmakers think to ask him); *Saturday Night Fever* (1978), *Grease* (1978), *Blow Out* (1981), *Look Who's Talking* (1989), *Pulp Fiction* (1994), *Get Shorty* (1995), *Hairspray* (2007), *The People v. O.J. Simpson* (2015).

ness is worldwide, it's transnational. They would have very little motivation to get into a grudge match, a shooting match, in California today, legal or not. The motivation to do it might be if your cartel were getting squeezed by another cartel.

And that's what's happening to Salma Hayek's[14] character, Elena, in the movie. She's responding to pressure, to the perception that in business terms, she's dead, she's ineffective, that she can't run the business that she inherited from her husband because she's a woman. Her cartel is broken up. Their methamphetamine production is down. She has to take decisive action.

This is not a war on drugs. This is a war *for* money.

Women have always been involved in the drug trade, and there have been a few successful ones at the top. In the 1970s and '80s, in Colombia, there was a woman named Griselda Blanco who was called "the female Scarface,"[15] who was supposedly responsible for four or five hundred deaths. She died [in 2012]. She went to jail in 1985, spent ten years there, and was almost indicted for three murders, but the case against her collapsed. She got out in 2004 and was deported back to Colombia. There have been some

notorious female drug lords, just as there were notorious female pirates.

Salma Hayek's character is a survivor. She's a very conservative businesswoman, very Catholic, who inherits this business because her husband has been killed, and who tries to save the remainder of her children from being killed. She hides her daughter to protect her from danger. At one point she even says she's proud that her daughter is ashamed of her. She's a very straight woman, but she's torn, because she wants to protect her daughter, and that becomes the key to her undoing.

There's also a sense she is not your typical movie drug lord precisely because she is a woman. Elena can be just as ruthless as a man in business dealings. But you don't see her lounging around the pool with a bunch of hunky young guys, or in any other situation that would seem like the movie was just taking the usual clichés of the movie drug lord and flipping the genders.

It's difficult for her because no matter how strong she is, she has to be constantly on guard, because of the culture of all these men who work for her. Their code. Their expectations.

Machismo.

That's right.

But I want to go back to an earlier question: *Midnight Express, Scarface, The Doors,* **and, in their**

way, *Salvador, Platoon,* **and** *Natural Born Killers* **dealt with drugs or were often about characters that used drugs, or were flat-out addicted. I wonder where** *Savages* **fits into this continuum?**

I don't know if that's true, the addiction part of what you said, because the only person in *Savages* who expresses any form of addiction in the movie is Blake Lively's[16] character, O, who experiences withdrawal symptoms when she's denied marijuana. But in her case, it's less an addiction than a concentration problem.

A lot of pot, and some coke, does get consumed in this movie, though. And the narrator, O, isn't the only character that has a problem. Ben and Chon are stoned through a lot of it, and Lado consumes a pretty hefty amount of cocaine.

14 1966– ; character actress trapped in Claudia Cardinale's body; *Desperado* (1995), *From Dusk till Dawn* (1996), *Dogma* (1999), *Traffic* (2000), *Friday* (2002), *Ask the Dust* (2006); Jack Donaghy's only plausible match on *30 Rock* (2009–2013).

15 Drug lord in the Medellín Cartel and one of the primary forces in the Miami cocaine trade during the seventies and eighties.

16 1987– ; sneakily subtle actress and model who could have been a Hitchcock blonde but is probably glad she wasn't; *The Sisterhood of the Traveling Pants* (2005), *Gossip Girl* (2007–2012), *The Town* (2010), *The Age of Adaline* (2015).

He does. But while he's sadistic, he's not erratic, and at the end of the day, he turns out to be a businessman. He's not insane.

Elena's not a drug user, either. She's a very conservative woman. She tells O, "Your love story is all fucked up, baby." She can't imagine being in a sexual and romantic relationship with two men at the same time. O's position is that it's fine. From her position, it works. The movie is told from O's perspective, so the movie shares her point of view. But Elena raises the issue with her. The difference between those two perspectives, the narrator's and everyone else's, is explored in different ways throughout the movie, and it comes home in that scene, and in the ending.

My own personal views on drugs are common knowledge, but they're outside the scope of the story that we're telling. The setting is important, but ultimately it's context for the working out of relationships between six characters.

In typical cop movie terms, every single character in this movie could be coded as a "bad guy." They could be a character that a DEA or cop hero in another film is trying to bring down.

Well, Ben is a good guy. And O is a good guy. I mean, she's a bit of a bunny, but she's not a bad person. Over the course of the movie she changes, and Ben does, too, against his will. They're all human. Even Lado. He's a sadist, but he's also a businessman, so he'll take a deal. *(Imitating Del Toro:) My money, gimme my money.* He's a fascinating character.

There's a scuzzy little character moment between Dennis and Lado that's like something out of a seventies drama. **Lado drops in on Dennis. Dennis has just made himself a grilled ham, cheese, and tomato sandwich. Lado takes the sandwich away from Dennis, but before he eats it, he takes the tomato slices off and tosses them away.**

(Stone laughs.) Yeah, that's Benicio. Only Benicio could come up with a detail like that. He's that way, very instinctive. To take the sandwich was probably enough, but Benicio pushes it further and makes it funny. Travolta and Del Toro, together or with the other actors, they're just great.

What did you know about Blake Lively, Taylor Kitsch, and Aaron Taylor-Johnson before you started production?

I didn't know any of them personally when I started. Aaron was the first to get cast, in London. I liked him in *Kick-Ass.* I offered him either lead male role. I'd bought the book, but the script hadn't been written. He committed to me, and he turned down two or three big films during the six-month interim that it took to get him a script. He stayed loyal to me, and I stayed loyal to him. There were a couple of points where I was tempted to cast somebody else because some bigger stars expressed interest, but I felt like Aaron was the right guy, so I didn't waver.

The moment I found Taylor, he'd just come off of *Friday Night Lights* and *Battleship.* To play Chon, I needed a foil for the character of Ben, somebody who was stronger than Ben and could back him up. Aaron and Taylor are both great-looking guys. They look sexy on-screen together. Kind of a Newman-Redford, *Butch Cassidy and the Sundance Kid*[17] thing: Aaron as the talker, the brains of the operation, Taylor as the quiet killer.

Blake was the last one of the three main roles to get cast. Jennifer Lawrence was going to do it, but the *Hunger Games* franchise made her an offer at the last moment, and she took it. Blake wasn't the character in the book, or even the character in the original script. The character [as written] had more of a punk rock, *Girl with the Dragon Tattoo*[18] kind of feeling, a Gothic nihilism. For whatever reason, there was a lot of that kind of female type around in films at that moment—*Girl with the*

17 One of the first meta-westerns, written by William
 Goldman and directed in 1969 by George Roy Hill;
 Paul Newman and Robert Redford's teamwork in
 the title roles inspired an even more successful
 follow-up with Hill, 1973's *The Sting.*

18 2008 Swedish pulp novel by Stieg Larsson; inspired
 a 2009 Swedish film directed by Neils Arden Oplev
 and a 2011 American remake by David Fincher.

They're all human. Even Lado. He's a sadist, but he's also a businessman, so he'll take a deal.

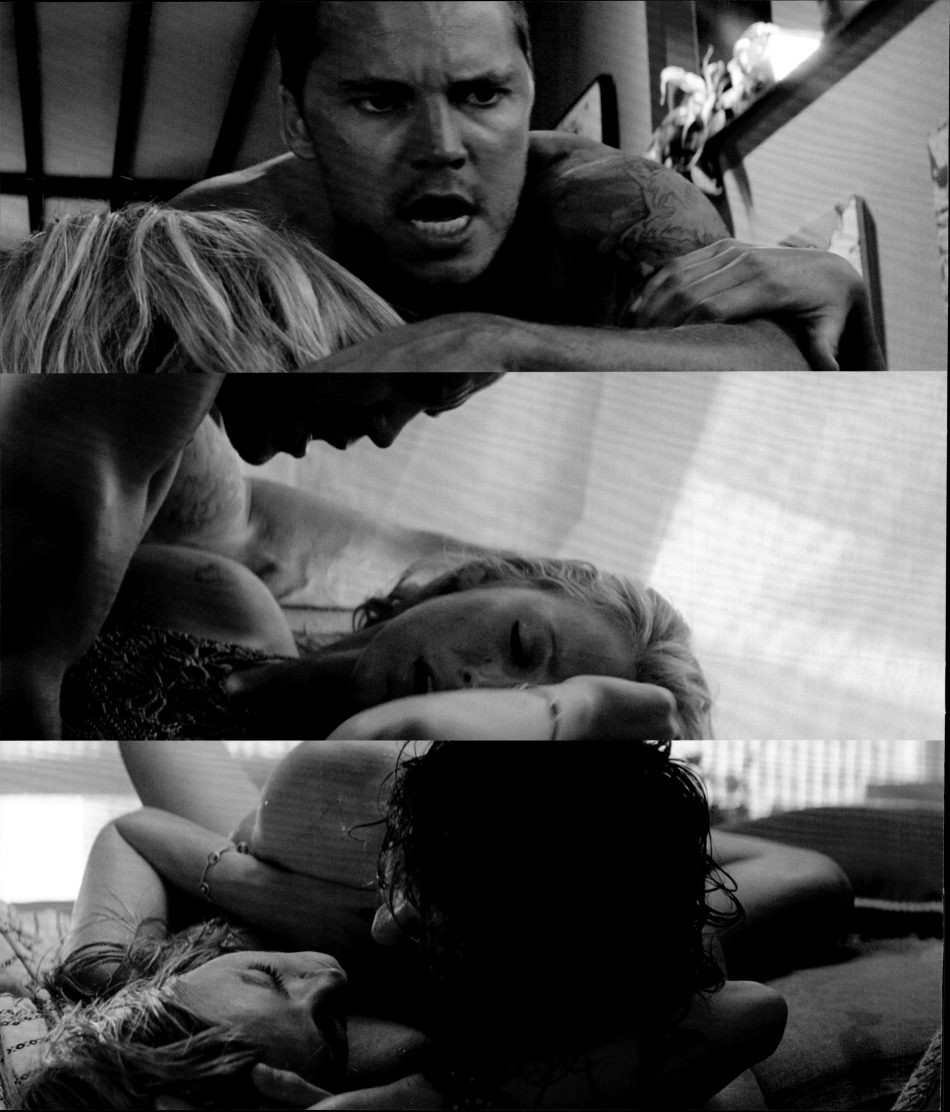

Dragon Tattoo, *Sucker Punch*,[19] and so forth—so I didn't want to do that again.

Then Blake walked in. She had that kind of Southern California feeling. She looked like the beach. But Blake has her own point of view. She's a very tough young woman, very smart, street-smart. She had a lot of ideas about the script. Of all the main actors, Blake, Benicio, and Salma probably gave me the most input. They wanted to change things, and in a lot of cases they did talk me around to their points of view.

Did you feel a particular affinity for Chon? I ask because you and Chon have biographical details in common. You were a decorated Vietnam veteran,

The three actors did that to me, just by being so damned attractive. I like to photograph good-looking people. I always did. But Aaron and Blake and Taylor also kept me young just by being themselves, by bringing their own points of view. There were a lot of points where they'd want to change dialogue because they didn't like a particular word, or didn't think it would sound like what a person in their twenties right now would say.

In terms of the whole movie, people ask me, *Why was it shot this way?* and I answer, *Because I think of myself as an actor-director.*

What do you mean, an actor-director?

understood when I've talked about the impact that rejection has on me. I don't think you know.

You're talking about *Snowden* now? About how you sent the script out to major studios in late 2014, and it seemed like one of them was going to come in and fund it, but then suddenly that all collapsed, and you had to go out and cobble together another budget from a lot of different sources and basically make an independent film, which is how you've been doing movies, with some exceptions, since *Any Given Sunday*.

That's right. To be rejected months before we were supposed to start shooting *Snowden*, by the mainstream, by the studio system, completely—executives who know this business loved this idea of me doing this script—rejected in every fucking boardroom!

Then Blake walked in. She had that kind of Southern California feeling. She looked like the beach.

and then you came home and slipped into this counterculture. It's a different era now, but Chon's on that wavelength. In real life, if you saw Chon walking on the beach smoking a joint, you might not guess that he knew twenty ways to kill you.**

But in Chon's case he's coming full circle. He's home from Iraq, but this is a world he's familiar with. He's a beach guy. He came from that area.

But yeah, I did feel a connection. There's a dichotomy there. That's something I get into in a lot of my work. In a way, these characters, Chon and Ben, are continuing ideas from *Platoon*. Chon is Barnes, Ben is Elias. Barnes is force, Elias is negotiation. I like that contrast between Ben saying, "Let's negotiate," and Chon saying, "You don't negotiate with savages."

An actor, every time he does a movie, becomes that character. He takes on that role, but then you see him later in real life and he doesn't resemble that role. I think that goes on with me, too. Every time I do a movie, I try to *become* that movie. I immerse myself in research, so much that it soaks through me. The styles of the movies reflect that.

Can you describe what it feels like to go through that process?

It's very intense, and ultimately very painful. I've actually done some acting, but I'm not talking about that. I'm using acting as a metaphor. For me, filmmaking is like acting, in the way that it takes over you. It becomes part of you. The role, the lines, the personality of the character, it's all in you. It's in your dreams. You think about the character without meaning to, in your sleep. I compare the process to acting because of that quality of immersion, that attempt to internalize the material and become the story. If the attempt is successful, the result is a good or at least an interesting film. But once it's done, it's over, and the actor goes back to being himself.

When you interview me right after I've made a movie, you have no way of knowing it, but you're not just interviewing me. You're interviewing the residue of the last movie that consumed me.

One footnote I'd like to add to this conversation: I don't know that you really

Yes, I remember this vividly. Late 2015, you were ready to shoot *Snowden*, and suddenly you lost a lot of your major studio funding. You felt pretty secure about having that money, didn't you?

Of course we did! We wouldn't have gone out with the script if we didn't think we had a chance with them. They were all calling my agent and saying, *We have an appetite for* Snowden*! We want to do it. We're not scared of it! We love it, we want to make it, what's your number?* All of that starts. And then: lull.

At the end of the day, twenty-five people read it. They were trusted. And then, after they passed, we went to the independents, the people who are supposed to be the good guys! Nothing.

I just want to say that's very hurtful, because it's a continuation from my My Lai project, "Pinkville" [END 6], and a lot of fucking scripts, including the one I tried to do on Martin Luther King: It's just a fucking tough haul for me to have made it back.

I think the box office success of *World Trade Center* proved that we could make good movies that people would go to see. So I think the issue was subject matter.

Tell me why you think the *Snowden* film suddenly got the cold shoulder from the major studios.

I can only speculate, but the lull was across the board. *Snowden* was too controversial.

I like to photograph good-looking people. I always did.

You're in your sixties. The characters are in their twenties. But this is not what I call an "old man movie." You're not looking back at a youthful past. It feels like the storyteller is in the house with these three young people, like Oliver Stone is the invisible fourth roommate.

19 Fashionably "kewl" R-rated 2011 comic book–styled adventure, from director Zack Snyder and his cowriter Steve Shibuya.

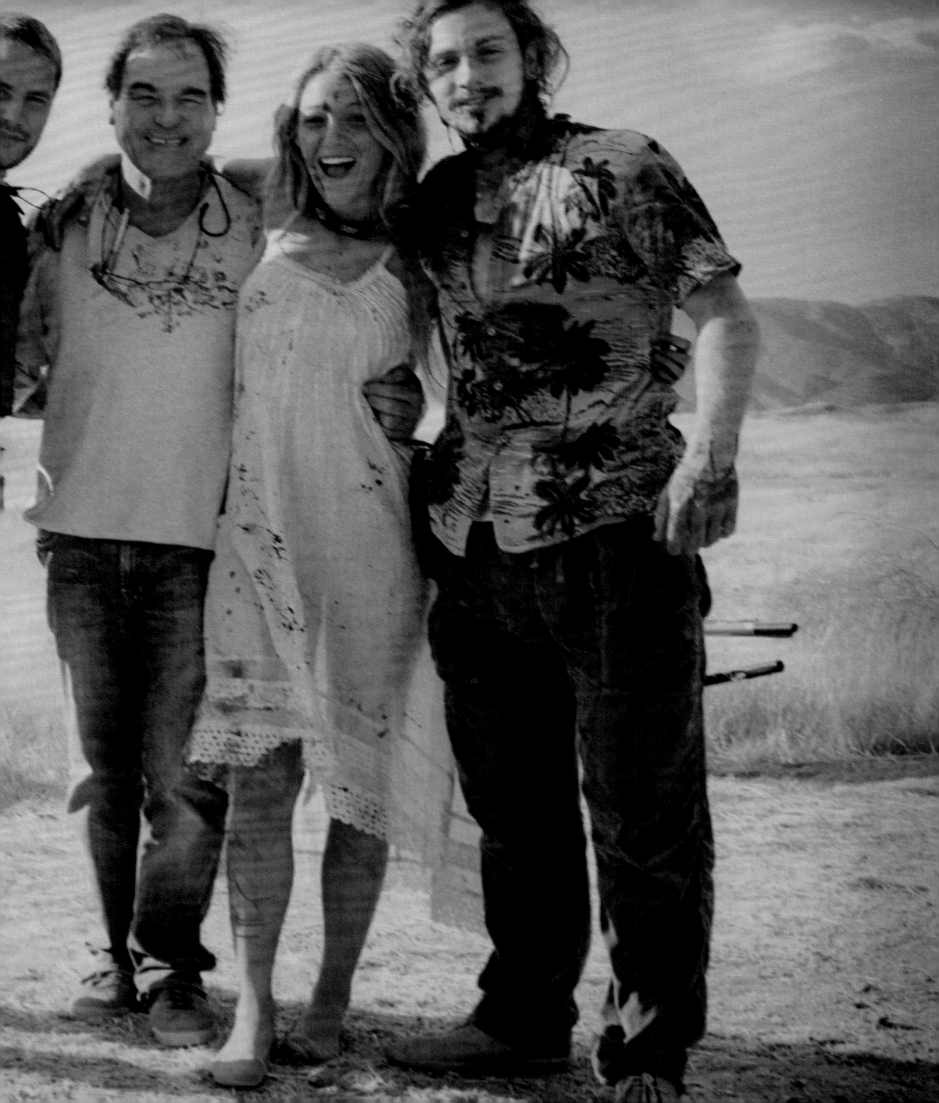

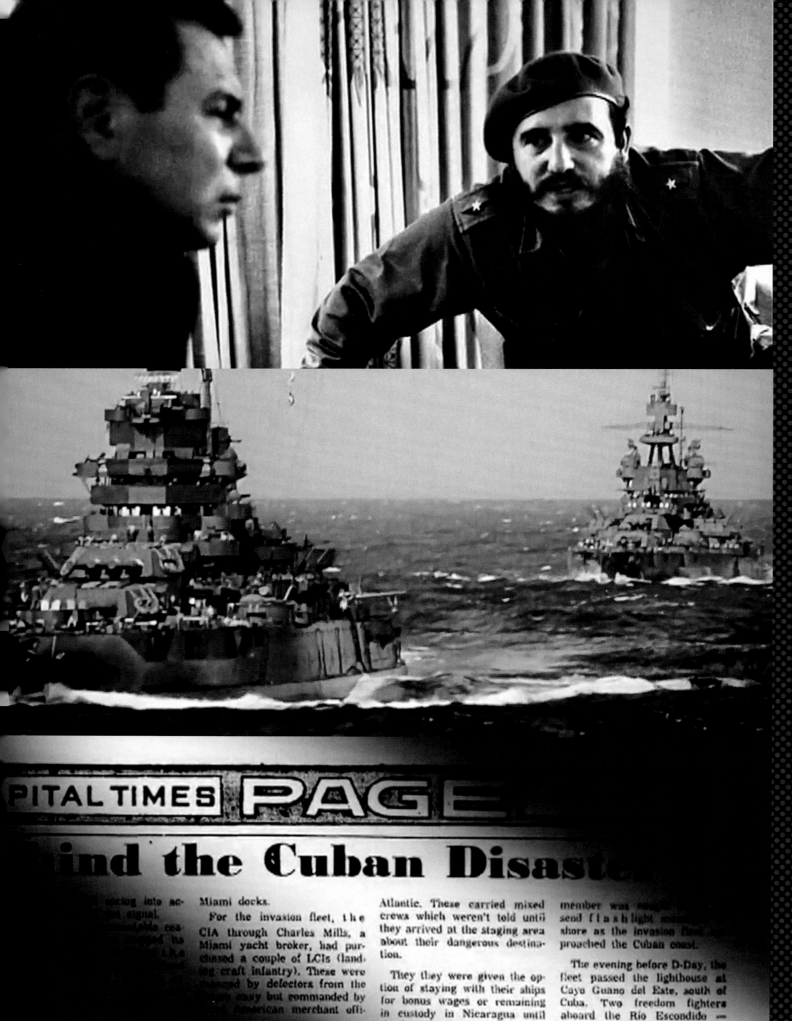

ind the Cuban Disaster

...soring into ac-
...e signal.
...dable rea-
...d to...

Miami docks.

For the invasion fleet, t h e
CIA through Charles Mills, a
Miami yacht broker, had pur-
chased a couple of LCIs (land-
ing craft infantry). These were
...nned by defectors from the
...navy but commanded by
...American merchant offi-

Atlantic. These carried mixed
crews which weren't told until
they arrived at the staging area
about their dangerous destina-
tion.

They they were given the op-
tion of staying with their ships
for bonus wages or remaining
in custody in Nicaragua until
the invasion was over. All ex-
cept a couple remained on
board.

For all the CIA's stress on
security, no one had bothered

member was caug...
send f l a s h l i g h t mess...
shore as the invasion fleet a...
proached the Cuban coast.

The evening before D-Day, the
fleet passed the lighthouse at
Cayo Guano del Este, south of
Cuba. Two freedom fighters
aboard the Río Escondido —
Garcia Batista and Avila Can-
cio—happened to be tuned to a
short-wave radio receiver.

Suddenly, from the light-
house, messages began to

Meanwhile they decided to do *Jobs*, a pro-American story.[20]

Something weird about my career is that it's more rejection than acceptance. It goes back to *Platoon* being rejected for ten years. It's about rejection. It takes its toll over time. It's not just one incident. It corrodes you. It's like salt water washing up over the years.

And yet in spite of it, I had a few instances where I just went through the eye of a needle. It's amazing that *Platoon*, which was a reject, a three-legged dog, got made for very little money in the Philippines, tattered clothes—I mean, everything was secondhand for us. Everything! The effects had to be secondhand! And it worked! I don't know. With *Snowden*, I had many of these same issues.

OK, I just wanted to let off that steam so you can understand how painful this all is.

Can we go back to one thing, though, just to clarify? Did any of the people at the studios who had originally been inclined to say yes to funding *Snowden* who suddenly turned around and said no explain to you why they suddenly said no?

They never come out and say it. You know the game. You never know why.

I know, but I want to hear you explain what that feels like, so people reading this book can understand it better.

Dino De Laurentiis, a pirate, said to me years ago: *It doesn't matter why. You'll never know.*

After all your successes, you're still stung by rejection, and you can still feel like a victim of preconceived notions.

Every film is different. People should judge the film by the film, and not what they know, or think they know, about the director.

What I'd like to do now is talk about your documentaries, including *South of the Border*, your three films about Fidel Castro, and *Persona Non Grata*, about the conflicts in the Mideast. And then maybe we can finish with your Showtime series *Untold History*. None of these documentaries endeared you to people who didn't like you or were on the fence about you. In fact they antagonized a lot of people—especially the stand-alone docs, because they were about political figures that the American media and the political mainstream were ambivalent or hostile about.

South of the Border, **which you wrote with Mark Weisbrot[21] and Tariq Ali,[22] profiles**

seven Latin American presidents in an attempt to humanize them and explain why the continent leaned left in the first decade of the twenty-first century. A lot of these guys are described in the United States as dictators or thugs, and at the heart of it all is Hugo Chávez of Venezuela,[23] who you say is described here as a "a strongman, a buffoon, or a clown." The Associated Press asked you why you didn't present the official American take on Chávez, and you said you "didn't see it necessary to present the opposition's case."

That's right.

Your three documentaries about the Cuban leader Fidel Castro[24] are also pretty much indifferent to the official American view of the man: *Comandante*, a fairly straightforward biographical portrait; *Looking for Fidel*, about the 2003 crackdown on dissidents in Cuba and the execution of three men who tried to hijack a US ferry; and *Castro in Winter*, more of an autumnal character sketch, from 2012. These are all basically sympathetic movies, even the middle one, where you show how ruthless Castro can be.

And then in *Persona Non Grata* you go and talk to Ehud Barak,[25] Benjamin Netanyahu,[26] and Shimon Peres,[27] about Israeli-Palestinian relations. That film is also pretty warm toward all of those people, even though some or all of them are considered the devil by certain factions in this country.

And you've gotten in a lot of trouble recently over your travels to Russia and your

statements about Russia, and how the country, and the culture there, has never been appreciated for the hit it took during World War II, and how a lot of what we describe as aggressive or invasive behavior comes from Russia's cultural memory of being invaded by France and Germany and fighting Japan.

This is maybe not what people want to hear in the United States when Russia's record

20 The life of Steve Jobs, cofounder of Apple, has been the subject of two films: an ill-received 2013 biopic starring Ashton Kutcher, directed by Joshua Michael Stern, and a 2015 feature directed by Danny Boyle and written by Aaron Sorkin, starring Michael Fassbender as the computer genius.

21 American economist, columnist, and codirector of the Center for Economic Policy Research in Washington, DC; critic of the International Monetary Fund, globalization, and the privatization of the US Social Security system.

22 1943– ; British Pakistani journalist and filmmaker; *Pakistan: Military Rule or People's Power* (1970), *Can Pakistan Survive? The Death of a State* (1991), *Pirates of the Caribbean: Axis of Hope* (2006), *Conversations with Edward Said* (2005).

23 1954–2013; president of Venezuela from 1999–2013.

24 1926– ; prime minister of Cuba, 1959–1976; president, 1976–2008.

25 1922– ; prime minster of Israel, 1999–2001.

26 1949– ; prime minister of Israel, 2009– .

27 1923– ; prime minister of Israel, 2007–2014.

441

on gay rights[28] and the treatment of dissidents [END 7] and Putin's political opponents[29] are all so wretched. But you keep saying it. And you devote a fair chunk of *Untold History* to showing viewers World War II through Soviet eyes. Why?

It's crazy, and I feel like I am screaming in the wilderness because I go out to a restaurant with you, or I go to a dinner party, and nobody is on this wavelength unless they've seen *Untold History*! They have no understanding of the situation! Unfortunately, they're on this other wave, which is like their received wisdom in the newspapers. And believe me, I follow the newspapers. I don't ignore them. They're painful when you read this steady stream of anti-Russian invective in this country. It's really scary! And I feel like there are other people who see this but . . . we're not getting through.

This sort of thing happened with many of your documentaries. After *Persona Non Grata*, you were attacked for meeting with Yasser Arafat.

You can't be allowed to meet him, you can't make a deal with Iran, you can't be allowed to negotiate, to be a diplomat! There's no statesmanship!

To say that your documentaries go against received American wisdom would be an under-

statement. You've made three basically sympathetic, or at least not hostile, movies about Fidel Castro. Three!

Yeah, sure.

I'm sure a lot of people in South Florida were not happy about that.

Not just South Florida, across the country!

"Oliver Stone and his pal Fidel Castro."

Yeah, and "Sean Penn and his friend Saddam Hussein," you know?[30]

But my question is why. Why do these documentaries? Why publicly stick up for leaders who are so troubling to so many in the US, and who are, in a lot of ways, to put it mildly, not what you would call nice guys?

I'm a dramatist/artist. I'm opening a dialogue. It's a dialogue. *Look at the man* is all I can say. The film is its own reward.

Looking for Fidel is the most hostile any journalist has ever been to Castro! Word for word! Look at it again, it's clear! Mike Wallace[31] wouldn't even have approached the degree to which I'm fucking questioning Castro. It's only because he liked me that he

It's crazy, and I feel like I am screaming in the wilderness.

didn't throw me out of the room. In fact, I remember him getting really irritated a few times, really getting on the edge of his temper. He's got a big temper, too!

28 Sexual activity between same-sex couples was decriminalized in Russia in 1993, but there have been few strides toward equality in the subsequent years. In 2013, a federal law criminalizing distribution of LGBT "propaganda" was enacted by Putin's government, which led to a surge of antigay hate crimes and violence.

29 The Russian opposition to Vladimir Putin's regime involves many parties, movements, and citizens. For example, the "white-ribbon opposition" is concerned primarily with fair elections.

30 Stone is referring to Sean Penn's three-day visit to Iraq in December 2002 on the eve of the buildup toward US invasion of that country, during which Penn visited children in a hospital, toured a water treatment facility bombed during the Gulf War, and visited Deputy Prime Minister Tariq Aziz.

31 1918–2012; Longtime correspondent for CBS's newsmagazine *60 Minutes*, nicknamed "the Torquemada of Television."

In *Persona Non Grata*, you're often playing devil's advocate no matter who you're talking to.

I liked Shimon Peres, I have to be honest, because I'd already met him, and I didn't go hard on him. And Netanyahu was—he's got his rap, you know? It's a very funny interview because a bomb goes off during it. *(Laughs)*

But I really want to get an answer to this pretty basic question.

Sure.

Why did you do them? I mean, given that you're constantly being criticized for being self-aggrandizing, for thinking you're a politician, for distorting facts, for selling fiction as fact? Given that the first question out of a lot of people's mouths when you do or say anything is, *Who is Oliver Stone to tell us what he thinks about this or that issue?* You go and make these documentaries where you're meeting with Chavez and Castro, and going into the Middle East and talking to Palestinians and Jews who are killing each other—you are just asking for trouble, aren't you?

Who wouldn't want to talk to a guy like that?

I had curiosity. Curiosity maybe kills the cat, but curiosity—I have a wonder about the world. I still have it. I read history, I read freely, I love knowing more about the way the world works, power and so forth, and I guess in my novice way, I wanted to stumble out there, see those people, and have a relationship.

So, simple curiosity? There are times in these documentaries where Oliver Stone, who's had such a contentious relationship with journalists, seems like a journalist himself.

More of a dramatist—but a journalist? A bit. Yes. I got things out of Castro that probably weren't heard before.

What did you tell all of your subjects when you were interviewing them? About your intentions?

I said, *I'm not here as a journalist. I'm here to make this exciting documentary about your life so people can see who you are. I'm going to say cut, and you're going to say cut, so we can both be happy. It's going to be fun, you know?* I didn't sell it to Castro as an interview, because he hates interviews and does them reluctantly.

What was he like as a personality?

Great! Charming! Everybody waits months to see him, he saw us after two days sitting there.

We got a night dinner, he came in at 11:00, we had dinner till about 4:00 A.M. And we had a charming conversation.

He went through the worst of the dragon. The dragon's breath swept over this tiny island, which you realize is only ninety miles away from the United States! You realize how dangerous this was? How much aggression was directed at Castro from us? How could he withstand it? Every South American country had fallen from 1900 on. Every single one—Chavez's even, to some degree. No, I think Chavez made it, although he died under what seem to me like rather suspicious circumstances. He was diagnosed with cancer in 2011 and the cancer was very wicked and very quick. He died two years later. I wouldn't put murder beyond the range of explanations, I wouldn't really, because the US hated Chavez so much.

Castro has survived. Eisenhower put out the hit on him, in late '59. "Get rid of him." That was the old John Foster Dulles line—he wanted to get rid of Castro before he died, but Allen Dulles went after him. It was, *Get rid of him in any way possible.* That's when [Allen] Dulles started not only economic strangulation, but basically sending in spies and everything he could, blowing up factories, water stations, and he also made assassination attempts! That's fucking crazy! They say he survived fifty attempts, maybe more! There were real attempts made on his life, but the guy survived! It's an amazing story unto itself, no?

It is.

Who wouldn't want to talk to a guy like that? Fidel is a huge man, he's got big energy, another energy. He's six feet two, or he used to be. He's a real figure, he's an army soldier. He has tremendous knowledge of the world, he reads all the time, he thinks. He's great on camera, isn't he?

He always was, going back to the fifties and sixties.

Even Errol Morris, in the celebrated documentary [*The Fog of War*], doesn't recognize the aggression that was directed at Cuba! It wasn't directed from them toward us, it was by us toward Cuba, but it's always presented as an equation that's equal now. The truth is, we started this thing, we were very aggressive, we became very defensive and suspicious about Cuba, and they fought back their way. Remember that they're a mouse sitting next to an elephant.

So when it comes to the official US line on Cuban history, you're saying up is down, black is white?

Yeah.

That's *Untold History*, too. Though at ten hours, you're turning black to white in a much more sustained way.

It's my best work, in a way! It's a compilation work.

You seem to be working out your worldview in that series, a worldview that has been in development throughout your life.

You got it. I mean, there's no better record of my existence, perhaps.

It does feel in some ways like a culmination. And it feels very intimate.

Because of the voice-over?

Yeah, partly. Oliver Stone is literally the storyteller here. That's your voice we hear on the soundtrack, narrating in a very calm, even tone. You're not talking loudly, you're talking softly. Someone asked me, when it hadn't aired yet, *What is it like?* And I said, *I don't know how to describe it, except I feel it's the closest I'll ever come to being inside Oliver Stone's mind.* That's how personal it felt. It's very stripped down, visually. There's no actors, no talking heads. It's a continuous montage, plus you talking.

Well, that's not exactly true. There are actors—vocal only, playing Churchill and Roosevelt and people like that. Voicing historical texts and reading parts of speeches where we couldn't find recordings of the actual people, stuff like that. And of course the movie clips we put in there have actors in them. Those bits are very important, for a couple of reasons—first, because they give you a break from the rest of it, and second, they tell you a lot about history, not just the history presented in that movie, but the consensus in this country about the subject of the movie at the time it was released. Sometimes a minute of a movie can do a lot of work that way. It isn't just about giving facts—getting the facts right is very important, obviously—but it's also about giving audiences the mood of the time. Like when we cut to Gregory Peck in *Twelve O'Clock High*, we're showing that this is a Curtis LeMay figure [END 8].

LeMay was the partial inspiration for General Jack D. Ripper in *Dr. Strangelove*, wasn't he?

That's right. That *Twelve O'Clock High* clip communicates that this is the mentality of certain people, a mentality that continued after the war, and then the culture absorbed it, responded to it, and maybe forgot about it.

Is that what this series is about, more often than not: these recurring patterns? The same things happen over and over, the same stories are successfully sold to the public, the same justifications are given for actions, over and over?

I'm not any less interested in history because the patterns have been clearly established. I want to know: Why is there an inability to reflect on oneself? Why is there no looking in the mirror? Why, when we talk about ISIS so easily and superficially, why don't we ever see that this grew out of our meddling in Iraq, creating a class of disaffected soldiers and Sunni officers removed from the Ba'ath Party? Don't they see that? Why can't they see this grew out of a ridiculous suggestion that grew out of the neocons, and [the al-Qaeda figurehead] Bin Laden, and how Bin Laden was forged in Afghanistan in the '80s, when we were arming the rebels to fight the Soviet occupation, and how his animosity came out of our putting troops in Saudi Arabia and Kuwait during the first Gulf War in 1990 and '91? And how the kind of anger Bin Laden harnessed grew out of our policy, in general, of meddling in the Middle East?

The thing that was most striking to me about the entire series is how consistent you are in identifying what you believe are the sources of these actions by different countries, by different historical forces. What you do is you explain the ideology behind the decision, or the ideological confrontations that are going on, such as the Cold War. And then you attempt to explain why these things really might've happened, and it often comes down to money, resources, seizing and holding land, or defending borders.

This is kind of like what you said you wanted to do in *JFK*: create a countermyth to go against the verdict of the Warren Commission, which

you believed was essentially a myth. In *Untold History* you've created a whole lot of counter-myths, to go against a lot of established narratives, a lot of received wisdom: The US believes in freedom and equality. If it wasn't for the Yanks landing at Normandy, everyone in Europe would be speaking German now. We never intervene in other countries' affairs unless it's for noble

There's no better record of my experience.

reasons. The Soviets were the villains during the Cold War and we were the good guys. The Vietnam War was a noble cause in the abstract, but the execution was poor, and we weren't allowed to win it. And so on. You and Peter Kuznick, your main cowriter, seem to take great delight in setting these ideas up and then kicking them over.

And I feel like these recurring patterns that you explore in the documentary somehow tie back into karma. You're describing a series of endlessly reliving the same mistakes.

It's over. We can't come out of it! The crazy, power-mad person always wins! The guy who's more dramatic and says, *It stinks, let's take down the government.* The McCarthy figures always sort of dominate. John McCain[32] is insane extreme. In Russia, they say, *What is wrong with John McCain?* They don't understand why he hates Russia so much.

Do you really think we're more aggressive historically as a country than, say, Russia or Turkey?

No, no, no! Russia doesn't have that history! Yes, sometimes on its borderlands, but no!

Another thing about the Soviet thing: After World War II, they invaded those lands. They destroyed the Nazi empire. They chose—because Roosevelt and Churchill very much wanted it—to go past their borders. After Stalingrad and Kursk, once they pushed the

32 1936– ; senior US senator from Arizona; 2008 Republican presidential candidate; in 2015, reacted to Russian airstrikes on Syria by calling Vladimir Putin "a rogue dictator" and warning, "What we should be saying to Vladimir Putin is that you fly, but we fly anywhere we want to, when and how we want to, and you'd better stay out of the way."

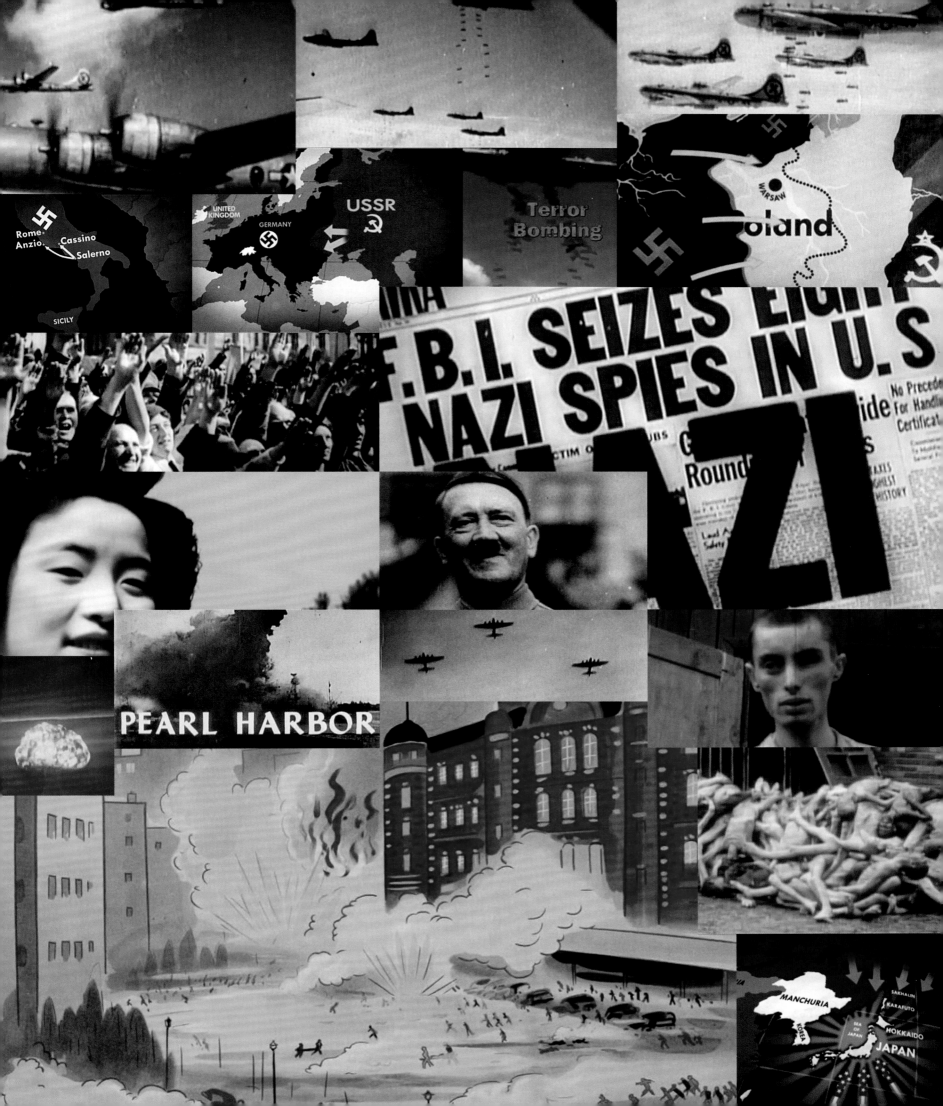

Nazis out of the USSR, back past their borders in 1944, they didn't have to go on. We, the Allies, wanted them to roll up the rest of the German war machine. Which they did. It probably saved us about a million soldiers' lives.

It was amazing what happened in Moscow. By early '43—that's when Stalingrad closes, when they win in January—that starts to change. You see it in the newspapers, Stalin's on the cover of *Life* magazine and *Time* and all that. He was *Time*'s Man of the Year twice, in 1939 and 1942!

Not necessarily, but when you said the phrase just now, it occurred to me that you and Kuznick seem to be mainly talking about history in terms of practical decisions: how to defend your borders, land, and resources, preserve your historical identity, and things like that. When you look at history through a moral or ideological prism, you may not see any of that.

This is what we never recognize. And Gorbachev, who many of us love, who's a personal hero, Gorbachev said this same thing

But why can't we discuss that possibility, I wonder? Why can't we discuss history in terms of, *They want this land, we want this resource?*

Because it takes away from the veneer of self-righteous American exceptionalism, and the veneer of doing this or that because of human rights, or on behalf of other people.

The craze for superheroes is an outgrowth of our John Wayne mentality. What the hell is Batman about? Without Batman, the law of society breaks down, so Batman is the superhero. He's a dictator, essentially, here to resolve the quagmire. It's the strongman theory of solving problems. There's something fucked up about all this superhero bullshit. You have to understand, superheroes are fascist. Marvel Comics creates heroes to save the world because we can do nothing. There's an element of the masked guy who comes down and saves the world from the bad guys, and the bad guys of course are undefined, always evil, evil guys. Why are they evil? We never know, they're just out there. They want to destroy cities. They're seen, but they're a terrorist threat, essentially. Cumulatively, the nineties were more interesting for me because of films like *JFK* and *Enemy of the State*, because the enemy wasn't so clear, except in Tom Clancy's world.[34] The superhero craze comes out of 9/11. Bush came in riding on his white horse all of a sudden, saying, *I'm going to save you, and as a Christian, I'm going to crusade against bad guys all over the world.* This is superhero talk. Bush told us, *They're out there and we're going to get them. Doesn't matter if they're in Afghanistan. We're going to get them in sixty fucking countries, including Iraq! Which, in my super fable, contributed to 9/11— and I am here to kick their ass!* That's what he kept selling: *I don't give a shit what international lawyers say, I don't give a shit about anything, I'm going to kick their ass.* That's

The craze for superheroes is an outgrowth of our John Wayne mentality. What the hell is Batman about?

It seems to me that what you're doing in that part of the series is explaining Russia's role in World War II in terms of a soldier. When I watch the World War II section about the Soviet Union, it doesn't sound to me like you're saying, *Stalin was a lovely, sweet man, and all the people who worked for him are wonderful people.* You're giving a different view of the war, maybe closer to how the Russian people see it, and explaining the motives of the USSR in a more basic way than Americans are used to hearing, and it probably all sounds cold or insensitive or contrarian to a lot of them.

Stalin was corrupt. His was a horrible government, he was a paranoid dictator—people were going to death camps and slave labor. But he had the respect of the people, and Roosevelt said: *We can do business with him.*

You're trying to explain why you think things happened, but without judging the morality or immorality of the participants?

Right. And that's our problem. The American conservative movement constantly talks about morality. They use it as a weapon to achieve their objectives, as opposed to recognizing the way the world works.

How does the world work?

You know: You have to do business.

This series could have been called *The Way the World Works*, actually.

You prefer that?

about respect in so many words, in his 1991 Nobel peace prize address: *Respect the Russian way.*[33]

By the way, joining these nutcases on the right, and they are nutcases, is the liberal interventionist movement for human rights, which is: *Oh, we have to go in and rectify this situation in the name of democracy!* Human rights are a very subjective thing, and they use it against Castro, against anybody who's designated as an enemy.

You think the human rights concerns of activists in the US are applied unequally to other countries?

They are always applied unequally.

It's like you and Kuznick are knocking down all these bits of received wisdom, often in ways that seem calculated to make the people who are invested in that wisdom angry.

You've also got all these details in here about oil. At one point you talk about the battle between Russia, Britain, and the US, struggling to control oil reserves after World War II, and how this plays into foreign policy decisions after the war. This talk of resources comes into play again in the fifties and sixties, when you're talking about Vietnam, and Asia, and the West's intervention in Asia. These incidents, you and Kuznick tell us, are also very often about resources: bamboo, rubber, oil. Resources, resources, resources.

When we mention resources in relation to history in this country, Americans say you're being cynical: *Ah, whaddaya mean the first Gulf War was a war about oil?*

33 "All members of the world community should resolutely discard old stereotypes and motivations nurtured by the Cold War, and give up the habit of seeking each other's weak spots and exploiting them in their own interests. We have to respect the peculiarities and differences which will always exist, even when human rights and freedoms are observed throughout the world." Then-president of the USSR, Mikhail Gorbachev, 1991.

34 The longtime conservative and Republican Clancy was a novelist best known for espionage thrillers, such as *The Hunt for Red October* (1984), *Patriot Games* (1987), and *Clear and Present Danger* (1989), many of which were turned into successful feature films and even video games.

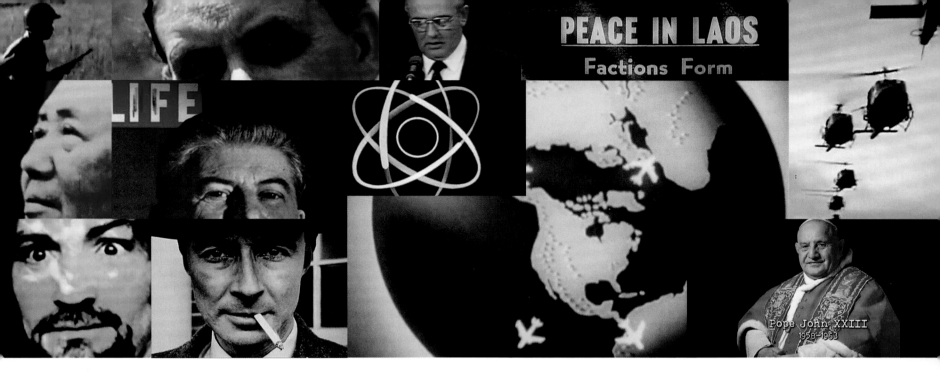

what he was saying. And on top of it, *I'm going to build a superstructure at home, which we'll call Homeland Security.* I hate that phrase. It sounds German to me! And we're going to build up this Homeland Security at fifty fucking billion a year, with all these contractors and everything. A few trillion dollars will go out every year into our "security" because we need it. Against who? It's the old Nazi thing. The Nazis were insanely paranoid against the Jews, gays, everybody, about the pure blood being stained, about immigration, and too much of the Slavic folk destroying the pure Aryan strain.

Do you see a temperamental similarity between the Germans and us?

Total.

How so?

I'm not going to get into that because Americans always get shocked, like, *How can you say that? We took the lessons! We were the victors.*

Why not? We've come this far.

As the famous pacifist, I forget his name, said, the problem with war is not the defeated, it's the victors, who believe they won because they are better, or more right. They haven't learned the lessons of war, which is devastating for everybody. We hired every fucking Nazi who would work against the Soviets, because they were good at it. The Nazis almost won World War II, they were on the Russian front, so they knew everything about the Russians.

But we're the good guys, right?

We're *not* the good guys. We are in the sense that we're white, we have briefcases, we can go into countries and talk about money. The only

war that was justified, in my view, was World War II, and we should've gotten into it sooner.

It's all just intervention. It's [President William] McKinley going back to the Philippines saying, "We've got to do this to protect our little brown brothers" [END 9]. People don't like to be pushed around. They don't want to be bullied, they don't want the US to call the shots or be the world's policeman. It's ideological, but it's also financial. It's the World Bank and the strangulation of these countries, putting countries in horrible debt sometimes, and never letting them get out because a bank never wants you to never get out of debt. They want you to be paying forever, like you pay the fucking cable company! I'm a slave of a monopoly of two or three companies controlling the Internet, cell phones, and the power! And we pay them and pay them and pay them!

We've been colonized by our own government. They feed us the TV, they feed us the power, the energy, the water, and they charge us, and we pay. Now we watch idiot TV shows with no real content, shows without anything that might really upset the status quo, stuff that's all easy to digest. And you have nice critics like you writing good stuff about shows that are innocuous. I'm not saying that's your fault, but we've created a false, artificial society where real criticism is dissuaded. Phil Donahue is taken off the air,[35] Oliver Stone is marginalized, Noam Chomsky[36] can't get a fucking forum except in limited lectures on university campuses. How do we get out of the strangulation we're in? We're controlled by the media—the perception of events—Wall Street,

military-industrial, and government. Those four factors control everything in this country! You see the power of the state coming in to crush our own people.

I want to warn people about the way we're behaving, the way we're intervening in the world, trying to run it. What could be clearer? We're willing to go to war, to topple governments, to use regime change. We use propaganda, then we brainwash our own people not to be aware of this. What more do you want?

We're *not* the good guys.

In 2013, Edward Snowden[37] copied classified information on global surveillance programs, conducted by the National Security Adminis-

35 Donahue is the creator and host of *The Phil Donahue Show* (1967–96), the first talk show to include audience participation. Donahue's follow-up program, a talk show on US cable network MSNBC, was canceled in February 2003, weeks before the US invasion of Iraq. Donahue had been a relentless critic of the Bush administration. An internal memo leaked to the press revealed that the channel's executives were worried that Donahue would be a "difficult public face for NBC in a time of war." MSNBC is a joint venture of Microsoft and NBC, which at the time was owned by General Electric.

36 1928– ; political activist, linguist, historian, and social critic, in an anarcho-syndicalist and libertarian socialist vein. Developed the "propaganda model" to explain how recieved wisdom and official narratives are propagated through mass media.

37 1981– ; former CIA employee and US government contractor, specializing in computer security and surveillance.

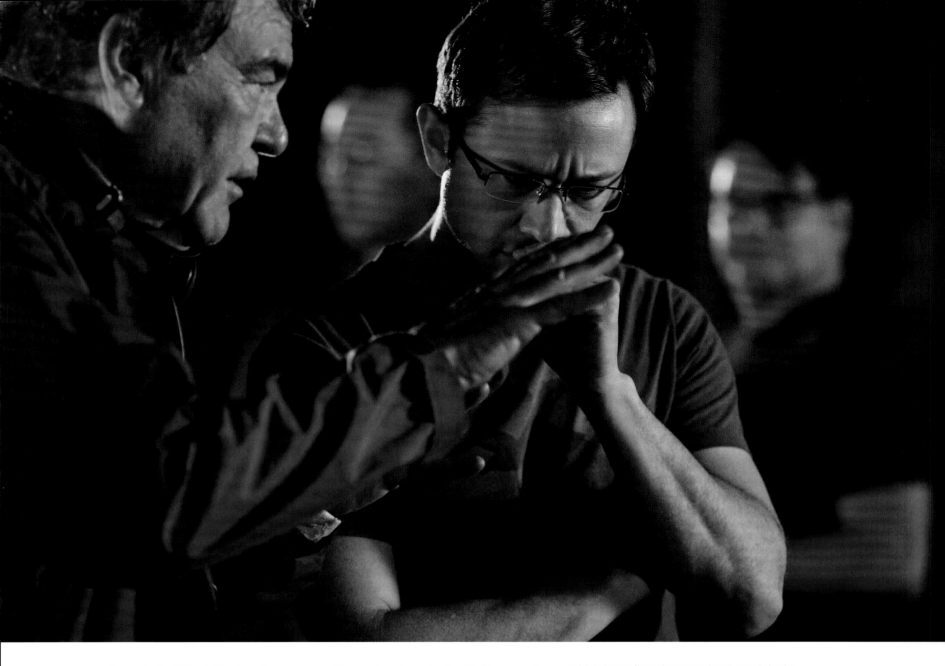

tration and the United Kingdom Government Communications Headquarters, with cooperation from private telecommunications companies. Then he flew to Hong Kong and told his story to the journalists Glenn Greenwald,[38] Laura Poitras,[39] and Ewen McAskill,[40] and the details were published in a series of reports in *The Guardian* of London. What did you think about Snowden's actions, as a detached observer?

I was totally for them. You know, I stated as much, I went public in support of Ed, I was one of his early supporters.

But when I did the movie, I consciously said to myself, *I've got to be careful here. This is going to be misunderstood*. And it will be! But I am doing this movie as a dramatist, not from my citizen side. I've outlined those differences for you. As a dramatist, I walk in the shoes of a person. This is George Bush, Richard Nixon, it's Ron Kovic, Le Ly Hayslip. With Bush, even though my personal feelings about his presidency were negative, I made an empathetic portrait.

How much of the script for this film comes from your own conversations with Snowden in Moscow, where he's been a guest of the Russian government since leaving Hong Kong?

I can't say.

How did your contact with Snowden come about, and what was it like spending time with him?

I was in China and got a call from Germany from Moritz Borman,[41] who produced *Alexander*. I was not working with him at that time. Moritz said, *Look, I know this Russian lawyer, Anatoly Kucherena. He called a friend of mine, a producer friend in Paris, and said he'd like to contact Oliver Stone*. I said, *Go to CAA*, but they insisted, and he was calling me, this lawyer, and he said he'd like to meet me in Moscow. He said he was a lawyer for Snowden. Anatoly's a wonderfully charming man. Bit of a bluffer—he's a lawyer. ▆▆▆▆▆▆▆▆▆▆▆▆▆▆▆▆▆ ▆▆▆▆▆▆▆▆▆▆▆▆▆▆▆▆▆▆

▆▆▆▆▆▆▆▆▆▆▆▆▆▆▆▆▆▆ ▆▆▆▆▆▆▆▆▆▆▆▆.[42] A contract finally was made between us and Anatoly to buy his book.

38 1967– ; former litigation attorney turned investigative journalist; columnist for Salon.com, *The Guardian*, and *The Intercept*; author of *How Would a Patriot Act? Defending American Values from a President Run Amok* (2006), *A Tragic Legacy* (2007), and *With Liberty and Justice for Some: How the Law Is Used to Destroy Equality and Protect the Powerful* (2011); critic of US expansionism, surveillance, and curtailment of civil liberties.

39 1964– ; documentary filmmaker; *My Country, My Country* (2007), about Iraqis under US occupation, and *Citizen Four*, coproduced with Glenn Greenwald, about Edward Snowden.

40 1952– ; defense and intelligence correspondent for *The Guardian*.

41 See footnote 9, page 381.

42 Redacted.

(opposite) Set photo: Oliver Stone directs Joseph Gordon-Levitt's performance as the title character of *Snowden* (2016).

(below) Production photo from *Snowden*: Snowden calls in from Russia to participate in a London interview justifying his decision to leak classified material.

Anatoly Kucherena's book is *Time of the Octopus*, right? And it's about Edward Snowden?

Well, sort of. There was a lot of good stuff in the book about Ed, but I didn't realize the degree to which it became a Dostoevsky-like confession between a lawyer and Ed, whose name had been changed to Joshua Cold. And there were flashbacks to Ed's life as imagined by Anatoly. Now, a lot of it is very fanciful, but some of it is accurate to some degree. My cowriter Kieran Fitzgerald[43] and I didn't know at that point, frankly, without having learned the real story, if we were going to do the movie as fictional or factual. It could easily have been a changed name.

In other words, you could have just told the story of an Edward Snowden-*like* figure.

Yeah, yeah. And probably would have been the easier way out, given all the difficulties. See, I had been through the Martin Luther King thing, and I didn't want to go through this again.[44]

The King film fell apart because the King estate owned the copyright on all of King's speeches, which means that basically they had approval over any biography that wanted to use the speeches—

That told me to stay away from real-life figures. They're fucking dangerous.

and they didn't like the way you were handling the stuff about his love life, the FBI wiretapping, and other aspects.

Yeah. That told me to stay away from real-life figures. They're fucking dangerous; they blow up in your face. If anybody's going to blow up, it's Snowden, so I didn't want to get burned again. I was reluctant.

But Moritz convinced me that this was a story worth doing, and we went back to Moscow and saw Ed several times. ▮▮▮▮▮ ▮▮▮▮▮▮▮▮▮▮▮▮▮▮▮▮▮▮▮▮▮▮▮▮ ▮▮▮▮▮▮▮▮▮▮▮▮▮▮▮▮▮▮▮▮▮▮▮▮ ▮▮▮▮▮▮▮▮▮▮▮▮▮▮▮▮▮▮▮▮▮▮▮▮ ▮▮▮▮▮▮▮▮▮▮▮▮▮▮▮▮▮▮▮▮▮▮▮▮ ▮▮▮▮▮▮▮▮▮▮▮▮▮▮▮▮▮▮▮▮.[45]

Several months later, Kieran and I were still changing the script madly all through January 2015, and we didn't know if the financing was in place. It was horrible—a big step forward, but it was still not there. We started shooting February 16 or 17 and the bank loan had closed a few days earlier. The errors and omissions,[46] which was crucial for a movie like this, was signed right before then, and it had to come from a smaller company in Australia willing to underwrite it. We couldn't go the normal routes, because we're not a studio film.

The big setback had been October–November [of 2014], when our draft was rejected by all the studios.[47]

These corporate boards wanted nothing to do with a Snowden picture.

43 American screenwriter and documentary filmmaker; *The Ballad of Esequiel Hernandez* (2007), *The Homesman* (2014).

44 See chapter 7, page 365.

45 Redacted.

46 A form of insurance that, in the film and TV business, indemnifies producers against lawsuits alleging infringement or defamation of copyright or trademark, libel or slander, invasion of privacy, and plagiarism.

47 See page 437.

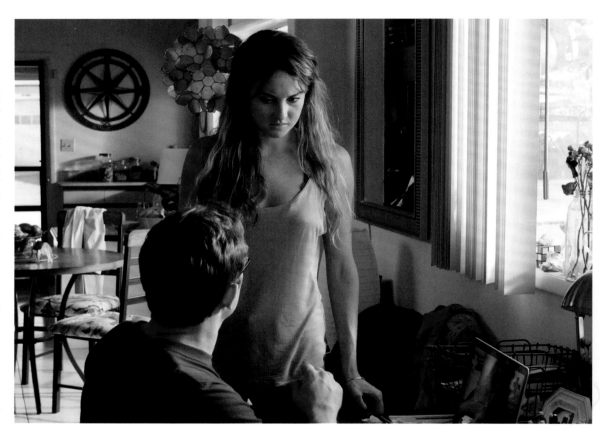

What were they afraid of, do you think? What some people call a "ripple effect"—where the entertainment companies aren't afraid of the NSA per se, but they are afraid that if they do something that criticizes the NSA, the next year they'll find themselves audited? Or some tax loophole that used to be open for them will suddenly be closed? Or they'll be seeking approval for some merger and they won't get it? Stuff like that?

I think it's self-censorship. Where you do something and corporate life follows . . . like they did with Snowden and all these telecommunications companies that signed onto the government's surveillance programs. Why did all those companies let the government tap them? Again, fear, right? Just plain fucking fear!

The NSA—oh my God, that mystique about the NSA still exists. I think it scared people, like, "We can't do anything about it." [Bill Gates's] company [Microsoft] signed on to the wiretaps early. Apple, I think, resisted for a while—that was when [Steve] Jobs was still there. I know a couple others resisted, too—Yahoo did. But they all gave in because of conformity. Everybody gives in. That's the problem.[48] Everybody turned us down except one independent company—thank God, or we wouldn't have made the film.[49]

Do you understand what I'm saying? It's pretty shitty. This is a guy who's a whistle-blower, he broke the law—the law currently, I should say. But we've made films about criminals since the beginning of Hollywood. So what is it about this particular "criminal" that makes him worse than John Dillinger?[50] I'm just asking you.

You really want my answer to that?

Yeah.

Because Ed Snowden went against the Beast.

Aha! You're using my terminology.

That's what this Snowden movie is about. It represents a logical continuation of one of your major themes. You've talked many times about the Beast with me, and it's a phrase that occurs in *Nixon*, and it's a theme throughout your work—this idea of the military-industrial complex, as seen not just in fiction films like *JFK* and *Nixon* but also *Untold History*.

The fear of Communism and the Cold War were the results of domestic selfishness,

I think it's self-censorship.

the desire to make more money, and keep the corporate control of the world, which today has grown into this monstrosity. It's no longer military-industrial, it's military-capitalist-corporate.

Interesting. There's a phrase in the *Snowden* screenplay, spoken by one of Snowden's mentors, a character played by Nicolas Cage: "Military-industrial-happiness management."

Yes! That line is very well done by Cage.

Throughout your work—and we're talking three-plus decades of directing here—often you present the true patriot as the person who is willing to go against the government.

Yeah, well, that's certainly true. It's reached *Alice in Wonderland* proportions. Snowden can't get a fair trial—he's a whistle-blower, he's not a spy. He's not in an espionage unit. And if you're in his situation and you let yourself be tried, often you don't know why you're being charged or the secret evidence against you, and you can't defend against the charges, because certain witnesses cannot appear.

Now you're talking about the secret courts that are discussed in the movie—the Foreign Intelligence Surveillance Courts.

Yes, and things like that.

48 According to an October 30, 2013, *Washington Post* story, based on information gleaned from Snowden's data, the NSA secretly broke "into the main communications links that connect Yahoo and Google's data centers around the world. . . . By tapping these links, the agency has positioned itself to collect at will from hundreds of millions of user accounts." The NSA and the Government Communications Headquarters (GCHQ) also copied "entire data flows across fiber optic cables that carry information along the data centers" of Silicon Valley tech companies.

49 *Snowden* was ultimately funded by Open Road, an entertainment company launched by theatrical exhibition giants AMC Theatres and Regal Entertainment Group.

50 1903–1934; Depression-era bank robber whose bloody crime spree was the pretext for the creation of the Federal Bureau of Investigation as we now know it.

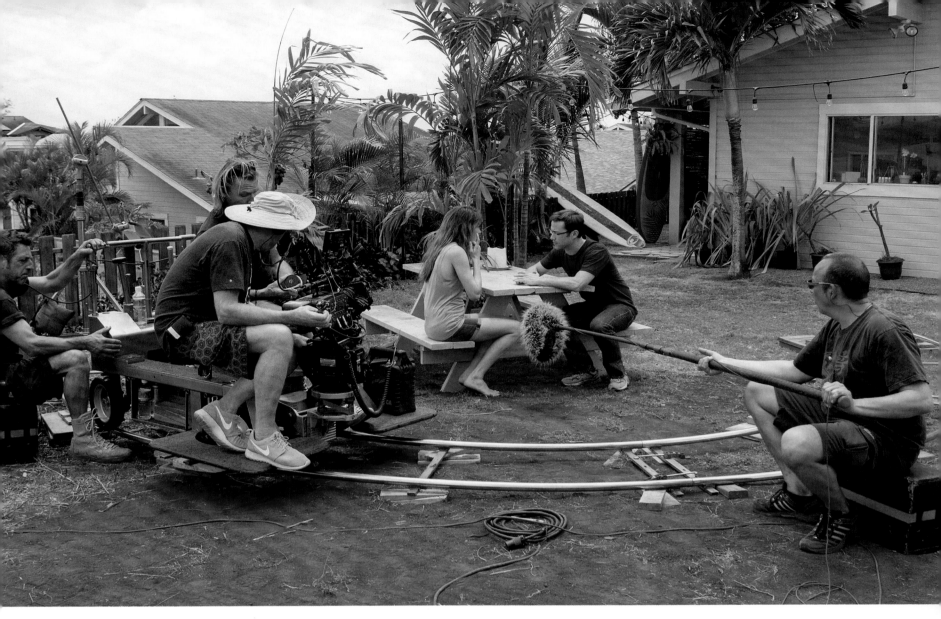

They can issue FISA warrants, in one of these FISC hearings, which are closed to the public and almost totally secret, so the press and the public can't even know that a request to put somebody under surveillance even took place, much less the reason for the request.[51]

Well, that's sometimes true in regular courts, too: If the government slaps "national security" on the case, you're automatically denied certain rights as to who you can interview and what you can say in court. That's a mockery of our justice system, saying anything you want to keep secret has to be kept secret because it's a matter of national security. National security has been completely distorted. What Snowden said very eloquently, far better than I could, was that "national security" as it's defined by the government is not so much about terrorism, it's about economic and social control.

Terrorism is a misnomer for a few single individuals who don't amount to much of a threat at all, and in the name of fighting terrorism, fighting the phantom enemies, like Russia, Noriega, Grenada, Saddam Hussein.

It's crazy that we've allowed ourselves to be so mythologized and distorted that we believe people like Ed Snowden are truly dangerous to a great country.

I think Ed is an icon. He became an icon. But I don't think I treated him like that in the movie. I think I treated him as a guy struggling with a lot of fucking problems, with a girlfriend, and this and that, and life. Is Ed going to take on his bosses? These are important men, these are powerful men, and he's only thirty years old. What the fuck? You don't declare your conscience at thirty! You've got to have something else on your mind and heart. You've got to be really a patriot, which I'd argue is what Ron Kovic and Edward Snowden are, you know?

What was Edward Snowden like, personally?

I found him very reserved, very articulate, extremely intelligent. I found him to have a sense of humor. And although he hadn't seen many movies, he could imagine things that the dramatist would imagine. He had the dramatist's ability of looking at things. But he was very accurate about his own world, and very

detailed and articulate. Very extraordinary for a young man. At the same time I don't find him to be forbidding. I know people who are intelligent who can be very forbidding, but he was certainly very open.

Almost all the time it was at the offices of his lawyer, in various rooms, and in the dacha owned by the lawyer. Never saw his security, although I know he had some, since it took time to get there, and never outside those [circumstances]. I would've loved to have gone to a restaurant with him, and I'm sure he could've, but I think he didn't want to be spotted in Moscow. I met his girlfriend, Lindsay Mills, there and then I met her on the set the day you were there.

You shot mostly in Germany?

51 Created in 1978, the Foreign Intelligence Surveillance Court was created to handle requests for wiretaps (mainly by the NSA and FBI) on people believed to be spying for other countries. Its records and procedures are secret, it meets at all hours of the day and night, and only government attorneys are allowed to appear before it.

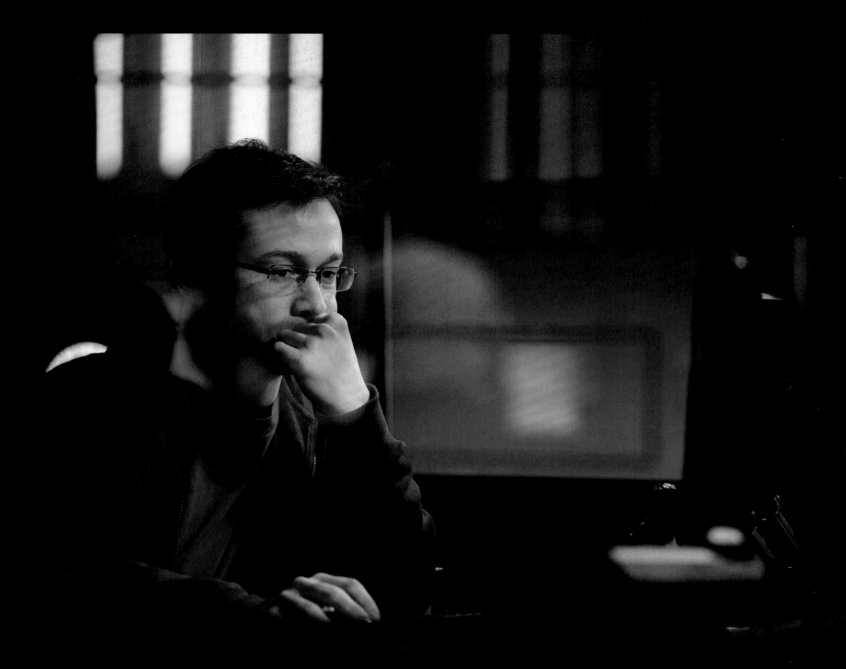

In Munich, because Moritz is German. Great crew, efficient, English-speaking. Wonderful town, easy to work in. We had a great subsidy deal with Bavaria, which is the state it's in. It originally started because I think Moritz was, justifiably, paranoid. We didn't know where this was going. We know now because it's safer, but we didn't know if this was going to get made. We didn't feel comfortable being on American soil to do this. Who knows the tentacles of the National Security State? Who knows? Honestly we don't know, it's a mystery. We just seemed safer, not to risk everything here. We did take a chance by leaving Germany because of the shooting schedule.

We left in the middle of the film to go back around the world because Shailene Woodley, who plays Lindsay, was leaving to shoot *Allegiant*, one of the movies in the *Divergent* series.**52** We went to DC to shoot her out one week, and then we went and did one week in Hawaii to get her done. And then we moved on to Hong Kong for a week—we got the permission of the Mira hotel**53** at the last second—then went back to Germany to finish the film. So that's two US weeks, but that's not the same as shooting an entire film and having your offices in the US.

Why Germany? Just because your producer was from there?

We felt Germany was more neutral as a US satellite basically, it had a more open attitude about Snowden, and a deep hatred for the surveillance state from the Cold War days. Thus they were more favorable to the film.

But, I have to say, all the German sponsors with American headquarters, like BMW, pulled out of the film, which normally would've been available if you shoot in Germany. ██████████████ ████████████████████'s who were not there for us in the end. Costrix wesprtox wseprsixs' wenox hod ts bx zhosgrd.**54**

It's a strange environment to work in, because I don't think they were told by the government not to work with us; I think their reluctance goes back to self-censorship, which, again, goes back to the McCarthy era.

52 Film series based on the young adult fiction trilogy by Veronica Roth, starring Woodley as Beatrice "Trice" Prior as a woman resisting a dystopian future world's division of the population into groups based on personality type.

53 The Mira Hotel Hong Kong is where Snowden is believed to have stayed in 2013 while leaking classified files to journalists.

54 Redacted.

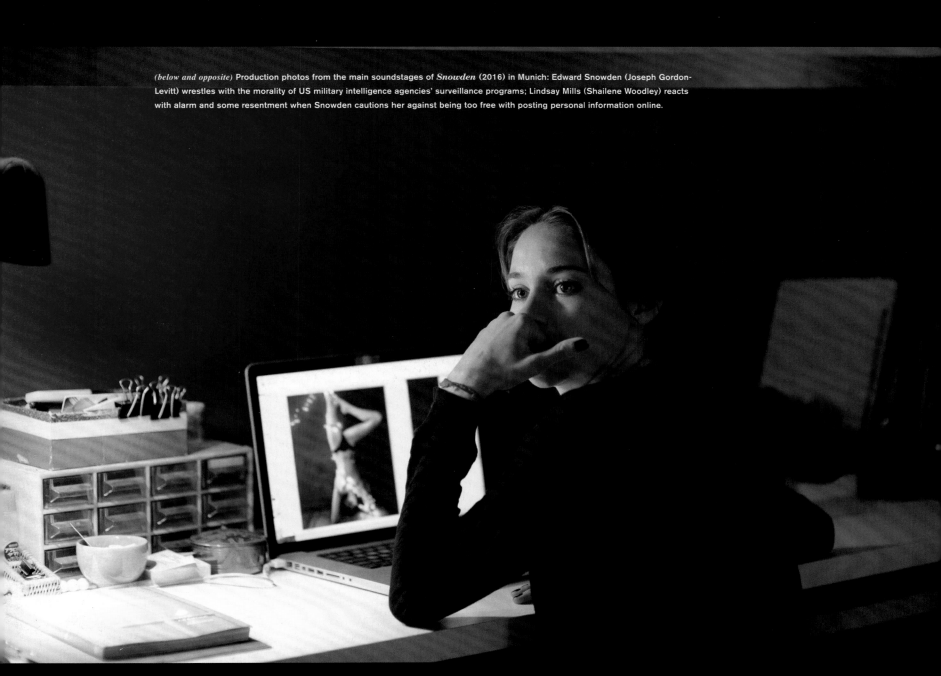

(below and opposite) Production photos from the main soundstages of *Snowden* (2016) in Munich: Edward Snowden (Joseph Gordon-Levitt) wrestles with the morality of US military intelligence agencies' surveillance programs; Lindsay Mills (Shailene Woodley) reacts with alarm and some resentment when Snowden cautions her against being too free with posting personal information online.

I heard a couple of comments from people on set in DC to the extent that they believed the production was spied upon when you were there.

I didn't feel that. I do think the NSA would have a problem if they were actually doing something actively; if that came out in the press, I think it would be very embarrassing to them.

But you did take security precautions to keep details of the shoot a secret?

What we did was more along the lines of, *Be careful on e-mails, don't say where you're going*, and stuff like that. We always had code names, and we tried to stay off phones and avoid talking about things openly. We became coded in our language.

That was the nature of being with Ed, too. Ed's into calligraphy and cryptology, you know. All our communications were hidden through Pretty Good Privacy, or some equivalent.

[My associate producer] Janet Lee did a great job of securing the script, which was always sent around in different formats and broken up. Actors would get secret codes to open iPads at a certain time for a certain hour and amount of time.

I experienced a version of that when you let me read it in DC. I sat in a trailer and was warned to keep my finger on the trackpad because if the computer went into sleep mode, I would have to have someone come in and type in a password so I could continue reading the script.

And the computer was not connected to the Internet: That was interesting, too.

No, we kept off the Internet. We took great precautions with the script. You have to realize that that script was worth something if it was leaked. It would've been a bounty, because it's about the major hacker in the world, so these people are very smart. I must've been hacked. I mean, I was hacked several times.

Looking for info on Snowden?

Information on the movie, I suppose. Tough stuff. And I'm surprised more didn't get out, frankly.

I am struck by, as you're telling the story of this difficult production, how much it sounds like your accounts of the productions of *Salvador* and *JFK*. Those films and other Oliver Stone films were shot very quickly, and the financing in every case was lower than you might expect, looking at what ended up on-screen—even *Alexander*, although that was a long shoot, had to be done quickly for a film of that size, and it was financed independently through a lot of different places.

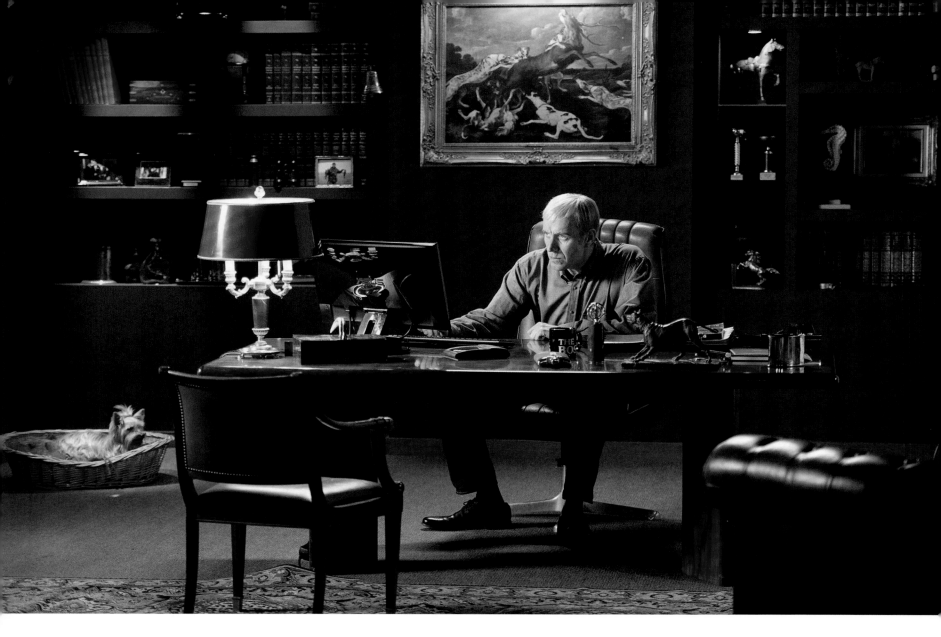

Do you ever think, "Goddamn it, why can't I just make a one-hundred-million-dollar studio film with superheroes or dinosaurs and have six months to shoot it and not have to hustle?"

I've thought that way at times but I couldn't do that, because I feel we all have a limited time, and I just don't know I'd be happy doing something I don't care about or realize was unimportant. You have to find a reason behind a movie to spend that amount of time. You know, even by the time I'm doing the editing, I'm going over stuff for the one hundredth time in detail, and it takes care. It's like the level of a craftsman or a jeweler or a watchman—someone who cares about the piece. I feel there's a craftsman aspect—just professional craft. Just to build a watch that you think is a piece of junk—I mean, I did work on *Mission Impossible II* and developed that with a writer, and we really put hours into it, but we were trying to make that series significant, and I think we tried to do an artificial intelligence story, very much like *Colossus: The Forbin Project*[55] from the sixties, which I always admired.

But it didn't fit the needs of that series, which needs a certain amount of action every few minutes: That's the way the series is built. I saw the new one the other night, and it was disappointing to me because the plots have to become more and more preposterous. I enjoy those movies—not often, but I enjoyed *Kingsman*, for example. It was fun to watch. And *The Man from U.N.C.L.E.*[56] Everything's being done to death now. Now that they've discovered the mega-size, everything's done mega, and when a spy film is done mega, it loses its charm for me. The Bond films aren't done tongue in cheek now, they're overdone.

As to your point, though, when I did the second and first *Wall Street*s, which were both studio films, I was paid, I was secure, I felt like we weren't going to run out of cash, they'd make this movie, they were on our side, and I had final cut. Never felt that way on *Platoon*, *Salvador*—they were hit-and-run jobs. Those were like, *Look behind you, make sure you're still there*.

On *Snowden*, we were rushed. I mean, I was flying back and forth from working on the

script here, and in Germany, trying to scout locations and cast the whole thing there, and England, and the States, too. It was endless detail. No money, and I'm talking to people who I'd love to be in the movie, and cast and crew, and I know they're working on a dream. Like, *Am I really making this movie?* How can I asked Mark Tildesley,[57] a very talented production designer, not just to design but to build the sets, when there's a limited amount of money to build?

The Open Road people were not in 50 percent. It wasn't a big deal, it was a certain amount. I forgot what it was, but France was

55 A 1970 film from director Joseph Sargent, based on the novel by D. F. Jones, about a supercomputer being given control over the US nuclear arsenal.

56 *Kingsman: The Secret Service*, 2014 Matthew Vaughn film based on Dave Gibbons and Mark Millar's comic; *The Man from U.N.C.L.E.* is Guy Ritchie's 2015 film remake of the 1964–68 NBC TV show.

57 Production designer; *28 Days Later* (2002), *The Constant Gardener* (2005), *Sunshine* (2007), and *High-Rise* (2015), among other films.

very important, Pathé.[58] They worked with us on *Alexander*. As much as there was respectability to this thing, it was underwritten for a while by a French bank. And even that was complicated. Germany was crucial because of the subsidy, but they came in, and Russia came in. A Ukrainian friend came in with money, so that helped a lot: cash. And then Fernando Sulichin,[59] who was my producer on *Untold History* as well as *Comandante* and all those documentaries . . . he came in with equity at the end. We wouldn't have made the movie without Fernando.

So you see, the parts are really tricky. The problem is, when you start to shoot you're basically still doing prep, too, so at every free moment, instead of being able to relax, breathe, think about tomorrow, you're also catching up. Most of my rehearsals happened on the weekends, and a lot of the actors were coming in for the first time. It was a grind, a hard film to make. It was cold in Germany—there'd be wonderful days and then *really* cold. We started with the military scenes in the fields, Ed training; it was freezing, but day by day, inch by inch, we chipped away, chip away, as my DP, Anthony Dod Mantle,[60] would say. We chipped away.

I had some conversations with Mantle about the look of the film. He talked about wanting to give a flavor of paranoid thrillers of the seventies.

Oh yeah. We had qualities like that. There's certainly the spy element: It's a thriller if it's good, if it's fun.

What sort of things did you try to do visually to get across the idea of conspiracy, paranoia, surveillance?

Well, with all the talk in the script about digital stuff, it's sometimes hard to understand everybody, and visually, it's a bunch of screens and faces. Some of the most dramatic stuff, nothing's happening in terms of exciting physical action. You don't think about that going into a movie like this, but hopefully you get the information you need to understand the story through texture. So it's context, it's music, knowing the stakes. It's about screens, faces, and lighting, and what you put on-screen. All that was well done by the design team—they were German, working with Ralph Echemendia,[61] one of our technical advisers.

What did you think of Joseph Gordon-Levitt's[62] work for you as Snowden?

I'm very happy with him. There's a push and pull on any creative relationship, and any director who tells you different is full of shit. Go back to Billy Wilder, Hitchcock—most are not as honest as they were, but the whole *everything is rosy,* that's bullshit. I loved Sidney Lumet, but he'd always say *everything's perfect,* and it's just not true. I talked to people who worked for Lumet, and it wasn't all rosy. Marlon Brando[63] did a movie with him called *The Fugitive Kind*[64] and Lumet did take one—*Marlon, that was great!* So Marlon kept hearing that, and then they'd do take two and Sidney would come up to him and say, *That's even better!* And

Is that your roundabout way of saying you guys disagreed a lot?

We disagreed, but that's normal. I'm trying to say to you I'm happy with him, and I'm being straight. I'm just really happy with the result, and it wasn't easy sometimes getting there, but we got there. I think the results are in his work. I think Shailene is certainly different in this movie; she grows on you. She represents a younger generation, and she's interesting. She's twenty-three, for Chrissakes! It's like directing my daughter. Her limits of life—she's very idealistic, and I love that, but she has limits of experience, you know? It's a very sweet kind of thing. And Joe is thirty-whatever, but he's grown up inside the world of acting—so there's another different experience of life, right?

What about Nicolas Cage? This is your second time working with him.

I enjoyed it very much. He really delivered a nugget. It's a nice little performance, important to the movie because it comes back again in the end.

Cage is good. People have always criticized him, but I think it's silly, you know? He did a great job with us in *World Trade Center*. You have to see that movie again to understand how strong he is in a role that's very straight. When you meet the real John McLoughlin, as Nic did, you want to play him—and that's who that guy is. You don't want to futz around with reality. Nic's performance really captures that guy. And the character of Will Jimeno, the guy that Michael [Peña] played, is also very close to the real person.

Sometimes I think Nic is very serious, and mournful looking, and I wish sometimes he'd laugh more, but when he laughs it's

Am I really making this movie?

then Marlon would start to fuck around, and he'd do another take another way completely, and then it'd be take three and Sidney would come up to him and say, *That's perfect!* So Marlon lost respect for him and sort of said, *Fuck this guy, he doesn't know what the fuck he's talking about, he's just always on a time clock.*

really beautiful. He's a wonderful man and I deeply respect him.

Prior to starting work on the script to this film, did you realize the extent to which Americans were being subjected to indiscriminate, mass surveillance by their own government?

No. No! I was quite surprised. I have an imagination, and in *1984*, you see sci-fi versions of

58 Pioneering Paris-based film company, aka Pathé Frères; founded 1908.

59 Argentine film producer of *Bully* (2001), *Spring Breakers* (2012), *London Fields* (2015), and six Stone projects, including *Snowden*.

60 Cinematographer known for his innovative work shooting video/digital formats for big-screen theatrical features: *The Celebration* (1998), *Dogville* (2003), *Slumdog Millionaire* (2008), *127 Hours* (2010), among others.

61 Known as "the Ethical Hacker"; advises on hacking and other information-security topics to the US Marines Corps, NASA, AMEX, Boeing, Google, and Microsoft.

62 1981– ; child actor turned affable-heroic leading man; *Third Rock from the Sun* (1996–2001), *Mysterious Skin* (2004), *Brick* (2005), *500 Days of Summer* (2005), *Inception* (2010), *The Dark Knight Rises* (2012), *The Walk* (2015).

63 1924–2004; father of modern film acting, and by some estimates, seventeen children.

64 A 1959 romantic melodrama directed by Lumet, starring Brando and Sophia Loren, adapted by Tennessee Williams from his 1957 play *Orpheus Descending*.

(below) The NSA's cryptographic technology room in *Snowden*, actually a set built on a soundstage in Munich.

(following spread) Anthony Hopkins as Ptolemy in *Alexander*: the historian setting the record; the storyteller shaping the story.

that kind of thing, but this was actual reality, and the motherfuckers could do it in bulk. There are going to be ways where you can simultaneously monitor five billion people, and if you want to retroactively go back and find certain information from all the stuff you've collected, you can. I mean, the machinery is going to get insanely thorough once artificial intelligence takes over. It already has.

I didn't know until I read the screenplay to *Snowden* that the camera on a laptop really could be triggered remotely to spy on the user. I thought that was an urban myth.[65]

Sure, that's what Ed told us. I didn't know about that, either.

Have you changed your practices or behaviors as a result of working on this movie?

To some degree, but not really. I can't live with hiding. I can't live with cryptology everywhere, but I do have some in my own system, and the editing room of this movie. But no, I'm not there. What am I gonna do? I mean, if I want to watch porn sites, I will! Fuck you, bastards! *(Laughs)*

When I first read this screenplay, it gave me flashbacks to when I first became a fan of your movies, because it reminded me of the spirit of *Born* and *JFK*, in that the hero was essentially a protester and a reformer. Do you agree with that at all? Do you feel that this is essentially in some way a hopeful story, or at least a not entirely depressing one?

I think it's a hopeful one, because as long as people are willing to go against the powers that be, there's hope. Out of that protest comes a sense of continuity. All through the ages we've had, from the Magna Carta to the revolutions to the civil rights and feminist movements, people who are sometimes a pain in the ass become the leaders of new ideas. I think that's so important.

All your films have autobiographical elements, of course, but have you ever thought about doing an Oliver Stone film that's just straightforwardly about Oliver Stone? With somebody playing you, officially? Or maybe something like what Jean-Luc Godard did later in his career, where you're in it as yourself, and you're sort of the protagonist and narrator of an essay-type film—something like *Untold History*, but pushed a lot further?

Maybe there's a mix of documentary, biography, and drama, sort of swirling around you?

That's very kind of you. You know, it's possible. When I can get away—maybe later in my life, when I'm old enough, when I can survive the outpouring of hatred that would come with that kind of movie. They'd say, "His ego is so massive, he had to make a movie about himself!"

But I remind you, Truffaut, Fellini, so many great filmmakers made disguised films about themselves—nobody more overtly than Fellini, and he's one of my greatest influences. So I'm not ashamed of the wish to make something like that.

But I am ashamed of it in *this* country. It's somehow easier to do that sort of film if you're European or Asian. It's harder to do it here, because of the shit you take!

65 Internet-connected cameras can be controlled not just by authorized users—for business security, so-called nanny-cams, and the like—but also by unauthorized users, often through malware surreptitiously installed on computers during seemingly routine software downloads, visits to websites, and so forth.

You pay a price, unless you do it in a way that's non-offensive.

I guess you could do it that way—but what would be the fun in that?

But it's a good idea. I will really take it under consideration. I'm seriously getting there, so I can maybe just sort of do it and run! And I don't want to run—I'd just like maybe to do a film like that. Maybe it's time.

You could start with a scene where a film critic interviews you about your life.

No, I'll start with a sex scene.

(Laughs) **Why am I not surprised?**

Did I ever tell you about the sniper?

The what?

The sniper.

No.

Well . . . after *JFK* came out, maybe in 1993, he contacted me. The guy didn't have any ulterior motives. He didn't want to be mentioned by me. He came to me through a series of weird letters through post office boxes. Everything would go to a PO box, and he'd locate it from offshore, from Bermuda, where he lived.

I don't know his real name, but he gave me a code name. It was Ron.

So, Ron reached out to me. He said he wanted to talk. He said he was dying of cancer and he'd become a Buddhist. That's why he related to me, because he said he'd read that I'd become a student of Buddhism, too.

I met "Ron" for the first time in Rochester, New York, where I'd gone to speak to students. He was quite nervous. He spotted me in the hotel lobby, and we went up to my room and talked for at least a couple of hours. He said he didn't want money or recognition. He said something like, *I want you to know this is from my conscience.* It was a very authentic story, the way he hold it. He said that he was originally assigned as part of a ten-man squad all recruited from the same department under the then-Deputy Director of Plans (DDP)—from a section known as "Psychological and Paramilitary." All ten men were sequestered through a three-month period of prepping and rehearsal. They were pulled in from all over the globe; none of them knew each other, or would know each other in the future.

So you're saying it was an inside job, done right there in Dealey Plaza?

It's a plausible story, if you think about it. You're trying to kill the President, make sure he doesn't get out of that fucking place alive, you put snipers there, right in with the same snipers who are supposed to be protecting Kennedy. They all had positions to protect him, you see? So they were all innocent in their minds, because they were all there for the President's security.

And then he told me something happened that was unexpected. He said it all went crazy. Somebody from his own team, from behind the fence—and he gave me a codename, because he thought he knew who it was—had fired on the President. There was a lot of chaos right away. He never saw that person again, and he barely got out of there in all the confusion. A small plane took him out of Dallas shortly thereafter. In a way, he still seemed to be in a sort of shock, years later, from it all. He was apparently only eighteen years old or so, at the time.

Remember, these guys were all snipers, good shooters, guys who don't miss.

We had several more meetings and correspondences over the years. He was always very nervous and cautious from off-shore, and then some time after 2000 his cancer got worse, and he disappeared. He mentioned that he'd had a son, and his son came to see me four or five years ago.

He was a very, very moving character. He was a bit of a hippie, a bit lost, and he told me the story of his father dying and told me he knew the same stuff I did. We were the only two people who knew, me and his son. The son had a bit more information, but the father told the son and me.

It's an amazing story.

Do you believe it?

I do, for two reasons.

First of all, the scenario he laid out was very practical. It's the way I would do it, if were going to do something like that. You kill the president, and your cover is security, and if the sniper or snipers who kill the president are hidden in with the guys who are supposed to protect him, guys who have no knowledge of this plot, and—well, it makes a lot of sense.

And his memory of it was so technical, filled with military jargon, details about radio communications right after the shots.

What's the second reason you believe him?

His motivation. He reached out to me because I was Buddhist and I was a filmmaker, and he thought I was an honest man. And also because of when I was defending myself right after *JFK* came out, when all those people were attacking me—he felt he owed me satisfaction of some kind.

There was no desire for recognition on his part. He didn't want to sell his story. He didn't even want me to tell anyone else that he told me his story.

It was a Buddhist thing. It was about sharing a story that would go on through time.

ENDNOTES

Compiled and written by Keith Uhlich and Matt Zoller Seitz

CHAPTER 1

Rejoice O Young Man in Thy Youth

1946–1969

1 First edition published by St. Martin's Press, September 15, 1998.

2 "Ever since the arrival of the first Europeans in the New World, Peyote has provoked controversy, suppression, and persecution. Condemned by the Spanish conquerors for its 'satanic trickery,' and attacked more recently by local governments and religious groups, the plant has nevertheless continued to play a major sacramental role among the Indians of Mexico, while its use has spread to the North American tribes in the last hundred years. The persistence and growth of the Peyote cult constitute a fascinating chapter in the history of the New World—and a challenge to the anthropologists and psychologists, botanists and pharmacologists who continue to study the plant and its constituents in connection with human affairs. We might logically call this woolly Mexican cactus the prototype of the New World hallucinogens. It was one of the first to be discovered by Europeans and was unquestionably the most spectacular vision-inducing plant encountered by the Spanish conquerors. They found Peyote firmly established in native religions, and their efforts to stamp out this practice drove it into hiding in the hills, where its sacramental use has persisted to the present time."

Plants of the Gods: Their Sacred, Healing and Hallucinogenic Powers, by Richard Evans Schultes and Albert Hoffman; Healing Arts Press (Vermont) 1992.

3 "The Hill School was founded in 1851 by the Rev. Matthew Meigs as the Family Boarding School for Boys and Young Men, making it the first such family boarding school in the nation—that is, the first school where faculty members lived with their students. After 163 years, The Family Boarding School continues to place a strong emphasis on family and community and providing a rigorous liberal arts education for young men and women to prepare them for college, careers, and life."

"History of The Hill School," accessed May 25, 2015.

4 Robert Roy MacGregor was an eighteenth-century Scottish folk hero known as the Robin Hood of Scotland. His most famous literary depiction is in Walter Scott's 1817 novel, *Rob Roy*. Classics Illustrated published a comic adaptation of the story in 1954 (issue no. 118). A film, also titled *Rob Roy* and starring Liam Neeson, was directed in 1995 by Michael Caton-Jones.

5 On the *Look 'n See* series: "1952 Topps Look n See is one of the most popular trading card sets of all-time. The set focuses on more than 150 years' worth of famous figures that helped shape America. The set remains heavily collected today by both set builders and fans of individual figures. A total of 135 cards make up the 1952 Topps Look 'n See checklist."

"1952 Topps Look n See Trading Cards," accessed May 25, 2015.

6 The scene is described in James Riordan's biography of Oliver Stone: The next day the headmaster called Stone in and rebuked him sternly for ignoring his previous message. "I was scared of him and he came down on me hard," Stone recalls. "It was like, 'When I give you a note like this, you come right away. You always obey my orders, understand?' At one point, he took me aside and said, 'I know you're going through a hard thing, but these things happen. You've got to try to do the best you can. Keep working. Keep forging ahead.' I mean, he could have said, 'Take a few days off and go home,' or something, but he didn't. I remember being embarrassed that he had to know about my pain. It was a private matter in my family and I was very upset that he knew about it. I didn't want to express anything; you held it in in those days. I sort of wanted to be a perfect kid. No problems. I wanted to be anonymous. I was proud that I was a good kid and now there was this big dent in my family. Everything was falling apart."

James Riordan, *Stone: The Controversies, Excesses, and Exploits of a Radical Filmmaker* (New York: Hyperion, 1995), p. 25.

7 Directed by John Sturges, *The Magnificent Seven* (1960) is an Old West remake of Akira Kurosawa's action epic *Seven Samurai* (1954). Yul Brynner plays a gunslinger who hires a ragtag group of mercenaries (Steve McQueen, Charles Bronson, and James Coburn, among others) to protect a Mexican village from a

marauding gang led by bandito Eli Wallach. One of many westerns and contemporary action films from the 1950s that echoed the interventionist tendencies of the Eisenhower/Kennedy/Johnson/Nixon years, often about cynical Yankee adventurers rediscovering their idealism by defending poor or downtrodden people against despots or bands of criminals; see also *The Professionals* and *The Wild Bunch*.

8 In Greek mythology, Perseus is considered the first hero. He is the son of the god Zeus and the mortal Danaë, and is best known for beheading the Gorgon Medusa and rescuing Andromeda from the sea monster Cetus. Theseus is another mythic Greek hero, the son of Aethra by two fathers, Aegeus and Poseidon, and the slayer of the Minotaur in the Labyrinth of King Minos. Alexander the Great (356–323 BC), about whom Stone would go on to make a film in 2004, is one of the most successful of all military strategists: His empire stretched from Greece to Egypt to India. Achilles is one of the central figures in the Trojan War: He slew Troy's hero, Hector, outside the city gates and was himself killed by Prince Paris, who shot Achilles in the heel with an arrow.

9 James Riordan described it this way: For Oliver Stone, the withdrawal of his mother's affection created a deep and disturbing fascination with women. They were an illusion to be grasped, but never attained. A dream to enjoy, but not to trust in, for one day, sooner or later, they always changed on you, or went away. "I've been excited by women for as long as I can remember," Stone said in an interview for *Rolling Stone*. "My first memory is of beautiful women in trees in a jungle. Erotic dreams from when I was three or four that have always stayed with me. I had a combination of shame and humiliation for having those sexual thoughts, but at the same time I had this tremendous desire to be around women all the time."

Riordan, *Stone*, p. 11.

10 In the scene Stone is referring to, *Platoon*'s protagonist, Chris Taylor (Charlie Sheen), says, "'Course, Mom and Dad didn't want me to come here. They wanted me to be just like them. Respectable, hardworking, a little house, a family. They drove me crazy with their goddamn world, Grandma. You know Mom. I guess I've always been sheltered and special. I just wanna be anonymous like everybody else. Do my share for my country. Live up to what Grandpa did in the first war and Dad did in the second.'"

11 Directional anti-personnel mine fired by remote-control that shoots a pattern of metal balls like a shotgun.

12 Aired as part of the *CBS Reports* series on January 23, 1982. The ninety-minute program, narrated by Mike Wallace, asserted that US intelligence officers had manipulated intelligence estimates to make it seem as if America was winning the Vietnam War. General William Westmoreland sued for libel, and the case went to trial. As the trial approached its end in 1985, Westmoreland suddenly dropped his suit due to a perceived apology from CBS. It stated that CBS "never intended to assert, and does not believe, that General Westmoreland was unpatriotic or disloyal in performing his duties as he saw them." Subsequently, CBS lost its libel insurance and produced fewer in-depth documentaries of this sort—a sign of the decline of investigative television journalism.

CHAPTER 2
Who's Gonna Love Me?
1969–1979

1 The Black Panther Party, a revolutionary black nationalist and socialist organization, active in the United States from 1966 to 1982.

2 Stone told *Film Comment*'s Patrick McGilligan in a 1987 interview that *Breathless* was an influence on his direction of *Salvador*, along with Elia Kazan's *Viva Zapata!* and Stanley Kubrick's *Dr. Strangelove*. He called it "the movie that most influenced me as a filmmaker . . . because it was fast, anarchic. I'm into anarchy." The *Breathless* cinematographer, Raoul Coutard, said that "we had no script. . . . Jean-Luc would just turn up with his little exercise book and scribble some notes and some dialogue and we would rehearse maybe a couple of times so I knew where to point the camera vaguely."

Jason Solomons, interview with Raoul Coutard, *The Guardian*, June 5, 2010, accessed June 8, 2015.

CHAPTER 3
The World Is Yours
1979–1985

1 James Riordan described the screenplay:

Stone forged on, writing a western for Charles Bronson, his idol at the time, called *The Ungodly*. The Sergio Leone "Dollars" trilogy of westerns starring Clint Eastwood had proven very popular in the sixties, and *The Ungodly* seems to be Stone's attempt to write something more accessible to Hollywood. . . . He particularly liked Leone's *Once Upon a Time in the West* (1968), with Charles Bronson as the hero and Henry Fonda as one of the coldest and most vicious hired killers in screen history. *The Ungodly* is patterned along similar lines. . . . Stone finished *The Ungodly* while he was working at a sporting films company called W&W Films, a job he obtained through one of Najwa's connections on Madison Avenue. Since he had directed a feature film, he was hired to sell the company's production skills to advertising agencies. W&W Films was successful at making baseball and football films and paid Stone very well, but he was a terrible

salesman. He hated trotting the company's reel around Madison Avenue, but couldn't afford to quit. Eventually, it turned into a con job. "I went in every day and just worked on *The Ungodly*," Stone admits. "I'd tell them I was on the phone trying to make sales all the time. I finished *The Ungodly* while I was there and then I wrote with Geoffrey Holder, an extended treatment, of a mythological sort of Cocteau/ Orpheus movie about Trinidad. I was at the company for about a year, but the boss got more and more concerned as time went by and no business was coming. All that time and I still wasn't out on the street. They let me go, but I got away with it for a while."

Riordan, *Stone*, p. 83.

2 Here is Stone's recollection of the screenplay:

I wrote *Break*, my first screenplay, in the first month or two I was back [from Vietnam]—fresh from the heat of war, wanting to get this surrealistic vision down. The hero falls in love with this lady from the forest who's like Dionysus or something out of *Hair*. She's leading the tribe against the American soldiers, and he comes under her

sway and deserts to join her group. Then he dies and goes to the Egyptian underworld where Osiris judges him. He ends up in prison, back in the States where I ended up, and where he's dreaming all this. He wakes up in prison and then goes back into the dream and has a sort of homosexual liaison with the Elias character, who is also in prison. Then he escapes in the dream, a sort of massive breakout from our society.

Riordan, *Stone*, pp. 67–68.

3 "I think *Once Too Much* has sort of an eerie parallel to Ron Kovic's *Born on the Fourth of July*," Stone says. "For me, it was a different version of *Break* in a way. It was a more realistic story about a kid who comes back from Vietnam, goes to jail, and eventually gets killed in Mexico with a hooker."

Riordan, *Stone*, p. 75.

CHAPTER 4
We Fought Ourselves
1985–1987

1 James Riordan wrote about Woods's reflections on getting cast in *Salvador*:

It was a gutsy choice for Woods. After all, he was going off to Mexico on a shoestring budget with a director that many people had warned him was a madman. "It was a lot of the same people who now say, 'Oh, Oliver, you're so wonderful,'" Woods says. "I mean, let's face it. This town is full of a lot of limp-dick assholes who make sucking up a way of life. I could name names, but I won't. They'd say, 'You're going

to work with Oliver Stone? Isn't he like a junkie or something? He's a jerk. He wrote *Conan the Barbarian* and directed *The Hand.*' And I'd say, 'He also wrote *Midnight Express*' and they'd go, 'Oh, yeah.' People said he was a drug addict, a drunk, violent, a liar . . . everything. They were really vitriolic about him, and I thought, 'I wonder why?' I'd met him once and he seemed like a nice guy. 'Why does he affect people this way? There must be something different about him.'"

Riordan, *Stone*, pp. 156–57.

2 Woods recalled, "Working with Stone was like being caught in a Cuisinart with a madman. . . . And he felt the same about me. It was two Tasmanian devils wrestling under a blanket. Still, he was a sharp director. He starts with a great idea, delegates authority well, scraps like a street fighter, then takes the best of what comes out of the fracas."

Riordan, *Stone*, pp. 162–63.

3 Walter Goodman wrote:
Mr. Stone has more on his mind than action. Taking his cinematic as well as political lead from the work of Constantin Costa-Gavras, he offers an interpretation of history, laying blame on conservative forces in the United States for abetting the horrors in El Salvador. It's an arguable position, but viewers who have learned from the advertisements that the movie is "based on a true story" will be hard put to tell whether the events on screen are actually known to have occurred

in quite the way they are pictured or to have occurred at all, or whether they are the products of surmise, embellished and arranged for the sake of heightening the drama and hammering in the political point.

Walter Goodman, review of *Salvador, New York Times*, March 5, 1986.

4 "With the help of Pierre David, who worked for [producer Arnold] Kopelson, an initial commitment was obtained from Orion Pictures to handle U.S. distribution for the film and put up a third of the money. 'The whole budget was 5.9 million going in and Orion came up with a million or $750,000 for the foreign rights,' Kopelson recalls."

Riordan, *Stone*, pp. 182–83.

5 Producer Arnold Kopelson recalls: One time I came on to the set rather early and everyone was standing around. . . . They were separated into two camps, the Americans and the Filipinos, and nobody was doing anything. I found out that Oliver had gotten pissed off at the head of the Filipino crew over something and he'd kicked him in the ass in front of the entire Filipino crew. The man was really upset. I understand that he was carrying a gun and was seriously contemplating shooting Oliver, and no one was going to work until this was straightened out. Finally, Oliver agreed that in a gesture to show his apology, he would let the man slap him in front of his crew. And that's what he did. It was like something out of an old Tarzan movie or

something . . . winning the cooperation of the tribe.

Riordan, *Stone*, pp. 204–5.

6 The mass killing of about five hundred unarmed civilians in South Vietnam on March 16, 1968. More than one hundred American soldiers from Charlie Company (Company C), part of the Twenty-third (American) Infantry Division, killed men, women, and children—even infants—and many women were raped. The incident did not become public for more than a year and a half, and Americans were sharply divided about whether to punish anyone. Twenty-six soldiers were charged, but only one—Lieutenant William Laws Calley Jr.—was convicted. He was sentenced to life imprisonment but ended up serving only three and a half years under house arrest.

CHAPTER 5
Break On Through
1987–1991

1 In Roger Ebert's 3½-star review of *Wall Street*, he wrote that the film is "a radical critique of the capitalist trading mentality. . . . What's intriguing about 'Wall Street'—what may cause the most discussion in the weeks to come—is that the movie's real target isn't Wall Street criminals who break the law. Stone's target is the value system that places profits and wealth and the Deal above any other consideration. His film is an attack on an atmosphere of financial competitiveness so ferocious that ethics are simply irrelevant, and the laws are sort of like the referee in pro wrestling—part of the show."

Roger Ebert, review of *Wall Street, Chicago Sun-Times*, December 11, 1987.

2 Canby wrote, "'Wall Street' isn't a movie to make one think. It simply confirms what we all know we should think, while giving us a tantalizing, Sidney Sheldon-like peek into the boardrooms and bedrooms of the rich and powerful."

Vincent Canby, review of *Wall Street*, *New York Times*, December 11, 1987.

3 Sheila Benson wrote, "In 'Platoon,' Stone's most glaring weakness—his need to choke his characters with mouthfuls of rhetoric—could be overlooked in the sweep and motion around them. It wasn't subtle, but with the sort of immediacy he was able to muster and with his impassioned sense of recollection, you didn't really miss subtle. Presumably Stone has insider information about Wall Street too; the movie is dedicated to his stockbroker-father. But this time there isn't enough of a war raging to keep the threadbare quality of the story from showing through."

Sheila Benson, review of *Wall Street*, *Los Angeles Times*, December 11, 1987.

4 American film journalist, currently at RogerEbert.com; in the seventies and eighties, local host for "Morning Edition" at public radio station KCFR-FM in Denver, Colorado, and producer of arts- and film-related segments for National Public Radio. Produced Berg's show at KHOW-FM in Denver in the nine months preceding Berg's murder.

5 Canby wrote, "'Talk Radio' . . . is a nearly perfect example of how not to make a movie of a play. Mr. Stone has fancied it up not only with empty narrative asides but also with idiotic camerawork, exemplified by his use, toward the end, of the Lazy Susan shot. Barry, sitting at his microphone, earphones in place, is studied by the camera as the studio turns around him. It's enough to make one dizzy, but is that enough?"

Vincent Canby, review of *Wall Street*, *New York Times*, December 21, 1988.

6 James Riordan's biography describes it this way:

Stone had been considering rewriting *Once Too Much*, the screenplay he had written in 1971 that was loosely based on his own experiences as a returning Vietnam veteran. "I started another script called *Second Life* about those same experiences, but I hadn't finished it. I reread that one and then I reread *Once Too Much*, and I put them both aside in favor of doing *Born on the Fourth of July*. My story was frankly esoteric, coming from a wealthier background. Ron's story is a broader story, but I could relate to much of it on a very personal basis. And what a privilege it was to go back for the second time in my lifetime and do an old script that I really loved."

Riordan, *Stone*, pp. 275–76.

7 Maslin wrote, "Incendiary even by Mr. Stone's high standards, 'The Doors' presents the group's career as a brave, visionary rise followed by a wretched slide into darkness, a slide implemented by drugs, alcohol, madness, world affairs and the demands of fame. This view is sure to arouse as strong a love-hate reaction as the Doors did themselves, but two things are certain: Mr. Stone retains his ability to grab an audience by the throat and sustain that hold for hours, without interruption. And he has succeeded in raising the dead."

Janet Maslin, review of *The Doors*, *New York Times*, March 1, 1991.

CHAPTER 6
Through the Looking Glass
1991–1994

1 Russian immigrant who later was a manufacturer of women's clothing in Dallas; became famous for his film of the John F. Kennedy assassination, taken with a Bell & Howell Zoomatic Director Series Model 414 PD 8 mm camera.

2 On January 31, 1968, on NBC, Johnny Carson conducted a special interview with Garrison on *The Tonight Show*. It lasted for a little more than forty-five minutes, not including commercial breaks, and was a frequently tense and awkward series of exchanges, with Carson poking and prodding at Garrison's calmly stated assertions about a conspiracy that went all the way up to the highest levels of government. Carson was unconvinced, saying he found Garrison's claims to be "a much larger fairy tale than to accept the findings of the Warren report."

3 Using the carbine and telescopic sight linked to Lee Harvey Oswald, the FBI conducted field tests on November 27, 1963, and March 16, 1964, but its firearms experts could not hit a stationary target with three shots. On March 27, 1964, three US Army marksmen firing the same weapon were unable to hit silhouette targets at the appropriate distance

with all three shots that each fired. On June 25–28, 1967, CBS aired a special entitled *A CBS News Inquiry: The Warren Report*, hosted by news anchor Walter Cronkite, which delved into all the evidence then available about the JFK assassination. In one of the four hour-long episodes, eleven volunteer marksmen attempted to simulate the assassination by firing three bullets each at a slowly moving target from atop a specially built sixty-foot-high tower. The results varied widely, and only one participant hit the mark with every bullet.

4 The Bay of Pigs was a failed military invasion of Cuba undertaken by the paramilitary group Brigade 2506 on April 17, 1961, in hopes of ousting Fidel Castro from power. The brigade, made up of anti-Castro Cuban exiles, was sponsored by the CIA and trained near the end of the Eisenhower administration; the invasion took place less than three months after President Kennedy took office. The expected widespread uprising did not take place, and the insurgents were defeated within three days by the Cuban armed forces. The invasion caused much embarrassment for Kennedy and the United States, angered anti-Castro Cubans who felt Kennedy had been unsupportive, further strengthened Castro's ties with the Soviet Union, and paved the way for the Cuban Missile Crisis of 1962.

5 The Berlin crisis of 1961 lasted from June to November and was a major incident of the Cold War, revolving around the ongoing post–World War II occupation by the United States, Britain, and France of West Berlin, a pro-Western oasis surrounded by the Soviet-controlled East Germany, including East Berlin. As East Germans continued to flee en masse to West Berlin, the Soviet Union issued an ultimatum demanding the withdrawal of Western armed forces from West Berlin. When that did not happen, barbed wire and other barriers went up all around West Berlin practically overnight. Kennedy sent US troops to the city, but a tense standoff between opposing tanks eased when Kennedy decided West Berlin was not worth a war. It remained under Western control but the two halves of the city were eventually divided by a concrete wall, which remained in place until November 1989.

6 In Stanley Kubrick's Cold War satire, *Dr. Strangelove or: How I Learned to Stop Worrying and Love the Bomb* (1964), George C. Scott's character, General Buck Turgidson, parodies this mentality. Advocating an all-out nuclear attack on the Soviet Union, Turgidson says to Peter Sellers's commander in chief, "Mr. President, I'm not saying we wouldn't get our hair mussed. But I do say no more than ten to twenty million killed, tops." Turgidson is also seen to have a binder labeled "World Targets in Megadeaths," which was a phrase coined by the physicist and military strategist Herman Kahn and discussed in his 1960 book, *On Thermonuclear War*, which theorized about the creation and implementation of a so-called doomsday machine as a supposed ultimate deterrent.

7 Janet Maslin wrote that Stone's "best direction is volatile, angry and muscular in ways that Ms. Hayslip's story, that of a resilient, long-suffering victim, simply cannot accommodate. Mr. Stone tells this tale vigorously, but he has the wrong cinematic vocabulary for his heroine's essentially passive experience."

Janet Maslin, review of *Heaven & Earth*, *New York Times*, December 24, 1993.

8 Theravada is the school of Buddhism that follows the Tipitaka, or Pali canon—the earliest recorded Buddhist texts. The predominant religion of continental Southeast Asia (Thailand, Myanmar/Burma, Cambodia, and Laos) and Sri Lanka, it states that insight must come from each aspirant's experience, application of knowledge, and critical reasoning, though it also insists that aspirants must heed the advice of wise men. Mahayana Buddhism, by contrast, draws on various teachings and doctrines, and it promotes complete enlightenment (usually attained only by a select few bodhisattvas) for the benefit of all sentient beings.

9 Longtime president of the Motion Picture Association of America (MPAA) and creator of the film rating system that is still in use today. On April 1, 1992, he published a seven-page statement about *JFK*, in which he is quoted as saying that "young German boys and girls in 1941 were mesmerized by Leni Reifenstahl's *Triumph of the Will*, in which Adolf Hitler was depicted as a newborn God. Both *J.F.K.* and *Triumph of the Will* are equally a propaganda masterpiece and equally a hoax. Mr. Stone and Leni Reifenstahl have another genetic linkage: neither of them carried a disclaimer on their film that its contents were mostly pure fiction."

10 On March 5, 1995, nineteen-year-old Sarah Edmondson and her boyfriend, eighteen-year-old Benjamin James Darras, watched *Natural Born Killers* at a family cabin in Oklahoma. Two days later, they went to Hernando, Mississippi, where Darras killed a cotton mill manager, William Savage, with two point-blank gunshots to the head. They then traveled to Ponchatoula, Louisiana, where Edmondson shot a convenience store clerk, Patsy Byers, who survived but was left a quadriplegic. Savage was a friend of the bestselling author John Grisham (*The Firm*), who publicly accused Stone of irresponsibility and said he should be held responsible for Edmondson and Darras's acts. Byers took legal action against both her attackers in a July 1995 lawsuit, which she amended in March 1996 to include Oliver Stone and Time Warner, the parent company of Warner Bros. On the advice of Grisham (who also wrote an article about the case, titled "Unnatural Killers," in *Oxford American* magazine in April 1996), Byers used a product liability claim, under which it was stated that Stone and Time Warner should have realized the deleterious effects of the film before making it. The suit was dismissed on January 23, 1997, with the judge stating that the filmmakers and Time Warner were protected under First Amendment rights. Byers appealed the decision but died of cancer later that year, before the suit could be resolved. It was eventually dismissed, on March 12, 2001, and a final appeal by Byers's lawyers was denied in June 2002, effectively closing the case. Edmondson served twelve years of her thirty-year sentence in Oklahoma before being paroled, and Darras remains in prison in Mississippi.

11 Stanley Kubrick's 1971 adaptation of Anthony Burgess's 1962 dystopian novella follows a sociopathic delinquent named Alex (Malcolm McDowell) who wreaks havoc across England with his fellow "droogs" until he is captured and forcibly rehabilitated through psychological conditioning. It caused particular controversy in the United Kingdom during two manslaughter trials in which the actions of two teenage boys were said to have been inspired by the film. Kubrick's family received death threats and protests. He eventually asked Warner Bros. to withdraw the film from British distribution. Kubrick spoke about the controversy, saying in part: "To try and fasten any responsibility on art as the cause of life seems to me to put the case the wrong way around. Art consists of reshaping life, but it does not create life, nor cause life. Furthermore, to attribute powerful suggestive qualities to a film is at odds with the scientifically accepted view that, even after deep hypnosis in a posthypnotic state, people cannot be made to do things which are at odds with their natures."

12 Assertions by killers that God or the Bible made them do it have been commonplace in many different supposedly civilized nations, the United States included. One of the highest profile cases was that of Mark David Chapman, who shot ex-Beatle John Lennon to death outside of the Dakota apartments in New York City on December 8, 1980. Chapman remained on the scene for hours with his copy of J.D. Salinger's *The Catcher in the Rye*, and repeatedly told police after his arrest that the novel was his "statement." His defense lawyers planned to present Chapman as a delusional psychotic who was not responsible for his actions and entered a plea of not guilty by reasons of insanity. Before going to trial for murder, Chapman changed his mind and pleaded guilty over his lawyer's objections, insisting that "the will of God" made him pull the trigger. In 2008, twenty-five-year-old Christopher Lee McCuin of Tyler, Texas, was charged with capital murder for killing and mutilating his twenty-one-year-old girlfriend, Jana Shearer; police at the crime scene found Shearer's ear boiling on a stove top, and a dinner plate on the kitchen table containing a fork speared through a chunk of her flesh. McCuin, too, said God commanded him to kill. In 2013, in Chesterfield County, Virginia, was charged with capital murder for shooting Master State Trooper Junius Walker to death, as well as two firearms counts and an attempted capital murder charge for allegedly shooting at another trooper on the scene. According to local news station CBSDC, Brown said that God made him commit the crimes and "called his grandmother several times in the weeks leading up to the killing to talk about the Bible, which was uncharacteristic of him." Perhaps many more criminals have defended their violent acts by saying the Devil made them do it, but God and the Bible give Old Nick stiff competition in the accessory department. In comparison, Hollywood films seem to have relatively little power over the decision

to commit felony violence, though to be fair, religion has more than a 2,000-year head start over pop culture.

13 For the writer-director Quentin Tarantino, 1994 was a golden year. He had only one previous director's credit, the robbery-gone-wrong film *Reservoir Dogs* (1992), though he had already sold his screenplays for *True Romance (1993) and the Stone-directed Natural Born Killers* (1994). But then he premiered his nonlinear crime opus *Pulp Fiction* at the Cannes Film Festival. It received numerous plaudits and won the festival's top prize: the Palme d'Or. When it was released in the United States, it became a monster hit and won Tarantino and his collaborator, Roger Avary, an Academy Award for best original screenplay. It also received six other Oscar nominations, including one for Best Director. (He lost to Robert Zemeckis for *Forrest Gump*.) Soon after, he became a go-to script doctor, notably on Tony Scott's submarine thriller, *Crimson Tide* (1995), which he punched up with references to the Silver Surfer and the famed comic book artist Jack Kirby. He also generated his fair share of controversy: A Michigan film student made a short film in 1995 titled *Who Do You Think You're Fooling?*, which attempted to show how Tarantino had more or less plagiarized Ringo Lam's 1987 thriller *City on Fire* for *Reservoir Dogs*.

14 Mexican poet, diplomat, and writer; won the 1990 Nobel Prize in Literature. A more extensive portion of the quotation referred to here is as follows:

The ancients had visions, we have television.

But the civilization of the spectacle is cruel. The spectators have no memory—because of that, they also lack remorse and true conscience. . . . They quickly forget and scarcely blink at the scenes of death and destruction of the Persian Gulf War or at the curves . . . of Madonna and of Michael Jackson. . . . They . . . await the Great Yawn, anonymous and universal, which is the Apocalypse and Final judgement of the society of spectacle.

We are condemned to this new vision of hell; those who appear on the screen and those of us who watch. Is there an escape? I don't know. One must seek it.

Octavio Paz, "The Media Spectacle Comes to Mexico," in *The Zapatista Reader*, ed. Tom Hayden (New York: Thunder's Mouth Press/Nation Books, 2002), p. 31.

15 Before becoming the worldwide celebrity he is today, Robert Downey Jr. was more widely known for his drug-related problems. Between 1996 and 2001 the actor was arrested numerous times for drug use and possession. He went to both rehab and prison a number of times yet always relapsed. He got a big break in 2000 when he joined the cast of the hit television series *Ally McBeal* and won a Golden Globe for his efforts. But he relapsed again, found to be under the influence of Valium and cocaine. He lost several roles as a result, and for a few years could not get hired (as on Woody Allen's *Melinda and Melinda* in 2004) because completion bond companies wouldn't insure the productions. He

eventually got another chance with the Marvel blockbuster *Iron Man* (2008), in which he was given the starring role in what has become a lucrative franchise, and he has been clean and sober ever since.

16 Tom Sizemore has battled drug addiction since his teens. He nonetheless carved out a career in Hollywood as a reliable character actor, but the foundations started to crack in 2003 when he was convicted of assault and battery on his then girlfriend, Heidi Fleiss, the former "Hollywood Madam." Over the next several years, he was arrested for a number of drug-related offenses, and he did a stint in jail for failing several drug tests while on probation for assaulting Fleiss. He later appeared with her on the reality show *Celebrity Rehab* with *Dr. Drew*, during which he got clean and sober, as of this writing.

17 Charles Voyde Harrelson was an organized crime figure and repeat murderer. Among his alleged victims was US district judge John H. Wood Jr., after a drug dealer named Jamiel Chagra hired Harrelson to kill Wood in 1979. Chagra was trying to avoid a harsh sentence for his own crimes. Harrelson was sentenced to two life terms, though later evidence suggested he merely took credit for the killing to receive a large payout. During the standoff in 1980 when police cornered Harrelson for Wood's murder, Harrelson confessed to killing John F. Kennedy in 1963. Some have theorized that he is the tallest of the "three tramps" seen near the Texas School Book Depository right after the assassination.

CHAPTER 7
The Darkness Reaching Out for the Darkness
1995–1999

1 In mid-March 1970, the left-leaning ruler of officially neutral Cambodia, Prince Norodom Sihanouk, was ousted in a coup by the pro-American prime minister, General Lon Nol. Then Cambodian Communists, aided by North Vietnamese forces, battled the unstable Lon Nol government. On April 30, President Richard M. Nixon announced in a televised address that tens of thousands of South Vietnamese and American ground forces were crossing into Cambodia to attack the North Vietnamese and their huge caches of supplies. The three-month "incursion"–to opponents, an invasion–prompted protests around the United States, and the claimed US successes proved only temporary. (See also page TK, footnotes.)

2 Nixon visited Dallas on November 21, 1963, at which point he was a private citizen working for the New York law firm of Nixon, Mudge, Rose, Guthrie, Alexander & Mitchell; its clients included Pepsi-Cola, and Nixon was in town to attend a meeting of the American Bottlers of Carbonated Beverages. The meeting was most likely an unremarkable business trip made sinister by the timing, as well as by comments that Nixon made to reporters at the Baker Hotel, where he was staying. He noted that the president had lost support in Texas despite having one of its former senators, Lyndon B. Johnson, as his vice president, and criticized Kennedy for failing to keep his promises, including "[doing] something about Castro in Cuba."

3 John Ford, Robert Aldrich, and Howard Hawks were three distinctive filmmakers of Hollywood's golden age (roughly, the thirties into the sixties) who worked in a wide variety of genres. Westerns were a particular specialty for each, and they sometimes touched (in very complicated and troubling fashion) on the plight of the Native American–in contrast to the primarily white casts. Ford's most famous western is *The Searchers* (1956), starring John Wayne as a Civil War veteran on a mission to find his niece, in the hands of a Comanche warrior; however, his most sympathetic film toward Native Americans is *Cheyenne Autumn* (1964), based on a true story about a band of starving Indians attempting a long march from their reservation back to their homeland. Aldrich directed *Apache* (1954), starring Burt Lancaster as the last Apache warrior, trying to return home and live in peace; *Ulzana's Raid* (1972) follows a naive young cavalry lieutenant (Bruce Davison) forced to reexamine his views as he, a scout (Lancaster again), and an Apache guide (Jorge Luke) search for the titular war chief (Joaquin Martinez) who is pillaging the American Southwest. Hawks's *Rio Bravo* is not about Native Americans but about the camaraderie (and sense of honor and duty) among distinct types of men–John Wayne's brusque sheriff, Dean Martin's sniveling drunk, and Ricky Nelson's cocky young gunslinger, among others–something Stone riffs on with the disparate ensemble of *U-Turn*.

4 This excerpt from Nelson George's book is about the cultural changes within basketball in the sixties, but it could apply to pretty much any American profession or institution, including pro football:

Throughout the sixties and into the next decade Black players began committing all these taboo acts. An antagonism between these players and their fans, unfailingly pointed out and often exploited by the sports media, built into a long, ongoing war of words. Phrases like "discipline problems," "schoolyard style," and "poor work habits" appeared on sports pages. They were supposed to be "informed" judgments, when actually they were merely coded terms for deeper conflicts over values, politics, and money that were causing turmoil in the entire nation, not just the sheltered dreamland of sports.

The era's cultural struggles spilled onto the playing field and into the locker room. The wearing

of an Afro hairstyle, an interest in the Black Panthers, or the playing of James Brown's "Say It Loud— I'm Black and I'm Proud" on an eight-track tape player on the team bus could be perceived as a break with acceptable athletic protocol. Just as civil rights gave birth to Black militants, pioneering ballplayers gave way to less complacent athletes. The brilliant center fielder Willie Mays, a humble Southerner, always eager to play and ready with the innocuous quote, was considered a "good Negro" role model not only because he played the game like a God but because he sported a "just-happy-to be-here" attitude.

The designation of certain African-Americans as "role models" and "credits to their race" was a staple of speechmakers and sportswriters of the period. But the role-model notion was nothing more than a placebo that clouded the general failings of the government in aiding its darker citizens. "If this gifted jock can make it, what's the matter with the rest of you Negroes?" the role model's presence implied.

Nelson George, *Elevating the Game: Black Men and Basketball* (Lincoln, NE: Bison Books, 1992), pp. 138–39, accessed June 14, 2015.

CHAPTER 8
By Steel and By Suffering
1999–2009

1 Amid a growing Islamic insurgency in Afghanistan, the pro-Soviet prime minister was executed by a rival's men in October 1979, and Soviet troops invaded the country on Christmas Eve and installed a puppet government. President Jimmy Carter imposed economic sanctions against the Soviet Union, led a boycott of the 1980 Summer Olympics in Moscow, and increased aid to the anti-Soviet Afghan guerrilla fighters, called the mujahideen. One of the major proxy fights of the Cold War, the Soviet-Afghan War lasted until February 1989.

2 In a January 1998 interview published in the French weekly newsmagazine *Le nouvel observateur*, Zbigniew Brzezinski, President Jimmy Carter's national security adviser in 1977–81, revealed the secret US role in drawing the Soviet Union into a long, costly war in Afghanistan:
Brzezinski: . . . According to the official version of history, CIA aid to the Mujahadeen began during 1980, that is to say, after the Soviet army invaded Afghanistan,

24 Dec 1979. But the reality, secretly guarded until now, is completely otherwise: Indeed, it was July 3, 1979 that President Carter signed the first directive for secret aid to the opponents of the pro-Soviet regime in Kabul. And that very day, I wrote a note to the president in which I explained to him that in my opinion this aid was going to induce a Soviet military intervention.
Q: Despite this risk, you were an advocate of this covert action. But perhaps you yourself desired this Soviet entry into war and looked to provoke it?
B: It isn't quite that. We didn't push the Russians to intervene, but we knowingly increased the probability that they would.
Q: When the Soviets justified their intervention by asserting that they intended to fight against a secret involvement of the United States in Afghanistan, people didn't believe them. However, there was a basis of truth. You don't regret anything today?
B: Regret what? That secret operation was an excellent idea. It had the effect of drawing the Russians into the Afghan trap and you want me to regret it? The day that the Soviets officially crossed the border, I wrote to President Carter: We now have the opportunity of giving to the USSR its Vietnam war.

Zbigniew Brzezinski, interview, "Les révélations d'un ancien conseiller de Carter: 'Oui, la CIA est entrée en Afghanistan avant les Russes . . . ,'" *Le nouvel observateur* (Paris), January 15–21, 1998, trans. Bill Blum ("The CIA's Intervention in Afghanistan"), Centre for Research on Globalisation, posted October 15, 2001.

3 During this period, Christopher Hitchens popularized a particular term, Islamofacists. As he expleined in an article in 2007, in which he stated, "The term 'Islamofascist' was first used in 1990 in Britain's *Independent* newspaper by Scottish writer Malise Ruthven." Then, comparing Islamofascism to the Nazi German variety, Hitchens wrote, "Both these totalitarian systems of thought evidently suffer from a death wish. It is surely not an accident that both of them stress suicidal tactics and sacrificial ends, just as both of them would obviously rather see the destruction of their own societies than any compromise with infidels or any dilution of the joys of absolute doctrinal orthodoxy. Thus, while we have a duty to oppose and destroy these and any similar totalitarian movements, we can also be fairly sure that they will play an unconscious part in arranging for their own destruction, as well."

Christopher Hitchens, "Defending Islamofascism," Slate.com, October 22, 2007.

4 During remarks outside the White House on September 16, 2001, President George W. Bush told reporters, "This crusade, this war on terrorism, is going to take a while,

and the American people must be patient. I'm gonna be patient." The president's use of the word "crusade" touched off an international debate about whether the United States was about to spearhead a twenty-first-century version of the Crusades of the Middle Ages, which were seen by Christians as a preemptive war to prevent the Islamic conquest of Europe and restore Christian access to the Holy Land in the Middle East, but by Muslims as a series of massive and prolonged invasions with an ultimate goal of permanent conquest and occupation.

5 In 1958, as a result of political and religious unrest in Lebanon—mainly between Maronite Christians and Muslims—the country's pro-Western president, Camille Chamoun, requested foreign assistance. President Dwight D. Eisenhower sent in several thousand troops, the first application of the so-called Eisenhower Doctrine that the US would protect regimes in the Middle East that it determined were threatened by Communism. The operation was called Blue Bat, and the soldiers occupied the port, international airport and other areas

in and around Beirut for three months until tensions eased.

6 On October 23, 1983, jihadists in different parts of Beirut set off powerful truck bombs outside two buildings housing US and French military forces, part of a United Nations peacekeeping mission in Lebanon after the Israeli invasion in 1982 to oust the Palestine Liberation Organization (PLO) from that country. The blasts killed 241 US Marines, 21 American sailors and soldiers, and 58 French soldiers. President Ronald Reagan promised retaliation, but no major operation materialized due to a split in the White House over who was directly responsible for the attack. By early 1984, Reagan ordered US Marines to begin withdrawing from the country in light of waning congressional support for the military's continued presence.

7 Think tank founded by Robert Kagan and William Kristol, neoconservatives dedicated to cementing US status as the lone remaining post–Cold War superpower, and active from 1997 to 2006. It released a statement of principles on June 3, 1997, that concluded that "a Reaganite policy of military strength and moral clarity may not be fashionable today. But it is necessary if the United States is to build on the successes of this past century and to ensure our security and our greatness in the next." The PNAC wrote a January 28, 1998, letter to President Bill Clinton advocating regime change in Iraq; signatories included the future Bush administration secretary of defense

Donald Rumsfeld (2001–2006), deputy secretary of defense Paul Wolfowitz (2001–2005), and deputy secretary of state Robert Zoellick (2005–2006). The latter had served as President George H. W. Bush's undersecretary of state for economic and agricultural affairs, deputy chief of staff, and assistant to the president, then later became one of the Vulcans, the name chosen by the foreign policy advisory team assembled to brief President George W. Bush during the 2000 presidential campaign under the direction of Condoleezza Rice, who became Bush's national security adviser (2001–2005) and secretary of state (2005–2009).

8 The group's report, *Rebuilding America's Defenses: Strategies, Forces, and Resources for a New Century*, urged the United States "to retain its militarily dominant status for the coming decades" by developing the means to "fight and decisively win multiple, simultaneous major theater wars." Other members included R. James Woolsey, a former CIA director (1993–95); Elliott Abrams, a foreign policy adviser to President Ronald Reagan and later to President George W. Bush; and John Bolton, a foreign policy adviser to President George H. W. Bush. Within hours of the 9/11 attacks, Woolsey suggested Iraqi complicity; in 2002 he said he thought Iraq was connected to the 1993 World Trade Center bombing and the 1995 bombing of the Alfred P. Murrah Federal Building in Oklahoma City.

9 General Wesley Clark, former NATO supreme allied commander Europe (1997–2000), later wrote about this: As I went back through the Pentagon in November 2001, one of the senior military staff officers had time for a chat. Yes, we were still on track for going against Iraq, he said. But there was more. This was being discussed as part of a five-year campaign plan, he said, and there were a total of seven countries, beginning with Iraq, then Syria, Lebanon, Libya, Iran, Somalia and Sudan. . . . He said it with reproach—with disbelief, almost—at the breadth of the vision. I moved the conversation away, for this was not something I wanted to hear. And it was not something I wanted to see moving forward, either. . . . I left the Pentagon that afternoon deeply concerned.

General **Wesley K. Clark**, *Winning Modern Wars: Iraq, Terrorism, and the American Empire*, (New York: PublicAffairs, 2003), p. 130.

10 In his address to a joint session of Congress and the nation on September 20, 2001, President George W. Bush said in part: Americans are asking, why do they hate us? They hate what we see right here in this chamber—a democratically elected government. Their leaders are self-appointed. They hate our freedoms—our freedom of religion, our freedom of speech, our freedom to vote and assemble and disagree with each other.

They want to overthrow existing governments in many Muslim countries, such as Egypt, Saudi Arabia, and Jordan. They want to drive Israel out of the Middle East. They want to drive Christians and Jews out of vast regions of Asia and Africa.

These terrorists kill not merely to end lives, but to disrupt and end a way of life. With every atrocity, they hope that America grows fearful, retreating from the world and forsaking our friends. They stand against us, because we stand in their way.

Quoted in John W. Dietrich, ed., *The George W. Bush Foreign Policy Reader: Presidential Speeches and Commentary* (Armonk, NY: M. E. Sharpe, 2005), p. 52.

11 In the eight-hundred-page joint congressional investigative report on 9/11, twenty-eight pages (about 7,200 words) dealing with "specific sources of foreign support" for the nineteen hijackers—fifteen of whom were Saudi nationals—were redacted. In 2013, Reps. Walter Jones (R-NC) and Stephen Lynch (D-MA) introduced a House resolution urging President Barack Obama to declassify this material. In a press release, they stated that "the information contained in the redacted pages is critical to our foreign policy moving forward and should thus be available to the American public. If the 9/11 hijackers had outside help—particularly from one or more foreign governments—the press and the public have a right to know what our government has or has not done to bring justice to all of the perpetrators." Efforts to declassify the material continued into mid-2015.

12 The so-called Powell Doctrine was a term created by journalists during the run-up to the first Gulf War, in 1990. Named after General Colin Powell, then the chairman of the Joint Chiefs of Staff under President George H. W. Bush, the doctrine states that a list of questions all have to be answered affirmatively before military action is taken by the United States: (1) Is a vital national security interest threatened? (2) Do we have a clear attainable objective? (3) Have the risks and costs been fully and frankly analyzed? (4) Have all other nonviolent policy means been fully exhausted? (5) Is there a plausible exit strategy to avoid endless entanglement? (6) Have the consequences of our action been fully considered? (7) Is the action supported by the American people? (8) Do we have genuine broad international support?

CHAPTER 9
The Freest Man
2009–present

1 Deregulation is the process of removing governmental regulations on certain activities, in the belief that an unfettered free market is the best environment for economic growth. In the eighties, President Ronald Reagan and Prime Minister Margaret Thatcher of the United Kingdom promoted programs of deregulation and privatization of economic, transportation, and other services in their respective countries. Many critics of their policies believe this set the stage for the eventual financial collapse in 2008, due in part to the unlevel playing field they created in the free market.

2 Michael Douglas's son with Diandra Luker. On July 28, 2009, he was arrested by the US Drug Enforcement Administration for possession of a half pound of methamphetamine and charged with intent to distribute. On January 27, 2010, he pleaded guilty to conspiracy to distribute drugs as well as heroin possession, resulting from allegations that his girlfriend had smuggled the drug to him in an electric toothbrush while he was under house arrest. He was sentenced to five years in prison on April 20, 2010, then got into further trouble when drugs were found in his possession while he was incarcerated. An additional four and a half years were added onto his sentence. The earliest he can be released from prison is 2018.

3 *Sunday Times* (London), July 25, 2010. Stone's statement earned the ire of the Anti-Defamation League, whose director, Abraham H. Foxman, issued a statement that said, in part, "Oliver Stone has once again shown his conspiratorial colors with his comments about 'Jewish domination of the media' and control over U.S. foreign policy. His words conjure up some of the most stereotypical and conspiratorial notions of undue Jewish power and influence. . . . This is the most absurd kind of analysis and shows the extent to which Oliver Stone is willing to propound his anti-Semitic and conspiratorial views." Stone offered a public apology, saying, "In trying to make a broader historical point about the range of atrocities the Germans committed against many people, I made a clumsy association about the Holocaust, for which I am sorry and I regret. Jews obviously do not control media or any other industry. The fact that the Holocaust is still a very important, vivid and current matter today is, in fact, a great credit to the very hard work of a broad coalition of people committed to the remembrance of this atrocity—and it was an atrocity."

4 After the post–Civil War period of Reconstruction—in which equal rights for African Americans were widely enforced—ended by 1877, what came to be called Jim Crow laws (after a black caricature in minstrel shows) effectively segregated whites and African Americans. Such laws, purportedly creating "separate but equal" status for blacks, were passed throughout the South and in many other states as well, and the US Supreme Court upheld their legality in its now much-reviled Plessy v. Ferguson decision (1896). Of course, there was nothing equal about the effects of the Jim Crow laws: When it came to schools, transportation, restaurants, restrooms, and a host of other public facilities and services, whites were far better off than blacks. Especially in the South, most Jim Crow laws remained in effect until they were overturned in the fifties and sixties by federal court decisions and legislation resulting from the civil rights movement.

5 George Soros is a billionaire philanthropist who in 2010 donated $1 million in support of Proposition 19, which would have legalized marijuana in the state of California. It was defeated 53.5 percent to 46.5 percent. In an opinion column for the

Wall Street Journal shortly before the vote, Soros wrote: "Who most benefits from keeping marijuana illegal? The greatest beneficiaries are the major criminal organizations in Mexico and elsewhere that earn billions of dollars annually from this illicit trade—and who would rapidly lose their competitive advantage if marijuana were a legal commodity. Some claim that they would only move into other illicit enterprises, but they are more likely to be weakened by being deprived of the easy profits they can earn with marijuana."

George Soros, "Commentary: Why I Support Legal Marijuana," *Wall Street Journal*, October 26, 2010.

6 In 2007, Stone was prepping to shoot "Pinkville," a script he wrote based on the investigation into the My Lai massacre. The film was cast with Bruce Willis and Woody Harrelson, but was derailed due to the Writers Guild strike. There have been subsequent whispers of Stone reviving the project, most recently with Shia LaBeouf, and in a Tweet from his Twitter account on February 13, 2014, Stone wrote, "Yes, Pinkville is still on the agenda, but recognize there are large costs against it and it's a film that's not in the climate of the time."

7 Dissidents are citizens of the Soviet Union, and now Russia, who have disagreed with the policies of the government in power. They have been actively prosecuted and sometimes put to death for their actions ever since the 1917 October Revolution, continuing through Joseph Stalin's regime and those of Nikita Khrushchev and Leonid Brezhnev. Cultural leaders such as Aleksandr Solzhenitsyn and Joseph Brodsky are among those who have been persecuted or forced into exile.

8 Curtis Emerson LeMay was a general in the US Air Force and the vice presidential running mate of the 1968 independent presidential candidate George Wallace. He is credited with designing and implementing the intensive strategic bombing campaign against Japan in the final year of World War II, in which low-level nighttime attacks with incendiary bombs destroyed at least portions of more than sixty Japanese cities. The firebombing of Tokyo on March 9–10, 1945—the most destructive bombing raid of World War II—killed about one hundred thousand Japanese, mostly civilians, and burned about one-quarter million buildings. Later the head of Strategic Air Command, the bombers carrying nuclear weapons, and then the US Air Force chief of staff, LeMay was the inspiration for Sterling Hayden's General Jack D. Ripper in Stanley Kubrick's satiric *Dr. Strangelove or: How I Learned to Stop Worrying and Love the Bomb* (1964)—a psychotic who sends nuclear-armed bombers off to attack the Soviet Union because, he says, the Soviets are using fluoride in American water to pollute our "precious bodily fluids."

9 The Philippine-American War (1899–1902) was an armed conflict by Filipinos attempting unsuccessfully to win independence after the United States acquired the Spanish colony as a result of the Spanish-American War (1898). Speaking to a delegation of the General Missionary Committee of the Methodist Episcopal Church on November 21, 1899, about his reasons for fighting to keep the country, President William McKinley said that "one night late it came to me this way—I don't know how it was, but it came: (1) that we could not give them back to Spain—that would be cowardly and dishonorable; (2) that we could not turn them over to France or Germany—our commercial rivals in the Orient—that would be bad business and discreditable; (3) that we could not leave them to themselves—they were unfit for self-government—and they would soon have anarchy and misrule over there worse than Spain's was; and (4) that there was nothing left for us to do but to take them all, and to educate the Filipinos, and uplift and civilize and Christianize them, and by God's grace do the very best we could by them, as our fellowmen for whom Christ also died.

"And then I went to bed and went to sleep, and slept soundly."

Quoted in *Nancy Gentile Ford, Issues of War and Peace* (Westport, CT: Greenwood Press, 2002), p. 165.

Index

Contributors

Matt Zoller Seitz (author) is the editor-in-chief of RogerEbert.com, the TV critic of *New York* magazine and Vulture, and a producer of video essays about film history and style for The Museum of the Moving Image, Salon, Vulture, and other venues. His books include *The Wes Anderson Collection* (Abrams, 2013), *The Wes Anderson Collection: The Grand Budapest Hotel* (Abrams, 2015), *Mad Men Carousel* (Abrams, 2015), and *TV (The Book)*, co-written with Alan Sepinwall (Grand Central Publishing, 2016).

Ramin Bahrani (preface) was named "director of the decade" by Roger Ebert in 2010. His films include *Man Push Cart* (2005), *Chop Shop* (2007), and *99 Homes* (2014).

Kiese Laymon (introduction) is an Associate Professor of English at Vassar College, the Grisham Writer in Residence at the University of Mississippi for 2015–2016 and the author of *Long Division* and *How to Slowly Kill Yourself and Others in America* (both Agate Bolden, 2013). He writing has been published by *Esquire*, *ESPN the Magazine*, *Colorlines*, NPR, *The Los Angeles Times*, *PEN Journal*, *Oxford American*, and *Guernica*. He is a currently a columnist at *The Guardian*.

Jim Beaver (contributor) is an actor, playwright, and film historian best known for his roles on *Deadwood*, *Justified*, and *Supernatural*. He is the author of *John Garfield: His Life and Films* (A.S. Barnes & Co., 1978) and a memoir, *Life's That Way* (Putnam, 2009).

Walter Chaw (contributor) is the senior critic for FilmFreakCentral.net. He has a beautiful wife, two beautiful kids, and runs a beautiful Alamo Drafthouse Cinema in his home state of Colorado.

Michael Guarnieri (contributor) is a film critic and screenwriter. A co-founder of the film blog The Solute, he is a freelancer whose work has been featured by RogerEbert.com and CriticWire. He lives in Chicago.

Kim Morgan (contributor) has written for *Playboy*, *The Criterion Collection*, *Filmmaker Magazine*, *Sight & Sound*, and many other publications. You can find her at her blog, Sunset Gun.

Keith Uhlich (footnotes and end notes) is a writer and critic based in New York. His work can be found at *The Hollywood Reporter, BBC, Mubi, Slant Magazine,* Vulture, and many other publications.

Alissa Wilkinson (contributor) is a critic and professor living in Brooklyn. She is co-author, with Robert Joustra, of *How to Survive the Apocalypse: Zombies, Cylons, Faith, and Politics at the End of the World* (Eerdmans, 2016).

Rebecca Carroll (consulting editor) is a producer of special projects on race at WNYC. She is a regular Opinion Writer at *The Guardian US*, and the author of five nonfiction books, including *Sugar in the Raw: Voices of Young Black Girls in America* (Clarkson Potter, 1997) and *Saving the Race: Conversations on Du Bois from a Collective Memoir of Souls* (Harlem Moon, 2004). She has held senior editor positions at *The Huffington Post* and *PAPER* magazine, and her essays, profiles, and film and book criticism have appeared in the *New York Times*, the *Los Angeles Times*, *Ebony*, and *The Daily Beast*, among others.

Text Credits

Excerpts from *A Child's Night Dream* (Chapter 1, End Notes) reprinted with permission of St. Martin's Press.

Portions of Chapter 2 (Oliver Stone's NYU years) and Chapter 9 (the interview about *Savages* and the critical essay on *The Untold History of the United States*) are adapted from articles that appeared on *New York* magazine's Vulture blog (www.vulture.com) in 2012 and 2013; they are reprinted with permission of New York Media.

The *Wall Street: Money Never Sleeps* interview is adapted from a 2010 *Salon* article, and the critical essay from a 2010 review in *The New Republic*; both are reprinted in Chapter 9 with permission of the author.

Portions of the conversation about *Born on the Fourth of July* are adapted from an April 2013 post-screening Q&A at EbertFest, and are used with permission of Ebert Digital.

Portions of the critical essays that open Chapters 5 (pages 185–86, on *Born on the Fourth of July*) and Chapter 7 (pages 316–17, on *Nixon*) are adapted from voice-over narration written by the author for the video essay series *Oliver Stone: The Official Story*, which appeared on the website of The Museum of the Moving Image in 2008; parts of the *Alexander* interview (383–94) are from a 2011 interview of Stone at the Museum; all material used with permission of the Museum of the Moving Image.

Article on Nixon by Corky Siemaszko courtesy New York *Daily News*: p. 333.

Excerpts from *Born on the Fourth of July* (207–11) reprinted with permission of Akashic Books.

Excerpts in End Notes from *A Cinema of Loneliness* reprinted with permission of Oxford Publishing Company.

Image Credits

The majority of photos, script pages and other documents in this book come from the files of Ixtlan Productions or directly from Oliver Stone, and are used with permission of Stone and Ixtlan, including: front cover (left and middle), pp. 18, 19, 26, 28, 32, 33, 34, 37–44, 46, 47, 49, 51, 52–61, 68, 70, 74, 77, 82–85, 91, 94, 111–14, 117–18, 121–24, 128, 134–48, 150–51, 153–56, 158, 160–62, 164 (note by Stone), 165, 167–69, 172–77, 179 (Polish *Platoon* poster), 179, 182, 184, 188, 196–200, 201 (split diopter note), 203–04, 215, 218–21, 229–30, 231 (storyboards), 234, 242, 244, 252–54, 257, 260–61, 264–67, 272–74, 282, 292, 296, 297 (storyboards), 298–301, 301 (knife instruction), 304, 306–07, 314, 322, 333 (*New York Daily News* clipping), 334–35, 338, 347, 349–52, 353 (Stone in broadcasting

booth), 354, 356 (top), 357, 360, 366–67, 374, 376, 401, 407, 430 (masks on wall of Ixtlan Productions), 439–40, 442.

Many of these photographs and ephemera, including the left and middle images on the front cover, were re-photographed by Matt Gush.

Production photos from *Snowden* are used with permission of Open Road Films: pp. 448–54, 457.

Still-frame images from Stone's films, still-frames from movies that influenced his life or fueled his personal development, and press kit photos or posters: pp. 2–4, 5–9, 12, 14–15, 63, 64, 72 (top: *Who's That Knocking at My Door?* still-frame), 78, 79–81, 89–90, 91, 97, 97–99, 108 (Universal Pictures press kit photo), 108, 110, 115, 117, 119, 120, 121 (*Eight Million Ways to Die* poster), 126–27, 130–33, 152, 157, 159, 163–64, 167 (*Platoon* press kit photos), 170–71, 180–81, 190–93 (still-frames from *Wall Street*, *Ace in the Hole*, and *Sweet Smell of Success*), 194–95 (still-frames from *Wall Street*, *The Wolf of Wall Street*, *Gangs of New York*, *Born on the Fourth of July*, 201 (split diopter still-frames), 204, 207, 212–13, 214 (*Lost Patrol* still-frames), 216–17, 224–25, 232 (*The Doors* still-frame), 233, 235–41, 247–51, 256, 258 (*JFK* and *High and Low* still-frames), 262–63, 268–72, 277–78, 280–81, 283–86, 295 (*Natural Born Killers* still-frames in collage), 297, 302, 303 (top), 305, 308–13, 316–20, 323–30, 336–37, 339, 342–46, 348–49, 355, 356 (bottom), 358, 361, 362 (bottom), 364, 379, 383, 386–93, 394, 396–99, 400 (top), 402–03, 405–06, 408–13. 416–24, 426–28, 432–36, 440, 443, 445, 447, 458–59, 460–73.

Associated Press: pp. 75, 87 (AP Photo).

Bobby Doherty: front cover (right), p. 415.

Getty Images: pp. 75, 201 (copyright 1982 *Denver Post* [Kenn Bisio]/Getty Images), 222 (copyright 1990 the Ron Gallela Collection/Getty Images), 223 (copyright 1976 New York *Daily News* Archive/Getty Images).

Getty Images Sport: p. 363 (copyright 1967 Getty Images Sport [Tony Tomsic]).

High Times: p. 429.

New York *Daily News* Archive: pp. 87.

New York magazine: p. 380.

Matt Zoller Seitz: pp. 25, 372–73, 401.

New York University photo archives: p. 76.

Film Comment and *Film Threat* covers: pp. 285, 289 (from the personal collection of Wallace Stroby).

Reuters (Tony Gentile): p. 441.

The estate of Ross Hall: p. 321.

Sight and Sound magazine: p. 291.

The Topps Company: pp. 35, 353.

Acknowledgments

The Oliver Stone Experience would not exist without the generosity, patience, and hospitality of Oliver Stone, his wife Chong and his daughter Tara; Oliver's staff at Ixtlan, in particular Janet Lee and Michael Harkins; Oliver's *Snowden* co-producer Moritz Borman and his cinematographer Anthony Dod Mantle, and everyone associated with the movie's distributor, Open Road Films. Thanks are also due to Howard and Jill Kirsch, Stephen Neave and Eric Albrecht, Amy Cook, Trey Moynihan and Hannah Seitz; publisher Adam Moss and my editors Lane Brown, Gazelle Emami, Gilbert Cruz, and Josh Wolk at *New York*; publisher Chaz Ebert, content editor Brian Tallerico, managing editor Matt Fagerholm and associate editor Nick Allen at RogerEbert.com: They collectively made it possible for a working journalist and single father to drop everything and go where the action was.

I also offer deep gratitude to consulting editor Rebecca Carroll, who helped shape this book philosophically as well as narratively; designer, Martin Venezky, a collaborator on two prior volumes who topped himself this time, under impossible circumstances; contributors Ramin Bahrani, Jim Beaver, Walter Chaw, Michael Guarnieri, Kim Morgan, Kiese Laymon, Keith Uhlich and Alissa Wilkinson, who provided unique perspectives on Oliver's life and work; Ron Kovic, who let me have an excerpt from *Born on the Fourth of July* at friend rates, out of affection for Oliver; Robert Abele, Margy Rochlin, Kim Morgan, Alonso Duralde, and Dave White, my regular hosts in Los Angeles; Michael Jacobs, Michael Sand, Eric Himmel, Steve Tager, John Gall, Michael Clark, Richard Slovak, Tricia Kallett, Danny Maloney, Mary Hern, and Liam Flanagan at Abrams; Steven Santos, Anath White, Talia Lugacy, Margaret Nagle, Aaron Aradillas, Sean Burns, Tony Zhou, Wallace Stroby and Bilge Ebiri, who gave me insight (and some artwork); Rob Humanick, Scout Tafoya, and superhero Simon Abrams, who helped me during the toothbrush-on-the-tiles phase of production; photographers Matt Gush and Bobby Doherty; my regular transcriber, Jeremy Fassler, aka The Flash; Lily Puckett, who handled intellectual property clearances and scheduling; David Lambert, who helped me sift through thousands of documents and photos at Ixtlan; *New York Magazine*, The Museum of the Moving Image, *Salon* and *The New Republic*, which indulged me as I wrote about and interviewed Oliver obsessively between 2009 and 2016; my followers on Twitter, who supplied me with some questions, obscure facts, and suggestions for additional reading and viewing; and critic and filmmaker Kevin B. Lee, who in 2008 collaborated with me on a four-part series of videos about Oliver's films that influenced four chapters of this volume.

Finally, I offer my deepest gratitude to my regular editor at Abrams, Eric Klopfer, a man of sound judgment and stylish eyewear; David Dixon, who in 1986 handed me a VHS cassette of *Salvador* and said, "You have to watch this right *now*," and the poet Marc Kaminsky, whose insights into storytelling and psychology shaped every page of this book.

FOR STEVEN FEUER

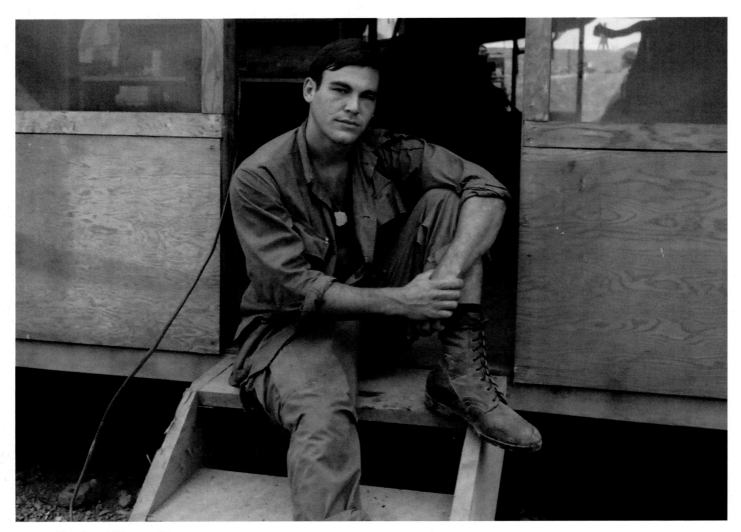

(above) Oliver Stone in Vietnam, 1967.

Editor *Eric Klopfer*
Consulting Editor *Rebecca Carroll*
Designer *Martin Venesky's Appetite Engineers*
Production Manager *Denise LaCongo*

Library of Congress Control Number: 2015949567

ISBN: 978-1-4197-1790-1

Printed and bound in China
10 9 8 7 6 5 4 3 2 1

 ABRAMS The Art of Books
115 West 18th Street, New York, NY 10011
abramsbooks.com